FACTORY MADE
Warhol and the Sixties

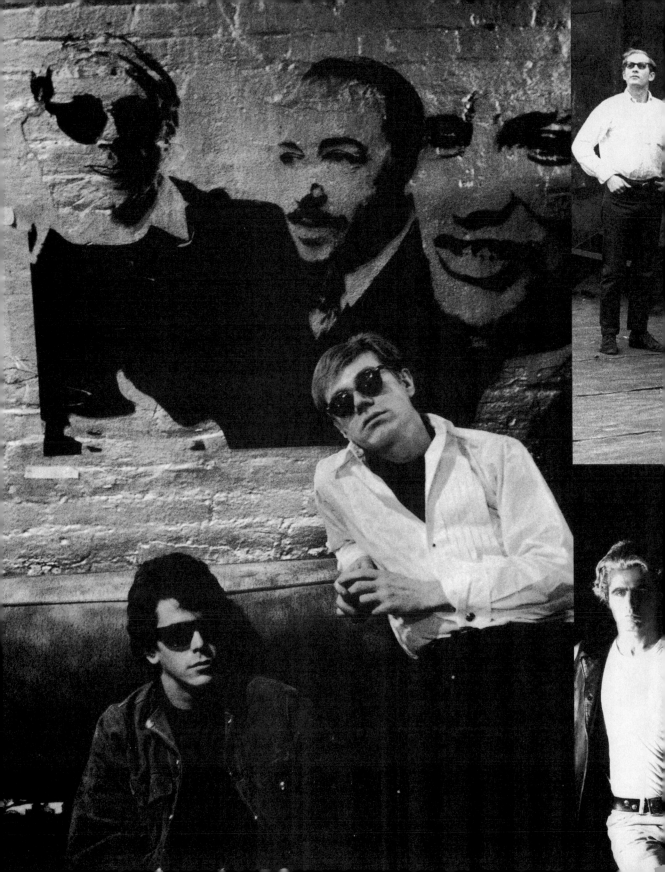

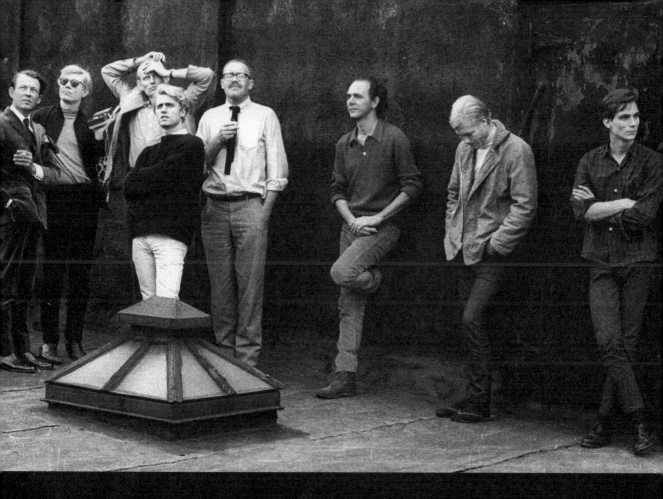

FACTORY MADE

Warhol and the Sixties

Steven Watson

 Pantheon Books, New York

Pantheon Books and colophon are registered
trademarks of Random House, Inc.

Permission to reprint previously published material
may be found following the acknowledgments.

Library of Congress Cataloging-in-
Publication Data
Watson, Steven.
Factory made : Warhol and the sixties / Steven
Watson
p. cm.
ISBN 0-679-42372-9
1. Warhol, Andy, 1928—Criticism and
interpretation. I. Title.
NX512.W37A4 2003– 700'.92—DC21
2003042970

www.pantheonbooks.com

Book design by Johanna S. Roebas

Printed in the United States of America

First Edition
9 8 7 6 5 4 3 2 1

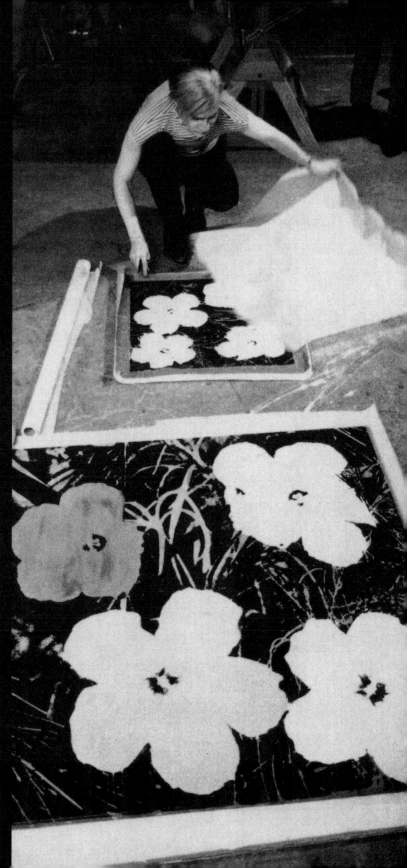

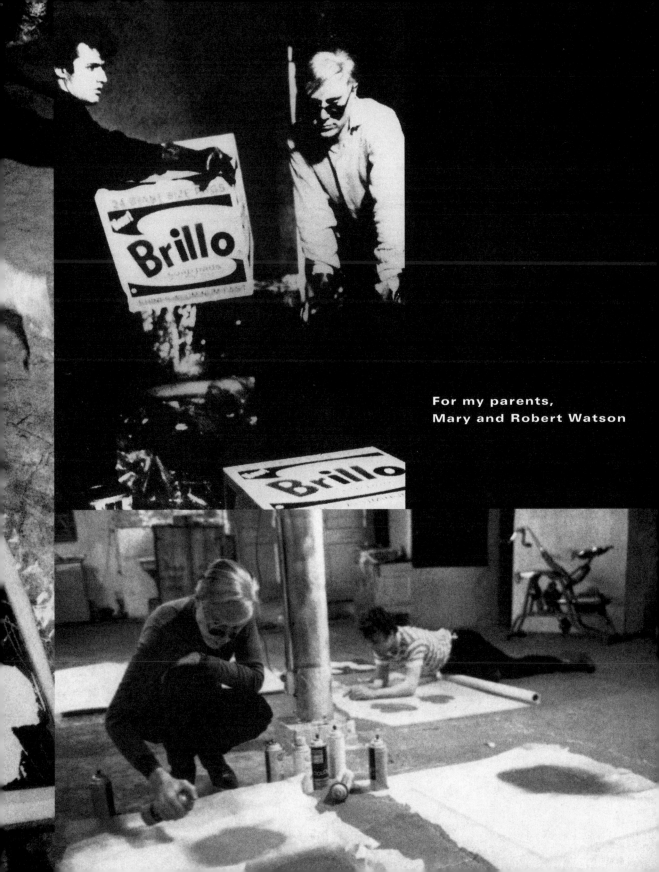

For my parents,
Mary and Robert Watson

Contents

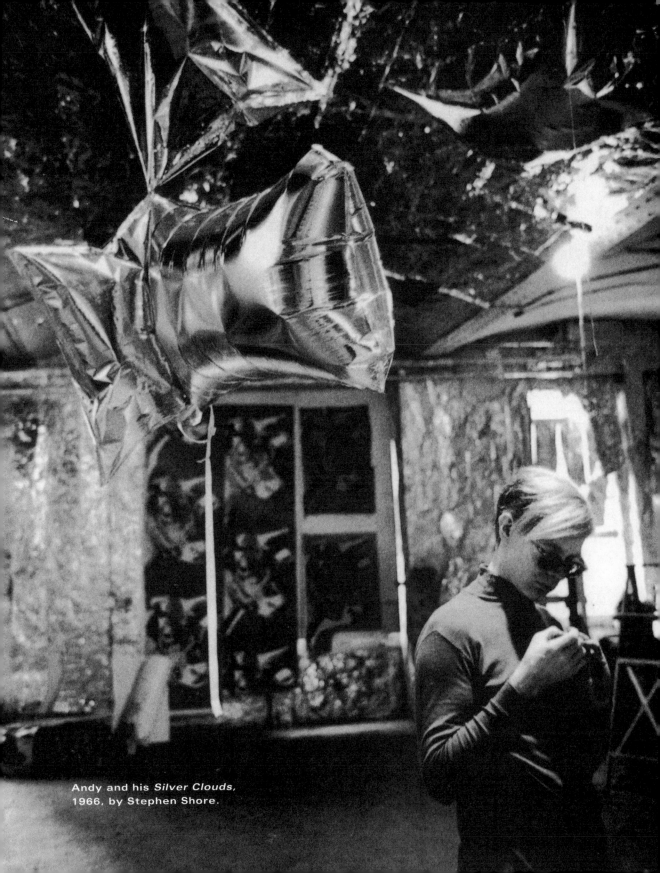

Andy and his *Silver Clouds*,
1966, by Stephen Shore.

Introduction

What is usually regarded as Andy Warhol's golden age started in 1960, when he began his earliest Pop paintings. It ended on June 3, 1968, the day Valerie Solanas shot him. He was declared officially dead for one and a half minutes.

Warhol lived on for another nineteen years, and even now, at the beginning of the new century, he remains the Great Posthumous Presence. His iconic silk-screened images—of Campbell's Soup cans and Marilyn Monroe—play in the public imagination. Auction prices continue to rise, exhibitions proliferate in museums and galleries, his place in art criticism and cultural theory expands, and Warhol-related consumer goods are marketed. It is as if Andy Warhol never went away. He was simply transformed into a tote bag, or a gender studies dissertation, or a reality TV show, or a thirty-seven-cent postage stamp. Long after his death Andy Warhol remains an enduring "brand," and his influence has permeated more aspects of modern life than that of any other artist of the twentieth century.

For a few years in the mid-1960s, during the Silver Factory era, Andy Warhol neither functioned as, nor aspired to the role of, the solitary artist. In 1965 he said he was leaving painting, and for a few years he returned to art only to finance his movies. What most interested Warhol at that time were activities that required collaboration and allowed him to create things that he couldn't do alone. Art making, especially in the form of movies, became an inherently social process.

In January 1964, he moved into the space that would come to be known as the Silver Factory. At the most literal level, "the Silver Factory" describes a geographical space (a fifty-by-one-hundred-foot former hat factory on 231 East Forty-seventh Street) over its four-year lifespan (from January 1964 to January 1968). That spatial-chronological nexus provided a social arena for collaborative experimentation. Within the first year at the Silver Factory, the combined connections of Warhol and his two assistants, Billy Linich and Gerard Malanga, generated a rich network of associations that reached into the worlds of poetry, fashion, film, art, and the amphetamine drug scene. The works produced during the Silver Factory period—more than five hundred movies, a record, a novel, hundreds of photographs—resulted from a group process. These works can be described in art-historical language, but they can also be discussed as artifacts of anthropology, sociology, and psychology. Taken together, they provide a mosaic portrait of the Sixties society that inhabited that space.

The group associated with the Silver Factory is often dispensed with in cursory lists: as speed freaks and drag queens, poets and Superstars, fashion beauties and avant-garde artists. Although many observers saw them as satellites revolving around a sun, dependent on Warhol's attention for their existence Warhol himself never described it that way. To dismiss Warhol's Silver Factory associates as fame-driven hangers-on, the Silver sleaze, is to spectacularly misconstrue his modus operandi. "I don't really feel all these people with me every day at the Factory are just hanging around me," he said. "I'm more hanging around them."

The artifacts of the Factory collaborations demand models of authorship that do not fit conventional monographic discourse, interpreting the artist as a solitary genius. The Factory group process of creation is inevitably flattened: whatever was created in Warhol's presence became "an Andy Warhol." One of Warhol's greatest "works" was, in fact, psychological: the creation of a physical/social place where people "performed themselves." They determined how they would present themselves to the camera or to the tape recorder; Andy Warhol framed them and pushed the button. The Silver Factory was a "social sculpture," in which Warhol broadened the concept of authorship. In an arena where everything was possible and self-determination was the rule, who could be credited as the author?

Warhol needed people to act as his hands for silk-screening (Gerard Malanga), his organizer (Paul Morrissey), his all-competent caretaker (Billy Name), his social buffers (Edie Sedgwick, Viva, Candy Darling), and his voice for books and interviews (Pat Hackett, Brigid Berlin). In

the process, Warhol often allowed his associates to do things they had never done before; he provided them an intimate stage for performing themselves. Some described that interaction's social dynamic as "mutual vampirism" while others just called it "total freedom."

Since its earliest years, just before World War I, the American avant-garde has been driven by overlapping social circles. They connected through little magazines, love affairs, patronage, politics, art shows, and operas. The works produced at the Silver Factory presented a magnitude of collaboration different from all of these. Previously, authorship was rarely at issue. But the trove of mid-1960s Factory work blurred the frontier between subject and author. Warhol's role remained ambiguous. Did he *direct* the Factory movies? Did he *write* the novel *a*? Did he *produce* the Velvet Underground's first album? In the usual meaning of those active verbs, Andy Warhol did none of these. Yet each project bears his imprint and would have been impossible without him. This ambiguity about authorship is different from the tradition of Marcel Duchamp's readymades. Warhol not only raised questions about authorship but made the process of creation a fundamentally social experience. Andy Warhol often made only the slightest transformations in the subjects he recorded. As he moved from silk-screened paintings to three-minute movie screen tests, the line between artist and subject became almost invisible.

The Silver Factory's collaborative experiments—especially the movies and the tape-recorded novel *a*—are less known than Warhol's paintings. Even *The Chelsea Girls*, the most widely seen of the Silver Factory films, demanded a great deal from an audience: watching two screens simultaneously, with bad sound. Others, such as *Sleep* and *Empire*, require hours of looking at subjects that barely move. The elements of narrative cinema have been erased: editing, story, continuity, activity. They require a different kind of attention than most audiences will give.

Discussing the Factory movies as "Warhol's works of art" is doubly problematic. It not only begs the question of authorship but suggests more specific intention than existed when the movies were made. Open-endedness was essential to the process and meaning of the movies. Warhol described them as "experiments." Warhol provided the equipment and the camerawork, while others acted within his arena of his provocatively encouraging permission. He sometimes provided a few minimal rules—don't blink, eat a banana, cut hair, take off your clothes—and then pushed the button. What would happen if a person

American avant-garde:
Alfred Stieglitz circle
(1900s–1910s)
New York Dada
(1910s–1920s)
Imagist Poets
(1910s)
Mabel Dodge's salon
(1910s)
The Harlem Renaissance
(1920s)
The Harvard Moderns
(1920s–1930s)
The Beat Generation
(1940s–1950s)
The New York School
(painters and poets)
(1940s–1950s)

were put in front of a camera for three minutes and called the outcome *Screen Tests*? What would result if you transcribed twenty-four hours in the life of Ondine and his friends and called it a novel? What would it look like to screen segments side by side and call it *The Chelsea Girls*?

The story told in this book does not aspire to art criticism or movie criticism or cultural theory or art history. Others have engaged those approaches, but often the Warhol-centric interpretations are comically at odds with the circumstances of creation. *Factory Made* tells the stories of a group in three dimensions, embedded in a few years in the social context of the mid-1960s. In that time the overlap between real life and reel life, art and gossip, tape-recording and writing became so blurred that resorting to the facts becomes oddly relevant.

Andy Warhol's role was essential—he was not simply the cameraman, but he was not exactly the director either. As participants here described it, he created an atmosphere of permission, and a visual aesthetic in his frame. His effect as a social sculptor had little to do with the time-honored constructs of charisma. Instead of being handsome, verbally adept, and charming, Warhol was self-conscious, blank, and unattractive. He could barely accomplish the most basic things: start a conversation, tell a story, move a camera, write a letter, make a meal, or arrange a party. His lack of competence in daily living skills sharpened his receptive perceptors. He relied on surface readings. He scanned headlines and tabloids, listened to the radio, flipped through fashion magazines; he played the same rock-and-roll records over and over; he watched television. The deployment of Warhol's inadequacies, and his benign permission inspired those around him to fill the vacuum.

The Silver Factory was, above all, a zone of possibility and play. Warhol greeted everything that happened with the same nonspecific enthusiasm. He absorbed the outlandish behavior of the Sixties culture, gleaning bits from art and gossip and fashion and movies. He simply said "wow" or "great." He didn't appear to filter reality as it registered on his radar, but of course he did. He framed. You were in the frame or you were not.

Warhol's role at the Factory was tantalizingly ambiguous. Were the Factory denizens a family, with Warhol as the permissive father? Was it a giant couch with Warhol as the silent analyst? Was it a court, with Warhol as its Machiavellian monarch? Or was it a movie studio, with Warhol as its passive mogul?

❏

The Silver Factory existed in a time of cultural upheaval now shorthandedly known as "the Sixties." In the popular imagination the Sixties are a semichronological period that began in the wake of Kennedy's assassination in November 1963 and continued until the Vietnam War wound down in 1972. The Sixties connote an era of political rupture and personal experimentation, and the activities of Warhol and the Silver Factory are at the center of that social context. Warhol's close friend Henry Geldzahler described him as a "recording angel," and Warhol documented the era from the perspective afforded him by the constellation of his Factory associates and his personal disengagement.

The Factory's overlapping concerns touched many key preoccupations of the era, from drugs, music, and sex to the ambiguities of gender, self-presentation, and the quest for fame. But it had remarkably few connections to the political activities of that tumultuous time: Vietnam, civil rights, gay liberation, or women's liberation. Warhol declared himself apolitical, voted only once, and avoided demonstrations of all kinds, but he was nonetheless thrust into political arenas by issues of the day: censorship, homophobia, sex, and drugs. The activities at the Factory became inexorably linked to that political shift, punctuated in 1968, when he was shot by a radical feminist.

The Silver Factory shouldn't be credited with all the activities that happened in its orbit, but it provided an extraordinary point of Sixties intersection. (Only Max's Kansas City connected Uptown and Downtown so broadly.) Warhol's oddly catalyzing presence provided a nexus. The Silver Factory operated at a moment when New York's downtown avant-garde provided an especially rich stew of activities. A list includes the Play-House of the Ridiculous, the Film-Makers' Cooperative, Max's Kansas City, Caffe Cino, Jack Smith's Cinemaroc, Judson Dance, and the Living Theater. The Factory drew from all of them for performers, inspiration, and audiences.

In order to delineate that complicated interaction of people, I drew a social map of the Factory relationships. They all feed into the phenomenon that is usually flattened to a single name: "Andy Warhol." These links—annotated with year of "entry" into the Factory and source of connection—provide the blueprint for the story that follows. The reader need not focus, just yet, on the details in order to recognize the advoracious pattern of connections. At the intersection of play, experiment, drugs, movies, and friendship, the Silver Factory still resonates today, nearly four decades later.

"Art is one big thrift shop."
—Jack Smith

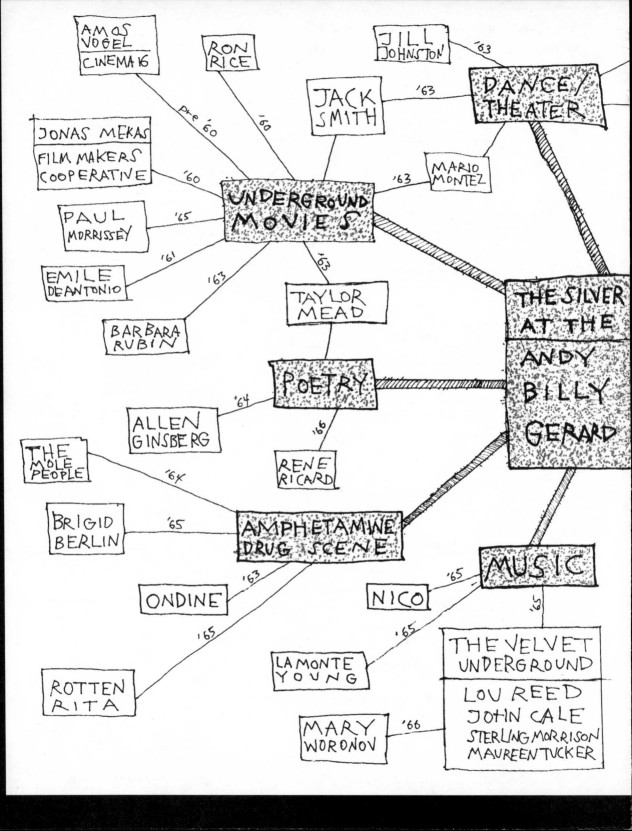

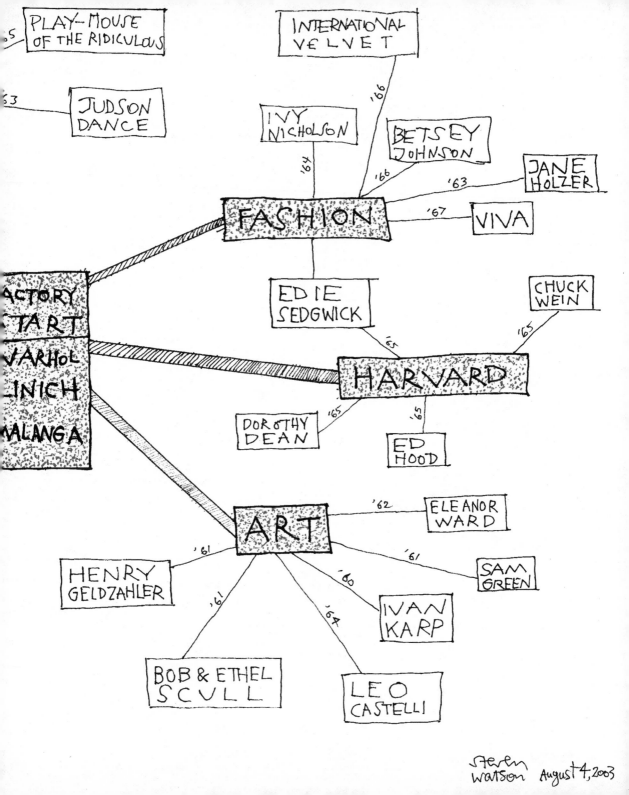

FACTORY MADE

Warhol and the Sixties

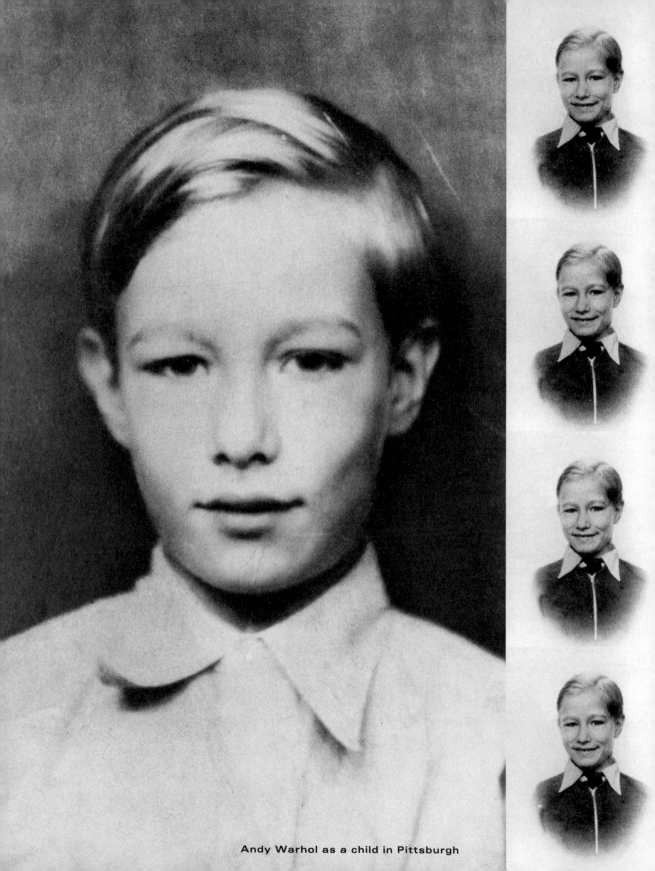

Andy Warhol as a child in Pittsburgh

Childhood Snapshots

The people who would come into the orbit of the Silver Factory grew up in America's postwar years, an era of cultural conservatism and financial comfort. The handful of childhood snapshots that follow show the early lives of the people who would shape the Silver Factory. They appear in order of birth; Taylor Mead is the eldest, and Joe Dallesandro is the youngest.

Taylor Mead usually declines to state his age: "Sometimes I say I am thirty-seven, or vice versa." In fact Mead was born at 3:30 P.M. on December 31, 1924. Raised in the wealthy Detroit suburb Grosse Pointe, he thought his social position was rather murky: "I felt like I grew up in the middle of the tracks," he said. "In society yet outside of it." His father, Harry Mead, ran Michigan's Democratic Party: he was a political boss who effectively manipulated power and provided the force behind Detroit's mayor, Frank Murphy. Harry Mead hated the Republicanism of Grosse Point, while his wife, Priscilla, aspired to its social life. Their conflict resulted in a separation shortly after Taylor was born, and he believes that it was only the stigma of impropriety and danger of abortion in the 1920s that allowed him to be born.

Taylor adored his mother and considered her "a cross between Irene Dunne and Mary Astor and Garbo." Her social position depended on her charm, her beauty, and her talent as a pianist. "She was

Birth Dates:
Taylor Mead:
December 31, 1924
Andy Warhol:
August 6, 1928
Valerie Solanas:
April 9, 1936
Bob Olivo aka Ondine:
June 16, 1937
Susan Hoffman
aka Viva:
August 23, 1938
Christa Paffgen
aka Nico:
October 16, 1938
Billy Linich aka
Billy Name:
February 22, 1940
Lou Reed:
March 2, 1942
John Cale:
March 9, 1942
Gerard Malanga:
March 20, 1943
Edie Sedgwick:
April 20, 1943
James Slattery aka
Candy Darling:
November 24, 1944
Joe D'Allesandro aka
Joe Dallesandro:
December 31, 1948

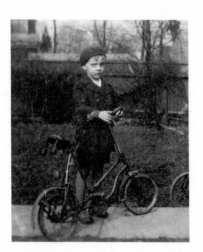

Taylor Mead, five years old,
August 1930

sort of one of the darlings of Grosse Pointe," said Mead. "And as a result I hardly ever saw her. I was brought up by black maids." Taylor would wait up late at night to hear the details of her evening at the country club or one of the grand houses of Grosse Point. Talking recently, he described himself as "a little boy with perfect clothes." His well-bred manners were peppered with bursts of outrageousness, which in retrospect he attributed to his insecurity over his equivocal social position. Even though the four-bedroom house he grew up in was altogether respectable, he was acutely aware that he lived on the edge of Grosse Pointe, and he didn't belong to the country club. "I don't think it bothered my brother so much, but it bothered me," said Taylor. "Because I had fantasies of being a king."

Taylor also had fantasies of travel. At the age of four he stowed away on a Greyhound bus because he wanted to ride on a bus and see the world. He walked up and down the aisles and chatted with the other passengers, and he seemed so at ease that it took a long time for anyone to realize he was alone. When he got to a little town called Washington Court, fifty miles from home, his family was notified. "There he was sitting on the steps of the hotel in his little red suit," recalled Taylor's older brother, Hudson. "He had wet himself, but he seemed very pleased at the publicity and being the center of attention."

From the fifth grade on Taylor became the star of school plays, turning everything into comic theater. He was so natural and commanding a performer that one of the teachers wrote a play for him called *Professor Obidiah J. Biddlebody*. In seventh grade, while playing an African king, he did an impromptu wild dance that brought the audience to its feet. When he was elected class president of the ninth grade, Taylor conducted meetings with an absurdist Robert's Rules of Order and insisted the class secretary sit on his lap. The teacher soon relieved him of his position, saying, "Taylor, you are conducting meetings in too much hilarity."

Mead was erotically aware from the age of five—at least he knew that he wanted the neighbor boys to tie him up or wrestle. He had his first sexual experience when he was twelve. While watching a movie, the boy in the next seat put his hand in Taylor's lap. Taylor immediately took him to a field outside the theater, under a full moon, and said, "Let's wrestle and no holds above the belt." Although he still didn't know the mechanics of sexual penetration, he had an orgasm riding home on his bike, and he now knew the exciting feelings that would later shape his

performing persona: he was beginning the transformation from "a little boy in perfect clothes" to a radical fag.

Andy Warhol sometimes said he was from McKeesport, sometimes from Philadelphia, and occasionally Hawaii; the birthdates he gave ranged from 1925 to 1931. When he imagined it in a 1971 film, Warhol said his mother gave birth to him alone at midnight in midst of a raging fire, and his first words were "Look at the sunlight."

Julia Warhola never registered the birth of her son. It was not until after his death that Isabella du Collin Fresne tracked down his birth certificate and the truth became clear: Andrew Warhola was born on August 6, 1928, in the bedroom of Andrei and Julia Warhola on 73 Orr Street in Pittsburgh. Both parents had emigrated from a small mountain village in the Carpathian Mountains in Ruthenia, formerly in Czechoslovakia, now in Ukraine. Theirs was an extremely marginal nationality—the Warholas were not just immigrants but eastern European, and the obscure location of Ruthenia, looked down upon by neighboring countries, put them at the bottom of the ladder. Bram Stoker portrayed Ruthenians as God-fearing peasants in *Dracula*.

The lot of working-class immigrants got worse at the onset of the Depression. Andrei lost his regular job laying roads for the Eicheleay Corporation, and he was forced to support his family with odd jobs, while Julia did part-time housekeeping for two dollars a day. She supplemented this income by cutting up tin cans, fashioning them into flower sculptures, and selling them door-to-door for twenty-five cents.

Warhol later described his home as "the worst place I have ever been in my life." The rooms in the brick row house were dark and cramped, and the five Warholas lived in these close quarters for six dollars a week. The apartment had a kitchen, bathroom, and two other rooms. Andy and his two older brothers slept in the same bed, and they bathed by sitting in a steel tub and pouring heated water over their bodies. Until Andy was eleven there was no radio, and so storytelling became the center of the Warhola home.

In the Ruska Dolina section of Pittsburgh little happened—it was a routine of work and church and making meals and sitting around. Andy grew to appreciate the slow pace of watching life. "Years ago people used to sit looking out of their windows at the street," he said. "They would stay for hours without being bored although nothing much was going

on. This is my favorite theme in movie making—just watching something happening for two hours or so."

The loquacious Julia Warhola presided over the storytelling evenings. She was a maternal woman with a broad face, a gap between her front teeth and thick gray hair that had once been blond. She often fractured Bible stories, telling Andy about "Moses born in the bull," and she created a myth of the days when, as an opera singer in Ruthenia, she had ridden from town to town on horseback belting out songs. She inevitably returned to her first meeting with Andrei, and the funny white coat and ribboned hat he wore on his wedding day. From the five-and-ten Julia bought comic books and read them aloud to her children in broken English. Andy became her main and devoted audience, and Julia noted that "Andy, he look like me. Funny nose."

From an early age, Andy had had a pasty complexion and was prone to sickness. He had trouble with his eyes at the age of two, a broken arm at four, scarlet fever at six, and rheumatic fever at eight. A side effect in ten percent of rheumatic fever cases was Saint Vitus' dance, a disorder of the central nervous system that resulted in a loss of physical coordination. Warhol was among that small group.

Andy's hand used to shake when he wrote on the blackboard, and when his classmates made fun of him, he became afraid to go to school. His sickness bound him to his mother, and her universal solution for sickness was an enema, followed by a cabbage and short-ribs dish called *kapushta*. He always referred to these episodes as "nervous breakdowns," and they figure prominently in his memory of his childhood.

These "nervous breakdowns" gave Andy uninterrupted time to cut and draw and think about movie stars. Julia plied him with movie magazines and coloring books and crayons. "Andy always wanted picture," said Julia. "Comic books I buy him. Cut, cut, cut nice. Cut out picture. Oh, he like pictures from comic books. I went to five and ten by my house." She rewarded him with a Hershey bar when he finished a page, and Andy grew to love sweets so much that she called him "my Andy Candy." It was during these months that Andy began absorbing the contents of movie magazines. He fell in love with Shirley Temple, and he painted a picture of Hedy Lamarr from a Maybelline ad but decided he could not paint and threw it away. But the seeds were planted for his obsession with movie stars and colored pictures. In the colored pages of comic strips he also found men who attracted him, even if they were not flesh and blood. "I had sex idols—Dick Tracy and Popeye," Warhol said.

"I had had three nervous breakdowns when I was child, spaced a year apart. I would spend all summer listening to the radio and lying in bed with my Charlie McCarthy doll and my un-cut-out paper dolls all over the spread and under the pillow."
—Andy Warhol

"Andy, just believe in destiny, you will get it in a dream . . . you will do something great, crazy, terrific."
—Julia Warhola

"My mother caught me one day playing with myself and looking at a Popeye cartoon . . . I fantasized I was in bed with Dick and Popeye."

Julia Warhola went to mass every day and observed Sunday strictly as a day of rest. Andy spent many hours with his mother in St. John Chrysostom Byzantine Catholic Church, where he absorbed religious images. The church was filled with incense and lit by rows of candles, and the lengthy liturgy was recited in Old Slavonic. Before Andy's eyes stood the iconostasis screen, which divided the sanctuary from the rest of the church; gilt gold outlined the arrangements of religious icons and provided the background for the holy figures. In the Byzantine Catholic Church the visual image was venerated as the mediator between the believer and the holy figure—the presence of an icon offered contact with the divine. Andy first experienced art through the religious paintings in the church, the mass-produced holy pictures that filled the Warhola household, and the commemorative card of the Last Supper stuck in Julia's Old Slavonic Prayer Book. This image would inspire his last paintings.

Andy's anxieties about school resulted in part from his learning difficulties. He had problems reading and writing, and the style of his misspellings and his later alienation from words suggest that he was dyslexic. He was verbal as a very young child, and Julia remembered him as a "wild baby" who began talking early and chattered away more than her other children. But his verbal imagination did not transfer to writing and reading. Social fears also contributed to Andy's school-phobia. He had problems with his skin: at eight he lost pigment, the other children called him "Spot," and his red, bulbous nose prompted his brothers to call him "Andy the Red-Nosed Warhola." Yet, Andy wanted to command attention, even at a young age. "I've always had a conflict because I'm shy and yet I like to take up a lot of personal space," he said years later. "Mom used to say, 'Don't be pushy, but let everybody know you're around.'" Andy had friends, most of them girls. He recalled not being close to anyone, "although I guess I wanted to be, because when I would see the kids telling one another their problems, I felt left out." Andy's outsider credentials had many dimensions: he was poor, dyslexic, eastern European, a mama's boy with a big nose and pale splotchy skin, sick, and spastic.

Andy's father, Andrei, was barely a presence at home, since he often worked twelve hours a day, six days a week. Andrei was eventually confined to bed as a result of peritonitis, and shortly before his death he left firm instructions. He had managed to save fifteen thousand dollars in

"I think I'm missing some chemicals and that's why I have this tendency to be more of a mama's boy."
—Andy Warhol

postal savings bonds to pay for Andy's first two years in college. When Andy was thirteen Andrei died in the night. The next morning Andy said that someone had awakened him by tickling his nose, and then he saw a body go out the door. That was his last sighting of his father, for Andy steadfastly refused to see his father laid out. He hid under his bed.

Andy was not an outstanding student—he graduated, ranked 51 in a class of 278, from Schenley High School—and was accepted by both the University of Pittsburgh and the Carnegie Institute of Technology. He

Andy in the student cafeteria at Carnegie Tech, c. 1948

chose the second, for Carnegie Tech offered a highly developed program in painting and design. Julia moved from the front bedroom so that Andy could have a proper studio, and she cashed in Andrei's postal savings bonds to pay the first-year tuition.

A few days after he celebrated his seventeenth birthday, Andy enrolled at Carnegie Tech, where he was regarded as the baby of the class. He had trouble with a freshman course called "Thought and Expression," which required verbal skills. After his first year Andy was placed on probation and made up work in summer school. He stayed up at night to work in his room with the lights on because he was afraid of the dark. During the daytime he sold fruits and vegetables from the tailgate of his brother's flatbed truck. In the process he came upon models for speed sketching. Taking about ten seconds for each subject, he would never move the pen from the paper. When he submitted his sketchbook, Andy was not only reinstated at Carnegie Tech but was awarded the forty-dollar Leisser Prize for best summer work by a sophomore. Over the next few years the faculty would repeatedly debate whether to drop Andy, but his supporters were ardent, and he polarized the faculty more than any other student in his class. Some of them appreciated the originality of his jagged line, and some wanted to protect his open naïve spirit. "He was like an angel in the sky at the beginning of his college times," said his closest Carnegie friend, the artist Philip Pearlstein. "But only for then. That's what college gets rid of."

In addition to his art, Andy joined a film club called Outlines, where he heard lectures by underground filmmaker Maya Deren and composer John Cage. He became the art director for *The Cano,* an undergraduate literary magazine, and was the only male member of the Dance Club. He also began to experiment with his persona. He bought himself a cream corduroy suit that friends called the dream suit and painted his fingernails different colors. He sometimes called himself Andre.

At the end of his college years at Carnegie, Andy aroused the sort of controversy that would later become his signature. In March 1949 the Pittsburgh Associated Artists held an annual exhibition, and Warhol submitted a painting entitled *The Bread Gave Me My Face, But I Can Pick My Own Nose.* Despite the support of faculty member George Grosz, the painting was rejected. Andy had fomented his first scandal.

After Andy graduated in June 1949, he considered teaching art in a local high school, but he knew that he wanted to go to New York, the center of the world. Without a clear plan or connection, he decided to join Carnegie classmate Philip Pearlstein and head for the city.

George Grosz (1893–1959) was a central figure of Berlin Dada during the 1920s and created bitter caricatures of the Weimar era.

"If anyone would have asked me who was least likely to succeed, I would've said Andy Warhola."
—Robert Lepper, classmate

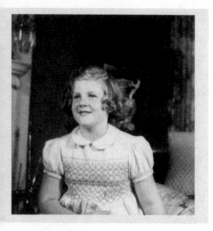

Brigid Berlin, the daughter of Honey and Richard E. Berlin, president of the Hearst Corporation, c. 1950

Brigid Berlin was born on September 6, 1939, nine months after her parents married. Her mother, universally known as Honey, was a twenty-one-year-old beauty, and her father, Richard Emmett Berlin, was a forty-three-year-old self-made multimillionaire. He had started out selling ads for *Yachting News* and worked his way up the ladder of Hearst Publishing to become chairman, putting him at the crossroads of the various components of the Hearst empire: publishing, movies, conservative politics, and society.

In her family's vast apartment at 834 Fifth Avenue, Brigid heard high-powered talk of people and places, and she came to understand early on her connection to movers and shakers, past and present. Brigid was named after the daughter of Carmel Snow, the legendary editor of *Harper's Bazaar,* and was taught to swim by the actor Van Johnson in Marion Davies's pool. New York mayor Robert Wagner gave his mayoral license plates to her father. Brigid recalled the family's Christmas midnight suppers, where Bobby Short played the piano and the guests included Ethel Merman, Morton Downey, Clark and Kay Gable, Cholly Knickerbocker, Joan Crawford, and Alfred Steele. When General Douglas MacArthur, the supreme commander of UN forces in Korea, returned to New York for his ticker-tape parade on April 20, 1951, eleven-year-old Brigid was perched in the second car behind the general's car wearing a gray coat and a plaid hat and passing by the crowd of 7.5 million people. "I remember waving, like that, because everybody was doing it," Brigid said. "I felt like such a celebrity at eleven."

A price was exacted for such celebrity at an early age; the Berlins held very clear ideas about how their children should fit into their social life. The mold was set, with hopes that their offspring would fit into it: two did, and two didn't. When their second child was not a boy, as hoped for, they nonetheless named her Richie Emmett Berlin after her father. Honey Berlin cared a great deal about appearances. She dressed the two girls, a year and a half apart, in identical cotton-smocked dresses made to order from Paris, with a sash and bow in back, plain unscalloped white cotton socks with cuffs turned down, and Mary Jane shoes in red, navy, brown, black patent leather, and white. If Honey thought her girls looked too pale, she pinched their cheeks until they grew rosy, and when she wanted their hair to have some curl, she took them to Marcelle for hot-wave permanents.

But Honey could not control Brigid in the arena of food. Her

Friends of the Berlins:
Joe McCarthy
Roy Cohn
Brenda Frazier
Shipwreck Kelly

"I don't think Mommie really cared about Richie and me. I think she really only cared about what we looked like."
—Brigid Berlin

appetite for ice cream, pies, Butterfingers, and Mars bars was insatiable and unstoppable. Brigid came to feel a link between food and performing because her father, who loved to take 16mm home movies of Brigid running toward him, always gave her a sweet as a reward. For Honey, the idea of having a fat daughter was a personal affront. The more her parents tried to thwart her eating habits, however, the more brilliant she became in refining her strategies of childhood rebellion, as recalled fifty years later in her essay "Sweets."

At dinner Brigid was allowed only diet food, served promptly at five-thirty in the afternoon on a card table in the corner of the dining room. But she was able to maneuver the cooks and nannies into feeding her. They would give her leftover mashed potatoes and look the other way when she stole a stick of butter from the pantry.

When Honey tried to control Brigid's food intake, Brigid responded by sneaking into the maid's dining room, which housed a freezer containing six flavors of ice cream from Henry Halper's drugstore. Brigid cut into the tall white cartons with a heated butcher knife. When Honey bought a doctor's scale and instituted a regimen of daily weighings, Brigid figured out ways to jimmy the scale by stuffing underpants and toilet paper under it. Brigid could always count on the aid of her sister Richie, the other black sheep of the Berlin family. The two sisters kept an altar in their bedroom, which lit up when they plugged it in, and they said mass to each other in the morning, with Brigid as the priest, using a white Necco wafer as the host. Brigid led a life of childhood rebellion amid a world of unsurpassed privilege. "I didn't ask to be born," said Brigid. "This is what they got so this is what they have to deal with."

Soon Brigid began peeling off hundred-dollar bills from her father's money clip—he never noticed—and telling her parents that she had to go to school early to study. Instead of proceeding to Convent of the Sacred Heart, she'd walk around the corner to Whelan's Drugstore for two chocolate malteds and jelly doughnuts. Then she proceeded to Schrafft's for a seven-thirty A.M. turkey sandwich on toasted cheese bread and a chance to stock up on fudge and candy, which she stashed in a Saks shoebox under her desk. She consumed everything she bought, and she was never full. By the age of eleven she weighed 160 pounds. "Where are we going to get your dresses next?" said Honey. "From Omar the Tentmaker?"

When the Berlins read about a hypnotist named Dr. Weinberg who appeared in *Life* magazine, they asked him to hypnotize Brigid. He made the hypnotic suggestion that all sweets tasted like codfish cakes, Brigid's

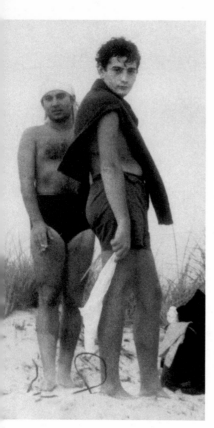

Bob Olivo becomes Ondine,
Jones Beach c. 1955, by
Harvey Milk.

least favorite food. When she finished her session with Dr. Weinberg, Brigid went to a newsstand and bought a Butterfinger, a Clark bar, and a Reese's Peanut Butter Cup. None of them, she happily found, tasted like codfish cakes. The Berlins took the next step. The family doctor prescribed amphetamines for Brigid. One of the effects of this synthetic drug, commonly prescribed in the 1950s, was a loss of appetite. Doctors had no idea of the turn that amphetamines would take in the 1960s.

Little is known about the childhood of Bob Olivo, who was born June 16, 1937, in Brooklyn. When his devoted mother, Ann, was recently contacted in a New Jersey nursing home, she declined to speak about his background, saying simply, "I was not a fan of Andy's gang." But she always remained a fan of her only child. She recognized early on that he was very bright and that he would need her. Bobby was bored by the pursuits of his childhood friends, but he pursued his theatrical instincts through the Catholic church where he served as an altar boy and wore extravagant vestments.

In the early 1950s, in a park in Jamaica, Queens, not far from Bob Olivo's house, a half-dozen homosexual boys hung out after school, calling themselves "Miss Thing" or "Lady Burma." When the neighborhood bullies chased them and called them sissies, the gang took refuge in a safe haven called the Three Star Diner, where the sympathetic manager let them linger in a booth without buying much. Bobby Olivo was the most commanding of the gang. "I sort of got this reputation in the fifties for being a wit, and for being very bitchy," he said. He attended Catholic school on scholarship, but by the time he reached his senior year, school officials threatened to withhold the scholarship. "I was caught in the men's room teaching some black boys to cha-cha," he said. "I was always being pulled off the table for doing 'Night Train' with a seventeen-foot fox stole."

Bob Olivo was given a new name one summer afternoon in 1954 at the Riis Park beach. As he emerged from the sea, a friend said he looked like the title character in Jean Giraudoux's play *Ondine;* the title role had recently been played on Broadway by Audrey Hepburn. "In the fifties you just couldn't go down to the beach without being Greta or Marlene or *somebody,*" said Bob Olivo, "so I went as Ondine, all the way through high school. I came out with a full-fledged identity."

❏

Christa Paffgen's versions of her childhood were largely fabricated, beginning with the date of her illegitimate birth and the identity of the father she never knew. Born in Cologne on October 16, 1938 (rather than 1942, as her official version had it), Christa Paffgen was christened on the eve of Kristallnacht; her name meant "daughter of Christ." The biography she provided of her fantasy father—an opium addict, a converted Sufi who lived in Tibet and India, and a friend of Mahatma Gandhi—differed from the usual childhood stories of made-up parents. From her father she inherited her towering stature, and from her more diminutive mother she inherited a dramatically beautiful face, with high, chiseled cheekbones and full lips. Her mother idolized Christa, her only child.

Among Christa's childhood memories—some more accurate than others—were trains on the way to Auschwitz, loudspeakers blaring American propaganda, thundering war planes, and dead bodies amid the rubble of bombed Berlin. Christa had few friends, and she performed poorly in school; her teachers considered her withdrawn and willful. She spent her hours home alone listening to the deep velvet voice of German diva Zarah Leander on the phonograph as she tried on her mother's clothes and hats, gazing at herself in a full-length mirror.

When Christa was fourteen, her mother found her a job as a shop assistant in a Berlin clothing store. She was supposed to climb a ladder to retrieve vests and corsets for the sales clerks. On her first day she publicly demonstrated her dislike of working. At the top of the aslant ladder she grabbed a box of vests, then let it slip through her fingers to the floor. She repeated the same dramatic gesture with a second box of garments, then a third. "I can't do this job," she calmly explained. "My hands are too clumsy."

Christa wanted to be discovered for her beauty, so each day she would walk up Ansbacherstrasse to the imposing facade of Europe's largest department store, Kaufhaus des Westens, known as KaDeWe, and hang around the huge doors. The strategy paid off when an agent for Berlin's fashionably exclusive clothing store, Oestergaard, invited her to become a walking mannequin for his salon at KaDeWe. This job taught Christa how to be a professional clotheshorse. "It was like an alternative school," she said. "I understood why everything had to be just as it was, which I never understood at school. I could see the effect of a walk, a turn, a position. And I was the center of attention."

From this point on Christa earned enough to support both her mother and herself. By the age of sixteen she began appearing in fashion

> "I cannot be surprised by hell, which I do believe in. I have seen hell, I have smelt hell, which was in Berlin when the bombs destroyed it. Hell is like a city destroyed, and it's beautiful to see."
>
> **—Nico**

magazines such as *Bunte Constanze.* A year later she moved to Paris to pursue modeling on a grander scale.

One afternoon a mentor, a handsome gay photographer with a single-word name, Tobias, told her that she couldn't continue calling herself Christa Paffgen. The name was neither international nor suited to her character and was certainly bad for business. Models should be called by one name. Tobias christened her Nico and that remained her name until her death. Christa Paffgen was buried, and the fabricated memory of her early life took over.

Years later, when he had become deeply immersed in Vedic astrology, Billy Linich looked back on his birth date, February 22, 1940, as both resonant and portentous. Part of its significance was the nature of his astrological chart, its sun sign on the cusp between Pisces and Aquarius, reflecting the transition from the Piscean to the Aquarian Age. And part was sharing the same date with George Washington, the father of his country. Billy's middle name was George and his father's first name was Washington, and it all seemed to go together. Billy Linich noticed these odd connections.

Billy recalled his parents as colorful tabloid figures in the style of the 1920s—"she was a flapper-type girl and he was a gangster-type guy"— who met at Woodcliffe Park, an amusement park with a roller coaster. During the Prohibition era Billy's father worked with the mob in Poughkeepsie, made bathtub gin, and drove a sixteen-cylinder Duesenberg. By the time Billy was born, his parents' jobs were less romantic and their means more modest; his father worked as a welder and his mother as a telephone operator. Since his father was a member of the ironworkers' union, Billy developed an understanding of the system of apprentices and journeymen, concepts that would prove useful to him in understanding the importance of mastering practical skills.

Billy Linich was introspective and independent in his interests. Instead of playing sports he read Henri Bergson and Khalil Gibran or hitched rides to nearby Vassar College to see Italian neorealist movies and MGM musicals. He liked to gaze at the Mid-Hudson Bridge, which was repainted every seven years with a heavy-duty industrial aluminum silver paint. "I always thought that was sort of a magic thing to do," said Billy, "paint a whole big thing all one color, silver." By the time he hit adolescence, Billy had grown tall and weedy and popular enough to be

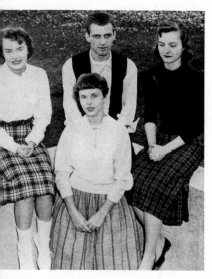

Billy Linich, president of his senior class, in his 1958 high school yearbook

elected to the student council and chosen senior class president. He was able to mask his shyness with a "Cold War–era cool" demeanor that could be mistaken for an all-American straight arrow. Although he recognized that girls in his school found him attractive, he couldn't quite imagine it, in part because he had a bad case of acne and in part because he knew he wasn't attracted to women. On weekends he surreptitiously went to Poughkeepsie's only gay bar, the Congress, but the closeted atmosphere made him feel paranoid.

Billy emulated new heroes on the screen, including Marlon Brando and James Dean. "I experienced this change as it occurred," Billy said. "In the poetic world it was the Beat Generation." He associated these new types with the fact that each year one of the class heroes would get killed in a car accident. "It became almost a death ritual when James Dean, our icon, got killed in a car crash," Billy said. "That's what we grew up adoring and idolizing." At the age of fifteen he went to a New York Chinatown tattoo parlor, put down fifteen dollars, and selected from a chart: a black panther for his biceps.

Billy Linich graduated from high school in 1958 as an honors student and immediately headed for New York without any clear plan. His aptitude tests predicted that he could be a success in business, but Billy was drawn to art. The only trouble was that he couldn't draw. His great-uncle, Andy Gusmano, who ran a barbershop in Poughkeepsie, gave Billy a three-piece barbering set that would provide an unexpected connection to Andy Warhol.

"I wasn't an outsider, but I was a person in Poughkeepsie with a secret. That made all the difference."
—Billy Name

Lewis Alan Reed was a first child, born at five A.M. on March 2, 1942, in Brooklyn's Beth El Hospital. His father, Sidney Reed (changed from Rabinowitz), was a tax accountant, and Toby Futterman Reed was a former beauty queen, now a full-time homemaker.

When Lewis was eleven, the family moved from their Brooklyn apartment to suburban Long Island, forty-five minutes from Manhattan. Dominated by ranch and colonial houses, Freeport was a suburban utopia with thirty thousand residents, mass-produced for postwar middle-class America. The Reeds' neighborhood, called the Village, was dominated by upwardly mobile Jewish families. Located at 35 Oakfield Avenue, the Reeds' single-story, angular home stuck out as 1950s modern; the neighbors referred to it as "the chicken coop." With their up-to-date home, two-car garage, and well-groomed lawn, the Reeds gave the

"I came from this small town out on Long Island, nowhere. I mean nowhere. . . . The only good thing about it was you knew you were going to get out of there."
—Lou Reed

appearance of a model 1950s suburban family. While his parents urged him to get good grades and become a doctor or a lawyer, Lou Reed hated Long Island and battled his parents' aspirations for his life.

The Reeds arranged for Lou to take classical guitar lessons at the local music store. When the teacher brought out the standard Mel Bay Songbook and asked Lou to play "Twinkle Twinkle, Little Star," he refused. He pulled out a Carl Perkins song and said, "Just teach me how to play that." That was Reed's first and last guitar lesson. But his fascination with rock and roll grew throughout his teenage years, fueled in part by the songs he heard on WGBB. He began collecting 45 rpm singles at the age of twelve, and soon stacks of black acetate disks had piled up in his room. That same year he wore a black armband, and he was certainly the only student at Carolyn G. Atkinson Elementary School commemorating the suicide of rhythm and blues star Johnny Ace. At fourteen, Lou had his first 45 pressed, a cover of the Jades' "Leave Her for Me," and the next year he sang "So Blue." He wasn't sure he could sing, but he felt completely confident about words. He wrote, "Half my head was taken up with rock-and-roll lyrics."

Music provided one way to rebel against Lou's existence, and by the age of thirteen he discovered something else that would disturb his parents: his homosexual feelings. "I always thought that's the one way kids had of getting back at their parents was to do this gender business," he later observed. As he reached his senior year, Reed was hanging out with "degenerate" members of his class, riding a motorcycle through the streets of Freeport, dating girls, smoking an occasional reefer, writing stories and poems about homosexuality—and listening to lots and lots of records.

"In retrospect, despite the fact that my childhood sounds as if it comes straight out of the film *How Green Was My Valley,* I was one of the luckiest boys ever born in Garnant."
—John Cale

John Cale was born on March 9, 1942, one week after Lou Reed, and grew up in a remote Welsh mining town called Garnant. John's father returned each day from the Geelllu Ceydrym coal mine so exhausted that he washed the coal dust from his skin and quickly switched on the radio. Music became the household's common tongue. "Music is a language as much as English and Welsh, and transcended them both in the ease with which I could use it to communicate," Cale later wrote. "It was a comfort I found nowhere else."

His mother did not fit the conventional image of the downtrodden coal miner's wife. Before marrying at thirty-six, she had taught primary school and pioneered a form of education that stressed inductive rather

than rote learning. John recalled her as "a vibrant, driven woman," and she made her only child the focus of her imagination. Early on he witnessed the joy she took in playing the piano, and he acceded when she signed him up for classical piano lessons at the age of seven. John initially hated the rigor of practice, but he found that it soon became a staple of daily life. He played the piano and then the violin, and on the radio he listened to whatever he could find. His tastes ran from the BBC Third Programme's *New Music* diet of Arnold Schoenberg and Karlheinz Stockhausen to Elvis Presley and Bill Haley from Radio Luxembourg or Voice of America.

Before he finished grammar school, John had already begun composing music; he was heavily influenced by Stravinsky's *The Rite of Spring*, whose thumping opening he likened to the first piece of rock and roll. One day when he was thirteen, two people from BBC Wales interviewed him for a program on talented children. They were impressed when he played them his one-and-a-half-page piece "Toccata in the style of Khachaturian" and gave them the manuscript. When they returned to Garnant to record John playing the piece, they forgot to bring the manuscript. John sat down at the school's grand piano as they turned on the recording tape. He played the first minute and a half from memory but still had to play another minute, so he improvised. He recalled that experience as liberating: "From then on I knew what I wanted to do: I wanted to play music and improvise."

> "I was so inspired and comfortable when she was there that I began to see her presence as crucial. Thus was born a lifelong reliance upon a collaborator to complete not only the work but *me*."
> —**John Cale on his mother**

When a marriage was arranged for Emma Rocco and Gerardo Malanga at the beginning of World War II, they were already middle-aged. Their only child, Gerard Joseph Malanga, was born ten months later. The Malangas lived in three small rooms in an apartment in the Fordham Road section of the Bronx. The bare floors were wood and linoleum, and among the few extraneous objects were a radio and later a television set. There were no books, for neither of them read; even speaking English was a struggle for Gerardo. But speaking Italian in the house was not permitted, for they were determined that their son would transcend their Old World roots to become fully American. Gerardo could barely foot the basic bills, working as the only non-Jewish freelance dry goods trader on Orchard Street. To afford extras for her son, Emma began working at the glassware counter at S. H. Kress. She made sure that her son, Gerard, had a copy of *Pinocchio*, and she bought him the second edition of *Merriam-Webster's Collegiate Dictionary,* a

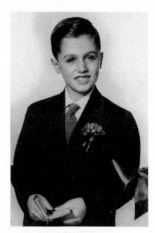

Gerard Malanga's first-communion picture, shot in a Bronx storefront studio, May 30, 1951

"Of all the memories I have of my mother, her untiring concern for my physical beauty still moves me to tears."

"Where my peer group was collecting baseball cards, I was an Orson Welles fan at the age of twelve."
—Gerard Malanga

subscription to the *National Geographic,* and eventually, a Smith-Corona portable typewriter. Most of all, she made sure Gerard could buy new clothes on layaway. He went to Bond's or a haberdashery at 125th Street and Eighth Avenue and recalled, "It was wonderful for a kid to go alone and buy my first real peak lapel houndstooth sports jacket, which was so gorgeous."

Before he was ten Gerard had impressed his parents with his drawings of local lampposts and cross-sections of the subway system, so the Malangas enrolled him in YMCA drawing classes two blocks away. When the teacher told them Gerard was "overgifted," they had aspirations that he would become an art teacher.

His twelfth year was a turning point in shaping his aesthetic consciousness. Through the drawing classes at the local YMCA Malanga became fascinated by the changing urban landscape around him. Upon learning that the Third Avenue Elevated was about to be torn down, he was determined to document its final ride with his Brownie Hawkeye camera. He pushed his way to the front car and planned out how he would use each of the twelve shots on his roll of Kodak film. He later jokingly referred to this early photography as his Lartigue period.

That same year, Gerard began turning the family's twelve-inch Philco to Channel 9 to watch *Million Dollar Movie.* This series marked the beginning of television broadcasting classic movies, and they were repeated each day for a week. His favorite movie was *Citizen Kane.* Instead of focusing on the movies' glamorous stars, Malanga cared about what happened behind the scenes, and he learned the different styles and logos of each studio. Unescorted by his parents, he haunted the local Loew's Paradise, the RKO Fordham, and the Valentine, a theater that showed not only rereleases but also foreign films that were advertised as racy. Malanga cobbled together his own version of movie history, collected the torn movie-ticket stubs he found outside theaters, and subscribed to a film trade magazine called *Box Office Barometer.* When it arrived in the mail each week, advertising movies that hadn't even been released yet, Gerard thought to himself with pride, "Wow! I'm in the know here."

The Sedgwicks had lived in the United States since shortly before the nation's birth and had some distinction but even greater pretension. A corner of the cemetery in Stockbridge, Massachusetts, known as the Sedgwick Pie, was designed so that the dead were laid with their feet

pointing at the center and their heads out. "The legend is that on Judgment Day, when they arise and face the judge, they will have to see no one but Sedgwicks," said one descendant, novelist John P. Marquand.

Edith Minturn Sedgwick was born in April 20, 1943, just after the family moved from Cold Spring Harbor, Long Island, to a fifty-acre fruit ranch in Goleta, California, a few miles north of Santa Barbara. The ranch was a crown element in her father, Francis Sedgwick's, peculiarly emphatic Arcadian dream, revolving around peak physical health, swimming, dogs, acreage, horses—and a full complement of children. The virtues of the western life were mixed with the inherited eastern values of associating with "top drawer" people, as defined by clubs and ancestry and school, what John Marquand called "the Groton-Harvard-Porcellian myth that he lived in." Although Edie's mother, Alice, suffered increasing difficulty in childbirth, her father was pleased he had sired more children than anyone else in his Harvard class. Edith, known as Edie, was the seventh child. The Sedgwick family ideal was reflected in a picture that *Life* magazine shot for an article, which never ran, about The Working Man. Here was the family by the fireplace after dinner, Francis reading to the youngest blond girl. Even here Edie managed to be in the exact center of the photograph closest to the fire, alone and captivating.

Despite Francis Sedgwick's desire to have children, he showed little interest in spending time with them and insisted that they call him not Father but "Fuzzy." He and Alice were utterly different from each other. When a Jungian analyst tested them, he found that Francis and Alice represented the most extreme examples of extroversion and introversion, respectively. The Sedgwick children thought their parents lived like Greek gods. Francis tended to his physique during uninterruptible morning exercises by the pool, writing novels, outside in a bikini loincloth, working on sculptures of horses—bombastic, self-confident animal figures. Both parents sang, with more gusto than skill, called each other "darling," and in the evening read aloud from Turgenev and Dickens. At dinner Alice dressed in an embroidered Chinese mandarin coat and satin pajamas, and Francis in a gabardine suit and bowtie. It looked like a very civilized life. George Plimpton, seeing them through a child's eyes, thought that they "made everyone else around feel a little rumpled and dowdy. I envied the children their parents."

There was also a more shadowed side to the Sedgwick family. In his twenties Francis had been diagnosed as bipolar, and he went through mood swings. Shortly after Edie was born, he added to his West Coast paradise a three-thousand-acre working cattle ranch in the Santa Ynez

"The tragedy was that along with their happiness and their incredible appetite for life, the forces of darkness were always there, although you would never have known it: the surface looked so good. So it was a life of extremes, paradise and paradise lost."
—**Saucie Sedgwick**

Valley. All this, for the grandiose purpose of helping the war effort, made the Sedgwicks land-poor. Francis's activities seemed manic, as did his increasingly open romantic affairs.

The older Sedgwick siblings had seen their parents in their golden youth, while Edie experienced the years of dissension. Edie later said to a movie camera that her father had had few sexual boundaries and had wanted her to go to bed with him from the age of seven on. She resisted the sexual advances of both her father and her older brother, who told her that "a sister and brother should teach each other the rules and the game of making love: and I wouldn't fall for that either."

When Edie was fourteen, she was sent home from the Katherine Branson School, in Marin County, because she had a pattern of intentionally vomiting after meals. Her oldest sister observed that Edie took her models of eating from her mother and father—in this, as in so many ways, opposites. Alice ate only special foods because of allergies, while Francis ate huge quantities, burning off the calories with exercise. Like her mother, Edie ate only special foods (and insisted on the same diet for her pet white rat, Hunca Munca.); like her father, she would eat great quantities, announcing to her sister, "I've got to go pig now." She would sit down to several courses of her favorite special foods. Between courses she would excuse herself to vomit. Very little reached her stomach.

In her early adolescence Edie walked in on her father making love to his mistress. He jumped up, slapped her, told her she didn't know what was going on. He said that she was insane, and a local doctor injected her with tranquilizers. Her mother was in denial that anything had happened, and Edie told friends that her father locked her in her room and kept her drugged. Edie had a double perspective about her parents' beautiful life. And she faced it alone, for by now all her siblings had gone away to school.

Traveling on New York 27, a few miles northeast of Lou Reed's hometown, Freeport, one came to Massapequa, where James Lawrence Slattery was born on November 24, 1944. His family had ties to the margins of glamour and show business—his mother had worked as a bookkeeper at the Jockey Club, and his grandfather was a retired vaudevillian who had been billed as "the strongest man in Boston." Jimmy felt close to his mother, but his alcoholic father terrified him, especially after unsuccessful days at the racetrack.

From an early age Jimmy had been mistaken for female, beginning

Jimmy Slattery's
favorites:
Lana Turner
Kim Novak
Joan Bennett
Gloria Swanson
Betty Grable
Zazu Pitts

when the Gertz Department Store in Jamaica, Queens, judged him the Most Beautiful Baby Girl. (His mother didn't dispute the prize.) "I was stage-struck when I was around four," he recalled. As Jimmy grew to adolescence, neighborhood kids called him "Marilyn" or "Greta," and their parents forbade them to play with him.

Real life could be found on television, not in the cops or Western series that were popular in the mid-1950s but in the constant reruns on *Million Dollar Movie.* When the theme music from *Gone with the Wind* came on, Jimmy could be found playing hooky from school, seated on the shag rug in front of the boxy television in the living room, glued to the Technicolor life of Hollywood in black and white. No one was home to supervise, as his parents were divorced and his mother worked. The same movie would be broadcast three times daily for a full week, so Jimmy not only watched but absorbed, line by line, pore by pore, costume by costume, the world of movies that were just old enough to become television fodder. In the process he became a repository of late-1940s feminine glamour.

Jimmy began acting out this life of movie glamour after seeing *The Prodigal* at about age nine. He wanted to become Lana Turner. Adding blue food coloring in the bathtub water to simulate Technicolor, he wound a yellow towel around his head to simulate blond hair, he put on his mother's backless gold heels and ocelot coat, and walked around the dingy Massapequa living room.

At thirteen Jimmy began to explore his identity in a small black diary. He wrote every day, trying out different styles of handwriting for his varying psychological roles, merging real life with movie dialogue; the line between the two was a thin one. He sketched exotic creatures in bubble baths with bouffant hairdos, invariably blond. (He passed the Famous Artists Talent Test but never pursued fashion drawing.) He had a revelation when he saw Kim Novak in *The Eddie Duchin Story.* "I think Kim Novak took over my life," he recalled.

Near the end of high school Jimmy Slattery looked back at the diary he began three years earlier: "Now I'm 17 going on 18," he wrote. "Life has changed so much for me since then." Jimmy had become insomniac and took sleeping pills. He had been introduced to sex with a salesman at a local children's shoe store. He had discovered a nearby gay bar called the Hay Loft, where he went in semidrag, and the other customers referred to him as "the Actress." When his mother found out, Jimmy told her to sit patiently at the kitchen table while he retired to his bedroom. He returned minutes later as a glamorous young woman. "Now, what are

Jimmy Slattery, aspiring to become his female self, c. 1954

you going to tell me?" he asked. "To live my life as a man?" Years later his mother said she had realized at that moment that there was no way to stop her son. He was too beautiful and talented to be just a boy.

When Joseph Angelo D'Allesandro III was born on December 31, 1948, his mother was sixteen years old. She had been married for two years to an Italian-American sailor, and just as Joe was beginning to recognize her face, she was sentenced to five years in a federal penitentiary for interstate auto theft. Her husband felt overwhelmed by the prospect of working and raising Joe and his younger brother, Robert, and none of the extended family stepped in to assist him. The two boys were sent to separate branches of the Angel Guardian Home, Robert to Brooklyn, Joe to Harlem. Joe's memory of his life begins in this inner-city agency, where he was one of the few white children among a group of African Americans up for adoption. Dallesandro's construction of his weeks in the home is largely based on things he was later told, for he was only three and a half at the time, but he now recalls it as a period when he had the power to choose any parents he wanted. As a healthy white baby, he was the pick of the crop. "It was just a matter of deciding which one I was going to say, 'Will you be my mommy?' to, and it was hard. I didn't want to say it. So you see, events in my life prepared me to be the kind of actor who could just come off the street and do it. I was taught to deliver lines when I was very young."

A Brooklyn couple named the Silanos decided to take both Joe and Robert into foster care, adding to the two children they already had. Living in Brooklyn until second grade, the family then moved to North Babylon, where the boys lived a stable life. Dallesandro thrived in his foster home and looks back on that decade as "the Wonder Bread years." But he could never reconcile the fact that his father visited him only once a month, and he decided that it was the evil foster parents who were keeping him away. "I couldn't understand it," he recalled. "I wanted my real father."

Joe first saw movies, lots of them, on television. Since he had trouble sleeping, his foster parents made a special rule: as long as he got up for school the next day, he could lie in the hallway outside their bedroom and through the doorway watch late-night movies. He watched the flickering images until he heard "The Star-Spangled Banner" play, signaling the end of the broadcast day, and then he would fall asleep. "I didn't have

any particular model for a movie star," he said, "but I loved the stories and imagined myself in them."

His foster mother recalled that Joe had a fairly conventional childhood, singing in the choir, delivering *Newsday* after school, but also that he had star qualities. "He had talent even when he was little," said Mrs. Silano. "My husband used to say, 'He is going to be a star.' "

"I started getting bad around twelve or thirteen," Joe Dallesandro said. He had always felt like an outsider at school, and he made up for his short stature by being tough. He had little control over his temper, and there were aggressive outbursts at school and at home. He desperately wanted his father to take him back, and on the monthly visits he would promise to not get in trouble. He tried to force the situation by repeatedly running away from his foster home.

His father finally agreed, and Joe moved in with him at his grandparents' house in Queens. But the trouble did not stop. He had felt inspired by seeing the movie of *West Side Story;* he loved the idea of belonging to a gang. That possibility was much greater in Queens than in North Babylon, Long Island. "When I went to the inner city and these tough guys tried to get tough with me, well, I just got into a thing where I beat up people all the time," said Joe. "It made me the leader to the school for a short while. There was no one tougher than me."

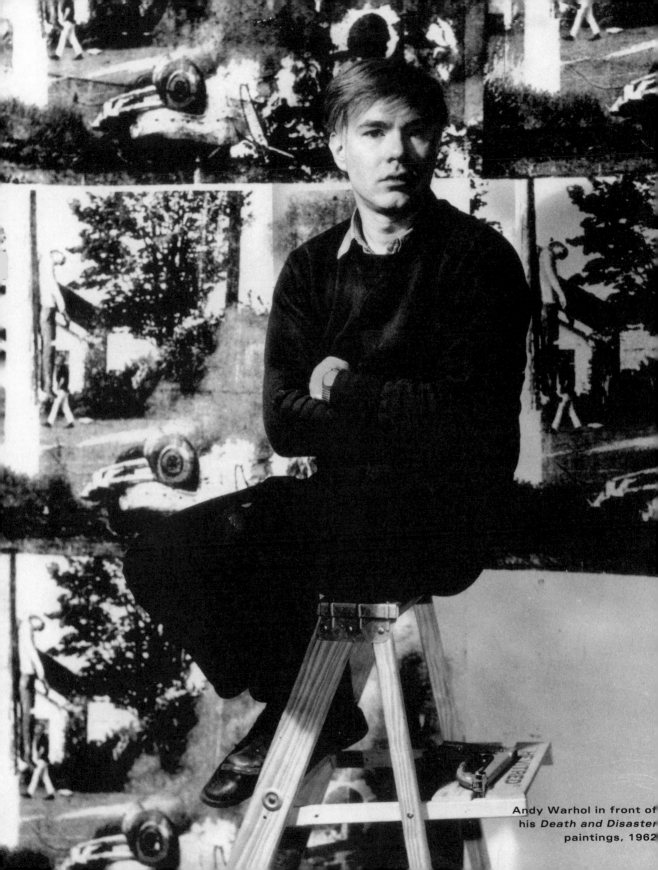

Andy Warhol in front of
his *Death and Disaster*
paintings, 1962

1960s Cusp

On Andy Warhol's second day in New York, he approached Tina Fredericks, the art director of *Glamour* magazine. She told him that she needed drawings of shoes, and she needed them the next morning by ten o'clock. She could not have given him a more perfect assignment. As a friend commented, "Andy not only loved shoes. He loved feet."

Andy Warhol's first published drawing appeared in the summer 1949 issue of *Glamour,* illustrating a story called "Success Is a Job in New York." It featured five shoes going up the ladder of success.

As the 1960s began, Warhol had climbed that ladder, seemingly with as little effort as the fey shoes in his illustration. Still in his early thirties, he bore the marks of material accomplishment: he had just bought a four-story townhouse at 1342 Lexington, designed in 1889 by Henry Handenbergh. His name appeared in a book called *A Thousand New York Faces and Where to Drop Them.* (He was listed not under "Artists" but under "Big Business.") He owned a modest but serious art collection that included paintings by Magritte and Tchelitchew, lithographs by Picasso, a drawing by Steinberg, and an aquatint by Braque. He wore hand-tailored suits from Hong Kong and expensive Italian shoes. He had won three Art Directors Club awards and was on a lucrative retainer with I. Miller Shoes. On the advice of his accountant, he had incorporated Andy Warhol Enterprises and invested in a diversified stock portfolio. The $71,000 that Warhol made in 1960 exceeded his earnings for any year in the 1950s.

From the moment he arrived in 1949, Andy's rise had been swift. He started off illustrating stories

in *Charm, Seventeen,* and *Mademoiselle* and drawing covers for Columbia Records; within five years he won his first top award in advertising. His biggest account came in 1955 when I. Miller invited him to do a weekly ad in the Sunday *New York Times.* Geraldine Stutz, who hired Warhol, explained that I. Miller, a venerable name in shoe fashion, "had gotten a little old-hat, a little passé . . . *slightly* over the hill." Andy's task was to update that image. For over two years he was given full pages and half pages in the Sunday *Times,* and best of all, they appeared in the Society section.

But Andy neither looked nor acted the part of a success in Madison Avenue's notorious "Ad Alley," whose income rose to nine billion dollars over the decade. Wearing thick geeky glasses, his hair perennially unbrushed, Warhol looked like a naïf. His daily uniform consisted of chino pants, a cotton T-shirt under a sloppy jacket, and paint-splattered sneakers. He never learned to tie his ties evenly, so he'd snip off the protruding end and keep a collection of them in a box. He carried his drawings in a brown paper bag, and when he opened it for an advertising presentation, a roach occasionally crawled out. Warhol wasn't embarrassed; it was simply part of his persona. He was known as "Raggedy Andy" or "Andy Paperbag." As he became increasingly successful, Warhol bought Brooks Brothers suits and Italian shoes, but he still contrived to look eccentric in the dandy tradition. He encouraged his cats to pee on his shoes to achieve the right patina before going into the world, and the backs of the shoes were scrunched down by his heels. "He wanted to appear shabby," said his friend George Klauber, "like a prince who could afford expensive shoes but couldn't care less and treated them as worthless." People thought he wore the same shirt day after day, but in fact Andy owned dozens of the same shirt.

His come-on lines for jobs were odd. A roommate of the early 1950s recalls him on the telephone, cold-calling potential employers. "I planted some birdseed in the park yesterday," he would say in a whispery voice. "And would you like to order a bird? And do you have any work for me?" The routine sometimes worked for Warhol—a friend called it "aggressive shyness." Warhol's eccentric exterior made him a memorable figure within the advertising world. Art directors who worked with him never forgot Raggedy Andy.

His illustration style was extremely recognizable: a look of casual sophistication, a lighthearted naïve Ben Shahn. In the classroom at Carnegie Tech, Warhol had experimented with inkblots, and from those experiments he developed his blotted line technique, the most primitive

handmade reproduction process. He hinged two pieces of Strathmore paper together with a piece of tape. He drew in ink on one side and, while it was still wet, pressed it against the adjoining paper. The ink adhered in a blotted fashion so that the line came out different each time, sometimes pooled or blotched, skittering along the page in irregular drips. He overlaid his line drawings with pastel washes of color, applying Dr. Martin's dyes slightly off register. Warhol often worked by tracing from photographs, borrowed from the New York Public Library photo collection, thereby twice removing the illustration from its original source. By 1955 he had hired an assistant, Nathan Gluck, to help him. Gluck noticed Warhol's interest in ways to work faster, to turn his images out from an assembly line.

However casual it appeared, Andy's rise was anything but effortless. He gained the support of art directors by making several versions of each assignment; they could select the one they wanted, and Andy passively accepted their choice. He plied his associates, from lowly secretaries to art directors, with unique yearly gifts. His most memorable strategy for remaining in the mind of art directors was sending them ephemeral promotional books. This practice, which Warhol began in 1953 and continued throughout the decade, was unheard of in the advertising trade. Seymour Berlin printed editions of 100 to 150 on white vellum stock, and Warhol held parties for his friends to color and fold them. The resulting books were fanciful and handmade. "Everything that Andy gave to you was either glued by his mother or stamped by Andy or folded by Nathan Gluck," said his friend George Hartman. "It was *very tangibly* the product of a human being." Long after other artists' postcards and posters had been thrown away, Andy's gifts became collectors' items.

Although material success was Warhol's driving ambition, it didn't deliver the glamour that he linked to celebrities and fame. His pursuit of fame struck his friends of the 1950s, from whom he constantly requested introductions to famous people, as a "peasant mentality." The most driven example of his campaign began a few years after he arrived in New York, when he saw a Henri Cartier-Bresson photograph of Truman Capote on the dust jacket of his first book *Other Voices, Other Rooms*. The twenty-three-year-old author embodied the kind of success that Warhol wished to emulate. Capote was connected to Greta Garbo and Cecil Beaton, and his book brought him attention in the camps of critics and tabloid gossips alike. Warhol pursued his new obsession with chilling industry, writing Capote fan letters nearly every day, trying to get into Capote's home, and stalking Capote outside the Stork Club. He even

devoted his first art gallery show, in 1952 at the Bodley Gallery, to works inspired by Capote's writings. Warhol's drive eventually led to an intense phone relationship that ended only when Capote's alcoholic mother yelled at Andy to stop bothering her son. "He seemed one of those hopeless people that you just know *nothing's* ever going to happen to," recalled Capote. "Just a hopeless, born loser." After the relationship cooled, Warhol transferred his obsession to others, hoping that their money or style or beauty would rub off on him. As his friend George Klauber observed, "More than anybody I ever met, Andy Warhol wanted to meet celebrities."

Warhol tried out several living situations—sharing a Village flat with Philip Pearlstein, then a basement apartment with seventeen roommates. For a while he lived by himself, but it was lonely and he was not used to taking care of himself. The problem was solved by the arrival of Julia Warhola and an assortment of cats. Julia moved from Pittsburgh in 1952 and remained in the same houses with Andy for nearly two decades.

Julia Warhola was a peasant woman in her early sixties, adrift in the big city. She arose before dawn, dressed in a simple cotton dress, a long apron, and a babushka and set about her daily chores. She helped Andy dress each morning. She swept the street in front of the house. She did the laundry and spread it across the furniture to dry. She made homey meals with mushrooms and barley, stuffed Czechoslovakian pancakes, and bologna sandwiches with "mayon-eggs," and she warned Andy about his appetite for chocolate and candy.

God and Andy were the two centers of Julia's life. She attended St. Mary's Catholic Church of the Byzantine Rite and made sure her son came with her every Sunday. He wore a cross on a chain around his neck and had in his pocket a rosary and missal. Julia was devoted and lively, but she lived in an utterly different world from her son. She threatened to move John Chamberlain's car crash sculpture in the vestibule to the rubbish. She seemed oblivious to his homosexuality and frequently wondered aloud when her son would get married. Friends rarely came to Andy's house, and when they did, he asked them not to swear in front of his mother. Julia regarded the male visitors as adopted sons and the women as potential wives. She'd say things like "You'd be a good wife for my Andy, but he's too busy." Early on Warhol saw the necessity of having a social center away from his mother.

Andy's social activities included gatherings of the advertising world and business lunches at the Café Nicholson; theater, opera, and movies filled in the gaps. He found a regular dinner hangout in an eccentric

Upper East Side general store–restaurant called Serendipity 3. Located in the cellar of a brownstone at 234 East Fifty-eighth Street, Serendipity specialized in rich chocolate deserts and was filled with art nouveau objects, the then-déclassé taste that Warhol embraced.

Andy had plenty of company during the 1950s, but intimacy proved elusive. He didn't have sex until he was twenty-five, with a boyfriend named Carlton Willers, a relationship that lasted a year. He carried on another charged affair a few years later with a man named Charles Lisanby, who was stylish and attractive and had the added cachet of working for Warhol's idol, Cecil Beaton. This relationship reached a disappointing emotional impasse in 1956 after Lisanby and Warhol traveled around the world. Warhol felt he had been spurned. His friend George Hartman noticed that when the affair didn't work out, Andy "became extremely *protective* of himself." Andy further shut down sexually, and his erotic drives were directed primarily toward voyeurism. He watched, and he listened, and he cultivated a state of aesthetic remove.

In the wake of his failed affair with Lisanby, Warhol made concerted attempts to alter his appearance. He did pinhole eye exercises so he could get rid of his glasses. To stay "pencil-thin," he worked out at the Twenty-third Street YMCA and became capable of doing fifteen dips on the parallel bars. To alter his red bulbous nose, a result of acne rosacea, he had his skin planed at St. Luke's Hospital. His face was frozen and sanded. It was extremely painful. "You stay in for two weeks waiting for the scab to fall off," Andy said. "I did all that and it actually made my pores bigger. I was really disappointed."

In his mid-twenties he became concerned about his growing baldness and took to wearing a hat that was not removed in theaters or at dinner parties. Andy's first hairpiece, purchased at the age of twenty-five, was a convincing brown streaked with gray. He soon replaced it with a uniformly gray wig, the first of many over the next three decades exploring the gradations between light silver and garish white. His perverse choice, which accentuated his blotchy pallor, didn't make him more handsome but moved the issue of attractiveness to a more aestheticized arena. "He told me he was from another planet," recalled Lisanby. "He said he didn't know how he got here. Andy wanted so much to be beautiful, but he wore that terrible wig which didn't fit and only looked awful."

Warhol's early domestic life in New York included a large group of roommates sharing a vast apartment at 103rd and Broadway. Much later Warhol described those years:

I kept living with roommates, thinking we could become good friends and share problems, but I'd always find out that they were just interested in another person sharing the rent. At one point I lived with seventeen different people in a basement apartment on 103rd and Manhattan Avenue, and not one person of the seventeen ever shared a problem with me. I worked very long very long hours in those days, so I guess I wouldn't have had time to listen to any of their problems even if they had told me any, but I still felt left out and hurt.

Back at Carnegie Institute of Technology, Andy Warhol and a few classmates had vowed that they would pursue the fine arts as well as the commercial arts; Andy's "Nosepicker" painting demonstrated his early ambition as an art world provocateur. Throughout the 1950s he hoped to be taken seriously in the art world and had several gallery exhibitions. None of Warhol's galleries were prestigious, and most of his exhibitions weren't even in stand-alone galleries: the Loft Gallery was a modest showroom adjoining an advertising office, Serendipity was a restaurant, and Bonwit Teller was a store. Just as they weren't "real" galleries, Andy's work was not regarded as "real" art. He was not on the radar screen.

Contemporary Galleries, early 1960s:
Kootz Gallery
Tibor de Nagy Gallery
Leo Castelli Gallery
The Tenth Street Galleries
The Green Gallery

It wasn't for lack or interest or effort. His drive to be included is suggested by his 1955 claim, stamped in gold, that "this Vanity Fair Butterfly folder was designed for your desk by Andy Warhol, whose paintings are exhibited in many leading museums and contemporary galleries." His friend Wynn Chamberlain witnessed a typical reaction: the gallery dealers who refused him a show laughed after he walked out the door. At one point Warhol and Ted Carey commissioned Fairfield Porter to do a joint portrait, a gesture prompted by the fact that Fairfield Porter showed with the Tibor de Nagy Gallery, the center of the Frank O'Hara–Larry Rivers circle. O'Hara provided another model for Warhol of a successful homosexual in the art world.

The sole recognition of Warhol as an artist came from the Museum of Modern Art, which included one of his shoe drawings in its April 1956 exhibition *Recent Drawings U.S.A.* (But when Warhol offered to donate *Shoe* to the museum's collection, Alfred Barr sent a polite rejection.) Emboldened by his museum exhibition, Warhol tried to enter the serious downtown art world through his former roommate, Philip Pearl-

stein, who showed with the Tanager Gallery, an East Tenth Street cooperative. Warhol submitted work that seemed designed to provoke: boys kissing boys. Explicit homosexuality was virtually unknown among exhibited work in the 1950s, and in contrast to downtown theater or film, the downtown art scene was avowedly heterosexual. Seeming to demand a double acceptance, both as an artist and as a homosexual, Warhol received neither. Pearlstein told him that the Tanager Gallery refused to show the work, saying that "the subject matter was treated too aggressively, too importantly, that it should be sort of matter-of-fact and self-explanatory. That was probably the last time we were in touch."

Andy Warhol continued to visit art galleries on Saturday afternoons. In January 1958 he saw a show of Jasper Johns's paintings at the Leo Castelli Gallery and he took it as a sign of a new phase in the art world. The paintings in Johns's first exhibition employed the most generic images: flags, Arabic numerals, targets, letters. Uninterpreted and unembellished, they were simply and physically *there,* rendered in a mixture of beeswax and pigment known as encaustic. These paintings turned their back on the subjectivity of abstract expressionism while remaining extraordinarily painterly. Two months later, when Warhol saw a Robert Rauschenberg exhibition at Castelli, he was confirmed in his belief that something new was afoot. At last he saw a way out of abstract expressionism.

Johns and Rauschenberg provided enviable models for Warhol. They were both homosexual and, at that time, were lovers. They were serious artists who were trying to break out of the ab-ex box, but they also had a foot in the commercial world, where they used the pseudonym Matson Jones. Like Warhol, they had designed Bonwit Teller's shop windows, under the imaginative reign of Gene Moore. At the age of twenty-eight Jasper Johns had already achieved critical acclaim— *Targets and Four Faces* appeared on the cover of January 1958 *ARTnews,* the Museum of Modern Art acquired four paintings from his first show, and Johns and Rauschenberg were key figures in the museum's 1959 exhibition *Sixteen Americans.* Warhol wanted to achieve for himself the acceptance of Johns and Rauschenberg, and as with his pursuit of Truman Capote years earlier, it became an obsession, driven by Warhol's professional transition from commercial illustration to the art world.

At the end of the 1950s, then, Warhol still had not arrived in the art world. Still, he had learned the strategies that would fuel his career over

the next decade: Work fast, and treat the world as an assembly line. Keep a voyeuristic eye on everybody, and deflect from yourself. Inspire people to do their best work for free. Find the fissures of provocation. Remove yourself. Depend on others.

"The Sixties" is not just the name for a decade but for a real-yet-mythical era of rebellion, America's great rupture. That seemingly cataclysmic break grew from seeds sown in the late 1950s and early 1960s, and downtown New York was a particularly rich ground for ferment. Among the early manifestations were experimentation with drugs, the multimedia of early Happenings, a resurgence in underground films, the beginnings of Off-Off-Broadway theaters, mimeographed little magazines, and alternative galleries. These ad hoc venues gave voice to the Sixties, and they were essential to its rich stew. As with most periods of cultural shift, the battle was waged in several arenas that combined politics, aesthetics, and lifestyle, mixing together sex, gender, drugs, rebellion, underground movies, and New York's downtown community.

The biographical fragments that follow will focus on the years just before and after the new decade began, arranged to represent some key issues that defined the decade.

Bettie Page
Born in Nashville in 1923, she became a pinup model in such magazines as *Wink, Eyeful, Titter,* and *Beauty Parade* and in photos that included S&M and bondage. In 1955 she was on the cover of *Playboy.* In 1957 she abruptly left her career at its height.

As the 1960s began, the concept of gender identity had little currency; it just wasn't part of the popular language that is now associated with identity politics. In the years right before Betty Friedan's *The Feminine Mystique* was published in 1963, women's roles were firmly prescribed in the 1950s mode. (The most influential feminist book was Simone de Beauvoir's *The Second Sex,* published in English in 1952.) There were a few sexual rebels, notably Bettie Page, who presented alternative images of sexuality. But their influence was limited to cult followings. The choices for being a woman were few in number and narrow in range.

There were even fewer public models for being homosexual. Publications directed at the homosexual audience consisted largely of physique magazines, and only a few openly homosexual publications were beginning, including *One, Drummer,* and the Mattachine Society publications. Gay bars included the loafers-and-jacket crowd on the Upper East Side, the Bird circuit (so called because many gay bars were named after birds), and bars in the Village. There were a few drag clubs,

including the Club 82, but they played to mostly straight audiences who came on tourist buses.

Within this social context, just before the Sixties began, the figures of this book explored several paths. In Paris Nico pursued a modeling career, embodying woman as goddess. In Maryland Valerie Solanas began to fashion barbs about the limitations of a male-oriented society. In Massapequa and New York Jimmy Slattery tried to find his place as a homosexual man who aspired to Technicolor female glamour. In California Edie Sedgwick showed symptoms of bulimia and anorexia nervosa, at that time undiagnosed maladies.

At the age of seventeen, in 1955, Nico moved from Berlin to Paris, and within the next few years she perfected the ice goddess look that she would maintain for the next decade. She claimed that it was Ernest Hemingway who urged her to dye her hair blond. "If a winner of the Nobel Prize told you to do something about your hair, that is something to consider," Nico said. "I could be a Nobel blonde." Her hair became ash blond, fashioned in long bangs that extended to her eyebrows to mask her large forehead and emphasize her luminous eyes and prominent cheekbones. She passed herself off as Swedish or Swiss, keeping her German roots in the background. Nico's beauty was crucially important to her identity not only because it sold products—face cream, clothes, dish detergent—and made her money but also because it drew people to her. As several close friends observed, Nico seduced people not for sex but for friendship. "She had romances, crushes on men, crushes on women," said her friend Carlos de Maldonado-Bostock. "But not lovers, never. Nobody could love her. She was unfuckable."

Nico developed a deeply ambivalent attitude about the power of her face and body. Did people want her because she was a statuesque mannequin? Because she was a sexual object? Because her image could sell face cream and detergents? Her appearance both connected her to others and prevented her from feeling like a fully formed person. She later sang a song lyric that put her quandary in a nutshell: "Have someone else's will as your own / You are beautiful and you are alone."

Her formal education was limited, and her interest in reading was practically nonexistent, although she carried a volume of Nietzsche's *Beyond Good and Evil* to polish her image. When she didn't know what else to do, she gave out a hearty laugh. "It covered up everything," said a

close friend from that period, "her ignorance, her lack of savoir-faire, her uncertainties, her fears."

Nico was in demand on the fashion catwalk and for print ads. But she felt caged by the limitations of modeling, and she regarded it as a springboard for something broader. She didn't know exactly what, but she trusted that fate would provide her connections. One such fateful connection happened at the end of the 1950s while she was sitting in a café on the Via Veneto in Rome.

Some friends who were acting in *La Dolce Vita* said that the director, Federico Fellini, was preparing to shoot an orgy scene, but no one knew how to act in an orgy. Nico thought she could advise them, and so she followed her friends to Cinecittà. From a table in the vast Mussolini-built studio, she picked up an elaborate candelabra, and this dramatic gesture excited Fellini: "I have dreamt of you," he told her. "I recognize your face. You will look wonderful with candlelight. You must be a star in *La Dolce Vita*."

When she told the director she was worried about acting, Fellini cast her as a model named Nico. The twenty-year-old Nico was hardly the film's star; she played in only a few scenes. He instructed her to chatter throughout her biggest scene, as she rode in the back of a convertible, her flaxen hair blowing. In another scene she removed the armored visor of a coat of arms and played with it on her head, and in another she bit the thumb of her on-screen fiancé. Cheeky, dramatic, and armored, these brief scenes offered a capsule portrait of Nico. Some of her lines could have come from her own life: "I finished modeling a year ago. Enough's enough."

Shortly after performing in *La Dolce Vita,* Nico met the man whom she thought was the prettiest man she had ever met—the French actor Alain Delon. In November 1961 she became obsessed with the idea that he would become the father of her child. Their offspring, she reasoned, would certainly be a creature to behold. It would also provide someone who belonged to her alone. During her brief affair with Delon she conceived a child and telephoned her friends in triumph. "It was like Snow White had met her prince," recalled one friend. Her friends and family urged her to have an abortion, but Nico remained adamant. "I just now want a baby of my own," she told them.

By the time Christian Aaron Paffgen (C for Christa, A for Alain) was delivered by cesarean section on August 19, 1962, Delon had forgotten his relationship with Nico. Her namesake, Nico Papatakis, signed the witnessing statement, and Delon denied paternity. Since Nico already

had a reputation for fabulizing her life, Delon's friends assumed that his alleged paternity was the product of her imagination. But when Christian Aaron, known as Ari, grew up, his face was the image of Alain Delon. Even as a baby, he looked so beautiful next to his mother that the publishers of *Elle* featured them on their Christmas cover in 1962.

Valerie Solanas presented a completely different image from Nico, wearing heavy men's shirts and short hair. An undergraduate at the University of Maryland in the late 1950s, she used her wit to attack the role men played: dominant and stupid. Her small public consisted of those who read her letters to the college newspaper, *The Diamondback,* and listened to her call-in radio show, where she instructed guests on how to combat men. On campus she was called "Maryland's own little suffragette," and one of her letters reflects her combination of comedy and bile:

> The he-man has had his hey-day, and the femmes are forging ahead. So, Stouthearts (if you are, indeed, Stouthearts), recapture your kingdom! Charge onward in your covered wagons! Take heed! Take arms! Take Geritol! Keep intact your ruggedness and defend your diminishing domain. But I must warn you, Stouthearts, your attack will be to no avail, since "The pen is mightier than the sword," and my pen is dipped in blood.

Valerie Solanas strikes a pose, c. 1957

Valerie Solanas was born on April 9, 1936, the elder daughter of Louis and Dorothy Solanas, a bartender and a nurse. Her younger sister, Judy, recalled her as tall and thin, always doing things faster and sooner than those around her. She played the piano at seven, read everything from Nancy Drew to Louisa May Alcott, and beat anyone on the block in Chinese hopscotch or double jump rope. She had a doll named Sally, a dog named Stinky, and a turtle called Myrtle, and she later described her childhood as idyllic. But it was not as easy as she made it sound.

Before Valerie reached adolescence, her father repeatedly molested her. "Valerie's sexual molestation by her own father, the one man she truly loved, catapulted her into an obscene, perverted world she could not comprehend," her sister wrote. "Who was there to protect her? Did she tell anyone, her mother, a teacher, her priest? Did they believe her or did they punish her for having the audacity to repeat such a horrid tale?"

At fifteen Valerie left home, and her mother said that she had run away to live with her father. In fact, Valerie was removed from school

because she was pregnant. She went to live with the Blackwell family at 723 Atlantic Street in Washington. When her out-of-wedlock son was born on March 31, 1953, the Blackwells named him David and raised him as their own. (Valerie never saw him again, and it was not until David Blackwell turned forty that he learned his mother's identity.) In the Solanas family the subject was completely closed. "I was told that Valerie had a baby, he was adopted by a 'decent' family and there was to be no more discussion about it," wrote her sister. "I doubt if anyone cared about Valerie's feelings."

Despite her irregular high school career, Valerie Solanas graduated with her class in 1954. Beneath her picture in the yearbook ran the caption: "Val. Brainpower and a lot of spirit."

Four years later Valerie Solanas graduated from the University of Maryland, with honors, elected to Psi Chi, the psychology honor society. Even more of an influence on her than her undergraduate courses was the work she performed in an animal laboratory run by Dr. Robert Brush. There she helped with experiments examining the difference between rats that learned to avoid electric shock and those that repeatedly resubmitted themselves to it. Later, of all Dr. Brush's assistants, Valerie stuck in his mind: "I would use the words *diffident* and *brash* at the same time," he said. "She was rebellious as hell." She buried herself in her work and began to make connections from rat genetics to the genetic basis of human personality. Using the scientific vocabulary and constructs she had learned in her psychology courses, she formulated theories about the differences between men and women. The animal research lab fed her increasing belief in the genetic basis for scientific determinism: the fact that men lacked a vital chromosome, she believed, led to their peculiar inadequacies.

As the 1960s began, Jimmy Slattery turned his obsession with female glamour into a profession. He enrolled in Laverne's Beauty School in nearby Rockville Centre, where he learned the basic techniques of hairdressing and makeup. He befriended a student named Sharon who would lead him to his first job. Sharon's mother, Lorraine, owned and ran the only beauty salon in Massapequa. Lorraine Brooks had performed a dozen years earlier at a female impersonator establishment called the Howdy Club where she was the only straight performer in the bunch. She recognized immediately that Jimmy was homosexual. She

warned her daughter to not fall for him as a boyfriend: "He's more likely to be a girlfriend." When her daughter questioned this assessment, Lorraine tested Jimmy. She spoke to him in homosexual vernacular—"Boy, dearie, you've really seen that right"—and Jimmy replied in kind.

That telling interchange put an end to romantic aspirations and also cemented a bond between Jimmy and Lorraine Brooks. She became his first employer and an all-accepting surrogate mother at a time when Jimmy didn't feel accepted at home, in school, or on the streets. Lorraine recalled that the Long Island ladies who frequented her shop not only accepted Jimmy but enjoyed his theatrical high spirits. "He was clever, he had a mind like a typewriter," she said. He filled the shop with gossip about movie stars and theater actors. He occasionally did Danny Kaye imitations or stood on the counter and sang Marlene Dietrich songs, such as "See What the Boys in the Back Room Will Have." He sometimes studied a middle-aged client and said, "I want you to look like Lana Turner in *The Prodigal*. Your hair is going to be cascading down your back." Or he might say, "This style suits you much better—oh, you have the 'Garbo look.' " If the customer protested that she wanted the same hair color she had had for the last five years, Jimmy persisted: she deserved to be more glamorous for her husband.

Early on, Jimmy Slattery developed the finesse that would make him so adept at passing as a woman. Some of the clients commented on the beauty of his eyes against his milky white skin; Jimmy had enhanced them with a delicate stroke of eyeliner so subtle that only Lorraine knew.

Although Jimmy always appeared bright with his customers, he told Lorraine Brooks about his sadness and his disagreements with his mother. When his depression was strongest, Brooks suggested he talk to a doctor. The visit would end with the doctor's prescription: male hormone shots to make Jimmy a man. He refused. He told Lorraine that he thought he was supposed to be a girl, and that his mother had taken male hormones at the time his genitals were being formed. (Using male and female hormones to explain sexuality was fairly standard practice in the 1950s; the typical alternative was the regimen of shock treatment that was administered to Lou Reed.)

In the early 1960s Jimmy Slattery began making his first trips to Greenwich Village. He never left home before dark and always phoned a taxi to pick him up at the modest Cape Cod house at 79 First Avenue and take him to the local train station, where he caught the Long Island Rail Road. When Jimmy boarded the train, he was dressed in simple dark

clothes. After he arrived in Penn Station and took a subway to Greenwich Village, Jimmy Slattery began to explore the possibilities of going semi-drag in public. He didn't wear a dress or high-heeled shoes, but he relied on an upturned collar, makeup, and attitude.

In 1958, at the age of fifteen, Edie Sedgwick was sent to St. Timothy's, an exclusive all-girl school in southern Maryland. At first her classmates thought Edie bubbly and dazzling, and her popularity peaked at Thanksgiving, when she was elected class president. A few months later her classmates noted some disturbing changes.

Edie's social pattern became increasingly fixed. She chose a single best friend at a time and did things exclusively with her in order to make the others jealous. Then she would drop the best friend and choose another, creating a tempestuous court of rivalries, showing her power and always insisting on displays of loyalty.

She began losing control in public, blowing up in classes, angering her teachers, exploding at friends, wearing the wrong color skirt and sneakers instead of saddle shoes. From the housemothers she racked up demerits (known as "tidy crosses"). In private she would fling herself on her bed, pick at her face, and bite her nails. Most disturbing was her eating habits. She would eat large amounts—what she called "pigging out"—and then force herself to throw up. Little was then known about the conditions of bulimia or anorexia nervosa.

Her exposed feelings and mercurial moods made her friends uncomfortable, but when she was up, she was both vulnerable and magical. A classmate recalled one such evening at the end of winter term. Edie, who was sitting in a white slip, a strap sliding off her shoulder, told her version of Sedgwick family life: "She made it sound like the perfect life and her family like gods. . . . We imagined adventures we'd have riding all day in the mountains getting sunburned, and then at night we'd wear long white dresses and bare feet and sit at the long family dinner table in the candlelight with all those handsome brothers. She made me fall in love with it." In Edie's portrayals, the Sedgwicks were monsters or gods, rarely humanly scaled.

Edie did not return to St. Timothy's the next fall. Alice became obsessed with protecting and caring for her, and Edie communicated in baby talk to her "mum-mum." With her father she exercised privileges that went beyond those of her siblings, driving his Mercedes 190-SL at will and passing as many cars as possible on Highway 101. Her younger

sister Suky recalled those days of dress-up, speedy cars, loud music, and ecstatic screaming. "But there was the fine line, too, between our fun and hysterics," she said. "Somewhere along the line, somehow—I seem to remember that the screaming turned into tears. It wasn't quite as much fun as it was supposed to be."

Alice tried to hide Edie's eating disorder from her husband, and he managed not to see it. They took Edie to Austria in lieu of returning to school. Within forty-eight hours the immensity of his daughter's problem dawned on Francis Sedgwick: she could not function on the most basic level of taking care of herself. He demanded that his daughter go to a psychiatric hospital called Silver Hill, where he had sent Edie's older brother Minturn a few years earlier. Alice threatened to leave her husband and take Edie with her.

In the fall of 1962 Edie entered Silver Hill, a private psychiatric hospital in New Canaan, Connecticut. Costing a thousand dollars a month exclusive of psychiatric care, Silver Hill operated like a country club; residents sat in antique Hitchcock furniture, dressed formally for dinner, and were always served from the left. In this setting Edie focused on perfecting her appearance, applying Germaine Monteil creams to her skin, using pale makeup to accentuate the contrast between her striking black eyes and her peaches-and-cream complexion, and wearing black tights to show off her long shapely legs.

As she had at St. Timothy's, Edie entered into extremely close bonds with her peers, which became struggles for control. She and a female patient at Silver Hill, for example, believed they shared the same soul, and one afternoon in her room Edie took control. The fellow patient later recalled, "I'd let Edie have it because she deserved it, being better or prettier or something, and Edie apparently agreed with me." At Silver Hill, Edie continued to pig out on food and then vomit, and her weight fluctuated out of control. When her weight dropped to ninety, Silver Hill recommended that she be moved to a more restrictive hospital. She was transferred to Bloomingdale, the Westchester Division of New York Hospital. Stripped of country-club gentility and luxury, all eating and medication were carefully monitored by student nurses. Edie's tough, vigorous female doctor refused any deviation from the rules, and Edie's eating habits finally seemed to be contained.

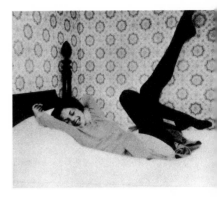

Edie Sedgwick at Silver Hill, 1962

At the beginning of the 1960s the Beat Generation style infused the idea of being a rebel in America. The Beat phenomenon—which exploded in

1957 with the publication of *On the Road* and the *Howl* obscenity trial—
had already become commodified in kitsch movies like *The Beat Gener-
ation* and television beatnik characters such as Maynard G. Krebs in *The
Many Loves of Dobie Gillis.* Those who wanted to rebel often wore jeans
and T-shirts, spoke hipster slang, and experimented with marijuana and
amphetamine. Their political positions had a low profile. They may have
believed in racial equality, but there was no broad civil rights movement
for them to join; they may have believed in women's equality, but there
was no feminist movement; they probably registered as Democrats, for
there was no SDS. In the era when the nation enjoyed peacetime pros-
perity and a popular uncontroversial president, Dwight Eisenhower,
both the critical mass and the galvanizing issues necessary to foment a
counterculture were absent.

Three snapshots suggest some of the rebel personas at that time.
Taylor Mead, by far the oldest, was a combination of Beat forefather and
wandering remittance man. Lou Reed was an adolesecent beginning to
experience his outsider status while still in high school. And Gerard
Malanga completed his senior year in high school as the 1960s began,
searching for his adolescent identity as a poet and a rock-and-roll
dancer.

Taylor Mead made it to high school graduation after spending periods in
progressive schools and at Loomis, an East Coast prep school. But he felt
that routinized education had destroyed his appetite for learning. He
had no idea where he could fit into the world, so he decided to study act-
ing at the Pasadena Playhouse. He didn't feel he learned much there
about performing, but he found the essays and plays of George Bernard
Shaw and immersed himself in reading them. This was perhaps the last
of Taylor Mead's focused attempts at formal study.

When Mead dropped out of the Pasadena Playhouse and returned
to Michigan, he knew no more clearly what he would do in the world. So
he decided to do the same thing he had done at the age of four—travel.
In the late 1940s Mead headed south from Detroit with fifty dollars in his
pocket, a radio in his hand, and his destination up for grabs. "I was prob-
ably the first to be truly identified with a portable radio," Mead wrote.
"My little red Emerson in the late forties and the fifties and my Nor-
mends [NordMende] later. FM had just come in, and there was nothing
but music on most of the stations."

When he was four, Mead had gotten only fifty miles, but now he went as far as his meager funds could take him. Beginning in the late 1940s he wandered for a dozen years, carrying the tradition of the *Wanderjahr* to epic proportions. He crossed from coast to coast five times and north to south another half dozen. His circuitous travels had little discernible pattern, but he enjoyed the absolute freedom of drifting imaginatively across America.

For Mead, travel provided the alternative to the routine world of work. He could hold a job for a short time—he even managed to successfully analyze stock trends for a Detroit broker. But there always came a point when he simply had to leave; he couldn't stand the deadening effect of routine. Psychiatric remedies had been tried, a year with a Freudian analyst and a summer in a psychiatric camp run by Anna Freud herself. But when the doctor suggested he had no real interest in change, Mead readily agreed. "I felt I had to go my own path to whatever 'recovery'—recovery from what?!? From Taylor Mead!?"

Over the years of wandering Mead subsisted on the hundred dollars his father sent each month by sleeping on beaches or back porches and heading south for the winter. He found himself in the subterranean landscapes of urban slums and country town bars that were a far cry from the Grosse Pointe country clubs of his youth. Along the way he ended up in a dozen jails. "No town understood me: the cops would arrest me on sight, just on general principles, and throw me in jail," said Mead. An early stint in a Columbia, South Carolina, jail crystallized his marginal position in society: "I had never been with a whole group of people, black and white, in a really common tank. And all social lines were just erased. A beautiful experience, actually. All that getting arrested contributed to my feeling of being an outsider. I began to appreciate the chaos of life more."

Mead discovered the darker side of prison life in a New York jail, known as the Tombs, and his first stint there was so grim that thereafter he carried a slim razor blade in case he needed to slit his wrists. Two of his New York arrests resulted from homosexual entrapment in cruisy men's bathrooms in Bryant Park and next to the Meat Rack in Washington Square Park. In the 1940s and 1950s he was beaten up, chased by gangs, and trapped in the Waldorf Cafeteria at West Eighth Street and Sixth Avenue. Mead appreciated the omnipresent edge of danger: "It was much sexier then. You never knew if the person was gay or receptive or *what*—whether you were going to get bopped or not. As a result a lot of

Taylor Mead, c. 1962, on the cover of his first published book, *Excerpts from the Anonymous Diary of a New York Youth*

so-called straight guys were much more open to going to bed. Policemen too. I loved the idea of straight and *not* straight."

After *On the Road* and *Howl* were published, Mead found the tribe to which he belonged. "Those people who dig me are approximately the cats who would dig *Howl* or *On the Road*," Mead wrote in the early 1960s. "They dig me because I'm succinct and real and don't go through a lot of complicated motions which might impose on some gloomy people as art." More than forty years later Mead still embraced the connection, calling himself "the last of the beatniks."

During his wanderings Taylor Mead wrote in a black notebook and sketchbook, and once he set his ballpoint to paper, he never changed a word. It was his own version of spontaneous prose, operating on Kerouac's principle of "First thought, best thought." Mead's pieces ranged from very short (like "Fuck fame") to a ragtag paragraph peppered with aphorisms, poems, taunts, and jokes. His writing was not publishable in the climate of the late 1950s, and it was distinctly unlike anything else that was then being written.

As he grew into adolescence, Lou Reed continued to rebel against his family and his school in Freeport, Long Island. Most disturbing to his parents was his talk about homosexuality. The family's struggle climaxed in 1959, when Lou was seventeen. They sent him to a psychiatrist. The doctor's prescription was chilling: quell his sexual rebellion and moodiness with electroshock treatment. The Reeds did not seek a second opinion; nor did they inform their son what was about to happen.

In the early summer of 1959 Lou Reed walked through the corridors of Building 60 in Creedmore State Psychiatric Hospital. During an uncomfortable moment in the waiting room, he saw a studded white metal door swing open to reveal what lay beyond: a pale figure lying unconscious on a stretcher. (Allen Ginsberg had gone through this same scene a decade earlier when he saw Carl Solomon and was inspired to write *Howl*.) Lou was next. A nurse strapped him to a table, gave him a sedative, and applied salve to his temples as he stared up at tubes of white fluorescence. "They put the thing down your throat so you don't swallow your tongue, and they put electrodes on your head," Reed recalled. When he regained consciousness, his skin was deathly pale, his eyes were bright red, his body twitched, and his memory was gone. The session of twenty-four shock treatments went on for eight weeks. Lou thought he had

become a vegetable, that every feeling, normal and abnormal, had been violently expunged.

This experience shaped Lou Reed's persona. He had the street smarts of his Brooklyn birthplace combined with the alienation of a teenage misfit in suburban utopia. And now he had rage to spare, which he could redirect into his songs. One song provided a simple commentary on his upbringing: it was called "Kill Your Sons."

After Lou graduated from high school in 1959, he struggled with the effects of the shock therapy. For a few semesters he attended New York University's Bronx campus, which was not far from the Paine Whitney Psychiatric Clinic, where he was enrolled in a course of intensive post-shock treatments. A friend recalled that weekly phone conversations with Lou were grim. Even on prescription tranquilizers, Lou could negotiate daily life only with difficulty. By the spring of 1960, when he finished his psychiatric treatment, he decided to go farther away from Freeport, to Syracuse University.

A large, expensive coeducational private university with Gothic buildings standing on 640 acres of land, Syracuse was mostly white and 1950s bourgeois, dominated by fraternities and sororities. Reed wore loafers, jeans, and sloppy T-shirts, his hair slightly long, sometimes straightened, and he could appear cute, pubescent, and slightly chubby. At other times he stuck out in the Syracuse atmosphere. One classmate summarized his position on campus as "Lou versus everybody else." When his friend Allen Hyman described hazing rituals, Lou's feelings about the fraternities became especially raw, so fresh were his memories of electroshock treatment. He asked, "What are you into—masochism?" He showed up at a Sigma Alpha Mu rush party wearing a comically small suit, covered in dirt. When a fraternity brother commented on Reed's inappropriate appearance, he responded, "Fuck you!" He was asked to leave. A few weeks into ROTC training Reed refused an officer's order and was summarily booted from the program.

Reed found his niche in music. WAER-FM, the campus radio station, provided one base. Shortly after he arrived at Syracuse, he started a jazz program called *Excursions on a Wobbly Rail*. On his jazz-dominated show, named after a Cecil Taylor piece, Reed mixed the free jazz of Ornette Coleman and Don Cherry, with James Brown, doo-wop, Dion, Archie Shepp, Hank Ballard, and rockabilly. He was constantly looking for new records for his show, and one night around three A.M. he heard someone downstairs playing Ray Charles and Lightning Hopkins. A few

"Syracuse was very, very straight. There was a one percent lunatic fringe."
—**Sterling Morrison**

minutes later he was knocking on their door, which was answered by Sterling Morrison, a fellow Long Islander from Bayport who played guitar. Borrowing a few albums for his radio show marked the beginning of a friendship that would bloom after the two men left Syracuse.

Lou Reed (center) playing guitar with his band, LA and the Eldorados, c. 1961

Reed's first band was acoustic, but in his sophomore year he went electric and formed a rock-and-roll band that was usually called LA and the Eldorados. Reed, an accomplished musician, was the motor behind the group, but his aggressive attitude earned him few friends among presenters. Sterling Morrison recalled that Lou Reed's bands got bad reputations so Reed would improvise new names for the band, such as Pasha and the Prophets. They arrived at their gigs with the same personnel and the same musical repertoire. Dressed in matching vests with gold lamé piping and jeans, the band performed at fraternity parties and Syracuse

bars for $125 a night. Although the band mostly played covers of songs by the R&B stars of the day, it also played some of Lou's first songs, including an early version of "Coney Island Baby," an insult song called "Fuck Around Blues."

On the other side of the Syracuse campus, both geographically and spiritually, was an apple-cheeked, bouncy freshman named Betsey Johnson. "She was not the lunatic fringe, she was very straight when she was there," said Sterling Morrison. "We used to make fun of her for that, that she ran with the wrong crowd." Before arriving at Syracuse from a small town in Connecticut, Betsey had attended a local dance school, where she learned to be a butterscotch candy, a flame, an octopus, Little Bo Peep, and a cowgirl. By the time she was a teenager, she was running her own dance group. Her enterprise entailed not only teaching routines to the dancers but also designing and making the costumes for them. In late high school her ambition was to join the June Taylor Dancers on television, but by the time she got to Syracuse, she realized "maybe Mitzi Gaynor or Jane Powell I'm not." She settled for the next best thing: cheerleading.

Through sleet and through snow Betsey led the Syracuse Wolverines. She would start off with a flip, then go into a mix of Spanish and jazz dance, peppered with no-handed flips. Betsey realized that there was no future for a cheerleader, but in the process she found out what clothes felt good for action. "I learned inside out to construct clothes that were good to move in, to dance in," she said. "And I could cut any idea I had in my head."

Gerard Malanga had never excelled in Catholic school. The nuns thought him too much of a chatterbox, and his grades weren't good enough to get into New York's best high schools. He even flunked tenth-grade English. But after enrolling at the School of Industrial Arts in 1957, Gerard began to polish his personal style, in both dancing and dress. Each day at lunch students brought in the 45's that Dick Clark played on *American Bandstand*, and Alan Freed on *The Big Beat*, and Gerard's friend Antonio Lopez added Tito Puente records. In the lunchroom they danced the lindy, the mambo, and the cha-cha, doing stylized dances crossing their hands overhead and twirling partners. As soon as school was out, Gerard raced home to catch *American Bandstand*.

Gerard Malanga as a teenager

Gerard got his first break in the fall of 1959, when a former date named Judy Kleinman invited him to be her dancing partner on *The Big Beat*. Alan Freed, the man who had named rock and roll, Mr. American Hot Wax, wasn't as big a name as Dick Clark, but his show broadcast live every afternoon from the Channel 5 studios on East Fifty-eighth Street. Gerard wore a sport jacket and tie, boots with pointed toes, and a hair dressing called Polymer that made his pompadour stand upright and held his carefully sculpted ducktail in place. The high school kids danced to top forty records, then watched as the day's guest singers lip-synched. Gerard soon became a regular dancer on the show.

When the record payola scandal broke at the end of October 1959, Freed's behind-the-scenes control in rock and roll was revealed, and *The Big Beat* was pulled off the air a week later. Gerard not only danced the last show but appeared in the *Life* magazine photo. "I was right up front, in focus," Malanga said. "I could say that that was my first appearance in the media."

In 1959, during his final high school year, Malanga was inspired by his English teacher, Daisy Aldan. "All of a sudden I was entranced," he said. "I could not wait to go to school every day because of this teacher, Miss Aldan. I sat at the front desk and I was hanging on every word she said in class. And I started writing love poems to her. . . . She was my guiding spirit through the world of poetry and poets. She made me aware of my feeling for language. She guided me in such a way that I willed myself into becoming a poet, to assume an identity—the identity of being a poet."

He wasn't the only student who fell in love with Daisy Aldan, but no one else in her class pursued poetry as ambitiously as Gerard. No ordinary high school teacher, Daisy Aldan was a published poet and translator of Stephane Mallarmé; like Gerard, she was fascinated with the Third Avenue El and had even made a movie about it; she edited poetry anthologies called *Folder* and later *New Folder*. The anthologies were illustrated with silk-screen prints by the Tiber Press, the prime silk-screen atelier used by artists during the 1950s. Daisy Aldan's circle of friends included most of the poets of the New York School. During Gerard's senior year, Donald Allen's seminal anthology, *The New American Poetry: 1945–1960*, was published, and Gerard realized how important his teacher's circle of poets was when he spotted all the familiar names in the table of contents. "I was already into name recognition," said Malanga.

Daisy Aldan recalled him—Jerry or Jer—as shy and attractive and "on the sidelines." His poetry came close to plagiarism, for he found

poets and emulated their style as his way of aspiring to become one of them. Alden noticed that he had "a tendency to write things that were meaningless but sounded good," but she was impressed by the poets he chose to rework, including Dylan Thomas and William Carlos Williams. "I knew he would get there," she said. "He recognized the famous."

Some notable poets read their work in Daisy Aldan's class. On one such visit Gerard Malanga began his ascent in the poetry world. The first rung on his ladder was meeting the poet Kenward Elmslie, for Aldan had assigned Gerard to escort him into the school building when he came to read. Gerard followed up Elmslie's classroom visit by writing a story on Beat poets—a two-page fold-out—for the school newspaper. Elmslie invited Gerard to his annual April 30 Loyalty Day party. Instituted as a camp nose-thumbing to the McCarthyism of the 1950s, Elmslie decorated his Greenwich Village apartment with Uncle Sam masks and draped it with red, white, and blue banners. Looking around the room, Malanga slowly realized that the guests comprised a galaxy of New York poets, including LeRoi Jones (later Amiri Baraka), Diane di Prima, Kenneth Koch, Frank O'Hara, Barbara Guest, James Merrill, and Howard Moss. "Every poet who was in Don Allen's anthology was in the flesh at this party," said Malanga. "I mean, you might as well be in a room with Hollywood movie stars. To me that was Hollywood." The Loyalty Day party and the Donald Allen anthology merged in his mind, a touchstone, prompting him to read the poets he had met and to collect their books and magazines.

Among them was fifty-year-old Willard Maas, who fell on his knees before the seventeen-year-old. As Gerard put it: "Willard saw his Rimbaud." Gerard was embarrassed by the ardent attention, but he also felt reverential toward Maas. He was a poet, after all, whose work appeared in anthologies. "I didn't catch the drift that he was a poet who was known from the early forties and late thirties, but not now." Maas pressed his phone number on Gerard and pleaded that he call. Daisy Aldan prevailed upon Maas to withdraw his attentions as long as Gerard remained her student. But Gerard had not seen the last of Willard Maas. His professional sensibility was being formed: a mixture of wide-eyed enthusiasm about the world, career energy, and an eye for stars.

The Sixties era is synonymous with drug experimentation and mind expansion, reflected not only in the wider use of drugs but also in the psychedelic look that it produced, whether in light shows, Peter Max

Names for amphetamine:

Blackbirds, Black Beauties: Strong amphetamine in pill form
Crank: "They call speed 'crank' because you wind your body up like a toy soldier." (Harvey Cohen)
Heropan: The Japanese name for amphetamines, referring to kamikaze pilots
Hexamine: Industrial amphetamine
Maxiton Forte: The French name for amphetamines
Pervitin: The German name for amphetamines, referring to Panzer troops

designs, or tie-dyed clothing. As the Sixties began, marijuana use was increasing in the wake of Beat-era visibility, and Timothy Leary was initiating experiments with LSD at Harvard.

The most widely available drug at the time was amphetamine, and most who used it did not even consider it to be a drug. Unlike marijuana or cocaine or heroin or peyote or opium, amphetamine was a strictly man-made psychoactive chemical. It carried neither the spiritual associations of opium nor the outlaw status of heroin. Whereas marijuana and heroin were popularly associated with Mexicans and African Americans, amphetamine was the drug of the white middle class. Offered to the public in 1932 in the form of the Benzedrine inhalers, amphetamine was seen by doctors as a panacea for everything from alcoholism and Parkinsonism to schizophrenia and obesity. Students used it to cram for final exams, truck drivers used it to make cross-country trips, and nurses used it for long shifts. Women often used it for dieting, for amphetamine produced a sensation that the stomach was tight and empty.

Brigid Berlin's pediatrician had prescribed amphetamine when she was twelve, to curb her weight. Over two decades she used it in all its forms. On September 6, 1960, when Brigid turned twenty-one, she inherited $150,000 from a family friend. Her parents had advised him against leaving the money to her, warning that she would just spend it all. She kept the $150,000 in an interest-free account so that she could access it at any time. A large chunk went into her residences. She had an apartment on East Sixty-fifth Street, which she furnished with expensive antiques. For her summer getaway she rented a house in Fire Island's gay community, Cherry Grove, and called it Brigid Dune. Her idea of an afternoon party was to send engraved luncheon invitations to three hundred people to come by her house, stipulating "no bathing suits" and have lobsters and poppers ferried in from nearby Sayville. Within a few years Brigid had gone through her inheritance. This did not stop her from spending money, but it necessitated new strategies. At first that meant charging items to her father's account, and later it meant stealing items from home and selling them for ridiculously undervalued prices.

In the early 1960s Brigid discovered another dimension to amphetamine: injecting it. She always stressed that she didn't go directly from swallowing Dexedrine pills to poking herself with a needle of liquid methamphetamine. The intermediary stage was initiated by a series of prominent society doctors. The first of them was the elegant white-

haired Upper East Side Dr. Freiman. Brigid arrived in his office in her Chanel suit and Hermès scarf, frightened about being injected because she didn't have any prominent veins. When she inquired whether it was going to hurt, Dr. Freiman pulled the Hermès scarf from her neck, blindfolded himself with it, promised her, "I'm going to make you feel better than any man has made you feel in your life," and shot her up.

The shot was a combination of methamphetamine, vitamin B-12, and lasix to counteract dehydration. She became a regular in Dr. Freiman's office, bringing along her younger sister Richie. The nurse, Willow, offered fresh strawberries and ginger ale from the refrigerator, and there was a large bowl of amphetamine pills that Brigid and Richie called "Lavender Lilies."

Soon Brigid and Richie found an even more prominent doctor, Dr. Max Jacobson, whose clients included John F. Kennedy, Tennessee Williams, Alan Jay Lerner, Winston Churchill, Eddie Fisher, and Stavros Niarchos. He was known as "Dr. Feelgood," and his shots often included amphetamine, steroids, placenta, calcium, and liver cells. As her desire grew for more frequent shots, she picked up a third dispenser, Dr. Bishop. Brigid and Richie often got shots from one doctor in the morning and another in the afternoon. "I got so thin, but it made me shop," said Brigid. "Oh my God. We'd leave there and beeline it to Bloomingdale's, and we'd change our outfits as we went through the store. We'd just leave whatever we were wearing in a dressing room, buy the new thing, charge it to our parents. It was charge to one, send to the other."

"There was nothing to make you feel marvelous like a quick purchase."
—Richie Berlin

The amphetamine market went through a sea change in the early 1960s, when illicit laboratories for manufacturing speed sprang up. The legendary underground pharmaceutical guru, Owsley, started the first of them in California, and he would soon supply Ken Kesey and his Merry Pranksters with LSD for their Kool-Aid Acid Tests. Homemade speed quickly spread, for it is only slightly more difficult to manufacture than alcohol; one fifteen-year-old boasted that she could make speed with a vacuum, a big glass, a regular pan, a heater, and a hair dryer. The quality and purity of homemade speed varied widely, for dealers usually cut it with Epsom salts, monosodium glutamate, photo developer, insecticides, or baking powder. Some users preferred the impure speed, for the "heavier flash" it gave and the intense "rush." These kitchens produced homemade speed not for Upper East Side ladies but for those who wanted a far more intense experience than the usual 5- to 25-milligram dose.

"a head":
a regular drug user—one could be a "pot head" and an "acid head"

"A-head":
an amphetamine addict "After two years of creative freaking I was flippy, nerves shot, scattered like a pane of glass hit by a rock. I was a hard-blown A-head."
—Harvey Cohen

These amphetamine users preferred to intentionally overdose for what the pharmaceutical companies called "thrill uses." Researchers warned against such use, noting that a dose over 50 milligrams can induce a paranoid schizophrenic state, restlessness, and visual and auditory hallucinations. One researcher noted that "no other group of drugs can affect or change personality traits to a greater degree than the amphetamines." By the mid-1960s, when a wide variety of amphetamines became available—Black Beauties, Obetrol, Desoxyn—the benny-heads of the 1950s gave way to the speed freaks of the 1960s. Ondine exemplified this new breed.

Ondine certainly did not require the stimulation of the central nervous system that amphetamine provided, but he enjoyed his own loquaciousness. Speed users were famous for their nonstop talk; although they could be irritating to captive listeners, they developed a rich oral tradition. Ondine would become one of its smartest and most flamboyant purveyors.

In 1954 Robert Olivo had emerged from the sea at Riis Park and been given the name Ondine, which he would carry for the rest of his life. The question remained: what could a man named Ondine do in the world? His childhood friend, Joe Campbell, had said to him, "You must go to work," and Ondine replied, "Uh, I'm searching for God." He had a brief fling with a fashion design school and a stint as a spear-carrier in the Metropolitan Opera's production of *Aïda*. Standing in line for the opera one day, Ondine met Joe Cino. In 1958 Cino had started a very casual theater in his coffeehouse at 31 Cornelia Street. The tiny stage gave intimacy to the performances, and Cino would announce just before each performance began: "It's magic time!" Many of the plays produced here were little more than sketches, but these humble performances marked the beginning of what became Off-Off-Broadway. When there were no plays ready for production, people read comic strips onstage. Ondine was one of them, for he could make anything sound funny. Especially when he was fueled by amphetamine.

Ondine first saw Andy Warhol at a party at La Monte Young's. Ondine sometimes called himself "the first Mrs. La Monte Young," and that evening he felt the energy of an orgy-in-the-making. Ondine noticed a silent presence in the back of the room: "That night he was staring at what was starting and I just thought that it was unfair: there was a certain look in his eye; it wasn't wonder, or wanting to get involved, or not being able to be involved . . . he was just *watching* with this watching eye, and I said, 'Get him out of here, man. I don't want to see him!

He's putting a damper on the whole party.' They got rid of him. That made him love me in a strange way. I had put my foot down."

Early Off-Off Broadway theaters, with founding dates:
The Living Theater (1950)
Caffe Cino (1958)
Judson Theater (1961)
Open Theater (1964)
La Mama (1965)

America's most vital avant-garde constellations have usually been connected to neighborhoods—from Greenwich Village in the 1910s to Harlem in the 1920s to San Francisco's North Beach in the 1950s. A neighborhood isn't simply a matter of mapped geography but includes the activities and characters associated with it. At the beginning of the 1960s Greenwich Village was the most famous bohemian neighborhood in America.

Ever since it blossomed as a bohemian community in about 1913, Greenwich Village had been a state of mind as well as a geographical area, and over the years no shortage of plays, novels, and paintings depicted Village life and lifestyle. It was self-conscious about its unique position on the map of American bohemia, and Village newspapers covered its activities. In the early 1960s *The Village Voice* spoke for this community. The weekly paper first appeared on the stands on October 19, 1955, twelve pages for five cents. Daniel Fancher, Edwin Fancher, and Norman Mailer aspired to something larger than a local community paper; they wanted to fill the void left by the demise of such progressive intellectual magazines as *P.M.* and *The New Masses*. Although the climate in the 1950s was unwelcoming to iconoclasm, the three men launched their brave enterprise on ten thousand dollars.

They published the paper out of a ratty office loft at 22 Greenwich Avenue. In the early 1960s, the paper leaped ahead in circulation, helped in large part by a three-month newspaper strike at the end of 1962, when it spiked from 17,000 to 40,000, then settled back to 24,000 when the strike was over.

The Village Voice regulars circa 1960:
Jonas Mekas and Andrew Sarris—film
Nat Hentoff—jazz
Michael Smith—theater
Norman Mailer—various
Jules Feiffer—cartoons
Jerry Tallmer—managing editor

As the decade began, Astor Place was the boundary between Greenwich Village and the East Village, the line between an increasingly expensive bohemia and a neighborhood of Eastern European immigrants. In search of cheaper rents, artists, writers, and musicians began to move east, and for rock-bottom prices they went to the Lower East Side. Over the next few years the main thoroughfare of the increasingly fashionable East Village would follow St. Mark's Place across Avenue A, where it moved up Tenth Street, around Tompkins Park, to Avenue B.

Among the people who began to populate the East Village were a photographer and budding filmmaker named Jack Smith and his associates John Vaccaro, Ronald Tavel, and Rene Rivera. A 1940s movie actress

Jack Smith, with his Bolex
camera, after shooting
Flaming Creatures, 1963,
by Jonas Mekas

named Maria Montez provided the link between them. By prevailing critical standards Maria Montez's acting was abysmal, but her buttery olive-skinned beauty had photographed beautifully in Technicolor in movies like *Arabian Nights* and *Cobra Woman,* and she was Universal's biggest star during World War II. On September 7, 1951, at age thirty-one, she drowned in a bath of reducing salts.

At the moment of her death, eighteen-year-old Jack Smith was working as an usher at the Orpheum Theatre in Chicago. He had taken this job because he was in love with movies, and in his early teens he had already shot an 8mm film called *The Saracens.* His mother had sewn costumes for the neighborhood kids in Smith's makeshift vision of Baghdad.

The publicity surrounding Maria Montez's death caught Smith's attention. He started calling her "the Marvelous One," erected an altar to her in his cluttered apartment, and lit candles to her twenty-four hours a day. "At least in America a Maria Montez could believe she was the Cobra Woman, the Siren of Atlantis, Scheherazade, etc.," he wrote. He considered her a perfect filmic object, the embodiment of "moldy" stardom, as he called it. When his friend Ronald Tavel asked him what he meant by that, Smith replied that, just as a sculptor seeks the most perfect three-dimensional object and found it in the Venus de Milo, so film requires the perfect two-dimensional moving object, and that search ended in Maria Montez. Ron Tavel recalled Smith's prerequisites for screen beauty:

> The eyes should be far apart, and the nose should be prominent because it is the central part of the face. The jaw should be very strong, even on a woman, or it's not going to shoot well. And the other thing is the idea in their head, that they really do want to be a star and do think they're beautiful and tell the camera that. Also, that they have a specific idea in their head and we should be able to read exactly what they are thinking. Even if it changes, we can follow the thought. This is what makes a person photogenic, according to Jack Smith.

Smith's obsession with Maria Montez was not a fan's pursuit of gossip and biographical details. When Tavel photographed a perfect red rose laid on Montez's tomb in Paris, he recalled Smith's reaction: "It was real and nothing special." Smith was interested solely in Montez's fetishized celluloid presence: "In my movies I know that I prefer nonactor stars

to 'convincing' actor stars—only a personality that exposes itself—if through moldiness (human slips can convince me—in movies) and I was very convinced by Maria Montez in her particular ease of her great beauty and integrity."

Jack Smith moved to New York in 1953, and four years later he opened the Hyperbole Photography Studio, a sort of an ongoing performance/installation, in a storefront space on Eighth Street near Cooper Square. Smith worked at the Medo Photo Laboratory where, after hours, he made large color prints of his photographs. In 1960 he made his exhibition debut at the Limelight Gallery.

Smith's photographs were unlike anything being shot at the time; the closest thing to a mentor was Josef von Sternberg. Smith brought models into his apartment, which harbored elaborate props and costumes, for what he called "s.s"—shooting sessions. One of his models, Joel L. Markman, described the process: Smith gave him a gooseymire faded gossamer gown, added patches of Woolworth chenille and a turban, and posed the model as a voluptuary on a tiny couch.

Although Smith's models were rarely conventionally beautiful, his fantastic set and his Von Sternberg–like direction allowed them to aspire to the sublimity of Maria Montez's celluloid world. "The Miraculous One was raging and flaming," he said to his friend Ron Tavel. "Those are the standards for art."

Jack Smith began his "s.s" in 1957 and continued searching for a modern counterpart to Maria Montez. In 1961, in the hallway of a Lower East Side apartment on Ludlow Street, he met a Puerto Rican man named Rene Rivera, who was in his late twenties. During the day Rene worked for the postal service, and friends noted that he looked tough and strong, with heavily veined arms that gave little idea of his promise as a glamorous woman. Smith instantly saw enormous potential. Rivera bought his clothes on the Lower East Side, from Klein's or May's, and rarely spent more than four dollars. He lived in a cheap apartment furnished with a huge chandelier hung with blue and red crystals, a maroon carpet, a chartreuse terrycloth-covered sofa, and a twenty-one-inch television with a pearl necklace draped around it. He was deeply Catholic, and in his prayers he always mentioned those most important: James Dean, Marilyn Monroe, Fred Astaire, Ginger Rogers, and Maria Montez.

Rene Rivera posed for Jack Smith, sometimes as a bare-chested man with a pencil-thin mustache and hoop earrings, but more strikingly as a

"The influence, the guru. The guru of me, of Charles, of all modern theater ideas, of Robert Wilson, of Richard Foreman, of Meredith Monk, and many, many filmmakers."
—John Vaccaro on Jack Smith

Jack Smith's secret flix:
"I Walked with a Zombie; White Zombie; Hollywood Hotel; all Montez flix; most Dorothy Lamour sarong flix; a gem called Night Monster, The Cat, and the Canary; The Pirate; Maureen O'Hara Spanish Galleon flix (all Spanish Galleon flix anyway); all Busby Berkeley flix; Flower Thief . . ."

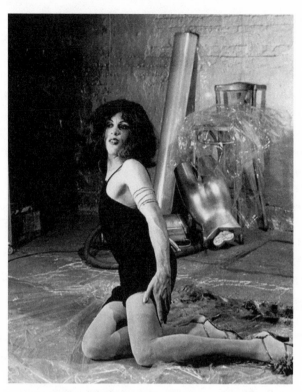

**Maria Montez at the Silver Factory, 1964,
by Billy Name**

femme fatale in feathers and shiny backless dresses. Rene disliked the term *drag;* he preferred *going into costume.* As his friend Joel Markman recalled, Rene's feminine incarnation embodied his fears and his dreams.

> The dread of her family discovering the secret of her life: queen, cocksucker, movie star, love goddess . . . She walks seemingly past the mirror but when exactly in line with the glass her head snaps around as if magnetized and she faces herself; hypnotically she is drawn to the mirror. All previous concerns forgotten. She stands there for a moment, arranging her vision. Metamorphosis of R. into R.'s idea of R. time hiatus negligible. Her performance for the photographer is an intimation of her real life . . . She lives in a world where she is actually the greatest and most desirable actress of all time."

John Vaccaro arrived in the East Village on December 26, 1961. The angular, slightly imperious thirty-two-year-old had journeyed via a circuitous

route. Born in Ohio, he graduated from Steubenville High School just after World War II and decided against going to college and instead headed to the Far East. For the next seven years he rambled around in Japan, Thailand, Mongolia, Laos, Bali, and all the countries in between, and along the way he absorbed the extraordinary stylization of Bunraku and Kabuki performance. When he finally returned to Ohio at the age of twenty-six, he began attending Ohio State University in Columbus. To support himself, he worked in an on-campus beer joint, and to increase business on Sundays, when only 3.2 beer could be sold, he instituted a stand-up act. He mixed Beat-style poetry reading and long semi-improvised monologues, backed up by a jazz band. It was all rooted in "finding me," recalled Vaccaro. "I was more famous on campus than the football team." What made him so well known locally was his ability to improvise routines, and he developed a highly tuned sense of how to make people laugh. But the self-imposed pressure to come up with new material ended in burnout and a nervous breakdown.

After spending eleven months in a psychiatric clinic, Vaccaro staged a comeback engagement at the Sky Room of the Dreschler Hilton in downtown Columbus, where he opened his act by saying, "I have just returned from a long engagement at the Kookie Hilton, where I played before a captive audience." He had by this time learned the timing and mechanics of making an audience laugh.

Bernard Michael Ruskin, known as Mickey, was in his late twenties when he entered a phase he would later describe as "my nervous breakdown." He had been groomed to follow in his father's footsteps in a New Jersey law office and was sent to Cornell for his undergraduate education. Dave Behrens, one of Ruskin's fraternity brothers, recalled him as a physically awkward man, tongue-tied with women, very lonely, anxious to be pledged by the fraternity but unable to impersonate a smooth fraternity image. "He wanted to be 'not like everybody else,' which I suppose ran through all of Mickey's life," said Behrens, "in the sense of wanting to be special."

After graduating from Cornell and passing the New York bar, Mickey Ruskin tried practicing law, but he soon found that suit-and-tie office life was not for him. He next tried a year and half in a pre-med school, earning grades that assured him a place in a top medical school, but realized that simply switching to another white-collar profession would solve none of his problems. "I turned around and decided that it

was too ridiculous," said Ruskin and returned to the grim reality of clerking in his father's law firm in Jersey City. One day around 1960 he came upon an advertisement in *The Village Voice* that read "Rent or Own Coffee Shop." Within a few weeks he rented the space and called it the Tenth Street Coffee Shop.

His footage was minimal—about ten feet wide by twenty feet deep—and the location on the short block between Broadway and Fourth Avenue, just up from Astor Place, was just beginning to be hot. Its proximity to the Tenth Street Galleries helped, and after about three months of working days as a law clerk and nights as a coffee shop manager, Ruskin realized he could live off his coffee shop profits. He never looked back. "I was in the business and wanted to stay," said Ruskin. "It was like coming home. I think the whole reason I had done this coffee shop was because I wanted to go to Greenwich Village; I had never been there."

"Mickey picked where it was happening," said a neighboring gallerist, and helped make it a happening block. A lawyer friend named Howard Ant suggested Mickey have poetry readings, bringing poetry beyond the West Village. The coffee shop soon became a center that attracted not only downtown poets but also their artist friends. The cramped quarters dictated close relations between audience and reader, and it encouraged candid reactions to the poems. Mickey preferred poets and artists to uptown lawyers, and he followed his intuitions about customers: "I found very quickly, from the first coffee shop I had, [that] if I followed my instincts and didn't let in the people I didn't like and only let in people I like, I could make a living, learn, and really have fun."

As soon as he graduated from Arlington High School in June 1958, Billy Linich headed south for New York City. He was smart, strong, lean, tall, and attractive, and that gave him some confidence that he could find his way in the city, even though he had no concrete plan and was painfully shy. An early acquaintance, the playwright Robert Heide, described Billy at that time as "an overgrown teenager, looking for someone to take him over and teach him something," Billy found sugar daddies in "high fag" hustler bars on the Upper East Side like the Tick Tock and the 316, where the standard look was a suit and tie and loafers. "This is the old world, not the gay world, this is the queer world," Billy said. The first of his sugar daddies was a stylish haberdasher with silver hair. Two more men with silver hair would follow in a similar role.

When Billy wanted more playful sexual companionship, he headed

down to the Village and hung out on the corner of Sixth Avenue and Eighth Street in front of Whelan's Drugstore, which, he recalled, "was the world's cruising-est corner at the time." He was picked up there by Peter Hartman, who briefly became his boyfriend. Hartman was a young classical composer and musician who introduced him to the poet Diane di Prima. From this introduction many doors opened, for di Prima was a crossroads of the downtown scene. She had many friends, a few fierce loyalties, and was involved in a lot of different scenes. "She had her darlings, one of them Freddie Herko," said Billy.

Freddie Herko had come to New York to study music at Julliard but soon ended up pursuing dance. His talent was abundant, but it was not clear how he would harness it. His close friend Ondine described him as a "total star dealing with space and time and dealing with his audience and dealing with everything in that little thing called the avant-garde. Nowhere to go but that simple stage that Yvonne Rainer and all those people had prepared for him. All night. But that was nowhere to go for Freddie Herko. Herko was involved in bigger things. He wanted to be seen. Fred Herko wanted to fly."

In the constellation of activities focused on Judson Church, Herko looked like a downtown demigod. He was lithe, dark, intense, and mercurial. Diane di Prima provided a constant in his life. They had lived together, been neighbors, and shared a lover (Alan Marlowe). They even staged a very private wedding, exchanging cheap silver rings before a Brancusi statue in the Museum of Modern Art. "I don't remember what we said if anything," di Prima wrote, "but I know the feeling was that we would help each other out, try to take care of each other in the craziness of our lives. Wherever they went."

At the beginning of the 1960s Diane di Prima was working at the Phoenix Bookstore, writing poetry, and carrying on an affair with LeRoi Jones. In the late fall of 1960 Jones suggested publishing a magazine using the IBM typewriter and Gestetner mimeograph machine at the Phoenix. This marked the beginning of *The Floating Bear* (inspired by Winnie the Pooh)—one of the early magazines of the mimeograph revolution—which was made up of poems, gossip, stories, overheard conversations, and reviews. It was given away rather than sold. Labor was free, and the means of publication were available, and by avoiding commercial status it hoped to evade censorship. (The ninth issue included "Roosevelt After Inauguration" by William Burroughs and a short homosexual play by LeRoi Jones. The United States Post Office censors confiscated the offending issue.)

Billy Linich felt entirely at home in the worlds to which Diane di Prima helped introduce him. Through her house on Cooper Square came a wide variety of people who embodied not only the aesthetics of the downtown community but the sexual savvy and comfort that were rare in Upper East Side bars and unknown in Poughkeepsie. Among di Prima's friends, the boundaries between family and lover and friend crossed freely. Peter Hartman, who had been Billy's boyfriend and Freddie Herko's boyfriend, proposed marriage to di Prima; she was meanwhile having an affair with LeRoi Jones, who was married to Hettie Jones. "People were complex, and we knew it," observed di Prima.

Billy Linich assumed a style that combined existentialist angst with the adventure of the Beat Generation; he dressed in black stovepipe pants and a James Dean rebel-without-a-cause jacket and carried a paperback volume of Rimbaud or the Pataphysics issue of *The Evergreen Review.* "It wasn't a matter of reading them," he said. "It was more like carrying a watch." One of his early memories of the Village was picking up a paperback copy of Allen Ginsberg's *Howl* in an Eighth Street book-

Remy Charlip, Rufus Collins, and Billy Linich in Central Park, 1959, by Eric Brunn

store and feeling an immediate electric connection to the book. "I was thumbing through it, and I read those lines—'I have seen the best minds of my generation'—and it sort of crawls out of the book and howls at you, like a Munch painting," said Billy. "They just howled out of the book and rolled down the street at your heels."

Billy easily fell into crowds because he was a low-key, easy person to have around. "B. Linich is like a dog," wrote an associate named Soren Angenoux, "a poodle—one does not have to have the same responsibilities towards him as towards other people—he is loved for the reasons a poodle is loved." Billy gravitated toward people who wanted to expand his horizons and to share their history with him.

By 1960 Billy was supporting himself as a waiter at the new Serendipity 3, a restaurant-store on East Sixtieth Street. In this convivial gay atmosphere attractive waiters drew many fans, and Billy had his share of admirers. One of them, a fellow waiter and aspiring director named Ron Link, took him to the San Remo on a Saturday night after work.

The San Remo's richly layered history provided a perfect backdrop for the education of Billy Linich. A portrait of the ultimate Village bohemian, poet Maxwell Bodenheim, hung over the long bar that dispensed "the strongest espresso this side of Italy" and the most-bang-for-the-buck alcoholic drinks. Situated at the corner of MacDougal and Bleecker Streets, the San Remo had a pressed-tin ceiling, a worn black-and-white tile floor, and scarred wooden booths. A widow named Betty Santini ran the bar with the aid of tough bartenders connected to the "minor mafia." She managed the place with an iron fist and demanded that customers pay their tab up front. Heavy drinking was acceptable, but if someone exceeded their limit, she would throw them out for two nights, saying, "You went over the edge."

Founded in 1925 as a working-class bar, the San Remo changed its character in the wake of World War II, becoming a hangout for hipsters, writers, and artists. This was where proto-Beat writers drank in the early 1950s, where Living Theater actors let down after rehearsals, where Paul Goodman's Gestalt therapy groups gathered after sessions, where Jack Kerouac picked up Gore Vidal. It was also a place that Andy Warhol began to frequent in the early 1960s. Warhol recalled it as "a few poets and a lot of fags coming down from the 53rd Street and Third Avenue area [a male hustler strip]."

Often dominating the room were the brilliant speed-driven mono-

logues of Ondine. With a noble profile that one friend compared to a Roman coin, Ondine's pale skin and dark hair stood out against his black turtleneck and leather jacket. He confessed to feeling a sentimental tie to the portrait hanging over the bar. "I'm sort of a little bit 1930s bohemian," he said. "There's a little of the natural Bodenheim in me, and I can't help it. It's, I know it's tacky, but . . ."

Billy Linich's shyness neatly dovetailed with Ondine's extroverted performance. "You can't enjoy what he's doing to your psychology if you're so weak that you become paranoid, and there are people who tend to do that," said Billy. "Otherwise, if you had any intellectual integrity at all, you would just feel his love, and you would enjoy it like it was better than a theater performance because it was really *live*."

One of the few people who could sharpen Ondine's wit was Dorothy Podber. Billy considered both Ondine and Dorothy "off the scale" in terms of intellect, wit, and cunning. Dorothy ran the Nonegan Gallery and hung out with Ray Johnson and Nick Cernovich, both associated with Black Mountain College. Their mutual friend Dale Joe (an artist who freelanced as an amphetamine tester, known as "the Nose" because he was sensitive and not addicted) recalled:

The essence of Ray and Dorothy was to outdo each other, like a George Burns and Gracie Allen. Ray would say, "Dorothy, do the shoe thing." She'd go into the other room and bring out a large box filled with shoes of different sizes, and she would put it in the middle of the room. He would play records Dorothy and he had found—stuttering records—that's part of the grotesque humor. She would circle the box, put on a shoe, circle the box again and put on a shoe over the first, then circle the box and put on a third shoe, until she had on so many shoes she couldn't walk and she'd fall down. Ray would say, "Thank you, Dorothy."

When collector Sam Wagstaff walked up six flights to Ray's studio on Norfolk Street, there were no works in evidence. Johnson then went to an armoire, opened it, and said, "This is my work!" Dorothy Podber jumped out, laughing wildly.

Billy regarded Dorothy Podber as the point where the Dada spirit met Zen met the underworld; she set the example of how to be smart and incisive while embracing chaos as a modus operandi. "Dorothy was more severe than John Cage, she was perilously exciting," said Billy. "People

went to Dorothy's for amphetamine and to just be fantastic. Dorothy had friends from the criminal element, one of her boyfriends was a chauffeur for the mafia, and then she had her professional crook friends who worked in chemical plants and got all the drugs. She'd have a huge bowl on the table of white powder, the highest-quality methamphetamine-hydrochloride. We didn't need to have money. Five dollars would get you the biggest amount of anything you needed."

Among Dorothy Podber's friends was the second silver-haired man in Billy's life, Nick Cernovich. He had studied at Black Mountain College and had designed the epochal little magazine of the 1950s, *The Black Mountain Review*. Upon moving to New York, Cernovich became a lighting designer. His technical skills were a scarce commodity, and he became the lighting designer for the most adventurous downtown performing groups, such as the Living Theater, the Judson Dance Theater, James Waring's dancers, and the Alwin Nikolai Dance Company. The year before Billy Linich met him, Cernovich had won an Obie award for best lighting. He was not bound by convention and made do with whatever equipment was available in the ad hoc spaces used for downtown performances.

With Nick Cernovich, Billy Linich had his first apprenticeship. It was informal and all-encompassing. Cernovich became Billy's employer, teacher, lover, and guide. Billy learned the trade and the magic of lighting design and worked as his all-around assistant. Billy envisioned this relationship in the classic apprenticeship tradition. "It was the end of the period of the romantic avant-garde, the romantic bohemia, where artists kept younger artists and a male artist would always have a young man around."

In addition to learning about lighting, Billy absorbed Cernovich's interest in Zen. Cernovich managed a bookstore called Orientalia, and he hired Billy to catalog new books and fill orders. Orientalia stocked hard-to-find books on Zen, Hinduism, Buddhism, astrology, and the occult. "I read the whole store," Billy said. "I have a huge appetite for learning everything about the whole field of Zen and astrology and yoga."

The spirit behind the downtown art and performance world was that of Marcel Duchamp, the "unknowable, but a glowing presence." His mantle was passed on to John Cage, whom Billy considered "the master temper of the New York culture in the early 1960s, the master who set the tempo and the tone of it." Other prominent figures in the community

were artist Ray Johnson, composer/musician La Monte Young, choreographers Merce Cunningham, and James Waring, and poet Diane di Prima. "They were your uncles and aunts, so to speak, because they were elders. Simply being in the presence of these people, your aesthetic was developed."

Harvard graduates who move from Cambridge to New York have been a staple of America's avant-garde and bohemia. (By comparison, Yale and Princeton provided few.) That tradition continued into the 1960s, with several people who would become associated with the Factory: Ed Hood, Henry Geldzahler, Dorothy Dean, and Chuck Wein.

At the beginning of the 1960s many interesting Harvard characters could be found in the vicinity of Brattle Street and Mount Auburn. For the mixed crowd of gay and straight, Porcellian and townies, there was a large volatile bar called the Casablanca. For the newly visible folk generation, there was a coffeehouse called the Mount Auburn, where Joan Baez made her debut. A block away on Mount Auburn Street was the apartment of Ed Hood. When the Casablanca closed at one A.M., a contingent often walked to Hood's apartment and continued the party. His special group of friends, sometimes referred to as the Lavender Brotherhood, even though they included many women, was treated to his ongoing open house. He was generous about liquor and spartan with food, sometimes resorting to Spam on crackers.

Ed Hood was a perpetual graduate student in English who never finished his degree. His friend Chuck Wein described him as "a live parody of southern gentility" whose mix of erudition and bitchy wit was a pleasure. One Harvard undergrad noted that just to be seen with him "marked" one as homosexual, and after one sexual episode in the Indoor Athletic Building, the university authorities threatened to bar him from stepping onto Harvard property.

The late-night parties in Hood's black-satin-lined rooms were both literate and light. "An especially nice aspect of these get-togethers," recalled Edmund Hennessy, a Harvard student and regular at Hood's parties, "was that they included no serious discussions of the merits of Jane Austen's novels, no diatribes about Kierkegaard or Kant, no analyses of Edith Sitwell's poetry. We were at Ed's to have fun." The middle-of-the-night activities included charades and Ed Hood reciting the first twenty lines of Milton's *Paradise Lost* while balancing a full, unspilled cocktail on the top of his balding head.

❏

Born in Antwerp in 1935, Henry Geldzahler was the second son of a successful diamond broker. His family emigrated to New York ten weeks before the Germans invaded Belgium, and Henry began his American life on Riverside Drive. At the age of five Geldzahler spoke fluent Flemish and French, and he quickly became adept in English as well. He absorbed the rich cultural possibilities around him, vowing to read the entire set of the Modern Library in their apartment and making his mother take him to museums on Saturdays. At the age of fifteen while looking at Arshile Gorky's retrospective at the Whitney Museum, he had a revelation. He stayed in the exhibition for three hours and became nauseated in the process. "This was the first time I realized that modern art was interesting enough to make me sick," he wrote.

After graduation from the Horace Mann School, where he was elected president of his senior class, Geldzahler went to Yale. He pursued his voracious appetite for art, taking art history courses, working in the summer as a volunteer at the Metropolitan Museum in the Department of European Paintings, and spending his junior year studying at the École du Louvre and the Institut d'Archéologie of the Sorbonne.

In 1957 Geldzahler graduated magna cum laude from Yale and went on to Harvard for graduate work in art history. He hit his intellectual stride—not in the classrooms, where students found him a little pedantic and scholarly—but in informal conversations at the Hayes-Bickford Cafeteria, known as the Bick. He was a round, dandyish presence, a plump baby face with a clipped chin beard; according to Calvin Trillin, he resembled Charles Laughton at sixteen. Geldzahler seemed to have enormous amounts of historical information at his fingertips, and his dexterous mind could go off in many directions. "You never got hung up on any one subject, and there were no fixed positions or ideologies," said his Harvard friend Paul Richards; "it was a *field* situation, in which everything interacted with everything else."

In early 1960, Geldzahler passed his Ph.D. general examinations and began writing a dissertation on Matisse's sculpture. That spring James Rorimer invited him for breakfast at the Ritz in Boston. Rorimer was the director of the Metropolitan Museum and had positive memories of Henry as a bright and ebullient undergraduate summer volunteer. After a four-hour talk he asked Geldzahler to work at the Metropolitan. Geldzahler demurred, frankly stating that he was more interested in contemporary American art, an area in which the Metropolitan was weak.

Within a few weeks Rorimer created a position for him in the Department of American Painting and Sculpture. In June of 1960 Geldzahler left Harvard, forgoing his Ph.D. and eager to report to the Metropolitan on July 15.

Dorothy Dean, born December 22, 1932, was twenty-seven when the 1960s began. Five feet tall, weighing eighty pounds, she was the daughter of a minister and had been the first African-American valedictorian in the history of White Plains High School. At Radcliffe, where she was on scholarship, she wrote her undergraduate thesis on "The Philosophical Foundation of Aesthetic Criticism" and received a B.A. in 1954. She was awarded a Fulbright scholarship to study art history at the University of Amsterdam, then returned to complete an M.A. in fine arts at Radcliffe in 1958. Though Dorothy Dean's early accomplishments promised a career, her friends wondered where she would end up fitting in. After she graduated, Dean had devoted herself to such thankless tasks as working for two years in the Brandeis University slide library and typing and editing the two-volume study of Italian Renaissance painting and sculpture by Sydney Freedberg.

Dorothy Dean was close to Arthur Loeb, the son of wealthy investment banker John Loeb. Born with minimal muscle strength in his left arm and leg, Arthur Loeb couldn't type, so he hired Dean. Arthur grew close to Dorothy and once asked her to marry him; it didn't matter that they never had a romantic relationship. A friend of Dean's reported that John Loeb offered Dorothy money to not marry his son. She refused. "I won't marry Arthur because I don't want to. But I won't not marry him because you say don't marry him." Dorothy Dean's strict personal code guided her life. She believed in the responsibility of friendship, the necessity of language as a means of vital communication, and the importance of not tolerating mediocrity. Dean's words and manner were formal; she carried a purse, she stressed the importance of grammar, and wrote thank-you notes in impeccable handwriting. Although she was African American, that did not stop her from referring to writer/activist James Baldwin as "Martin Luther Queen," or freely using the word *nigger*. Her friend John Simon noted, "I think if anyone had told her she was black, it would have come to her as an astonishing revelation." No one in the Harvard circles had a tongue that was as witty and scalpel-sharp. Among the nicknames for Dorothy Dean were "Nurse Dean" and "The Curd of Human Kindness."

Dorothy Dean gave Chuck Wein his Harvard name; she dubbed him Chuckles because of his exuberant manner. Wein had grown up in Beverly Hills, the son of a mafia lawyer whose finances fluctuated wildly. Wein arrived at Harvard in 1956 with the intention of becoming a nuclear physicist, but by the time he approached graduation in 1960, his ambitions had shifted. He had become interested in Chinese history, in the possibilities of out-of-body soul travel, in Taoist alchemy, and in psychedelic drugs. At that moment Timothy Leary was just beginning to proselytize for LSD's spiritual qualities, and Wein saw the potential for mind expansion and ego destruction. He talked volubly and dropped names in monologues that ranged widely from subject to subject. His style was charismatic, and some described him as a Svengali figure. "I knew Chuck in '58, '59, and '60," said Henry Geldzahler. "He always seemed to be in the process of witchcraft of some kind, you know, taking a personality and controlling it and molding it and then sort of throwing it away like Kleenex when he was finished with it." A Radcliffe student named Mary Lowenthal recalled the transforming force of his personality. "He had an eye for people who didn't sit right in the world," she said. "He leaned into you and learned everything. He put his whole self into you."

No one knew what Chuck Wein would do after graduation that June 1960, least of all Wein himself. He headed to Asia.

The newest wing of the avant-garde community was film. Although there had been experimental filmmakers in America since the early 1930s, they initially functioned alone, and there were few venues for showing their work. Literature had a functioning system of little magazines, art had a variety of galleries, and performance had a variety of little theaters and one-night presentations. The future of experimental film was determined by only two men, Amos Vogel and Jonas Mekas. Both were European émigrés who had fled fascism: Vogel arrived in New York in 1939 from Austria, Mekas in 1949 from Lithuania. Their agendas for experimental film differed. Vogel worked to fill an existing need—the huge gap between Hollywood and the film-as-art shown at the Museum of Modern Art—and Mekas hoped to catalyze a revolutionary cinema. (No one was asking for it, but he envisioned the need.) Throughout the 1960s these two men would clash with each other, but it was their sepa-

Terms for Experimental Films

Experimental-independent film:
In 1958, a group of films that received Creative Film Foundation awards.

Abstract cineplastic film:
Films on which the film directly drew; the term was inspired by Len Lye's retrospective in 1959; it also describes Harry Smith's films.

American New Wave:
Used circa 1960, the term was drawn from the French New Wave (Nouvelle Vague) that began in 1959.

New American Cinema (NAC):
A term favored by Jonas Mekas in the early 1960s to describe the generation after Maya Deren, James Broughton, Marie Menken, Willard Maas, etc. Historically it covers roughly the period between *Pull My Daisy* in 1959 and *The Chelsea Girls* in 1966.

Underground:
The many associations of the word (the political underground, the underground man, the commercial underground) lent itself to independent movies, and it was especially used in the Sixties (e.g., Sheldon Renan's 1967 book *An Introduction to American Underground Film*).

rate and joint efforts that created the foundation for independent film. Without their efforts, the films created at the Factory would exist with no audience.

Amos Vogel's Cinema 16 screened its smorgasbord of films (ranging from documentary shorts to Kenneth Anger's *Fireworks*) on Wednesday nights at the Central Needles Trade Building Auditorium and on Sunday mornings at commercial art theaters. Vogel also created an independent film distribution service and provided the primary showcase for all independent films in America. Although the films appealed to different audiences, Vogel later said that "the films all had a common denominator; they created a disturbance in the status quo."

Vogel produced four single-spaced pages of notes about the films he showed, in order to give viewers access to difficult movies through the commentary, by himself and independent film's most lucid interpreters. Chief among them was Parker Tyler, widely regarded as the American critic most familiar with both the history and the aesthetics of experimental film. Tyler, a wide-ranging intellectual, seriously analyzed film of all sorts, from the kitschiest Hollywood feature to the most poetic avant-garde short. Tyler's and Vogel's notes provided a critical language for audiences unfamiliar with avant-garde films.

Throughout the 1950s Amos Vogel envisioned Cinema 16 as "a direct interaction between some kind of social agent and the surrounding social situation at the time. I was such an agent."

Twenty-six-year-old Jonas Mekas, a poet and war refugee, immigrated to New York in October 1949 from Lithuania. Within a week of his arrival he attended a Cinema 16 program, and he never missed one for the next fifteen years. Within a year of his arrival he bought a Bolex 16mm camera and began shooting a movie diary. He quickly became, in his words, "a raving maniac of cinema."

Although Mekas could see films, he realized there was no film literature of value in America, no *Sight and Sound,* no *Cahiers du Cinema.* He suggested to his brother Adolfas that they launch a film magazine. In December 1954 the first issue of *Film Culture* was published. As the magazine's editor, Mekas created his first forum for experiments in film, and over the next several years *Film Culture* published America's most original writers on film. In the process of catalyzing film criticism, Mekas launched several careers. "You always need one person, one person to make the difference," said Andrew Sarris, "and for me that's Jonas." A seventeen-year-old named P. Adams Sitney soon came into Mekas's fold and became a major influence on *Film Culture.* Sitney recalled, "The

thing about Mekas was that he would always invest in people who had incredible passion."

Whenever he encountered such a person, Mekas invariably offered the same advice: buy a camera and start shooting movies. Among those who responded to his suggestion were Paul Morrissey and Ron Rice.

Paul Morrissey was the unadulterated product of Catholic education, from the nuns at St. Barnabas School to the Jesuits at Fordham Prep and then Fordham University from 1955 to 1959. He considered the Catholic education system "the best thing that ever happened to me." While at Fordham, he met Donald Lyons at a screening of Tennessee Williams's *Baby Doll,* the day after the Catholic Legion of Decency declared it indecent. The circumstances of that meeting were apt, for both were Catholics who were drawn to provocation. "A hundred percent of the later Paul Morrissey was there at the beginning," Lyons recalled. "He was witty, perversely opinionated, sometimes tediously opinionated, and unique."

Paul Morrissey, c. 1960

Morrissey's diet of movies included those directed by such favorites as John Ford, Elia Kazan, Carol Reed, and early Federico Fellini, as well as the British films that became available for broadcast during the 1950s. Morrissey disliked much of what was considered "serious cinema"— Ingmar Bergman, the French New Wave, and most of the American underground cinema.

Even in these early years Morrissey experimented with making short 16mm films using his Bolex camera. He shot films about people committing suicide by diving off a dock or being swallowed up by a garbage truck. Lyons recalled an early one in which he played a priest who strangles an altar boy in the Bronx Botanical Garden. "He saw film as his vehicle, as absurd, comic, nasty parables about modern civilization."

Morrissey joked that his biggest influence was a man named Tony Marzano, an Italian from Long Island who starred in some of his films. In late 1960 he had heard about a Tony Marzano screening from Mekas's movie column in *The Village Voice,* and he arrived at a storefront in an East Village tenement on Tenth Street.

> It was just a white space, and he had a projector there and he was showing his ridiculous films. He thought he was doing Orson Welles, with expressionism. I said to myself, "Jeez, anybody can do this. You shoot something, and then you rent a

space and you project it and you put an ad in the *Voice*." And that's just what I did. Right after that I found a storefront that looked just like the gallery on Tenth Street, but it was at 36 East Fourth Street. The apartments upstairs were like $35 a month, but the storefront was $5 less. And I said, "Gee, you don't have to climb stairs, and I can paint it white and call it a gallery and show movies." So I called it a nickelodeon, but I didn't charge a nickel, I must have charged a dollar.

Morrissey followed the smorgasboard strategy used by Cinema 16—screening the short silent movies he shot (a five-minute work called *Ancient History*, a sixteen-minute film called *Mary Martin Does It*), 16mm documentaries from the New York Public Library, and Brian De Palma's first short film, *Icarus*. The police shut Morrissey's nickelodeon down after a few months, citing lack of a permit.

Ron Rice was a twenty-four-year-old high school dropout from Brooklyn who was inspired by reading Jonas Mekas's column in *The Village Voice*. When he met Mekas at the Cedar Bar in May 1959, Mekas told him where to buy cheap outdated stock on Eighth Avenue. "He wanted to start by filming some paintings," Mekas wrote in his diary. "I told him it was all wrong, he should leave paintings to the painters. He agreed, and we had a beer to that."

In early 1960 Rice headed to Squaw Valley, hoping to shoot the Winter Olympics, and when that plan didn't work out, he continued heading west. He arrived in San Francisco in the spring of 1960 and headed toward North Beach, where there were coffeehouses and poetry readings. When Rice walked into one of the most popular hangouts, the Co-Existence Bagel Shop, he saw Taylor Mead get up on the bar and begin to recite a poem.

Mead was inspired that night by the presence of alcohol and marijuana and wild people in the audience. "They were defying everything," he recalled, "and so I got up on the bar and I read one of my wildest poems:

I have blown
And been blown
And I have never had a woman

I have been in great jails and terrible jails
The great jails were the tanks
And the terrible jails were the model prisons.

"I just blasted it out," Mead recalled, "and most of the poetry then was not that gay. And I just outshouted them, and then they ended up applauding me." When Ron Rice introduced himself, Taylor Mead was immediately charmed. "Generally he had an ebullient freshness that at that time was very positive and creative," wrote Mead. "If he wanted to do something, make a film, or a woman, he would do it directly and almost precipitously. He was fresh and refreshing." Rice was also fascinated with Mead, and a few days after the reading in the Co-Existence Bagel Shop, the two saw *Pull My Daisy*. This twenty-eight-minute film, directed by Alfred Leslie and Robert Frank, was the underground version of the Beat Generation, just as Albert Zugsmith's B-movie *The Beat Generation* was the Hollywood version. Impressed by *Pull My Daisy*'s artful play, Mead recalled, "We both said, 'That is what's happening.' The spontaneity of Allen and Jack Kerouac and everybody, just wandering around and a camera following them, and interesting people. And Ron said, 'That is the movie we have to make. We will make a movie about you wandering around San Francisco. *The Flower Thief*.' "

Rice and Mead couldn't pull off a production like *Pull My Daisy*, which was less spontaneous than it appeared to be. It cost fifteen thousand dollars and featured a real script and narration by Jack Kerouac. Rice and Mead instead made a film for five hundred dollars, financed in part by Rice's forged checks on his girlfriend's account. He used nonsynchronous sound, black and white World War II surplus machine–gun film, a hand-held, borrowed 16mm Bolex camera, and a kiddie cart for dolly shots. Ron Tavel later wrote about *The Flower Thief*, "What would seem at first to be creative handicaps were, paradoxically, some of the strongest factors working in his [Rice's] favor: poor reasoning, lack of education, literary and logical ignorance, and absence of narrational continuity."

Just as Rice was about to shoot the first scene, Taylor asked him what made cinema an art form. "I was struck dumb, but I managed to get out the words," wrote Rice. "Film is an art because of the difference between a natural event and its appearance on the screen. This difference makes film an art form. Taylor said NO, the thing that makes a film an art is that film creates a reality with forms. We could not agree. We argued and

"All art is a scandal—life tries to be—Taylor Mead succeeds—I come close!"
—**Tennessee Williams**

fought until the light disappeared. The following day we realized how absurd we were and agreed not to argue the subject. From this agreement, *The Flower Thief* was born."

Ron Rice followed Mead and other North Beach characters—whom Mead described as "the last twenty or so genuine intellectual wastrels of the area." Rice shot on location in buildings that were about to be demolished and on the city's winding hilly streets. Against these backdrops Taylor Mead's performance made up for any lack of plot. Rice dedicated the film to "the Wild Man," referring to the days when a Hollywood studio "would keep a man on the set who, when all other sources failed (writers, directors), was called upon to 'cook up' something for filming." The term evoked Taylor Mead perfectly. "He was the perfect slapstick goofball because you didn't have to cue him," Billy Linich said. "He's a self-contained performer."

When *The Flower Thief* opened at the Charles Theater in New York in July 1962, Eugene Archer gave it a rave review in *The New York Times*. It ran seven weeks and became the most popular $500 film ever made. Unlike most underground films, *The Flower Thief* was accessible and lighthearted.

Taylor Mead somehow had preserved his own randy, scatological version of innocence. He thought everything he did—picking his nose, mooning the camera—was amusing to others. He had a political/anarchic edge, but he battled the bourgeoisie with an arsenal of boogers and dingleberries; his revolution remained at a comic, preinfantile stage. As one viewer put it, Mead looked like "the seed that never reached the egg."

Perhaps the most daring element in Mead's screen persona was his unabashed homosexuality, like nothing the movies had seen—a long way from the swishiness of Franklyn Pangborn, or the fidgety bikers in Kenneth Anger's *Fireworks,* or the prisoners in Jean Genet's homoerotic *Un chant d'amour.* Mead was unheterosexual, unabashed, unapologetic, and untragic. Although Mead disassociated himself from the low camp performance associated with homosexuality, he wrote, "I'm as queer as a three-million-dollar bill."

In 1958 Jonas Mekas began writing a column called "Movie Journal" in *The Village Voice,* and he rode the wave of that increasingly influential publication. By the beginning of the 1960s he was practicing advocacy journalism for a New American Cinema. He believed that new independent films marked the end of the 1940s and 1950s, "the symbolist-

surrealist cinema of intellectual meanings," and presaged "a cinema of disengagement and new freedom." He predicted it would be a historic and beautiful period.

In the summer of 1960 Mekas felt there was sufficient critical mass in underground movies to begin organizing their filmmakers. At a meeting of filmmakers on September 28, he suggested that the twenty-three present simply declare that they exist. That was the first step. A few went to Emile de Antonio's apartment to discuss possibilities of distribution, while Mekas gathered points for a manifesto of the New American Cinema.

The group statement that Mekas wrote sounded a revolutionary tone: "There are many of us—the movement is reaching significant proportions—and we know what needs to be destroyed and what we stand for." The manifesto declared that the commercial cinema was bankrupt, that personal expression should not be mediated by producers or distributors, that film should be free from restriction by censors or distributors. The New American Cinema linked itself historically to a rising tide of new film all over the world, notably the French Nouvelle Vague and the English Free Cinema groups. The statement concluded, "As they, we are not only for the New Cinema: we are also for the new man. As they, we are for art, but not at the expense of life. We don't want false, polished, slick film—we prefer them rough, unpolished, but alive; we don't want rosy films—we want them the color of blood."

The efforts begun at this meeting resulted in January 1962 in the formation of the Film-Makers' Cooperative, a distribution center for independent films whose first rental catalog offered fifty-six films by twenty-seven filmmakers. Amos Vogel understood that there was not enough room for both the Co-op and Cinema 16. He soon ended Cinema 16 and directed his attention to founding the New York Film Festival. "I'll make the following rash statement," Vogel said. "In my opinion, Jonas was more interested in building a Jonas Empire than I was in building an Amos Empire at Cinema 16."

In late fall 1961 Jack Smith met a woman name Marian Zazeela, and over the next several months she became his muse. In the summer of 1962 Smith was planning a movie with her as the heroine. He was inspired by the success of *The Flower Thief* at the Charles Theater and by the fact that such a film could receive a rave review in *The New York Times;* he conceived the film to premiere at the Charles.

Smith's total budget for making the film was $300, most of which was devoted to developing the film and renting a coffin. The film stock itself was cheap, since Smith stole a variety of black-and-white and color reversal film stocks—Agfa, Ferrania, DuPont, and Perutz Tropical film—from the outdated film bin at Camera Barn. He didn't pay his actors, who were mostly models, for his still photo "plastiques"; they included Francis Francine (aka Frank di Giovanni) and Rene Rivera (aka Mario Montez). For his set Smith used the tar-papered roof of the Windsor Theater at 412 Grand Street, managed by Walter Langsford (who also ran the Charles Theater). The production was rudimentary, and the costumes were not. A ladder was strung across the roof so that Smith could film his actors from above, with Billy Linich serving as assistant.

Perched on that jerry-built catwalk, twenty-four-year-old Ronald Tavel poured plaster onto the performers for the rape-earthquake-orgy sequence. He had more of a formal education than any in the bunch: he had completed undergraduate study and earned master's degrees in Elizabethan prose and philosophy from the University of Wyoming. Always precocious, he became familiar with theater as a child actor with the Originals Only Company and had begun constructing narratives in second grade in the form of illustrated comic book adventures in far-off places. After his college years he traveled to Europe and ended up in Morocco, where he began writing an ambitious novel, *Street of Stairs*. Only recently had Tavel returned to New York and found his way via Maria Montez to the most interesting people in the East Village.

By the end of the summer Jack Smith had decided on a title for his film: *Flaming Creatures*. The film was an Arabian Nights transvestite extravaganza, and it surpassed all other independent films of the time in offensiveness—even including such controversial films as Stan Brakhage's *Window Water Baby Moving*, Kenneth Anger's *Fireworks*, and Jean Genet's *Un chant d'amour*. It showed nudity, penises both limp and erect, transvestites, breasts, and overt homosexuality. *Flaming Creatures* set the bar for outrage and presented the issues that would dominate the censorship wars of the mid-1960s.

Looking for images to define his new art, Andy Warhol started with pictures he knew well: advertising, comic strips and pulp tabloid. It wasn't so much a turn away from the highbrow existentialism of *Partisan Review* as a desire to use forms of *Lumpenproletariat* American materi-

Jack Smith's Buzzwords:

Exotic: a high compliment

Moldy: possessing the aura of recent cultural detritus

Pasty: phony or false (not necessarily a derogatory term)

Pasty normal: heterosexual

Andy Panda: Andy Warhol

als. Advertisements were the sources that he understood, a few words punched home with an image designed for instant consumption. Others had used advertisements in art, but Warhol was perhaps the first to present them as uninflected portraits.

Just as he had traced photographs from the New York Public Library and used the blotted-paper reproduction method, Warhol now made slides of advertisements and comic strips. He projected them onto a blank canvas while painting, at first leaving drips in and obliterating certain sections of the projected image. These renditions of new subject matter retained the visual mannerisms of the ab-ex generation.

Andy Warhol creating his first signature paintings is an often-told story, with Warhol instantly becoming the king of Pop Art. But in fact a few years passed between these early iconic paintings and their first exhibition. In order to introduce them to the world, he depended on two men, Ivan Karp and Henry Geldzahler, with an assist by Emile de Antonio.

It was Warhol's fascination with Jasper Johns that led him, in late spring 1960, to Ivan Karp, in the backroom of the Leo Castelli Gallery. Enthusiastic and plain-spoken, the gallery's thirty-three-year-old director understood that the cost of a Johns painting was probably not within the budget of the odd-looking man with the white skin—Johns's paintings were already going for $2,500 and up. But he realized that this potential customer, who mumbled his name as Andy Warhol, wanted "a little evidence," and so he took out a few small works on paper. Warhol wanted one—a drawing of a light bulb. Since it measured only 6½ by 8¾ inches, Andy was impressed by the $450 asking price. He negotiated it down to $350, on a protracted payment schedule, and then asked if there were anything else he should see. From the racks, Karp pulled a painting that had arrived at the gallery just a week before. The five-foot-tall oil on canvas had been painted by an assistant professor at Rutgers named Roy Lichtenstein, and it was called *Girl with Ball;* it showed a cartoon panel with its Benday dots. Karp remarked how provocative it was, and Andy replied agitatedly, "Ohhh, I'm doing work just like that myself." Intrigued, Karp accepted an invitation to visit Warhol's studio.

When Karp arrived at the Warhol's studio, he recalled that a record of Dickey Lee singing "I Saw Linda Yesterday" was playing in the background at full volume. Warhol said he had played the record twelve times

already that day. When Karp asked why he played the same one, since there were so many others, Warhol replied, "That's how I learn about it."

Andy had cleaned up the studio, hiding evidence of the commercial art being done there; he had found that it prompted visitors to look at his art in a different way. He showed Karp dozens of canvases, mostly black-and-white paintings of display ads: wigs, nose jobs, television sets, cans of food. Some of them were sketchy and painterly, with ostentatious drips and sections of the images smudged out. When Karp asked why some had drips and splashes, Andy replied, "But you have to drip, otherwise they think you are not sensitive." Karp told Warhol that Lichtenstein was making it possible to exclude expressive marks from the canvas, and that Warhol's only works of consequence were the straightforward unembellished ones: "Think of the possibilities of not dripping!"

Karp was primed for seeing these images, for within the previous few months he had visited the studios of Roy Lichtenstein, Tom Wesselmann, and James Rosenquist. And now Andy Warhol. "Four artists who didn't know each other, who were doing work that was distinctly related to one another," Karp said. "I was in a state of thralldom. I was experiencing tremors day and night. This is a tremor of the twentieth century, and I felt it and I knew it and I was awake to it. So in my daily meetings with collectors I would announce my thralldom."

Karp calculated that in 1960 there were maybe fifteen people who bought contemporary art on a regular basis. He took eight or ten or them to Warhol's house, including Morton Newman, Al Ordover, Emily and Burton Tremaine, and Richard Brown Baker. At least six of them bought works for prices that ranged between $400 and $600. Without cutting in a gallery the prices were low. "These were prosperous people with independent judgment," said Karp. "That is a rare breed anywhere."

In 1961 Warhol went to collector Robert Scull and said, "I want to sell you some paintings. I don't care how many you take. I just need fourteen hundred dollars. Here, take five. Okay, take six." Scull soon became one of his biggest collectors. By 1962 Emily and Burton Tremaine were buying fifteen canvases. But none of Karp's attempts to proselytize for Andy Warhol resulted in gallery representation.

When Karp brought Leo Castelli to Warhol's townhouse, the painter appeared at the door wearing a mask for a *bal masqué.* "I think we should all wear masks," Warhol said. Warhol handed out two more and Karp and Castelli joined in. So Castelli first saw Warhol's work through the eyeholes of a mask.

Castelli thought Warhol's paintings looked too much like those of

Roy Lichtenstein to be taken into the gallery. It was a matter not simply of visual similarity but of the possible tension it would cause among the stable of gallery artists. Warhol protested that he was "not doing the same thing at all. You are mistaken. This is an entirely different kind of idea that I have." But in 1961 Castelli couldn't see the difference and declined to represent both Lichtenstein and Warhol.

During the summer of 1960 Ivan Karp met twenty-five-year-old Henry Geldzahler in Provincetown. Geldzahler had just made his decision to drop his Harvard Ph.D. and was about to head to New York and begin a career in the art world. He quickly realized how valuable Karp could be in his art education. "You're going to be my conduit into the art world," he said to Karp. "I know that you know everybody, but you are not a vivid character. And that you're not a fashionable character. You just know your people."

Karp immediately liked Geldzahler and considered him a buoyant, educated, lively spirit. "About sociology he was totally equipped," said Karp. "He knew the social aspects of the art world better than he knew the art of the art world. He was at a high pitch of romance with the art community, and he liked what he saw." When Karp introduced him to Warhol, he thought they might like each other, but he was not prepared for what happened.

Three days after beginning his job at the Metropolitan Museum of Art, Geldzahler walked into Warhol's house at 1342 Lexington Avenue. The vestibule was dominated by John Chamberlain's car crash sculpture. Then he walked past a large Mr. Peanut, a spangly Carmen Miranda platform shoe with a five-inch heel, a gold Coca-Cola bottle saved from a Tiffany window display, a cigar store Indian, an Empire couch, and a Toulouse-Lautrec print. When Geldzahler came to Andy's studio, he found rock music playing on a phonograph, a television flickering without sound, and stacks of fashion and teen magazines lying open. "I thought, 'That's the most modern thing I ever saw,'" Geldzahler recalled. Warhol told him that he wanted to keep his mind as blank as possible while he painted, and he watched Geldzahler appraising his clutter of objects. Instantly assessing Warhol's taste, Geldzahler invited him to the Metropolitan to see paintings by the faux-naïve artist Florine Stettheimer. Warhol recalled the thrill of meeting a person who had instantly realized that he would appreciate Stettheimer, whose glittering impastoed scenes and portraits had only a small following in 1960.

"Curators weren't famous. Well, I was the Pop curator."
—Henry Geldzahler

At one moment that afternoon the two men looked at each other, and both started laughing. "The laugh was that we're in society but also outside at the same time," said Geldzahler, "and the continuity is that we both had a historical sense—Carmen Miranda on the one hand and the paintings in the basement of the Metropolitan Museum on the other. We had common sympathy and background."

Geldzahler had few specific duties in the Metropolitan's Department of American Painting and Sculpture. After spending his mornings at his desk, he headed downtown to visit artists' studios, using Ivan Karp's suggestions. The majority of the studios were between Houston and Fourteenth Streets, but a few were farther downtown, like the Coenties Slip studios of Larry Poons and James Rosenquist. "I spent the first two or three years in New York just running around and looking," Geldzahler said. The most forward-looking artists were all seeking a way out of the cul-de-sac of abstract expressionism. Tom Wesselman was making American still lifes of commercial products, George Segal was creating large plaster-cast figures, and James Rosenquist was transforming his Artkraft Strauss billboards into art. "It was like a science fiction movie," Geldzahler said to Warhol, "you Pop artists in different parts of the city, unknown to each other, rising up out of the muck and staggering forward with your paintings in front of you."

Geldzahler occupied a unique position: he was engaged by the most

Henry Geldzahler, assistant curator at the Metropolitan Museum, mentor of Andy Warhol, 1964, by Billy Name

prestigious museum in America but did not have to adhere to its credo on contemporary art, since it had virtually none. He also had few conceptual restrictions; his mind was nimble and always "moving with the flow." The art critic and historian Barbara Rose, then married to Frank Stella, observed that Geldzahler was the oil that made the art-world machine run. Soon people began to call him the Little King.

Geldzahler possessed what Warhol called a "Pop attitude," and he was completely comfortable with Warhol appropriating ideas from others. Geldzahler became an important source of some of these ideas, and Warhol pumped him for all sorts of information. Although their exchanges sometimes sound like an ironic comedy routine, this was one of Warhol's ways of gathering the facts that he could never absorb in print. "What always impressed me about [Warhol] was the way he seemed plugged into the Zeitgeist," said Geldzahler. "He was really the unconscious conscience of the Sixties."

As unattached homosexuals, they both had the time and inclination for their relationship, which manifested itself in the intimacy of daily conversation. Warhol would later describe himself as "the first Mrs. Henry Geldzahler." From 1960 to 1965 Warhol talked constantly to Geldzahler on the phone, and Geldzahler found that Warhol could be more himself when he could relax behind the "mechanical funnel" or "baffle" of the telephone.

Henry and Andy telephoned each other when they woke up and at the end of the day, just before going to sleep. "Sometimes [Andy] would say that he was scared of dying if he went to sleep," said Henry. "So he'd lie in bed and listen to his heart beat. And finally he'd call me." The nightly disembodied voice made Warhol at ease as he gossiped with Geldzahler, staving off his fear of sleep.

Warhol liked the fact that he and Henry were encountering a change in the New York art scene. "So that was good for at least four hours a day on the phone right there," Warhol said. Vicariously experiencing Geldzahler's peregrinations in the downtown art world, Warhol learned precisely where to position his art so that he would not tread on someone else's territory.

Warhol became an expert at eliciting information and especially gossip, which was not only an abiding interest but also a source for his work. He especially wanted to know who was sleeping with whom, and what they did together, and who got paid how much for which artwork. "He's a voyeur by eye and by ear," Geldzahler said, "and sometimes he'll

"He was very much a night creature, and literally afraid to go to sleep. He wouldn't fall asleep until dawn cracked because sleep equals death and night is fearsome, and if you fall asleep at night you're not quite sure about waking up again, but if you fall asleep in the daylight it's a kind of comfort knowing the sun is out there."

—Henry Geldzahler

stimulate you into saying something by making up gossip, and then you deny it and tell him something else . . . and then he's just delighted. He loves to transmit stories, too."

Andy Warhol also benefited from his connection to Emile de Antonio. A former professor of English and philosophy, de Antonio had switched in midcareer to become an impresario of the avant-garde. He began with John Cage, his Rockland County neighbor. The two set-builders for a Cage concert, Rauschenberg and Johns, had been so impressed by de Antonio's canny energy that they recruited him as their agent. Thereafter De, as he was known, worked as a freelance connector. He worked only with friends, and he didn't respect the customary distinctions between art and commerce. On the first day Warhol met him in the spring of 1960 through *Glamour* editor Tina Fredericks, he treated de Antonio like an intellectual and said, "Oh De, I hear you write everything. How did the First World War begin?" De Antonio refused to fall into the trap of being a sage.

Warhol recalled, "De was the first person I knew of to see commercial art as real art and real art as commercial art, and he made the whole New York art world see it that way, too." He provided the ideal conduit between the two worlds, a free agent, untethered to either gallery or discipline. Since he lived nearby, de Antonio often stopped by at Warhol's after work, and the two drank whiskey from Andy's Limoges cups.

Emile de Antonio's films:

*Point of Order
Milhaus: A White Comedy
The Trials of Alger Hiss
Underground
Painters Painting*

Andy and De shared another interest: movies. At the beginning of the 1960s, they would frequently go to double bills on Forty-second Street. For de Antonio, going to the movies was primarily a means to nurse a hangover for he was a heavy drinker, but his love of movies was genuine, and he began making them on his own in the early 1960s beginning with *Point of Order.* Impressed by the precision of his speech and thought, Warhol said, "He made you feel somehow that if you listened to him long enough, you'd probably pick up everything you'd ever need to know in life."

Since de Antonio was a close friend of Rauschenberg and Johns, Warhol pestered him with questions about why they weren't interested in him. Every time he saw them, Andy thought they were cutting him. Over brandy after dinner, de Antonio told him. "Okay, Andy, if you really want to hear it straight, I'll lay it out for you. You're too swish, and that upsets them. . . . Yes, Andy, there are others who are more swish—and

less talented, but the *major painters* try to look straight; you play up the swish—it's like an armor with you.' "

Andy's friends were at the heart of the art world, but he still had no gallery. Out of desperation he considered returning to his old staple, the Bodley Gallery, but the director thought the new paintings looked ridiculous. Ivan Karp approached Sidney Janis, Richard Bellamy, Martha Jackson, and Robert Elkon. Martha Jackson was the only one to express interest—she offered Warhol an exhibition for December 1962. (The relationship was helped by the fact that Warhol had bought a Jim Dine work for fifty dollars from Jackson.) Meanwhile, the pop images of the new art were proliferating.

When Andy Warhol saw Claes Oldenburg's storefront exhibition of *The Store* in December 1961, he returned home feeling agitated. That evening, when his friends Ted Carey and Muriel Flatow visited him, Warhol told them that it was too late for the cartoon paintings now. "I've got to do something that really will have a lot of impact that will be different enough from Lichtenstein and Rosenquist, that will be very personal, that won't look like I'm doing *exactly* what they're doing," Warhol said. Muriel Flatow offered him an idea in exchange for fifty dollars. After he had written out the check, she posed a question: what did he like more than anything? "I don't know, what?" Andy responded. "Money," she said.

Andy considered the idea of silk-screening images of money; it would be like printing up counterfeit cash. He went to an acquaintance named Floriano Vecchi, who had run the Tiber Press since 1953. Since the press published books by poets, illustrated by artists, Vecchi knew the mechanics of reproduction and the sensibility of artists. Warhol asked him to make a silkscreen of his drawing of a dollar bill. Vecchi was too busy during the Christmas season and declined. But he instructed Warhol how to do it: draw the same design on acetate, and then make a screen. Over a few visits Vecchi taught him how to pull an image using a squeegee and how to add base to make pigments more buttery, so they would flow better. Among the first were silkscreens of Campbell's Soup cans.

The first dealer to show the soup can paintings was Irving Blum whom Ivan Karp had introduced to Warhol. Blum first visited Warhol in December 1961, and again in May 1962, at the moment when Warhol was

"To be successful as an artist, you have to have your work shown in a good gallery for the same reason that, say, Dior never sold his originals from a counter in Woolworth's. It's a matter of marketing, among other things."
—**Andy Warhol**

being featured in *Time* magazine in an article, "The Slice-of-Cake School," featuring Roy Lichtenstein, James Rosenquist, Wayne Thiebaud, and Warhol. When Blum arrived Andy was working on his sixteenth *Campbell's Soup Can.* The dealer was surprised to hear that Warhol had no gallery, and since Blum had an opening in July, he offered Warhol a show. The Ferus Gallery showed such serious West Coast artists as Ed Kienholz, Wallace Berman, Bruce Conner, George Herms, and Jay DeFeo. Neither prices nor sales were high at the Ferus Gallery, but they could count on coverage from at least one art magazine, the recently founded *Artforum,* whose office was just upstairs from the gallery. Warhol sent thirty-two small canvases. On each was a hard-edged, uninflected portrait of a Campbell's Soup can.

Looking back, the first exhibition of Warhol's *Campbell's Soup Can* paintings in July 1962 appears to be a historical watershed. But at the time the impact of the event was underwhelming. Warhol did not travel to California, and there was no party event for the July 9 opening. Blum placed the thirty-two canvases, one soup can per canvas, in a single line around the gallery. Most of the gallery visitors were mystified, but when a nearby gallery put dozens of real cans of Campbell's Soup on display and advertised them at three for sixty cents, the exhibition became a minor news item. The interest shown by John Coplans, writing in *Artforum,* spread the word and spurred people to take a position on Warhol. The discussion did not translate into sales, however. The actor Dennis Hopper was the first to buy, and only five others followed him—even though the paintings were priced at a mere hundred dollars. Before the exhibition was over Blum decided he wanted to keep the thirty-two paintings as a set, and he bought back the handful that had been sold. Warhol was pleased by the idea since they had been conceived as a series, and he agreed to sell Blum the whole group for a thousand dollars with Blum paying monthly hundred-dollar installments. Although the money Warhol received was a pittance compared to his commercial work, he had passed a milestone: his first serious art show.

While his exhibition was on view in Los Angeles, Warhol remained busy in New York painting images of the contents of his mother's kitchen: Martinson's coffee cans, Coca-Cola bottles, S&H Green Stamps, and large Campbell's Soup cans. During the run Warhol received a discouraging letter from Martha Jackson about his upcoming show. The letter derailed his hopes for a New York show and crystallized his problems in being accepted by a gallery.

It became quite clear to me that your work is going to be extremely controversial. Apparently it is not necessary to give you a show to find out the reason—in your case, that is. All I had to do was to wave a few photos or a transparency in front of faces to get a strong reaction. As this gallery is devoted to artists of an earlier generation, I now feel I must take a stand to support their continuing efforts rather than confuse issues here by beginning to show contemporary Dada. While Jimmy Dine verges on the Dada group, I do not consider him a Dada artist essentially. The introduction of your paintings has already had very bad repercussions for us. This is a good sign, as far as your work and your statement as an artist are concerned. Furthermore, I like you and your work. But from a business and gallery standpoint, we want to take a stand elsewhere. Therefore, I suggest to you that we cancel the exhibition we had planned for December 1962.

The Ferus show closed on August 4, 1962, the day Marilyn Monroe committed suicide. A few days later Warhol bought a publicity still of Monroe from *Niagara*. He cropped it below the chin and sent it off to get a silkscreen made. He had found a way to mechanize the art-making process. He first applied colored shapes that corresponded to Monroe's mouth, hair, eyes, eyelids, and collar. On these multicolor grounds he silk-screened her face, repeating the process in different combinations. His assistant Nathan Gluck urged him to line the images up carefully, but Warhol worked fast, and the face and the colors were often slightly off register. Warhol didn't care—he liked it that way.

De Antonio then introduced Warhol to gallery dealer Eleanor Ward, an imposing fading-movie-star-like beauty who had moved up through advertising to Christian Dior to opening an art gallery in 1953. Since her gallery was in a reconverted stable, she called it the Stable Gallery; in 1960 she moved to a new space on the ground floor of her townhouse at 33 East Seventy-fourth Street. She was intrigued by Warhol's paintings, but her gallery schedule was full. In 1962 she was summering in her converted ice house in Old Lyme, Connecticut. Miffed that one of her young artists, Alex Katz, had shown work with Martha Jackson, she booted him from her gallery and had a prime November exhibition slot to fill. As Ward recalled, she was lying on her vast lawn not thinking of the art world. "Everything was utterly *remote*." Suddenly a voice in her mind

Stable Artists:
Cy Twombly
Robert Rauschenberg
Joseph Cornell
Richard Stankiewicz
Alex Katz
Marisol
Robert Indiana
Isamu Noguchi

said, "Andy Warhol." She sat up and thought, "How extraordinary!" and immediately called Warhol and asked to see his work.

Ward went to Warhol's house accompanied by her friend Emile de Antonio, wondering whether he should fill her empty slot. The three drank quadruple whiskeys in white Danish cups, and by the time de Antonio called the question—was she or wasn't she going to give him a show?—everyone was pleasantly inebriated. Ward pulled out her lucky two-dollar bill, waved her cigarette, and said, "Well, I'll give you a show, but you've got to paint me a two-dollar bill."

Warhol's new career advanced again a month later on September 18, when Robert Rauschenberg brought Ileana and Michael Sonnabend to Warhol's house. Ileana Sonnabend (formerly married to Leo Castelli) and her new husband planned to open a gallery in Paris, and they offered Warhol a show.

On October 31 Warhol was featured with three paintings in a group show called *The New Realists* at the Sidney Janis Gallery. This exhibition represented the next wave of artists who had turned their back on abstract expressionism, and it profoundly disturbed the older generation. Several of them—including William Baziotes, Robert Motherwell, Philip Guston, Adolph Gottlieb, and Mark Rothko—resigned from the gallery in protest. Afterward Willem de Kooning went to a party thrown by the collectors Burton and Emily Tremaine, whose guests included Warhol, Robert Indiana, Roy Lichtenstein, James Rosenquist, and Tom Wesselmann, reflecting the new complexion of the art world. Burton Tremaine greeted de Kooning, "Oh, so nice to see you. But please, at any other time." Some guests were shocked to see him turned away. "At that moment," James Rosenquist said, "I thought, something in the art world has definitely changed."

Across town from the Janis Gallery, exactly a week later a show at the Stable Gallery was devoted entirely to Andy Warhol. Walking into the main gallery—a large room connected by a wide hallway to a back room—the visitor was confronted by an enormous range of work. There were several versions of Marilyn Monroe and a multiple portrait of Troy Donahue. In the middle of the room was *Dance Diagram*, exhibited horizontally a few inches above the floor so one looked down on it. In the smaller back gallery hung the first of the *Death and Disaster* paintings, *129 Die*, as well as a matchbook painting (*Close Cover Before Striking*) and *Baseball*. Although Warhol's subsequent exhibitions usually focused on a single theme, his first Stable show offered a virtual retrospective of the new Andy Warhol. It sold out to prominent buyers, and many of

Names for Pop Artists, early 1960s:

Neo-Dadaists
New Realists
Commonists
Vulgarists
Sign Painters
New American Dreamers
Popular Realists
Factualists
Polymaterialists
Kitsch-niks.
—David Bourdon

them attended the party Henry Geldzahler threw for Andy. The controversy it raised in the art world is reflected in this post-opening interchange between two influential curators at the Museum of Modern Art:

Peter Selz: Isn't it the most dreadful thing you've ever seen
 in your life?
William Seitz: Yes. I absolutely agree with you. I bought one.

Another influential figure at the Modern, Philip Johnson, bought a painting and soon provided a new springboard for Warhol's career. Before 1962 was over, he donated his *Gold Marilyn* to the Museum and invited Warhol to be one of the artists that would create work for the round New York State Pavilion at the 1964 World's Fair.

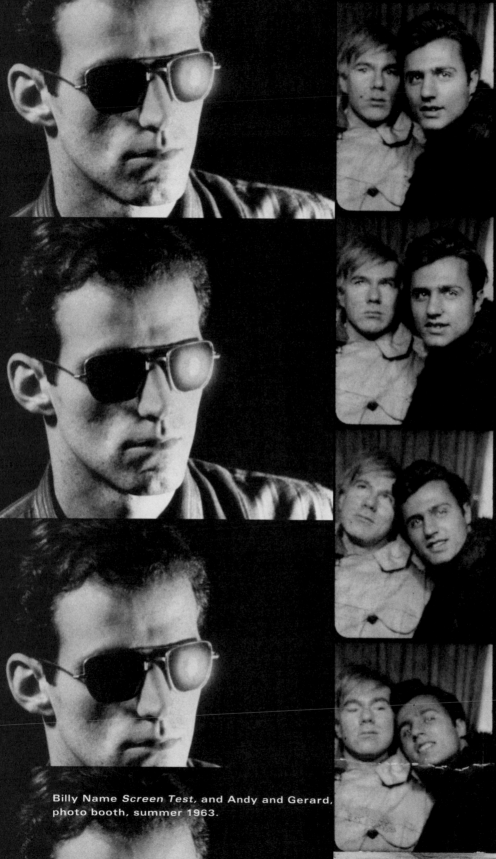

Billy Name *Screen Test*, and Andy and Gerard, photo booth, summer 1963.

WITH LUVB FROM ANDY "PIE" AND GERRY "PIE"

1963

Andy Warhol's professional life so far had represented a dichotomy between the commercial and the avant-garde art worlds. The success of his exhibition at the Stable Gallery offered a momentary victory in that struggle, but added to that dynamic would now be the worlds of Hollywood movies and the underground film movement led by Jonas Mekas. By 1963 Warhol was familiar with both, but they played no part in his professional life.

When he was growing up, Warhol had seen Hollywood as the ultimate vehicle for fame. Hollywood stars were America's aristocracy, and movies provided a common language that was more broadly available than the vocabulary of art and high culture. "I loved going to the movies, and I probably hoped that the movies showed what life was like," he wrote about his lifelong fascination. "But what they showed was so different from anything I knew about that I'm sure I never really believed it. . . ."

By the beginning of 1963 Andy Warhol had come into the orbit of Jonas Mekas. Last seen organizing the Film-Makers' Cooperative, Mekas had widely expanded his activities. His column continued to appear each week in *The Village Voice,* and he continued to edit and publish *Film Culture,* which came out quarterly. The Film-Makers' Cooperative catalog boasted dozens of films. Mekas referred to them as the New American Cinema, but the term more widely used was "underground movies." Coined by

Stan Vanderbeek in 1961, this term reflected their marginal position as well as their tenor of social and political alienation.

Most important, Mekas helped increase the possible number of venues open to the independent films he championed. In March 1961 he came upon film distributor Dan Talbot at the Charles Theater, a beat-up seven-hundred-seat theater on Avenue B between Eleventh and Twelfth Streets. With Talbot's help Jonas instituted midnight programs on Friday and Saturday, modeled after the Cinémathèque in Paris. By 1963 the underground venues had shifted quarters several times—from the Charles, to the Bridge Theater, and to the Midnight Mondays of underground films at the Bleecker Street Cinema. "Jonas had a knack for finding these terrific theaters that were going out of business or needed some new blood, and he persuaded the owners to rent them out on certain nights," recalled Gerard Malanga. "So it was a great opportunity for Jonas and for the underground cinema. Jonas was basically having a floating cinematheque. That's what it should have been called, the floating cinematheque." Amos Vogel attended Mekas's screenings at the Charles and other venues. He kept his eye on the audience and noticed that instead of growing it seemed to be shrinking in size. Always conscious of the need to build an audience, Vogel was not optimistic about the fate of American independent films if they were identified only with experimental works.

In addition to these regular screenings of underground movies, Mekas arranged showings at the Living Theater, at the Brata Gallery, and at the New York Poets Theater. Perhaps most valuable for Andy Warhol were the screenings in the makeshift quarters at the Film-Makers' Co-op. The back of the loft, an area about twelve feet across and twenty-five feet deep, served as an informal screening venue for filmmakers. Joan Adler, a frequent audience member, recalled, "The screen would be opened with the office as a dark backdrop, and the audience would drag up chairs, sit on the floor, or lie on the sofa to one side of the cleared space." This was the venue for filmmakers' works in progress. Like the tea rooms of early Greenwich Village, like the coffeehouses of Beat culture, like the salons of the avant-garde, the Co-op provided the social nexus for the underground film community in the 1960s.

Andy Warhol became a regular visitor to the Co-op's informal screenings, although months passed before Jonas Mekas could attach a name to Warhol's pale, silent presence. In this darkened setting Andy didn't have to compensate for shyness or think of conversational ploys.

Nor did he feel marked as homosexual in a heterosexual crowd as he had in his contacts with the downtown galleries. In the mid-1950s Jonas Mekas had deplored "the conspiracy of homosexuality that is becoming one of the most persistent and most shocking characteristics of American film poetry today." But by the early 1960s he had recanted this sentiment, calling it a "Saint-Augustine-before-the-conversion piece." Mekas's old position made little sense in a community that continued to be dominated by homosexual or homophilic filmmakers, such as James Broughton, Kenneth Anger, Gregory Markopoulos, and Jack Smith.

In this arena Andy Warhol could watch and absorb without social distractions. In the process of seeing rough footage, film doodles, raw documentaries, and experiments with color and drawing on film, Warhol witnessed what was possible. He also realized that these filmmakers were not technical wizards. These in-process experiments, coupled with the underground movies shown in theaters in early 1963, provided him with an extraordinary education. In Ken Jacobs's *Little Stabs at Happiness,* Warhol saw an example of a director including the perforations at the beginning and end of film rolls. In *Fleming Faloon* he saw the use of multiple screens, and he saw a program of the San Francisco underground, including James Broughton, and a program of Ed Emshwiller. There were movies by Claes Oldenburg at the Brata Gallery, and Gregory Markopoulos, and Stan Brakhage's 1956 *Flesh of Morning,* advertised as "a film of masturbation." Bits and pieces of what Warhol saw that spring would find their way into his own work.

Appearing most prominently on the underground movie screens during the first six months of 1963 was Taylor Mead. He starred in no less than three films shown that spring. In each case Mead seemed to be not just an actor but the centerpiece of the movie. An odd thing had happened to Taylor Mead since he was last seen in San Francisco making *The Flower Thief:* he had become America's first underground movie star. The movie star was a concept that Andy Warhol understood perfectly.

Several critics compared Taylor Mead to Charlie Chaplin and Harry Langdon, and Jonas Mekas raised Mead to archetypal status: "He walks across the garbage cities of the western civilization with his mind pure and beautiful, primeval, unspoiled, sane, a noble idiot, classless, eternal."

By the summer of 1963, just before he met Andy Warhol, Mead had become the most-used actor in underground film. On the West Coast he

had starred in Vernon Zimmerman's *Lemon Hearts* (1960) and Bob Chatterton's *Passion in a Seaside Slum* (1961). In New York he played a convict in Adolfas Mekas's *Hallelujah the Hills!* At the Judson, David Gordon choreographed an homage to Mead, called *Lemon Hearts Dance,* in which Gordon danced in faux-Spanish style in a strapless dress.

Taylor Mead found that people recognized him during his daily rounds of wandering, radio listening, and cruising, and he was sometimes annoyed at the burdens of his new stardom. Mead wrote, "I wandered the streets trying to figure out 'the meaning of life' or relax my neurosis and interrupt my 'train of thought' or my 'hang-up.' "

The most influential film that Andy Warhol saw at the Film-Makers' Co-op that spring was Jack Smith's *Flaming Creatures.* Parker Tyler had invited his friend Charles Henri Ford, who in turn brought Warhol to the private screening. Tyler recalled that the foundations had already been set for such a phantasmagoric film: "By then, beatnik bawdiness and shabbiness, the proud, gay, to-hell-with-the-red-white-and-blue avant-garde, the just plain, raggedy-raggedy film was firmly entrenched a go-go." But nothing yet matched the spectacle they saw that night, which Smith had shot in out-of-date 16mm color film.

Flaming Creatures would soon became a test case for freedom of expression. It got coverage like no underground film before, driven by its notoriety and its flamboyant multisexuality. Warhol would absorb these lessons soon enough—the attention paid was similar to the scandal over Warhol's work—but Parker Tyler thought Warhol learned something different the night he first saw Smith's film. "Unquestionably what most struck Warhol by the display on the screen that night was its easy-to-doness," Tyler wrote. "Apparently you just had to have personality drive and picturesque obsessions: the queerer the better."

That spring Warhol increased his activity at the red-brick former firehouse on East Eighty-seventh Street between Lexington and Third that he had rented as a studio. There he was alone silk-screening the *Death and Disaster* paintings. He attended the fiftieth anniversary of the 1913 Armory Show, which publicly introduced modernism to America in 1913; he watched dancer Yvonne Rainer's *Terrain,* lit by Robert Rauschenberg at the Judson Church; he viewed a Mr. New York contest; and he went to a day of Fluxus-like performances, called Yam Festival of Happenings, at George Segal's farm. His antennae were keenly tuned, and his eyes and ears were open to a wider world.

As Jonas Mekas was approaching his fortieth birthday, he thought about midlife and pondered what he could still accomplish. Others might be amazed by what he already done—create a small empire for underground movies—but Mekas felt immersed in darkness. He was determined to break through to the next level.

"It's at forty that we die, those who did not die at twenty," Mekas wrote in his diary. "It's at forty that we betray ourselves, our bodies and our souls by not going further, by taking the easiest decisions, retarding, throwing ourselves back by thousands of incarnations. . . . What am I doing with my life? The race is beginning. The race has begun."

During the spring months Mekas increased his *Village Voice* proclamations that a revolution in films was upon us. At the beginning of May he identified the "four works that make up the real revolution in cinema today": Jack Smith's *Flaming Creatures,* Ron Rice's *The Queen of Sheba Meets the Atom Man,* Ken Jacobs's *Little Stabs at Happiness,* and Bob Fleischner's *Blonde Cobra.* Each of them contained homosexual elements, he noted, describing the homosexual as the classic outsider: "Homosexuality, because of its existence outside the official moral conventions, has unleashed sensitivities and experiences which have been at the bottom of much great poetry since the beginning of humanity." Mekas embraced the films that would challenge most directly the censorship laws. What these films depicted in common, he wrote, was "a world of flowers of evil, of illuminations, of torn and tortured flesh; a poetry which is at once beautiful and terrible, good and evil, delicate and dirty."

One of Andy's most frequent film-going companions that spring and summer was a young stockbroker named John Giorno. Warhol liked Giorno's lean, Mediterranean looks and his ready-to-try-anything attitude. On Monday nights they often went to the midnight screenings that Mekas had set up at the Bleecker Street Cinema, but by June these had come to an end because the theater complained they were ruining its reputation. ("Dig that!" responded Mekas.) Watching the reels of one bad movie, Warhol said to Giorno, "They're so terrible. *Why doesn't somebody make a beautiful movie! There are so many beautiful things!"* Over Memorial Day weekend, Warhol borrowed a 16mm camera from Wynn Chamberlain and shot footage of Giorno sleeping. This first attempt proved to be so underexposed that it was unwatchable.

Billy Linich returned to New York in the spring of 1963, after a period of rest and healing from constant exhaustion. A doctor had told him that his basal metabolism was dangerously low, so Billy had gone to southern California to recover at Diane di Prima's. At the beginning of the year, she and Alan Marlowe, now husband and wife, had rented a house in Topanga Canyon. She welcomed visitors, not only because she felt isolated but also because they provided a buffer zone in her new and difficult marriage. "Billy Linich arrived the earliest and stayed the longest," di Prima wrote. "Billy was at that time doing a bit of everything: writing, collaging, taking odd combinations of drugs, making mots that sounded way hipper than they probably were, and mostly *looking* wise with a little half-smile and crinkly eyes."

Billy's ashen pallor disturbed her. She and Marlowe jointly took on the mission of nursing him back to health, even though they had no money and barely enough food for themselves and di Prima's child by LeRoi Jones. At the beginning of another pregnancy di Prima awoke each day to morning sickness and felt nauseated until she devoured liver for breakfast. All winter long Billy Linich lay on the couch, gradually regaining strength and color. Finally, after two months, he began to get up and look forward to adventure. When Freddie Herko arrived that spring, Billy felt well enough to travel. The whole household went on a trip north, stopping in Big Sur and Marin County, staying with such friends as the poets Kirby Doyle and Michael McClure.

When he arrived back in New York that spring, Billy threw himself into work designing lighting. One of the dance pieces, choreographed by James Waring, was called *The Billy Linich Show*. It was the first time Billy's name had appeared in a title. As June began, he designed the sets for James Waring's *Pocket Follies*. When it was over, Billy collapsed onto the floor of his apartment. He felt his energy had completely deserted him, and he had no idea what to do about it.

By that spring Edie Sedgwick had done so well in maintaining her weight and behavior at the hospital that she earned the privilege of a day pass. On her day out Edie met a Harvard student, took him to her grandmother's apartment, and had her first sexual intercourse. "That was my first time I ever made love, and had no inhibitions or anything," she said in a filmed interview five years later. "It was just beautiful." When she didn't get her period, the hospital doctors made arrangements for the abortion that Edie had a few weeks later.

She left the Bloomingdale Hospital soon afterward, at the age of twenty. After spending two years in hospitals, she wanted to face the outside world.

The mood in New York that summer was upbeat. Warhol's friend Wynn Chamberlain recalled, "It was very sweet because everyone felt optimistic." The Mod look from Carnaby Street had not arrived, and the Beatles wouldn't perform on *Ed Sullivan* until 1964. No one had yet bombed Vietnam.

It was the high season of acoustical folk singing, combining the earnest and sweet musicality of Peter, Paul and Mary with the collegiate look of the Kingston Trio. The edgier Bob Dylan had just released his first album. But the dominating music was American rock and roll, and Andy Warhol immersed himself in that sound. He played it nonstop in his studio and at home on weekends, and he headed out to the Brooklyn Fox Theater with Ivan Karp, Wynn Chamberlain, and James Rosenquist, for Murray the K shows with the Ronettes, Little Anthony and the Imperials, and the Shirelles.

The surprise best-selling book that summer was Betty Friedan's *The Feminine Mystique.* Although it had been published in the midst of a newspaper strike with a print run of only three thousand copies, the book found a wide readership through excerpts in both *Ladies' Home Journal* and *McCall's.* Friedan's ideas were not exactly new—many thought they sounded like a diluted version of Simone de Beauvoir's *The Second Sex*—but Friedan adapted them to the outlook of the middle-class suburban American housewife, written in the language of a women's magazine. When the book appeared the following year in paperback, it was the number-one nonfiction best-seller, helping bring about a new wave of feminism.

Andy Warhol began the summer of 1963 by appearing in the June issue of *Harper's Bazaar.* He was among the "New Faces, New Forces, New Names in the Arts" that were defining the decade. Wearing dark glasses and a sloppy unbuttoned coat, his face among the other scene-makers is the most impassive, the least animated. Warhol's design animated the four-page spread. He had taken a dozen of the chosen up-and-comers to a Photomat booth—among them were his friend Henry Geldzahler, the dancer Edward Villela, the writer Donald Barthelme, the painter Larry Poons, and the avant-garde musician La Monte Young. Warhol dropped quarters into the slot, and the machine

did the rest—an ideally simple means to produce an image. He casually laid out the strips—some single, some repeating—as a collective portrait of the coming generation. Not only was Warhol one of the "New Faces," but he was also the producer and the image-maker.

That summer Warhol translated his magazine assignment into his first commissioned portraits, of Ethel Scull. Commissioned portraits would become his bread and butter in the 1970s and 1980s, but on his first time out Warhol had to stamp the traditional portrait form with the Warhol look.

"As Marshall McLuhan so brilliantly put it, jet planes and Pop Art and discotheques are all an extension of our central nervous system." —Ethel Scull

Robert and Ethel Scull were key art collectors. They had started pouring their taxi fortune into contemporary art in 1956, when they still lived in a small house in Great Neck. Five years later they began collecting Pop Art through the influence of Richard Bellamy at the Green Gallery. By this time the Sculls had moved to upper Fifth Avenue. Their long white living room was sparsely furnished with two white couches, a pair of Mies van der Rohe's leather and steel chairs, a thick oak coffee table, and a Steinway grand, to better show off their burgeoning collection, which included works by Jasper Johns, Frank Stella, and Lucas Samaras. Thanks to the allowances Scull gave some artists, John Chamberlain could stop being a hairdresser, Larry Poons a short-order cook, and James Rosenquist a billboard painter. From Warhol, Scull bought a *Campbell's Soup Can* painting with the label coming off. Warhol had previously appealed to Bob Scull's collecting instincts, and now he appealed to Ethel's society instincts.

Warhol took Ethel Scull to a Times Square amusement arcade and installed her in a four-for-a-quarter Photomat booth. She was wearing a Yves Saint Laurent for Christian Dior suit and dark glasses. As he dropped quarters into the slot, he said, "Now start smiling and talking—this is costing me money." He spent over twenty-five dollars and watched the photo strips slither from the machine, still moist with developer. When he asked Wynn Chamberlain what he should do, Chamberlain pulled out squares of brightly colored, nearly fluorescent cardboard. Andy incorporated these colors into his portrait, *Ethel Scull Thirty-Six Times*, featuring thirty-six panels, each 15⅞ by 19⅞ inches. The portrait not only continued the serial imagery that fascinated him but also created a huge (79 by 143 inches) and fashionable image for the taxi mogul's wife. The portrait provided a flattering form of social climbing, especially after Ethel's double chin was retouched. The press attention to her portrait was pasted in a red leather scrapbook with THE SCULLS AND THE PRESS stamped in gold on the cover.

Henry Geldzahler regarded Ethel Scull as an early example of Warhol-created stardom: "What he did with Ethel Scull in the portrait was to create a superstar out of her by putting her in that twenty-five-cent Photomat machine and saying: 'Now move your head. Now move it the other way. Now throw it back.' He was creating. He was being an art director. He was also creating an image of a superstar out of a woman who could have been one of a series of women."

Gerard Malanga had first glimpsed Andy Warhol at a party that Willard Maas and Marie Menken threw for Stan Brakhage in the fall of 1962, when he saw Menken chasing a pale man around the dining room table, trying to kiss him and hug him while he was saying "Ewww." Malanga didn't know who he was. Gerard was more interested in the poets, and his formal introduction to Andy took place on Sunday, June 13, in the garden behind the New School, following a poetry reading by Frank O'Hara and Kenneth Koch, when Charles Henri Ford introduced them. Malanga had spent the spring writing poetry and attending Wagner College, and he spent Saturday nights with Ford going to cheap movies on Forty-second Street. Ford mentioned to Andy that Gerard needed a job.

By the time Malanga met Warhol, he had already established a network within the downtown poetry community, and it gave him a base of operations that combined prestige and practical politics. For a twenty-year-old he was remarkably well connected, and he owed his introductions to Willard Maas, the poet he had met at the end of his last year in high school. Gerard had met Charles Henri Ford at Wystan Hugh Auden's fifty-eighth birthday and struck up a relationship with the legendary editor of *Blues* and *View*. By that time, he been awarded a poetry prize by Robert Lowell, had studied with Kenneth Koch, and had worked briefly at Frances Steloff's Gotham Book Mart and at Cinema 16. His poems had been published in *Chelsea Magazine, Locus Solus,* and *The Minnesota Review.* The professional experience that would make him most useful for Andy Warhol, however, had nothing to do with these famous people and publications. Thanks to his high school English teacher Daisy Aldan, Gerard had worked as an $1.25-an-hour apprentice for one of her former students, Leon Hecht, from whom he learned the craft of silk-screening fabric for RoosterCraft ties.

That Sunday afternoon Warhol decided on the spot to hire Malanga to help him silk-screen paintings. Gerard agreed but said he couldn't start the next day because he had to clean out his desk at Wagner College,

where he was still a student. He showed up Tuesday, June 11, at eleven in the morning at the firehouse. The firehouse had two floors, each 26 by 101 feet. Since the building leaked in back, only the front third was used for silk-screening. The door was ajar when Gerard arrived, and Warhol called down from the second floor. Malanga climbed the stairs to find Warhol turning a canvas around while Barbara Rose and Ed Wallowitch looked on. Gerard's first task was to help silk-screen a series of *Elizabeth Taylor* on forty-inch-square canvases that had been prepared with solid fields of silver spray paint. (Elizabeth Taylor was very much in the news for the scandalous breakup of her marriage and for being the first movie star to be paid a million dollars, for *Cleopatra*, which had just opened at the Rivoli Theater.)

Warhol's summer would be filled with the production of *Elvis Presleys*, in preparation for a show Irving Blum would mount at the Ferus Gallery in Los Angeles. Each morning Gerard telephoned Andy around ten-thirty to see if there were any errands to run. Andy arrived at the firehouse around noon and mixed paint in coffee cups while Gerard arranged the canvases on the cement floor, doing a transfer tracing from the clean acetate silkscreen. When Warhol gave his approval, they would jointly push the paint through the nylon mesh, Andy beginning to pull the squeegee and Gerard finishing it in a single fluid motion. They soon became an industrial team, and Gerard would clean the screens with Varnolene. In the process Gerard began making a few suggestions about screen placement. Andy always welcomed the suggestions whether he followed them or not. When the two were screening multiple images of Elvis Presley—from a publicity still for *Flaming Star*—Gerard suggested they screen a few canvases with the image slightly off register. Whatever mistakes occurred in the process Warhol said, "It's part of the art." Gerard thought his new boss had a kind of Zen-like attitude. "I think it can be boiled down to one statement," Malanga said. " 'Embracing your mistakes.' "

On Malanga's second day of work, Andy invited him to tea. "I become inwardly tense at the suggestion but don't show outward signs," Malanga later wrote. "I accept the invitation, all the time thinking that he wants to put the make on me. It's not so much the invite that makes me tense but something about the way he looks I can't quite make out. He has an almost ghostly appearance as if the pigment in his skin were sand-papered, transparent." They walked to 1342 Lexington, and Gerard was amazed to see a pink facade. Inside he found piles of newspapers, UPI photos of car accidents, and Americana, while Andy put on his favorite

record, "Sally Go Round the Roses." When he met Julia Warhola, Gerard immediately recognized something familiar and sensed her excitement at meeting him. "She said something like 'Oh, you are Andy's younger brother,'" Malanga recalled. "So she was relating to me and Andy as brothers who were going to look out for each other." Malanga was one of the few who witnessed Andy's interactions with his mother, largely because he was the only one who worked with Warhol at the nearby firehouse. That summer Julia often fixed them lunches of Czechoslovakian hamburgers, stuffed with diced onions and parsley on white bread, accompanied by 7-Up on ice. Gerard caught glimpses of Julia's basement room, which contained a Motorola television set, a kitchen table covered with a flowered oil tablecloth, a single bed, and a dresser filled with religious statues. Malanga noticed that Julia spoke to her son in Ruthenian dialect, and Andy responded with annoyance, saying, "Oh, Ma, stop it." When he realized that his new assistant was taking in this domestic scene, Andy grew embarrassed.

In the early summer of 1963 a skinny, effeminate, buck-toothed fifteen-year-old named Harold Ajzenberg confessed to his parents that he was homosexual. He then broke an ashtray and slashed at his wrist; the result was just a scratch, but it was the grand gesture that counted.

Harold Ajzenberg didn't look like his name. His mother was Puerto Rican and his father an American soldier who had left shortly after Harold was born. Harold had grown up with his grandparents in a yellow ramshackle house outside Ponce, Puerto Rico, and it was in the sugarcane fields there that he had danced with his gay uncle and learned about sex. When his mother remarried, the family moved to Miami. Though his life was comfortable and his parents were not unkind, after confessing his homosexuality he knew he had to leave. He stole his mother's bracelet—with twenty-three aquamarines—and desperately sold it to a jeweler for twenty-seven dollars. (For decades afterward Harold felt guilty about betraying his mother and usually pretended that the money had come from a paper route.) Harold needed to leave fast, with his friend Russell, who seemed experienced and ready to head to the big city. Before leaving Miami Harold took a pair of tweezers and pulled the braces off his teeth; he then traced a thin line of Max Factor on his upper lip. This was the first of his many physical alterations.

The twenty-seven dollars got Harold and Russell as far as New Brunswick, Georgia. Harold then made a tearful telephone call home,

pleading for money to return home, and when it arrived by Western Union, the two used it to continue hitchhiking north. A trucker dropped them off in Times Square, and there before them on the marquee of the Rivoli was the towering image of Elizabeth Taylor in *Cleopatra*. With their remaining few dollars Harold and Russell took a room in a flophouse hotel and began to look for work. But no one wanted to hire a fifteen-year-old without skills.

Harold discovered Bryant Park, where transvestites and hustlers hung out, and soon fell in with a group of young gay men from Miami. They all split a single room in a flea-bitten hotel at Seventy-second and Broadway, hustled on the street for twenty-dollar tricks, and pooled their funds. They invited Harold to join the pool. Thus began Harold's first career.

Billy Linich spent hours that summer lying on the floor. Located at 272 East Seventh Street, the three-room tenement flat cost fifty-five dollars a month. The apartment was large enough for friends to crash, too, and his shifting group of flatmates included Ondine, Freddie Herko, and a young man named Richard Stringer (aka Binghamton Birdie), whom Herko had picked up in Washington Square Park. Billy was glad the apartment was on the ground floor because he felt too weak to climb stairs. A neighbor, Michael Katz, brought chicken soup to revive him, but Billy was afraid he would never again be able to manage the construction work required for organizing lighting; he didn't have the energy for it. One day Ondine gave him some white powder and suggested he try sniffing it. It was methamphetamine. "All of a sudden I had energy so I could get up off the floor and start doing things," said Billy. "And because it enabled me to work I started doing it every day. So that was the introduction of my amphetamine phase."

Fueled and inspired by speed, Billy began to think of his new apartment as a conceptual set piece, an environmental sculpture, a place in which to design an intervention, just as he had at the Judson Dance and Living Theaters. At the local hardware store he bought Krylon silver spray paint—which had just become available for seventy-nine cents a can—and at the grocery store he bought rolls of Reynolds aluminum foil. For about three weeks he proceeded to silver every surface in the apartment—the walls, the ceiling, the furniture, even the silverware. In a moment of amphetamine-induced enthusiasm, he began to fashion sinuous tinfoil flowers for the refrigerator door. But he stopped himself,

realizing that the silver concept depended on severe purity. Just as the chrome would be unsullied by color so must the form be unsullied by ornamentation. "When it comes to elaboration within or on a base," he said, "I tend to stop if the base looks like a complete work in itself."

By the summer of 1963 Mickey Ruskin had sold his second café, Deux Magots, and hooked up with a childhood friend named Bobby Crivit, who wanted to start a jazz club. They opened the Ninth Circle in the West Village. It became not a jazz club but a musicians' hangout, and Ruskin learned how to run a convivial steakhouse where no one had to wear a coat and tie. Meanwhile the poetry-reading scene moved to Café le Metro, which was a combination antique shop and coffeehouse on Second Avenue.

At this juncture in the evolution of downtown poetry readings, Gerard Malanga became a regular. He hoped to find a community of poets who were a generation younger than the poets he had met through Willard Maas and Daisy Aldan. "The Metro Café was a great educational opportunity because it allowed a lot of poets, whether they were conscious of it or not, to become educated in terms of reading each other's texts."

In early July Andy Warhol, Gerard Malanga, and Charles Henri Ford went to Peerless Camera, which advertised itself as "the world's largest camera store," at 415 Lexington, across from Grand Central Station. Knowing that his friend Marie Menken shot her films with a 16mm Bolex, Gerard suggested buying that model. "Andy was not your technical expert," wrote Gerard. "He wanted everything to be totally easy, like *push the button and let it roll*. This was his technical and technological aesthetic surfacing." Warhol bought the camera for twelve hundred dollars. His purchase coincided with a new technology that had just come on the market: a motor drive attachment that could be clipped onto the side of the camera. Warhol could shoot a hundred-foot roll of film without stopping to crank. This was the first of many new film and video technologies that would shape Warhol's art.

Many of Andy's first three-minute reels were informal hand-held shots of his friends—Henry Geldzahler brushing his teeth, John Giorno cooking at the stove, Harold Stevenson walking up and down stairs, Jill Johnston and Freddie Herko dancing on the roof of Wynn Chamber-

lain's building. The movies are small valentines to his friends, and in the early years he frequently gave prints of the films to his subjects.

That summer of 1963, appearing in the twenty-ninth issue of Jonas Mekas's *Film Culture,* Taylor Mead wrote an article declaring "The Movies Are a Revolution." Hollywood films, he wrote, suppressed the real excitement of American life, trying to put a lid on the explosion that was ready to happen:

> All of you have got to dig—we are the bank robbers, rapists, sodomists, all the yearning mad desires of the populace which the government has to let be seen or else wow an explosion. . . . What should the people, the vast audience being oppressed by Hollywood movies, do? Either they speak on street corners and toss aside your lousy government (s) or you let them breed with vast audiences the secret thought hopes and frustrations that gestate new personalities new ways of looking at and understanding and undermining and building new countries worlds people—oh most insidious triumphant ponderous art oh big bad beautiful sick chromium plated real lost Hollywood. If you don't give the people good pictures this year Ron Rice and Taylor Mead will storm the palace with howling hungry public one way or another—you are dangerously boring the public this year you phony stuffed tight dungarees and padded bra no nakedness land—the people may be laughing at Jerry Lewis and crying with Ava but that is because they haven't anything better to laugh and cry with them when the empty hungry feeling persists watch out!

Taylor Mead was eating at the Horn and Hardart one afternoon when Paul Morrissey recognized him from *The Flower Thief* and complimented him on his performance. A friend had lent Morrissey a 35mm camera that summer, and Morrissey suggested that he shoot a short movie of Taylor and a white Rolls-Royce. "I was just fooling around," Morrissey said. "I call it scribbling." The silent film's jerry-built narrative didn't matter much, because Paul Morrissey was mostly interested in capturing the star's personality.

"Everyone always forgets about Taylor's age," said Morrissey. "You always think he's very young, when his age is not quite as young as his attitude—and it has something to do with that ability to not lose his special quality. Most people don't have it though; they have it at first and then they lose it. With someone like Taylor Mead, his span is not concluded. I think he has many untapped resources—he'll always be good if people will use him."

Morrissey impressed Taylor Mead. "He was always very reticent and very dedicated, and he always seemed to know where he was going to somehow," Mead said. A few weeks later Mead suggested an introduction to his new friend Andy Warhol and even proposed that Morrissey join them on a trip across country for Warhol's opening at the Ferus Gallery in September. But Morrissey declined, and two years would pass before he met Andy Warhol in the summer of 1965.

By midsummer Jonas Mekas's floating cinematheque was again homeless, with no venue to show the New American Cinema. He was ejected from the Bleecker Street Cinema, ending the Monday Midnight series of underground movies. "Frankly the theater's management was ashamed of us," Mekas told *The New Yorker.* "They wanted a clean, proper repertory theater, and they said we were disorganized, unsophisticated, and anarchistic. It's true, we are." The programs usually made about eighty dollars a night, and this was divided among the filmmakers according to the length of their films. But Mekas did not feel defeated. "We've made a new arrangement for Monday-evening programs at the Gramercy Arts Theater, and that should be happier."

The owner of the Gramercy Arts asked Mekas if he could give a job to his seventeen-year-old niece as a way of "rehabilitating" her in society. Barbara Rubin had grown up in Queens, begun fighting weight problems with diet pills, then discovered how great she felt when she took a handful all at once. Unable to handle Barbara, her parents had hospitalized her.

When Barbara Rubin arrived at Mekas's loft, he was struck by her preternatural wisdom, her beauty, and the breadth of her experience. For the first few months she rarely spoke, but one afternoon when the subject of drugs was brought up, she revealed her expertise. "She was the professor, they were just kids talking about drugs," Mekas recalled. "Of course her reputation went up."

Over the next few years Barbara Rubin's amphetamine-fueled energy in service to the downtown community was guided by her belief that a new age was coming, and it needed new leaders. "She had a visionary view of cultural change," said Allen Ginsberg. "That's why she was interested in the Beatles. That's why she was interested in me and why she was interested in Dylan. She saw us as spiritual men, heroes of a cultural revolution involving at first mainly sex and drugs and art."

"We had mummies and a cobra woman and bats and mermaids and werewolves. We made love to each other. It was pretty normal."
—John Vaccaro

Andy Warhol and John Giorno spent a few weekends that summer in Old Lyme, Connecticut, in the summer house of Wynn Chamberlain, next door to art dealer Eleanor Ward's reconverted ice house with its broad lawn. Dozens of people crammed into Chamberlain's two-story house, making do with very few beds. A number of them—including Warhol, Diane di Prima, and Gerard Malanga—were participating in the filming of Jack Smith's epic *Normal Love*. In the cast were several actors who had performed in *Flaming Creatures*, including Joel Markman, Beverly Grant, and Rene Rivera (who had appeared under the name of Dolores Flores and was now billing himself as Mario Montez), as well as Tony Conrad (then performing / droning with La Monte Young) and Patti Oldenburg. Taylor Mead appeared in drag and introduced himself to Eleanor Ward, without knowing to whom he was talking. "Hello, I'm Eleanor Ward," he said. (She was not amused.) Francis Francine, a former carnival transvestite performer, attended to his pink gown. Diane di Prima was in the last day of the pregnancy that had begun when Billy Linich was recovering in her house in California. She dressed in a G-string and pasties, her stomach huge with the baby, Alexander Hieronymous Marlowe (who would be born at two the next morning). Gerard Malanga dressed in a Rudi Gernreich bikini bathing suit and a turban, and Jack Smith gave Andy Warhol a faded wine-colored antique dress to wear. The elaborate costume preparations spilled over onto Eleanor Ward's lawn, and she was disturbed to find bits of hair and glitter on her grass.

At Jack Smith's request Claes Oldenburg had designed the model of "The Great Pasty Birthday Cake," but he had left before its construction was complete. That sunny afternoon the whole cast was going to dance on the three-tiered wedding cake. "For the first time I found myself wishing I held a camera in my hands," wrote Diane di Prima. "To shoot what I saw."

It was Gerard Malanga's first appearance in a movie, and he recalled that he took it seriously. "It was an intermingling of Jack's creatures with what presumably we were supposed to be, new creatures. It was like a collision course, in a friendly way, of course. An intermix of an underground milieu. Like the McCoys are on one side of the fence and the Smiths are on the other, and we're going to get together and make an underground movie."

At the center of this party was director Jack Smith. He knew little about the technical details of filmmaking, but he knew precisely the look and atmosphere that he wanted: pink extravagance. Reality could not get

Jack Smith shooting *Normal Love* in the field behind Eleanor Ward's summer house in Old Lyme, Connecticut, August 1963. The figures on the wedding cake, designed by Claes Oldenburg, include Andy Warhol (in dark glasses), Gerard Malanga (in bikini underwear), Mario Montez, Francis Francine, and Diane di Prima, by Norman Solomon.

in his way—if the cows were the wrong color, he painted them; if the trees were too green, he sprayed them. He attended to the costumes and the look, the colors, the fabrics, the folds, the sheens, and the props with the attention he had mastered in his still photo studio.

The day came to a climax when the cast went out to a glade behind Eleanor Ward's house called Bayberry Meadow. They climbed onto the tiers of Oldenburg's pink wedding cake and began to dance. Diane di Prima did a big-bellied shimmy. Next to her Andy Warhol looked blank as he sashayed. On top of the cake was Francis Francine, who sank into it with bumps and groans as he went down, saying, "That motherfucker doesn't care what happens to me." Shooting hand-held with his 16mm Bolex, Jack Smith didn't give specific direction, but in the film the mixed troupe looks remarkably unified in its style. Billy Linich described Smith's effect: "Jack oozed his aesthetic. And you either knew exactly what Jack wanted or you weren't interested in that scene. Andy picked up that you don't really have to direct people. You have to get them into the sense of what you are doing."

Andy Warhol was so taken by Jack Smith—and by the scene that afternoon—that he stepped off the cake and filmed a three-minute silent "newsreel," *Jack Smith Shoots* Normal Love. One participant noted, "Andy Warhol is the only person to keep his sunglasses on while the camera is turning."

Years later Diane di Prima pondered the difference between *Flaming Creatures* and Smith's subsequent *Normal Love,* which remained forever unfinished. "By the time Jack Smith was in the editing process, he was bedazzled by speed and the glamour of the footage. It literally cast a spell from which the artist never emerged to shape and name his work. It seems now to be a metaphor for the aesthetic dilemmas that beset those particular years, filled as they were with creative invention, and with amphetamine. We were, as the poet Ed Dorn said of another time and place, another people, 'Crazy with permission.' "

Ever since he was a small boy in Wales, John Cale had imagined New York using impressions cobbled together from the sounds he heard over the airwaves. When he arrived in the city in August 1963, he regarded it as a gargantuan apparition, and the first thing he noticed was the steam and odors rising from the hot urban streets. He had come to New York after a month in the bucolic setting of Tanglewood, where Aaron Cop-

land and Leonard Bernstein had sponsored him as a composer-in-residence, bringing him to America.

"I was introduced to New York via the elegant, accomplished world of European classical music, but I was really in search of the revolution under the surface," said Cale. "The bohemian sidelines where new ideas were nurtured, fought over, rejected, and new styles from the indigenous awkward American avant-garde were given voice."

Cale regarded John Cage as his mentor, and Cage said that he had passed on the baton of the avant-garde to a composer named La Monte Young. Young organized a group called the Theater of Eternal Music that started in California and included a shifting group of musicians. Billy Name (the former Billy Linich) recalled that Young was always the patriarchal center of his community: "If you were going across the prairie in a Conestoga wagon, La Monte was the father and he always had a wife and everything was like his scene," said Billy. "Everybody was there playing with him, but he was the hierarchical chief."

La Monte Young recalled his initial contact with John Cale: "The first thing that started coming through in the phone call was the empathy, the sense that he really wanted to work with me." The twenty-one-year-old musician appeared at Young's loft and found a large, open space scattered with pillows but not a single chair. The air was suffused with the smell of marijuana and Middle Eastern cooking. Young sold marijuana to friends and was proud of his product's quality. Billy Linich considered him "the highest-quality dope dealer in the avant-garde movement."

The connection between Cale and Young was immediate, eased by Cale's first experience with marijuana. He recalled that one benefit of being stoned was that it seemed to make his indecipherable Welsh accent irrelevant; those around him just smiled and laughed instead of using words. They were together in a world of sounds.

The rate of production at the firehouse went up enormously after Gerard Malanga arrived on June 11. The extraordinary range of paintings silk-screened that summer showed Warhol at the top of his form, watching and listening to the media and transforming events into images: race riots, poisoned tuna-fish cans from the A&P, car crashes, suicides, and the electric chair.

Henry Geldzahler had given him the idea a year earlier, on June 4,

La Monte Young
Young played jazz saxophone on the West Coast in the late 1950s and became a key player in the Fluxus movement in the early 1960s, directing a loft concert series at Yoko Ono's studio and publishing *An Anthology* in 1963. His compositions explored extended duration.

1962. He told Warhol that he should stop doing consumer objects. "I wanted Andy to get serious," Geldzahler recalled. "I said, 'It's enough life. It's time for a little death.'" When Andy asked what he meant, Geldzahler pointed to the headline in that day's *New York Mirror:* 129 DIE IN JET. Warhol took his advice and painted that day's front page, beginning the *Death and Disaster* series that occupied much of the summer of 1963.

Warhol's images of death were mediated only by his selection and composition. He read little more than newspaper headlines and listened constantly to the radio—a strategy of inspiration that reflected his difficulty with reading.

Andy Warhol watched John Giorno sleep at intervals over Memorial Day weekend in Wynn Chamberlain's house in Old Lyme. Giorno had gotten drunk on black rum, and when he awoke at sunrise to urinate, he found Andy lying on the bed wide awake, his head propped on his hand. When Giorno asked him what he was doing, Andy replied "*Watching you!*" Giorno returned to sleep, occasionally awakening to find Warhol gazing at him. The last time he saw Andy was at eleven-thirty A.M., and when he awoke a final time, at one-thirty P.M., Andy had gone.

In that space of that night Warhol, pleasantly buzzing along on Obetrol, his boyfriend somnolent before him, envisioned his first movie live, in real time. Eight hours of sleep, as the saying goes. In the hot and crowded New Haven Railroad train going home, Warhol asked Giorno to star in a movie. Giorno replied, "*I want to be like Marilyn Monroe!*" Andy's first attempt at filming, using a camera borrowed from Wynn Chamberlain, didn't work because he didn't know how to use the light meter. But he knew that the idea was good.

Warhol's fascination with Giorno was put on film in July and August 1963. The two went to Giorno's apartment after one A.M. While Giorno removed his clothes and fixed his usual vodka nightcap, Andy set up his tripod and adjusted a floodlight. None of this prevented Giorno from immediately dropping off to sleep. Warhol's Obetrol helped maintain his focus throughout the night. He shot until five A.M., changing reels of black-and-white 16mm film every three minutes, sometimes placing the camera at the end of the bed, sometimes next to the pillow. When Giorno woke up in the morning, he found empty yellow film boxes on the floor. His performance, his chance to be like Marilyn Monroe, had taken place while he was unconscious. This same procedure took place intermittently over a month of nights. In the meantime Warhol looked

at his rushes on his hand-cranked movieola and said, "*Oh, they're so beautiful.*"

At a Frank O'Hara poetry reading in late July 1963, Gerard Malanga introduced Andy Warhol to Ted Berrigan, the publisher/editor of *C* magazine. Berrigan's fledgling magazine was part of the mimeograph revolution that was transforming little magazines; for the first time publishers could bypass printers and take the means of production into their own hands. Many downtown artists and poets supported this new trend by offering their art or poetry for free. On August 1 Berrigan sent Warhol the first two issues of his magazine, and announced that number three would have a cover by artist Joe Brainard and a poem by Gerard Malanga. A few days later Berrigan wrote in his diary that "Andy Warhol said he'd like to do a cover for *C*."

Issue number four of *C* was devoted to Edwin Denby, who held a strategic place in the art and poetry worlds. As one of de Kooning's closest friends, he was associated with the abstract expressionists; as America's premier dance critic, he knew the world of performance; and through his poems he knew the younger generation of poets. After meeting Frank O'Hara in 1952, Denby was adopted as an avuncular associate of the New York School of poets, where he became, in the words of John Gruen, "our private celebrity and intellectual leader."

By agreeing to design a cover for the magazine, Warhol inserted himself into a strategic position among a group of poets who dominated the art criticism of the period, notably Frank O'Hara, John Ashbery, Barbara Guest, and James Schuyler. The New York poets belonged to the same Tibor de Nagy Gallery circle that Warhol had unsuccessfully tried to infiltrate a few years earlier. O'Hara's key position in the art and poetry worlds was especially important to Warhol. For the Denby issue of *C*, O'Hara contributed both an essay, "The Poetry of Edwin Denby," and a poem, "Edwin's Hand."

Gerard Malanga remembered that "Frank just kept the keys to the door, he wasn't going to let Andy in," and, John Giorno recalled that O'Hara "used to laugh at Andy, make fun of him to his face and torture him." Warhol tried to woo him by giving him a *Marilyn* after the success of the Stable show, but O'Hara relegated it to the closet, and when Warhol drew an imaginary picture of O'Hara's cock, Frank crumpled it up. Warhol was regarded at that time as "the prophet of doom," recalled Wynn Chamberlain. "There was complete division between the Warhol-

Geldzahler camp and the O'Hara–Rivers–de Kooning camp." This background—the "deep gossip" of the art-poetry world—found its way to the cover of *C*.

While preparing for the upcoming show at the Ferus Gallery, Warhol and Malanga went to Edwin Denby's apartment with a Polaroid camera and black-and-white film. The poet greeted them and gave Malanga one of his outdated passport photographs as a welcoming gesture. Presenting a clear idea of what he wanted, Warhol directed Denby to sit in a straight-backed chair, with Malanga standing behind him, his hands on Denby's shoulders. Warhol made several shots in this position and then instructed Malanga to lean over and kiss Denby on the mouth. He snapped eight shots in all. Warhol selected two centrally composed photos and mounted them with enough space between them to allow for the magazine's thin spine. The seated pose became *C*'s front cover and the kissing photo became the back cover.

To Malanga, the image looked like an elder statesman of poetry welcoming a younger poet, and he claimed to be oblivious to the homosexual connotation of the paired photos. It was just a pair of Polaroids, mounted on stiff board, sent off to Harry Golden. But two little Polaroids could cause a scandal.

In the fall of 1963 Edie Sedgwick moved to Cambridge, Massachusetts, to study art under the tutelage of her cousin Lily Saarinen. Cambridge also provided the twenty-year-old with a way to stay a continent away from her parents. To a newspaper reporter Edie said her move offered the means of "trying to orientate to being twenty."

Lily Saarinen quickly realized that Edie was talented and that she would demand all of her time. Edie's attention to art, as erratic as her hours, was devoted to a large sculpture of a horse, and she spent the early winter of 1963 perfecting it. As the damp towels were removed each sculpting session, the figure changed imperceptibly. After seeing the horse repeatedly, her friend Ed Hennessy observed that it never changed: "It was always just perfect." Edie was carrying on the tradition of her father, whose equestrian statues she ridiculed. She knew firsthand the feel of a horse's body between her legs. "Young girls do love horses," Saarinen said. "It's wonderful to have a great, powerful creature that you can control . . . perhaps the way she would like to have controlled her father."

Edie Sedgwick looked perfect, too, with her long legs and button

nose, her understated makeup, her simple skirts from Saks, and her tasteful blouses from Lord & Taylor. Standing next to her gray Mercedes, Edie looked as if she had stepped from an advertisement for preppy good taste. The only things that controverted this image were her hands. A Cambridge friend observed, "She chain-smoked, her fingers had nicotine all over them; she had clay and stuff under her fingernails. Those hands didn't belong to this incredibly beautiful girl."

On September 9, 1963, Taylor Mead read his poems aloud in an evening devoted to jail writings, and shortly after that he met Andy Warhol. Henry Geldzahler introduced the two one day outside the Metropolitan Museum, after Mead had been wandering through Central Park with his portable radio. It was difficult to determine who was the bigger star in 1963. In Warhol's eyes, Taylor Mead was the first underground movie star. Mead knew of Andy Warhol as the painter of the Campbell's Soup can, and he was immediately taken by its amoral vision. "I thought he gave the United States what it deserved—he turned the spotlights back on them," said Mead. "I thought Warhol was the Voltaire of the United States." Warhol invited Mead and Geldzahler to his townhouse. "We had all kinds of little sandwiches, and I met his mother," Mead recalled. "I learned later that it was the royal treatment, and I rather felt it then, too."

John Cage organized a concert of Erik Satie's *Vexations,* in which a single eighty-seven-second piece of music was repeated 840 times. The concert began on Monday, September 9, 1963, at six P.M. and finished on Tuesday at 12:40 P.M. Customers paid five dollars admission and got a refund of a nickel for every twenty minutes they stayed, plus a twenty-cent bonus for listening to the entire program. (When a fireman made a safety check to ensure that no more than 197 people were in the audience, he found eighteen, "each in a silent cocoon of contemplation.") An illustrious tag team of ten pianists gathered at the Pocket Theater, a former porn theater at 100 West Third Street, to play the marathon piece. There were always at least three pianists on hand at the Pocket Theater, one performing, one in the wings, and one counting. The choreography of their transitions—the new player's left hand moving in as the exiting player's right hand moved off—made it a continuous piece.

John Cale was one of the pianists, and he gained publicity when his picture appeared in *The New York Times* and he subsequently appeared

"Andy has sought by repetition to show us that there is not repetition really, that everything we look at is worthy of our attention. That's been the major direction for the twentieth century, it seems to me."
—John Cage

"If anyone wants to play this motif 840 times, it would be advisable to prepare oneself for it in utmost silence and reverential stillness."
—Erik Satie

on *To Tell the Truth.* "Cage and Cale," chuckled La Monte Young. "It was a very nice touch." Cale later recalled Cage's importance in the avant-garde community: "Cage had a way of making everyone understand why they were doing things and, more importantly, what their role was."

Wynn Chamberlain, who accompanied Andy to the *Vexations* concert, remembered, "It was one of those things where Satie just repeats and repeats for twenty-four hours. It clicked in Andy's brain."

One afternoon in the early fall of 1963, Andy Warhol rounded the corner at Lexington and Fifty-ninth and bumped into Nicky Haslam, whom he knew as the art director of *Show,* Huntington Hartford's new magazine. Standing next to Haslam was a twenty-two-year-old woman with an extraordinary corona of blond hair that rose up from her head and cascaded down her shoulders. Haslam introduced her as Jane Holzer, and before the conversation had proceeded very far, Andy asked her if she wanted to be in a movie. *It beats the shit out of shopping at Bloomingdale's,* she thought, and immediately said, "Sure."

Jane Holzer (née Brookenfeld) had been raised in Palm Beach, Florida, where her father had made a fortune in real estate. Jane went to the progressive Cherry Lawn School in Darien, Connecticut. After graduation she attended Finch Junior College, popular with girls who wanted to study art history and be in New York on the Upper East Side. Jane discovered ways around the rules, but she still ended up restricted to campus. Eventually she decided to flunk her exams. During her last spring quarter at Finch it was a rare night that she was in her dorm room rather than dancing at El Morocco.

When the school asked her to leave, Jane Holzer began to model. At twenty-one she married Leonard Holzer, a slim and handsome recent Princeton graduate and heir to a real estate fortune.

Jane Holzer wasn't quite ready to settle down to a quiet life in their twelve-room apartment on Park Avenue, whose green walls were hung with Dutch paintings. "I was not ready for the Sadie Sadie Married Lady part yet," she said, "so I continued modeling."

In the summer of 1963 fashion arbiter Diana Vreeland discovered Jane Holzer. David Bailey shot her for British *Vogue,* and her modeling career soon moved into high gear. Fashion photographer Jerry Schatzberg observed that photographers were becoming the contemporary equivalents of impressionists in their ability to capture the excitement of the time. Painters had become old hat. "David Bailey created four girls that

"These are the girls of voyeurs—not real women at all, but the feminine parts of men."
—Nicholas Mosley

summer," Holzer recalled. "He created Jean Shrimpton, he created me, he created Angela Howard and Susan Murray. Avedon hasn't done that for a girl, Penn hasn't, and Bailey created four girls in one summer."

Jane Holzer was hip. She understood that the Rolling Stones playing at the Ad Lib were more important than the Beatles, and she knew that the best clothes came from Tuffin & Foale, a tiny showroom on Carnaby Street. A reporter from *Women's Wear Daily* saw her there in August tearing clothes off the racks and saying, "This stuff swings . . . It's much better than New York!" All this happened just around the time Holzer met Andy Warhol. The two served each other well, for each reflected the other's rising cachet, the bright burn of celebrity-in-the-making bouncing off each other.

In the summer of 1963 the fashion world christened her "Baby Jane," inspired by the 1962 movie *Whatever Happened to Baby Jane?* Holzer might be photographed arriving at the Metropolitan Museum wearing white Courrèges boots, a Jax shirt strung with diamonds, or lounging at home in a little ribbed poor boy sweater with short sleeves.

Baby Jane Holzer was not a conventional beauty, but her great mane of blond hair framed her face and offered a repertoire of mannerisms— tossing it, brushing it, pulling at it—that were ideal for the Warhol camera. "Someone at Kenneth's back-combed it, and that was the beginning of big hair," said Holzer. "The truth is, in Miami Beach it was all over, but maybe it's more chic when Kenneth does it."

Who could imagine south Florida setting fashion? But that was how topsy-turvy fashion and society were in the mid-1960s. In this transitional moment Baby Jane Holzer's willingness to try anything captured the media imagination. Diana Vreeland called Holzer "the most contemporary girl I know," while *Newsweek* observed that she epitomized "the pants-wearing young set who feed on the hybrid world of pop, flick, and hip." "You never get what it is," Holzer said. "It's something that just happens."

Andy Warhol's connection to Baby Jane Holzer certainly helped. He didn't create her look, but he gave her a place in the underground scene and shaped her vocabulary—and even her worldview—by adding "super" to everything. "Andy calls everything super," she said. "I'm a superstar, he's a superdirector, we make superepics—and I mean, it's a completely new and natural way of acting. You can't imagine what really beautiful things can happen!" Holzer was readily available for Warhol's upcoming epics—including *Kiss* and later *Batman/Dracula* and *Soap Opera.*

"For the restless hedonists who purport to lead the new, fashionable society, novelty is the staff of life."
—Marilyn Bender

"Some people look at my pictures and say I look very mature and sophisticated. Some people say I look like a child, you know, Baby Jane. And I mean, I don't know what I look like, I guess it's just 1964 Jewish."
—Jane Holzer in 1964

Jet Set:
"The jet set doesn't come to parties in a car—they come in helicopters."
—Ethel Scull

Elvis Presley was the sole subject of Andy Warhol's exhibition at the Ferus Gallery in September 1963: none sold. His canvases had grown larger after he hired Gerard Malanga, and they were also more expensive to ship. In the wake of his sold-out debut exhibition at the Stable Gallery, one might assume Warhol felt flush. He was instead experiencing the vagaries of the art world. Eleanor Ward had refused to show his *Death and Disaster* paintings. Andy felt financially strapped. He decided not to frame his paintings before shipping them to L.A. He simply left the silk-screened images on long, uncut rolls to be stretched and framed on the West Coast. Warhol decided he wanted to drive across the country, to save money and also to witness the United States firsthand. "It seemed the thing to do," Malanga recalled. "See America on the road."

Malanga's decision to go with Andy meant that he wouldn't return for the fall semester at Wagner College. He didn't realize that students could take leaves of absence, and his parents wanted him to finish school and become an art teacher. But Gerard couldn't pass up this adventure, and he committed himself to a new future that could not have been envisioned a few months earlier. His only remaining tie to Wagner College was the print mechanicals for the Wagner literary magazine that he carried along. Malanga hoped to complete this final task, but since he never found any time during the trip to do any work, the magazine appeared a year late.

Neither Warhol nor Malanga could drive, so Warhol enlisted two driver-companions, Wynn Chamberlain and Taylor Mead. The car, a new black Ford station wagon, was owned by Wynn Chamberlain, who was well connected, and often generously opened his loft on the top floor of 222 Bowery for showing movies and throwing parties.

Both Julia Warhola and Emma Malanga were concerned about their sons driving across the country. Henry Geldzahler recalled Julia shaking her fist at the ceiling and declaring, "Andy, Andy, no fly. Many big shots die in sky. Mike Todd." The two mothers finally decided that the two "brothers" would protect each other. The morning the foursome assembled at Andy's townhouse, Julia came out to the street to wave good-bye.

The American landscape was familiar to Taylor Mead, but this was the first cross-country trip for Gerard, Wynn, and Andy. They laid down a mattress in the back of the station wagon and reclined as the country whizzed by, a continuous animation of telephone wires and trees, fol-

lowed by long stretches of open sky, with a soundtrack of AM pop songs. "So Andy and I were luxuriating on a mattress," Gerard Malanga recalled. "We were literally being chauffeured out to L.A. and back." Everybody except Andy smoked marijuana. Along the way Warhol read a magazine article about debutante Hope Cooke, who left Sarah Lawrence College to marry the Crown Prince of Sikkim. Looking out the window at the stretch of barren landscape whizzing by, he wondered aloud how she could leave America for Sikkim. Along the way Warhol insisted they stay in motels because they were more American than hotels; Andy always shared his room with Gerard, while Taylor and Wynn shared another. The foursome spent a night in St. Louis, then dropped down to Route 66, crossed Oklahoma and the Texas panhandle, stayed overnight in Albuquerque, and spent the last night in Palm Springs. Chamberlain recalled that Taylor drove Andy crazy: "Every filling station, we'd pull up and fill up the tank and Taylor would disappear. And then we realized that every station we came to Taylor was giving the filling station boys a blowjob. Andy got so mad, "Come on! We're going to Los Angeles, the party is in thirty-six hours!"

As the foursome drove farther west, the landscape grew brighter and more open and majestic. It was a lark, with Andy paying the tab for everyone on his Carte Blanche credit card. Mead recalled, "It was a whole new way of looking at the United States, filled with the bright, primary colors that Warhol or Lichtenstein might have painted. Especially the signs over the motels along Route 66. As we got farther west, all the signs on motels were real Pop Art."

The biggest sensations of all were the signs and billboards along Sunset Strip in Los Angeles: towering images, exaggerated colors, reproductions that were hyperreal and improbably big. "Oh, this is America!" Andy repeatedly said. He loved the plastic white-on-white surfaces and wanted his life to imitate *The Carpetbaggers,* which he had watched repeatedly that summer.

Within a few years the glamour of Warhol would rival that of movie stars, but in 1963 glamour-by-association was still a one-way trip. "Nobody knew who Warhol was. It was like this invasion of creeps into people's houses," said Wynn Chamberlain. "That wasn't what Andy was aiming at—he wanted to be Cecil Beaton." Upon their arrival, Dennis Hopper and Brooke Hayward threw a movie star party for him in their new Topanga Canyon home. Filled with Pop Art, their house was the intersection of the Los Angeles Beat scene—including artist Wallace

Berman, and artist/actors Russ Tamblyn and Dean Stockwell—and
mainline Hollywood, including John Saxon, Sal Mineo, Troy Donahue,
Robert Walker Jr., and Suzanne Pleshette. Gerard Malanga said, "Andy
and I were both stargazing, we were in awe that this was happening."

The second great party of their trip took place at the Pasadena Art
Museum, celebrating the October 8 opening of Marcel Duchamp's first
American retrospective, *By or of Marcel Duchamp or Rose Selavy* curated
by Walter Hopps. Warhol knew Duchamp's reputation, for he owned
Duchamp's *Box in a Valise.* Just before entering the museum, Warhol and
Malanga met Duchamp in the garden. Only in retrospect does this regis-
ter as a monumental meeting of two of the most influential artists of the
twentieth century. There were no fireworks at the time. "We were like
giddy little kids," Malanga said.

The black tie reception afterward was held at Pasadena's *ne plus ultra*
Green Hotel, and when Mead appeared in an oversize heavy-knit white
sweater that he'd borrowed from Wynn Chamberlain, he was refused
entrance. "I looked like sort of an informal golfer or beach-lounger
amongst all the 'black ties,' " Mead recalled. When a *Time* magazine pho-

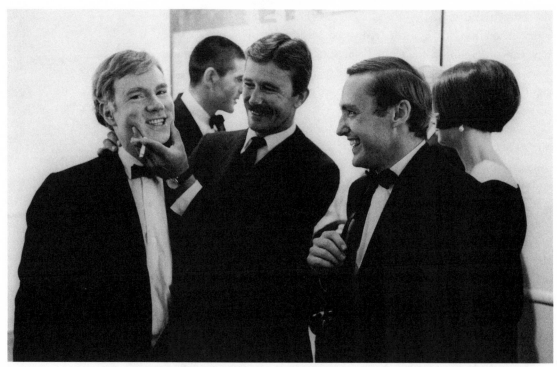

Andy, Billy Al Bengston, and Dennis Hopper at the opening of the first
Marcel Duchamp retrospective in Los Angeles, October 1963, by Julian Wasser

tographer bumped him, Mead haughtily responded, "How dare you! How dare you! Don't push me, I'm *Taylor Mead!*" Hearing of Mead's plight, Duchamp appeared, personally escorted Taylor to his table, and seated him at his left for dinner. "Duchamp wasn't interested in Andy, not at all," said Chamberlain. "But he was fascinated by Taylor." Mead could not resist dancing with Patti Oldenburg to the large orchestra. "We were the sensation of the party," said Taylor. "So they realized that it was good that they let us in, because we were the entertainment."

At the end of dinner Malanga introduced himself as a poet to Duchamp and during their short time together they talked about a readymade poem. "When Duchamp told me that I could create a poem without having to write it by finding a readymade and then changing it a little bit here and there, I thought, 'What a fascinating idea.' . . . He gave me a gift. And he gave me the ball and I ran with it.' " (A few months later Malanga appropriated two textbook paragraphs describing the sense of smell, reconfigured the paragraphs into lines, changed a word or two, called it "Temperature," and published it in *The New Yorker* in the following August.)

At the end of the evening Andy did something uncharacteristic. He got so drunk on pink champagne that on the way home he vomited on the side of the road. "In California, in the cool night air," Warhol recalled, "you even felt healthy when you puked—it was so different from New York."

Andy Warhol had brought his new 16mm Bolex camera to California. His intentions weren't specific, but he knew that Taylor Mead could star in a movie, and there would be plenty of time between Duchamp's Pasadena opening and his Ferus opening. Inspired by seeing a sign for Tarzana, Mead suggested a movie about Tarzan. When Naomi Levine heard about the movie, she flew to Los Angeles unbidden since, as she told everyone, she was in love with Andy.

Taylor was offended by Naomi Levine's unscripted arrival: "What nerve—to have taken a plane and followed us to L.A.—how pushy!" The concept and situation for the film were inspired by Mead, who called it his "most anti-Hollywood film," even though it was geographically closer to Hollywood than any other film he made. The movie was called *Tarzan and Jane Regained . . . Sort Of.* Taylor wore a loincloth that kept slipping down, while Dennis Hopper climbed a tree for coconuts and Naomi Levine bathed and fondled her breasts.

Naomi Levine
Naomi Levine was an independent filmmaker (*Flowers*). By mid-1963 she decided she was in love with Warhol, who described her as the first underground film queen.

Tarzan and Jane posed more production problems than *Sleep*, Warhol's movie of John Giorno sleeping. Its cast, large by Warhol's standards, included the artists Claes Oldenburg and Wallace Berman. The locations included the Beverly Hilton's swimming pool, the Watts Towers, and John Houseman's Hollywood mansion. Since there were no electrical outlets in these outdoor locations, Warhol hand-cranked the camera and often shot hand-held. The footage looked like a Ron Rice movie.

After two weeks in Los Angeles the foursome began the return trip, looping across the southern part of America. Stopping in Las Vegas, Mead noted that it was as if "Andy was inside of a Pop Art museum." As they swung through Texas; Wynn Chamberlain recalled some disturbing signs: "We knew Kennedy was going to be killed," he said, "because we came back through Texas and there were these huge billboards, 'KO the KENNEDYS,' bought and paid for."

Andy Warhol, Taylor Mead, Wynn Chamberlain, and Gerard Malanga arrived back in New York in mid-October. They returned to controversy on several fronts. The issue of *C* featuring Edwin Denby and Gerard Malanga on the covers had appeared: on the front they held hands and on the back cover they kissed on the mouth, lips apart, eyes closed. Cultural historian Reva Wolf called it a work of "visual gossip." The paired images of Denby and Malanga caused a small scandal among the New York poets, who thought their saintly Denby had been taken advantage of by callow opportunists.

In 1963, when homosexuality was still a coded language, its explicit presentation was outrageous. Since so many of the New York School poets were homosexual or bisexual—including Frank O'Hara, John Ashbery, James Schuyler, Edwin Denby, Kenward Elmslie, and James Merrill—Warhol's paired images seemed designed to reflect the homosexuality of the whole group. Warhol had exposed private knowledge in the public arena and constructed a "visual rumor" of a homosexual relationship between Malanga and Denby, spreading it in the circles where it mattered most. Malanga interpreted the cover as Andy's response to the coldness of the Frank O'Hara clique: "So this was a revenge."

The cover of the November issue of *ARTnews* featured a painting by Clyfford Still, but inside a series of interviews about Pop Art reflected the new generation who were replacing Still in the art world. This was Warhol's first interview. Since Gene Swenson conducted

it with a hidden microphone, the interview is less guarded than his later ones.

Warhol went further than the other three artists interviewed for that issue (Roy Lichtenstein, Jim Dine, and Robert Indiana) in his embrace of the machine's anonymity. Rather than arguing that advertising and mechanical reproduction were the mediums of the day, he said, "I think everybody should be a machine. I think everybody should be like everybody. I think somebody should be able to do all my paintings for me. I think it would be great if more people took up silkscreens so that no one would know whether my picture was mine or not." (Andy's statement was not simply provocation, as his subsequent working process at the Factory revealed.)

The most important downtown event that greeted their return was the forcible shutting down of the Living Theater. For the past twelve years Julian Beck and Judith Malina's group had been the mainstay of experimental theater in New York, described by *The Village Voice* as America's "most original, profoundly adventurous, and persistently important theater institution." On October 18 federal authorities went through the three-story building at Fourteenth Street and Sixth Avenue and tagged all the theater's possessions—costumes, sets, personal papers, and files— as property of the United States of America, in lieu of $80,000 nonpayment of back taxes. The Living Theater was also evicted from its 160-seat auditorium, for it owed the landlord $4,000 in rent.

There was no question of their legal culpability, but the swift and vigilant action catalyzed the downtown community. By eight P.M. Thursday evening a crowd had gathered at the corner of Fourteenth Street and Sixth Avenue. Federal agents declared the building quarantined, but Beck and Malina and a few others sneaked in a back door. From the third-floor office they hung huge impromptu signs: U.S. GOVERNMENT STOPS ART and SAVE THE LIVING THEATER. They filled baskets with the theater group's personal records and lowered them by rope to those outside. When the police tried to remove Beck, he staged a sit-in on the stairway. A sit-in by only a few people was not enough of a force, and they were eventually ousted from the building, but the event dramatized a new era of battle between the city and the downtown avantgarde.

"I wouldn't vote—are you serious? After Kennedy's murder, does a guy vote??"
—Ondine

"It's absolutely moving and beautiful. Not sarcastic, and it's not some sort of stunt. It really is a complete compelling work when shown in the way he wanted it to be shown."
—Frank O'Hara, on the Jackie Kennedy series

At two o'clock Friday afternoon, November 22, 1963, Andy Warhol and Gerard Malanga were walking through Grand Central Station, beneath the dome of illuminated stars, when they heard the announcement of President Kennedy's assassination. As they reached the exit sign at Lexington and Forty-third Street, Warhol said, "Let's go to work." They rode the Woodlawn Express to Eighty-sixth Street and walked to the firehouse. That afternoon they silk-screened *The Kiss*. In the film still from the 1931 *Dracula*, Bela Lugosi is just about to bite the neck of the sleeping blonde, Helen Chandler.

On the day of the Kennedy funeral, he went with John Giorno to a party at Billy Kluver's. Andy asked Jill Johnston to run in circles with a gun so he could film her while the assassination played on the television in the background. In 1964, in the wake of the Kennedy assassination, Warhol created a portrait of Jackie Kennedy, *That Was the Week That Was*, based on eight different photos of Jackie in mourning. The portraits of Jackie Kennedy and collector Ethel Scull promoted a version of celebrity that was oddly democratic.

When Lou Reed heard the news, he was in a Syracuse bar watching a football game on the television over the bar. This moment inspired him to later write a song, "The Day John Kennedy Died," that concluded with Reed's dream of being the President of the United States, of being young and idealistic, and understanding that someone could shoot him.

Billy Linich was headed downtown in a taxi, on his way to his draft board for a recertification review. When he heard the bulletin come over the radio, he thought it was "like an Orson Welles Radio Broadcast, but real. Kennedy was 'our' president, and this was like being stabbed personally. Very strange—it gave a hollow feeling to the world, because there was no 'what next' to come. It was an end to a divine energy current running through America, and especially through the artists' world."

At the firehouse, Andy Warhol and Gerard Malanga worked every morning silk-screening car crashes and suicides, and in the afternoon they scouted for a new studio in Hell's Kitchen and the West Twenties. New York City, which owned the firehouse, had put it up for auction, and Warhol thought he couldn't afford to buy it. Although he was now famous as a Pop artist, his notoriety did not result in sales. He no longer had the regular paycheck from I. Miller, and his commercial work was minimal. The Ferus exhibition had yielded few sales, and Eleanor Ward

refused to show his *Death and Disaster* series. Perhaps the success of the Stable Gallery show would turn out to be his brief moment—as he would later put it, his fifteen minutes.

Kiss was the first of Warhol's films to be publicly screened. Beginning in November 1963, Jonas Mekas showed new segments each week at the Gramercy Arts Theater. Mekas called them serials, the perfect form and name for Warhol's experiments. Despite their throwaway quality, the *Kiss* serials pushed the edge of what was shown in movies.

Kiss may have been inspired by early Thomas Edison films, or a Garbo film called *The Kiss* (screened by Cinema 16 only a few months earlier), and was driven in part by Naomi Levine. She wanted to make movies, and she was in love with Andy; kissing for his camera became an alternative to kissing him. The earliest three-minute segments of *Kiss* were shot in the fall of 1963 in Levine's apartment on the southeast corner Avenue B and Tenth Street. A wide net was cast among the friends and acquaintances of Andy, Billy, and Gerard to solicit his kissers.

Some of the kissers were already couples offscreen. Some mixed a heterosexual woman and a homosexual man (such as Marisol and Robert Indiana, fellow artists at the Stable Gallery). John Giorno claimed he had to push Warhol to show two men kissing, and when Warhol agreed, he shot them in a way that deviated from the previously stationary camera—starting the frame close in, then pulling back to reveal two men.

The setup was simple: the Bolex was placed on a tripod, the Tri-X film was loaded, the key light was turned on, and two people kissed until the three-minute magazine ran out. Warhol cropped the frame to just faces, with an occasional shoulder.

Some of the kisses were full-on, tongue-thrusting, intense kisses, while others were more conceptual. Completely explicit and without coyness, these kisses went beyond the range of Hollywood types, and Archer Winsten of the *New York Post* wrote, "*Kiss* does have a certain erotic aspect, as well as racial, which will arouse a viewer to a strong reaction either for or against." Instead of culminating with swelling music or a suggestive fade-out, these kisses end silently: your time is up. Watching them as a series had the effect of coitus interruptus—*Kiss* never rose to a climax—the repetition leveled the erotic charge, as if the kisses were products off an assembly line.

Kiss introduced an element of competition: who were the champion

kissers? One participant, Stephen Holden, recalled the experience as intimidating, especially after hearing about other kisses. "Smart and original people realized it was an opportunity to do something clever," he said. This was not simply a lone participant's experience; critic Parker Tyler noted the challenge offered by *Kiss*, "forcing them to fresh prodigies of osculative style to justify, it seems, the camera time being spent on them. Here already was a flagrant 'impurity.' The human subjects involuntarily betrayed that a sort of theater was present, a 'show' which felt obliged to sustain the 'interest.' "

Naomi Levine, who kissed the most men in the serial, might be called the star of the film. She was later disturbed to read that some regarded it as a "put-down of heterosexual orthodoxy," since she ardently believed in heterosexuality.

> Having known most of the men that I kissed in the film quite well, I would say that *Kiss* was a tribute to heterosexuality on our parts—it's what I'm for. I know it's normal, corny, simplistic, and boring for most New Yorkers, but to me it's natural; it fulfills my identity as a woman, without which I would be completely out of touch with the natural rhythms of life; like lapis lazuli spinning out on the beaches, the cracking up in autumn of golds, the despair of winter, the blumph bloomiatingly of spring, etc., a raindrop exploding on my eye; natural and a kiss.

Billy Linich's apartment was still freshly silvered and gleaming that fall when he gave one of his days-long, amphetamine-fueled haircutting parties. The concept was simple. People dropped over to his apartment, and while they waited around for Billy to cut their hair, they carried on a makeshift party where marijuana and amphetamine were available. These get-togethers had started a few years earlier with Billy cutting the hair of Judson and Caffe Cino lighting designer Johnny Dodd, and they grew in size; by the fall of 1963, dozens of people came. With so many people needing haircuts, Billy and painter Dale Joe often cut hair side by side. Billy used the haircutting skills he had learned from his great-uncle, Andy Gusmano, who ran a barbershop in Poughkeepsie. The gregarious practicality of this party concept reflected the homemade quality of the downtown community.

Billy Linich's apartment became the crossroads of several downtown groups, a subject for the gossip that appeared in the mimeographed little

"Maybe you find somebody you love four minutes, maybe ten minutes. But I mean, why lie to yourself? We know we're not going to love one man all our lives. Maybe it's the Bomb—we know it could all be over tomorrow, so why try to fool yourself today?"
—Jane Holzer

magazine *The Floating Bear.* In early 1964 it published a poem by John Daley called "Billy Linich's Party." The poem contains snatches of overheard conversation and observations associated with seven haircuts, and they offer a glimpse of who came to the haircutting parties and what they talked about: "The worst thing about Billy Linich's party was that Dorothy Podber (the meanest girl in town) had removed M. C. Richards' ashtrays. The next worst thing was that Lucinda Childs didn't come." Michael Katz said it was "a very sexy party," and James Waring added, "a timeless and sexy party." During the sixth haircut there is a ditty: "Well, Gerry Malanga / was a-doin' the conga / in a little cabana / in old Havana / and someone stuff his hair into his fly." Living Theater ticket-taker Malka Safro, dancer Remy Charlip, and poet Diane di Prima all appear, and the poem provides a good example of the gossip poems that were found in such little magazines as *C, Fuck You: A Magazine of the Arts, The Floating Bear,* and *The Sinking Bear.*

Billy's close friend Ray Johnson brought Andy Warhol to a haircutting party in early December. "The lights were set so when Andy came in, he walked into a silver jewel," Billy Name later recalled. "I was cutting Johnny Dodd's hair, and it looked like it should have been a movie, of course."

Warhol responded immediately. He asked if Billy and Johnny wanted to make a haircutting movie. Having just found the space for his new studio, Andy then asked a question that would change Billy's life: would Billy apply the same silvering process to the dingy raw space on Forty-seventh Street that he was about to rent? "Andy didn't just see a guy's place and think, 'That's real cool—he's got foil all over the place,' " Billy said. "He saw that I had done an installation."

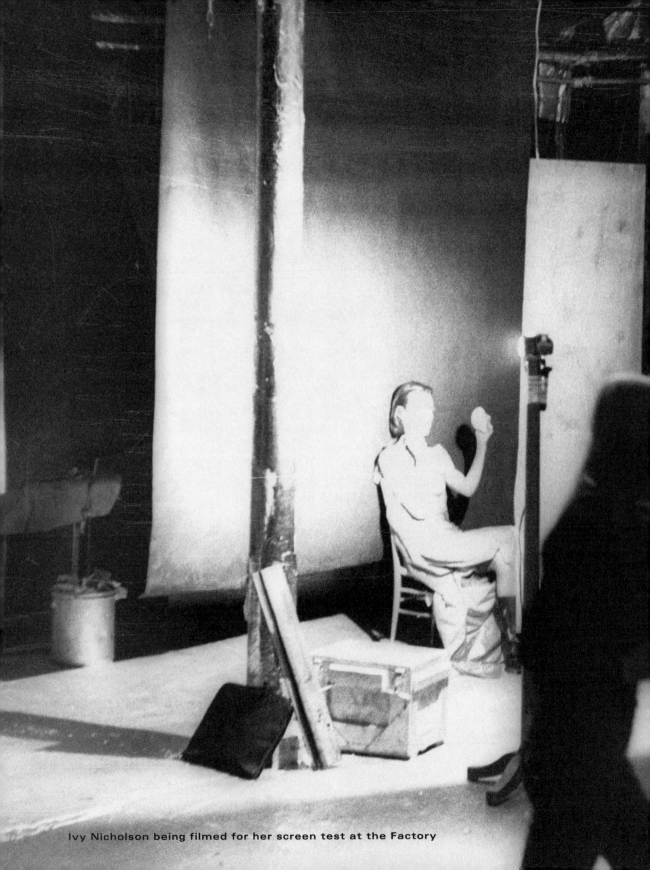

Ivy Nicholson being filmed for her screen test at the Factory

1964

Billy Linich first saw Andy Warhol's new space at 231 East Forty-seventh Street in early December 1963. He rode up the freight elevator, opened the gated doors at the fourth floor, and stepped into the front corner of an industrial loft about fifty feet deep and a hundred feet long. One of the walls was brick, and the ceiling had three arches. A bank of windows to the south offered the only available light for seeing the raw space: the previous tenant, a hat manufacturer, had removed all his electrical fixtures. Wires hung down from holes in the ceiling, and the floor was dirty gray concrete. It possessed none of the trademarks of the era's artists' studios: it wasn't white, it wasn't light-shot, and it wasn't downtown. Whoever heard of an artist's studio down the street from the United Nations Building?

Billy Linich began working on this unpromising space in January 1964. For the first weeks working time was restricted to winter's meager daylight hours. Then Billy installed wiring and three-hundred-watt General Electric indoor-outdoor floodlights and spotlights, bright enough for making art or for making movies. He soon tired of the subway ride downtown and the long walk from the Astor Place subway stop over to 272 East Seventh Street, where he still kept his silver apartment. Once the lighting was installed, Billy asked Andy for a key to the loft so he could work whatever hours he wanted. In late January 1964 Billy moved into the back northwest corner of the space. His home for the next four years consisted of his found-on-the-street couch, a sink, and two Factory bathrooms, where he screwed in a bare bulb and posted a hand-lettered sign that read PLEASE FLUSH GENTLY!!!

Around the same time Gerard Malanga also moved into the new space. He was perennially without an apartment and couldn't travel back to his mother's house in the Bronx because of a subway strike. Billy and Gerard were entirely different kinds of residents. Billy was neat, spare, and ascetic; less was more, and he could sleep on the couch or on the floor. Gerard introduced boxes of his poetry books to the loft, and when they were set in the middle of the space, Andy drew the line. He could abide the clutter involved with art making, and he welcomed the stray objects that Billy would find in the street to embellish the raw loft, but he didn't want books in a place where art projects filled the space. After a few weeks Gerard moved into a spare room in Allen Ginsberg's apartment on East Fifth Street.

Drawing on his theater experience building sets, Billy ordered wholesale four-by-eight-foot sheets of ⅜-inch plywood and hinged them together. They were simple, flexible, and cheap. "They were like flats on the stage, and they were all painted silver," Billy said. "If you put them together, they were very large. They became backgrounds for movies and area dividers. So if I was going to sleep, I was just invisible behind them on my couch."

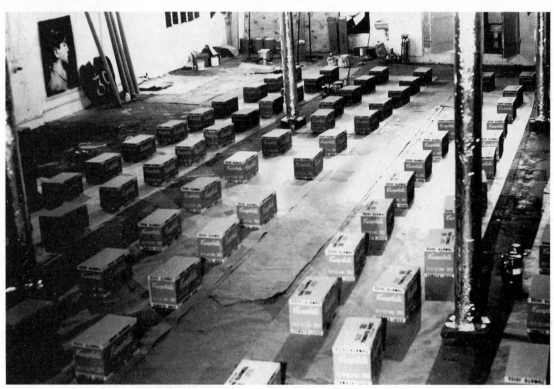

Q: What is your
 profession?
A: Factory owner.

"It was the perfect time
to think silver. Silver was
the future, it was spacey—
the astronauts wore silver
suits—Shepard, Grissom,
and Glenn had already
been up in them, and their
equipment was silver, too.
And silver was also the
past—the silver screen—
Hollywood actresses
photographed in silver
sets."

—Andy Warhol

**The Silver Factory, created and photographed
by Billy Linich/Billy Name, February–March 1964**

Billy started the monumental task of silvering the former hat factory. The simple way would have been to paint the walls silver with an industrial sprayer. But Billy opted for the more painstaking job of attaching long rolls of Reynolds aluminum wrap to walls and columns, using glue and an industrial staple gun; he climbed high ladders and covered hot-water pipes, covering even the windows. Billy was drawn not only to aluminum foil's shiny reflectivity but also to its used, lived-in-look surface. Even when the shinier Mylar became cheaply available, Billy preferred the crumpled aesthetic. He sprayed the floor and sections of the brick wall, using DuPont Krylon paint. Each day Billy sniffed amphetamine, a drug that was ideal for the task of meticulously transforming the dingy loft. Its influence, combined with Billy's diligence, allowed him to focus intently on each silver inch of its surface, right down to the toilet bowl, which was newly silvered down to the water line. In the process Billy bonded with the physical space, and before the winter was over, he became its custodian and protector.

Billy not only created the outlines, he also filled in the space with objects. He began with mirrors, some of them whole, some shards, which he installed in the bathroom, over sinks, next to film cabinets. The mirrors seemed to extend the space, and Billy sometimes checked him-

self out in them as he worked; the teenager with acne had grown into a graceful, lithe man with a coolly handsome face. Warhol recalled, "He had a dancer's strut that he liked to check in motion."

Billy furnished the space, and the biggest cache was found right down in the basement, where a previous tenant had left old furniture. Billy hauled pieces up in the freight elevator—a work table for Andy, a desk, wooden chairs on wheels. "I would just bring them up piece by piece, and Andy would spray them silver," Billy said. "And they would be absolutely glowing and brilliant." In addition to borrowing from the basement cache, Billy brought things from home, from theatrical supply stores, and especially from the street. "I would just walk everywhere, and I would find things scavenging," Billy said. On a roof he found a white plastic sign for Vic Tanny's gym with blue plastic letters, and in front of a Second Avenue club he found Sammy Davis placards, and on a midtown sidewalk he picked up the bottom half of a mannequin. He bought carpet at a steep discount because a section was badly bleached. He

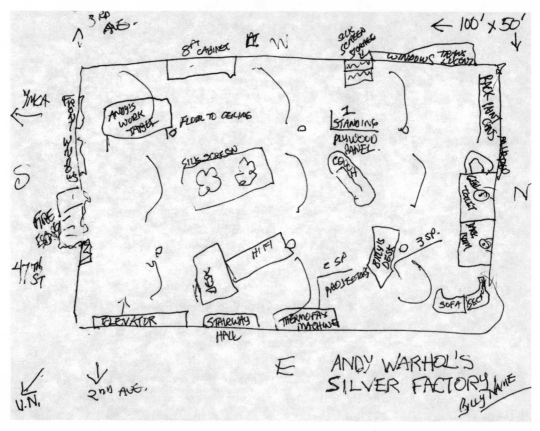

Billy Name's sketch of the Silver Factory

picked up a Lucite and glass china cabinet, added a heart-shaped sign that Ivan Karp had found in a former firehouse, and installed a mannequin's hand that so intrigued Jack Smith that he stole it. In the middle of the floor sat a used mirrored ball that came from a theatrical supply house.

"It was like constructing this environment—for me, the whole place was a sculpture," said Billy. "And each time I added a piece to it was like adding another gem to the collection. I never did a specifically articulated thing, I always did a maximal job. But it was the same art thing, it was the same signature, or my tag: the whole silver thing."

"One of my finds became a movie star," Billy said. He spied a large old maroon couch on Forty-seventh Street, with Art Deco lines and gray piping along the edge. Since the couch was already mounted on casters, he just wheeled it down the block, onto the freight elevator, and up to the fourth floor. Six months later it would become the title star of Warhol's film *Couch*.

Billy also provided the soundtrack for the space. He borrowed Andy's Harmon Kardon hi-fi and brought in his collection of opera records. He had been schooled by Ondine, who loved not only to play opera but to sing along during his favorite passages and to give impromptu talks. "Ondine would play records and explain what we should listen for," said his friend Dale Joe. "He could really get you involved." When Ondine was around, Maria Callas was usually the centerpiece, singing *Aïda, Iphigenia in Tauris,* or *Lucia de Lammermoor.* Billy

and Ondine listened to a wide range from bel canto to the expressionism of Richard Strauss's *Die Frau ohne Schatten.*

Andy and Gerard played rock music in the front, and for the first few months Dionne Warwick's voice dominated the work area.

The artificial light bouncing off surfaces of wrinkled silver gave the Factory an eerie atmosphere. "It looked like a horror show," said Ondine. "It was the *Big Rocky Horror Show.*" To catch a bit of natural sunlight, one had to go up to the roof or step out onto the fire escape. Chatting there one afternoon, Andy, Billy, and Ondine named the new space. Andy knew he didn't want it to be the Studio, which was too much of a cliché. The Lodge? They settled on the Factory, referring to its previous state and to a new industrial style of art production. "Factory is as good a name as any," said Andy "A factory is where you build things. This is where I make or *build* my work. In my artwork hand painting would take much too long, and anyway that's not the age we live in. Mechanical means are *today,* and using them I can get more art to more people. Art should be for everyone."

Silver became the trademark of that era of the Factory, and it provided the perfectly ambiguous symbol of the activities that took place at 231 West Forty-seventh Street over the next few years. Silver meant different things to all those who participated. Warhol speculated that Billy loved silver because it was "an amphetamine thing—everything always went back to that." Warhol associated it with the shiny space suits of astronauts and the past—the silver screen—Hollywood actresses photographed in silver sets.

Billy's description of his silvering job reflected his philosophical outlook, which was both completely concrete and utterly abstract. "Conceptually chrome is all colors," he said. "It isn't minimalism, it's maximalism." And since he thought in terms of light rather than color, a combination of everything came together in bright white rather than dense black. "It's electric. It's synthetic, it's fusion. It's out of the ordinary, and it's tense and it's hip and it's cool and it's spacey. It's a knock-out Wonderland."

Henry Geldzahler saw reflected in the Factory installation everything from the silver screen to Andy's frosted silver wig. Geldzahler also recalled Warhol's brainstorm one afternoon in the summer of 1963 while silk-screening an *Elvis* with Gerard Malanga. "He realized it was possible to double the size—and therefore the price—of his paintings by twinning them with a silver blank, a canvas of the same dimensions as his full-sized *Elvis,* silk-screened black on a silver-painted ground," said

Geldzahler. "There, I think, we can pinpoint the birthplace of the silvered Factory."

"Silver was perfect too because it was a mirror," wrote critic Stephen Koch. "It was everything turned inward and imploding and at the same time light, the pallor of Warhol's face as if it never saw daylight. It was the space of a mirror. Warhol's responsibilities were the mirror's responsibilities, his replies the mirror's replies."

For his second show at the Stable Gallery, Andy Warhol decided to go beyond painting to sculpture. Friends at that time recalled his excitement looking at products—particularly large boxes in a supermarket. The box was the serial unit of merchandising. He asked his assistant Nathan Gluck (who still did occasional commercial work for Warhol) to go to the supermarket near Warhol's house and bring back some empty cardboard cartons. Gluck returned with several boxes with elegant designs, but Warhol was visibly disappointed. No, he wanted something more ordinary for his "commonist art." Warhol next dispatched Gerard to search for more specimens of merchandising, and he was pleased when Gerard returned with boxes from Brillo, Mott's apple juice, Heinz tomato juice, Del Monte peaches, and Kellogg's Corn Flakes. Warhol began making his first sculptures at the same time Billy Linich was silvering his raw space.

The boxes were flattened out and delivered to Harry Golden, who created silkscreens of the logos. Gerard found a carpenter in the East Sixties who made hundreds of plywood boxes. Billy Linich painted the boxes white or tan, for the cardboard look, using a brush and roller. Gerard and Andy then lined up the boxes according to shape and brand name, screening the tops of each one in their assembly line. Gerard cleaned the screen with Varnolene while the boxes dried. They turned the line of wooden boxes ninety degrees and repeated the screening process, averaging about two sides per day. The next day they turned them to a new side, repeating the process until all six sides were done. Standing in long, neat rows—all told, more than four hundred of them—the boxes transformed the new space into an art factory.

During these early months of silvering the loft, and for a few months following that period, the intimacy between Billy Linich and Andy Warhol grew more romantic. It was based on the silver space of their new home, wedding creativity and domesticity. Billy was the domestic, the custodian, the all-competent manager and journeyman, and Andy was

"It was amazing! Work never stopped there! It was amazing!"
—Ondine
on the Factory

the technically incompetent master. "He didn't say much, and when he did, it was either very practical and mundane or very enigmatic," said Andy.

Not long after Billy began living in the loft, he and Andy had a brief relationship. "Before that he was enamored of me or sweet on me and wanted me around, but we found that we were both too Jimmy Dean-ish to make it work," said Billy. "We couldn't find a way to get it out, and it got so tacky we just stopped doing it. But the friendship and love did jell." The working relationship soon absorbed the romantic relationship. Andy liked to watch Billy's lithe, slow, graceful hyperfocused movements, his vigilant attention to the details of his task in the large silver space. Billy said,

> That was why it was easy for me to move in there because I didn't have to move into his house and have one of those tacky relationships. We were both very awkward and shy about the whole sexual thing. With Andy you had to be able to do something practical for him. Whenever he had a boyfriend who did do something, things would get so busy that it would change from a love relationship to a working relationship. . . . I was controlling the place and protecting him. And I did it very well.

Ondine, a close witness to the relationship during this period in 1964, emphasized the mutuality and interdependence that suffused the relationship. "I would assume that, ah, the names of Warhol and Linich . . . should be synonymous with each other. That's how important he [Linich] is." He credited Billy with introducing into the space a variety of people from the overlapping worlds of Black Mountain, Judson Dance Theater, and the amphetamine world. Soon it was no longer simply an art world space. Most important, he credited Billy with offering the necessary practical foundation for Andy's working method. "He provided Andy with all the materials, and Andy dealt with the essence," said Ondine. "Warhol dealt with making it a reality, and Linich used the ether—the air—to bring forth the people, the ideas. . . . [Billy] had a way of stimulating your own ideas but *not* so that it was manifest, [not] so that *he* presented the ideas. The idea was that the idea was there so that Warhol could use it. It was a *total* wedding. . . . I mean Linich is a, like, an *essential*."

❏

In late 1962, right after Warhol's groundbreaking show at the Stable Gallery, Philip Johnson had approached him to commission an artwork for the 1964 New York's World Fair. Johnson had moved with enormous speed on his decision—less than a month after Warhol's Stable show and the first time Johnson had seen his art. The commissioned work was to be mounted on the concrete exterior of the round New York State Pavilion, which was a hundred feet in diameter, along with work by eleven other artists. Warhol's work would be seen by millions of people, however glancingly. Warhol asked his friends what should he do. He told Nathan Gluck that he wanted to silk-screen a giant pickle, in homage to the Heinz pickle pins that were distributed at the 1939 World's Fair. (The Heinz corporation was located in Pittsburgh.) Wynn Chamberlain recalls suggesting he do the ten most wanted men, and he introduced Warhol to a New York policeman named Jimmy O'Neill, who provided mug shots of an obsolete FBI list of the ten most wanted fugitives. Warhol corresponded with the FBI and received a wanted poster of Howard Francis Pugley in 1962. Warhol was thinking about this motif early on, but it may have also been influenced by Marcel Duchamp's *"Wanted" Poster*, which he'd seen in Pasadena a few months earlier. Warhol blew up the 1-by-1⅕-inch photos to 40 by 48 inches, which lent the images the graininess of a giant tabloid.

The campy pun in *Thirteen Most Wanted Men* amused Warhol, and from it grew a movie project that played with the same idea: *The Thirteen Most Beautiful Boys*. In December 1963 Gerard had suggested Warhol shoot a film reel of him to use as a headshot. Malanga had already selected still frames from *Sleep* to publicize the movie, and he thought the same process—multiple frames, with exposed sprocket holes—could be used to promote his poetry career. Gerard's screen test was carefully lit by Billy, with lights on each side, one brighter than the other, highlighting the waves of his pompadour and his handsome features against a black background.

In January 1964, with *Thirteen Most Wanted Men* still on his mind, Warhol embarked on a new project. It continued the process initiated by the headshot of Gerard and the serial mold of *Kiss*. This series helped him to hone the minimalist film style that became his signature. Most important to the social dynamic at the Factory, the series provided Warhol with the means to lure people to his ersatz film studio: "Do you want to star in *The Thirteen Most Beautiful Boys*?" was an effective pickup line for a man who didn't have a wide repertory of conversational gambits. These three-minute films marked the beginning of a series that

Philip Johnson
(1906–) This famous architect was also an influential collector and, beginning as early as 1932, a proselytizer for the International Style. He had financial means and adventurous taste, and his selection of Warhol provided the imprimatur of classic modernist taste.

ran to more than four hundred reels. For what began in *The Thirteen Most Beautiful Boys* expanded to *The Thirteen Most Beautiful Girls, Fifty Fantastics,* and *Screen Tests.* Whatever title Warhol gave them, they were all done in exactly the same format: a static headshot until the film ran out.

Warhol shot at least forty-four hundred-foot film reels that he marked *The Thirteen Most Beautiful Boys,* understanding that it would have been politically unwise to restrict a selection to thirteen. By recombining the individual segments in varying formats, the process could be ongoing and embracing. (Warhol's process always invoked rejection/inclusion.) He expanded his purview to include women in *The Thirteen Most Beautiful Women.* When a series of them were projected as the backdrop for a cocktail party, one guest suggested that "there must be as many Thirteen Beautiful Women around as there are beds that George Washington allegedly slept in."

The serial production that grew out of *The Thirteen Most Beautiful Boys* was the longest lasting of all Warhol's projects. He began *Screen Tests* in December 1963 and continued until January 1967, a span of over three years. *Screen Tests*'s subjects offer an index to the Factory's expanding circle, and also reflect the sources from which Warhol gathered his own group. These films provide a visual stamp of entry into the Factory, like identification photos of newly arriving immigrants taken at Ellis Island.

The earliest *Screen Tests,* from December 1963, feature attractive young men who were never heard from again, including a porn actor, and Warhol's intimates Gerard and Billy. These first subjects reflect the roots of the project: not some August Sander-esque index of society but a desire to capture male beauty for *The Thirteen Most Beautiful Boys.* But throughout 1964 he cast a much wider net, drawing from the worlds of poetry, art, dance, underground film, drugs, and fashion. The two key figures who introduced people to the Factory were Gerard Malanga and Billy Linich.

Gerard was a gregarious and ambitious connector. Introducing people to the Factory dovetailed with his desire to bring poets there, which would not only bolster his own poetry career but would also put the spotlight on poets. The overlapping of the art and poetry worlds had been a hallmark of the New York School, when poets wrote reviews of artists; Malanga wanted to continue that tradition. Gerard was always on the lookout for beautiful women as well. He would romantically pursue several women who were fashion models, always realizing the value of

having an attractive face in the crowd. Perhaps the first of these was Ivy Nicholson. While the poets connected the Factory to a scruffy downtown world, fashion models like Ivy linked it to a glossier uptown world.

Billy Linich was shy and spent most of his time in the Factory space itself. But he introduced to the Factory his own rich network of downtown contacts, drawing on the Judson Dance and Living Theaters and the Poets Theater group (Diane di Prima, Alan Marlowe, Lucinda Childs, Rufus Collins), as well as his connections to the music world of La Monte Young and Marian Zazeela. Most important, Billy brought his amphetamine cohorts to the Factory, a circle known as the A-Men or the Moles. At its center was Ondine, who became a spiritual center of the Factory.

Andy Warhol introduced a few people from the art world: his dealers, Irving Blum and Ivan Karp, collectors Frederick and Isabel Eberstadt, Jewish Museum curator Alan Solomon, and critics Robert Pincus-Witten and Gregory Battcock.

Once the subject had been invited for a screen test the procedure was straightforward. The subject sat before a blank background, usually the four-by-eight-foot silver plywood dividers that Billy had hinged together. Andy or Gerard or Billy sometimes asked the subject to sit as still as possible before the camera, which was set on a tripod, for the duration of the reel. Sometimes they asked the subject not to blink and not to be overtly expressive. Billy's lighting varied—raked across the face, head-on, from below, usually dramatic and theatrical. The camera framed the face, usually cutting off at midshoulder. Andy or Billy or Gerard pushed the button and usually walked away, leaving the subject alone facing the camera. After three minutes, the film ran out and the screen test was finished. There were a few variations on the simple procedure— Pop artist James Rosenquist, for example, seems to be standing on a rotating platform that spins around like a record—and some subjects are holding up objects, enacting silent commercials for consumer products. But for the most part, the setup is remarkably similar, providing a litmus test of the subject's response to the unblinking camera. The film was processed within a few days, and the results would be shown at the Factory and sometimes at one of Jonas Mekas's floating cinematheque theaters.

The parameters were perfectly Warholian, simple and complex. The situation was set up so that Warhol maintained psychological power in the Factory version of the casting couch. His subjects were acting out the collective Hollywood dream, with Warhol as the front-office producer

1965
Paul America
Eric Anderson
John Ashbery
John Cale
Joseph Campbell (aka Sugar Plum Fairy)
François de Menil (2)
Henry Geldzahler
Bibbe Hansen
Willard Maas
Marie Menken
Paul Morrissey
Ivy Nicholson (2)
Nico (Christa Paffgen)
Ondine (Robert Olivo)
Lou Reed
Barbara Rubin
Edie Sedgwick (3)
Mary Woronov

1966
Allen Ginsberg
Jonas Mekas
Allen Midgette
Nico
Francesco Scavullo
Ingrid Superstar

and voyeur. The effect of sitting completely still, looking into bright lights, was glamorous and uncomfortable. "I look like a refugee from the Menninger Clinic," observed Sally Kirkland, one of the original *Thirteen Most Beautiful Women*. "You sit staring at the camera and after a while your face begins to disintegrate." It was difficult to suppress yawns, eyes became dry and teared, and the subjects often seemed vulnerable in their blankness. Even the most perfect facade could not be maintained, and the viewer watched the process as it happened. The subject, as if on an analyst's couch, went through a repertory of mannerisms as a way of greeting the blank void of the camera's stare: tossing the head, pushing the tongue against the cheek, avoiding the camera's gaze, pursing and moistening the lips, flicking hair, shifting eyes, swallowing, on and on, for the seemingly endless three minutes. Andy told the press that one of his favorite early *Screen Tests* was Ann Buchanan: "She did something marvelous. She cried."

Looking at the topography of a face for three minutes cut both ways. It offered the subject an opportunity to be captured young (most were in their twenties and early thirties) at the peak of their attractiveness. It was a chance to be framed and lit as a star, an early and truncated version of Warhol's "fifteen minutes of fame." But extended scrutiny, with nothing else to watch, also prompted the viewer to meditate on the subject's imperfections, the eyes too close together, the stray hair poking out of a nostril, the too-long bangs, the flabby neck, the pockmarks, the gap tooth, the receding chin, the encyclopedia of idiosyncrasies to which the human face is subject. Warhol never subjected his own face to the *Screen Test* treatment, but Gerard Malanga shot his own version.

The *Screen Tests* were projected at sixteen frames per second, so that even a slight movement was rendered in a dreamy slow motion, in a format called art projection that magnified the image. Real and unreal, the huge faces possessed enormous presence and formal beauty, whether seen on a screen or against an ordinary wall.

Andy Warhol found his signature cinematic style very quickly: an emotionally uninflected camera that neither panned nor zoomed, the use of real time instead of edited time, and a frame dominated by tightly cropped parts of the anatomy, usually a face. It is customary to think the movies sprang full-blown from the mind of Andy Warhol and that they were all the same. Saying something was like "a Warhol movie" became shorthand for saying it was boring, blank, and long.

When asked what movie era he most appreciated, Warhol responded: "The early 1910s. That was about when movies were just starting." The silent films that Warhol shot in 1963 and 1964 look like an organized exploration of movies' most essential qualities—time, space, and movement. But before he achieved the cinematic purity of those films, Warhol pursued several routes—in *Sleep, Tarzan and Jane Regained . . . Sort Of,* and *Batman/Dracula*—that he would soon abandon in favor of the ultimate simplicity.

Sleep was not as effortless as it appeared to be: a series of shots from different angles of a sleeping man. After Warhol had shot hundreds of feet of footage, he had no idea how best to assemble it. He solicited the help of Sarah Dalton, a sixteen-year-old British student who lived a block from Andy. She had no experience in film, but she was smart and willing. He gave her one instruction: "There are parts where it changes too much. I want it to look the same. Try to make it more the same." He wanted the movie to appear to be one continuous night of sleep, rather than a film shot over several nights, with some sections repeated. Trial reels show that Warhol shot the sleeping man with a moving hand-held camera rather than a fixed tripod. Sarah Dalton worked at his townhouse and made storyboard drawings of the camera perspective on the sleeping figure, as a Hollywood director would do—but as no underground filmmaker ever would do. She assembled the footage, repeating certain shots and leaving others out, compiling a 16mm film that runs

John Giorno in silk-screened images from *Sleep*, 1964, by Billy Name

five hours and twenty-one minutes. Sarah, who would later become a professional film editor, could recall no intervention on Warhol's part. About the fact that they had made so many changes, Warhol said to her, "Let's keep it a secret—we just won't tell anyone."

Some reels were shown full length while others were intricately edited. Reel five, for example, contains 133 splices, constructed from ten- to twenty-foot sections repeated ten to twenty times. The complex montage of the final film contains shots that range from a few feet in length to the full hundred-foot reel. Its many repetitions echo the repeated musical phrases in the Erik Satie concert *Vexations*. Film historian Callie Angell, who is writing a catalogue raisonné of Warhol's films, concluded that Warhol's difficulty in editing film encouraged him to simply use the unedited camera roll. Thenceforth his films were constructed of three-minute silent reels and, later, thirty-three-minute sound reels. One key element of movie making, editing, was jettisoned entirely.

Sleep began its three-day run at the Gramercy Arts Theater, starting at eight P.M. on January 17, 1964, and finishing five hours and twenty-one minutes later. On the first night two small transistor radios were tuned to WMCA to provide an ambient low-volume soundtrack in the nearly empty theater. Other than Jonas Mekas, the only newspaper critic to attend was Archer Winsten of the *New York Post*. He reported that there were six viewers in the audience and after two hours two of them had left and three more had entered. (It sounded like the dynamics of the Satie concert a few months earlier.) Among the handful of people in the theater was Paul Morrissey, who had arrived because his friend, the filmmaker Ken Jacobs, was working as the projectionist. Morrissey stayed a few hours and then left, refusing to return to a Warhol screening for a year and a half. Archer Winsten gamely returned two days later and reported a similarly small audience, who this time were watching without any sound to distract them from the simple image.

Jonas Mekas recalled that the lobby of the Gramercy Arts Theater was the site of whatever drama took place those evenings, as the few members of the audience, taking breaks from the movie, asked themselves: What were they watching? "An exercise in hypnosis? A test of patience? A Zen joke? It abandons the usual movie experience for what? Pure cinema, no fake entertainment, no fake stories, isn't that something worth trying? Does this bringing down to absurdum mean that we have to start from scratch, to forget all previous movie experiences?"

"The path of the true innovator may be profitless," concluded Archer Winsten, "but no one can say they don't enjoy themselves as they

John Giorno:
Your films are just a way of taking up time?
AW: Yeah.

"A movie like *Sleep* gets them involved again. They get involved with themselves, and they create their own entertainment."
—Andy Warhol

pursue the Ultimate into that last corner where All and Nothing become One."

The brief release of *Tarzan and Jane Regained . . . Sort Of* presents Warhol before he found his signature style and abandoned its free-form activity. The clapboards on the set credited Wynn Chamberlain as director and Warhol as photographer.

Taylor Mead was annoyed by the fact that Warhol didn't complete *Tarzan and Jane Regained . . . Sort Of* immediately after returning from the West Coast. Not only had Andy become embroiled in moving to the new studio on East Forty-seventh Street, but he had also lost interest in the hand-held, narrative aesthetic represented by *Tarzan and Jane*. The film would only confuse people, Warhol reasoned. They might mistake the style as that of Jack Smith or Ron Rice.

Mead took up the cudgels to get the film put together and shown. He edited it, leaving almost everything in, "arranging it in a more or less flowing sequence." *Tarzan and Jane Regained . . . Sort Of* premiered February 18, 1964, and the credit read, "Directed sort of by Andy Warhol." In his *Village Voice* review Mekas observed that a new cinema of entertainment was developing, an underground film for broader audiences.

Batman/Dracula, Warhol's collaboration with Jack Smith, remained uncompleted. The production raised the problems of two sensibilities working together when it was unclear who controlled the final result. Smith created the scenes, and Warhol controlled the camera. At the time *Batman/Dracula* was being shot, in the spring of 1964, Smith was the most well known of all the underground filmmakers. Warhol had always admired Smith, as he said to an interviewer: "When I was little, I . . . thought he was my best director. . . . I mean, just the only person I would ever try to copy, and that . . . He's the only one I know who uses color . . . backwards."

Jack Smith didn't exactly direct his actors, but he created an atmosphere and a strong aesthetic by obsessively focusing on makeup and costume. Blatantly theatrical in its style, *Batman* alluded to a story and used elaborate costumes. Although Warhol was behind the camera, the aesthetic was set by Smith. The shooting sessions started with his makeup. Smith believed that, since he had no lines, the way to get into his Batman character was through the process of makeup: "It is a chance to be alone

"You're MGM, and I'm just Warner Brothers."
—Andy Warhol to Jack Smith

and concentrate and time also for your soul to escape through your eyes to the mirror and come back to you in character," he said to Gerard Malanga. If Warhol was known for his static camera, Smith was unsurpassed in the degree of slowness in any given performance. Long before Robert Wilson, he slowed movement to its limits. When he was supposed to move from one point to another, Smith was inevitably incapable of making it there before Warhol's hundred-foot roll of film ran out.

Smith's performance ended up unseen, for *Batman/Dracula* represented a narrative path at the moment when Warhol was branding a style of filmmaking that was unmistakably his own.

When it became clear that the film would never be edited or shown—it turned into one of the legendary unscreened films—Smith began to increasingly resent Warhol. (In a 1965 movie, *Camp,* Smith moves very slowly toward a glass cupboard in the Factory that holds only a *Batman* comic, and Smith says, "Should I open the closet?" Smith then puts on dark glasses and says, "Let's open the closet now.") Smith told Gerard Malanga that Batman was his favorite role. Of all the underground directors he worked with, Warhol had given him the most room for improvisation and had also been the most demanding, so Smith saw the fate of his performance—unedited and unreleased—as particularly tragic. *Batman/Dracula* introduced tensions in Warhol's relationship with Jack Smith that were never resolved.

"I just make the same movie over and over again, only with different people in front of the camera."

"But it's so easy to make movies, you can just shoot and every picture comes out right."
—Andy Warhol

Andy's obsession with portraiture immediately surfaced in his filmmaking. He revived a tradition that appeared in America's first avant-garde: to not only create portrait likenesses, but to reconceive the form. In the case of Warhol, a portrait usually focused on a single characteristic action. The result was part gossip, part plastic expression, and all absolute likeness.

The first of these film portraits to be shot was *Haircut.* When Warhol had walked into Billy's apartment in early December 1963, he had immediately envisioned a haircutting film. A few weeks later he shot three, but the one most frequently shown is called *Haircut #1.* The seventeen-minute film manages to be many things: it commemorates Warhol's immediate connection to Billy at the haircutting party; it is a portrait of Billy and his diligent care for others; it presents Billy's circle of friends associated with Judson Dance Theater (dancer and choreographer Freddie Herko, choreographer James Waring, and lighting designer John Dodd); and its theatrical lighting evokes Billy's dance-world aesthetic.

Billy later recalled that Andy instructed him simply to cut Johnny Dodd's hair as in real life, while Herko considered his performance a piece of "very deliberate minimalist type choreography" that reflected the Judson embrace of everyday movement as dance. Herko's choreography lent itself to Warhol's first exploration of deep space, as he moves toward the camera and then turns and walks slowly into the deep space of James Waring's apartment, gradually disappearing into the shadows. Wearing white jeans, a cowboy hat, and no shirt, Herko removes seeds from marijuana in a sieve, fills a meerschaum pipe, and turns to look directly at the camera as he smokes it. In the final sequence Herko's clothes are off and his legs are crossed, hiding his penis, except for a brief moment as he uncrosses them. The film ends with the four men bursting into silent laughter.

A description of the activity in the film, however, fails to suggest how carefully Warhol framed the actions that took place when he turned the camera on. *Haircut* does not yet present Warhol at his most pared down—the film is shot from six different angles, and each take is carefully designed to maximize the effect of the high-contrast Tri-X film. The frames accentuate the deep space of the film's composition, one spatial plane behind another. Billy's theatrical lighting is not merely a matter of technical competence but a key element in the visual design, with lights apparent in the frame. The film presents simultaneous activities that engage the viewer's attention. One focus is the haircut in the foreground, the constant clipping and occasional unheard conversation, and the smoking of cigarettes. The other is Herko, whose activities—smoking marijuana and frontal nudity—were shocking for their time but are presented with neither affect or shock. Just as Herko choreographed his apparently artless performance, Warhol choreographed his camera in artful setups and the film's recording of a haircut is self-consciously shaped to create a picture of homoerotic buddies. It is a sexual film without sex. The electricity remains beneath the surface.

Gertrude Stein had experimented with presenting someone's "bottom nature" in her word portraits; Charles Demuth presented them as "poster portraits"; Virgil Thomson as musical portraits; and Marius de Zayas as "absolute caricatures" that resembled equations.

By the time Andy Warhol shot his next portrait, Robert Indiana in *Eat*, he had pared down his aesthetic to a single stationary take recording a single action. He may have been influenced by the dance pieces at the Judson Dance Theater, whose concerts he had seen since the spring of 1963. While dance usually favored complexity and technical difficulty, the Judson dances examined simplicity and minimal technical steps. Presenting the act of eating was one of the preoccupations of several

Judson dancers, including Steve Paxton, Judith Dunn, and Carolee Schneemann.

On the evening of February 1, 1964, the night before appearing in Warhol's film, Indiana went to see *Tom Jones,* with is celebrated, voluptuous eating scene. In preparation for Warhol's arrival, Indiana assembled vegetables and fruits that he would like to eat. Warhol arrived at his studio on Coenties Slip, selected a single mushroom, and told Indiana to eat it as slowly as possible, so that it would last through the twenty-seven-minute reel. Indiana ate the mushroom with restraint and self-possession. Adding a note of drama, his cat Particci sat on Indiana's shoulders for several minutes. Indiana's reward came when the film ended and Warhol treated him to a huge meal across the street at the Seamen's Church Institute.

Eat exemplifies Warhol's minimalist films—exploring how little action could sustain a film shot from a single stationary camera on a tripod. Warhol made two interventions: as always, he showed it at the silent speed of sixteen frames per second, instead of at the sound speed of twenty-four frames per second, and he altered the sequence of the nine three-minute rolls so that the mushroom seemed to inexplicably grow and shrink.

Drunk, which was shot later in 1964, presents, like *Eat,* a single act of consumption, but the stakes this time were higher.

Its subject, Emile de Antonio, was one of Andy's oldest and most influential friends. Andy had repeatedly asked de Antonio to make a film with him, but initially de Antonio declined. "Come on, Andy," he said. "Our work is so different in every way. It's politics. It's form. Ah, call it 'camp.'"

Finally de Antonio agreed:

Okay, I said I would do a film that I think is an ultimate gesture. I'll drink a quart of whiskey in twenty minutes. Marine corps die doing this, and I think if you're going to do a gesture, you might as well risk your life on it. So he got very excited because Andy is to me the ultimate voyeur. He's the prince of voyeurism because he finally doesn't have to go to his window. He doesn't have to peek into windows. He makes people come to him and do their thing while he deigns or deigns not to look. . . . In the first reel I'm not at all drunk. I drink the whole bottle in the first

Emile de Antonio on the Factory stairs, in the final stages of *Drunk,* after consuming a bottle of J & B whiskey, by Billy Name

thirty-five minutes, but Andy was still an amateur with that equipment because it took twenty minutes for him to unload it and load it. So that by the second reel of the film I was totally drunk because in that period of time the whiskey had taken its effect. I was able to walk out of there. I think that most people would have died. . . . The only thing that I regretted was that Andy, ah, had such crummy whiskey.

Only the original print of *Drunk* exists. Like many Warhol films it remains unseen—in this case because de Antonio did not sign a press release and put his lawyer on the case. *Drunk* reflects an element—de Antonio going as far as he could go—that would become a staple in Warhol's films. In this case the "dare" was posed and enacted by the subject, but he found he did not want it viewed by anyone else.

Not long after Diane di Prima had met Freddie Herko in the mid-1950s, she had begun writing poems about him. He was her muse and dedicatee: "warmer than fireside have you been to me / touchstones for beauty here on this cracking earth." Her poems to him continued regularly over the years and would be published finally as *The Freddie Poems*. They featured Freddie in funny pajamas, Freddie as Praxiteles, Freddie in the morning sun. But the poem di Prima wrote for his twenty-eighth birthday was not sunny:

> *dear Freddie, it's your birthday & you are crazy*
> *really gone now, crazy like any other old queen*
> *showing off your naked limbs a little withered*
> *making fairy tales into not very good ballets*
> *yes, now you are 28, you are shooting A*
> *you are getting evicted & there is another coldwave*
> *you are worried about your costumes—can you take them*
> *with you & to where? you are late for a performance . . .*
> *and we think a lot*
> *about keeping you away from jail & the madhouse*

When di Prima read this birthday poem in public at NYU, Frank O'Hara told her that he was shocked. She sadly replied that she was only saying something that everyone knew. By this time Freddie Herko was walking around in a black cape (the local Puerto Rican kids called him "Zorro"), sometimes playing a set of Pan pipes, or walking in the middle of the street, oblivious to the cars rushing by.

In the spring of 1964 Taylor Mead was the lead actor in a theatrical double bill of plays by Frank O'Hara and LeRoi Jones. Opening on March 23, 1964, O'Hara's one-act play, *The General Returns from One Place to Another,* offered Mead a chance to enact a campy General MacArthur, arriving in Manila and ordering every inch of the palace marble to be polished so that it shined like the Arctic snow. In Jones's play, *The Baptism,* Mead played a homosexual minister who was also Satan. Like many Off-Broadway plays, this production was staged in a small theater (the Writers' Stage on East Fourth Street); it was produced by a new group called Primary Stages. The double bill ran four performances over two

weeks. Every performance was double-booked, even before Michael Smith's rave review appeared in *The Village Voice*.

The double bill seemed destined to transfer to an Off-Broadway theater, the Cherry Lane. LeRoi Jones was the hurdle. Between the time he wrote *The Baptism* and his next play, *Dutchman*, he had moved toward support of racial separatism. He refused to let his play be staged. Taylor Mead circulated a petition to make the play go on, but it was a hapless tactic. At the end of the 1963–64 season Mead was cited by the Obie committee (the Off-Broadway awards established by *The Village Voice*) for his performance.

Edie Sedgwick's first links to the social world of Cambridge came through a Harvard undergraduate, Edmund Hennessy, who had grown up in Santa Barbara. He had never known her in California because he had attended the fashionable Crane Country Day School in Montecito, while Edie was tutored at home in Goleta. A brilliantly amusing dandy who seemed to have stepped from the pages of *Brideshead Revisited*, Hennessy was fascinated with the era of Aubrey Beardsley and *The Yellow Book*. He was drawn to Edie's natural intelligence and her high spirits. In retrospect, Hennessy believes that his homosexuality—his private term was "on the committee"—contributed to their closeness: "I was clearly on the committee, and I may have reminded her of her favorite brother, Minty, who was also *comme ça*." Hennessy was highly social—he was either giving parties or going to them—and through him Edie quickly became involved in a social scene away from both the pathology of the hospital and the strictly Porcellian manner of her brother Jonathan. She was more amusing than Radcliffe students and entirely different in style, and that proved to be a social advantage.

On March 4, 1964, Edie's closest sibling, Minty, hanged himself at Silver Hill, on the day before his twenty-sixth birthday.

The next night Chuck Wein stepped off Brattle Street into the gallery that adjoined the Casablanca bar, and Ed Hennessy hailed him. He expressed his amazement to see Chuck back from the desert. Hennessy was referring to Wein's most recent adventures—living in Tangiers and working as a tutor to William Burroughs's son. Wein had returned just a few days before. Hennessy lifted a glass of chartreuse (echt *Brideshead*) and insisted that Wein must meet Edie Sedgwick. Taking him by the elbow, Hennessy propelled him past the red-and-white-checked tables in the dimly lit bar, all the while telling Wein about Edie.

A few feet before they reached her, Hennessy concluded his thumbnail sketch with the bombshell information that her brother, Minty, had just hanged himself at Silver Hill.

Wein saw Edie standing by the jukebox, listening to Lotte Lenya singing "The Alabama Song." She seemed to be completely absorbed in the sounds coming from the jukebox. "She was like a wind-up doll who had lots of delightful bits, but she was excessively bubbly, compulsively giggly," said Wein. "You had to slow her down, calm her down, look her in the eye and talk to her to get her out of the defense. She had a whole of armada of defenses, just an amazing repertoire of stuff, and she seemed to be very, very on top of it. But there was a faraway look in there." When Edie realized that Wein knew about her brother, she changed her manner: Wein recalled that she became "so real about what was going on, there was no personality front, and a spontaneity of expression I had never seen before."

For the next several days after that meeting at the Casablanca, Chuck Wein was drawn into the Sedgwick family saga as recounted by Edie. He felt compelled to understand the plight of this woman who was captivating, charming, and bright but incapable of functioning in the world. He heard about her time in Silver Hill and her father's desire to return her there. "I had some fantasy of Arthurian knighthood and Lancelot, and—being sort of rebellious—I thought I could challenge this sickening family that had destroyed this girl," recalled Wein. "She was charming, but she was like a child, and she was very willful and difficult."

Wein's first objective was to wean her from the many pills prescribed by her psychiatrists, moving from eight Nembutals a day down to two. Edie later described Wein's personal importance in a conversation with her close friend, Ed Hennessy: "The basis of my faith in living at all is somebody like Chuck who will understand what I say and whom I could understand, who was the first person to say something other than I was insane and brilliant, or something that means zero. If I didn't do the normal thing, I might as well die."

On April 20, 1964, Edie Sedgwick turned twenty-one, and she wanted to celebrate with a dance party. Ed Hennessy and his friend Robert Smith had to rent the Harvard Boat House, hire a band, select a caterer, determine a menu, and invite the guests. "The whole episode opened my eyes," wrote Hennessy, "and I realized for the first time that Edie simply couldn't make things happen on her own. Her studied helplessness was something of a surprise to me." The party was a huge success, and during the course of it Edie changed her dress three times. She

was celebrating not only her birthday but also coming into a trust fund from her maternal grandmother. It was dispensed by the Morgan Guaranty Bank at a generous rate of ten thousand dollars a month. Cambridge suddenly seemed like too small a pond for her. Some of her friends were also about to leave—notably Ed Hennessy, who was setting off to Paris, and Chuck Wein, who was heading for New York. She resented the fact that there were too many family members around, cramping her style.

In late spring 1964, Edie packed a jumble of boxes, mismatched luggage, and stuffed animals, and Tommy Goodwin drove her fully packed gray Mercedes to New York.

The shutdown of the Living Theater in October 1963 marked the beginning of the antagonism between the city and its avant-garde. Over the next six months the battle intensified sharply, and the civic authorities under Mayor Robert Wagner directed their bureaucratic energies at crippling key downtown institutions in preparation for the opening of the New York World's Fair, to take place on April 22.

After the closing of the Living Theater, Diane di Prima and her husband Alan Marlowe, under the auspices of the New York Poets Theater, rented the New Bowery Theater. From February to May 1964 it was a key venue for the downtown community and also a prime target in the cleanup of New York. On Tuesday, March 3, at the second screening of Jack Smith's *Flaming Creatures,* the theater was raided by Officers Michael O'Toole and Arthur Walsh. The police seized Smith's film and confiscated one of Andy Warhol's earliest three-minute reels: *Jack Smith Shoots* Normal Love. Warhol's film, which was never recovered, documented not only early Warhol but also Jack Smith's working methods. The audience at *Flaming Creatures* was rounded up—among them Joe Campbell and his lover, Harvey Milk, who were appalled to be hauled off in a paddy wagon to the Ninth Precinct house on East Fifth Street. Jonas Mekas was not present at the screening but rushed over to the theater and insisted the police arrest him. Di Prima insisted that she be arrested instead, in what she described as "a fine contest of Sicilian vs. Eastern European bravado." Since the police arrested Jonas and three other males (Ken Jacobs, Pierre Cottrell, and Jerry Sims, who had been casually roped into taking tickets that night), they decided to also cite the New York Poets Theater. The theater's landlord, Mrs. Bergery, was not sympathetic to her tenants' position and once remarked that she thought the

At the New Bowery Theater, February to May 1964:
Dance: James Waring, Freddie Herko

Music: La Monte Young, John Herbert Dowell

Movies: Andy Warhol, Brian De Palma, Jonas Mekas

Theater: one-act plays by Frank O'Hara, Diane di Prima, Wallace Stevens; performances by Peter Schumann's Bread and Puppet Theater

stains on her red theater curtain were caused by men ejaculating in the front row, overstimulated by the experimental movies. She had not seen *Flaming Creatures* but denounced it as "not art" and said, "Anything that's bad enough for Detective O'Toole is bad enough for me." A sign was posted: THIS POETS THEATER CLOSED BY ORDER OF POLICE.

During the same week New York's License Department charged Jonas Mekas's main venue for underground film, the Gramercy Arts Theater, with presenting an improperly licensed program of Ron Rice's films—*Chumlum*, *The Queen of Sheba Meets the Atom Man*, and *Senseless*. Later that week in Los Angeles, Kenneth Anger's *Scorpio Rising* was seized by the vice squad, suggesting that censorship was not only a New York phenomenon. (The week his film was banned, Anger received a Ford Foundation grant for experimental filmmaking.) On March 17 Kenneth Anger and Stan Brakhage screenings at the New Bowery Theater were canceled, and the next day the same thing happened to the films of the Kuchar brothers.

Jonas Mekas took the occasion to square off in *The Village Voice*.

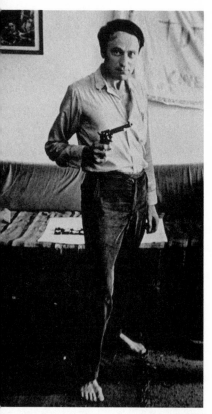

Audience Members:
Stan Brakhage
Larry Rivers
Morris Golde
Panna Grady
Cecil Taylor
Richard Lippold
Joan Mitchell

Our equipment, projectors and screens have been seized. Our film, Jack Smith's *Flaming Creatures*, and rushes from his yet unfinished *Normal Love*, Andy Warhol's *Newsreel*, and Jean Genet's *Un Chant D'Amour* are lying on the police shelves. Somewhere something went completely wrong. The city and the State have turned against its avant-garde in its arts, the most sensitive budding points of spiritual and esthetic activity are being hurt. Bureaucracy is triumphing. Civic duty is running amok. . . .

This is what this is all about. An important shift in the ways of life, in moral attitudes, is about to take place in America. Really the shift has been going on for some time. What's lacking is the official stamp. That's what this is all about. The clash between a going away generation and a coming generation. Much of what the Old Generation calls immoral and obscene; much of what it calls non or anti-art is to us Beauty, because it is part of our life. Old ways of life to us seem full of false morality; much of the art of yesterday begins to look like a lot of nothing.

The following week Amos Vogel wrote an article in *The Village Voice*, called "*Flaming Creatures* Cannot Carry Freedom's Torch." Vogel charged Mekas with mistakenly regarding New York in 1964 as "a pre-

Jonas Mekas, underground movie revolutionary, late 1963

revolutionary state" and staging a "putschist" move without public support, calculated to provoke incursions from the Police and License Departments. "Mass media public has increased; audiences and critics have waned," wrote Vogel. He considered *Flaming Creatures* too uneven a film—"a tragically sad film noir, replete with limp genitalia and limp art"—to be the proper cause célèbre for the New American Cinema. Vogel did not approve of *Flaming Creatures* being lumped together with Jean Genet's *Un chant d'amour* in a guerrilla skirmish over censorship. Vogel regarded Genet's film as a major work of art, bearing no relationship to the New American Cinema, and he objected to "showing it in a tiny theater, without even daring to announce its title in the press, in an almost stag-film atmosphere designed to invite the police into seizing it."

Vogel recognized censorship's chilling power to restrict freedom of speech and had fought it for a dozen years. But he also saw independent film becoming synonymous with its most experimental sector. Vogel understood the psychology of film audiences in New York, and he knew the wide range of non-Hollywood films that needed to find their audience. He turned his efforts to developing the New York Film Festival.

A trial was set to determine the obscenity of *Flaming Creatures*, triggering the most visible censorship debate since the William Burroughs *Naked Lunch* trial in the early 1960s. The three judges refused to allow extensive expert testimony on the film's artistic or socially redeeming values, but they made a few exceptions. Susan Sontag, who had published a defense of *Flaming Creatures* in *The Nation* prior to the trial, was asked what she would consider pornographic. She cited the posters outside Time Square movie houses that advertise war movies in conjunction with sadistic atrocity movies. Allen Ginsberg was asked to define *avant-garde:* "I would say that the avant-garde is a group of people up front looking to experiment with their own consciousness, their own hearts, their own feelings, in an attempt to better communicate with other human beings." Jonas Mekas and the others were found guilty.

Jack Smith wasn't even remotely grateful and condemned Mekas for the *Flaming Creatures* bust. Smith thought Sontag was an opportunist and that Mekas was taking a radical stand because it was chic, made him look like a saint, and at the same time advanced his career.

That spring New York agencies tried to close down poetry readings at Café Le Metro, which became the battleground for an important First Amendment fight. It was not an obscenity trial but one determined by bureaucracy; the city license inspector launched it, citing the New York

Laws covering "neighborhood clubs" allowed all kinds of events, so long as:
1) there was a book containing the members' names;
2) members were issued identification of their club membership;
3) members paid dues of some kind and could make donations, with the transaction taking place off the club's premises.

coffeehouse law of 1962, which said that entertainment was allowed only in an establishment that sells liquor. Since cabaret licenses were expensive the ruling de facto limited the public reading of poetry. Allen Ginsberg and others pursued the legal rights of "neighborhood clubs," allowing poetry readings to continue.

The most widely reported attack on freedom of expression was Lenny Bruce's bust at the Café à Go Go on April 7, 1964. Around ten o'clock, just as he was about to go onstage for his second night at this cafe at 152 Bleecker Street, Bruce was arrested on charges of giving an "indecent performance." Professor Irwin Corey went on in Bruce's place and delivered a comic routine against police suppression. "A cop is an amoeba," he said, "and Greenwich Village is a place surrounded by precincts." A petition was circulated by the ad hoc Emergency Committee Against Harassment of Lenny Bruce and sent to Mayor Robert Wagner charging that "obscenity has become a cudgel against free speech and only encourages intimidation of performers and their public." The district attorney pushed for rapid adjudication of the case in order to cleanse the city before the upcoming New York World's Fair.

Only the little magazines of the mimeograph revolution escaped censorship. Ed Sanders continued to publish *Fuck You: A Magazine of the Arts,* and Ted Berrigan's *C* published a Ron Padgett story featuring a sexually graphic image on the cover. These publications survived because they were distributed by hand and thus avoided the U.S. mail.

In mid-March Jonas Mekas published a manifesto on censorship, and the next week he wrote his "Movie Journal" column from the Tombs, having been busted for showing Genet's *Un chant d'amour.* One of the arresting detectives remarked that Mekas should have been shot right there in front of the screen. Several people, led by Diane di Prima, Julian Beck, Jonas Mekas, and Aldo Tambellini, formed a group called Committee for Freedom for the Arts and planned a march.

On Wednesday, April 22, about two hundred people gathered in Bryant Park at dusk, grouped around a large black coffin lettered WILL FREEDOM BE BURIED? As it grew dark, they lit candles and marched, carrying the casket up to the newly opened Lincoln Center. Julian Beck and Judith Malina wore placards that said FUCK and CUNT. Alan Marlowe carried a sign that said NEW YORK IS A SUMMER POLICE STATE.

When the group reached Lincoln Center, they extinguished their candles in a fountain at Lincoln Center "to point up that state art—as in

Lincoln Center—was putting out the light of the arts in our town." Diane di Prima addressed the crowd:

> All you need to do plays is a script and players. All you need to show a film is film and a projector. All you need to make love is one or more people who want to make love. There is no piece of paper on earth that can give you the power or right to do these things. It is time for dancing in the street and singing in the streets again, and we must make joy. Make joy, speak truth, do your work, and everything else will take care of itself.

Half a dozen mimeographed handouts on different colored paper were passed out, issued by groups ranging from the Film-Makers' Cooperative to the New York League for Sexual Freedom. The march served as an umbrella organizing event, bringing together many of the causes that would be associated with the Sixties—sex, drugs, and freedom of expression. A look at the evening's speakers and their words provides a preview of the rhetoric and rallying cries of the revolutionary years to come.

"HELP! The freedom of the artist is being violated. When the freedom of the artist is jeopardized, Watch Out! It is a sign of a government that fears the free expression of its people."
—the manifesto of the Committee for Freedom for the Arts

Allen Ginsberg read a list of grievances, including the censorship of *Flaming Creatures* and *Un chant d'amour,* the banning of *The Tropic of Cancer* and *Fanny Hill,* actions against Off-Broadway theaters and coffeehouses, the housing problems of the Artists-Tenants Association, and the federal seizure of the Living Theater.

Julian Beck widened the issues beyond artists: "We are concerned with freedom for everyone. As long as they continue to put people in jail, none of us is free. We will not be free until we open all the doors of all the jails."

Taylor Mead read an anti-police poem that began, "Welcome to the land of the free / Pull over to the curb / Show your I.D., / We're checking you out. / Take down your pants. Feel his ass Joe . . ."

The group sang "We Shall Overcome" as the somewhat bewildered Philharmonic patrons arrived for the eight P.M. performance.

In this fractious atmosphere of censorship and antagonism, Andy Warhol delivered the mural that Philip Johnson had commissioned for the New York World's Fair. It consisted of twenty-five masonite panels, each forty-eight inches square, featuring the silk-screen blown-up faces of *Thirteen Most Wanted Men.* On April 16 Johnson telephoned Warhol

and said that the artist had twenty-four hours to remove his work from the New York State Building or replace it. Up for reelection, Governor Nelson Rockefeller was afraid that, since the subjects whose faces Warhol used were heavily Italian, a portion of his constituency would be offended by the stereotypic link between Italians and crime. In Warhol's earlier incarnation as a commercial artist, he would have been compliant—"whatever the client wanted" was the rule. But his provocative proposal to Johnson suggests how Warhol had changed in the intervening years: he proposed replacing *Thirteen Most Wanted Men* with blown-up images of Robert Moses, a strategy for showing the censor in place of the censored work. (And Moses was not attractive.) Johnson rejected the proposal, recalling, "I didn't think it made any sense to thumb our noses at Mr. Moses, and I thought it was in very bad taste."

In response to the censorship of his mural at the World's Fair, Andy Warhol's stance was the opposite of a manifesto: instead of fiery words, he offered mute silence. He passively refused to cooperate with the World's Fair officials by making a new image that would meet their standard of appropriateness. Instead, he instructed that *Thirteen Most Wanted Men* be painted over in silver. When he and Gerard Malanga and Henry Geldzahler arrived in Flushing at the fair site, they could see the images barely showing through, but soon Warhol's section of the wall was a sheet of gleaming silver.

Warhol later said that he was glad they were gone, because he "wouldn't have to feel responsible if one of the criminals ever got turned in to the FBI because someone had recognized him from my pictures." But his remark sidesteps the fact that his painted-over World's Fair work had become a sort of abstraction about censorship. "It was so shocking a mural and mirror of the actual society, they refused it," said Allen Ginsberg. "When the searchlight of his mind came into that particular area, one could see how revolutionary the insight was."

The 1964 New York World's Fair made every attempt to be upbeat and modern. The Hall of Free Enterprise pioneered automated responses—one could touch buttons to answer questions about capitalism and free enterprise. There was a Pavilion of Dynamic Maturity for the elderly, and an Abraham Lincoln replica in the Illinois Pavilion that not only shook hands with fairgoers but also realistically sweated. Michaelangelo's *Pietà* was installed in the Vatican Pavilion, and viewers glided past it on a conveyor belt. Hovering over the polyglot of exhibitions was the

giant Unisphere, which was, in Ada Louise Huxtable's phrase, "eternal in its banality."

Andy Warhol's second exhibition at the Stable Gallery opened on April 21, and it looked like the interior of a grocery warehouse. He had asked Billy Linich to go to the gallery and install the box sculptures. Billy lined up Heinz boxes, Brillo boxes, and Kellogg's boxes in rows just wide enough so that people could squeeze by, as in a supermarket. The maze-like installation created an artificial sense of the gallery being packed. Since only a few people could enter at any one time, the line snaked down the block.

The party that followed the exhibition's opening marked the public debut of the Factory. Billy had stayed up nights to get it ready, and as a final touch, he installed bright red, green, and white spotlights. Dozens of people packed into the space, ranging from Mrs. Jacob Javits and Philip Johnson to the Ahmet Erteguns and Naomi Levine. To Warhol's great pleasure, four key Pop artists—Roy Lichtenstein, Claes Oldenburg, Tom Wesselmann, and James Rosenquist—came by. Bob and Ethel Scull paid for the caterer, Fun Fair of Coney Island, whose fare consisted of hot dogs and cold beer served by young men in white caps. The guests listened to the king-size jukebox that had been rented for the occasion, and the pop music of the day filled the reflective space. Pinkerton Guards stood at the street level to ensure that only those on the guest list, devised by Eleanor Ward and the Sculls, were admitted.

This second Stable show succeeded in creating a buzz. Critic Sidney Tillim called it "an ideological tour de force" and described the paradox that Warhol had set up. The emphasis on a quantity of identical-looking items seemed to deny the possibility of aesthetic importance. "The decision not to decide is a paradox that is equal to an idea which expresses nothing more than to give its dimension." The boxes echoed Duchamp's readymades, but they had been carefully crafted, the dimensions imperceptibly smaller than the originals. Even Jasper Johns admired "the dumbness of the relationship between the thought and the technology."

There was only one problem. After pushing Eleanor Ward to show his boxes, they didn't sell. "He thought everyone was going to buy them on sight, he really and truly did," Ward said. "We all had visions of people walking down Madison Avenue with the Campbell's Soup boxes under their arms, but we never saw them." Warhol priced his four hundred sculptures modestly—ranging from $200 to $400 per box, depending on

Barbara Rubin, filmmaker and connector, among Warhol's *Brillo Boxes*, at the Stable Gallery, April 1964, by Billy Name

the size—but the strategy didn't work. Even Bob and Ethel Scull, who had planned to buy a lot, canceled their entire order. One partygoer remarked, "Imagine what a day it will be when an oversize Brillo box is held up for auction at Parke Bernet!" Recognizing that it would be a long time before they sold, he asked Nathan Gluck to carefully wrap them in plastic dropcloths and put them in a spare room upstairs in Warhol's townhouse. There they remained for many years.

In the midst of Warhol's Stable exhibition a new controversy arose. James Harvey, an artist who also worked in commercial design, publicly claimed credit for the design of the Brillo box and accused Warhol of artistic plagiarism. The controversy was played out in *Time* and the press. The combination of poor commercial sales and this controversy led to a strain between Ward and Warhol. She grew more skeptical about his prospects and to Warhol's disappointment, was reticent about showing his *Death and Disaster* series. He also thought she was delinquent in paying him for earlier sales.

At this critical moment Leo Castelli stepped back into the picture, with Ivan Karp strongly supporting him. Henry Geldzahler had per-

suaded Castelli to change his mind about Warhol looking too much like Lichtenstein. Warhol had moved from painting to silkscreen and now to sculpture, so that his work was discernibly unlike that of anyone else in the Pop pack. Castelli invited Warhol to exhibit at his gallery at 4 East Seventy-seventh Street. Warhol had long dreamed of being represented by Castelli, for it was the center of the Pop maelstrom (one journalist called it "the smash hit of the current trend") and represented his heroes, Jasper Johns and Robert Rauschenberg. Warhol accepted.

Since Warhol was too shy to sever his relationship with Eleanor Ward in person and was incapable of writing to her, Billy Linich drafted a letter to her on his portable Olivetti. The letter was entirely courteous and proposed that the Stable handle him for the remainder of the 1964 season, ending in June: "I have thought about this decision for quite a while and my final determination does not result from any particular incident but rather from a more general state of things. The Stable Gallery is co-directed, from what I can tell, with tremendous restraint and decorum which is nothing to complain about except that I expected something different. It's hard to put into words. It has something to do with a state of excitement I think—and my particular state of mind in relation to that." When Billy proposed alternate closings ("affectionately," "most sincerely," or "cordially"), Andy wrote in the margin, "all three."

Eleanor Ward felt that Warhol's defection ungraciously failed to recognize her courage in exhibiting him when no other gallery would. She communicated to him via a go-between that moving to Castelli was a bad idea. Warhol, she warned, would get secondhand treatment, and the gallery would fall apart. Castelli's gallery was, in fact, on the upswing.

Once Andy Warhol had achieved the goal he had been striving for since the late 1950s—to be represented by the most respected contemporary gallery in New York—he was faced with the question of what to make next. Leo Castelli offered him an exhibition to open November 21, 1964. The gallery was a large space, and Warhol wanted to make work that would sell.

Warhol was still taking art world direction from Henry Geldzahler. In April 1964, en route to the World's Fair, Geldzahler had reversed his advice of the year before. Warhol had painted enough death pictures, said Geldzahler. Now it was time for life. He opened a magazine to a centerfold of flowers and suggested it should be something as simple and life-affirming as that.

What could be more popular than flowers? After the darkness of the *Death and Destruction* series and the unmarketability of the *Brillo Boxes,* silk-screening flowers seemed to be a good move. They were safe to hang on the living room wall. Flowers had no obvious connection to anything in Warhol's past, although some critics would interpret them as pansies, and therefore a coded evocation of homosexuality, and others as opium blossoms evoking drugs. In fact, the flower Warhol used was a hibiscus blossom. It was an image he had found in the current (June 1964) issue of *Modern Photography.* The photograph, shot by Patricia Caulfield, contained seven hibiscus blossoms across a two-page foldout. Warhol made a few changes: he cropped the image to four flowers; rotated one of the flowers 180 degrees, so that it touched an adjoining flower; and altered the pink, red, and yellow blossoms to his own colors. "I like painting on a square," Warhol said, "because you don't have to decide whether it should be long-longer or shorter-shorter or longer-short: it's just a square. I think every painting should be the same size and the same color so they're all interchangeable and nobody thinks they have a better painting or a worse painting. And if the one 'master painting' is good, they're all good."

Warhol and Malanga had never silk-screened so much so fast. The sheer number of paintings produced became part of Andy's game, and the art game, and the art. He reached a peak of production during June and July, and it was not just Gerard who helped with the silk-screening process. "Friends come over to the Factory and work with me," Warhol said. "Sometimes there'll be as many as fifteen people in the afternoon, filling in the colors and stretching the canvases." Andy and his assistants produced as many as eighty canvases a day, totaling some nine hundred *Flower* paintings over those summer months. The paintings came in different sizes: the economy size was four inches square (they came six to a box for thirty dollars), while the jumbo size filled a large wall.

Shortly after the New York World's Fair opened, Edie Sedgwick arrived in New York in her 1957 Mercedes roadster with Tommy Goodwin at the wheel. Their logical destination was Danny Fields's apartment on West Twentieth Street which, since 1962, had been known as a "safe house" for the Cambridge group. The day after Edie arrived, Fields recalled the shock of seeing the arrival of "forty-seven pieces of luggage and eight hundred makeup kits." Edie's possessions offered her a sort of security during her first period of unprotected living in a big city. During her

High production at the Factory: Warhol silk-screening *Flowers*, summer 1964, by Billy Name

weeks on West Twentieth Street, she managed to tie up the bathroom and the phone simultaneously and leave cigarettes burning in ashtrays, and she soon drove Fields's male roommate out. But however difficult she was to live with, Danny Fields was overwhelmed by her beauty. "I would become sexually aroused from being alone with her," said Fields, despite the fact that he was homosexual. "It was a beauty that transcends masculinity, femininity, a tragic short-lived gift of poetry, Keats, a flower that lasts a day, a morning glory."

Edie planned to take sculpting classes and to move into her grandmother's Upper East Side apartment until she rented her own. But she had little experience maneuvering in a world as complicated as New York. "I came to New York to see what I could see," she later told a *New*

York Times reporter. "That's from a children's book, isn't it?" That was as much of a plan as she had.

Edie's mother arrived in town in the fall and installed her in a walk-up apartment on East Sixty-fourth Street between Madison and Park. A Rockefeller lived on the same block, and Edie's building had jet-setting occupants who frequented the exclusive currently trendy discothèque, Le Club. To furnish the interior in a manner appropriate to the address, mother and daughter went shopping. They bought solid crystal paper-weights, fur scatter rugs, and heavy cigarette lighters. "She didn't have affection for any of these things: a lot of them she didn't even under-stand," said Danny Fields. The only things in the apartment Edie was attached to were two animals—a large overstuffed rhino that she dubbed Wallow, purchased from Hammacher Schlemmer, and a five-foot horse she had drawn on the wall in pencil. Although Edie's mother offered both the apartment and its furnishings with her blessing, the gift only partly defused the Sedgwick family conflict. Edie's father still wanted to put her in Silver Hill. It wasn't clear whether he feared that Edie would tell tales of family incest, or whether she was a pawn in the marital strug-gle, or if he really thought she was crazy.

His concern was not without basis: Edie's bulimia continued unabated, although her condition remained largely unnoticed and undi-agnosed. Francis Sedgwick was probably more concerned with the out-flow of money. She was receiving $10,000 a month, but her friend Tommy Goodwin estimated she went through $80,000 in six months. Her cosmetics bills alone came to thousands, and the restaurant bills were staggering. Edie ate at pricey restaurants—her favorites included L'Avventura and the Sign of the Dove—and when she was home, she ordered in blinis and caviar from Reuben's on Fifty-eighth Street between Fifth and Madison. Edie always signed the bill, not only for her-self but also for her entourage of friends. One of her monthly games was pulling out the bills and spreading them before her and wondering aloud to her friends where they all came from.

"I started out in the Brooklyn and Long Island public school systems and have hated all forms of school and authority ever since," Lou Reed wrote. Syracuse University was no exception, and by the spring of 1964 he was eager to graduate and move on. "The colleges are meant to kill," he wrote a few years later.

Some were amazed that Lou Reed could negotiate college while also experimenting with a catholic regimen of drugs; he used LSD and ate peyote and drank a codeine-laced cough syrup called turpenhydrate. He popped 750-milligram Placidyls and snorted cocaine and drank liquor and smoked pot. At twenty-one he experimented with heroin, skirting addiction, inspiring him to write a two-chord sing-speak blues song, "Heroin." He described himself as a "smorgasbord schmuck." As a result of academic lassitude and marijuana smoking, he was put on academic probation.

Despite the blandness of the university campus, Lou Reed found models that were important to forming his identity. "I don't have a personality of my own," he said. "I just pick up on other people's." Two of them were Lenny Bruce and Jack Kerouac, but his most influential model was his writing teacher. Delmore Schwartz's brilliance had been discovered early on, and he was the wunderkind of the *Partisan Review* crowd. By the time he met Reed in 1963, the writer was near the end of his rope. Schwartz ingested amphetamine pills daily, drank heavily, and barely slept at night; he suffered form bipolar disorder and had been in and out of hospitals. At forty-nine, old enough to be Reed's father, Schwartz provided a completely different set of paternal qualities than Reed's biological father. Schwartz mixed arrogance, brilliance, and encouragement in a way that riveted Lou.

"Delmore was my teacher, my friend, and the man who changed my life," Reed recalled. "He was the smartest, funniest, saddest person I had ever met." By the time Schwartz entered his life during his junior year, Reed had already begun writing. He had even published two issues and a hundred copies of a short-lived magazine, *Lonely Woman Quarterly*, named after an Ornette Coleman composition. An untitled story, which he signed Luis Reed, mined the literary territory of family dysfunction that would become essential to his later song lyrics—he depicted his father as abusive and his mother as sexually smothering. Above all he made people feel uncomfortable with suburban life.

In the fall of his senior year Reed heard Bob Dylan, who played a concert at Syracuse in November 1963. Dylan was popularly considered the first person in the rock and folk worlds to legitimize song lyrics as poetry. Reed dropped his aspirations to enroll in a graduate writing program at Harvard and instead focused his literary energy on lyrics. He showed very little of his work to Schwartz, who despised pop music and always swore to Reed that he must never betray his gift: "I'm gonna be

Delmore Schwartz (1913–1966) An editor of *Partisan Review* (1943–55), Schwartz showed literary promise early on. His first book, *In Dreams Begin Responsibilities,* was published in 1938, and his final collection of stories was published in 1961, shortly before meeting Lou Reed. Schwartz provided the model for the main character in Saul Bellow's *Humboldt's Gift* (1975).

leaving for a world far better than this soon, but I want you to know that if you ever sell out and go work for Madison Avenue or write junk, I will haunt you." Schwartz's combination of rabid injunction and paternal confidence felt to Reed like a tribute. He never forgot it.

That June 1964, two weeks after his graduation, Lou Reed was summoned by the draft board. He arrived, chewing on 750-milligram green Placydils, and he told the draft board that he wanted a gun and was ready to shoot anything in front of him. "I was competing with a drag queen and a junkie to get out," Reed wrote. "It was the only thing my shock treatments were good for."

Graduating from Syracuse in Lou Reed's class was Betsey Johnson. Her course through her undergraduate years was in marked contrast to Reed's. Her scholastic record was impeccable—Honors Society, magna cum laude—and she was a cheerleader. "I had a lot of good-girl stuff," she said, "and good-girl discipline stuff." Her life as a coed was everything a woman on a 1964 campus could hope for: she went out with a quarterback, got pinned to a baseball player at Trinity, joined Alpha Zeta Delta, and for a long time remained a virgin.

In her senior year Betsey submitted a piece to a writing contest at *Mademoiselle.* The prize was not money but a fashion internship. Two weeks before graduation she got a call saying she had won the contest and was invited to New York. She immediately packed, skipped graduation, and headed for the city—at the moment when youth was becoming the driving force in fashion.

John Cale's introduction to La Monte Young in the summer of 1963 had, by the end of that year, blossomed into a full-blown musical discipline. Cale recalled that his first months in New York could have been happily devoted to cavorting in the big city, but he was always grounded in his daily rehearsals with La Monte Young, Marian Zazeela, and Tony Conrad. "La Monte provided me with a very important personal habit: discipline and a daily approach to work," said Cale. "Working daily with La Monte allowed me to grow, to break through barriers to creativity." In Young's loft there was ongoing conversation about scientific intervals and Indian drones and avant-garde music, and the words slipped without boundaries into sound. The discussion was usually tempered by Young's high-grade marijuana. During their rehearsals Young

"He started immediately delineating which intervals were allowed and which were not. No harmonics, just sound bites of three and seven."
—John Cale

started out playing the saxophone, but when he got frustrated with constant tuning, he dropped the instrument and used his voice instead. Conrad also sang, Zazeela played the violin, and Cale played the viola. Each of them held a single note to create sustained meditative drones.

Henry Geldzahler invited the group to play at his birthday party. They went to his Seventy-ninth Street apartment, removed the mattress from his elevated loft bed, and performed their music there. Below, among the guests, was the pale presence of Andy Warhol.

John Cale spent a great deal of his time in Tony Conrad's top-floor apartment at 56 Ludlow Street. Conrad owned a variety of tape recorders and brittle acetate tapes and lots of records, organized neatly on banks of shelves. "Tony built a truly remarkable little device out of a quaint mixture of antique parts soldered together that allowed him to combine or add up to seven layers," said Cale. Just hanging around 56 Ludlow was an education for him—Jack Smith would come by to work on recording a soundtrack for *Normal Love,* and the next-door neighbor, Angus MacLise, would drop in with his drums. It offered a different world of sounds from what he heard at La Monte Young's.

Tony Conrad studied mathematics at Harvard in the early 1960s, then began playing with La Monte Young's group, Theater of Eternal Music. In 1965 he made a controversial film, *Flicker,* which reduced film to alternating black and white frames in different patterns.

At the heart of the 1964 campaign against underground film was censorship of sexuality—and especially homosexuality. Even before he began making movies, Andy Warhol had a stake in this battle, for he was an avid consumer of gay porn and physique magazines. To him it was not an abstract issue about freedom of speech but a concrete issue of receiving images that he wanted.

By 1964 the presentation of sexuality was opening up on many fronts. Terry Southern's sex romp, *Candy,* was on the best-seller lists. *City of Night,* John Rechy's novel of homosexual hustling, was out as a Grove Press paperback. There was a production boom in explicit homoerotic illustration in graphic physique magazines, like *Fizeek Art Quarterly,* because censorship restrictions were more lenient for drawings than for photographs and films. Toplessness was in the news that summer as Rudi Gernreich's "monokini" was made famous when photographed on model Peggy Moffit, and on June 22, Carol Doda opened the first topless nightclub, at North Beach's Condor Club in San Francisco. The Sexual Freedom League started in 1964, initiated by Jefferson Poland, Tuli Kupferberg, and others. Later that year Tuli Kupferberg joined with Ed Sanders to start a music group called the Fugs (named after Norman

"The New York Times refused to advertise it. [We] have read it and found it to be smutty." —*The New York Times* spokesman, on *Candy*

Rudi Gernreich (1922–1985) was a visionary futurist fashion designer. Best known for his 1964 topless bikini, he also designed the "no-bra" bra, pioneered the use of vinyl and plastic in fashion, and favored androgyny over traditional boundaries of feminine and masculine attire.

Fugs Songs:
"Group Grope"
"Boobs a Lot"
"Kill for Peace"
"What Are You Doing After
the Orgy"
"Dirty Old Man"

Mailer's euphemism for *fuck* in *The Naked and the Dead*), and the songs they performed suggested a distinct sexual advance over AM rock and roll.

Andy Warhol was familiar with the strategies for creating homoerotic images that remained within the law. Physique magazines and movies used images that were homoerotically coded double entendres. Most of them were not hard to understand; a classic featured a man eating a banana.

Perhaps the earliest homosexual mail-order movie shorts were produced by Richard Fontaine in 1949, and the field expanded when Bob Mizer entered movie production. Mizer was the kingpin in the world of homoerotica.

Bob Mizer began his career in 1945, referring male photo models for physique and soft-core porn magazines. Shortly thereafter he formed the Athletic Model Guild (AMG) and would continue to photograph men for nearly fifty years. In 1951 he started publishing his own magazine, *Physique Pictorial.* It was cheaply produced on heavy nonglossy paper and measured only five by eight inches. For the hefty yearly subscription price of six dollars, the magazine arrived through the mail in a plain brown envelope at irregular intervals four times a year. In 1958 Mizer broadened his empire to movies.

The audience for these movies increased in the early 1960s with the popularity of 8mm projection in private homes. There was also a cheaper alternative, a hand-cranked mechanism called an "8mm action viewer," which could be purchased in 1964 for $5.95. These homoerotic shorts had a simple format—they usually consisted of posing, wrestling, or fighting. The characters might change from film to film (men in togas, cowboys in chaps, swimmers in tight suits, cops in uniforms, hotrodders in leather jackets), but the story followed the same formula: men meet, physically interact, and show some skin.

This was exactly the kind of circumscribed narrative concept Andy Warhol could embrace and absorb. And since 8mm Kodachrome films were silent, he didn't have to worry about sound. The distribution of his earlier films was usually semiprivate—they were sometimes shown at the Factory or at friends' lofts. Even at the public screenings at the cinematheque, the audiences were about the size of a downtown party. In this way it paralleled the audiences for physique movies, which were shown at private parties, usually alone, and rarely in a public space.

**Pre-Stonewall Terms
for Homosexual:
Bloomingdale faggot,**
Fruit stand and Lavender
brotherhood (Dorothy
Dean's terms)
Gorilla queen
A homosexual who is
deliberately gauche or
gawky; "I'm not learning
manners from a gorilla
queen."
Private secretary
The traditional British
euphemism for the
younger man in a homo-
sexual relationship.
Christopher Scott recalled
a passport officer putting
his passport inside that
of Henry Geldzahler
and writing "private
secretary."

❏

In the wake of the censorship scourge in the spring of 1964, Warhol filmed *Blow Job*, his most provocative sex film to date. The film consisted of nine three-minute rolls, shown end to end, with white leader between; in structure it was the same as *Kiss* and *Thirteen Beautiful Boys*. On-screen was a handsome young man, a porn and theater actor of the era. Warhol's static camera focused entirely on his face, while all the "action" happened below the frame where Willard Maas was giving him a blow job. The young man's face sometime twitches, and he scratches his nose and wrinkles his brow for the first seven reels. In the eighth roll there is an ecstatic contortion and spasmodic movement as his head is thrown back, fully visible for the first time in the light of Billy Name's single-bulb lighting. In the final reel the young man looks as if he is zipping up his pants and buckling his belt, then lighting a cigarette. The act has been shown in all its texture, without ever showing anything remotely censorable; the title provided the erotics. As historian Thomas Waugh noted, Warhol had perfectly established the erotic rhetoric of the sexual revolution: "the tease."

When *Blow Job* was first shown, the title was not advertised. Taylor Mead walked out after ten minutes, loudly announcing, "I came already." At a later showing of *Blow Job* at Columbia University, students sang in unison, "We Shall Never Come!"

Warhol made another joke porn film called *Mario Banana*. The star, Mario Montez, wearing white gloves and a bad wig, peels a banana. He stares into the camera, lasciviously chews on the end of the banana, and then shoves it in and out of his mouth five times. It was a visual double entendre as old as the hills.

As a set, as a character, as a piece of furniture, the couch that Billy Linich had found on East Forty-seventh Street provided a centerpiece in the Factory, and its ample size and generous curves could accommodate a variety of activities. As the title character in *Couch*, it offered a new twist on the question Warhol often asked when he started out making movies: "If I put you in my next movie, will you go *all the way*?" Sex was a key link between the reels of *Couch*, and it offered a revolving group of subjects.

As erotica, *Couch* cuts against one's expectations. In the early segments men and women sit on the couch in various states of dress, hardly relating to one another. The reels are filled with tender and homely moments, provided especially by Ondine—kissing Gerard, throwing a

"Write H O M O S E X U A L eight times . . . because *homosexual* is such a beautiful word . . . it's beautiful when it's written out!"
—Andy Warhol

"Don't you make no dirty movies!"
—Julia Warhola

Cast of *Couch*:
Ondine
Walter Dainwood
Naomi Levine
Binghamton Birdie
Amy Taubin
Gerard Malanga
Jane Holzer
Jack Kerouac
Allen Ginsberg

scarf over his naked body, wearing his glasses while performing oral sex—that defy standard porno. The film treats sex like an ordinary daily activity, such as eating or smoking.

The inspiration for *Empire* came from an eighteen-year-old named John Palmer, while he was camping out on the roof of the Film-Makers' Cooperative. Seen from Palmer's sleeping bag each night, the Empire State Building six blocks away dominated the New York skyline. Palmer had come to New York from Hartford, Connecticut, with an art background and an interest in film. He knew about Warhol's *Sleep,* although he had not seen it. "It occurred to me, after Man Ray, what about a movie of a building?" Palmer wrote. "As a movie. Not as time lapse or *National Geographic* but as MOVIE."

One day while he and Jonas Mekas were lugging copies of *Film Culture* to the post office branch at the Empire State Building, Palmer suggested, "We should tell Andy. This is a perfect icon, a perfect image for Andy." Mekas presented the idea by talking to Andy Warhol and Marie Menken.

By the summer of 1964 Andy Warhol had moved away from the editing of *Sleep,* the multiple camera setups of *Haircut,* and the narrative of *Batman/Dracula. Empire* required only a handful of decisions: where to point the camera, and when to turn it on and off. Around this time the Empire State Building's spire was floodlit by master lighting designer Douglas LeHigh, just in time for the opening of the World's Fair. Before, it would have been too dark to film.

Jonas Mekas had recently rented a large Auricon sound camera, to film a movie of the Living Theater's production of *The Brig.* He shot the play in real time, and two days later, Diane di Prima showed the movie at the New York Poets Theater. The sound was crude and the process simple, so Warhol decided to shoot the Empire State Building with an Auricon. Marie Menken, who worked in the Time-Life Building, arranged with Henry Romney that Warhol, Jonas Mekas, John Palmer, and Gerard Malanga could set up the camera in Romney's Rockefeller Foundation office on the forty-first floor of the Time-Life Building. On the evening of July 25, 1964, while the sun was still visible, Mekas set the camera on the tripod and framed a shot of the world's largest building. Warhol looked through the lens, said yes, and turned the camera on at 8:10 P.M., about ten minutes before sunset.

In the background, dwarfed by the Empire State Building, the Met-

ropolitan Life Insurance Tower was topped by a light that flashed every quarter hour, so that in the film the audience can not only feel time going by but see it as the lights flash. The passing of time and the change of light are the only dramatic events in the film, with the exception of a brief glimpse of Warhol and John Palmer reflected in the window at the beginning of reel seven. (This image of the filmmaker had never been mentioned until Callie Angell noted it in restoring the film—which suggests how few people had actually watched the legendary film in its entirety.)

Surviving bits and pieces of description from Jonas Mekas's column suggest the jovial tone of those long hours of filming. When Andy gazed at the building, he repeatedly said, "An eight hour hard-on!" Henry Romney jokingly tried to goad Andy into making the movie more action-filled: "Andy?! NOW IS THE TIME TO PAN!" John Palmer occasionally noted, "The lack of action in the last three twelve-hundred-foot rolls is alarming." At one moment the group makes a string of campaign promises, and Andy contributes, "Jack Smith in every garage."

After the night of shooting, 654 feet of film were delivered to the lab. But when John Palmer went to pick them up, the lab would not release the film without payment. He called Warhol from a phone booth. "Ohhh, John, I don't have any money to pay for thaaaat," he said. "It will just have to stay in the lab." Palmer suggested he could try to get the $350 from his mother; if so, he would have to appear on the credits as codirector. The phone went silent for fifteen seconds, Palmer recalled, and then, "Andy, in a voice I never heard and will never forget, said, 'Now you're learning.' "

The result is a moving picture of a stationary object, a silent film shot on sound equipment. Whatever the circumstances of its communal creation, *Empire* became an indelibly Warhol image. "Andy was so taken with the Auricon," recalled Mekas, "that he abandoned the silent camera. Unfortunately, I am guilty of that."

To support himself, John Cale not only worked at Orientalia but also moonlighted as the delivery man for La Monte Young's drug dealing. Young's steel box of drugs was kept in Cale's Lispenard Street apartment. When an order was made, Young would telephone and communicate in code what he wanted. *Oboe* meant opium, *A* meant amphetamine, *piano* meant pot, a *movement* meant a pound. A man would come to the apartment, unlock the box, and give Cale the appropriate amount to deliver. One day Young called up and said there was a suspicious figure banging on his door. Cale was to take him to a phone booth and dial the number.

"It's an eight-hour hard-on. It's so beautiful. The lights come on, and the stars come out, and it sways. It's like Flash Gordon riding into space."
—**Andy Warhol** on *Empire*

Empire, 1964

"My guess is that *Empire* will become the *Birth of a Nation* of the New Bag cinema."
—**Jonas Mekas**

The suspicious figure was in fact another dealer who had given information to the police. They ransacked La Monte Young's apartment but found only a half ounce of opium and a nickel bag on Cale. They were both arrested for drug dealing and thrown in the Tombs for the night. When they got out, they got rid of the steel box, and Cale quickly sold the lease to the Lispenard Street apartment. He moved in with Tony Conrad at 56 Ludlow Street.

At fifteen, Joe Dallesandro was expelled from high school. His infraction had been relatively minor—playing with one of the female hall monitors by throwing his long black kerchief around her neck. The principal made a variety of threats, then suggested that Joe's behavior was perhaps his father's fault. At that point Joe dove across the desk and broke the principal's nose. He hadn't meant to exactly, but once his temper had been triggered, it went unchecked.

Without a connection even to school, Joe moved increasingly toward gang life and always hung out with slightly older guys. He became part of a group that stole cars in New Jersey, drove them over the line to New York, and sold them for parts. Joe took part in forty-six such thefts before he was caught. The forty-seventh was a disaster. Joe was driving, and he panicked and crashed through the gate of the Holland Tunnel and sped to the other end, where he was stopped by a roadblock and six squad cars. Thinking Joe was armed, the police started to fire. One bullet hit Joe just about at his right kneecap, and other bullets riddled the car. Joe put his car in gear and headed straight toward the police. He managed to escape, sank the car in the Hudson, and returned to his father's home with a bullet in his leg. When his father took Joe to the hospital, he was apprehended and arrested.

In 1964, Joe was remanded to Camp Cass Rehabilitation Center for Boys in the Catskills. He thought he was going to work on a farm and milk cows. Camp Cass was a sprawling area where the residents did jobs like cutting down trees for fifty cents a day, scrubbing pots and pans, and cleaning latrines. Joe learned to make homemade tattoos, which were very popular at Camp Cass. "You take a piece of thread, wrap it around a needle, just leaving a small point on it, and then you dip it in India ink," said Joe. A friend drew a design saying "Little Joe" on a scroll. Joe went over it with needle and ink so many times that it came out black, thick, and indelible.

Joe was sentenced to stay at Camp Cass four months, but he ran

away before his time was up. He stayed in the woods for three days, then headed to the highway where he could hitch a ride and escape to who knows where. He was barely sixteen years old.

On the first anniversary of their meeting, Holly [aka Harold Azjenberg] was given a Macy's charge card by his mate, Jack. Holly's first shopping spree occurred just after appearing at the draft board around the time of his eighteenth birthday, on October 26, 1964. Determined to avoid the draft, Holly showed up at the Selective Service office with freshly bleached platinum hair, hot pants, and sandals and wearing heavy blush makeup. After a symphony of wolf whistles and jeers, Holly was summoned into the doctor's office. He removed his shirt and showed the budding breasts that had been induced by hormones; the doctor immediately dismissed him from service. In celebration, Holly bought a new wardrobe to match his new hair. It was the first of many extravagant shopping trips. Holly wanted to wear Mary Quant, Yves Saint Laurent, Courrèges's flat go-go boots with tiny slits in the sides and open toes. Holly plunked down five hundred dollars for a cerise suede suit and a blue silk charmeuse blouse sprinkled with matching brown paisley. For a clotheshorse like Holly, the credit card provided his passport to a dream life. But the two-thousand-dollar bill that arrived in the mail was a nightmare.

Around this time Holly encountered Jimmy Slattery on the streets of Greenwich Village.

> One night I saw this vision, like nothing I had ever seen anything before. And it was a creature underneath a lamppost, and she had on bangs. It was her Audrey Hepburn look, with these glasses on top of her head, and a big fluffy sweater. I really thought it was the most beautiful creature I ever saw in my life. I wasn't sure if it was a man or a woman, I was pretty sure it was a guy, but it looked so beautiful. And she was having a fight with some street hustler, and he threw an ice cream cone in her face, and I remember feeling so bad, but she was kind of snippy and snotty. She had an attitude problem. So we became friends.

Jimmy Slattery already had a reputation on the street as thinking he was too good. By contrast, Holly had quickly grasped the importance of

"Down with dishpan hands! Out with beige housedresses! Forget the rollers in the hair! Darling, I was going to revolutionize the role of the Sixties housewife."
—Holly Woodlawn

ties to the male hustlers on the street, for they bought sodas and cigarettes—and most important, they protected. He also understood the flip side, the danger of one of them pulling a knife or revealing your true sex to a john.

A few days later Holly saw Jimmy standing on the corner of Seventh Avenue and Christopher Street. When Jimmy said he would be the next Greta Garbo, Holly thought he was cracked. Holly entertained more attainable ambitions—to be a clotheshorse or the the wife of a good man.

Jimmy admired Holly as a pioneering cross-dresser; both attended beauty school, and as their friend Ron Link observed, "both were fascinated with women who took men for a ride, men who bestowed jewelry and great gifts." Shortly after they met, Jimmy began telephoning Holly from Massapequa, delivering monologues about Lana Turner and Kim Novak. Although many of the references were wasted on Holly, as were the uncanny imitations of Joan and Constance Bennett, Holly was impressed by Jimmy's encyclopedic knowledge.

On weekends Jimmy would take the LIRR to Penn Station and meet Holly. They dawdled over a cup of coffee for as long as the proprietor let them, then strolled through the Village, lingering on Christopher Street between Sixth and Seventh Avenues, the center of the Village's gay neighborhood. Sometimes they hung out at Rienzi, a coffeehouse on MacDougal Street. Holly recalled that Jimmy, going through "her intellectual phase," sometimes listened to quasi-Beat poets, drank coffee and tamarind juice, and carried a copy of *War and Peace*.

Holly recalled their visits as dominated by Jimmy's obsession with stardom; for Jimmy, the concept was both abstract and totally concrete—he thought that if he could achieve the look and mimic the voice, he was a star. Jimmy sometimes claimed he was a distant cousin of Kim Novak, and he referred to the house in Massapequa as "my country home." When Jimmy played games of celluloid make–believe with Holly, he assigned roles that made clear the difference between the two of them. Suggesting they portray movie stars at a premiere, for example, Jimmy decreed, "I'm Hedy Lamarr and you can be my girlfriend Zazu Pitts."

Although Jimmy's mother had given up objecting to her son's drag, she asked him to stay indoors so the neighbors wouldn't see him, not even going to the mailbox. Jimmy began to understand the imprisonment of nearby Christine Jorgenson, the world-famous transsexual who lived in a beautiful house but rarely left it.

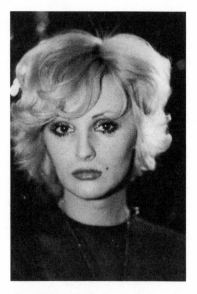

Candy Darling coming into her most evolved fantasy of herself

In the summer of 1964 Taylor Mead seemed to be everywhere. He was in Ron Rice's movie *The Atom Man Meets the Queen of Sheba* and onstage at poetry readings and even on a few bookstore shelves, where his hand-collated and mimeographed volume *Anonymous Diary of a New York Youth* was selling. Mead had become famous enough to inspire a backlash. When a *Village Voice* letter solicited film scripts, it cautioned that it wanted "none of that Taylor Mead stuff." In late August 1964 a fledgling filmmaker named Peter Goldman wrote a letter to *The Village Voice* complaining about "films focusing on Taylor Mead's ass for two hours." In the next week's letters to the editor, Taylor responded, "Andy Warhol and I have searched the archives of the Warhol colossus and find no 'two-hour film of Taylor Mead's ass.' We are rectifying this undersight with the unlimited resources at our command. Love and kisses, Taylor Mead."

Two days after Mead's letter appeared, Warhol shot a sixty-six-minute opus that consisted entirely of Taylor Mead's ass. Warhol asked him to stand still, but as Mead recalled, "I was having nothing of 'minimalism.'" Dramatically lit against an inky black background, cut off from head and feet, Mead's sculptural white buttocks look like a Weston pepper, or an O'Keeffe flower, or a Brancusi kiss. Mead's variations are astonishing. After exhausting his vocabulary of wiggling, scrunching, clenching, undulating, sashaying, shaking, and farting, he appears to shove a variety of objects up his ass. (He is actually pulling them through his crotch with his hands, so that they semiconvincingly appear to be swallowed up by Mead's voracious anus, like a Pop version of circus clowns climbing out of a tiny car.) Mead initially shoves small things such as tissues and dollar bills and tongue depressors, but after twenty minutes the objects grow ever more various, as if Mead were swallowing the detritus of American culture.

Taylor Mead's Ass turned out to be his last film for Warhol for more than three years. "I knew what contempt Andy and Gerard had for people who pushed, so it was up to Andy to call me," Mead said. In the late fall of 1964 Mead felt betrayed by Warhol for not showing the film, by LeRoi Jones for not allowing a second production of *The Baptism,* and by the entire New York commercial ethos.

"So rather than shoot Andy and kill LeRoi, I took the cheapest Icelandic Airlines flight to Europe," said Mead. In a knapsack he packed his belongings—a sleeping bag and two two-thousand-foot reels of *The*

Materials used in
Taylor Mead's Ass:
A *Time* magazine with Queen Elizabeth on the cover
A movie star glossy of Natalie Wood
A soft-core porn magazine called *Big*
A paperback of *Anna Karenina*
A Tide box
Hemingway's *A Moveable Feast*
A program for the first New York Film Festival
Mead's *Anonymous Diary of a New York Youth*
Flowers
Fail Safe
De Tocqueville's *Democracy in America*
Suzanne Langer's *Philosophy in New Key*
Ouspensky's *In Search of the Miraculous*
A photo of Dick and Liz
A vacuum cleaner nozzle

Queen of Sheba Meets the Atom Man. Prepared to set off, he wrote, "I was prepared for sleep and business."

During a layover in Reykjavík, Mead realized that his flight number had been changed and saw his plane taxiing down the runway. He jumped over a fence and ran into the path of the huge plane, waving it down. Mead was grabbed before he could be swept into the propeller, then was put atop a motorized mobile stairway that took him to the plane. "In the Icelandic dawn I felt like Eric the Red with the wind romantically blowing in my hair on top of the shiny aluminum motor staircase. I thought, 'I can't go back to New York.' "

Looking back on the Sixties, Andy Warhol concluded that amphetamine was behind most of the interesting activities at the Factory. Amphetamine was the drug that drove the Factory, and few of its regulars completely abstained from using it. At one end of the continuum was Mario Montez, who never ingested anything stronger than aspirin. Next up the scale was Andy Warhol, who took a quarter of a pill of Obetrol each day; he had started using this prescription diet drug in early 1963, when he thought he looked pudgy in a photo. "But even that much was enough to give you that wired, happy, go-go-go feeling in your stomach that made you want to work-work-work," said Andy. "So I could just imagine how incredibly high people who took the straight stuff felt."

Some, like Gerard Malanga, used speed to party a few times a year. Malanga recalled a few nights with what he called "the Dawn Patrol," and those all-night experiences inspired a group of poems called *Clockwork* about the experience. But amphetamine was never a regular habit with Malanga, who primarily smoked marijuana.

At the next level was Billy Linich, who ingested powdered amphetamine every day from the summer of 1963 until 1969. He was afraid of needles, so he took amphetamine by mixing it in water, or sniffed it. A five-dollar film canister of methamphetamine powder would last him a month. "Meth was my daily maintenance thing," said Billy. "It was a bonus that you got high also, but it wasn't my motivation for doing it." Billy was by no means restricted to amphetamine, and long before LSD became commonly available on the streets in 1965, he had benefited from its unique perspective.

The final boundary line was the use of needles; those who shot up were considered the ultimate users. They were using amphetamine not just for daily maintenance but for thrills, cosmic insight, and comic

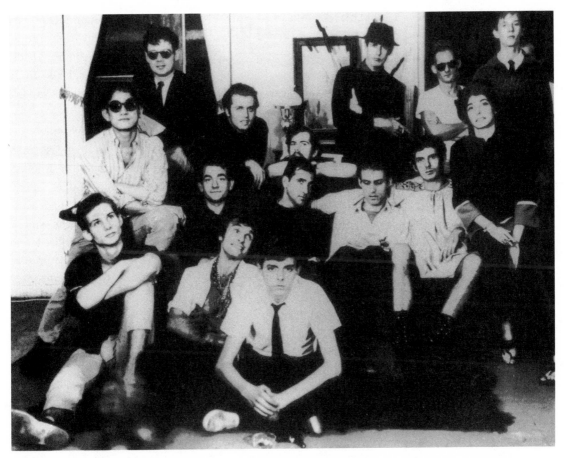

The Mole People: the sometimes brilliant, often amphetamine-driven circle led by Ondine, 1964; from left to right, back row: John Daley, Gerard Malanga, Michael Smith (theater critic for *The Village Voice*), Ron Gronhord, Jack Champlin, Gregor Arnoku, and Ken Wollitz (obscured); middle row: Dale Joe, Ondine, Norman Billiard Balls (aka Norman Holden), Billy Name, Charles Stanley, and Dorothy Podber; front row: Binghamton Birdie (aka Richard Stringer), Freddie Herko, and Dino

opera. Ondine and Brigid Berlin were part of this group. Brigid Berlin even renamed herself after the act of shooting up amphetamine. "Because I poked myself in my fanny with amphetamine, I called myself Brigid Polk. But not Poke," she explained. "I spelled it Polk like the President."

Although speed was not yet identified as a dangerous or marginal drug, the group whose lives were devoted to its "thrill uses," and especially those who injected it, were associated with the margins of society.

One such outcast family, the one most closely connected to the Factory, was referred to as the A-Men, or the Mole People. The first name not only paid homage to their drug of choice but also punned on the

Catholic background that many of them shared. The second name, the Mole People, had several associations. "We called them Mole People because they only seemed to come out at night," said Danny Fields. "Their skins were light, and they were very intense." It was also a campy put-down—as if they were creatures from the B-horror movie *The Mole People*, released in 1956.

The Mole People showed a surprising sense of self-conscious group identity—they had not only a name but a founder (Norman Billiardballs) and an annual family group photo (shot by Michael Katz). The Mole People revolved around a combination of opera, homo-, hetero- and bisexuality, sharply tuned wit, and intentional overdosing on speed. Danny Fields described them as those "who moved through a transitional stage from beatnik into a more stylized and campy version."

The soundtrack behind their marathon conversations was inevitably opera, especially if Ondine was around, and favorites included Strauss's *Elektra* and *Die Frau ohne Schatten;* Verdi's *Macbeth;* Gluck's *Iphigenia in Tauris;* and Donizetti's *Anna Bolena* and *Lucia di Lammermoor,* particularly with Maria Callas.

As a sort of initiation ritual, members were given new names, a tradition that grew out of the name-giving in the homosexual world of the time (where men were sometimes called "Mary," "Loretta," or "Ethel," as in "Get *you,* Mary"). Dale Joe, a member of the Mole People, observed, "It was a way to become anonymous and to put people down, make fun of themselves and each other. You would comment on them artistically as well as personally." For example, Norman Holden got the name Norman Billiardballs because he painted orblike shapes on the canvases he showed at Dorothy Podber's gallery. Richard Stringer was called Binghamtom Birdie because he came from Binghamton and was considered bird-brained.

The Mole People partied in floating rooms—sometimes in hotels, sometimes in apartments, sometimes after midnight at the Factory. Their time together, often without break or sleep, could stretch to seventy-two hours or more. Finding a room was a real issue, for many didn't have a stable residence.

People like Ondine and Dorothy Podber posed an additional hazard, for they had little respect for normal limits. Coveted objects were likely to disappear. An evening recalled by Ondine's friend, Joe Campbell, suggests the risk. At the end of a dinner party Campbell gave,

Ondine said that he and Rotten Rita would wash the dishes. When Joe heard crashing sounds, he found that Ondine and Rotten were running the rented china plates under hot water and then gaily tossing them out the fourteenth-floor window.

The most elegant meeting place was Henry Geldzahler's brownstone apartment at 112 West Eighty-first Street. He had two high-ceilinged white rooms hung with paintings by Jasper Johns, Frank Stella, Ad Reinhardt, Larry Poons, and two Andy Warhols. Overlooking these rooms in a sleeping balcony was his platform bed.

When Geldzahler went away on weekends, he entrusted the apartment to Billy Linich, who cleaned it, did handiwork, and built a walk-in closet. He also invited his amphetamine friends to come over and listen to opera records on Geldzahler's hi-fi. Geldzahler later recalled how amused his answering service was when asked to field calls for the mayor, Ondine, or Rotten Rita.

> Billy's was a crowd of amphetamine users who were united into a dark family and because of their love of opera. I still find in my record cupboards less well-known works with Billy Linich's name in ink on the inside cover. It was part of the mystique of these *amies de minuit* to remove records or velvets from one apartment to another; these were never stolen, only liberated.

Rotten Rita and Binghamton Birdie brought burgundy velvet capes and rich fabric backdrops from their workplace, and in makeshift costumes they acted out scenes from Bellini's *Norma* and Puccini's *Tosca*, as they lip-synched or sang along to hi-fi records and added their own flamboyant flourishes. Geldzahler returned one evening to hear Maria Callas singing the aria of Floriana Tosca as she is about to leap into the Tiber; at the climactic moment an elaborately garbed Ondine jumped from Geldzahler's eight-foot-high sleeping platform.

The Mole People could not have entered such places in society were it not for the presence of Billy Linich. He was widely regarded as a protector and a safety zone. When Billy was on the scene, things didn't get "liberated." Thirty-five years later, when Billy heard Mary Woronov describe him as "the protector of the chaos" at the Factory, he responded with great pleasure.

In the hierarchy of the Mole People, Ondine was at the top. "Andy could be considered an angel, but Ondine was definitely an archangel,"

Nests:
The living quarters for people on amphetamines, often small and housing a few dozen people.

Pad people:
Those who have a permanent home; as distinguished from **street people:** "The pad people are victim to the invasion of the street people, who bring gifts and offerings."
—Harvey Cohen

Shooting Gallery
A place (hotel room, apartment) where a group of people inject drugs and take refuge.

said Billy. The power Ondine wielded had nothing to do with material wealth or accomplishment, for he had neither money nor a job nor a stable home. When the weather was good, he sometimes took up residence in Central Park, and the only thing he could rely on was the forbearance of his loyal mother, Ann, in Red Hook, Brooklyn, who always took him in. Nor did Ondine's authority have anything to do with his ability to function in the conventional world. When he reported for unemployment and was asked about his skills, he responded, "Watching old movies on television." Ondine's charisma owed something to his striking looks, but it was his brilliant speech that made him larger than life. Nearly everyone around him during those early amphetamine years attested to his sharp humor. He had honed his wit on Dorothy Podber, but even before that he had developed the art of witty attack. (A friend recalls Ondine in the late 1950s parading through the nude section of Riis Park, elaborately dressed, and issuing scathing thumbnail put-downs about the inadequacies of the sunbathers' private parts.) As Ondine's close friend Mary Woronov recalled, he "left egos dangling like abandoned marionettes." His tirades were punctuated with a laugh that sounded like a rough purr, and were driven by a stammer and lots of emphases—his effect was about the accented rhythms of his speech as

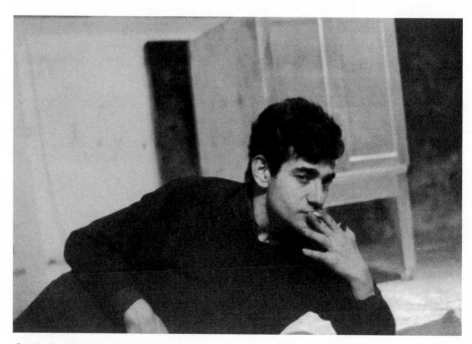

Ondine, 1964, by Billy Name

well as his words. He gave the impression that he was always on speed, but one of his oldest friends, Joe Campbell, noted that he was the same both on and off it.

Mary Woronov, a close friend of Ondine, observed that Ondine had marathon sex and many partners but only one abiding love: Harriet Teacher (which was not her real name). Ondine recalled first seeing her when he walked into Norman Billiardballs's apartment and noticed in the corner a beautiful woman in fantastic garb with a staff in her hand. Ondine had an immediate reaction: he insisted Norman throw her out. "I'll beat the shit out of you," Ondine said. "Get the hell out of here." She took her staff to leave and said, "He's divine, he's violent." The voltage between the two of them was immediate; they had each found an outrageous kindred spirit who shared wit, amphetamine, and extreme actions. Ondine said, "We used to make life so unbearable for people; it was just so wonderful."

Harriet Teacher was the closest thing to Ondine's female counterpart among the Mole People. She named herself and wore costumes—a purple velvet cape that came nearly to the ground, oilcloth dresses, veils, and spats in the middle of summer.

There was no question that Harriet Teacher considered herself and the Mole People to be at the top of a hierarchy that was divorced from the real world. When Billy, playing with the idea of the demimonde, once observed that they were demigods, she drew herself up regally and exploded. "*Demi*gods! We're *gods*!"

Several of the Mole People appeared in Warhol's early films, but Warhol was especially fascinated by Freddie Herko. "The people I loved were the ones like Freddie, the leftovers of show business, turned down at auditions all over town," said Warhol. "They couldn't do something more than once, but their one time was better than anyone else's. They had star quality but no star ego." Freddie appeared in *Haircut* and *The Thirteen Most Beautiful Boys* as well as a movie of dancing on Wynn Chamberlain's roof and a longer series of reels of Herko on one roller skate.

Freddie Herko was the first of the Mole people to show the side effects of massive amphetamine intake. By the late summer of 1964 he had trouble with his ankles, and his highly tuned energy had become jittery and disorganized. "I have destroyed my house, and it's a sin to

**Freddie Herko leaps,
spring 1964,
by George Herms**

destroy your house," he said to Diane di Prima. Seeing Herko's physical and emotional pain, Billy Name concluded that when he realized he couldn't dance to his full ability, he saw no more light in the future. "Freddie was a very demanding person about life," said Billy. "It had to be *great*."

During the summer and fall of 1964 Herko lived with a dancer named Debbie Lee in her apartment near St. Mark's Church. His withdrawal from the world was gradual and complete. He no longer left the apartment. Then he retreated to an end of the hall, then to his room. He ended up in his walk-in closet, where he lavished his speed-driven focus on beads and fabrics. His friend finally asked him to leave. He began to give away his things to friends—a white Buddha and a plate with an American flag on it. The week before he died Freddie invited all his friends to the rooftop of a house called the Opulent Tower. He was going to show a new dance, called "the flying dance," and he wanted his oldest friend, Diane di Prima, to read some "flying poetry" for him. Only a few showed up, and Freddie was not there. But some of his friends could sense what was coming—it was like watching a suicide in slow motion.

On October 27, 1964, Johnny Dodd saw Herko dancing out of control on the counter of Joe's Dinette in the Village. Herko said he hadn't had any drugs for three days. Dodd invited him to come to his apartment a few blocks away on Cornelia Street. When they arrived, Herko went into the bathroom, poured a bottle of Dodd's perfume in the hot drawn bath, and settled into the tub.

When Dodd put Mozart's *Coronation Mass* on the stereo hi-fi phonograph, Herko's mood noticeably picked up. This was one of his favorite pieces. Dodd sat on the couch as Freddie toweled himself dry. Still naked, Freddie began twirling around the living room. On the ceiling above was painted a baroque scene of heaven, a witches' ball hung from the center, and on the bare brick walls were a collage of stage props, gold damask, and postage stamps. They flashed before Freddie's eyes as he leaped about the room, coming closer to the window, whose bottom half was open. In retrospect, Dodd said, "it was obvious that Freddie had to do it now: the time and the place were right, the decor was right, the music was right." As the orchestra began to play the "Sanctus," Herko made a grand leap out the window, missing the frame and, for a moment, seeming to go straight up. And a few seconds later Herko landed five flights down on the far side of Cornelia Street.

There were many memorials for Freddie Herko. His family gave a formal open-casket funeral in Ossining, with massed flowers in the form

of a grand piano. Diane di Prima invited friends to participate in the forty-nine-day service from *The Tibetan Book of the Dead*; each evening shortly before seven she unlocked the door for a gathering around the kitchen table to read prayers.

Debbie Lee opened her house for the final dispersal of Freddie's goods: black velvet, shards of mirrors, wands, broken statuary, an attaché case filled with perfectly clipped-out figures from physique magazines. Judson Church held a Thursday-evening memorial that combined dance, poetry, and music, and *Film Culture* published a memorial piece called "The Incandescent Innocent."

The memorializing of Freddie Herko reflected his symbolic importance to the downtown community—like Maxwell Bodenheim or Joe Gould to earlier generations—and his leap sealed his legendary status. Herko's life and death suggested both the purity of his devotion and the dangers it posed. He was the first of the amphetamine casualties, a graphic warning about the limits of the body. "It was neither the beginning nor the end of anything, but it was a hinge," wrote Diane di Prima, "a turning point for many of us. People, I think, came to realize they would die, and they began to take steps, to move toward the work they most wanted to do."

Andy Warhol told friends that he wished he had been there to film Freddie's leap. Many were appalled by the apparent callousness of the remark. But others saw it as a fit tribute to Herko's culminating gesture of complete dedication to dance: he could not do more. Ondine considered the leap as Herko's act of completion: "He prepared himself for that moment . . . and Warhol was able to get from Herko, and Herko was able to get from Warhol, a sense of completion so that Herko could have actually died as he wanted to do all his life."

Andy Warhol had wanted to make a short film of Dorothy Podber, relying on Billy's conviction that she was an anarchic genius. He called up and said, "We all know you are so wonderful with animals. My idea is a film where you are releasing goldfish in the pool at Rockefeller Center." When she responded that it was a dumb idea, he proposed others, but she rejected them all. Finally one day in late 1964 she decided that she was ready.

She called her friend Dale Joe and asked him to assemble a costume, which consisted of tight leather pants, a leather jacket, and dark glasses. Finally she strapped on a gun belt with a holster and a small gun. When

"Ye Compassionate Ones, Fred Herko is passing from this world to the world beyond. He is leaving this world. He is taking a great leap. No friends hath he."
—Tibetan service

Participants in Herko's Judson Memorial:

Frank O'Hara
Diane di Prima
LeRoi Jones
Arlene Rothlein
Phoebe Neville
Deborah Lee
Al Carmines
John Herbert Dowell

she arrived unannounced at the Factory, accompanied by her Great Dane, Warhol said he couldn't see her just then as he was shooting a picture. She responded with some irritation, "Oh, can I shoot a picture?" When Andy said, "Sure," Dorothy carefully removed her gloves, pulled out her black German pistol, and took aim at a colorful silk-screened image of Marilyn Monroe's large face, the first of several silk-screen images stacked against the wall a few feet away. She pulled the trigger and shot Marilyn through the forehead, just above the eyes. She carefully put on her gloves, smiled at Andy, returned the pistol to its holster, said good-bye, and walked down the stairs with her dog.

The paintings were retitled *Shot Light Blue Marilyn, Shot Orange Marilyn, Shot Sage Blue Marilyn,* and *Shot Red Marilyn.* Twenty-five years later *Shot Red Marilyn* was auctioned for $4.1 million, the highest price paid to that date for a Warhol.

After she left, Andy said, "Ooooh, Billy, please don't let Dorothy come over here again like that." Billy was less concerned about Dorothy's actions than about Andy's not understanding them. His Black Mountain friends or cohorts from the Living Theater or the Judson "would have known it was Dorothy's performance piece and would have laughed or would have said, 'Dorothy, that was really great!' When you have a Zen master, it's not all just love. It can be concisely enlightening. Dorothy was more like concisely enlightening."

When Warhol's *Flowers* opened at the Castelli Gallery in November, one wall of the main gallery was hung with rows of two-foot-square paintings—twenty-eight in all—and the wall on its right was hung with eighty-two-inch-square canvases, while the largest was over thirteen feet on each side. No matter the size, the image was always the same—four flowers, one in each quadrant, against a field of green foliage. Hibiscus blossoms in the bright unnatural colors of the Day-Glo Sixties against the receding jungle green.

The show sold well. Its commercial success was both well timed and necessary not only for Warhol's financial state but also to make a positive impression with the gallery. "It was easy for various collectors, who were involved in contemporary American art," said Leo Castelli. "And so that show was all sold out. It was very easy."

The sales of the *Flowers* encouraged Warhol to keep cranking them out. Ron Tavel recalled spending Christmas Eve 1964 with Warhol at the Factory, where he was screening more *Flowers* right up to the time he would attend mass with his mother. "When should I stop?" he asked. "I don't know how many to make. Should I stop making them?"

❑

In November 1964 Andy Warhol bought an Auricon sound camera. This was the camera of choice for television journalists shooting in the field—it didn't require elaborate microphones, and the sound was optically printed on the filmstrip, making it possible for the afternoon's events to appear on the six o'clock news. Although the sound was crude, the all-in-one process appealed to Warhol's fear of technical incompetence and lent itself to his aesthetic of unaltered reality.

When Warhol told Gerard Malanga that he was looking for voices, Malanga suggested a visit to Café le Metro to hear poets read. One November evening Warhol heard Ronald Tavel read abstract passages from his novel *Street of Stairs,* and he returned a second time to hear Tavel read his poetry. Tavel caressed each line; one observer in the crowd that night noted that his voice sounded exactly like the snake in the Garden of Eden. After the reading Gerard introduced him to Warhol, who promptly invited Tavel to talk in Warhol's first sound film. He didn't want the soundtrack to relate to what was happening on-screen, and he didn't want Tavel to prepare. Just show up at three-thirty on December 13, he said. Tavel could read anything, Warhol said, his fiction or poetry, "or I think the telephone directory would be best, because I know you'll make it interesting, but try not to."

On the afternoon of December 13, when Ronald Tavel stepped out of the freight elevator into the Factory, the first thing he saw was a *Double Elvis* painting, and he mentally noted the interest in doubleness that he shared with Warhol. Throwing a little chaos into the mix, Warhol had changed his initial plan: there were now three speakers—Tavel, Billy Linich, and poet Harry Fainlight—and to ensure that the sound had nothing to do with the action, Warhol wanted to hang a curtain between the speakers and the actors.

Warhol's simple title, *Harlot,* promised Hollywood sleaze and also punned on the name Harlow. The country was in the midst of a Jean Harlow craze, including Irving Schulman's *Harlow: An Intimate Biography* and two biographical movies. Ronald Tavel noted that "Jean Harlow is a ready-made contemporary rallying point."

A group of about fifty reporters, photographers, and onlookers arrived promptly, and so did the handful of crew and three cast members. Only the star was missing. When Andy called at three-thirty, Mario Montez said he was still in bed. He arrived an hour and a half later with bleary eyes and a five o'clock shadow, lugging costumes and a makeup kit. He brushed the press away, exclaiming "No pictures! No pictures!" and swept behind a tall silver divider and into the bathroom. Mario

shaved and emerged in a blond wig and a yellow chiffon gown. Despite his dark stocky shoulders and Puerto Rican accent, Mario Montez had become Jean Harlow. "Make no mistake about it: Mario Montez believes he is the Queen of the Silver Screen," wrote Tavel.

On camera, Mario Montez reclined against a blond woman in a white dress holding a freshly shampooed cat, part Angora, part Alleytom, named White Pussy. Two men, Gerard Malanga and Philip Fagan, stood behind them, in dark suits that contrasted with the whiteness of the two women. Mario ate bananas in an orgy of phallic consumption that comprises virtually the entire action of the film, while the three men made random conversation in the background.

"The track sounds like three people talking on 42nd Street."
—Jack Smith

At the end of 1964 came two awards of sorts: one aesthetic, one social; one underground, one high society.

Tom Wolfe was the first to define the new trend in fashion and society, and Marilyn Bender of *The New York Times* also noted something different: the society fashion celebrity. Ever since formal society broke down in the wake of World War I, the endless searches for the "Girl of the Year" were fed by the need for society underpinnings. That alternative version of society had gone by several names—the Smart Set in the 1910s, Café Society in the 1920s through 1950s, high bohemia in the 1930s and 1940s—and now Wolfe detected yet another turn in the grand social wheel. The Sixties debutantes cared little about appearing in the Social Register; they wanted to be seen in Eugenia Sheppard's column, dancing

Jane Holzer *Screen Test*, 1964

in discotheques and wearing trendy boutique couture which Wolfe called "pariah fashion." It was born not in the bastions of wealth or traditional chic but in the black subculture, from homosexuals, even working-class south Florida. Baby Jane Holzer could survey this gaudy smorgasbord of bouffants, stretch pants, French thrust bras, brush-on eyelashes, outsize beehives, and elf boots and exclaim: "Aren't they supermarvelous!" No one epitomized that particular kind of New York anything-goes glamour better than Holzer. In December 1964 Tom Wolfe pronounced her "Girl of the Year."

Jane Holzer had recently celebrated her twenty-fourth birthday in Jerry Schatzberg's huge apartment at 333 Park Avenue. Appearing in a black-velvet jumpsuit by Luis Estevez, with exaggerated bell-bottoms, she blew out the twenty-four candles, and then they all went downstairs to Schatzberg's studio, where Goldie and the Gingerbreads—four women in gold lamé tights—played rock and roll until the plugs were finally pulled at five A.M. It was referred to in the press as the Mod Ball, and after that Jane was always described as a Mod. But she thought "everyone missed the point about that," since the Mods were always in their teens.

The media considered Baby Jane Holzer a radar tuned to the twitching, unpredictable social scene. A queen of underground film, she was at home in what Wolfe discreetly called the world of high camp ("so indefinably Yellow Book") or mixing with Park Avenue millionaires. When editors telephoned her and proposed doing a story because she was "very big this year," Holzer got furious. "That made me feel like, 'All right, Baby Jane, we'll let you play this year, so get out there and dance, but next year,

Sources of Pariah Styles 1965, according to Tom Wolfe:
Lower East Side bohemians
Boho campies
East Seventies campies
Harlem delivery boys
Potheads
Pop artists
Photographers

well it's all over for you next year, Baby Jane.' I mean—! You know? I mean, I felt like telling him, 'Well pussycat, you're the Editor of the Minute, and you know what? Your minute's up."

Since their founding in 1959, the annual *Film Culture* Awards had become the most prestigious recognition possible within the world of underground film. In early December Jonas Mekas announced that the sixth annual *Film Culture* award would be given to Andy Warhol. Single-handedly making the decision, Mekas cited *Sleep, Haircut, Empire, Eat, Kiss.*

> Andy Warhol is taking cinema back to its origins, to the days of Lumiere, for a rejuvenation and a cleansing . . . With his artist's intuition as his only guide, he records, almost obsessively, man's daily activities, the things he sees around him. . . . Andy Warhol's cinema is a meditation on the object world; in a sense, it is a cinema of happiness.

Some filmmakers regarded it as a cheeky move to give the award to a man who had been making movies for a little over a year and adopted the most passive role in filmmaking. "This guy comes along who does absolutely nothing and knows absolutely nothing," said Gregory Markopoulos. "Other people have to set his camera up, load it, focus it, and he just shoots nothing, and he's the biggest thing going." Andy Warhol had become the most prolific figure in the New American Cinema, dominating the field in sheer product and in media attention.

The *Film Culture* Award came as no surprise to anyone who had been reading Jonas Mekas's column in *The Village Voice.* Mekas had quickly decided that Warhol was seminally important to the course of underground film. "Anti film makers are taking over," he wrote on December 5, 1963. "Andy Warhol serials brought the pop movie into existence. Is Andy Warhol really making movies or is he playing a joke on us? This is the talk of the town." Calling Warhol a transforming influence would become a commonplace, but Mekas came to this conclusion after the public screening of only two three-minute films and a private screening of the uncompleted *Sleep.* Attaching Warhol's name to the award instantly brought it wider attention. "It gave a lot of publicity generated by Warhol that would help the underground film movement," said Gerard Malanga, "and I think Jonas saw that opportunity."

At the award ceremony, held at midnight on December 7, 1964, Warhol was present only in his celluloid image. The film showed Mekas giving a basket of produce, from which Andy distributed apples, mushrooms, bananas, and carrots to Baby Jane Holzer, Ivy Nicholson, Gerard Malanga, and other members of the Factory, which they proceeded to eat very slowly in an overcranked sequence that paid homage to Warhol projecting his sound film at sound speed. With Mekas and Gregory Markopoulos behind the camera, the film self-consciously framed the award as something given to a group, accompanied by the pop sound of the Supremes. Warhol's physical absence from the award ceremony followed his dictum that the machine should do everything. It also allowed him a way out of confronting filmmakers who might be angered by his selection, a combination of shyness and justifiable fear.

In his end-of-the-year column Mekas looked back, first to the period of clash in the spring, then at an odd turn of events.

> By autumn, however . . . the magazines and uptown decided to join the underground and make it part of the Establishment. These new tactics of the Establishment brought an obvious confusion in the ranks of the underground. The year 1965 starts with the underground directors, stars, and critics regrouping and meditating. There are three choices: 1. To be swallowed by the Establishment, like many other avant-gardes and undergrounds before them; 2. A deeper retreat into the underground; 3. A smash through the lines of the Establishment to the other side of it thus surrounding it.

By the end of 1964 Edie Sedgwick had become a familiar figure in New York's Upper East Side, and her rise took place in the new social arena of the discotheque. "That was the time of the new girls in town in New York; every once in a while somebody would arrive and make quite a stir," said her friend Joel Schumacher (then a window dresser, now a movie director). "Edie was certainly one of them." Unlike most rising socialites, Edie did it without tying herself to a man. Not that there weren't men in her life—she saw several that season—but she was not seen as part of a couple. "She was in strange places faster than anybody else," said Schumacher.

Among the men she met, the ones who would play the most important role in her life, were Bob Dylan and his friend and musician, Bobby

Film Culture **Awards from 1959 to 1964:**

1959
John Cassavetes (for *Shadows*)

1960
Robert Frank and Alfred Leslie (for *Pull My Daisy*)

1961
Robert Drew (for *Primary*)

1962
Stan Brakhage (for his body of work)

1963
Jack Smith (for *Flaming Creatures*)

1964
Andy Warhol (for *Sleep, Eat, Haircut, Empire, Kiss*)

"They're all hypnotized by the blandness . . . the smoothness of the finish. Critically you can't deal with Warhol any more than you can deal with the plaster . . . what Warhol uses is icing instead of plaster . . . and the sparkle on top of the icing is amphetamine."
—**Jack Smith on Warhol**

Neuwirth. Tommy Goodwin called Dylan and said he had to meet "this terrific girl." When Dylan telephoned her shortly before Christmas 1964, they met at the Kettle of Fish, one of the classic hangouts of the Beat era and after. Neuwirth recalled that evening, "She was always fantastic. She believed that to sit around was to rot, an extension of the Sixties pop culture from a Bob Dylan song 'he not busy being born is busy dying.' "

Francis Sedgwick ordered Edie to return to California for Christmas and simultaneously requested that her older brother Bobby stay away because his increasingly strange behavior disturbed the family during holidays. Edie felt conflicted, for Bobby had asked her to show him New York at Christmastime. She understood how much she meant to him, and with Minty gone, Bobby was the sibling to whom she felt closest, but she went to California.

The year ended with two accidents that happened almost simultaneously on New Year's Eve. Bobby Sedgwick was racing the lights up Eighth Avenue on his Harley-Davidson, without a helmet, and crashed into the side of a bus. He lingered on without regaining consciousness for twelve days and died at the age of thirty-one.

On the opposite coast that New Year's Eve, Edie Sedgwick had taken her father's Porsche out for a joyride with her friend G. J. Barker-Benfield. She ran through a flashing red light, and the car was sideswiped and thrown against a light pole. Her companion hit the windshield, requiring twenty-two stitches, and the car was totaled. Edie sustained minor injuries. Newspapers ran a photo of the smashed car, carrying a caption, "How did two people step out of this car alive?"

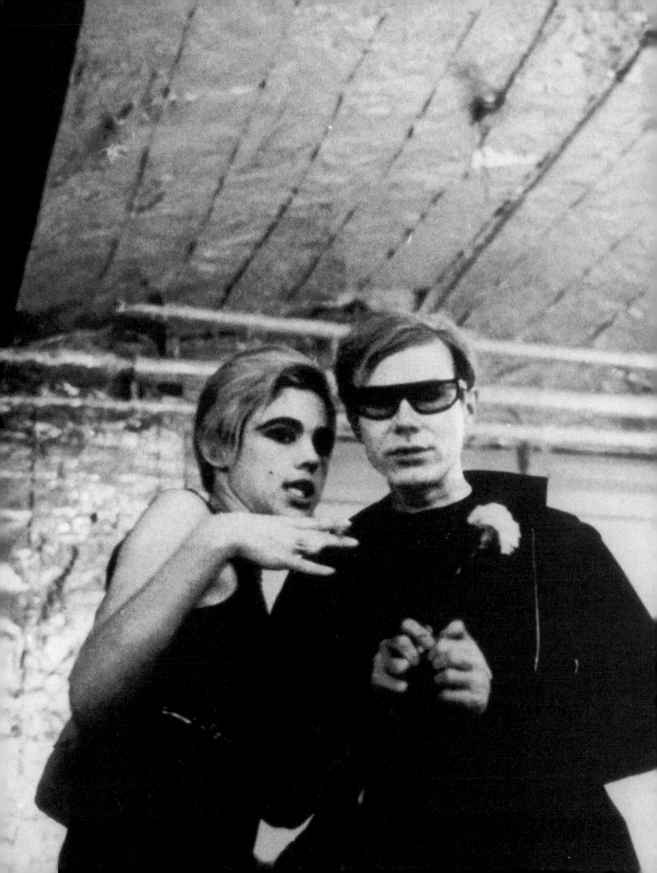

1965

The year 1965 became known as the year of the superstar, a word indelibly linked with the movies Andy Warhol produced at the Factory. The term didn't come into currency until that summer, though the concept had been around for a few years before that. Warhol was not the only one creating superstars out of "nobodies" by putting them before a camera. Jonas Mekas devoted one of his first 1965 *Village Voice* columns to the new pantheon of underground stars. He had been aware of this development since the previous February, after seeing Taylor Mead in *The Queen of Sheba Meets the Atom Man,* and he predicted "a new star cinema" of the underground. This star system was different from either that of the glamour personalities of Hollywood or the psychological seriousness associated with Method. These stars included performers in films by Ron Rice and the Kuchar brothers, but the list was dominated by the overlapping stables of Jack Smith and Andy Warhol.

Mekas's pantheon of underground stars combined the grandiosity of B-movie screen stardom, the emotional intimacy of an encounter group, the scale of opera, and the rawness of documentary. The new stars were "real," not hidden behind the protective veneer of acting out a character created by someone else.

In underground film the vision of the director had traditionally dominated. One might refer to a Maya Deren film, a Bruce Conner film, a James Broughton film, a Kenneth Anger film, but the actors performing in them were usually relegated to anonymity.

"What do you call a group of superstars? A tinfoil of superstars? A decadence of superstars? A gabble of superstars?"
—**Ross Wetzsteon and Sally Kempton**

"Stand still, climb a ladder, bounce a ball, jump in a pool, paint yourself blue, take a half-hour walk across the stage, shout at the audience."
—**Taylor Mead**

In 1962, while Andy Warhol was making portraits of Hollywood stars, Jack Smith and Ron Rice were creating different kinds of stars. Rice had a knack for finding engaging people, letting them go in front of the camera without getting in their way. For Jack Smith, stardom was a plastic conception and an obsession: it wasn't the glamorous stardom that fascinated Andy or Jimmy Slattery or Holly but what Smith called "moldy" stardom.

Warhol owed a lot to Jack Smith, and he knew it. At the beginning of Warhol's own filmmaking career he had observed, during the shooting of *Normal Love,* how Smith worked with a nonprofessional cast. "I picked up something from him for my own movies—the way he used anyone who happened to be around that day," said Warhol. He would film several people who had started out with Jack Smith, including Mario Montez, Francis Francine, and Beverly Grant. Although Warhol received credit for the concept of the superstar, Jack Smith was the one who articulated both the phenomenon and the term. Smith created his odd variant on a Hollywood studio in Cinemaroc, a combination of California glamour and Moroccan exoticism.

In early 1964 Jack Smith designed a layout of five black-and-white photographs, accompanied by his idiosyncratic captions. Published in the first issue of Ira Cohen's little magazine *Gnaoua* with the title "Superstars of Cinemaroc," Smith coined the word *superstar* before it was associated with the Factory and provided a description of his superstar aesthetic. "The people that it means the most to are the ones that turn out to be superstars," Smith said to Gerard Malanga. "Stars are a manifestation of the tastes of an era."

Such underground films as John Cassavetes's *Shadows* and Robert Frank and Alfred Leslie's *Pull My Daisy* emphasized acting that appeared spontaneous and documentary. Shortly after they were made, Jonas Mekas wrote, "In cinema, acting must be free, spontaneous, improvised."

Happenings also introduced a model for performing, demanding that the actor not act or assert his personality but behave according to a partly architectural concept. The Judson Dance Theater espoused a similar interest in task-oriented behavior as performance: walking across the stage or eating a sandwich, performed by a trained dancer, could comprise a performance. Through his connections to the worlds of art, dance, and film, Andy Warhol knew all of these approaches to performance.

Warhol took the on-camera freedom of the *Screen Tests* a step further. He allowed unedited spontaneity to be a prime feature of superstar

performances, and there was no safety net. Unlike Smith, Warhol didn't focus his actors through involvement in their costume or elaborate sets. Nor did he direct anyone in the specifics of their performance. He sometimes positioned them, provided the framing of the camera, offered a loose situation, and maybe asked someone to repeat something they had done. From the beginning he didn't want them to act. The stars were forced to improvise—and it was both an opportunity and a demand. Whatever the stars did on-screen defined the movie, and Warhol did nothing to alter it. "I usually accept people on the basis of their self-images," he said, "because their self-images have more to do with the way they think than objective images do."

Ondine, one of Warhol's favorite superstars and one of the most frequently filmed, provided a subjective description of the transformation before Warhol's camera from person to superstar:

> He wasn't featuring people doing things. He was allowing people to mirror himself in a way. . . . I have *never* been able in my life to . . . take my movements and my gestures and my ideas and whatever, I thought, and winnow them down to twenty minutes and have everything I wanted to say and do, *totally reflected* in a piece of film. Warhol was the person that gave me that forum. That stature.

Superstars assumed larger-than-life names. This practice reflected the Hollywood studio system of renaming stars, as well as Smith's practice of giving his Cinemaroc Studio stars exotic names. Warhol understood the importance of brand names—he had already proved that Campbell's and Heinz could be stars—and his superstars were packaged for the press as various flavors of Instant Pop Personality.

At the Factory superstar names came into widespread use in the summer of 1965, when the amphetamine crowd—the Mole People—became a driving presence at the Factory. So the name became part of the superstar package. Just as he provided the artistic framework that transformed sleeping into *Sleep*, Warhol encouraged the adoption of names that helped transform individual personalities into something grander. Named, packaged, and framed, they emerged on celluloid larger-than-life.

Everything was changing quickly in the Sixties, when rapid cycling ruled in the art world, the fashion world, and the film world. The reign of

a superstar did not last a year. After a few months of being bathed in the Factory's publicity, each superstar was retired, and another stepped into the spotlight. In early 1964 Warhol called Naomi Levine "the Queen of Underground Movies." Then Baby Jane Holzer outshone her and became the Girl of the Year in 1964. Edie Sedgwick would be the superstar of 1965, to be succeeded by Nico, who was promoted as Miss Pop 1966. In Warhol's version of stardom, beauty and glamour were inextricably linked with its demise. Ondine put it succinctly in the summer of 1965: "Divinity, star, what's the next category? After a star is what. Hasbeen."

During the first six months of 1965 Warhol's movies were dominated by Ronald Tavel's scripts, and he continued writing screenplays until March 1967. He wrote twenty-two screenplays in all, fifteen of which were filmed. They were written and shot in rapid succession; Ondine dubbed Tavel "the Lamar Trotti of underground films." Describing his function to one of the Warhol actors Tavel quoted Jack Smith: "To write for movies is not to write." And the actor quickly responded, "To act for movies is not to act." Partially because of his dyslexia, Warhol had little narrative sense. Just as his silent films explored the formal nature of time and space, his sound films explored the formal nature of words but the words were not necessarily connected to the images the camera was capturing. Tavel recalled that he and Warhol were both committed to the reality of spontaneous performance instead of scripted narrative.

> "They're not-real people trying to say something. And we're real people not trying to say anything."
> —Andy Warhol on Hollywood

Tavel could write scripts very rapidly in part because of the lack of dictates of an unmoving camera. He was drawn to the rigor of Warhol's rules and film conception. "It was a ruthless, rigid aesthetic, one pared away till nothing but the essential remained," he said. "I was in need of just such chains: an elemental, savagely simple approach to art. Warhol once said to reporters: 'I give people things to do: I keep them busy.' And I am enamored of rules."

Warhol's style of communicating what he wanted Tavel to do was as lacking in detail as the notes Warhol occasionally scribbled to himself on scraps of paper and in the margins of books. "It was usually about two sentences," Tavel recalled. "And the second one was always 'Do you understand?'"

> "In all the years that I worked with him, I don't think we had more than five minutes' conversation."
> —Ronald Tavel

In retrospect, Tavel felt that his experience with Warhol's anxious, pallid silence and simple rules—"extremely severe, almost like you think

Ronald Tavel looks at himself in his fifth-floor apartment at 27 St. Mark's Place, circa 1962

of a Japanese master"—shaped his writing aesthetic, not only in his movie scenarios but also in his later plays. Warhol would present a situation in a few phrases, and Tavel would deliver a filmable script a few days later. No one mistook his words for naturalistic dialogue, for they were rooted not in real life but in Hollywood genre films.

In late 1964 Warhol met a handsome, dark-haired man named Philip Fagan. Although Fagan wasn't gay he became Warhol's boyfriend for a few months. Just as John Giorno had provided the object of his camera fascination in *Sleep,* Philip Fagan now became the subject of many silent three-minute reels, a project to record the process of aging day by day. Warhol's attention complemented Fagan's narcissism. He liked being in front of the camera so much that he wanted to star in Warhol's movies, retain Tavel to write scripts, and jettison everyone else—especially Gerard Malanga, whom he regarded as a rival.

In January 1965 Warhol decided to shoot a thirty-three-minute sound reel of Fagan. He asked Tavel to interview Fagan, posing questions that would force Fagan to do expressive things with his face. That was all. Tavel went about his task by "devising a rigorous inquisition calculated to draw from his face the maximum number of telling expressions that I could imagine." The day of the shooting, Warhol framed Fagan in a classic headshot. When the camera began to roll, Fagan closed up, and despite all of Tavel's ploys, he was diffident, unrevealing, and wooden. "I could sense the heat of Andy's body just behind me," said Tavel, "how nervous he was and how disappointed."

For his next film Warhol gave Tavel the same instructions—get the star to react. But this time the star was Mario Montez, who had already demonstrated his comfort in front of the camera. "No one moves all the muscles in his face the way Mario does," said Tavel. "He really knows what to do in front of the camera. He has an instinct for it." For Tavel the challenge was to elicit a reaction within the relentless thirty-three-minute length of the reel. "The quickest way is to torment people into a reaction," said Tavel. "And he was vulnerable. I was tormenting myself, but I was determined that I wasn't going to have someone sitting still."

Tavel's unctuous offscreen voice began the humiliating screen-test interview by anointing Mario Montez with a new starlet name, "Saliva Pulham." Tavel tested him on diction ("Say *diarrhea*"), line reading ("Let me drink it, love juice, more!"), and impersonation ("Think of yourself as a female geek"). Shortly before the second reel ran out, Tavel instructed Montez to unzip his dress and take out his penis, off camera, and give "a real cock-teaser look."

Throughout most of the screen test Montez remained demure and hopeful in counterpoint to Tavel's increasingly demeaning demands, creating the sense of two people in different planes. "What you saw on the screen was the genuine belief on Mario's part that this was all so," said Tavel, "and his willingness to cooperate during it."

Tavel had gotten his reaction. But when he saw the film, he was appalled at the lengths to which he had gone and how much he had inadvertently revealed about himself. "This puzzled Andy, how crazy I got, the extremes I went to," Tavel said. "He wanted an interesting film, and he clearly thought this was an interesting film. I invented that style of taking people to extremes, and they would use it thereafter forever," said Tavel.

Screen Test #1 and *#2* pioneered the interrogation form that would become a staple in Warhol films, but none of the later films were so focused in the task: getting a reaction in real time.

"Taking it out and putting it in, that sums up the movie business. And remember your contract depends on it."
—Ronald Tavel

Tavel considered the resemblance between his scenarios and the resulting movies "purely coincidental." That did not displease him. Even as he considered himself the director of all the movies he wrote, he also thought that he had lost control early on. "Actors came and went as they pleased, were always late and seldom learned their lines."

Tavel quickly understood that Warhol's model was a factory, turning out movies on an assembly line. Warhol's dream was to produce a movie a week and have it screened within seven days. Tavel didn't mind being part of that process because Andy worked with the same degree of industry and intensity. In reality, Tavel calculated that over the next six months they made a movie every two weeks.

"Ronnie can write abstractly."
—Andy Warhol

In February Andy Warhol was offered a one-person show at the Institute of Contemporary Art in Philadelphia. The ICA was a modest noncommercial institution—like a European *Kunsthalle*—with two generous gallery rooms located on the University of Pennsylvania campus. Its first director was a young philosopher named Ti-Grace Atkinson. For an artist to be offered a one-person show less than a year and a half after his first serious gallery exhibition was virtually unprecedented. It mirrored the stylistic turnover that dominated the art world after the abstract expressionists. But such an offer could not have happened without the help of Warhol's friend Sam Green.

Green, at age twenty-four, had recently become director of the ICA through a combination of events. When he applied for the job in late 1964, he was running the art gallery at Wesleyan University and had put his name on the art-world map with an ambitious show of post-ab-ex-generation artists called *The New Art*. Green applied for the ICA job on art department stationery, and since his father was chairman of the art department, his name appeared prominently. Father and son shared the same name and Green is convinced that many of the ICA board hired him because they thought he was his father. It was a big job considering Green had finished last in his high school class and never went to college. In February 1965 Green proposed a Warhol retrospective, and he recalled the ICA board's immediate objections: "He's a fag from New York, he's just a fashion thing, we've read his publicity, this is no serious artist." But Green had a powerful supporter in the chairman of the board, Mrs. Horatio Gates Lloyd III. When she saw that the board's decision was going against Green, she spoke up on his behalf. "Well, ladies and gentlemen of the board, perhaps we could settle this by allowing me to go to New York

and see Mr. Warhol's work and see if this is an appropriate retrospective for the institute."

Green arranged for Warhol and Mrs. Lloyd to meet at a dinner for Nikki de St. Phalle. The two were seated next to each other, with Green across from them to keep an eye on how things were going. Warhol seemed uncommunicative, not responding to any of the diplomatic conversational ploys at which Mrs. Gates was so adept. "But he had gotten his routine down, and so he got her to talk and expose herself and who she was," said Green. When she asked Warhol about his interest in movies, he just looked at her and said nothing. "Mr. Warhol," she said, "is there anything wrong?" Warhol looked at her and said, "Uh, gee, Mrs. Lloyd, you are so great. I just think you're really terrific. Would you be in one of my movies?" Mrs. Lloyd reached for her pearls and said what a fascinating idea, what role did he have in mind. Warhol said, "Would you fuck Sam?" When Green heard that, he thought, "Oh God, there it goes." But he soon realized that Warhol had known exactly what he was doing, and Mrs. Lloyd knew how to handle such situations. "Mr. Warhol, what a very interesting idea and I'm quite flattered," she said. "However, you might realize that my husband is the administrative head of the CIA, and it might not be appropriate for me to play that role. Could you think of another?" Before the evening was over, Green was optimistic. "After that moment at the table, they just got along like a house on fire." The retrospective was approved and scheduled for the fall.

"I didn't see it as schizophrenic at all. I just had a job as a songwriter. I mean, a real hack job."
—Lou Reed

After graduating from Syracuse University with honors in June 1964, Lou Reed returned home to Freeport, Long Island, to live with his much-hated parents. He chafed at the restrictions they imposed, but he didn't know where else to go. He commuted Monday through Friday to Long Island City, where he worked for Pickwick International, a small recording company that operated out of a converted warehouse with a tiny cement-basement recording studio equipped with an old Ampex tape machine. Here they turned out 45's by groups who sounded and looked so generic (the Roughnecks, the Beachnuts) that the unwitting shopper who saw them in supermarket bins for ninety-nine cents might mistake them for the real thing. Reed was industrious—during his first five months at Pickwick he wrote fifteen prefab songs with such titles as "You're Driving Me Insane," "Johnny Can't Surf No More," "Let the Wedding Bells Ring," and "Hot Rod Song." He described himself as "a poor man's Carole King."

In January 1965, while Reed was churning out ersatz rock songs at Pickwick International, he scanned Eugenia Sheppard's gossip column and read that ostrich feathers were au courant. Seizing the moment, stoned on marijuana, he dashed off a potential dance craze called "The Ostrich." The lyrics instructed the dancer to place his head on the floor and have his partner step on it: "Do the Ostrich!" Pickwick recorded Reed's song as a single, performed by a handful of pickup musicians that Pickwick International named the Primitives. When a dance show invited them to play and demonstrate "The Ostrich" on the air, Pickwick had to quickly assemble a real band to back up Reed's lead vocals on television.

Meanwhile, at 56 Ludlow Street on the Lower East Side, two women in their early twenties were inviting the residents of the heat-free apartment to a party on the Upper East Side. John Cale and Tony Conrad were musicians, and since they had long hair, the girls thought they looked like the Beatles. Cale and Conrad thought this invitation was very funny and went along for the ride. "These guys looked so alien to us, we couldn't believe it," said Tony Conrad. "I mean this was the other side of the Queens Life Central." The aliens turned out to be the producers of Pickwick International; on seeing two musicians with long hair they immediately invited Cale and Conrad to play "The Ostrich" on television. Picking up fast money playing for a two-bit rock band on television and on tour sounded like a great joke. "We thought we were secretly rock-and-roll types anyway," said Conrad, "and that we would like to do it."

In late January 1965 John Cale, Tony Conrad, and Lou Reed met in the studio of Pickwick International. Reed explained that "The Ostrich" consisted of guitars tuned to one note. "We couldn't believe that they were doing this crap just like in a sort of strange ethnically Brooklyn style," said Conrad, "tuning their instruments to one note, which is what we were doing too, in Young's group, so it was very bizarre. In fact we were tuning to two notes and they were tuning to one." Schlock rock met musical minimalism.

For a few months this rock-and-roll combination—Cale, Reed, Conrad, and Walter de Maria—traveled around in a station wagon on weekends and performed "The Ostrich" onstage in front of screaming teenagers in Pennsylvania high schools. Although "The Ostrich" never caught on, it introduced Reed to Cale and became the genesis for their own band.

At the time of this meeting, John Cale was feeling professionally

"These guys have really got something," the deejay said at the end of their first performance. "I hope it's not catching!"

Walter de Maria
Walter de Maria (1935–)
was a close friend of La
Monte Young in San
Francisco, moved to New
York in 1960, wrote essays
on art for Young's *Anthol-
ogy,* ran the 9 Great Jones
Street Gallery in New York
in 1963 with Robert
Whitman, and played
drums for the group that
became the Velvet Under-
ground. De Maria later
created two important art
installations, *The Light-
ning Field* (1977) and *The
Broken Kilometer* (1979).

boxed in. He had little interest in pursuing the route for which his classical training had prepared him, and La Monte Young offered no financial remuneration. "I was terrifically excited by the possibility of combining what I had been doing with La Monte with what I was doing with Lou and finding a commercial outlet," said Cale. "My collaboration with Lou simply overtook my community of interests with La Monte." Tony Conrad, his roommate at the time, recalled that "John was moving at a very fast pace away from a classical training background through the avant-garde and into performance rock and then rock."

In February Lou Reed moved into Cale's life: physically, psychically, musically, and chemically. At first it was a weekend relationship, for Lou's parents forbade him to go to New York during the week. When Tony Conrad moved out of the thirty-dollar-a-month Ludlow Street apartment, Cale invited Reed to take his place. It was a large L-shaped flat furnished with mattresses on the floor and orange-crate furniture lit with bare bulbs. Since there was no heat or hot water during cold winter days they scrounged the neighborhood for crates or wooden pallets, or wrapped themselves in carpets to keep warm. They survived on large pots of oatmeal and an indeterminate vegetable stew. To make money they sold their blood, played music on the street, and posed as nonexistent characters in sensational fifteen-cent tabloids. (Lou appeared as a sex-maniac child killer, John as a man who killed his lover to prevent him from marrying his sister.)

The social landscape around the Ludlow Street apartment contrasted sharply with the Long Island suburb that Reed had just left. The streets below were dotted with drug-dealers and to collect the rent, the landlord arrived with gun in hand. Allen Ginsberg thought this Lower East Side community mixed and fostered "the apocalyptic sensibility, the interest in mystic art, the marginal leavings, the garbage of society." Opening himself to the milieu's edgy possibilities, in early 1965 Reed wrote to his mentor Delmore Schwartz, "Finding viciousness in yourself and that fantastic killer urge and worse yet having the opportunity presented before you is certainly interesting."

"As soon as Lou moved in, I started to learn about what we did and did not have in common," said Cale. "He was perceptive, so he could see that I was more scared and insecure than he was." Their first sustained discussions, Cale recalled, concerned risk and danger, shock treatment and insanity. The fact that Cale worried about his own sanity helped him to comprehend Reed's outrageous behavior and his "uncanny ability to

bring out the worst in people." It wasn't personally directed at any individual, Cale concluded, but was aimed at making "him feel he was in control, rather than living in a state of uncertainty or paranoia."

The two men connected most dramatically through drugs. Delivering La Monte Young's drugs provided Cale with an ample supply. "Before I met Lou, I had snorted, smoked, and swallowed the best drugs in New York, courtesy of La Monte, but I had never injected anything. We smoked pot, took acid and other pills, mostly downs or Benzedrine." Reed added something new to Cale's drug education. He gave instruction, for example, on getting the maximum effect from Placidyls: shave off the capsule coating until it's ready to break open, then ingest the pill with ginger ale.

More important, Reed and Cale shared experiences with heroin. "I was squeamish about the needles," said Cale. "Lou took care of that by shooting me up for the first time. It was an intimate experience, not least because my first reaction was to vomit." But after the initial reaction of nausea, the two felt more friendly and psychologically at ease. "This was magic for two guys as uptight and distanced from their surrounding as Lou and I," said Cale. "It opened a channel between us and created the conspiratorial us-against-them attitude which would become a hallmark of our band." The band they formed was at first called the Falling Spikes, in honor of their drug use. Neither claimed to be addicted. "I was never a heroin addict," said Reed. "I had a toe in that situation. Enough to see the tunnel, the vortex."

The two men came together in their music. When Cale first heard Lou's serious songs—"Heroin," "I'm Waiting for My Man"—played on acoustic guitar, Cale couldn't separate the sound from that of a folk singer. "I couldn't give a shit about folk music," said Cale. "I hated Joan Baez and Dylan. Every song was a fucking question!" But Reed showed Cale how his songs had grown out of his work with Delmore Schwartz. Cale soon realized the songs were utterly unlike folk music: "There was an element of character assassination going on," he said. "He had strong identification with the characters he was portraying. It was Method acting in song."

Cale wanted to distance the band from the folk ethos and suggested that the songs be backed up with a Phil Spector–like sound from a four-piece band. The fact that Lou could improvise words so easily gave free rein to Cale's musical improvisation. "Lou brought me to life in New York more than anyone else had," said Cale, "and I felt that I had finally

"Take the sensibility of Raymond Chandler or Hubert Shelby or Delmore Schwartz or Poe and put it to rock music."
—Lou Reed

Mid-1960s Marijuana Words:
Lady Help
Cannabis sativa
L
Alias boo
Pot
Tea
Grass
Mary
Mjane
Grefa
Muta
Reefers
Sticks
Joints

found my task in orchestrating music for him. We wanted to be the best band in the world and we thought we could be. We were in it for the exaltation and could not be swayed from our course to do it exactly as we wanted. We had in common stubbornness, ambition, paranoia, and fear."

The Factory's connection to fashion was essential to establishing its visibility. Two different articles in *Life* suggest how Warhol movies that were critically pummeled in one could be revived in the second as fashion. On January 29, 1965, *Life*'s resident pundit, Shana Alexander, filed a "Report from Underground." She described the premiere of *Harlot*, as 350 "cultivated New York sophisticates who were squeezed into a dark cellar staring at a wrinkled bedsheet." She linked Warhol and *Scorpio Rising* as "a neat example of the total disarray in which our old standards of obscenity, public decency and art all find themselves today." Her dismissal of *Harlot* was a simple acerbic put-down: "It had the fleeting charm of a bright saying lisped by someone else's child."

Seven weeks later Warhol's films appeared again in *Life*, this time in the fashion section, featuring models against stills from Warhol's unfinished movie *Batman/Dracula*. The newest fashions "are in the tradition of—if you'll pardon the paradox—of the wild and way-out new cinema form known as the underground movie," the reporter wrote. The models included Warhol's friends, Ivy Nicholson and Baby Jane Holzer; by association the Factory seemed fashionable and hip. The article's appearance was doubtless helped by the fact that Sally Kirkland was one of the *Thirteen Most Beautiful Women* and her mother was *Life*'s fashion editor.

That spring Tom Wolfe was among the first to describe the direction of fashion and Pop society. He called his article "Pariah Styles: The New Chic." At a recent party he had attended, the crowd included everyone from Baby Jane Holzer and Joan Collins to Peter Lawford and Tony Perkins. Although no one was dancing, the Castaways played in the background, dressed in tight chinos. "*The* music in Pop Society is exactly what the Castaways are playing—Teenage Rock 'n Roll."

Where high society had previously looked to Paris and London for fashion and couture, Wolfe observed that the new styles came from sources closer to home: "Lower East Side bohemians, boho campies, East Seventies campies, Harlem delivery boys, potheads, pop artists and photographers." Adorning the party guests Wolfe saw a mink-tailored

motorcycle jacket, black stretch pants so tight they showed the panties beneath, decal eyes, and bouffant hair "done San Gabriel Drag Strip-Girl style, *essence* of Pop Art." Surveying the panorama with a degree of irony, Wolfe saw the guests making a desperate attempt to prove their aristocracy by imitating the underbelly classes. "This is *1965* for chrissake," Wolfe wrote. "There *must* be some way to have Society do this thing—go *pariah*—utterly, divinely naturally, baroquely, naturally *and* baroquely somehow, making itself like a stepped-on roach . . . with *élan.*"

Even though the Factory was hardly a fashion center, Warhol's name became synonymous with the latest vogue. Warhol = underground movies = "the new boho avant-garde art form" = backdrop for fashion = Pop society. Despite the imprecision of the equations, they made for media-friendly fodder and carried the authority of *Life* magazine.

In this atmosphere of fashion experimentation—with a firm eye toward the burgeoning youth market—Betsey Johnson came of age at *Mademoiselle.* When her boss, D. J. White, went on maternity leave, Johnson had taken over the fabric department. She dove into her boss's Rolodexes and learned about factory locations for offbeat fabrics—everything from parachute fabric and shower curtains to casket lining and the pinstripe gray wool of the Yankees' uniforms. She was naturally energetic but also boosted by the amphetamines she took to lose weight. When she wasn't working at *Mademoiselle,* Betsey developed her own mini-line of clothes, made catalogs, and placed them in strategic ladies' rooms. Soon she had more orders than she could handle.

That spring of 1965 the English fashion entrepreneur Paul Young was planning a New York branch of Paraphernalia, one of the hippest clothes shops in London. It was slated to open in September on Madison Avenue between East Sixty-sixth and Sixty-seventh Streets. *Mademoiselle* editors recommended that Young hire twenty-two-year-old Betsey Johnson as a designer. She started her new job at sixty-three dollars a week.

A chief inspiration for her clothes was the dance recital clothes she had created in high school. "Those tricky little numbers had to perform on your body or you were in trouble," said Betsey. "I always wanted my clothes to move on the body, to be as much an extension of the body as a leotard." A few weeks after she made her drawings, Betsey Johnson was out in the factories, overseeing her first line of clothes for Paraphernalia.

On March 26, 1965, movie producer Lester Persky threw a birthday party for Tennessee Williams in his Upper East Side apartment overlooking the Fifty-ninth Street Bridge. At this party, over a marble table, Andy Warhol met Edie Sedgwick and Chuck Wein. Wein had shoulder-length peroxided hair and striking yellow-green eyes, and Edie was wearing her brunette hair in a beehive hairdo, a leopard shawl thrown over her gown, and a plaster cast on her leg. When he saw her, Andy sucked in his breath and said, "Oh, she's so bee-you-ti-ful."

Ronald Tavel approached Edie and told her he was scouting for stars. She looked like Nyoka the Jungle Girl, he said, and would fit right in against a jungle background. Her features were completely symmetrical, and she seemed to glow like a vulnerable Fitzgerald heroine.

At that point Edie Sedgwick knew little about Warhol. When Wein told her that he was the king of Pop Art, she replied, "What's that? Pop tart?" Wein quickly took advantage of their introduction to Warhol and visited the Factory a few days later. Andy suggested they should do something together, and Wein jumped in enthusiastically. "There was no cogitation about any of this," Wein later recalled. "It was a happening. The whole damn thing was a happening. You think as you go."

Edie fascinated Andy from the beginning. He saw her promise and her glamour, and he also understood that "she had more problems than anybody I'd ever met." It wasn't until Edie appeared with him on April 9, at a gala Metropolitan Museum preview for *Three Centuries of American Painting,* that Warhol realized how much attention she could draw. At the event, attended by Mrs. Vincent Astor and Lady Bird Johnson, Andy wore yellow sunglasses and a ragged tuxedo jacket over paint-splattered black work pants. Standing next to him, her leg now out of the cast, Edie wore lilac jersey lounging pajamas over a body stocking, nothing more. She had bleached her brunette hair and rinsed it with Silver Minx colorant, and Billy Linich had cut it on the Factory fire escape. Edie told reporters that she just liked the idea of having light hair and dark eyes, but it was widely believed that she dyed her hair to become Andy's twin. Visually, they became a matched set.

Shortly after the Metropolitan opening Warhol invited Edie Sedgwick and Chuck Wein to accompany Gerard and him to the Paris opening of his *Flower* paintings at the Ileana Sonnabend Gallery. Such an invitation was extravagant for a friendship that was only two weeks old, and it suggests how quickly Warhol warmed to Edie.

Andy Warhol wanted each of his movies to be different. So Tavel's films went from the interrogations of *Screen Test #1 and #2* on through a variety of Hollywood genres—the political film (*The Life of Juanita Castro*), the Western (*Horse*), domestic drama (*Kitchen*), and the courtroom drama (*Hedy*). Warhol's earlier bloc of movies—*The Thirteen Most Beautiful Boys, Couch, Screen Tests,* and *Kiss*—had been about repetition. During the Tavel period Warhol demanded the opposite.

Ronald Tavel's ingenuity was tested on several fronts in the spring of 1965. He had to imagine and write scenarios that represented different genres; he had to create them very quickly; and he had to formulate strategies so that the cast could deliver his lines, even though they never tried to memorize them. Tavel listened on buses to snatches of conversation around him, he dreamed up lines of dialogue, and he made a list that he could draw from. Then he sat down in apartment 5R at 27 St. Mark's Place and didn't leave until he had finished a screenplay.

In April Tavel did a script for a film about politics called *The Life of Juanita Castro.* He later wrote, "Warhol had introduced me to a cousin-in-exile of Fidel's, and it was from him that I saw a ridiculous angle on politics: that the fate of the entire world could rest on the outcome of a family dispute. I read an article in *Life*, "He Is My Brother and He Must Go." But further it was an opportunity to take a stand on a subject that was growing gradually more aggravated each passing month: Politics and the Artist."

To circumvent the problem of people learning lines, Tavel put himself in the role of on-camera director and prompter and fed the actors every line and action in the script. It was like a rehearsal devised to be the final product, an alienation effect developed from necessity.

After the success of Mario Montez's performance in *Screen Test #2,* Mario was cast as Juanita Castro. At the last minute Mario declined, saying, "I don't do things with politics or religion." Andy quickly recruited his old friend Marie Menken for the part. She agreed to appear as long as she could drink liquor during the filming. The problem of filming the first large cast was solved by seating them at different levels—some on the floor, some on chairs, some standing. That way Warhol could maintain a static camera and include everyone in the frame.

Tavel's approach to politics was oblique, and it was clear that nothing could be taken as reality. (Some of the men were played by women.) Warhol further added to that obliqueness by shooting the second reel

"They were like the Lucy and Desi of the art world."
—**Billy Name**

The Life of Juanita Castro, including Marie Menken (in wicker chair), Ronald Tavel (behind her, with script in hand), and Ultra Violet (far right), by Billy Name

from the perspective of the right side, so that Juanita Castro delivered her big speech to an unseen audience. Marie Menken's screen presence was like a female Broderick Crawford, tough and boozy; the movie would have been entirely different with Mario Montez in the role. As it turned out, *The Life of Juanita Castro* had its own trajectory, first as a Factory movie, then as a play for the fledgling Play-House of the Ridiculous.

Horse was conceived as a Western, and Warhol assigned Ron Tavel a cast of four young men: Gregory Battcock, Tosh Carillo, Dan Cassidy, and Larry Latreille. One was an art critic, one a florist, one a poet, and one a recently-arrived-from-Canada boyfriend of Henry Geldzahler. As Tavel wrote the script, *Horse* laid bare the homoerotic subtext of men alone together on the plains. Tavel interviewed each of the actors to get ideas. "They were shaking," he recalled. "Why are they afraid of me? I thought because the ghost behind me, the ghost of the Great White One, the Pal-

lid One. They're afraid of him, not me. Then I thought: the henchman who does the work for the Grand Inquisitor. What, he's blameless? You cannot say I'm taking orders, the old moral problem. Because I'm doing this voluntarily also. I am ethically and morally responsible."

Tavel was grappling with both the ethical implications of his participation in Warhol's films and the film aesthetic. "All this time I was wondering what film was, not just art but film itself," he said. "And I thought we shouldn't tell a film what it's about, it should tell us. Set up a field in which it operates. Particularly within this Warhol aesthetic." Gerard Malanga wrote the actors' lines in large print on vanilla placards and arranged them in order. Tavel wrote out a placard with each actor's name. The instructions to the actors were simple: look at Tavel, and if he's holding your name up, look at Gerard and read your line.

Warhol had rented a small horse for the movie, but when the Factory's elevator door opened, a massive black stallion named Mighty Bird stepped out. Although the horse was accompanied by a trainer and tranquilizers, he posed a threatening presence in the confines of the Factory. Right next to Mighty Bird were lights and a sound boom going up and down. Tavel tried to concentrate on the lines but at the same time feared the horse would strike out. Andy seemed content. He only worried that the "Western" looked too realistic, and he instructed the sound man to lower the boom so that it appeared in the frame. Three years later, Warhol made his next Western: *Lonesome Cowboys*. By that time the Factory approach to movie scenarios was entirely different; there were no lines, and the West was a physically real place.

Several talkie films later, Ron Tavel felt his mind was exhausted. "After *Juanita Castro* I didn't know where to go anymore, and that's when Gerard came up with *A Clockwork Orange* as a vehicle," said Tavel. "And Andy felt he owed him a star turn at this point."

Gerard Malanga had appeared in more Warhol films than anyone else, but he was usually on the sidelines, smoking a cigarette, a strategically placed element in Andy's screen composition. Gerard now felt he wanted more. Warhol purchased the movie rights to Anthony Burgess's novel *A Clockwork Orange* for $3,000 which had come out in 1962—an unprecedented act for someone who didn't easily lay out money. But this symbolic act of giving was mixed with passive aggression. Andy didn't like to feel pushed.

When *A Clockwork Orange* was presented to Tavel, he suggested that Gerard write the scenario, since he was as much a writer as Tavel. Gerard declined. Tavel started to read the book and gave up halfway through.

Then he set off on his usual breakneck pace in writing scenarios. This one was different, for it had a plot and literary roots and required a different sort of realization. At first it was to be called *Leather,* but Warhol thought *Vinyl* sounded more modern. Tavel turned out an S&M saga with literary overtones; Gerard's character was named Victor, V for violence. No other movies of the day depicted sadism so graphically—or regarded it with such offhand amorality. "One of the things Warhol was always talking about, and I was, too," said Tavel, "was what you can do that hasn't been done before. Unexploited territory. Sadomasochism, transvestites—such things came in not only because they were novel but also theatrical . . . all image and display."

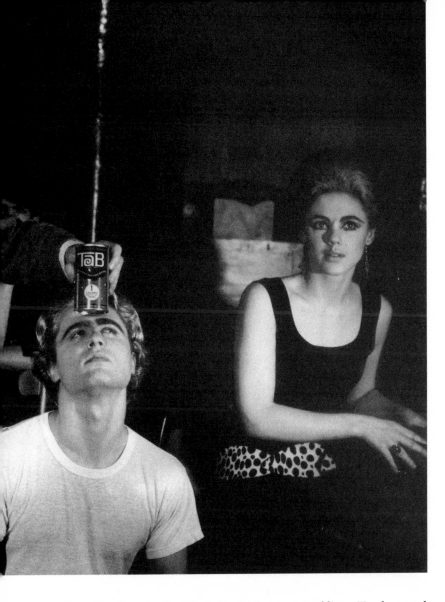

Since Tavel's script for *Vinyl* required memorized lines, Tavel wanted
to rehearse the movie before shooting it, but the late afternoon
rehearsals were haphazard, Andy often didn't attend, and sometimes he
sabotaged Gerard's attendance by sending him on errands. "To me they
were perpetually arguing," said Tavel. "Gerard always feeling he's being
slighted and never getting his due and his place in the sun. Andy was
being particularly cruel, sending him out on errands and all-night jobs
so he couldn't learn the script."

The all-male cast included a professional actor (J. D. McDermott), a
Puerto Rican florist (Tosh Carillo), a young, possibly underage Canadian
boy (Larry Latreille), and two Warhol regulars, Ondine and Gerard. By

the day of the shooting Tavel realized that the actors could not memorize their lines, so he wrote out the play on a long scrolled idiot sheet.

A few dozen people showed up to watch the filming. Among them was Edie Sedgwick in a short black dress and leopard belt. Andy made a sudden decision to put her in the movie. Tavel was upset because Edie knew nothing of the story, and he had conceived the movie as an all-male claustrophobic milieu. Andy persisted. He could set her on Billy's silver trunk, and she didn't have any lines, so she could just sit there.

The film starts with Andy's camera close up on Gerard Malanga's face in profile, turning from right to left. The camera pulls back slowly to show Gerard lifting weights, wearing a T-shirt, white jeans, and a leather garrison belt. The camera pulls back further to reveal a claustrophobic space with several people receding to a murky black. The right side of the screen is anchored by Edie smoking Viceroys and drinking from a white Styrofoam cup. In the center of the screen Gerard reads his lines from the scroll: "The old up yours" he repeats. The recent hit by Martha and the Vandellas begins to blare—"Nowhere to Run"—and Gerard begins frugging, showing off his profile, while, on the right side of the screen, Edie does her own smoother version of the same dance. In the back Tosh Carillo can be made out dripping hot candle wax on the milky skin of a bare-chested adolescent, Larry Latreille.

Meanwhile the young thug Gerard is apprehended, and Ondine, on speed, appears, to beat up Gerard. Ondine could barely pull himself together for his big scene, but he took to the beating with relish. "Did you see what a mess I made of that woman, when I pulled her up by the hair?" he said to Tavel. "I made a mess out of her."

Tosh Carillo, the sadist, begins to methodically tie Malanga up and put a studded leather mask on his face. Watching his script being transformed, Tavel was amused by the assured procedure of the practiced sadist, working so efficiently with leather straps and shoelaces and hot wax, all the while smoking a cigarette.

Incarcerated in a mask, Gerard drops out of the frame for a long period, and Edie Sedgwick dominates it. She reacts to the S&M display by just flicking her cigarette and crossing her legs. Tavel later said,

> The film became like one of those vehicles for a famous star, but it's somebody *else* who gets discovered ... like Monroe in *Asphalt Jungle*. She had a five-minute role, and everyone came running: "Who's the blonde?" The second I laid eyes on Edie I knew she was going to work. She had a charisma beyond words,

and charm, and great beauty. Her eyes were very large brown eyes, and I knew those were going to pick up like mad on the camera. And lovely milky skin and a kind of glitter in her eyes, they dazzled. She gave me ideas.

The movie ends as music comes on—"This Could Be the Last Time" and "Run Sally Run" and "I'm So Tired of Waiting for You." Tosh Carillo pulls Gerard Malanga up and shoves amyl nitrate poppers under his nose, and they dance slowly while the music blares.

In the spring of 1965 the Factory became a larger social arena. The biggest influx was due to Edie Sedgwick and Chuck Wein because their presence introduced people from the Cambridge circle: Dorothy Dean, Ed Hood, Arthur Loeb, and Ed Hennessy. Two others that entered the Factory orbit that spring—Stephen Shore and Isabelle Collin-Dufresne—reflected the openness of the Factory's social network.

Sixteen-year-old Stephen Shore was the youngest person to spend time at the Factory up to this point, although soon other teenagers, such as Ronnie Cutrone and Bibbe Hansen, would be hanging around at the Factory. Stephen Shore already knew he wanted to be a photographer. At the age of fourteen he had submitted a portfolio to Edward Steichen at the Museum of Modern Art. "It may have been a case of not knowing what the rules were," said Shore. That same ignorance of the rules allowed him to approach Andy Warhol at one of the open screenings at the Filmmakers' Cinematheque, and ask to spend time at the Factory taking photographs. Warhol told Shore that he was about to leave for Paris, but he would be in touch.

When he returned, Warhol telephoned Shore and invited him to come to the filming of a movie at L'Avventura. (The film would later be called *Restaurant*.) Shore was surprised and pleased that Andy remembered him. When he arrived at the Factory, Shore immediately felt welcomed by Billy Linich. Having briefly heard Shore's voice on a late-night classical music station, Billy recognized it. There was an instant bond.

Shore initially felt a little scared of Andy, because of the sexual interest he thought Andy was expressing. (Sitting next to him, Warhol said, "Don't you like me?") When Shore made it clear that he was straight, Warhol's attentions stopped, and after that "no one ever acted in a way that made me uncomfortable."

Stephen Shore photographed the Factory environment off and on

Stephen Shore at the beginning of his photography career, by Billy Name

for the next two years. Billy Linich and Stephen Shore created the most evocative photographic portrait of the Silver Factory, and though Shore never appeared in Factory movies, he proved essential to recording those years.

Isabelle Collin-Dufresne appeared at the Factory in the early spring, wearing a pink Chanel suit. She bought one of Andy's biggest and freshest *Flower* paintings for five hundred dollars. She drove a Lincoln and lived in a Fifth Avenue penthouse and was very beautiful. Andy immediately recognized that she had presence, and he cast her in his next movie, *The Life of Juanita Castro*. What Warhol did not grasp so quickly was the lengths to which Isabelle Collin-Dufresne would go to garner publicity. She quickly renamed herself Ultra Violet, a far cry from the name of her wealthy family of glove manufacturers. She had gone through adolescent rebellions, and her parents had placed her in a Catholic home, where she continued to rebel. When her parents asked her where she would like to

"A lady without a cent has no future."
—Ultra Violet

go, she immediately said, "America, the land of the free and the brave!" She landed in New York and soon became the mistress of Salvador Dalí, so that by the time Warhol met her, she had a sort of pedigree. Following her brief appearance in *The Life of Juanita Castro,* she became a regular performer in Factory films two years later.

The transformation of the Silver Factory from a workplace to one of the centers of Sixties' society was reflected in one party. Contrary to its popular image, there were not many parties at the Silver Factory. People hung out waiting to take off for evening events, people were invited to watch the shooting of films, and Billy had impromptu amphetamine parties after midnight. But parties with invited guests were rare.

The most glamorous party took place on April 25, 1965. Lester Persky hosted the event with Andy, calling it "The Fifty Most Beautiful People Party" and modestly describing it as "the best party of the Sixties." Persky regarded the Factory as ideally positioned between the avant-garde druggy counterculture and the mainstream glamour of the fashion and celebrity world. This was to be the crossover event, where the bohemian avant-garde community frugged with celebrities.

Some Factory members regarded Persky as a dubious character. He made commercials for Glamourene, earning him the nickname "the Wax Queen." He had a large East Side apartment, lots of money, and a string of writer acquaintances. At that moment Persky was producing a film of Tennessee Williams's, *The Milk Train Doesn't Stop Here Anymore,* so he invited both the author and Judy Garland, who badly wanted to play the lead role of Flora Goforth. After Judy demonstrated all the ways she could play the role, Persky said, "The funny thing is, Judy, that Tennessee thinks of you as a great *singer* rather than a great actress." Reverberations from that remark were felt all evening, and every time Judy Garland stood next to Williams, she found another way to protest that she could act too. "My God!" said Persky. "She's transmogrified one *remark* into a complete *visitation!*"

There were phone calls on the day before the event to fill out the guest list, and Billy Linich set up the silver turntable and a silver stool. Linich recalled that it was the first time alcohol was served at the Factory, and he put out whiskey and ice and stirrers on a silver table in front of the couch. At nine o'clock the freight elevator doors opened, and the first guests arrived. Carrying Judy Garland cradled in their arms from the

Isabelle Collin-Dufresne, or Ultra Violet, who grew up in Grenoble, photograph by Angelo, 1965

"Going to a Warhol party
(I really mean this) currently
rates higher with them than
being asked to Jackie
Kennedy's for brunch."
—Lillian Roxon

"Once you were in those
silver aluminum rooms
in the Factory, you were in
the world . . . like going
through the looking glass
in a way."
—Danny Fields

freight elevator were Lester Persky and Tennessee Williams. It was a grand entrance, but only Andy and Billy were there to witness it. They quickly set Garland down.

At one point Judy Garland, Tennessee Williams, and Montgomery Clift all sat on the famous Factory couch, and for a while the party revolved around them. But with Rudolph Nureyev's entrance, the attention turned to him. One of the guests, Stephen Holden, remembered that he looked "like a Tartan prince" and cruised the room. Billy Linich played Motown and Supremes and Rolling Stones records, and at one point Nureyev taught Judy Garland how to frug. Watching them on the floor, Billy felt the intensity of Nureyev's eyes and was frustrated he couldn't leave his post to dance: "Second most powerful cruise I ever felt in my life, with eyes like diamond beacons."

Gerard Malanga regarded that party as the moment when the traditional stars were out and a new breed of superstars came in. Edie and Rudy attracted more attention than Judy and Monty. Warhol noted a similarity between Edie and Judy: "a way of getting everyone totally involved in their problems. When you were around them, you forgot you had problems of your own, you got so involved in theirs."

"Glamour is aura."
—Gerard Malanga

To Jonas Mekas, as he wrote in his diary, "only Tennessee Williams seemed to be having a good time, dancing and prancing with the nymphettes and having fun surrounded by the boys." Yet the party continued into the next afternoon and ended with a dinner at Lester Persky's, catered by his favorite pasta cook, Johnny Nicholson from Café Nicholson on East Fifty-eighth Street. Only a select few were invited. The high point of the dinner was Judy Garland belting out "Somewhere over the Rainbow" to Nureyev, her mouth filled with pasta.

A few days after the Beautiful People Party, Andy flew to Paris for the opening of his *Flowers* exhibition at the Sonnabend Gallery. Along for the ride were Gerard Malanga, Edie Sedgwick, and Chuck Wein.

In the throes of discovering Pop Art, Paris was primed for Warhol. That spring a shop called Popard was decorated with murals of "Blondie"; journalists inevitably asked Brigitte Bardot and Jeanne Moreau what they thought about Pop Art; *Paris-Match* and French *Vogue* planned photo shoots of Warhol; attendance at the Sonnabend Gallery broke records. Poet–art critic John Ashbery, who was living in Paris at the time, said Warhol's visit had lit "the biggest transatlantic fires since Oscar Wilde brought culture to Buffalo in the nineties."

**Tennessee Williams and Marie Menken dance
at the Factory, 1965, by Billy Name**

Ed Hennessy, who had been living in Paris since he left Cambridge, was surprised by the dramatic transformation that had taken place in Edie. Gone were the tasteful preppy clothes and in their place, he recalled, "she wore earrings that resembled chandeliers and necklaces that Tutankhamen and Babe Paley would have envied. She looked like a hooker from Mars." It was April in Paris, and the weather was mild, but Edie brought along two white mink coats. She wore one over her shoulders and carried an identical one in her luggage as a "backup." At the Sonnabend opening her white mink coat caused as much attention as the *Flower* paintings on the walls.

The night after the opening Andy and Edie and Ed Hennessy shared a table with Salvador Dalí at the Crazy Horse Saloon. A spotlight directed on the table indicated the presence of celebrity, and loudspeakers announced the joint presence of the father of Surrealism and the father of Pop. Dalí bowed and basked in the attention, while Warhol squirmed, and Edie leaned over to ask Dalí how it felt to be a famous writer. Dalí enjoyed Edie's unintentional joke. It was simply another sign that she could do no wrong.

The Warhol entourage spent another evening at a nightclub called Chez Castel, preparing for a publicity shoot featuring fifteen white rab-

In: "Deeply" fashionable at the moment (in crowd, in group, in style)
In: A multipurpose ending for countercultural events: be-in, sit-in, smoke-in, lie-in

bits and the beautiful actress sister of Catherine Deneuve, Françoise Dorleac. A friend of Gerard Malanga's named Dennis Deegan made his way across the room to their table, accompanied by a tall, striking blond woman. It was Nico. She thought Gerard looked like a slim version of Elvis Presley, and before the evening was out, she adroitly dropped names ranging from Alain Delon to the Rolling Stones. She later recalled that Edie Sedgwick was too preoccupied with her lipstick to pay attention to her.

In the spring of 1965 John Cale and Lou Reed began playing on the streets of New York, under the name the Falling Spikes. An amphetamine aficionado and poet, Angus MacLise, lived right down the hall in the Ludlow Street building; he sometimes drummed with La Monte Young. His participation offered the added advantage that they could tap electricity for their electric guitars from his apartment. Extension cords snaked down the hall in the Ludlow Street building.

In spring 1965 Cale and Reed ran into Sterling Morrison, Reed's friend from Syracuse. Since none of them were urgently occupied at the moment, they decided to jam together. Those sessions soon became more regular. Sterling would take the subway from City University, where he was studying English literature, and Angus MacLise walked down the hall, often showing up late and continuing to drum long after everyone else had quit rehearsing.

"One of the things that we didn't notice at the time but realized later was how very important those early rehearsals were," said Cale, "the way we bummed around on Friday nights and just played and played and played. We started detuning instruments, playing with gadgets, puttering about in general until we landed with something. We spent a lot of time looking for other ways of doing things."

Their marathon rehearsal sessions began on Friday nights. The next morning each of them ingested a blue tranquilizer and four quarts of beer and smoked a joint, and they then practiced until eleven at night. "Our music evolved collectively," Sterling Morrison recalled, and it combined rock and roll with the consciousness-altering musical discipline learned from La Monte Young. The group added guitar feedback and an electric viola that sounded like a jet engine. Reed was inspired by now-forgotten songs of the time: "Smoke from a Cigarette," "I Need a Sunday Kind of Love," "Wind" by the Chesters, "Later for You, Baby" by the Soli-

Sterling Morrison, Lou Reed, and John Cale, 1966, by Stephen Shore

taires. "All those really ferocious records that no one seemed to listen to anymore were underneath everything we were playing," said Reed. "No one really knew that."

While developing Reed's songs, the band began to cohere, and a breakthrough was "Venus in Furs." They had found their nasty signature style. "We heard our screams turn into songs," Reed wrote, "and back into screams again."

The next problem was where they would play. The band didn't consider themselves to be entertainers, and there were few models on the music scene. "Rock and roll consisted of Joey Dee and the Starlighters, guys who played the uptown clubs and had matching suits," Sterling Morrison said. "We didn't have any of those things so we had no chance whatsoever of working on the Manhattan club scene. That was beyond us, we just couldn't do it, any more than we could have gone to Las Vegas to play." They didn't want to be cute, like the Monkees, or sincere, like folk

singers. Their image was aloof and nasty and urban. As Cale summed it up, "Our aim was to upset people, make them feel uncomfortable, make them vomit."

They found a suitable venue for performing when another neighbor in their Ludlow Street building, underground filmmaker Piero Heliczer, invited them to play at the Filmmakers' Cinematheque on Lafayette Street for two events, called Launching the Dream Machine and The Rites of the Dream Weapon. Angus MacLise and Piero Heliczer described them as "ritual happenings." They featured Piero Heliczer's films projected through veils hung between the audience and the screen. Multicolored lights and slides were superimposed on the veils, and on the stage were dancers. The strange and overwhelming sound that overlaid this intermedia action issued from behind the screen, where the band improvised their music. In its multimedia overwhelming of the senses and in the band's invisibility, this performance reflected the group's evolution and quickly defined a place for them in the avant-garde. The Happenings that had begun in New York at the end of the 1950s embraced music and film and dance; by 1965 the maximalist multimedia era was beginning. "For me the path ahead became suddenly clear," recalled Sterling Morrison. "I could work on music that was different from ordinary rock and roll since Piero had given us the context to perform it in."

When Edie Sedgwick flew back from Paris in late May, she found that her mother had rearranged her apartment and had left a note saying where to find her brown leather jewelry box and her two boxes of extra pink glasses. "Everything is back in order, and *please* keep it so. Your cleaning women will continue to evaporate if they find a mess!"

Edie was going through her grandmother's trust fund at an alarming rate. She would take her friends to the Ginger Man or L'Avventura, her favorite restaurants, and scan the menu. She inevitably thought all the items looked "divine" and couldn't decide on a single dish. Her friend Ed Hennessy wrote,

> Her solution to the problem was very odd and very expensive. She would order three or four entirely different dishes, all at full price. When they arrived, she would sample them and eat the one she liked best. Then she would visit the ladies' room and throw up. After that she would return to the table and eat another of the meals, and so on.

In the era before *anorexia* and *bulimia* were household words, Edie's habits seemed charmingly eccentric.

Edie continued to fear that her father would force her to go back to Silver Hill: "plop her in the bins" was the way he put it. Edie's financial crisis heightened that summer. The Morgan Guaranty Bank executor put her on a strict allowance, and creditors appeared at her door with bounced checks. Edie asked Lester Persky to give her money to leave the country. He gave her a hundred dollars, and she was infuriated by his niggardliness.

By that time Edie had adopted a new wardrobe that dramatized her plight. She left her elegant designer dresses in the closet—she thought they made her look like a scarecrow—and adopted a new look that quickly set fashion. Chuck Wein recalled that he and Edie began their shopping expedition at Bonwit Teller's boys' department, where they bought a drawerful of striped T-shirts. Then they went downtown to Ninth Street and Avenue B, the heart of what was not yet the fashionable East Village, and bought long dangly earrings from a street vendor. "I swish them the way other girls swish their hair," Edie said. They continued down to Canal Street where Wein bought a fluorescent zoot suit and Edie purchased more spangly accessories and cheap T-shirts imported from Yugoslavia. It was Edie's idea to wear a simple leotard instead of a dress or pants. Nothing could be simpler, and she hated dealing with buttons. Leotards not only showed off her legs to great advantage but were cheap.

This ersatz wardrobe, created out of Edie and Chuck's campaign to fight back against the Sedgwick family, became the season's new look. Edie appeared in the pages of American *Vogue* in July 1965 balanced on her stuffed rhino, Wallow. "She looks like a bird," said Ondine, "about to take off." The photograph by Enzo Sellerio captured the imagination of the fashion world, and Edie suddenly became a celebrity—not because of anything she had accomplished but because of her image. The timing was ideal, for the look of a thin, lively, elfin creature embodied what *Vogue* called the Youthquaker. Edie projected the same protoanorexic charm that would make Twiggy famous a year later.

Chuck Wein recalled that Edie had little desire to be a model. "She was already a socialite," he said. "Who wants to be a model? There was no link over to any broader cultural context than beauty." But modeling provided her the means to assert her independence and stay out of Silver Hill. "I want a further step for me," she said to her friend Ed Hennessy. "It's my choice. I would be mad, I suppose, if it weren't for somebody like

Chicerino:
"The Young Chicerino," *Vogue*'s 1965 term for a new generation that is the "world's natural heiress, ready right now to claim her inheritance. . . . Style is her badge, the badge of her generation."

Chuck, who taught me that I'm not insane. . . . I see no way that isn't a trap." Modeling would be her occupation for several months: the Girl of the Year in 1965, the Youthquaker who represented the new generation.

Through fashion magazines Edie Sedgwick inspired other women. Some wanted her rail-thin energy; others responded to her insouciant little-girl beauty. She was sexy but not sexually threatening, and she could be both Pop and *haute*. Patti Smith, then a seventeen-year-old living in south New Jersey, recalled the moment she saw Edie's picture and immediately thought, "That's it. It represented everything to me . . . radiating intelligence, speed, being connected with the moment." Many responded like Smith, to an image of the youth generation that was audacious, casual, and stylish—an American response to the Mod fashions coming from London. Diana Vreeland observed that there were only two times in the twentieth century when youth set fashion: the 1920s and the 1960s. With her stylish figure, her beauty, and her family money, Edie Sedgwick offered a 1960s counterpart to Zelda Fitzgerald and Lady Brett Ashley. Fashion designer Betsey Johnson employed her as her first fitting model and recalled how boyish she was: "In fact she was the very beginning of the whole unisex trip."

Even in a small and crowded discotheque, Edie stood out from the other dancers in their Pucci slacks, hip-hugger denims, and Mod dresses. In her bangles and leotards she was the perfect package for the Sixties revolution in fashion. Each day she awoke late in the morning and drank cup after cup of coffee and ate toast with Royal Jelly. She began on the phone around noon, sometimes doing interviews that Chuck Wein arranged in order to get her name in the paper. Then she prepared her face for the round of evening activities. She emphasized her eyes with blue and gray watercolor paint instead of eye shadow, and to cover the scars of her car crash six months earlier, she carefully shaded the area between her eyebrows to look like an Arab woman's tattoo. Finally, she crayoned a beauty spot on her right cheek to call attention to her dimples. Genevieve Charbon, briefly her roommate, recalled that Edie spent hours applying her makeup. "She did it very well, because she would go out for twelve hours, leaving in the afternoon and not returning until the next dawn, a hundred parties in between, and her makeup would never budge," said Chabon. "Absolutely flawless."

Edie focused on the evenings when she joined Andy and his entourage. They would eat dinner at L'Avventura, then go to a party in a West Side health club, where Edie would strip down to a black bra and bikini panties and jump on a raft in the swimming pool. Then came the

round of discotheques and parties, from Arthur and the Scene to Huntington Hartford's A-list parties, punctuated by camera flashes and snatches of interviews. The night Edie met Mick Jagger at the Scene, she was wearing a Gernreich dress made of shiny cinnamon-colored football jersey, with pushed-up sleeves, bangle bracelets, and very high heels. The "Gotham on the Go" columnist for the New York *World Telegram* shouted into the ear of the "silver-topped queen of the underground movies" and asked her: where is the *real* Edie Sedgwick? Edie stared back incredulously and shouted over the music, "The real Edie is where the action is. Fast cars, fast horses, and people doing things!"

At the end of a night of party rounds, Andy and Edie returned to their respective Upper East Side beds. Chuck Wein went back to the West Forties, where he played pool for a couple hours or sat at Kelly's bar watching hustlers, before returning to the Hotel America. His room at the dive on West Forty-seventh Street was certainly affordable—thirty-two dollars a week for a suite of three rooms—and he enjoyed the mix of hustlers and hookers who streamed through the lobby and the raffish sleaze of the surrounding Times Square area. Bars in the West Forties—especially Kelly's and the Wagon Wheel—became gathering places for the Cambridge crowd of Dorothy Dean, Chuck Wein, Arthur Loeb, Henry Geldzahler, and Joe Campbell.

Chuck Wein's presence at the Factory aroused some tension, in part because of his manner. He was smart and spouted ideas constantly, but he sometimes sounded like a New Age used-car salesman on a speed rap. Some thought he had latched on to Edie for the free ride, using her to gain power at the Factory. Ron Tavel saw him as an interloper, trying to assume the role of Factory screenwriter. Wein himself minimized his career ambitions—he never had any throughout his life. He regarded the movies as part of the campaign "to get Edie a life." Warhol provided the ideal means of doing that.

From the moment Edie Sedgwick became associated with Andy Warhol, the media created a niche for her. After the first screening of an Edie Sedgwick film, *Poor Little Rich Girl*, Leonard Lyons was already proclaiming, "Edie Sedgwick is the new star of his 'underground' movies." In *The Village Voice* Jonas Mekas wrote that the movie "surpasses everything that the 'cinema véríte' has done till now." These large claims rested on the showing of a two-reel film (66 minutes), the first unintentionally out of focus, to an audience of about forty people. Edie Sedgwick walked out after the blurry reel, afraid that she was being ridiculed.

Edie privately complained to Ondine and Andy, "They're trying to

put me in the Baby Jane role." At the moment Edie had little interest in assuming someone else's role. She was struggling to forge her own identity, especially her financial independence from her family. In late July she wrote a letter to her mother declaring her independence, and at the same time relying on her mother "to get me through." Edie addressed five envelopes to Mrs. F. M. Sedgwick but could never finish the letter; Dorothy Dean completed it.

Television entrepreneurs saw potential in Edie, for she seemed to be a new kind of media star. Filmways considered doing a soap opera about her life, paying her three hundred dollars an episode. She appeared on talk shows with Les Crane and Merv Griffin and was regularly invoked as the Greta Garbo of underground movies. "If all I cared about was me, I

**Edie prepares for her screen test,
March 1965, by Billy Name**

could make a million," Edie said. "And that's what they'll never understand."

The media promoted Edie as the "girl who may put Baby Jane Holzer out to pasture," an *All About Eve* of the hip Sixties. "Baby Jane Holzer, she represents a certain pop culture," said Malanga. "What can we say Edie represents? She may just represent a transition into something better and more extraordinary and fantastic." When *Time* compared her to Holzer, Edie replied, "I didn't know I was replacing Jane. In fact, I'd never even heard of her. I hardly ever read the papers. I am not trying to create an image or a following. I act this way because that's the way I feel like acting. If people like it—fine. If they don't—that's their problem."

Edie struggled to balance the identities she presented to the press, to her family, to her doctors, and to her intimates. She often just made up things, as Andy counseled her to do.

During Edie Sedgwick's period at the Factory in the spring and summer of 1965, Chuck Wein organized most of the films she appeared in, including *Restaurant*, *Poor Little Rich Girl*, *Afternoon*, and *Beauty #2*. Warhol shot all of these films, and they bore his identifiable look—static, black and white, rigorously framed—but the situations and casts were suggested by Chuck Wein. The Harvard crowd was his chief source, so these films included Dorothy Dean, Arthur Loeb, and Ed Hennessy. Designed to let Edie be herself, these films reflected Warhol's desire to film twenty-four hours in the life of a star.

Poor Little Rich Girl stars Edie in the morning, *Afternoon* and *Beauty #2* show her later in the day, and *Restaurant* presents her at dinner at L'Avventura. They were mostly documentary, unfiltered slices of Edie's life in the company of her friends. *Beauty #2* was a different matter, for Wein enacted the off-camera interrogation situation that Ronald Tavel had introduced in *Screen Test #1 and #2*. The difference between the Tavel and Wein interrogations is striking. Tavel presented a theatrical interrogation, sadistic and literary, driven by the explicit challenge to project oneself into a fantasy world. Tavel knew exactly the direction he was going, even if he had no idea of the final destination.

Chuck Wein wrote nothing down and had no endpoint in mind. "It was just an incredible group of people all doing their best to mold the energy as they moved through" was the way he described it. "There was no cogitation about any of this." Although Wein's offscreen presence in

"It's like watching a Henry Moore sculpture out of focus."
 —Edie Sedgwick on
 Poor Little Rich Girl

Chuck Wein:
"You're not vain and narcissistic."
Edie Sedgwick:
"No, I'm just self-involved."

Beauty #2 was seen as pushy—Billy Linich said to Edie, "He was out to get you"—Wein doesn't attempt to test Edie but looks for ways to encourage her to talk; Gino Piserchio, whom she had met a few hours before with his photogenic dog, Horse, filled out the composition. Warhol had hoped for more of a fight, and he was afraid *Beauty #2* was a little bland.

Chuck Wein envisioned the movies of Edie Sedgwick as material for a longer film, or sequence of films, that could reach a wider audience than the Filmmakers' Cinematheque circuit. That required selection and editing, but Warhol wanted them to remain unedited and unfiltered. In July 1965 Wein told a reporter,

> He still won't cut or edit, but he has agreed to let me put together all these hour-and-a-half segments we have been doing with Edie, things like *Your Children They Will Burn, Not Just Another Pretty Face, Beauty #2,* and *Isn't It Pretty to Think So,* which is the last line of Hemingway's *The Sun Also Rises.* We call what we are doing *synscintima*—"syn" for synthetic, "scin" for scintillating, and "intima" for the personal or intimate nature of the films. We have dubbed the whole thing "reel-real" or the idea of the reel of film creating the reality.

The language is clearly Wein's (Andy would never use the words *scintillating* or *synthetic* or quote Hemingway), and Wein was making up some of the titles on the spot. But tapes from the period support the assertion that Warhol was thinking about multiple ways of using the film that he had shot. "We're going to do it different ways, Chuck's way and my way," he said in late July. "I want to do experiments, all kinds of things, moving the camera. Experiments for a larger film. If someone wants to take them apart and make a big movie, that's okay."

The newest visitor to the Factory, Paul Morrissey, suggested to Andy, "You should do it yourself."

During a mid-June rehearsal for Ronald Tavel's scenario for *Kitchen,* while Edie Sedgwick and Roger Trudeau were talking about sex in the shower, Tavel had a brainstorm: "Suddenly I saw the two of them stripping together under a running faucet." When Tavel presented the idea, Andy Warhol said, "Yes, *Shower* will be the next movie." Tavel locked

himself in his room and wrote the play in a feverish forty-eight hours. It seemed to come without any plan, devoid of character or plot or obvious subject matter. "It was dirty like the Mae West I had loved for so many years, it was action-packed and streamlined for movement," Tavel wrote. When he left his room and returned to the world of the Lower East Side, he felt as if he were on LSD, and when he saw the trees along the north side of Tompkins Square, they looked like a Maria Montez landscape. He headed up to the Factory on a Friday afternoon and ran off a dozen copies on the silver Thermofax machine. Andy mildly complained about the copying cost.

When Chuck Wein read the script over the weekend, he was dubious. He recalled that Edie had felt uncomfortable with her role in *Kitchen*, wondering if she was being ridiculed as a woman. Wein didn't like the plays Tavel wrote for Edie and considered his discussion of the work overintellectualized, "like the most boring lecture at a mediocre college. I felt like it was yesterday's liver and onions," said Wein. "I certainly didn't want it a day late and a dollar short."

When Ron Tavel returned to the Factory on Monday, Warhol murmured that he didn't quite understand *Shower*. Edie Sedgwick, sitting on the couch, said to Tavel, "I think you're capable of something better than that. I mean, that kind of thing isn't worthy of you." Warhol noncommittally suggested that perhaps the script could be changed. "But the day an actress starts dictating her scripts, art goes out the window," wrote Tavel a year later, "and I gathered up my scripts and went out the door."

The momentary separation came at an apt time. After six months of turning out feature scenarios, Tavel felt he had arrived at a dead end. "I couldn't go any further within Warhol's aesthetic," Tavel said.

But Tavel's leave-taking wasn't the end of his connection to Warhol. More important, it wasn't the end of *Shower*. Warhol told Tavel that it was one of his best scripts and suggested he take it to director Jerry Benjamin to stage as a play.

Benjamin was too busy to direct *Shower*, but he referred Tavel to John Vaccaro. Although Vaccaro hadn't directed anything, he knew how to make people laugh. As Tavel recalled, Vaccaro grabbed the script from his hands and threw him out. "Everybody told me not to do it," said Vaccaro. "They said it was terrible, disastrous. But I had an idea. From looking at it, I said, 'I can do this.' " He called Tavel twenty-four hours later and agreed to direct it.

"I suspect that a hundred years from now people will look at *Kitchen* and say, 'Yes, that is the way it was in the late Fifties, early Sixties in America. That's why they had the war in Vietnam. That's why the rivers were getting polluted. That's why there was typological glut. That's why the horror came down. That's why the plague was on its way.' "
—Norman Mailer

Ridiculous:
Coined by Ronald Tavel or actress Yvette Hawkins in 1965, this term described a de-illusionistic theater aesthetic, an over-the-top performance style. There were two groups that used the word: the Play-House of the Ridiculous, beginning 1965, with Ron Tavel's plays and John Vaccaro's direction; and The Ridiculous Theatrical Company, beginning 1967, with plays and direction by Charles Ludlam.

Tavel went to the Coda Galleries, which had recently been started to showcase psychedelic art and where a play by Michel de Ghelderode was being staged. Tavel approached Isaac Abrams, the gallery proprietor, and said, "Call that a show? I'll give you material that will really draw the crowds." To Tavel's astonishment, the proprietor said, "Fine, you open on Thursday, July 29"—four weeks away.

Tavel put together a double bill of two recycled Warhol screenplays, *Shower* and *The Life of Juanita Castro*. He saw how naturally a screenplay for a single stationary camera lent itself to a one-set play. The idea of recycling his writing was appealing. Jack Smith told him that the problem with two one-acts was that American audiences were attracted to a single package, and he wondered if Tavel could come up with an embracing idea. Ever since college Tavel had wondered where theater could go after Theater of the Absurd and decided on "Theater of the Ridiculous." Its manifesto was: "We have passed beyond the absurd; our situation is absolutely preposterous."

John Vaccaro threw himself into the direction, while Jack Smith designed the costumes and devised a set consisting of two showers. On a budget of twenty dollars, using found objects, they created a jerry-rigged shower system that emptied into a plastic swimming pool. Miraculously, it worked. As for lighting, Vaccaro recalled, "You turned the lights on or off, that was it." They set up folding chairs and dressed the cast in body stockings. "We simulated everything," said Vaccaro. "Blow jobs, everything. I sang 'Ass of Ages' to Beverly Grant's asshole, in a shower."

The tumultuous history of Ridiculous Theater began with a script rejected for filming that gave birth to the most in-your-face performance style of the decade.

Beverly Grant and John Vaccaro in *Shower,* **July 1965**

Chuck Wein met a young woman named Ingrid von Schefflin in the lobby of the St. James Hotel, which was even trashier than the Hotel America. At the St. James people were more likely to rent rooms for sex than to actually live there. Ingrid lived in Wyecoff, New Jersey, and worked a day job as an office clerk. At night she hung out in the West Forties, picking up occasional tricks and enjoying the sleazy good-time atmosphere. Wein took an instant liking to her because she was unpretentious and funny, and although she had little education, she was bright and street-wise. He wanted to inject a more democratic note into the Factory, where the women were mostly upper class (from Brigid Berlin and Edie Sedgwick to Baby Jane Holzer). When Wein suggested she

should appear in a movie—one of the segments of a movie series about hustling—her excitement was voluble. Ingrid shrieked when she was very happy and shrieked when she was upset. "I was thin and had blond hair, and Chuck thought I was funny," Ingrid recalled. "He promised me that I would be discovered!"

When Chuck introduced Ingrid to the Factory, she was regarded as the poor man's Edie Sedgwick. On the surface Ingrid was utterly unlike Edie—she was rangy (five foot eight), big-boned and big-breasted, and crude in her style and language. She laughed loudly and she talked loudly. By the end of 1965, however, she had transformed her look, with hair cut short like Edie's, and she had been given a new name: Ingrid Superstar. Several people thought she was the butt of a walking joke—pretending that the Ugly Duckling was going to become a Superstar. "That only goes to show you Andy's lack of class in that situation," Chuck said. "His insensitivity toward people's feelings. It was hypocrisy." Mary Woronov described her as "a Dorian Gray version of Edie" and thought she had no talent. But Ingrid Superstar would perform in Warhol's films up to May 1968.

Ondine rarely stinted with guidance. About his earlier incarnation as a lovelorn columnist for *The Sinking Bear,* a reader had written, "Where would we be without you?" Edie regarded Ondine as a special figure, because in his life he had transcended all conventional demands. In the summer of 1965 he was sleeping in Central Park. "I was really out of it—very far out," Ondine said. One day at the Factory he complained of his poverty and said he'd do anything: "I needed just enough money to buy amphetamine and I was fine." Edie said she needed a maid. Andy questioned her need for a maid, since she already had one, but Edie persisted, and for a period of few months Ondine became Edie's "French maid" for thirty dollars a week.

Ondine developed a daily routine that summer. He'd wake up in Central Park by the lake, take a morning swim, and then drop in on Rotten Rita on West Eighty-sixth Street. They shot speed and put on Maria Callas very loud, with Rotten singing along. In late morning he headed east to wake Edie up. "She couldn't hear anybody else ring a doorbell except me. I can ring a bell so nervously that you could be dying and you'd get up to answer.

"That was my main duty as French maid," said Ondine. Edie "was barbituated and there was no way she could get up except resentfully. . . .

"You're the ninety-ninth dimension, and I'm at the ninety-ninth percentile but not the ninety-ninth dimension, so that we do correspond, but . . ."
—Edie Sedgwick to Ondine

When I got there, she'd start coming to and ask if I had any amphetamine. I'd give her some, and she'd be fine." Edie sniffed the amphetamine or took it in her coffee. Ondine put on Maria Callas and ordered in roast beef sandwiches and potato salad. Then Edie would give her earrings to Ondine to wear while he threw the *I Ching*. "It was very serious about rulers and about being truthful to the Prince," said Ondine. "At that point we thought Warhol was the Prince."

Ondine and Edie often talked about how wonderful and difficult it was to be with Warhol. "Other people were telling her that she should concern herself with being a very famous star," said Ondine, "putting it in her mind that she was the greatest thing since Greta Garbo or Marilyn Monroe—she owed it to herself to be that famous. She didn't know what to do. She began to get qualms. She told me I was her guru at one point, and I said, 'I refuse the challenge. I'll be nobody's guru, darling. I can't even guru myself.' . . . I felt the greatest thing I could do for her was to be her friend. Strictly her friend."

In July Lou Reed, John Cale, and Sterling Morrison taped a rehearsal of their songs, using a Wollensak tape recorder that Cale had inherited when Tony Conrad moved out of the apartment at 56 Ludlow. Three of the band's key songs recorded that day—"Heroin," "I'm Waiting for the Man," and "Venus in Furs"—presented subject matter that clearly set them apart from pop, rock, and folk. But the music was a long way from the sound later associated with the band. "I'm Waiting for the Man" sounded like country blues with an urban setting, for example, and only in a late take did Cale burst into a squealing range of sounds from his viola. "A lot of the early stuff was conceived in a way that was a lot more laid back than it later became," said Sterling Morrison. "We were really practicing the songs at the same time we were laying them down."

The tape was not a finished demo, but when Cale went to England in the late summer, he used it as a way of getting the band's foot in the door. Cale recalled one moment of exceptional brazenness. In London he appeared on the doorstep of Marianne Faithfull and said, "We're looking for a deal. Think you can get Mick to put in a word for me?" Cale recalled that she coolly gazed at him "as if I had horns on my head" and closed the door.

The trip wasn't fruitless. Cale returned to New York with a pile of new records that became the soundtrack at 56 Ludlow Street that fall. "Of

course John's peculiar tastes determined what he brought back for us to hear," said Sterling Morrison. "But we couldn't escape the conclusion that these obscure English bands were closer to our sensibilities than the 'pop' groups here in the U.S." Cale strongly connected with the sound of the Kinks and the Who. "It made us feel on the one hand that we were not alone, but on the other hand that time was closing in on us," said Cale. "They spurred us on to break through ourselves before these new bands stole all our thunder."

The July 17, 1965, world premiere of *Beauty #2* paired with *Vinyl* was billed as "an untraditional triangle (without love), squared by Horse, a Doberman pinscher." In the audience that evening was Paul Morrissey, who had last seen a Warhol movie over a year earlier, when he was one of the handful who had watched *Sleep* (or at least the beginning of it). At that moment Gerard Malanga was putting together an issue of *Film Culture,* and he invited Paul Morrissey to do an interview within the next week. By the time the superstar issue of *Film Culture* appeared in 1967 Jonas Mekas had cut out the interview, but Malanga's surviving transcript provides a clear picture of Paul Morrissey at the moment before he became involved with Andy Warhol.

Morrissey had clearly already thought about what makes a superstar. "A superstar is somebody who deserves to be on the screen all the time, preferably in close-up," he said. "The initial impact that the star makes is always the best. You'll find, with almost every performer, that their very early works—if not the very first—are almost always the best. And at that point where they start thinking of themselves as performers, that is the point they lose most of what they have."

Morrissey described the director's role as one of subordinating himself to the stars of the movie. But when he was asked about one of the performers in his film *Civilization and Its Discontents,* Morrissey's response reflected a hands-on style of directing: "He was very good. He always did exactly what I said, and he didn't care at all what I was telling him to do."

Morrissey had no plans for a future in movies. He liked making them, but he was discouraged by the fact that they were never shown, and he had lost interest in making silent films. He was dubious about American underground films because he believed their nonnarrative approach was a dead end.

The so-called poetic cinema that avoids the need for sound by piling together shots of objects, people, color patterns, lights, editing flashes, and so on is a trashy bore and simply a form of moving wallpaper to be used within four or five minutes and to my mind has little worth even in advertising, except to attract attention by annoying. . . . They will never have any appeal to other people who are not directly involved in 16mm film. It's an incestuous thing. But it's the kind of thing that Jonas Mekas and *Film Culture* magazine have always promoted most heavily, simply because it's the kind of thing that is most enthusiastically disliked. . . . Commercial films are more fascinating and lively, but I, myself, have always thought that there was room for self-made 16mm films that are not commercial, that do not pretend to be poetry, that simply exist as films with some sort of life of their own and not necessarily an extension of some already existing art form.

Morrissey shared some attitudes and tastes with Warhol. Neither believed in premeditated setups. On the issue of editing, Warhol was stricter (the reel could be the only unit of editing), but Morrissey also avoided editing as a flashy device. Both liked working with nonprofessional actors, and both had instincts for finding the people who could hold the screen. (On his second visit to the Factory, Morrissey was already making suggestions for interviews, beginning with an eccentric English antiques dealer named Stanley Amos.) They shared tastes in actors too—Taylor Mead from the underground, and Brigitte Bardot from the mainstream.

Morrissey and Warhol differed widely in their approach to narrative. Morrissey insisted that "movies are a medium that traditionally and necessarily [is] grounded in a literary and dramatic framework and [has] only incidental connection to poetry and painting. That is to say that it must be possible to cast the idea of the film in sentence form, and it must also involve people." Warhol was brilliant at titles and cognitively tuned in to static images. He told stories through images and through one-line concepts. His notebooks, filled with single words and images within a frame, reflect his quite different approach to movie making.

When Gerard Malanga introduced Morrissey to Warhol in the lobby of the Colonnades Theater, Morrissey remembered, "Andy was always at a loss for conversation, and his conversational gamut was usually 'Oh,

Abstract:
One of Warhol's favorite words. He used to say "It's so abstract" about things as disparate as sex, Candy Darling's death, politics, and leather bars.

Paul Morrissey as a young filmmaker, summer 1965, by Stephen Shore

why don't you be in a movie.' The line to me was 'Oh, I saw your movie. It was great. Why don't you come up and help me make movies.' "

Brigid Berlin was introduced to the underground amphetamine scene through an amphetamine dealer whose real name was Kenneth Rapp. The only people who called him Kenneth Rapp were his coworkers at his job at a fabric store; his closer friends referred to him as the Mayor, or Rotten Rita, or just Rotten. Just as Brigid had recognized the pecking order in the Upper East Side medical offices—where some were whisked in ahead of others, or got amphetamine with special mixtures, or were given strawberries while they waited—Brigid found in this new community a different hierarchy. Since Rotten Rita controlled the supply of amphetamine, he maintained a powerful position, and he soon bestowed on her a respectful name for the speed world: he called her the Duchess. "He was the Mayor and she was the Duchess, an equal and a peer," said Billy Linich.

Brigid quickly developed a crush on Rotten Rita. It made no difference that he was homosexual or that he was of a completely different

"Three things I dig; my vodka, my poke, and my pillys."
—**The Duchess**

Brigid Berlin and Kenneth Rapp (aka Rotten Rita), 1965, by Billy Name

social class. Brigid spent long stretches of time in Rotten Rita's apartment in the West Eighties. She knew that when she left the house, it could be days before she returned, so everything necessary for a stay was lodged into neat compartments in a large basket. It always contained a set of Rapidograph pens with the finest points possible, a selection of Magic Markers, Winsor & Newton watercolor paints, trip books with blank pages, and a bottle of Majorska vodka. When Brigid arrived at Rotten Rita's, she often found him cleaning his apartment in his underwear, the hi-fi blaring a Maria Callas LP. Brigid opened up her basket, took out her Rapidograph pens, and settled into long hours filling the blank pages of her trip books. The drawings on these pages were usually marked by intricate design and obsessive all-over pattern. "I think I would win the prize on detail," said Brigid. "I would make so many circles with the smallest size point of a Rapidograph and then put circles inside the circle. I would make people out of these circles. There wasn't an inch to put another circle or another dot. Then I would do these blotches with Magic Markers, and when I'd outline them, they'd look like maps."

"He was almost like an outpost. If you were in the colonies, there he would be running the Hudson Bay Company for fur trappers up in Canada, because his apartment was way uptown on the Upper West Side."
—Billy Linich on Rotten Rita

Brigid wanted more than the go-go feeling that Andy Warhol got from his Obetrol pills—she wanted to be "up there." In this state her behavior was not so much wild as it was obsessively in and out of con-

trol. She took up the fashion of what she called "lava-lavas," going topless, in the tradition of Christina Paolozzi, wife of the well-known plastic surgeon, who had created a sensation by going topless in *Harper's Bazaar*. The difference between the two women, however, was a matter of more than a hundred pounds. Brigid also took up the habit of dyeing corduroys in a rainbow of colors and wearing them, but no matter how wild she appeared, she shunned many of the activities associated with the Sixties bohemia. She despised the smell of marijuana and never used it. Nor did she use LSD. She hated rock music and looked down on the new class of people called hippies. "I was always very responsible," Brigid recalled. "I always went for my check-up exactly on time, and I had my teeth cleaned every three months. I was determined to never not have it together. My drawers were always perfect. I invented cleaning with Q-tips. I couldn't stand it if the grooves in the radio had dirt in them. I'm still like that. I still like to do, off speed, all the things I did on speed."

One day in the summer of 1965 Rotten Rita telephoned Ondine and suggested he meet the Duchess. (She formally used her married name, Brigid Parker, and Billy Linich first interpreted that to mean that she came from the Parker Pen family or lived on Park Avenue.) Brigid and Ondine met at a little bar on Second Avenue called Dinko, and each quickly realized the scale of the other's flamboyant brilliance. "It turned out to be this Brigid Berlin monster," said Ondine appreciatively. "He can really drive me to the point of insanity," said Brigid a few weeks later. "I can't take it." Ondine was just at the edge of what Brigid could tolerate, but there was no question about how funny he was.

That summer of 1965 Brigid came to the Factory, and as Billy Linich recalled, the combination of Brigid and Ondine made the presence of amphetamine at the Factory far more palapable. It was Ondine and Brigid who encouraged Billy to leave the Factory; he'd get into a taxi and zip around the city with them, just to listen to the sparks their minds gave off. "I was never an Andy Warhol groupie," said Brigid. "I really enjoyed Billy and Ondine and didn't give a hoot if Andy was along or not."

Most of speed culture's signature productions—the endless cleaning, the makeup jobs, the detailed running monologues—were ephemeral. Billy's friend Johnny Dodd had filled his door with canceled George Washington stamps, for example, each silhouette profile clipped with nail clippers and installed row on row. When Dodd moved, Warhol bought the door from the apartment building and had it removed. But perhaps the most enduring speed production was Andy Warhol's first "novel," *a.*

"She isn't breaking capillaries, she's breaking brain cells. Couldn't you see her brain cells popping?"
—**Ondine on the Duchess**

Andy Warhol was phobic about writing, but he envisioned a way to write a book that not only compensated for his huge verbal limitations but also created a work that was utterly of the moment. He simply taped it on a small, portable cassette recorder which first became available in 1962.

Warhol set his parameters strictly: he would follow a central character for twenty-four hours and tape everything on his recorder. The resulting book was planned to consist of twenty-four chapters, each with two parts corresponding to the thirty-minute cassette reels. Nothing would be left out. And it would follow his dictum: do it fast, easy, and cheap.

Creating a tape-recorded novel was a strategic literary gesture, in some ways as elegantly subversive as Marcel Duchamp's *Fountain*. It threw authorship into question, it exposed the crafted convention of "realism," it collapsed mechanical process and art, it explored literary time in a new way, and it demonstrated that a person who couldn't write could do a book.

Andy Warhol's recording passion went back to 1964 when he bought a cheap gray cassette recorder, about four by six inches. It accompanied him everywhere, an intermediary between him and the life unfolding before him. It offered the same buffer as the telephone, and it provided a perfect way of being intimately involved with—and also removed from—the action. "The acquisition of my tape recorder really finished whatever emotional life I might have had, but I was glad to see it go," said Warhol. "Nothing was ever a problem again because a problem just meant a good tape, and when a problem transforms itself into a good tape, it's not a problem anymore. . . . Better yet, the people telling you the problems couldn't decide anymore if they were really having the problems or if they were just performing."

The idea of transcribing conversations and making them into a book had been in the air, Gerard Malanga recalled. In fact, Warhol had bought the recorder with a transcribed novel in mind. Warhol said, "I'd gotten a letter from an old friend that said everybody we knew was writing books, and that's what made me want to. So I was on my way to having literature covered, too." Soon his ambition was wedded to a particular subject, Ondine, and a particular day—Friday, July 30, 1965.

On that day President Lyndon Johnson signed the Medicare bill, a federal judge ruled that civil rights demonstrators in Bogalusa, Louisi-

ana, had to be protected, and Bob Hope announced plans to build his own Disneyland on sixteen thousand acres northwest of Los Angeles. The novel, *a*, began at two P.M. on the corner of Fifth Avenue and Eighty-sixth Street. Andy arrived late, having waited for Gerard to show up at the Factory, and he carried his cassette tape recorder and twelve hour-long cassette tapes. Ondine had been up on amphetamines for a few days and hadn't slept. Andy had taken Obetrols the night before and stayed up all night looking at magazines. Ondine had spent the morning trying to reach Rotten Rita because he was running low on speed. He also hoped to join Rotten in a visit to Brigid Berlin at the Roosevelt Hospital. Like most of Ondine's days, it was largely unplanned. The two gossiped and walked along Madison Avenue until they got to Seventy-seventh Street where they stopped in at Stark's and bought coffee and *Schnecken*— Ondine relished the sound of the word as much as the taste. On the other side of the room they saw Robert Rauschenberg and David Whitney. Ondine didn't know who Rauschenberg was so Warhol explained that he was "the number-one artist." Ondine protested that Andy was number one because he made not only paintings but movies. Warhol replied, "If it wasn't for him I wouldn't be able to do the kind of work I do."

Back on Madison Avenue again, they talked about Edie Sedgwick's drug use. The night before someone had accused Ondine of "fucking Edie up on drugs," asking what drugs he put in her morning coffee. Ondine was indignant; he just asked her what she wanted and gave it to her; "I mean it is completely above board." She rarely wanted uppers in the morning, "and we both agree that that's the best ticket for her." But he worried that she was taking too many barbituates at night.

After they had finished their coffee and *Schnecken*, Andy gave Ondine five blue Obetrol pills, 10 milligrams each, and said, "Here's your fun." Ondine swallowed all of them, promising to replenish them as soon as he connected with Rotten Rita. It would be his fuel for the day.

When the two taxied over to 231 East Forty-seventh Street to the Factory, they found sixteen-year-old Stephen Shore eager to shoot some photographs. Ondine took up his role as the Oracle. ("The oracle is open. What do you wish to ask the oracle?") He offered Shore some unsolicited guidelines on how to lengthen his penis (tie a rope around the head and move it back and forth for six months until it stretches). He also delivered one of his many diatribes on "HOW TO BECOME A PROFESSIONAL HOMOSEXUAL or how to be a good fag": Ondine was annoyed with the posturing of cruising, he considered Fire Island Pines to be strictly déclassé, felt gay bars were ghettos, and much preferred the

"He's half expressionism."
—Andy Warhol on
Rauschenberg

St. Mark's Baths. Ondine developed his own term, "All Woman" (AW), to describe the kind of homosexual he liked.

A delivery man arrived on the freight elevator with a new Norelco videotape camera designed for home use, an EL 8015/II model with a remote-controlled vidicam zoom lens. Warhol estimated it was worth about $15,000 (the actual retail price was $3,950), and everyone who came in that day was amazed at how big the box was. Andy didn't want to unpack the box, which was about three feet long on each side, so it remained unopened.

Conversation in the Factory that afternoon was dominated less by the revolutionary new machine than by matters of getting food at Bickford's, going to the baths, and posterior tightening through yoga. In the midst of this Ondine conducted phone interviews with applicants and transcribed the conversations that were currently being recorded. He insisted to the secretarial recruits and to Andy that there must be Factory policies: no phone calls before eleven A.M., messages must be written down on the board next to the phone, and the call's recipient had to be told of calls.

By midafternoon the Factory was filled with several of the regulars of that summer 1965 period. Edie Sedgwick came in with Chuck Wein, Gerard Malanga arrived to work in the afternoon, Paul America was hanging around, Jonas Mekas telephoned, and the newest addition to the group, Paul Morrissey, appeared.

Ondine and Paul Morrissey began an extended discussion of opera. They talked about the virtues of Maria Callas, Puccini, *Norma,* and the music critic Alan Rich. After their first talk, it was clear that Ondine and Morrissey appreciated each other; Ondine assumed the teaching mode, recognizing the presence of an intelligent audience. In the midst of the conversation Ondine exclaimed to Paul, "You seem so delightful," and Paul soon returned the compliment by saying, "Oh, I like to hear you talk." (A few minutes later Ondine called Morrissey "a gentleman.")

Warhol explained to Ondine that Morrissey was a filmmaker, but "nobody knows except—uh, nobody knows except him."

Andy, Ondine, Edie, and Chuck hopped a taxi to Lester Persky's apartment at Fifty-ninth and First Avenue. Along the way they discussed Edie's recent interviews for *The New York Times* and on Les Crane's television show. Television producers wanted to broadcast five minutes of Edie in a Warhol film, but Warhol protested, "Oh no, they can't do it, no they can't do that," because it would be like "cutting the film." Edie said she was trying to make people understand things but found the interviews "too processed."

At Lester Persky's Ondine took a bath and shaved—he approved of the rust-free bathtub but thought the apartment was "too beach house"—and then walked with Edie onto the terrace. They looked down on the Fifty-ninth Street Bridge while the Beach Boys played in the background. Alone with Ondine, Edie wondered aloud why she "keeps hanging on Drella [Warhol]" and told Ondine that "there's only one person I'm gonna be with and that's you." Ondine counseled her to be patient, that we must all be resigned to dying. Edie said she had already died once, and Ondine told her everyone must start again, each time it was harder but there was "more equipment." Ondine told her that Andy was wiser than Chuck Wein, wiser than himself, because he was not devoting stupid energy to difficult things but just enjoying it.

Lester Persky called Andy's taping machine "a passive put-on." "As a result of having this," Persky said, "Drella doesn't have to participate in life." Ondine took offense at this observation and later took several opportunities to rail against the vulgarity and witlessness of Lester Persky whom he considered a lower form of life. Edie chimed in: when she was first mentioned in the press, Persky's response had been, "Don't forget I discovered her."

A friend of Chuck Wein, Genevieve Charbon, who had recently arrived from Paris, joined them just as they were ready to leave Persky's to get food. After rejecting the Automat, they headed to Clichy. Ondine started a game of rating people in descending categories: "Divinity, star, penny-pigger, schlitzmonger." Persky was a schlitzmonger. The game fizzled out as they moved on to talk of amphetamines, weight loss, maintaining one's looks, and frequency of orgasm. Andy offered Ondine two more Obetrols, since there were four hours of taping left, but Ondine took only one.

The group (Warhol, Edie, Ondine, Genevieve, and Chuck) next headed up to West Eighty-sixth Street and Columbus to the apartment of Rotten Rita which was filled with objects (Ondine compared it to the back room of a Viennese warehouse) and opera music. Ondine called it the "campaign headquarters" for Rotten Rita whom he was pushing for mayor of New York. One by one they retired to the bathroom where Rotten Rita expertly gave shots of amphetamine. Ondine tried on a black sheath dress, all the while singing along to the opera.

Brigid Berlin telephoned from the Roosevelt Hospital where she had been staying for twenty-four hours. The day before, her dentist had been so alarmed by black and blue marks all over her body that he immediately admitted her for tests. In her luxurious corner room Brigid was

Ondine and Andy during the taping of *a,* **July 30, 1965, by Stephen Shore**

Names used in *a:*
Ondine: Bob Olivo/Ondine
Drella: Andy Warhol
Taxine: Edie Sedgwick
The Duchess: Brigid Berlin
Rink Crawl: Chuck Wein
The Sugar Plum Fairy: Joe Campbell
Billy Name: Billy Linich
Do Do Mae Doome: Dorothy Dean
Rotten Rita (Kenneth Rapp)
Gerard Malanga: Gerard Malanga
Paul: Paul Morrissey

"There is nothing else I
can do but carry on
the tradition."
—Rotten Rita to
Brigid Berlin

holding forth, giving the doctors and nurses an education on pills. The intern who interviewed her about her diet was taken aback when she told him that she drank three quarts of vodka a day and didn't eat regularly. When asked if she used any medicine, Brigid rattled off a long list of her pills and vitamin B-12. On her first day in the hospital she had managed to steal the blood pressure machine and made plans to steal a variety of pills with her *Physicians' Desk Reference* handy. It's only fair, she reasoned, since she knew as much as any of the medical staff about pills. There were new light-blue-speckled pills that were powerful methamphetamine hydrochloride, Blackbirds (20-milligram biphetamines T 20), Prelude (pink round pills from Ciba-Geigy), and Endomyn. But Brigid, tired of most pills, confirmed that pokes were still the best: "A poke, a poke is the—is the biggest—is the most beautiful up there is."

Brigid's phone call was broadcast into Rotten Rita's apartment via speakerphone and became part of the day's tape. When Brigid heard that Rotten Rita was administering masterful bloodless shots in the bathroom, she became worried that he would take over her informal practice. "Then who will I have left to poke? And that's my hang-up. Not the poke, my dear, but the pokee." She advised Chuck Wein, whom she had met a few nights before and had given a shot, to stick with pure amphetamines in a 30cc bundle and to stay away from cloudy mixes. Brigid called herself a doctor, "a very ethical doctor," who hadn't yet been busted for malpractice.

Brigid described her anomalous position in the amphetamine world. "Nobody, my dear, nobody in the whole fucking world is wilder than I am," she said. "I'm not weird at all." She dressed in a blazer from Battaglia (an exclusive men's store that was on Park Avenue between Fifty-seventh and Fifty-eighth) over her Dunhill shirt, with a polka-dot ascot and tapered khaki pants and polished loafers. All her instincts betrayed her upbringing: when she proposed that the Warhol gang visit her in the hospital, she offered to send a car and planned a brunch with Steak Diane sent in from "21." She always carried Colman's English mustard in her pocketbook in case it wasn't available when she was ready to dine. By the time she hung up the phone, she had sketched out a fantasy costume party.

Thinking about the day as a book, Ondine felt it might take the form of a book that you could play only on a tape recorder. He suggested titles: *Sunday at the Races? A Day at Stark's?* Andy quickly countered with the

simplest title imaginable: *a*. Ondine laughed and said, "Then we'll go on to *b*, right? Oh, perfect."

The twelve-hour taping session ended in the middle of night on the telephone. Andy was getting ready to go to New Jersey the next day at ten A.M. with Chuck Wein. Ondine phoned Billy, who was holding forth at Henry Geldzahler's, and the two considered Brigid's upcoming operation and speculated what would happen if she married Rotten Rita. With Brigid's father and the Hearst Empire behind them, Billy suggested they could start another Spanish-American War. When Andy warned him the tape was running out, Ondine said he was ready for another taping session, perhaps the next day. He closed by saying, "Let's see—my last words are Andy Warhol."

An art-historical version of that same day, July 30, might pay more attention to the huge unopened box that had arrived containing the Norelco video camera. Among the first artists to experiment with the new medium of video, Warhol made at least eleven thirty-three-minute tapes of people, the most important of which was *Outer and Inner Space*. The setup was simple: Warhol twice taped Edie Sedgwick in profile, thirty-three minutes each. She then sat before the monitor on which these played, her face in three-quarter profile facing her taped profile, and she responded to off-screen questions from Chuck Wein. Warhol filmed her twice in this position and then put the two films side by side. The resulting film comprised Warhol's first double-screen experiment, and the doubling led to further complexity, as the four faces of Edie Sedgwick played off one another. The two video profiles are flat, glowing, depersonalized masks, while the filmed faces seem to be in conversation with the videotaped faces.

Each of the four faces talks, and the incoherent sound functions as a backdrop, a spur to the constantly changing expressions on Edie's face. At one minute her face shows delight; without transition, she seems wounded, distracted, and uncomfortable. The simple title, while playing on science fiction, evokes the stark difference between Edie's radiant public exterior and her often-tortured interior life.

My Hustler was the brainchild of Chuck Wein, with the help of Dorothy Dean, who pulled together some money and a location. The money

wasn't much—a matter of train fare and hotel accommodations for a
night on Fire Island. It came from her friend Sam Playa, whom she met
at Kelly's, the hustler bar near the Hotel America. Hustling was the gen-
eral subject of the movie, and Wein thought about different kinds of
hustles: the male hustle at Kelly's bar; the black hooker hustle that took
place outside the Hotel America; the social jet-set hustle of promoter
Romy Aguirre and Serge Obolensky at the nightclubs. Dorothy Dean
wanted Joe Campbell to play a main role. She had been infatuated with
him since meeting him on Fire Island in 1964. She called him the "Sugar
Plum Fairy" and sent him mash notes written in colored inks on three-
by-four-inch notepaper. She repeatedly asked him to be the father of her
baby, not just because he was so handsome but also because of his
unvarying sweetness. "You're going to be a star, and the movie's about
hustling," she told Campbell. "That's a big subject," Joe said from experi-
ence.

Joe Campbell had known about hustling since his teens, when he
was often the most-desired boy on the gay beach at Riis Park in Queens,
where he met Harvey Milk and began a seven-year relationship. After
they broke up in 1963, Joe Campbell had trouble negotiating his life. He
moved to Florida and soon crashed his motorcycle; a few months later
he unsuccessfully attempted suicide by taking pills. "If you're going to
commit suicide," Harvey Milk counseled him, "you should go deep in a
forest, cover yourself up with leaves and needles, then take all the pills

> "These movies are making
> a complete fool out of me!
> Everybody knows I
> just stand around in
> them doing nothing and
> you film it and what kind
> of talent is that? Try to
> imagine how I feel!"
> —Edie Sedgwick

you want." At the time when Dorothy Dean invited him to appear in the movies, Joe Campbell's spirits were at a low ebb.

"I wanted to bring Cambridge into the movie," Chuck Wein recalled. "The only people learned enough to play the bitchy fighting-for-the-trick are educated people who know that literary tradition. I thought it was interesting to expose Warhol to that." He invited Ed Hood to play a balding professorial john who uses the services of Dial-A-Hustler. The movie was planned at the time when Edie Sedgwick was questioning the value of appearing in Andy's films. At a party at the old Sign of the Dove on Third Avenue and Sixty-sixth Street, she made it clear to Chuck Wein that she was not interested. He enlisted Genevieve Charbon, who had recently returned from Paris, to play the part of a neighbor competing for the hustler. "We had no planned scenario," said Chuck Wein. "It was based on a thousand nights with Ed Hood and with Genevieve Charbon, and trusting in the knowledge of what they could bring."

The story was altered by the entrance of Paul Johnson. Lester Persky had discovered the strapping young man hitchhiking to New York from Fisher's Island, and Persky was so taken by him that he suggested they continue on to the discotheque, Ondine. Persky brought Paul Johnson over to the table where Andy was sitting with Chuck and Edie. The young man was soon given a new star name, derived from the Hotel America, where he frequently lived. "I went through a period of paranoia

about it," said Paul America. "I mean, every time I saw that word—and it's everywhere—I related it to *myself*. The country's problems were *my* problems."

Paul America was good-looking and sexually available; at different points he became the lover of Ondine, Richie Berlin, Debbie Caen, and Henry Geldzahler. Henry Geldzahler recalled that there "became a big competition between Edie and Chuck for Paul. Chuck loves that situation."

By the end of the summer Chuck Wein was determined to make movies that used editing and a moving camera. *My Hustler* would have a real "location," Fire Island Pines, which in its early days as a gay community, provided a scenic backdrop. Wein wanted to improve the sound quality so he consulted Danny Williams, whom he had known at Harvard back in 1960, for technical advice. Williams suggested they upgrade their sound by renting a Nagra tape recorder, which they did.

The day before the shooting, Paul America and Gerard Malanga went to Bob Heide's apartment to dye their hair at a peroxide party; both became blondes for the next few months. Those who trouped out to Fire Island included Ed Hood, Paul America, Genevieve Charbon, Joe Campbell, Dorothy Dean, Billy Linich, Gerard Malanga, Stephen Shore, and Danny Williams. It was an overcast day, and Chuck Wein sensed tension in the air because of annoyance about late arrivals, lack of good weather for the shooting, and squabbling over where people would stay.

Before they began shooting, Wein talked to Morrissey and Malanga. Paul Morrissey recalled that Wein said: "We can't let Andy just turn the camera on and let it run—we're not just going to waste this whole trip. You operate the camera, and I'll tell them what to do, and we'll make something like a real movie with stops and starts."

Morrissey was in sympathy with Wein's desire to make a narrative movie with stops and starts but was caught short by the proposal.

> I wasn't expecting it, and I think he thought he'd get away with it because Danny would go along with him. But I know that I just didn't want to do it, and I thought he was putting all too much emphasis on this, which was another experiment, you know. It was not realistic to take two or three people out on a boat and think you're going to make a movie that's going to go out into theaters. Maybe they'd show it at Jonas's on a Monday night. At that point I didn't think these things were possible.

Wein recalled something much milder—he simply wanted Warhol to pan the camera. It was something of an in-joke challenge—who could get Andy to pan? He thought Andy felt a little new pressure with the addition of Danny Williams, but Danny never had a takeover in mind.

The problem posed by the setup was the fact that Paul America was sitting on the sand, while Ed Hood and Genevieve Charbon were looking at him from the deck many yards away. "What are we going to do?" said Andy. "Uh, they're there, and Paul's sitting over there." Morrissey said, "Well, it's easy, Andy, you just move the camera back and forth," At first Warhol didn't want to move the camera and asked Morrissey to do it, so Morrissey panned the camera from Ed and Genevieve down to Paul America on the beach.

It wasn't until they had arrived in the Pines that Joe Campbell realized that Paul America was playing the hustler who was the object of competition. Campbell would play the role of the over-the-hill hustler who knew the ropes. They appeared together in two of the reels. "I wasn't the least bit interested in Paul America," said Campbell. "He had nothing. I guess he was a shape, but there was nothing inside. He had no lust, no desire, no agenda apparently of any kind at all, even in drugs."

The second reel was an indoor shot with Paul America and Joe Campbell in the beach house bathroom. Andy told Joe that the scene should be sexy, but the only direction he gave was to open the medicine cabinet and "just read off a long list of brand names." The fact that there was absolutely no chemistry between Paul and Joe didn't ruin the scene but gave it a different, more jaded feel. It always seemed as if something might be about to happen between them, but potential sex never became manifest.

When shooting *My Hustler* was over, everyone relaxed. That night an omelette was served along with orange juice that, unbeknownst to the drinkers, was laced with Sandoz acid that Chuck Wein had brought along. (Wein said that Danny Williams had put acid in the orange juice, but most people later believed it was Wein himself.)

Neither Morrissey nor Warhol had ever had taken acid. Malanga saw Warhol early the next morning tidying up with a whisk broom and searching through the garbage. Warhol said, oh, he was just looking for something. Paul Morrissey was reportedly in a fetal position under the deck of the house, but he recalled simply trying to get out of the sun and wondering if he was feeling any effect. He thought it felt like strong caffeine, a substance he never touched.

"Well, because every inch counts. In this kind of business."
—Joe Campbell

"I sure wish it could have been someone more responsive. It was like talking to a dead person."
—Joe Campbell on Paul America

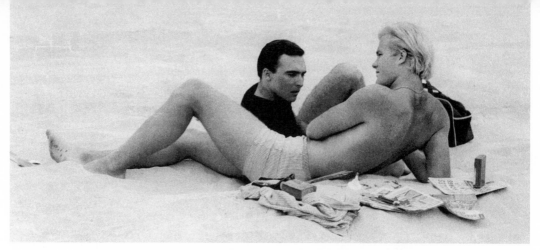

The recently peroxided Paul America and Joe Campbell, during the shooting of *My Hustler* in the Pines, September 1965, by Billy Name

Only when the filming was over did Ed Hood get into bed with the two "hustlers." "Ed Hood in his abstract way was trying to be sensual, trying to be sexual, trying to touch the flesh," recalled Campbell. "This had been going on all day and half the night, and everybody was getting bored and drunk and drugged, and somebody wanted to get it over with, but nothing ever happened. It wasn't the moment. It was like a strange two-day vacation."

That strange vacation became *My Hustler*. (The title played off a little-remembered 1962 Shirley MacLaine vehicle called *My Geisha*.) It would become the first Warhol film to be widely commercially successful.

Danny Williams had worked as an editor with several of the most exciting documentarians of the day: Robert Drew, Richard Leacock, and most lastingly the Maysles brothers (Albert and David). These men comprised the documentary wing of the New American Cinema. Two films that Danny Williams edited for the Maysles brothers, *Showman* and *What's Happening: The Beatles in the U.S.*— are considered classic works of new American documentary.

My Hustler was the first time Danny Williams appeared on the scene. Chuck Wein had known him at Harvard as a photographer.

Wein appreciated the technical skill that Williams could offer to the Factory—organization, technical competence, and most of all, editing. Danny was brought in as part of Chuck Wein's push for edited movies at the Factory, but Williams quickly filled other roles. The most important was that of Andy's boyfriend.

Danny Williams was often described as being more "normal" than many of the people at the Factory. That surface presentation covered more complicated feelings. "His struggle for personal identity was more anguished than many," wrote his mother. "He did not easily accept things as they are. His person-to-person relations were always fiery. An emotional being in an intellectual, undemonstrative Yankee family."

After running away from the juvenile home in the Catskills in early 1965, Joe Dallesandro traveled across the country and began working just over the border in Mexico. That summer he hitchhiked up to Los Angeles.

Joe was dropped off at the main downtown bus station, an ideal place for a handsome and available young man to make connections. He quickly learned to hustle. "I'd come from New York where I'd seen people do the hustle," he said, "and I knew that people could get away with anything if they just knew what to say. My hustle was about getting anything I could for nothing." He was taken in by a middle-aged African American man, and when Joe saw his apartment in Watts, he was amazed that the complex had a swimming pool. "This was a ghetto, and they had a swimming pool? This was luxury!" He supported himself working in a West Hollywood pizza parlor at La Cienega and Santa Monica. The only problem was that Joe wanted to learn to cook. His father had always stressed education, and Joe's boss assigned him to washing dishes, a job without learning or advancement.

> "Hell, when I was sixteen, I was an adult. By the time I was eighteen, I was a child again."
> —Joe Dallesandro

But around this time Joe found a new vocation: presenting his body on film. In a physique magazine version of Schwab's drugstore, an admirer suggested he go to Bob Mizer, the founder of the Athletic Model Guild. By the summer of 1965 Mizer had shot more than five thousand male models, including street kids, hustlers, body builders, would-be actors, soldiers, and sailors. He paid fifty dollars for a posing session, and Joe Dallesandro needed cash.

> "AMG was the genesis of beefcake photography."
> —photographer Christopher Makos

Joe arrived at the AMG studios in South Los Angeles, at 1834 West Eleventh Street. He found a fortresslike compound of seven buildings, guarded by double iron gates edged with razor wire. When the guard admitted him, Joe passed eight attack dogs, a caged monkey, and a rectangular pool, then walked right into the main house where Mizer lived. Around the studio were the props of physique photography—a papier-mâché column for the Roman slaves scenes, a locker room, a shower, motorcycle regalia, sailor suits, a farm backdrop, Stetsons, and chaps.

Mizer was a "wholesome" physique photographer. He shot his models nude in posing straps that his mother knitted for them, but he kept the nudes for private viewing, not for publication. He avoided overt sex scenes. He published models' real names whenever possible, scrupulously recording their measurements. He scorned physique publishers who photographically enlarged their model's penis, calling this ploy "the Big Basket Fraud." For his own delectation, Mizer assigned his models a

Joe Dallesandro

Joe Dallesandro's
statistics as
recorded by
Bob Mizer in
Physique Pictorial

Waist: 29.5 (pulled in to
27.5)
Biceps: 13.5
Wrist: 7.12
Neck: 15.6
Chest: 39 normal
(expanded to 40)
Hips: 36.6
Thighs: 21
Calf: 14.12
Ankle: 9.4
Shoulders: 47
Tit-to-tit: 8.75
Tit to navel: 9.75
Head circumference at
temples: 22.5

number of symbols that encapsulated their background, sexual tastes, and personality, but his secret code is only now being broken.

Joe Dallesandro added three years to his age and told Mizer he was nineteen. Dallesandro recalled his single session with the photographer as a crash course in posing. Mizer taught him the tricks of the trade—to oil his body, to lube his hair and part it on the side, to thrust his hips slightly forward in order to emphasize his abs. "He gave my body the perfect V," Joe said, "the perfect V I didn't have." Joe had always felt self-conscious about his size—five foot six and 140 pounds—but on camera, he appeared to be perfectly proportioned and larger than life.

As always, Bob Mizer worked fast. Using four-by-five-inch negatives, he shot thirty-nine images of Joe in the shower and another thirty-five of Joe flexing and reclining on a bench against a black background. Those photos were published in mail-order catalogs, books, and magazines and still sell briskly today.

Joe made his movie debut on his same first day with Bob Mizer. He appeared nude in a twenty-minute film reel. He flexes, flashes a smile, leans back on a table, shadow boxes, and lies down for the camera's last lingering pan across his oiled body as the lights go out.

"My introduction to the gay world did two things," Joe Dallesandro said. "One, it saved me from life in prison for murder, which is probably where I would have wound up. How? Because the gay world showed me that you didn't have to beat up every man you saw or hurt people to make a point. Two, it taught me never to be homophobic, even before there was such a term."

By mid-1965 Gerard Malanga was becoming one of the pinup boys of the downtown scene. He considered himself primarily a poet, but he appeared on the covers of magazines as well as inside, and in movies. Malanga wasn't the first poet who was a sex object, but few were as publicized.

In addition to kissing Edwin Denby on the covers of *C*, Gerard had appeared nude in an orgiastic scene of Barbara Rubin's *Christmas on Earth* and on the cover of Ed Sanders's mimeographed magazine, *Fuck You: A Magazine of the Arts*. The magazine's third-anniversary issue demonstrated that the mimeograph was alive and surviving censorship.

For a twenty-three-year-old poet working for $1.25 an hour, Gerard Malanga had achieved remarkable downtown visibility. That notoriety

may have contributed to the jokes about his combination of ambition and self-regard. "Notes on Contributors" reported that Malanga "has fucked 1000's of New Yorkers in this Total Apertural Assault. He has published in over 763 magazines in his maddened effort to receive the Nobel Prize." Ondine would call him the birdbrain of the Factory, a second-rate poet with unlimited capacity for posing. Sometimes Gerard's self-promotion was transparent, such as in his *Vinyl* press release: "Gerard Malanga offers us a performance that is unique in cinema history."

The third-anniversary issue of *Fuck You: A Magazine of the Arts* featured on its cover a still from *Couch*. A third of the way into the magazine appeared a piece called "Friends of Gerard Malanga (commissioned by Ronnie Tavel)." Illustrated with a stylized spurting penis, the piece consisted of two lists, including twenty-eight men and seventeen women. When Ron Tavel read it at Café le Metro, the growling laughter testified to the gossipy joke about the possibilities of sexual flexibility.

In Ithaca, New York, a Cornell undergraduate art major, Mary Woronov, was experimenting with "gender slipping," as she called it. She was tall and thin and severely beautiful, with slanting eyes, Slavic cheekbones, and a long brown mane of hair. She was theatrically out of place on the Cornell campus, where she recalled that women were submissive and men were thugs or nerds. "In my elementary class, I was the strongest and the biggest, I was always that way," she recalled. "I was never a coquettish feminine thing."

Mary Woronov spent the summer of 1965 in Provincetown and returned to Cornell wearing the costume that would later become the look of a gay male clone: tight black jeans, large boots, and a garrison belt with the buckle turned to the side. Few women at Cornell aspired to this look, although there were plenty of men who wanted to look like the next Jack Kerouac or Neal Cassady. Mary Woronov had been sent to college to meet a suitable husband, but her route to a man was more circuitous than most.

> I liked macho guys—the bane of my life. I couldn't go with these guys because they fucked everything, yet I really wanted them. So what I did in my brain was to say if I can't have them, if I can't make them want me, the other thing I can do is I can have them by imitating them. I spent most of the time at Cornell imi-

Literary Sex Icons
Jack Kerouac
Arthur Cravan
Arthur Rimbaud
Neal Cassady

"Friends of Gerard Malanga" in *Fuck You: A Magazine of the Arts*
Wystan Hugh Auden
Barbara Rubin
Allen Ginsberg
John Ashbery
Bob (Ondine) Olivo
Naomi Levine
Ronnie Tavel
Taylor Mead
Fred Herko
Andy Warhol
Henry Geldzahler
Kenneth Jay Lane
Willard Maas

"Every girl thought every other girl was beautiful; every boy thought every girl was beautiful; every girl thought every boy was beautiful."
—Diana Vreeland

tating these guys. I dressed like them. I grabbed girls by the elbow and told them what I wanted. I'd practically scratch my fucking balls. I did practically everything but ducktail my hair. But I wasn't gay, I never liked women's skin.

Mary Woronov danced on a tiny stage in an Ithaca bar called Leonardo's. She and a friend named Susan dressed in black jeans and ripped T-shirts. "It was better to dance in front of them than to dance with one stupid guy," Woronov said. "Why have just one when you can have twenty?" A friend named Jack obligingly drove Mary and Susan to a strip club in Syracuse, where the manager gave them pasties and suggested they dance for the crowd of men. It was not what Mary had in mind. "The idea of whore never came into my mind," said Woronov. "I knew I was expressing something they could not get anywhere else. Want is better than have, that was my motivation. You want to want. You don't want to have me. That would be a grave mistake."

In the fall of 1965 Gerard Malanga took the bus to Ithaca to visit his friends David Murray and Dan Cassidy, poets who were friends of Mary Woronov's. Gerard carried with him the 16mm Bolex he shared with Barbara Rubin, for he was experimenting with making movies.

When Mary Woronov first spotted him at the Ithaca bus station, Malanga looked like no one she had ever seen. "He was not pushing the guy thing." He'd toss his peroxided hair, he wore beads, he walked around theatrically. Even though Mary knew he was not gay, she noticed that Gerard "would flaunt queerness the same way I would flaunt masculinity. People wouldn't read him as queer—he was so flagrant, they would read him as something from Mars. And he had tremendous power, which interested me. And the stage never stopped for Gerard."

Malanga immediately grasped Mary's potential as a performer. "She knocked my socks off," said Gerard. "I said this girl is so talented, and she doesn't even know where it's all coming from." When he asked her to be in a movie, which he called *Mary at Triphammer Bridge,* she walked across the bridge over the gorge with such larger-than-life attitude that it became a dramatic event. "I didn't know what she was talented for, but she was a very striking individual, this tall woman with an incredible face and long mane of hair," said Gerard. "She was like a wild horse, she had a filly feel."

Mary Woronov wouldn't allow anyone to push her around, and in Gerard she found someone with an extraordinary ability to understand

Mary Woronov, 1965

her. "He was conscious enough to never push anything onto me," she said. "He understood what I wanted, he understood what I didn't know I wanted. And he was very careful not to destroy anything about me."

Valerie Solanas prized her heavy old manual typewriter. From one temporary crash pad to the next, from the Hotel Earle to the Chelsea Hotel, she always carted it along, and when she had no home, she kept it in a storage locker. On this typewriter Valerie would type her three works. The first was written in 1965 and published in *Cavalier*, a magazine in the style of *Playboy*, the following year. The article, "A Young Girl's Primer on How to Attain to the Leisure Class," was 95 percent dialogue sandwiched between a few narrative paragraphs, an article-on-its-way-to-becoming-a-play.

The tone was funny and brash, like a downtown Moll Flanders, mixed with the subversiveness of Joe Orton and the snap timing of

stand-up comedy. Valerie cheerfully transformed her street panhandling into acts of freedom and her sociopathy into antipatriotism, presenting her grueling daily round as a carefree occupation. In the article she meets a masochist who asks her to walk on him with golf shoes; she counsels a socially insecure hooker to hang out in front of saloons at the four A.M. closing time and presents herself as "Miss Last Chance"; she runs into a middle-class lady leafleting for a peace candidate but reads the leaflet and dismisses her as "one of Betty Friedan's 'privileged, educated' girls."; and she offers her routines—a dirty word for fifteen cents, constantly shifting prices for conversation, introductions, and specialties. Psychologically and verbally, the article is a vaudeville act of cheerful bile. It closes: "I pan around, wondering how I can best help rid the world of war, money, and girls who hand pamphlets to men only."

Even before "A Young Girl's Primer on How to Attain to the Leisure Class" was published, Valerie Solanas had begun transforming the article into a play. She thought up four titles and liked each one so much that she put them all on the cover of her self-published *SCUM BOOK: Up Your Ass, From the Cradle to the Boat, The Big Suck,* and *Up From the Slime.*

"I dedicate this play to ME, a continuing source of strength and guidance and without whose unflinching loyalty, devotion and faith this play would never have been written."
—Valerie Solanas

Valerie's analysis of American society was dramatized through street encounters between the hustler-panhandler heroine Bongi Perez and a variety of types: the unconscious woman, the john, the Christian right, and the drag queen. It included Bongi's routines about bargaining her body, ranging from $25 for a fast hand job in the alley, to $50 for a five-minute session. For $10 more she would sneer, curse, and talk dirty. "Then there's my hundred-dollar special, in which, clothed only in diving helmet and storm troop boots, I come charging in, shrieking filthy songs at the top of my lungs."

The play runs along on its vaudevillelike comedy routines, but beneath the humor lies Valerie's mission against men: "You have a short-circuited nervous system," says Bongi. "All roads lead to Rome, and all a man's nerve endings lead to his dick. . . . You might as well resign yourself: eventually the expression 'female of the species' will be a redundancy."

Paraphernalia opened in late September 1965. Ulrich Franzen designed the store renovation to emulate "a continuous Happening." He joined two brownstones so that the double-height windows looked into a dramatically spare white interior. The only Paraphernalia clothes visible

inside were those worn by the fabulous live models frugging in the window. The store had a fashionable Madison Avenue address, two doors down from Vidal Sassoon's hair salon, but the prices were not uptown prices. Sixties styles zigzagged so quickly that one might as well charge throwaway prices for throwaway fashion. A Norell dress began at five hundred dollars, and Mainbocher began at more than twice that. Paraphernalia's range of separates sold for under fifty dollars.

Gerard Malanga introduced Betsey Johnson to the Factory when he asked her to design silver accessories for a photograph. Her ideas represented a new approach to casual fashion—detachable sleeves that could be zipped on and off, adhesive foil scallops that could be attached to a vinyl dress, or a dress that could be implanted with seeds that sprouted, lasting no longer than the life of a plant.

When Andy Warhol announced that he was going to stop painting to make movies full time, many wondered whether it was just an outrageous ploy, a publicity stunt for media attention as the artist who doesn't paint. Although Warhol appeared frequently in gossip columns and fashion shoots, the sensation hadn't translated into sales. And he produced so much work that the prices of individual works were devalued. Some speculated that if he stopped painting, his prices would go up, just as they did for an artist who died and would produce no more. He told Paul Morrissey that "he wanted to stay out of the art business for a while so that his early art could go up in value."

Warhol's decision to leave painting came at a time when Pop Art had been broadly exposed, not only in galleries but in group shows and in museums devoted to the Pop phenomenon. It was still a hard commodity to sell and was no longer the latest thing. Philip Leider, the editor of *Artforum,* noted, "By 1965 or 1966 it was becoming clear that the next step wasn't going to take place on the canvas, that it wasn't going to be a matter of what was the next move on a two-dimensional surface." Warhol told interviewers that he was beginning a new stage in his life. "I don't paint anymore, I just do movies now. I could do two things at the same time, but movies are more exciting. Painting was just a phase I went through."

In the early fall of 1965 Warhol began thinking about his next exhibition at the Leo Castelli Gallery at the same time Pontus Hulten was curating a Warhol retrospective at the Moderna Museet in Stockholm,

Upcoming Trends, 1965:
Minimalism
Earthworks
Conceptualism
Fluxus

Billy Kluver (1927–) emigrated from Sweden to the United States in 1954 and soon worked as a member of the technical staff at Bell Telephone Laboratories. In the early 1960s he collaborated with artists (Jean Tinguely, Jasper Johns, Yvonne Rainer, Robert Rauschenberg, John Cage), introducing them to new technology. In 1966 he helped found the influential organization Experiments in Art and Technology (EAT).

scheduled to open in February 1968. Warhol wanted to create a work that eluded definition in the art world and at the same time memorialized the art career that he was ready to let drift away. "I didn't want to paint anymore, so I thought that the way to finish off painting for me would be to have a painting that floats," he said to his friends. "So I invented the floating silver rectangle that you fill up with helium and let out of your window."

Warhol had been interested in weightlessness since 1964, when he approached Billy Kluver about designing a floating lightbulb, perhaps in homage to the Jasper Johns's drawing of a lightbulb that Warhol bought in 1960. Kluver was the ideal person to think about weightlessness, for he was trained as an engineer, worked in collaboration with artists, and understood what was technologically possible.

Kluver determined that it would be impossible to create a lightbulb that floated, but he came up with an alternative plan, using a material called ScotchPak that had been recently developed by Minnesota Mining and Manufacturing. An extremely thin silver material, it could be sealed with the use of an inexpensive heat machine. The interior could be filled with helium. Andy loved the idea. It reminded him of a balloon, and ScotchPak was inexpensive (50 cents for 20 inches, and in bulk he could get 700 yards for $400). He bought a secondhand heat machine and was ready to produce his farewell work.

Pontus Hulten During his period directing the Moderna Museet (1958–73), Hulten made the museum into an important outpost of modernism. He subsequently guided other museums, including the Centre Georges Pompidou, and created such important exhibitions as *Paris/New York, Paris-Berlin, Marcel Duchamp, The Machine,* and *Bewogen-Beweging.*

On October 4, 1965, while Pontus Hulten was visiting New York to plan the Warhol retrospective in Stockholm, a group of people gathered at the Factory and played with the possibilities of creating a huge silver balloon. Warhol thought of it as a farewell to art. Equipped with his omnipresent tape recorder, Andy interviewed Billy Kluver, who said, "I'm an engineer in the daytime, making Infinite Sculpture for Stockholm using land design." Pontus Hulten held the ScotchPak while Billy Kluver cut it and helped seal it. Then they took the freight elevator to the roof and filled the silver tube with helium. Warhol asked what the floating sculptures should be called. Pontus Hulten suggested calling them "superstar," and Andy said the sculpture should be as big as the roof, "as big as Elvis."

The first *Silver Cloud* was a forty-foot tubular balloon that looked like a snake. Andy grew excited about the process, peppering the conversation with exclamations about its beauty. "Oh, look at it, it's right out of a movie. With the movies everything is called Up—Up movies, Up art."

The wind was light that day, Billy Linich shot several photographs, and then with bells ringing in the background, Warhol released the silver

The people who gathered on the roof of the Silver Factory to witness the first of the *Silver Clouds,* Warhol's farewell to art. They included Harold Stevenson (holding the *Silver Cloud),* Billy Kluver (fourth from left), Andy, Gerard, and Pontus Hulten, October 4, 1965, by Billy Name

form into the air. As it floated up, Warhol wondered if people might take it as a delegation for Pope Paul VI, who was arriving down the street at the United Nations that afternoon at 3:40 to declare, "No more war, never again war!" Then as a helicopter went overhead, Warhol grew afraid it would cause a wreck. Most of all he was afraid the police were going to come and investigate. Maybe, he suggested, it would be wise to have a remote control for the silver balloon. Far outweighing his anxiety was the sheer exhilaration of the event. "It is the first art sent into space," Pontus Hulten said to him. Of all the Happenings that Hulten had seen, he added, "I think this is the only thing that ever really happened."

Andy returned to the Factory and telephoned Genevieve Charbon to tell her that the launching was "one of the most exciting things that ever happened. Up to God, all the way up."

At the same time Warhol was "leaving art," he was having a retrospective at the Institute of Contemporary Art. Its director, Sam Green, sent out

"It was fabulous: an art
opening with no art!"
—Andy Warhol on the
ICA show

four thousand invitations and offered exclusive coverage to each of three television stations—all for a few rooms and a basement that could not hold more than four hundred people. A few days before the opening Sam Green painted the floor silver and installed the show to Warhol's specifications. There were twenty-seven works, from 1962 to 1964, including all of Warhol's major series: there were *Marilyns, Elizabeth Taylors, Jackies, Death and Disasters, Robert Rauschenberg,* a *Brillo Box, Flowers,* and a *Suicide.* Before the press preview, however, Green realized that Warhol's opening might work best without any art on the walls. He had planned it to be a huge event, but could the two rooms contain the crowd? At the press conference, when one of Warhol's *Tuna Fish* paintings was impaled by a television light stand, Green realized that the only way to keep the paintings safe was to remove them, leaving up a few *Flower* paintings and seven grocery carton sculptures in a corner. The removal of the paintings made good newspaper copy. "Since nobody knew what to say about his art, they would at least know what to say about Warhol's antics," said Green.

Andy decided that a Pop Art opening should have disco music. Ivan Karp hooked him up with Norman Dolph, a Columbia Records sales executive who ran the first mobile disco in New York. Dolph had become an institution among downtown artists because he had a standing deal that, in exchange for artwork, he would bring his two-turntable rig and speakers and a varied collection of records. One of the perks of Dolph's position at Columbia was being able to play records before anyone else ever heard them.

"POP ART IS JUST
COMEDY IN ART."
—placard at ICA
opening

On October 8, the night of the ICA opening, Mrs. Lloyd, chairman of the ICA, held a "supercivilized" dinner in her home. Since the poster image was Warhol's *S&H Green Stamps,* she had ordered up a blouse in S&H Green Stamps fabric. Sam Green wore a matching tie. When the Warhol entourage arrived at the ICA gallery at 9:40, flashbulbs exploded. The newspapers estimated that a thousand people had by that time packed into the rooms. "It was simply *everybody,*" said Green. "The university came to watch the Institute fail because they didn't like me. The society came because Mrs. Lloyd had worked them all up and they had to support their own place. The collectors in Philadelphia came who thought it was really fun to be on the cutting edge." Patti Smith recalled taking the bus up from South Jersey and finding that the ICA "was like slitting open the belly of a discotheque and walking in." Norman Dolph's mobile disco encouraged people to dance, as he led off with "Can I Get a

Witness" and moved into "Barefootin," "It's All Over Now," "You Really Turn Me On," and other hit records. Those who wanted to frug or do the Jerk were frustrated because there was not an inch of free space to move in the claustrophobic rooms. Estimates of the crowd eventually ranged from two thousand to four thousand people, and in the crush three people fell out of a low window and ended up in the hospital. Green recalled that he was both exhilarated and frightened. "We didn't know it was going to go that far—it was like something out of *The Day of the Locust*," he said. "There was a time when we thought we were all going to die." David Bourdon, Andy's old friend and now the *Village Voice* critic, worried that "the entire Pop Art brain trust" was going to be trampled in the melee.

The crowd seemed to want to be in touch with the celebrity that Andy Warhol and Edie Sedgwick embodied. One man yelled, "Get his clothing!" while the crowd chanted, "We want Andy and Edie!"

In that moment Edie Sedgwick seemed to possess everything—energy, charisma, looks, fluid movement, and fame. Green was amazed at her aplomb in the frenzied scene; she was in her element. She became the center of the crowd's attention because she was the only one who could respond to them.

Sam Green knew that the situation was dangerous, and he knew that Andy did not like to be touched. He maneuvered Andy and Edie to an old iron staircase that was sealed off at the ceiling, where there had formerly been an exit. Four policemen guarded the bottom of the stairs with their sticks, and Edie and Andy presided at the top. Edie was wearing dangling Kenneth Jay Lane earrings and a Rudi Gernreich floor-length T-shirt made of pink Lurex-like material, featuring outlandishly long, slinky, stretchy sleeves that rolled up at the wrist. The crowd was frustrated at every turn—no art to look at, no room to dance—and Warhol didn't do anything. His silence was not his usual enigmatic public presence; some friends noted that he was "white with fear," while others interpreted his expression as a rapturous smile. Andy had witnessed this kind of crowd reaction to rock stars, but he couldn't imagine it happening to an artist, and he especially couldn't imagine it happening to him.

Edie Sedgwick was left to carry the show alone. Someone passed up a microphone, and she spontaneously began to vamp—"Oh, I'm so glad that you all came tonight, and aren't we all having a wonderful time? And isn't Andy Warhol the most wonderful artist!" Edie's words charmed the

"I wasn't into girls or anything, but I had a real crush on her."
—**Patti Smith, on Edie**

"It was as if Mick Jagger had been stuck on the subway and discovered by sixteen teenage girls. He was pinned against the wall. I think it was the moment that Andy knew he was a star."
—**Sam Green on the ICA show**

**Opening night at the Institute of Contemporary Art,
October 8, 1965, with Edie trapped by her own celebrity**

audience. Andy, Edie, and Sam Green remained on the top of those stairs for over two hours.

Meanwhile, museum officials gave orders to break through the former exit, and an architectural graduate student, equipped with crowbars and an ax, ripped up the floor. Andy and Edie escaped through the restored exit, which led into the adjoining private library stacks, then over the roof and down the fire escape. "It was the only way out," said Sam Green. From the perspective of a moment of quiet and safety, the young director looked back on it all with great pleasure: "I was lucky, the Institute was lucky, the university was lucky, Philadelphia was lucky, Edie and Andy were lucky, and everybody won."

During the same month Warhol's retrospective opened at the Institute of Contemporary Art, Tony Conrad was walking along a Bowery sidewalk and saw a battered paperback book. Its cover bore images of a whip, a black high-heeled boot, a mask, and the title *The Velvet Underground*. He brought the book to the Ludlow Street apartment, and Lou Reed, John Cale, and Sterling Morrison adopted the name for their band. *Underground* associated them with the underground movie milieu and the bohemian and leftist attitudes of the downtown scene, and *Velvet* gave the name a kinky note, akin to the S&M images that appeared on the book jacket.

The Velvet Underground first played under their new name in Summit, New Jersey, on November 11, 1965. Pop music journalist-cum-promoter Al Aronowitz arranged a gig that took place in a high school and paid the band seventy-five dollars. Their first experience with an agent didn't work out. Aronowitz thought their music sounded "totally inaccessible." The Velvet Underground's short set of three songs was sandwiched between two bands called 40 Fingers and the Myddle Class. The Velvet Underground opened with "There She Goes Again," but when they launched into "Venus in Furs," the students gasped in disbelief. By the time they closed their act with "Heroin," the students were howling in outrage. Al Aronowitz observed that the band had "an oddly stimulating and polarizing effect on audiences." But at least one of the band members, Angus MacLise, couldn't tolerate the performing conditions. Even the measly seventy-five-dollar group payment represented tainted commercialism. "You mean we start when they tell us to and we have to end when they tell us to?" asked the outraged drummer. He quit.

Lou Reed was incensed, but the band had to find a new drummer, quickly. Sterling and Lou recalled a Syracuse classmate named Steve Tucker, whose younger sister, Maureen, played drums in the Intruders, a three-person Long Island cover band. Maureen's mother had bought her the whole set—a snare, a bass drum, a floor tom, and a beat-up cymbal—for fifty dollars, and Maureen had taught herself how to drum. There was no precedent for a female rock drummer, but she was available and had her own drums. In late November 1965 Maureen Tucker traveled from Levittown to 56 Ludlow Street. Mo, as she was called, worked as a computer keypunch person during the day and at night listened to Olatunji, Bo Diddley, and Charlie Watts on the hi-fi. She was a straight arrow: she didn't do drugs, and she didn't like bad language. Her repertoire of drumming techniques was limited—she didn't know how to do a drum roll, and her formal musical training was limited to three weeks of clarinet lessons in the fourth grade. But she was game to try, and when she heard Lou Reed sing "Heroin," she was impressed: as Mo Tucker put it, "You could just tell that this was different."

When LSD became widely available on the street around the summer of 1965, it altered not only drug fashion but also visual perception. The drug's cosmic, ego-bending effects encouraged sensory overload. Forms flowed together, bathing the senses in an orgy of color and light and ooz-

"It will shock and amaze you. But as a documentary on the sexual corruption of our age, it is a must for every thinking adult."
—cover of *The Velvet Underground*

The cover that inspired a band: The Velvet Underground. This book was found on a Lower East Side street by Tony Conrad, October 1965

ing biomorphic forms. The look of psychedelia was a far cry from the compulsive minutiae of amphetamine art.

By late 1965 forms of psychedelic expression were on view downtown. In addition to a few galleries that exhibited "psychedelic art," Robert Goldstein ran Lightforms, while Jackie Cassen and her partner Rudi Stern projected hand-painted slides at their Theater of Light evenings at the Dom.

In November 1965 Jonas Mekas organized a month-long New Cinema Festival. This grab bag of "expanded cinema" reflected his campaign to consolidate the downtown forces of dance, music, film, and theater. Running through Mekas's columns in *The Village Voice* was propaganda for "expanded cinema" as an organic, revolutionary form that was emerging. Since expanded cinema drew from a variety of historical sources—the Living Theater, music, Happenings, Fluxus, light-motion art—Mekas was able to cast a wide net for the New Cinema Festival.

Mekas included everything from performance and video to multiple projectors and hand-drawn slides, all in an attempt to surround the viewer with sound and images in an enveloping cinematic mural. "Yes, it works! It works!" exclaimed Mekas. Critic Parker Tyler disagreed. He regarded the mixed-media phenomenon as a Barnum-and-Bailey trick sold under the rubric of art. "Mixed media, as practiced, means not only film *plus* TV *plus* live actors *plus* sculpture *plus* electronics *plus* whatnot, it also means the tour-de-force of subjugating audiences with wow devices, participation flattery and snob ideologies (i.e., no-art and Pop Art cant)."

The invalidation of a critical response made "expanded cinema" ideal as ambient art. It required no thinking, just experiencing, and that led to commercial uses: a nonthinking young crowd was a large demographic.

At that moment in late 1965 there were two plans in the works to marry the psychedelic aesthetic of the light show to the discotheque environment. Such an enterprise was perfect for the growing number of young people who preferred marijuana or psychedelics to alcohol. The discotheque was still in its infancy in late 1965. The biggest discotheques were Ondine and Arthur, the East Side establishment run by Richard Burton's ex-wife Sybil. Ondine's dance floor was the size of living room, while Arthur's was about twice the size. Their runaway success and the newly popular McLuhanesque landscape of media and lights and sound spurred the development of two megadiscotheques, both scheduled to

Up: a buzzword

Up Art: Warhol's experiments with the *Silver Clouds:* "I'm doing something called clouds because it's called Up Art."
—Andy Warhol

Up There or I'm Up: Feeling the effects of speed. "Up there, but not beyond to the outer limits of reality."
—Ingrid Superstar

Uppers or Uppies: amphetamine in pill form. "I don't take my uppies anymore. I just take my pokes."
—Brigid Berlin

open in the spring of 1966. The first of these, Cheetah, was planned for the Bond's site in midtown. The second was to be housed in a huge abandoned airplane hangar in Long Island. Michael Mayerberg, the organizer of the enterprise, wanted to enlist the chic aura of Andy Warhol and Edie Sedgwick as a means of enticing people to fill the disco's seventeen thousand square feet. Mayerberg proposed that Andy Warhol show up for the opening weekends. All Warhol had to do was appear with his entourage and shoot movies. Mayerberg even suggested they could call it something like the Andy Warhol Discotheque. Andy proposed Andy Warhol's Up (a name that reflected Warhol's interest in both helium and speed).

Paul Morrissey suggested a bigger plan: Warhol should emulate Brian Epstein and sponsor a house band. Showing Warhol movies behind the band would give them a chance to recycle movies that had had very limited distribution, and maybe the combination would give people a reason to trek out to Long Island.

The Velvet Underground's first regular job began in mid-December 1965 at the Café Bizarre, on West Third Street east of MacDougal. By the time they played there—each member made five dollars a night for two sets— the Café Bizarre featured stale Greenwich Village bohemianism. There were fishnets on the walls, sawdust on the floor, and tourists drinking espresso coffee and drinks concocted of ice cream and coconut fizz and liquor. The club offered the group a chance to experiment and perform in public regularly enough to tighten up their performance. "With every show we were coming more alive," said John Cale, "like Frankenstein's monster discovering that it could walk."

During their twenty-minute sets the band played covers of other bands' songs, but the heart of the evening was the band's original songs. The Café Bizarre management forbade too much noise, and for some songs they insisted that Mo Tucker replace her drums with a tambourine. The stage was on the same level as the floor, directly abutting the tables and chairs, and the band's sound overwhelmed the long narrow room. A sailor said to them, "Play that again, and we'll beat the shit out of you." The band played it twice as loud.

The Velvet Underground's connection to Andy Warhol came about in this unlikely tourist space, the fortuitous collision of several people— Barbara Rubin, Gerard Malanga, Paul Morrissey, and Nico.

Barbara Rubin had heard the band rehearse at 56 Ludlow Street, and she believed they could be cultural heroes of a new age. In her mind, that select group included Allen Ginsberg, Bob Dylan, the Beatles, and Jack Smith. She directed her energy into exposing all of them to one another. "She saw us as spiritual men, heroes of a cultural revolution involving at first mainly sex and drugs and art," said Allen Ginsberg. "Her genius was sympathizing with everybody's desire to get together in work with their fellow geniuses." One way to give the Velvet Underground exposure was to film them.

Gerard Malanga and Barbara Rubin planned to film the group, using the 16mm Bolex camera they shared with each other. Unsure about technical matters, Gerard invited Paul Morrissey to help with the light meter. When Morrissey heard about a new band named the Velvet Underground, he said to himself, "This is too good to be true. They call themselves the Velvet Underground—for underground movies, which was just a coincidence. A strange lightbulb was going off in my mind."

When Morrissey saw the Velvet Underground, two things stood out.

John Cale, who wore an enormous rhinestone necklace above his black turtleneck, with this wonderful face and a Richard III haircut, and he played the electric viola—and I thought, "This is great!" The other was the drummer, because I didn't know if it was a boy or a girl. Nobody had ever appeared in a rock group up to that point—it's hard to believe, with how far things have come nowadays—where you had no idea if it was a boy or a girl, and it was so intriguing.

"She looked like she could have made the trip over right at the front of a Viking ship, she had that kind of face and body."
—Andy Warhol
on Nico

When the set was over, Morrissey approached Cale and suggested that Andy Warhol should be their manager. He told them about the huge discotheque that was set to open in April. "For some reason when I'm

Nico *Screen Test*, December 1965

looking for something, the first thing I see always works out for me," said Morrissey.

Morrissey told the band that their association with Warhol could bring fame and money. "There's a girl we know named Nico who made a record produced by Andrew Loog Oldham, and Bob Dylan wrote a song for her," said Morrissey. "And I think she should sing with you."

Nico had flown to New York in early November, after a brief reunion with her three-year-old son, Ari. She had no clear plan for her trip to America, but she knew she could always find modeling jobs. The first of these, advertising "Bernhard Altmann's cable stitches of baby-sized braids on rich-as-whipped-cream-cashmere," reminded Nico why she wanted to escape modeling. She arrived in New York with a small but real musical portfolio. Brian Jones brought Nico to the Factory the first time, following up on Gerard Malanga's invitation when they had met in Paris six months earlier. She gave Warhol and Morrissey her 45 single; she sang Gordon Lightfoot's "I'm Not Sayin'" and Jimmy Page's "The Last Mile" on the flip side. More intriguing was the fact that she had sung a Bob Dylan song.

When Nico met the Velvet Underground, said Morrissey, "Nico was sort of the bigger of the two. She had had one record only released in England, and she was in *La Dolce Vita*, and she was a famous model. Nico was somebody, they were nobody."

Paul Morrissey recalled that Warhol was nervous about the idea of a connection to the band. Warhol didn't know anything about contracts or managing rock bands. He had been interested in rock and roll in the abstract—listening to rock music while he painted, or singing in a back-up group. But he had no idea about management. At the time rock agents were used only by top performers, like Albert Grossman's management of Bob Dylan. Morrissey suggested, "It's a good idea that you manage them because it will make it look like art." Morrissey pointed out

Andy recognized that "what we were doing with music was the same thing he was doing with painting and movies and writing, i.e., not kidding around."

—Lou Reed

that Jean Cocteau had managed a boxer in the 1930s, offering a precedent and a tradition.

Morrissey proposed setting up a company, Warvel Inc. All money earned by the band would be directed to the company, 25 percent would be deducted, and the band would receive the rest. Warvel would be responsible for setting up gigs, paying rent, providing musical equipment, and encouraging publicity. Everyone got something—Warhol got fame in a new area, while the Velvets found a niche for themselves that didn't exist in rock and roll.

But how could Nico be incorporated into the group? The Velvet Underground were lukewarm about her single, "I'm Not Sayin'," and disliked its folk sound. "The group needed something beautiful to counteract the kind of screeching ugliness they were trying to sell," Morrissey said, "and the combination of a really beautiful girl standing in front of all this decadence was what was needed." Nico wanted to be the chanteuse for the band, even though her languid style and contralto voice were hardly suited to the driving rhythms of "Heroin" and "I'm Waiting for the Man." Reed didn't want to be replaced as singer, and Nico countered that she didn't know what to do onstage between her numbers. Lou acidly suggested that she could always knit. A compromise was reached. Nico would sing three songs, including new ones that Lou Reed would write for her. Reed would sing his signature pieces, "Heroin" and "I'm Waiting for the Man." When she wasn't singing, Nico would simply adorn the stage with a tambourine, a beautiful live mannequin.

The last of Warhol's Edie Sedgwick movies to be screened publicly was *Lupe,* inspired by Mexican film star Lupe Velez's 1944 "suicide by Seconal." The movie's action was minimal, set in Panna Grady's apartment in the Dakota. At the center of the film Edie wakes up facing a mirror, like a double baby doll in pink. Billy Linich is the only other person in the movie. He arrives in dark glasses, gold chains on his right wrist and a black ring on his little finger, smoking through a cigarette holder. He cuts her hair, in preparation for her final act, suicide by Seconal. The rest of the film is Edie alone in the beautiful Dakota apartment, nodding out at the dining table, coming alive when the music comes on. And finally, Edie, the icon of whiteness, mirrored literally and figuratively, in an all-white room, overdoses on downs, with her head in the toilet bowl.

Near the end of the year Mary Woronov visited the Factory as part of a Cornell field trip to see artists' spaces. When she arrived, she was struck by the exclusion of natural light: "It was more like a subway stop than an artist's studio." Gerard Malanga walked up and convinced her to sit for a *Screen Test,* which she recalled as a sort of baptism and a transforming experience. "Afterward, like a new convert I couldn't stop talking about what a genius Andy was; the way people's expressions changed in *Screen Tests,* making it a psychological study, the idea of conferring immortality onto unknowns, the deafening speechlessness of it. What I didn't realize was that Gerard was the silver hook of a very different fisherman, and I was being reeled in."

Bob Dylan briefly came into the Factory orbit late in 1965, largely due to the zeal of Barbara Rubin. She was determined to bring Andy Warhol and Bob Dylan together as part of her campaign of introduction in the service of the cultural revolution. Warhol was eager to shoot a movie with Bob Dylan, while Dylan's agent, Albert Grossman, was interested in Edie Sedgwick as a costar for Dylan. Rubin engineered a meeting in December.

The meeting was a disaster. "Every time they put a Bob Dylan record on, we'd take it off and put on Maria Callas," said Ondine. "And he sat there, and he sat in his chair quietly and got more and more pissed off." Dylan showed open disdain for the Factory atmosphere, which he considered faggy and decadent. Dylan sat for a three-minute *Screen Test,* and Barbara Rubin shot footage on the 16mm Bolex she shared with Gerard Malanga. When that was finished, Dylan surveyed Warhol's paintings, pointed to a *Double Elvis,* and said, "I'll take that one." His assistants carried the painting to the station wagon below and strapped it on top. Warhol turned beet red. A year later Warhol made a movie called *The Bob Dylan Story.* Meanwhile the *Double Elvis* became a dart board, and then Dylan traded it for Albert Grossman's couch.

"I love you in spite of your avant-garde self-conscious Peter Paul and Mary phony scenes/façon modeles—you are crazy. Can you give me some money? Merry Xmas Andy Warhol—the Pop Jesus Christ!"
—Taylor Mead's postcard to Warhol

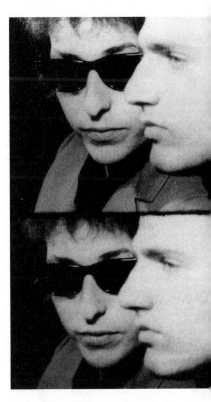

From Gerard Malanga's film *Note-books,* 1965: Bob Dylan and Gerard

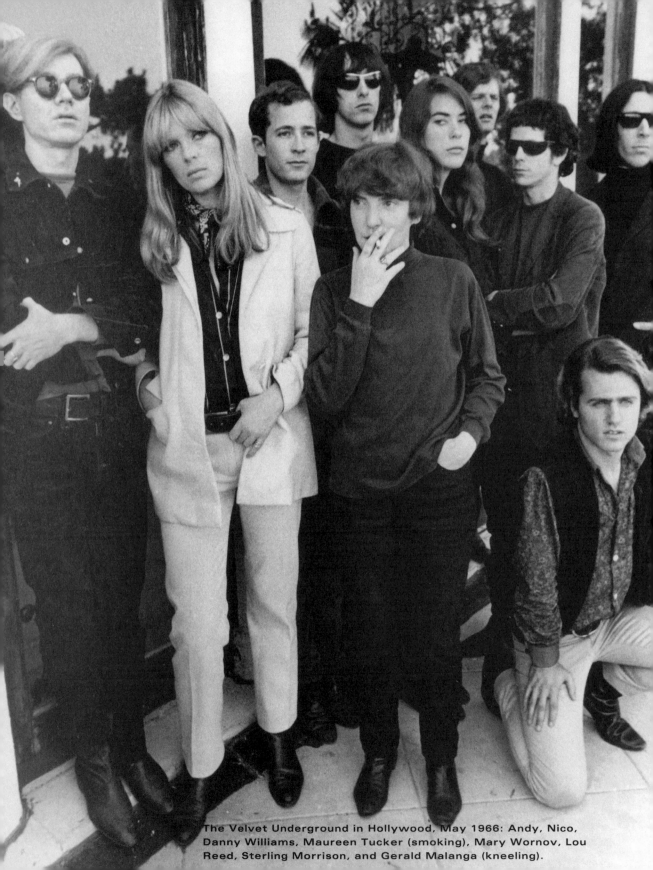

The Velvet Underground in Hollywood, May 1966: Andy, Nico, Danny Williams, Maureen Tucker (smoking), Mary Wornov, Lou Reed, Sterling Morrison, and Gerald Malanga (kneeling).

1966

In the first seconds of 1966 Andy Warhol was listening to James Brown performing live at the Apollo Theater. He had traveled uptown in a limousine with Gerard Malanga, Edie Sedgwick, and Donald Lyons, and Harlem was only the first of three stops that evening. They traveled to Danny Fields's apartment in the West Twenties, where they watched Walter Cronkite talking about Piero Heliczer's film, *Venus in Furs.* On the television screen the Velvet Underground played "Heroin." The final stop that night was 450 Grand Street, to hang out with Lou Reed, John Cale, and Sterling Morrison in their unheated apartment. Edie shivered in her leopard-skin fur coat, and Andy flipped through a magazine. It was appropriate that the first hours of 1966 connected the band and Andy's entourage; the Velvet Underground would dominate activities at the Factory for much of the year.

The band's first date was slated for January 10. Merging the band, Nico, and Gerard's dancing into a coherent entity had to be done fast.

Nico moved ahead in her characteristic way, by attaching herself to a powerful man. "She would try and do little sexual-politics things in the band," observed Sterling Morrison. "Whoever seemed to be having undue influence on the course of events, you'd find Nico close to them." She intuited that Lou Reed was the dominating power in the band and began an affair with him. "I was this poor little rock-and-roller," said Reed, "and here was this goddess." Sterling Morrison cautioned that "you could say that Lou was in love with her, but Lou Reed in love is a kind of abstract concept." The relationship

lasted all of January and broke up before mid-February, but it accomplished what Nico had hoped it would. Reed moved from the band's communal apartment into Nico's Jane Street sublet apartment where she made him pancakes. "Lou Reed was very soft and lovely," Nico recalled. "Not aggressive at all. You could just cuddle him."

During this domestic interlude Reed wrote three songs for Nico that became centerpieces of the Velvet Underground's performance. One night in early 1966 Nico said, "Oh, Lou, I'll be your mirror." He sat down and wrote her a love song, "I'll Be Your Mirror," that is both tender and searching and that evokes the narcissistic vulnerability of their connection. "I find it hard to believe that you didn't know the beauty you are," the song opens. When Warhol suggested Reed write something about Edie Sedgwick as a femme fatale, Reed wrote "Femme Fatale," which Nico sang. And finally he wrote "All Tomorrow's Parties," whose mournful folklike melody is wedded to a woman who thinks of costumes and parties. Cale observed that these "psychological love songs" added a new dimension to the band. The tenderness that entered Lou's songs seemed real and unsentimental.

When the band gathered to rehearse at the Factory one afternoon in mid-February, Nico picked up tension from Lou, and after a long pause she said, "I cannot make love to Jews anymore." In the wake of this rejection Lou ingested a combination of Placidyls and codeine that rendered him helpless. Nico could call the shots in their affair, and Cale said that "she just swatted him like a fly." But Reed always maintained an upper hand in the band, much to Nico's resentment. "He likes to manipulate women," she said. "You know, like program them." Nico doggedly held on to her somewhat tenuous place in the band, but the question of what she would do onstage persisted.

On his second day at the Factory John Cale met Edie Sedgwick and felt an immediate connection. "It was just two lonely people meeting at the Factory," said Cale. "Although desperate and on her last legs with Andy, she still possessed all the elemental magic, frayed beauty, and presence of Marilyn Monroe."

Cale moved into Edie's apartment on East Sixty-fourth Street, and they had a passionate affair that lasted about six weeks. Cale felt amazed to be in the company of such a beautiful woman, but he worried about her complete dependence. He knew she was "lost, not at all in control of what she was doing," and he was concerned at the number of prescription drugs she was taking. "She expected that I would become her nurse

and eventually be brought down by it," said Cale. "I wasn't about to get involved."

The Velvet Underground and Nico officially debuted on January 10, 1966, in an unlikely setting. Dr. Robert Campbell had invited Warhol to speak to the New York Society for Clinical Psychiatry at its annual black tie banquet at Delmonico's. When asked about his odd choice, Dr. Campbell rhetorically asked, "How can you be immune to art and the creative process? Surely you're aware of the barely visible line between genius and madness." Warhol decided that his "lecture," "The Chic Mystique of Andy Warhol," would consist of his films for visuals and the Velvet Underground for sound. That way Andy wouldn't have to talk. The experience would be called "Up-Tight" because everything Warhol did made people uptight and also because Jonas Mekas and Barbara Rubin were more actively making people uptight with their invasive Bolex cameras.

When the guests arrived in the gold-and-white grand ballroom at six-thirty, they found the Warhol entourage, including Gerard Malanga in a black sport coat and bowtie and whip, and Edie Sedgwick chewing gum and sipping a martini. Billy Linich had given John Cale a "Richard III haircut," and he wore a black suit and a stone-studded neck choker from Kenneth Jay Lane. Nico stood in a sleek white pantsuit. As soon as the group of three hundred doctors and spouses started their roast beef entrée, bedlam broke out. The Velvet Underground played full volume as Nico began singing in her unearthly voice. Gerard Malanga started his whip dance, and his partner, Edie Sedgwick, tried to sing along, but even in the din it was obvious to Gerard that she had no voice. Meanwhile Barbara Rubin and Jonas Mekas trained their cameras on the psychiatrists and screamed such questions as: "What does her vagina feel like?" "Is his penis big enough?" "Do you eat her out?" Psychiatrists rose from their tables as if they were encountering the nightmare of seeing their patients take revenge. "I'm ready to vomit," a guest complained. "I suppose you could call this a spontaneous eruption of the id," observed Dr. Alfred Lilienthal, while a psychiatrist at his table demanded to know why they were being exposed to these nuts. "Put it down as decadent Dada," said another. Andy Warhol simply bowed out of any responsibility for the event. "I have an earache, so I really can't hear," he said, "or see, for that matter."

"I never lost sight of the idea that our value lay in the sense of

Uptight:
The jittery, semi-paranoid feeling often associated with amphetamine. More broadly, a synonym for *worried:* "Don't get uptight!" Also the name given to the first multimedia event, January 10, 1966, in which the Velvet Underground, Nico, films, dancers, and film shooting were combined. "*Uptight* used to have a good connotation—you know, like Steve Wonder's song, 'Uptight,' but we changed it to mean rigid and paranoid. Hence methedrine."

—Ronnie Cutrone

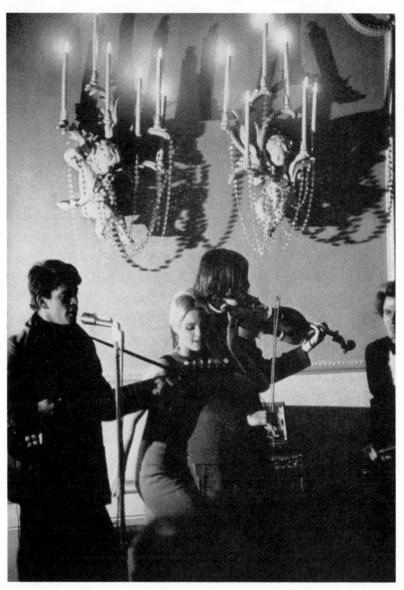

Lou Reed, Edie, John Cale, and Gerard perform in the
Delmonico Ballroom for the New York Society for
Clinical Psychiatry, January 10, 1966

strength we had established before going into the Factory," said John
Cale. He understood that Warhol was more interested in people than in
music. "He latched on to Lou because he was this creature of another
part of New York life that he didn't have at the Factory, an example of
Long Island punk," said Cale.

Cale, who was dubbed Black Jack, recalled that Reed accentuated his flamboyant gay style in this environment, and the band called him Lulu. "In many ways it was the best home he ever had," said Cale, "the first institution where he was understood, welcomed, encouraged, and rewarded for being a twisted, scary monster." Cale was initially dubious about Warhol's activities—they seemed to him a diluted version of the downtown avant-garde scene—but he soon grew to appreciate Warhol's blankly supportive style. "What Andy did was provide an intellectual location for us; everybody around us was of the same frame of mind, had the same intention," said Cale. "Although it was chaos we were after, this was a very beautiful chaos we were in."

"Music's never loud enough. You should stick your head in a speaker. Louder, louder, louder."
—**Lou Reed**

For the past year Mickey Ruskin had run no bars, and he was itching to return. When he sold his most recent ones, the Ninth Circle on West Tenth Street and the Annex on the Lower East Side, he signed a noncompetition clause specifying that he couldn't open a new club in the Greenwich Village Precinct for two years.

At the end of 1965 he had found a place just over the line from the Village Precinct, at 213 Park Avenue South, between Seventeenth and Eighteenth Streets. The former owner had started it as a pharmacy and turned it into a restaurant called the Southern. The neighborhood didn't offer the rich bohemian air of the Tenth Street Galleries or the Village. But on December 6, 1965, Ruskin signed a long-term lease for the space, with very little money down. "I was afraid it would fail," said Ruskin. "I couldn't imagine having a place anywhere but the Village."

He began 1966 by supervising the renovation of his newly leased two-story restaurant. He kept the lunchtime trade he'd inherited and added some of the followings from his former hangouts in the East and West Village. Meanwhile he tried to bring the kitchen up to speed as a steakhouse, tested different cuts of aged meat cooling in the basement, and supervised construction by a carpenter named Tex. The customers didn't mind the noise and disorganization because they felt they were taking part in the new place's birth. In the harried weeks leading up to the opening, Ruskin's artist and poet friends constantly dropped by to give support and ideas. They included Donald Judd, Frosty Myers, Neil Williams, Joel Oppenheimer, and the three Larrys—Poons, Bell, and Zox. Joel Oppenheimer came up with a name for the new restaurant. Whenever he thought of steak, Kansas City came to mind, and the rest was intuition: "If you're looking for an *M* name and you want a restau-

ranty kind of thing, Max's comes to mind." Ruskin was dubious, but after a few days of market research, trying out the sound of "Max's Kansas City" on people, he decided to go with it.

There was nothing high style about the renovation, just a rebuilt alcove area and a long curved bar area backed by Formica panels. At either end of the bar were fishtanks, and it was Ruskin's inspiration to put a piranha in each one; at the end of every day he fed them goldfish. Ruskin knew the place needed to have a cheap and friendly gimmick, like the peanuts he had served on the bar at the Ninth Circle. Oppenheimer suggested chickpeas, which Ruskin set out without soaking them. Watching customers struggle with them amused Mickey. "Fuck 'em," he said, "if they can't take a joke, fuck 'em!"

What would be on the walls? Neil Williams made arrangements for several artist friends to give Ruskin artworks in exchange for a tab at Max's Kansas City, which would include meals but not tips. "It was not part of the grand plan," said Ruskin, "but it turned out to be one of those fantastic coincidences." He didn't know much about art, but he loved having artists around, and he decided what art to display on the basis of

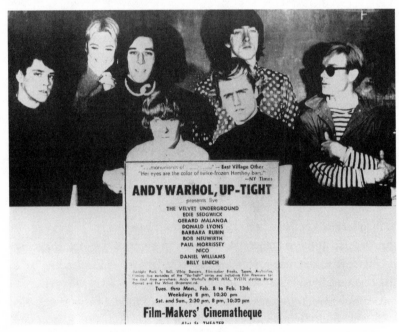

"Up-Tight," before it became the Exploding Plastic Inevitable,
advertised in *The Village Voice*, February 1966: Lou Reed,
Edie Sedgwick, John Cale, Maureen Tucker, Gerard Malanga,
Sterling Morrison, and Andy Warhol

whose personality he liked. Without hidebound art-world predilections or attention to reviews or market prices, Ruskin supported both known and unknown artists quite generously. Donald Judd and Frank Stella and John Chamberlain were on the tab, but so were lesser-known artists such as Gerald Ogilvie-Laing.

The barter's value to Ruskin was not only the panache of having cutting-edge art on the walls but the fact that the artists became regulars; it was the only place they could afford to eat in style. Lawrence Weiner observed that "one of the keys to success in running a restaurant or bar is to attract two kinds of people: artists because artists drink, usually right to their income, whether they're poor or rich—and fashion models."

At the opening-night party on January 15, 1966, Ruskin estimated that more than a thousand people came through the new space. Some were skeptical and thought it couldn't last. Would Max's be able to overcome its unlikely location? "Bars were out by then," said Barbara Rose, "and this one was off the beaten track." The drinking circuit generally ran from the San Remo to the Cedar to Dillon's to the Ninth Circle. But Max's benefited from the closing of the legendary Cedar Bar, which had been the reigning art bar. The new Cedar never caught on, and much of that crowd was siphoned off by Max's—especially since Max's was anchored by the artists who were tied to the restaurant by the golden umbilical cord of Mickey's tab.

From their debut at the psychiatrists' banquet, the Exploding Plastic Inevitable was more than a band; it became a multimedia happening. It went through several names—from Up-Tight to Erupting Plastic Inevitable to the Exploding Plastic Inevitable—and at the same time the personnel shifted as they moved from New York to Rutgers to Ann Arbor. The Edie Sedgwick contingent—Edie and Donald Lyons and Bob Neuwirth—dropped out. Barbara Rubin and Ondine went to Rutgers as dancers and never appeared with the Velvet Underground again. And in the process Billy Linich got a new name. When his name appeared on the posters, it wasn't glamorous enough and looked hard to pronounce. Once when he looked at a form that asked for his name in the blank space provided, he wrote "Billy Name." The name stuck.

The Exploding Plastic Inevitable's first road trip in March was a bonding experience for the group that included not only the band but Andy Warhol, Mary Woronov, Danny Williams, Gerard Malanga, Paul Morrissey, and photographer Nat Finkelstein, among others. The band

rented a recreational van that had its own generator. "It was a self-contained world," said Sterling Morrison. "We'd pack everyone in there and just roll." The EPI's van was an odd sight as it tooled through the midwestern towns, a Teutonic goddess at the wheel, and all the passengers dressed in black, most of them wearing dark glasses. At one point, when everyone was getting hungry and the bus was breaking down, they stopped at a drive-in hamburger stand outside Toledo, Ohio. The chubby waitress came on the bus to take orders, and everyone looked so utterly strange that she became frightened, recalled Finkelstein: "She was running face to face with the wildest bunch of animals she ever saw." After everyone kept changing their orders, the waitress reported them to the state police, who soon showed up. When they asked who was in charge, Lou Reed pushed forward and said, "Of all people—Drella!" The police came to a compromise: no one would be arrested, but the bus had to be out of the state within an hour. This instance suggests just how alien the Velvet Underground looked to middle America.

But on campuses the entourage was a hit. They had sold out two shows at Rutgers, but the real smash hit took place in Ann Arbor. The students loved the band, and during the intermissions journalists interviewed Andy about his movies and his ambition. "If they can take it for ten minutes, then we play it for fifteen," Warhol told them. "That's our policy. Always leave them wanting less."

Edie Sedgwick was not part of this tour since her position at the Factory had changed radically in late January. At that time Bob Dylan had been in New York recording songs for his next album. Edie was clearly on his mind evident in the song "Leopard-Skin Pill-Box Hat," which he was recording that month, and in "Just Like a Woman," which was recorded in early March. Both songs, widely considered to be evocations of Edie, appear on *Blonde on Blonde*.

At that time Dylan's manager, Albert Grossman, wanted to sign Edie to a contract, offering her a chance to become a real leading lady in a real movie. Edie also imagined a romance with Dylan, who harbored his own secrets. A few months earlier, on November 22, 1965, he had privately married Sara Shirley H. Lowndes, and their child, Jesse Byron Dylan, was born in January. The marriage was reported in *Melody Maker* in December. Warhol heard the news before Edie did and said, in a deceptively casual manner, "Did you know, Edie, that Bob Dylan has gotten married?" Edie grew pale.

"You could hear her screaming even when she wasn't screaming—this sort of supersonic whistling."
—Henry Geldzahler on Edie

The scene came to a climax at the Ginger Man in late January. Bob Heide, a friend present that evening, recalled that Edie was crying, telling Andy how hard it was because he wouldn't allow her to get close to him. She told him not to show her films anymore, because they made her look silly. "They're going to make a film, and I'm supposed to star in it with Bobby," she told Warhol and Morrissey. She said that Dylan was meeting her, and she had to leave. When he arrived and they went off together, Andy turned beet red. It wasn't the last time Edie came to the Factory, but the magical connection they had once felt was never the same again. When Warhol felt hurt, he never forgot.

Around the time Edie Sedgwick broke off her relationship with Andy Warhol, his relationship with Henry Geldzahler grew more distant, in part because of Warhol's involvement with Edie and the media. As Billy Name recalled, "the focus of the press shifted from the artwork to the personality, and Henry wasn't interested in that type of thing." In addition, Geldzahler had met Christopher Scott, and they began a relationship that would continue for fifteen years. Christopher Scott was a Waspy beauty who was well educated and living with his close friend, a young actor named Charles Ludlam. Geldzahler and Scott met on Christmas night 1965, at a birthday party for Jonas Mekas following a screening of Warhol's movie *Henry Geldzahler*.

> "Andy Warhol can't paint anymore, and he can't make movies yet."
> —**Henry Geldzahler**

Geldzahler spent the first months of 1966 completely inaccessible, involved in his new romance as he drove him across the Moroccan desert with Scott. When he was back in New York, the relationship with Warhol had changed. "There's nothing more depressing than calling up somebody you've been calling up for years, any time of the day or night you felt like it," Andy recalled, "and suddenly someone else is answering the phone and saying, 'Yes, just a minute.' "

There was a professional conflict as well. When Geldzahler was appointed the American commissioner to the Venice Biennale, he didn't tell Andy until just before leaving for a vacation. It had been assumed that Geldzahler would select Warhol for the exhibition, but in Geldzahler's mind the art-world politics were very complicated. His position at the Metropolitan was always tenuous because he operated in an institution that paid little attention to contemporary art (that was the mission of the Museum of Modern Art and the Whitney) and was ruled by conservative board members. The museum's director, James Rorimer, and American curator Robert Beverly Hale were supportive, but

Geldzahler was always aware of the need to also marshal support from the East Coast intelligentsia and media to push through his often-radical ideas. He wanted to succeed Hale as chief curator of American art so that he could remain in a museum he loved.

At this particular moment in 1966 Geldzahler knew that Pop Art was no longer cutting edge. Kynaston McShine had just staged *Primary Structures,* an exhibition at the Jewish Museum that suggested that the next wave was minimal art; proposing Pop was offering yesterday's news. In spring 1966 Geldzahler had appeared in a Claes Oldenburg Happening, floating on a rubber boat wearing a terrycloth robe and smoking a cigar; the resulting publicity had seemed an affront to several Metropolitan trustees, so Geldzahler felt protective about his position in the museum. He later said, "I knew that if I took Andy to Venice, I would never succeed Bob Hale."

Geldzahler's decision reflected not only art-world politics but also his growing distrust of his relationship with Warhol. He later said to Jean Stein, "The essential thing about the whole Warhol world and the reason I got out of it . . . *had* to get out of it to save myself, is that Andy's a voyeur and he needs exhibitionists around . . . which is all right. But he's also a kind of a sadist. He's a voyeur sadist, and he needs exhibitionist-masochists in order to fulfill both halves of his destiny. And it's obvious that an exhibitionist-masochist is not going to last very long. You know, you go up in a fine burst of flames and then you die out. And then the voyeur-sadist needs another exhibitionist-masochist."

Christopher Scott recalled the split that began in February 1966: "Henry sensed that he was about to be thrown away, and he decided, 'I'm going to beat him to the punch.' Henry was very objective about it. This was a duel between two old friends who knew they were going to be in conflict."

The confluence of conservative art politics and personal distrust prompted Geldzahler to organize an exhibition of four American artists. His choices were politic and balanced: Helen Frankenthaler, Jules Olitski, Ellsworth Kelly, and Roy Lichtenstein. The inclusion of Olitski and Frankenthaler was a nod to Clement Greenberg's promotion of "post-painterly abstraction." The choice of Lichtenstein over Warhol provided a safety net—Lichtenstein presented a more classical version of Pop Art, and he lacked the overlay of lifestyle weirdness that inevitably accompanied Warhol.

Geldzahler did not tell Warhol about his decision, even though they still talked on the phone. Andy found out about it from *The New York*

Times. Thereafter, when someone asked if he had heard the news about Henry, Warhol replied, "Henry who?"

The spring of 1966 proved to be a rich season for pop culture. The trends that had started downtown now spilled into the culture at large in fashion and gossip and public intermedia. Multimedia discotheques were born, as was Ridiculous Theater and the first commercially successful Warhol film. And at the Castelli Gallery Andy Warhol made his "official" farewell to art.

On March 30, 1966, Holly and Jimmy Slattery watched *Color Me Barbra* on Seymour Levy's Sylvania color TV. Another Streisand fan watching her on television was a gangly five-foot-eleven theater-struck adolescent named John Curtis Holder.

Holder's father called him Jack, and his family called him Curtis, and he introduced himself to his new friends that night as Jackie Curtis. The new name offered a way of retaining his family identity while finding a star name that was conveniently androgynous. He had just moved away from his grandmother's house because she was threatening to restrict his intake of movie magazines. In the daytime Jackie intermittently attended the High School of Industrial Arts. In his off-hours he ushered at the Winter Garden Theater in order to watch Barbra Streisand over and over again in *Funny Girl.* On weekend matinees he had haunted the stage door of *Once Upon a Mattress* in order to talk to his comedic hero, Carol Burnett.

Jackie Curtis was large-boned and red-haired and always dressed in jeans and moccasins. His grandmother had offered advice: "Don't ever let anybody tell you you're handsome—because you're tall, gaunt, awkward, scary-looking, and lucky." Jackie was imaginative and witty and talked in a kind of movie-obsessed stream of consciousness. He knew from an early age that he wanted to perform, not simply for the romantic ideal of embodying a movie star—as with Jimmy Slattery—but in the hope having of an actual career on stage. He went to tryouts as a chorus boy, an actor, a singer; he grasped every opportunity to get his name in the press; and he carefully gathered his clippings and carried them with him in a shopping bag, to show to anyone who wanted to see them.

Jackie Curtis added a new dimension to the drag friendship of Jimmy and Holly, completing the trio. They began to think of themselves

Curtis Holder, or Jackie Curtis, at sixteen, spring 1966, by Gretchen Berg

as the three heroines of *How to Marry a Millionaire.* "That was their pattern, and they even referred to each other as Schatzi, Pola, and Loco," recalled their mutual friend Ron Link. Holly was the earthy working-class girl, Candy the glamorous star, and Jackie the zany wit.

Jackie's father was a baritone singer in a gospel group that traveled through Tennessee. His parents had separated when he was a year old, and he went with his mother to New York. His grandmother, who worked as a building superintendent in a Lower East Side neighborhood, raised him. When she was widowed in 1950, she put on long false eyelashes, dyed her hair platinum, and worked as a taxi dancer at the Majestic Ballroom on Broadway in the Forties, where she earned the nickname "Slugger Ann," which remained with her the rest of her life. (Walter Winchell gave her the name when she decked two men who had been inappropriatey fresh with one of her girls.) Both her grown daughters—Jackie's mother and his aunt—joined her there, one working as a dancer and the other as a coat check girl. Slugger Ann also worked as a cook, and when Jackie was eight, she bought a bar on Second Avenue and Tenth Street and called it Slugger Ann's. It was there, in the rooms behind the bar, that Jackie grew up.

At the age of four, after seeing *Singin' in the Rain* and *The Wizard of Oz,* Jackie knew he wanted to be a movie star, to sing and dance "and have more than four marriages." He recalled a childhood feeling very out of place among the kids in the neighborhood. "I felt I was placed in a straw basket and floated down the river and just got in. By mistake." Many hours of his childhood were spent in dark places—not only movie theaters but Catholic churches, where he went with his grandmother, lit candles, and prayed that a talent scout would discover him.

Andy Warhol's second show at the Castelli Gallery opened April 2, 1966. The walls were covered with wallpaper featuring a repeating pink cow's head against a yellow background. Hovering just below the white ceiling, weightless silver pouches floated, responding to air currents and the movement of people in the gallery. These two gestures looked like Warhol's dumbest, most debased exhibition, but they resonated with other currents in the art world.

The *Cow* wallpaper looked like the ultimate expression of Warhol's interest in serial repetition—an end of the line. The image was inspired by Ivan Karp's suggestion that Warhol do something "bucolic." Karp collected paintings of cows and remarked that it was an enduring motif in

art history. Gerard Malanga found the image of a Jersey cow in a second-hand agriculture magazine. "He hated that cow at first. I had to force that cow on him. I said, 'Andy, it's got a kind of motherly quality, there's a maternal look to this cow.' " This particular cow's head resembled Borden's cow, Elsie, another figure made famous by advertising. Some critics regarded the wallpaper as a didactic statement about the dead end of painting, which simultaneously poked fun at Clement Greenberg's obsession with flatness as the absolute element of painting. "The cow ends on the line," Paul Morrissey said to Warhol. "Wallpaper never ends on the line—the line is supposed to be obscure so the image can repeat itself." Andy replied, "I know this isn't the way to do wallpaper. That's why I'm doing it this way."

Warhol's *Silver Clouds* were about three by four feet, the helium con-

Andy and Gerard install the *Cow* wallpaper,
April 1966, by Stephen Shore

tained by extraordinarily thin aluminized plastic film. These lovely airy objects reacted to everything around them—both visually reflecting things on their shiny silvery surface, and kinetically responding to actions around them.

They also reflected the art world at that moment, which was moving away from paintings that hung on the wall and sculptures that stood on pedestals. His clouds demonstrated the new attention to materials and process. (In the case of the *Silver Clouds,* the process of heat-sealing and helium-filling was everything.) In their simple shape, they echoed the purity of minimalism, as well as randomness, shininess, and technology. The *Silver Clouds* were everything and nothing. They provided the perfect medium for Warhol to reach the end of the line in the art world.

The *Silver Clouds* eluded a commercial art system predicated on ownership. Galleries were interested in selling objects of enduring shape and increasing value. Warhol's clouds were cheap—only fifty dollars apiece—but were also completely impermanent. They wouldn't stay in one place, and they required periodic refills. Billy Kluver suggested that they be sold with a ten-year service warranty, while Leo Castelli preferred to provide with each cloud a helium cylinder so that owners could service the clouds themselves. In any case, Warhol's decision to show them at Castelli was a perverse and sly refusal to behave by the rules of commerce. Ivan Karp recalled selling only a handful of the *Cow* images and a couple of *Silver Clouds.*

By the spring of 1966 the plan to feature the Velvet Underground at Michael Mayerberg's discotheque had unraveled. The band was passed over in favor of the Young Rascals, who projected a friendly image for teenagers. Disc jockey Murray the K. was a name deemed more of a draw than Warhol. So Andy's Up became Murray the K.'s World. Just after Paul Morrissey delivered the bad news to Andy at the Café Figaro, Jackie Cassen and Rudi Stern overheard them and suggested they play at the Dom on St. Mark's Place, which they had leased for their Theater of Light. "You're kidding, where?" said Morrissey.

The Polsky Dom Narodny was an East Village Polish wedding and social hall (*Dom* is Polish for "home") with a high stage on the second floor, a bar, and even a balcony. But the charmless space had no lighting system and smelled of cat urine. In 1966 St. Mark's Place was just evolving into the edgy East Village, and the only vaguely hip establishments on the block were a soda fountain called the Gem Spa and Khadejha, a

shop for African-style dresses. Paul Morrissey quickly arranged a deal with the managers of the Dom. Warhol paid about $2,500 up front to lease the hall for the month of April.

Just in time to meet the Monday deadline for *The Village Voice*, Warhol, Morrissey, and others created an advertisement that was artless and impromptu. Morrissey glanced at the liner notes of Bob Dylan's *Bringing It All Back Home* LP, which Barbara Rubin had left behind in the Factory. Three words—*exploding, plastic,* and *inevitable*—popped out. Suddenly the whole experience—the dancers, the music, the lights—had a new name. The advertisement popped the perfect 1966 question: "DO YOU WANT TO DANCE AND BLOW YOUR MIND WITH THE EXPLODING PLASTIC INEVITABLE?!!"

The *Village Voice* ad promised "Live Music, Dancing, Ultra Sounds, Visions, Lightworks, Food, Celebrities, and Movies: ALL IN THE SAME PLACE AT THE SAME TIME."

On Friday afternoon, April 8, Warvel Inc. signed the contract leasing the Dom, and that same afternoon at three o'clock the band moved their equipment in. From the Factory Billy and Andy and Gerard and Paul transported five projectors and five carousels of multicolored slides from Jackie Cassen and Rudi Stern. They also brought the revolving mirrored ball that usually lay on the floor of the Factory. Gerard Malanga started painting the back walls white, so that the films and slides could be projected cleanly.

By eight o'clock that Friday evening, a huge crowd had shown up at the Dom: 750 people paid the $2.59 admission fee, and the rest were turned away. Inside, Ondine and Brigid Polk circulated through the crowd and gave friends and acquaintances pokes of amphetamine. Morrissey and Warhol stood in the balcony, taking turns at projecting silent black-and-white films—including *Vinyl, Eat, Sleep, Kiss,* and *Harlot*—on the freshly painted wall behind the band. Warhol had punched holes in colored gels mounted in slide frames—five carousels' worth—so that colors and shapes kinetically popped around on the films. Meanwhile strobe lights flashed on and off, leaving a ghostly afterimage. The looming silent movies became another layering element. Jonas Mekas noted that the Exploding Plastic Inevitable were not the only intermedia performances at the time, but they "provided the most violent, loudest, and most dynamic exploration for this new art."

The variety of light effects did not spotlight the band, which neither moved nor spoke, and the dancers became the most visible stars of the show. Cale privately thought the dance routines were idiotic, but they

"In the Dom, the 'house band' finally found a house."
—Andy Warhol on the Velvet Underground

"Between twenty and ageless . . . with the mind of a child and the looks of an archangel."
A *New York Times* reporter on Nico

relieved the musicians of the pressure to do anything but play. The band dressed in black dungarees, black leather jackets, and high-heeled boots, and they soon began wearing dark glasses because the barrage of strobe lights and colored projections could be blinding. "I'm sure everybody thinks that was our scheme—we all wore black and wore sunglasses so we'd look eerie and sinister," said Mo Tucker. "But it wasn't that at all. That's just the way we were anyway." Turning their backs to the audience, the band members rendered themselves nearly invisible in the visual and aural overload.

Once adjusted to the initial sonic blast of the Velvet Underground, the listener at the Dom could hear the undertones of R&B, improvisation of free jazz, and the mystical drone of La Monte Young. But these roots had been abstracted, stripped down to the essential riffs and rhythms of rock and roll, and utterly transformed in the process. Gone were the feel-good melodies associated with hot dates and fast cars, gone were the dance rhythms of sock hops; these songs were distressing, loose, and dark. Reed told a reporter during the run at the Dom: "Let 'em sing about going steady on the radio. Let 'em run the hootenannies. But it's in holes like this that the real stuff is being born. The universities and the radio kill all that, but around here it's alive. The kids know that."

Propelled by an overwhelming sound, the music showed the continuity between art and violence, the thin line between order and chaos. Reed's driving vocals met onslaughts of feedback from John Cale's viola. "John and Lou would go off into space, and there needed to be something grounding the whole mess, and that was Sterling and I," said Mo Tucker. Tucker recalled that she had to watch Lou's lips to know where they were. She pounded her mallets so hard that the head of the bass drum repeatedly broke. "I'd go 'boom,' and my arm would go right through it," she said.

Gerard Malanga coordinated the dances for the Velvet Underground and invited Mary Woronov to be his primary partner onstage. Other dancers would come and go—Ingrid Superstar, International Velvet, Ronnie Cutrone, Eric Emerson—but Mary and Gerard were the dance couple that embodied the Velvets' look. Gerard had thought about dance routines since the high school days of *The Big Beat* and more recently when he and Baby Jane Holzer had danced with the Fugs, introducing a dance called the Gobble. Since early adolescence he had self-consciously tried to create a "look." For the Dom shows he wore skin-tight black leather pants, a Marlon Brando T-shirt, and bleached hair, and his favorite prop, a whip, became a Velvet signature. One afternoon at Ken-

"It was the only thing that ever, ever swept me off my feet as music since early Mahler. They were a revolution."
—Danny Fields

"They were like audio-sadists, watching the dancers trying to cope with the music."
—Andy Warhol on the Velvet Underground

Dancers with the Exploding Plastic Inevitable: Eric Emerson leaps and Ronnie Cutrone watches, 1966, by Stephen Shore

neth Jay Lane's jewelry studio, Malanga saw studded leather arm bands. "Help yourself," offered Lane, and Gerard grabbed several, along with a Celtic cross and the silver snake choker that John Cale would wear onstage. "The Velvets wore all KJL jewelry," said Malanga. "It was very chic."

Knowing that a whole evening of the same dance routines would become monotonous, Gerard created scenarios for each of the songs. He described them as "free fall dances" with mininarratives and props. To illustrate "Heroin," Malanga did an elaborate routine of tying up with a belt and injecting himself with a ball-point pen. While the Velvets sang "I'm Waiting for My Man," Gerard sat on a wooden crate and lifted Andy's dumbbell weights. For most of these dances Mary Woronov followed Malanga's lead. "I invented my own way to complement him, and it worked," she said. "There was no Balanchine guiding us, just amazing intuitiveness."

Mary Woronov towered over him, thin, strong, dominating. She created rock-and-roll images that were completely unlike those of go-go girls. After her dancing experience at Leonardo's bar in Ithaca, she felt at

"I was using it as an apparel decoration; I thought how neat to have this little whip tied to my belt. . . . I got this idea maybe from seeing Lash Larue movies as a kid. I didn't know what S&M was."
—Gerard Malanga

Gerard doing his whip dance with the Velvet Underground, 1966, by Stephen Shore

ease in front of a crowd, and she was relaxed with Gerard, too. He had dressed her, taught her the routines, handed her a whip, and transformed her into a beautiful dominatrix. She recalled:

Not that I knew about S&M. You had to go to a porno store in some grimy ghetto to find a Bettie Page book. . . . We were the only band that said, this is sexy and hot. We were the only people who were saying, this is not sick, this is fun, this is good for the soul. . . . I don't know how Gerard knew this, but he took a passive role and gave me the active role. He was always on his knees to me with his head bowed, and I was always above him. We were female/male, but I was never hanging on him, the roles were switched."

The dancers exemplified the ad hoc nature of the Velvets' performance, using whoever was around to add to the stew. "If these first shows were better, it's because it was easier to do them, we had the stuff there, had our people there, endless volunteers," said Sterling Morrison. "Anybody who wanted to do anything could do it."

Flanked by John Cale on her left and Lou Reed on her right, Nico stood center stage for her few songs, spotlit in a white pantsuit. She didn't move, she didn't smile, and her face betrayed little emotion or connection to the audience. Her blond flaxen hair, her six-foot body, and her pale, fine-boned face provided a focus for the audience's attention:

beautiful and otherworldly, the Dietrich-Garbo Überchanteuse. She gave the performance a Weimar undertone, prompting one critic to call it "I am a Camera cum Junkie," while another described her as the Julie Christie of the underground. When Nico hovered over the microphone to sing, out came a strangely unisex voice, mournful and low, stretching the words. But Nico was not happy with her position center stage—she felt like a mannequin. "I was a model on the stage," she said. "I was doing the same thing I had done for ten years, and I was sad because it was not a development."

Those three weeks at the Dom became a participatory nonstop party. Barbara Rubin invited Allen Ginsberg to join in, and he would chant Hare Krishna; Walter Cronkite and Jackie Kennedy stopped by to see what was happening with the new generation; and TV crews showed up. The poet John Ashbery, who had been away in Paris during the rise of intermedia, found himself utterly disoriented. "I don't understand this at all," he said, and burst into tears. En route from Houston to Paris a young dapper man named Fred Hughes went to the Dom, and when he saw Nico, he could hardly believe that he was now in the presence of the girl he had fallen in love with in *La Dolce Vita*. He lost no time in telling his friends the de Menils, "There is only one rock group—the Velvet Underground."

"We all knew something revolutionary was happening," Warhol said. "We just felt it. Things couldn't look this strange and new without some barrier being broken." During one of her moments off stage Nico stood with Andy in the left corner of the balcony and looked down on the crowd. She saw a sea of bobbing figures in gold miniskirts and colored mesh, Paco Rabanne dresses covered with plastic disks, bouffants and flips and ducktails, bell-bottoms and dresses that ended far above the knee, vinyl, feathers, and suede. On this crazy-quilt of 1966 fashion played pulsating strobe lights in different colors. It was the ultimate derangement of the senses. Nico turned to Andy, manning the projectors, and said, "It's like the Red Seeea, paaaaarting."

After the success of the Velvet Underground and Nico at the Dom, the group wanted to cut an album. Since taping a rehearsal nine months earlier, the band had coalesced musically, and it now had Paul Morrissey's organizational drive and Warhol's name. Instead of recording a demo and waiting for a corporate executive's permission to go further, the band would make the record themselves and offer it as a finished product.

Eric Emerson (1944–75) came into the Factory orbit through the EPI performances at the Dom in April 1966, at the age of twenty-two. He grew up in a working-class New Jersey family, performed with the New Jersey Ballet, and worked as a hairdresser. He was married; his father considered him "a little sweet," and Eric responded, "What he don't understand is that my generation can swing both ways." Emerson would be cast in *The Chelsea Girls*, *Lonesome Cowboys*, and *San Diego Surf*.

"He's real quick, incredibly quick. I'm very slow."
—**Nico on Lou Reed**

"It was fun to see the Museum of Modern Art people next to the teeny-boppers next to the amphetamine queens next to the fashion editors."
—**Andy Warhol**

Warhol approached Norman Dolph, the mobile deejay who had played the records at the ICA exhibition in Philadelphia. Dolph worked for Columbia Records and had a few connections. At the small meeting Dolph recalled that "Morrissey was the spark plug. He said about ten words for every one and a half of Andy's." Warhol put up $800 and Dolph put up $600 for studio time and half-inch tape, with an understanding that Dolph would give Warvel Inc. the master tapes in exchange for a small Warhol painting. Dolph approached his friend John Licato at Scepter Records Studio, located on the fourth floor of what later became Studio 54. It was an active studio, state of the art circa 1962, popular for recording gospel and rock and roll, and it had recently upgraded to a four-track recording system in order to record Dionne Warwick.

Over a few days the Velvet Underground and Nico recorded during moments of unused studio time. Warhol came to recording sessions and sat in the tech room with his tape recorder and said very little. "There was no question that John Cale was the musical one—he was the one who would talk about chord changes and E-flat," said Dolph. "Everybody else was playing out of the place they were playing from." When Nico was ready to sing her song, she was treated in a way that looked to Dolph like "a delicacy and respect that was strange in this whole conflagration of stuff going on."

Dolph, who had no recording experience, made sure that the sound mix sounded about right and that nobody touched any knobs. But the musical judgment about what were the best takes was strictly Lou Reed and John Cale's. Dolph recalled, "The people from Scepter heard this going on and thought, 'Someone's wasting their money.' "

When their studio recording time was up, they spent a day mixing, and they were finished. All they needed was a record label. Norman Dolph sent reference acetate tapes to a Columbia executive, who responded in a memo. "It was corporately worded," Dolph recalled, "but between the lines you could hear someone saying, 'What the fuck is this?!?!' "

Warhol paired his art opening of *Silver Clouds* with the premiere of *My Hustler*, which had been in the can for a strangely long time. "See sea, sand and sin in MY HUSTLER," said the advertisement in *The Village Voice*, describing the movie as a "devastating scrutiny of socio-sexual mores." Nowhere are homosexuals or gay people or camp or any of the other code words mentioned, but *My Hustler* became a seminally important

gay film. It took in four thousand dollars during its first week at the Filmmakers' Cinematheque, becoming one of the Cinematheque's most popular films, and it was certainly the first openly homosexual film to bring in such money. Its subject matter was taboo, but it was aesthetically fairly straightforward, and far fewer would have trouble "getting it" than with any other Warhol film thus far.

The same week *My Hustler* opened, Vivian Gornick's article "It's a Queer Hand Stoking the Campfire: Pop Goes Homosexual" dominated the *Village Voice* cover. Her piece was among the first to identify a trend: homosexual domination of Sixties pop culture. Fashion had always been gay-dominated, but around this time Robert Riley, a leading design consultant, said, "Trends in men's clothes are set by adolescents and homosexuals because they are the most overtly sexual people." Pop had always been identified with camp, which was often a code word for homosexual. The Judson Poets Theater tried to avoid the term—"wacky not campy," they instructed. But it was nonetheless through the odd vessel of camp sensibility that homosexuality emerged as a transformer of pop culture. Camp had been made intellectually fashionable by Susan Sontag's essay "Notes on Camp," published 1964, when discussions of "high camp" and "low camp" and "conscious camp" and "unconscious camp" filled cocktail conversations and academic journal articles.

In the spring of 1966 Sontag told a Columbia University audience, "I think camp should be retired," and two months later Joyce Haber wrote a "Sunday Calendar" column in the *Los Angeles Times* on "Grounds for Belief Camp Is Old Hat." The fact that camp was even discussed in such disparate venues suggests how a once unspoken sensibility was penetrating American culture.

The most radically aggressive performance style at that moment was the Play-House of the Ridiculous, which incorporated camp and went far beyond. A double bill of plays by Ronald Tavel opened on April 21, 1966: *The Life of Juanita Castro* had originally been a Factory movie, and *The Life of Lady Godiva* was created expressly for the theater. Their spring 1966 production marked the beginning of a company with its own theater in a second-story photographer's studio at 13 West Seventeenth Street. It lacked a stage and lighting equipment, and it wasn't up to current building code, but the pressed-tin ceiling was charming, and its space could squeeze in a hundred people, and the rent of a few hundred dollars was affordable. The new company leased it for a few months, and

Bill Walters came in and concocted a handmade lighting board. He erected a platform stage, created a wing on the left side, and transformed a bathroom into a unisex dressing room. Jack Smith designed the extravagant costumes, and they were executed by Tavel's mother and aunt, credited in the program as "Fran and Flo."

When New York City officials ruled that the Ridiculous couldn't run a theater without a license, the Ridiculous crew came up with a simple solution. They changed their name from "Theater of the Ridiculous" to "Play-House of the Ridiculous Repertory Club," and instead of paid admission, they asked for a two-dollar "suggested contribution." They ran Thursdays through Sundays at eight-thirty, advertised under "club notes," and managed to evade New York City's technicalities. The program promised that future productions would include *Screen Test* and *Indira Gandhi's Daring Device*.

Parading across the tiny stage in *The Life of Lady Godiva* were a shoe fetishist, a fat sheriff, a local S&M nobleman, angels, and a lewd horseman. There was also a chorus of singing nuns, whose hit song, "Morning Horniness," was sung in counterpoint to a chorus of angels.

In these first "official" Ridiculous productions, the hallmarks of the Ridiculous style were already apparent. The casts, for example, drew not only from New York's pool of trained actors but also from natural unschooled performers. Ron Tavel described them as "the crazies coming off the street who are so phenomenal that when you see them walking down the street, you say, 'That person has to be onstage: they were born to it.'" These neophytes offered director John Vaccaro a group to mold into his own stage vision, fueled by the fresh intensity of amateurs.

In its April 25, 1966, issue *Newsweek* presented a special lifestyle section about the Pop explosion. Pop fashion was becoming big business. Ivan Karp, identified as "the Sol Hurok of pop," reported a booming art market, where Pop works that sold for $500 five years before now went for $8,000. Advertising began to simulate Pop paintings and images. The fashion director at *Harper's Bazaar* estimated that Pop style was responsible for more than 10 percent of the current fashion, virtually all of it directed toward the 18-to-25 market.

In the spring of 1966 Diana Vreeland, editor in chief of *Vogue*, chose a photograph of Jean Shrimpton in a bizarrely styled Dynel wig and colored plastic earrings for her next cover. That same spring Mildred Custin, president of Bonwit Teller, became alarmed at the inroads made

by tastelessness into the high-level fashion houses of Paris and Seventh Avenue. Jackie Kennedy was shortening her dresses, and by the end of the year she had raised her hem several inches above the knee, giving a sort of permission for older women to wear miniskirts.

Paraphernalia was New York's most Pop clothing store, and twenty-four-year-old Betsey Johnson was regarded as the brightest designer in American ready-to-wear. Her designs included simple T-shirt skirts and miniskirts, textured stockings, primary color designs, supergraphics, and almost anything in vinyl, from a hat to a bathing suit. "You'd spray with Windex rather than dry-clean," said Johnson. "We were into plastic flash synthetics that looked like synthetics. It was 'Hey, your dress looks like my shower curtain!' The newer it was, the weirder—the better."

Like limited edition artworks Paraphernalia's product was not mass-produced, and when its life was over (after a few weeks or months), it went out of the store. Keeping up with the speed of change in 1966 was an incredible challenge. "If a dress is sold out today," recalled Johnson, "you can get a knock-off: you can get it somewhere else. It is *nothing* like

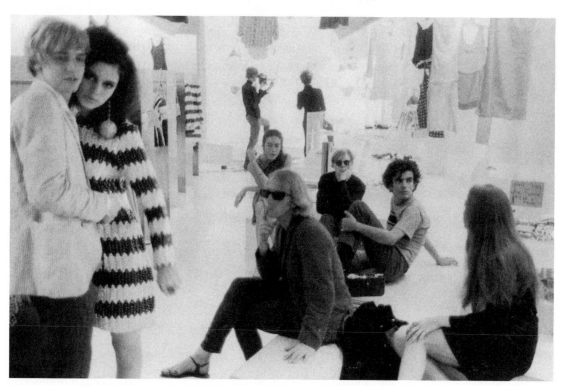

At the opening of Paraphernalia, Madison Avenue and Sixty-sixth Street, fall 1965: Rene Ricard, Susan Bottomly, Paul Morrissey and Edie (in background), Mary Woronov, Andy, Ronnie Cutrone, Eric Emerson (in foreground), and unidentified woman, by Stephen Shore

it was then. I felt the customers at Paraphernalia were looking to our clothes as passports to a new age, a new birth."

"For centuries, haute couture was based on the tastes of the aristocracy," said Rudi Gernreich, designer of the topless bathing suit. "Now all styles stem from the people, particularly the young." When the Twist geared up in the mid-Sixties, high fashion offered short black cocktail sheaths made of *peau de soie* that worked even for twisting at the Peppermint Lounge. But that kind of adaptation—elegant materials and handcraftsmanship and as much taste as the situation allowed—was thrown out the window for the oncoming discotheque age. Designers were exploring new industrial materials for clothes—they were cheap, they were Sixties, they were art.

After she broke off with Andy Warhol in early 1966, Edie Sedgwick spent time holed up with her boyfriend Bobby Neuwirth in Woodstock. She later told Gerard Malanga that she needed to get away from the frenetic world of publicity for a full year. But she returned to New York after a few months. She hoped to model, although as always she had few professional aspirations beyond supporting herself to maintain financial independence from her family. Gloria Schiff, a senior editor at *Vogue,* recalled her extraordinary promise as a model. When Edie arrived at her office in blue jeans and a pea coat, Schiff considered it *unsoigné* and noted that Edie used too much makeup. "While an angular and unmoving face benefits from makeup," Schiff said, "Edie had a face that wasn't a canvas; it was moving all the time. It never stopped."

The *Vogue* crew stripped Edie of makeup and applied mascara, blush, and lip gloss. When the photographer, Gianni Penati, flirted with her, she loosened up and giggled, and the *Vogue* editor could suddenly imagine her possibilities: "You realized what wonderful things could happen to her as a model or a star . . . visualizing her dressed in different outfits or in other locations. There was a tremendous range in how she looked and the way she projected." Years after Edie's death Schiff looked through those photos and said, "Her face and her looks in these pictures are totally contemporary. They could appear in any fashion magazine tomorrow." When Diana Vreeland saw the pictures, she exclaimed, "We've got a star!" and planned to devote a whole issue to her.

But the deal collapsed, mostly because they feared her reputation as a drug user and a wild party girl. "She almost did become part of the family at *Vogue,*" said Schiff. "If that had happened, she would have had

Edie in *Vogue*, March 15, 1966, by Gianni Penati

tremendous protection. Edie's timing was just a fraction off." The niche that Edie could have filled was quickly identified with Twiggy.

Another passport to the new age was the discotheque, mixing sexuality and light and fashion and sound. As intermedia became more public, the aesthetic moved toward psychedelia, and the emotional temperature rose. Before it found its political focus, the youth revolution was a big rock-and-roll show delivered under the influences of psychedelics and hormones.

The month of April 1966 had opened with the Velvet Underground in the makeshift Dom, and it ended with the explosion of a high-tech discotheque in midtown. The new clubs were often alcohol-free, as the customers were more likely to use marijuana and amphetamine as their drugs of choice. The most elaborate discotheque was Cheetah, on Broadway and Fifty-third Street, where everybody, according to *Life,* looked like "a kook in a Kubla Khanteen."

The three thousand colored lightbulbs dimmed and flicked and popped into an infinity of light patterns, reflecting off shiny aluminum sheets. Cheetah held two thousand people and offered not only dancing but a library, a movie room, and color television. "The Cheetah provides

the most curious use of the intermedia," wrote Jonas Mekas. "Whereas the Dom shows are restricted (or became restricted) to the In-circle, Cheetah was designed for the masses. An attempt was made to go over the persona, over the ego to reach the impersonal, abstract, universal."

On February 6, 1966, at a party in Robert Rauschenberg's Pearl Street studio, Leo Castelli gestured for Gerard Malanga to come to his corner of the room to meet a young woman. Her image was irrevocably stamped in Gerard's mind: she was tall, her hair was pulled tightly into a stylish bun, her unflinching eyes seemed to glow, and she wore purple velvet. From the beauty mark on her right cheek, Gerard immediately recognized her as a fashion model. Castelli said, "Gerard, this is Benedetta Barzini; Benedetta, Gerard." These simple words initiated an intense romance and would become the dedication to Gerard's book of poems.

Not long after, on Gerard's twenty-third birthday, poet Rene Ricard introduced him to a beautiful seventeen-year-old Brookline debutante named Susan Bottomly. (She was the daughter of the prominent Boston lawyer who was largely responsible for the capture of the Boston Strangler.) When she had seen Edie's photo in *Vogue,* she said to herself, "This is the image that represents the way I feel." At her coming-out party Susan made a wish that she could become a Warhol superstar.

Gerard immediately envisioned Susan Bottomly in this role, and before his visit was over, he filmed a portrait of her. She sat before a mir-

> "She was a seventeen-year-old in a twenty-one-year-old body."
> —Gerard Malanga on Susan Bottomly

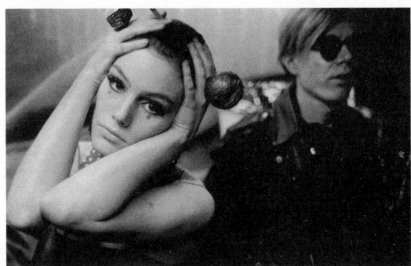

Susan Bottomly and Andy, 1966, by Stephen Shore

ror, applied makeup, and drank. (One could describe it as *Poor Little Rich Girl* meets *Drunk*.)

A few days later Susan Bottomly and Gerard Malanga took a train to New York and settled into the Chelsea Hotel. At the age of sixteen Susan had already appeared on the cover of *Mademoiselle* and signed up to be a model with the Eileen Ford Agency. Gerard was pleased to introduce her to Andy. "I was conscious of making the first film of Susan Bottomly, and in a sense I was making my own superstar discovery," said Gerard. "That was a very conscious feeling. So that when I returned to New York, I could say, 'She's already appeared in one movie. And it's my movie.'"

A few days after coming to the Factory, Susan Bottomly sat for a *Screen Test,* and it quickly became clear that she might become the superstar of 1966. She was soon given her Factory name: if Elizabeth Taylor = *National Velvet,* then Susan Bottomly = International Velvet.

After their pulsating success at the Dom, the Exploding Plastic Inevitable were quickly booked in Los Angeles, at the Trip, a hip club on the Sunset Strip. A boomlet of publicity greeted the twelve-person troupe as they arrived in a land never seen by most of them but richly imagined.

But the West Coast trip felt foredoomed. "From the moment we landed in Los Angeles on the last day of April," Cale said, "we sensed something was wrong." On the way from the airport the Mamas and the Papas filled the AM airwaves with "Monday, Monday," and the group was immediately struck by their own oddity at the moment. This was the onset of Flower Power, grooviness, psychedelic poster design, organic food, hippies, and love and peace. The drugs of choice were not amphetamine and heroin but marijuana and LSD, and the mood was as euphoric and innocent as the Velvet Underground was downbeat and experienced.

"The mentality of the West Coast was so vapid and directionless. Our attitude was one of hate and derision."

—**John Cale**

"It will replace nothing, except maybe suicide."

—**Cher Bono on the EPI**

Several celebrities—including Sonny and Cher, Ryan O'Neal, and Mama Cass—showed up for opening night. Most influenced by the evening was Jim Morrison, who adopted Gerard Malanga's S&M look and dancing style for the Doors, the band he was just starting. Morrison had his first look at Nico, who would later be his lover.

The Los Angeles newspapers didn't know what to make of the Warhol phenomenon, and they resorted to humor and stern moralism in about equal measure. In a parody piece entitled "Andy Peacepimple Puts a New Complexion on Night Life," columnist Art Seidenbaum took the humor route. The band was called "The Ever-Imploding Lead Bal-

loon," Nico was identified as "a blond Nordic standing three-way lamp, turned on dim," and the movies were "slices of nonlife." But Seidenbaum's final lines blew the cover off the facetious humor that dominated the article: "What Peacepimple offers is neither art nor order but contempt, contempt, which is death by negation. This is his night; the underground goes west; the put-on, put-down, put-over is national."

Paul Jay Robbins, the critic for the alternative *Los Angeles Free Press,* presented the experience without a dash of humor and ended: "I had come through an intense spatter of nihilism—the peculiar brand of it so fashionable in New York circles—with a renewal of energies. Warhol's show is decadence, clean as a gnawed skull and honest as a crap in the can. It is only an extrusion of our national disease, our social insensitivity. We are a dying creature, and Warhol is holding our failing hand and sketching the carcinoma in our soul." The West Coast–East Coast bifurcation now had its rock component; the western journalists and customers thought they were seeing a musical version of *The Decline of the West.*

On the third night the Velvet Underground's gig was cut short through no fault of their own. Caught in a quarrel between club managers, the club was shuttered, and their engagement ended. (The phone operator at the club suggested people instead try Johnny Rivers at the Whiskey À Go Go.) To receive the balance of what they were owed by their contract—over three thousand dollars—the group had to file a claim with Local 47 and stay in Los Angeles. But just hanging out was not what any of them wanted to do. Dormant tensions began to fester.

In those days motels and hotels did not allow rock-and-roll bands to stay, so Paul Morrissey had booked the Castle, a five-hundred-dollar-a-week two-story faux-medieval house near Griffith Park that was in such a state of ruin that further damage would elude notice. Lou and Nico got the best rooms. Mary Woronov decided she wanted to stay at the Tropicana instead of sleeping with Gerard at the Castle. "I swear I saw a flicker of triumph in Andy's eyes, while Gerard's stare radiated such betrayal I started to burn," she later wrote. She knew that Gerard would pick up girls, but she didn't want to be around for this phase in their relationship. "Suddenly we became estranged, and we were only performing together onstage," said Mary. "And it was very painful for me." Woronov slept in a bed with Maureen Tucker, who, she recalled, "was so frightened she wore her entire wardrobe to bed every night." An attempt by roadie Frank Faison to cheer them up by taking them to Venice Beach utterly

failed. No one got out of the car. They just looked out the windows at the Pacific Ocean.

At the opening of Andy's *Silver Clouds* at Irving Blum's Ferus Gallery, Andy stood in a corner watching people bump into his floating sculptures. There were two things on the walls: a large photograph of Warhol, and Billy's photograph of one of the silver clouds floating away from the Factory roof. "Oh, aren't they beautiful?" Andy said. The Velvet Underground thought the *Silver Clouds* were ludicrous. "We knew that the real reason for those clouds was to take them up on the roof of the Factory and let them float away," wrote Woronov. "In the gallery I thought they were sad, trapped in that hot little room."

After waiting around for three weeks, the twelve-member team headed north for San Francisco. Bill Graham had pleaded with them to play at his Fillmore Auditorium. In the process of building up its reputation, he was starting to import groups to mix with the former program of only local bands. Bringing in Andy Warhol and the Exploding Plastic Inevitable served his mission to prove that San Francisco was not musically isolated.

The Exploding Plastic Inevitable were already skeptical about San Francisco's music scene, and their relationship with Bill Graham was rocky from the outset. Graham's light show consisted of a slide with a picture of the moon, and a camera obscura with glass in a bowl that created an amorphous goo floating across the wall. That was all. The EPI informed him that they did not consider this a light show, and Danny Williams organized a new one.

Morrissey's acidic brand of running commentary cheered the band in their dispirited state. "Paul had become our hero in L.A. because he could never open his mouth without trashing everything," recalled Mary Woronov. "He'd roll down the window and yell at the hirsute passersby, 'Get a haircut!' " He called the Fillmore the Swillmore Vomitorium, and he made provocative cracks about the inadequacy of the West Coast bands and their pathetic light shows. Pointing to a group onstage, he wryly commented, 'Why don't they take heroin? That's what the really *good* musicians take.' " Graham may not have grasped the levels of irony in Morrissey's statement, but he knew that he was being attacked.

The Velvet Underground headlined the program, which was called *Pop-Op Rock* and featured Frank Zappa and the Mothers of Invention as well as a third band, recently formed, called the Jefferson Airplane. All the bands fed off the publicity provided by Warhol's celebrity, whose

SF/West Coast Bands:
The Charlatans
The Electric Train
Big Brother and the Holding Company
The Jefferson Airplane
Quicksilver Messenger Service
The Grateful Dead

"They call this a *light show*? I'd rather sit and watch a clothes dryer in the Laundromat."
—Paul Morrissey

name appeared on the poster above the bands' names. Graham was astounded at the number of people who showed up.

At that moment both the Velvet Underground and the Mothers of Invention were about to sign contracts with Verve-MGM, fostering sibling rivalry between the two. Frank Zappa announced over the microphone that the Velvets "really suck." A member of the audience during that engagement recalled the nascent hippies cringing while the Velvets played. "No one knew what it was," said one audience member, Rosebud Pettet. "People thought that consciousness could only be raised by talking about enlightened or political subjects. And not by talking about whipping each other and taking really bad drugs. They scared the fucking socks off everybody." Some of the Fillmore regulars left after an hour and wandered around the lobby muttering about bad trips. A young critic named A. D. Coleman wrote:

> The audience for that event was not composed of New York's middle-class culture-hound intellectuals hell-bent on displaying their avant-garde cool; these were happy young people out to have a good time listening to music and dancing. That the Warhol entourage turned them (and me) off completely suggested to me that, taking away all the bullshit about the role of the artist and his battle with society, Andy Warhol and associates are out to put the world on a bummer.

At the end of the Velvet Underground's second and final performance, they played "European Son" and leaned their instruments against the amplifier. In the course of the song, Cale hit the cymbal in a way that caused it to hit Reed's head, and the band walked off the stage, leaving the instruments' feedback blaring through the auditorium. "San Francisco, of course, didn't even know the set was over," deadpanned Mary Woronov. Bill Graham pulled the plug and then stormed backstage, screaming that the band was fifteen minutes short.

After the final show in San Francisco, Malanga and Reed went to a neon-lit all-night coffee shop, and Malanga laid his whip on the table while getting food. When he returned to his table, two policeman greeted him and asked him to step outside. "As soon as I got outside, they threw me up against the wall, handcuffed me, threw me in the backseat of a police car, and drove me off to the police station," said Malanga. "I felt like my life had been taken away." When they told him he was being arrested for carrying a concealed weapon, Gerard scoffed, "That's a big

whip, there's no way of hiding it." Malanga spent a night in jail. His court appearance caused a complication in the return plane ticket, and Andy didn't want to pay the extra fare. Gerard recalled it as one of Andy's power plays. Mary Woronov threatened to stay on the West Coast with Gerard if Warhol didn't pay the extra fare. As they waited for the plane to board, the huddled group felt undiscovered and unhappy. "We were retreating from California like Napoleon from Russia," wrote Woronov, "in utter defeat."

In mid-June, after Andy Warhol and the entourage returned to New York, he was worried about money. The films he had already made—and there were now more than three hundred—cost money, even though he had paid no one. Ivan Karp noted that there was little in his art sales to justify Warhol's ambition to make his films longer and in color. Nor did there seem to be any realistic hope that the films would ever turn a profit, for experimental film programs were rarely high-paying venues. The rock band had been profitable during its run at the Dom. But the costs of the EPI's West Coast tour, with an entourage of a dozen people, had eaten up those profits. The album wouldn't bring in money for at least a year; it wasn't scheduled for release until March 1967. And Warhol had announced his retirement from painting.

The financing for the series of films that became *The Chelsea Girls* came partly from a portrait commission. Even though Warhol had supposedly announced that he had given up art, he periodically resumed painting to pay the movie bills.

Holly Solomon
Screen Test, 1966

For several months Holly Solomon had considered commissioning a portrait from Warhol. She was a thirty-two-year-old actress studying with Lee Strasberg and was married to Horace Solomon. About to undergo a hysterectomy, she worried about her mortality and wanted a portrait to leave behind for her children.

Holly Solomon switched back and forth between commissioning Warhol to create the portrait (he wanted six thousand dollars) and commissioning Roy Lichtenstein (whom Horace preferred). Holly decided on Lichtenstein. When she deposited money at the Castelli Gallery, the assistant, David Whitney, misunderstood, thinking the money was for Warhol. When the mistake was realized, Ivan Karp stepped in and counseled her to not rectify it, appealing to her sympathy. "Look, let him do

the portrait," said Karp. "He's all alone, the Velvet Underground, everyone's going away for the summer, and he has nothing to do. So let him do the portrait, and if you don't like it, I'll sell it in the fall."

Warhol took Holly Solomon to the same bank of Photomats on Broadway and Forty-seventh Street that he had taken Ethel Scull to a few years earlier. After Holly was installed in a booth with twenty-five dollars in quarters, Andy left, and Holly did acting exercises to vary her appearance in the pictures.

Andy then made silkscreens of eight different images and invited the Solomons to select the three they wanted. By the end of the evening, the Solomons had bought them all, and they were hung in their salon, along with two *Marilyns*, a *Liz*, and Lichtenstein's *Anxious Girl*. "I had all the girls in the living room," she said. Holly regarded Andy as "very generous to people, because what he tried to do was to give people what he thought they wanted. I wanted to be Brigitte Bardot, I wanted to be Jeanne Moreau, Marilyn Monroe all packed into one," she said. When she looked at Warhol's portrait, using the colors of the Pucci dress she was wearing, Holly Solomon saw herself as an "archetype of the sexually liberated woman of our time."

The money from Holly Solomon's commissioned portrait allowed Andy to shoot the reels that would become *The Chelsea Girls*. Beginning in the late summer he began shooting thirty-three-minute sound reels, all taking place in small interiors outside the Factory. Although the interiors varied, all of them evoked generic low-rent rooms, and they reflected the tight quarters often used by the amphetamine crowd for speed marathons. *Grand Hotel,* only different.

Warhol didn't originally plan a unified film, but over the summer, as he and his entourage found themselves frequently at the Chelsea Hotel, or next door at the El Quixote, drinking sangria, a strategy developed. Several of his stars—International Velvet, Nico, Edie, and Brigid—lived in the Chelsea area. Warhol wasn't especially attracted to the Chelsea Hotel's association with artists and bohemians; it was just convenient to shoot there.

Putting together the reels from the summer of 1966 offered Warhol a chance to show off his current superstars, as if the Factory really were like MGM, a movie studio with its own string of contract players. He had Nico, Ondine, Brigid Polk, Ingrid Superstar, Mary Woronov, Gerard Malanga, Eric Emerson, Marie Menken, International Velvet, Mario Montez, Ed Hood, Rene Ricard, and the music of the Velvet Underground in the background. The dozen thirty-three-minute episodes

were related to his exploration of portrait making, and, taken together, they formed a collective portrait of Factory friends.

Debbie Caen:
Herb Caen's daughter and the former girlfriend of Paul America and Gerard Malanga.

Brigid Berlin was a walking encyclopedia about drugs, and she plays a drug dealer in her scene. She used the screen name Brigid Polk. Brigid's counterpart in the cramped room is Ingrid Superstar, and it is clear that Brigid is the dominator. When Ingrid says to Brigid, "You really like to destroy people, don't you?" the audience genuinely believes it. Immaculately dressed in scarf, earrings, and corduroys, Brigid presents herself as an authoritarian dealer who peddles her wares on a bike and on the telephone. She quotes a price on LSD (twenty 750-milligram caps per eighty for $30) and offers Eskatrol and Doriden. Involving the well-born and unsuspecting in her new role, she telephones real people, including Arthur Loeb and Debbie Caen. Brigid was already known for broadcasting phone calls over speakers, and now she was implicating her callers on film.

As Warhol remembered it, Brigid so completely entered the fantasy that no one could tell the difference between her performance and her reality, not even Brigid, or the managers at the Chelsea Hotel. "I give pokes where I give them," she said as she poked Ingrid Superstar in the ass. The switchboard operators at the Chelsea Hotel, listening in, found Brigid so believable that they summoned the police. They arrived and searched everyone in the room but found only two Desoxyn pills.

For his reels Gerard Malanga concocted a triangle of a bohemian young man, his domineering mother, and his shy girlfriend—a thinly veiled portrait of himself. Mary Woronov played his girlfriend—just after they had broken up—and Gerard asked his mother to perform with him, playing herself. When she refused to appear before the camera, Gerard recalled something that Marie Menken had said to him: "I would adopt you as my son, Gerard, but I can't because your mother is alive." He invited her to play his mother. The sequence was shot in an apartment on West Fourth Street, chosen because the walls were covered with images, and it looked like a bohemian crash pad. The Velvet Underground were installed in the next room and improvised music. In contrast to the toughness she projected in another reel, playing Hanoi Hannah, Mary Woronov opted to remain completely silent in this reel, forcing Marie Menken to provide the fireworks. Menken berates her son and slaps his whip on the bed, all the time looking like a female Broderick Crawford in a funny hat.

In addition to the improvised character sketches, Warhol included two plays with written dialogue by Ronald Tavel, *Hanoi Hannah* and *Their Town*. The movie is usually projected with the sound off for *Their Town*, but *Hanoi Hannah* suggested to Tavel what could happen when an actress actually learned his lines; Mary Woronov became a new muse for him, just as Edie had been a year earlier. Tavel had refashioned the S&M relationship of *Vinyl* to evoke the American fascination with strong political women, such as Tokyo Rose. He added to this tradition a female dominatrix named Hanoi Hannah, one of the few references in Warhol's oeuvre to the ongoing war in Vietnam.

Three of the women in Tavel's segment—Mary Woronov, Ingrid Superstar, and International Velvet—were likely contenders to become the Girl of the Year after Nico's reign as Miss Pop ended. If *Hanoi Hannah* was the audition for the role, Mary Woronov was the winner. It wasn't simply her beauty, for International Velvet provided alluring competition; and it wasn't just her vocal power, for Ingrid Superstar could be as loud. Woronov's theatrical intelligence shone through; she was the only one who learned lines and knew how to use silence. With her stage experience, she had ample advantage.

Around the time of shooting the segment, Edie, Mary, and Susan went to dinner at the El Quixote with Andy and Gerard. Woronov recalled, "The entire dinner was about who would be Andy's next star." She wanted to act in the movies, but when it came to being the year's superstar, she thought, *Oh, you mean fill Edie Sedgwick's shoes? No thanks.* She regarded the evening as a sadistic attempt to goad them into a catfight and walked out. The role of next year's star remained up for grabs.

The new male star in *The Chelsea Girls* was Eric Emerson. Andy gave him a simple direction: talk about your life and at some point start to take off your clothes. Billy Name lit Eric Emerson's soft, hypnotic monologue of self-love as if he were in the middle of the dance floor at the Dom, spotlit red on one side and blue on the other. Eric looks like a Sixties super-graphic of hippie narcissism, an advertisement for infantile polymorphous perversity. After talking about the pleasant taste of his own sweat, Eric removes his shirt and begins to touch himself all over, playing with his ear, stroking his hair. Having just taken LSD, he is enthralled with everything he touches. He also reveals the emptiness just on the other side of his beauty. "I'd do anything to get someone to care, someone to

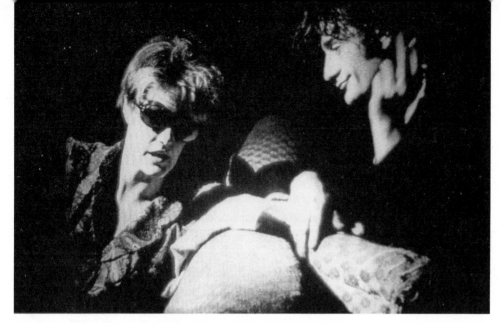

Ingrid Superstar as a confessor, Ondine as the Pope in
The Chelsea Girls, **by Billy Name**

listen," he says. "I used to talk to myself, but I didn't have anything to say. I sit and groove on myself." Famous for his sexual availability—there was a side room at the Dom that became known as Eric's Fuck Pad, and he outdid these sexual exploits a few years later in the back room at Max's— the portrait reflects the availability of his body, to both men and women. Eric insists he isn't homosexual: "I may groove on having sex with a gentleman, but it's part of having a good time." Sex is unmoored from everything, including gender and even partners; Eric embodies the pleasure principle gone Sixties. But he underlines the limits of what he reveals to other people: "They only see what I want them to see. And that's not very much." If they saw his real problem, he fears that they'd be bored: "People only listen so long."

The film concludes with a Warholian black-and-white dichotomy. On one screen is Nico, the ultimate Nordic, and on the other is Ondine's saturnine, hawkish, translucent profile against an inky black and white interior.

Ondine's were the last reels to be shot, concluding the film's production during the second week of September. The segment begins with Ondine tying up just above the wrist and injecting methamphetamine sulfate into a vein. He says at the beginning that he doubts he'll be able to say a word—a rare occasion for Ondine, and an acknowledgment of the

camera's presence. But once Ondine assumes his venerable role as the Pope, the words roll out effortlessly.

Declaring that "the Pope is in session," he begins to counsel a young woman named Rona Page, the girlfriend of Jonas Mekas. It soon becomes clear that she lacks the imagination of the Pope. When she shows skepticism about the existence of God and asks where Heaven is, Ondine is offended and tells her to leave. She retorts that he is a phony. At that point something happens that breaks through the dramatic conventions expected in a fictional movie. Ondine is not acting an enraged Pope, he has become one, and something to truly fear. He lashes out verbally—"You're a bore, a bore, a—*bore*"—and then slaps her not once, not twice, but three times. Rona Page becomes genuinely frightened when she realizes that Ondine is not going to stop and no one is going to stop him. "You filthy horror, how dare you? I'm a *phony*? Well, so are you." Finally the slapping subsides. The Pope Ondine sequence was not only the last to be shot but also Warhol's favorite.

The tension and disintegration that marked the Exploding Plastic Inevitable's West Coast trip continued in more desultory fashion over the next few months.

Lou Reed spent a few weeks in Beth Israel Hospital, recovering from hepatitis, probably from dirty needles. Reed couldn't rest easily in his hospital bed, however, knowing that the band was going to be playing during the week of June 21 to 26 at Poor Richard's in Chicago. Angus MacLise returned as the band's drummer, his first performance since the band's debut at Summit High School, and Mo Tucker shifted to bass; Cale sang. Gerard Malanga recalled Reed sitting at the edge of the bed, jaundiced and sickly looking, firmly reminding MacLise, "Just remember, this is only temporary." At just the moment when control of the band was becoming an issue, what would be the effect of the band playing without him? In the midst of his stay, Delmore Schwartz died. He had been Reed's first mentor, and the band dedicated its song "European Son" to him. When Gerard Malanga suggested that he and Lou attend the open-casket wake at the Sigmund Schwartz Funeral Home on lower Second Avenue, Reed put on black jeans and boots and leather jacket and checked out of Beth Israel, against medical advice, never to return. "He just showed up like a slob," said Malanga, and they arrived in the midst of Dwight MacDonald's eulogy. Reed went on to the burial and later said,

"During my Popage the Catholic Church has disappeared and Greenwich village is in its place. . . . This is a new kind of confession—it's called True Confessions."
—Ondine,
on *The Chelsea Girls*

"Delmore Schwartz was the unhappiest man who I ever met, and the smartest—till I met Andy Warhol."

Meanwhile, out in Chicago, the Exploding Plastic Inevitable played without any of its big names present—no Warhol, no Reed, no Nico. Even Mary Woronov was absent, replaced by Ingrid Superstar. Nevertheless a crowd filled Poor Richard's that June—the time was right, just after the end of school, and the band was billed as "THE NEW SOUND." They were so popular that Poor Richard's held them over an extra week. Andy telephoned Lou Reed in the hospital and said, "Oh, they got great reviews. Gee, it seems okay without you. Everyone's happy."

That June Nico arrived in Paris and knocked unannounced at the door of Pauledith Sourbrier, who was raising her son, Ari. "Even the way she arrived at the house was exceptional," Madame Sourbrier recalled. "She would just turn up, hello, as though you had seen her last one hour before. There was never a warning, an arrangement. She arrived, and after she had exhausted your hospitality, she left." Ari's fourth birthday celebrations were in preparation, and as a sort of gift, Nico had decided to bring Ari back to New York with her. It was one of her first attempts at being a mother.

After returning from California, unmoored from the Exploding Plastic Inevitable and from her relationship with Gerard, Mary Woronov found a new identification with Ondine and the Mole People. She described this period in hallucinogenic terms in her memoir, *Swimming Underground*. Mary was certainly familiar with amphetamines from her adolescence at Cornell, where Coke bottles filled with methedrine had been a standard accessory among her friends. But the Mole People practiced a different level of speed use, and she thought they got their name because "they were known to be tunneling towards some greater insanity that no one but this inner circle was aware of." At first she followed Andy's warning to stay away from them, but she changed her mind one night when Ronnie Vial invited her to visit the Mole People, who had been up for five days making necklaces. "But the real reason I got in the cab with Ronnie was because he said Ondine would be there," wrote Mary.

Woronov and Vial walked into a gold-painted room that seemed to be vibrating with bead-stringing activity. Mary sat with her jaw clenched, stringing beads, until "suddenly Ondine's voice made my heart leap." Ondine entered, threw a scarf over his head, assumed his role as Pope, and said that he would be receiving confessions in the back room. When Mary stepped into it, she found Rotten Rita draped in a shower

Lou Reed
Screen Test, 1966

curtain, and Ondine dressed in a brocade drape that had been freshly pulled down from the wall; only Billy Name remained in his standard jean and T-shirt outfit, holding a long cigarette holder. *Tosca* blared from the hi-fi, and Rotten Rita wrapped a towel around his head for a turban and sang along with Maria Callas.

Getting high around Rotten Rita was usually a paranoia-inducing experience for Woronov, since he commanded so much attention and was often described with a single word: *evil.* "Maybe it was chemical, but if you were high and Rita and the President were in the same room, Rita would be more important," Mary wrote. "That was Rita's charm; he was extremely impressive for no real reason."

One night at the home of a fellow amphetamine user named Wonton, Ondine pulled out a worn Maria Callas LP album and asked to play it on Mary's record player in her apartment. "So high your blood would explode and splatter your brains all over your cranium—excruciating, you'd love it," he promised. Callas's voice filled Woronov's apartment on St. Mark's Place, and Ondine put on a cloak and ran about the room, jumping off a table at particularly dramatic moments. During her intensive exposure to Ondine's logic, Woronov wrote, "I composed my first rigid speed concerto in logic, which I will now play for you: Order = Fear of Death; Chaos = True Reality. We took drugs to battle the cages of order, in order to embrace the chaos of the divine order. I + Order + Ondine = Chaos ~ Andy + the black primal creative negative."

After her sessions with the Mole People, Mary Woronov returned to her parents' home in Brooklyn. She used the BMT subway ride under the East River as her zone of forgetfulness, passing from chaos to domestic order. Her routine was to take a bath and sleep, dress appropriately, and make dinner conversation with her parents so that no one would be the wiser. These returns home offered passive normalcy after the edgy exhaustion of her nights with the Mole People. At one point her identity shifted. "When I was home I didn't belong," she wrote. "I had changed. There were no outward signs, but I knew it. It was no longer them, it was us. Their rules were mine, their insanity my reality, and as for the rest of the world, it just didn't matter. I was a Mole."

After coordinating lighting with the Exploding Plastic Inevitable in California, Danny Williams returned to New York that summer. In late July he visited his family in Massachusetts: on July 25, 1966, after staying up three nights straight on speed, he rode a Pullman overnight from New

York to Boston. The next morning he arrived at his family's home at Pigeon Cove for a family gathering organized to coincide with a local antiques auction. Over beer and a three-helping turkey feast, Danny excitedly described his lighting and film experiments. At 10:25 he drove off in the family car, wearing a brown-and-green-checked shirt, grease-stained gray corduroys, and black buck shoes. At a nearby beach, he parked the car, and he looked out to the rocks where, as a boy, he had set lobster traps. Danny took off his clothes, folded them neatly, dived in, and was never seen again.

Mrs. Williams called the Factory on July 27. Andy would not come to the phone. She finally reached Stephen Shore, who told her Danny had not recently appeared in New York. She wrote letters to his friends and dispatched a New York friend to the Factory, where he talked first with Billy Name and then with Andy. "They all expressed great concern and had no idea that he would not return after a couple of days away," she wrote the Missing Persons Bureau. "There was plenty of work for him to do."

By mid-August, when Danny's mother contacted the Missing Persons Bureau of the Salvation Army, most of her hope was gone. That same day she wrote a letter to Andy Warhol, saying that Danny had been excited about the prospect of finding a special gift for Andy at the auction—he had hoped to find a piece of antique metalwork. After his death they wanted to carry out his wish, so his father selected two old lock clasps, about eighteen inches long, for Andy.

On September 1 Danny's mother wrote Andy again. She was now reconciled to Danny's disappearance; she believed that he had been dizzy from exhaustion, had stopped to clear his head, had taken a swim in one of his favorite spots, had gotten a cramp, and had drowned. "Our only consolation is the fact that this is a beautiful spot—a place Dan loved—where as a boy for three summers he lobstered."

A week later two workmen found his clothes, neatly folded, and it became unalterably clear that Danny had drowned. The response in the Factory seemed eerily quiet. Not only had Andy declined to come to the telephone when Mrs. Williams called, but Danny Williams virtually disappeared from memory. The final reels of film he shot, probably of the Velvet Underground, were never developed and have now disintegrated.

After the summer was over, around the time *The Chelsea Girls* was being completed, the Exploding Plastic Inevitable played in their home loca-

Andy, 1966,
by Gretchen Berg

tion at the Dom. They were in top form, and the show got a long and rapturous review from Richard Goldstein in *The New York Journal Tribune,* which concluded "Andy may finally conquer the world through its soft underbelly." But the band felt bitter about their space being stolen from them. For after their success at the Dom, Albert Grossman had rented it and opened it as the Balloon Farm. "What we found 'repellent' was not the 'show,' but rather the fact that we were back in what we consider to be 'our' ballroom, and even worse, were working for the very people who had taken it from us," said Sterling Morrison. "Given a choice between working for them or nothing, we chose nothing." It would be nearly a year before the band would again play New York, and after that it would be three more years. For a quintessentially New York band, the Velvet Underground had little New York presence.

Paul Morrissey was annoyed with the Velvets; he had entered into the task of managing the band for commercial reasons, and now they refused to work. "In the end Andy's connection with the Velvet Underground, like anything that happened to Andy, just made a gold mine of good fortune for him, and he became identified with rock and roll and the young generation," said Morrissey. "But I did it hoping to make some money."

Warhol designed the cover for the *Velvet Underground and Nico* album. Warhol was initially thinking about putting his 1962 painting *Nose Job* on the cover, but he soon came up with a better idea. The cover would consist of a life-size yellow banana on a white field, with his rubber stamp signature in the lower right corner. This brilliant dumb idea reflected the bananas that had been a staple prop in his 1964 films (*Mario Banana, Harlot,* and *Couch*), as well as the recent craze for getting high by smoking banana peels.

"It's an extremely pretty sexy banana, and the album cover peels, which is nice, to reveal the inside of a very sexy, groovy banana."
—Lou Reed

After the summer Gerard Malanga's mind became filled with thoughts of Benedetta Barzini. Before he had had girlfriends; now he was in love romantically and obsessively, and Benedetta would occupy his mind for the next year. After their brief meetings in the spring of 1966, she had spent the summer in Massachusetts performing at the Williamstown Theater Festival. She returned at the end of September, and for their first date Gerard invited her to the black tie opening of the new Whitney Museum building designed by Marcel Breuer.

For the next few weeks Gerard lovingly planned the places he took Benedetta—Timothy Leary's concert, *Turn On, Tune In, and Drop Out,*

macrobiotic meals at the Paradox, dancing to a live set by the Doors at Ondine, poetry readings by Allen Ginsberg at Town Hall and by John Wieners at the Ninety-second Street Y. On October 23 Gerard wrote in his Secret Diary, "Tonight Benedetta said she loved me."

Gerard was infatuated with Benedetta's beauty and her intellectual aristocracy. Her father, Luigi Barzini, was a respected Italian intellectual and the author of the best-selling *The Italians.* The relationship quickly assumed greater dimensions in Gerard's mind. "Even at the time, it seemed obvious to me that our relationship was archetypal—in terms of Dante and Beatrice," Malanga said.

Their relationship was physically consummated only once, on a Saturday night in Cambridge, following a performance of the Exploding Plastic Inevitable and a party at Ed Hood's, in Gordon Baldwin's flat. Benedetta showered and Gerard smoked a joint, and the candles guttered, and they climbed into bed together. "Her eyes wide open in love, I could see in the darkness," wrote Malanga in his diary. "She tells me she loves me. I ask her to marry me. She says yes."

Just before Gerard left New York for a four-day Exploding Plastic Inevitable tour, he told his mother that he would be married. She responded that she would make sure that the wedding bands would be there when he returned.

When Gerard arrived back at Newark airport no one met him. The next day, in a small bar on East Seventy-third and Third, Benedetta unilaterally ended the relationship. In his diary that night Gerard wrote, "She explains that she cannot love me. I am speechless and in a state of shock."

The relationship would last much longer in Gerard's mind. Although Benedetta's physical presence had disappeared, he pored over her in his poetry and film for the next several months. At the Factory he appeared depressed and desultory and abstracted; Benedetta filled his head as his muse for poetry and film. The poems were published as *The Benedetta Barzini Poems* and the film was called *In Search of the Miraculous.* Gerard had previously shot portrait films of Andy Warhol, Mary Woronov, and Susan Bottomly, but this was his first ambitious film. Benedetta would occupy his mind for the rest of 1966, and his film about her would prompt his first exit from the Factory, in the fall of 1967.

Benedetta Barzini, the muse of Gerard Malanga, photo-booth sequence, fall 1966

Considering Nico a more marketable and manageable star than Lou Reed, Paul Morrissey worked out a strategy for her to sing without the

band. As Morrissey recalled, the manager of the Dom wanted to change the downstairs bar for racially oriented reasons. "This discotheque's driving me crazy," he said to Morrissey. "It's making a lot of money, but only Negroes are coming to it. That girl Nico—Negroes can't stand her. She has no rhythm for a start. I think if Nico sang in my bar, it'd drive a lot of whites in and some of the Negroes out." Morrissey rigged up a small platform at the end of the long bar, and from this odd perch Nico sang. The Velvet Underground made a tape that she used as her backup, awkwardly leaning down to press the tape recorder on and off between each song. Nico's repertoire comprised seven songs. In addition to Lou Reed's four songs, she sang one each by Bob Dylan, Gordon Lightfoot, and Jimmy Page. Even with Nico's extremely slow delivery, they constituted only a twenty-minute set. ("Thirty with her entrance," said a friend.)

Bands:
Sam the Sham
and the Pharaohs
Gary Lewis
and the Playboys
Bobby Hebb
The Yardbirds
Jimmy Clanton

The Velvet Underground moved to the life of a touring rock band, traveling on Greyhound buses through the Midwest and up to New England. They played gigs in Chicago, Boston, and Provincetown, at the University of West Virginia in Morgantown, in Cincinnati, Cleveland, and Hamilton, Ontario. In the process the band members were often pressed into service as embodiments of Sixties fads, wearing Mod fashions, and flower-print T-shirts. Perhaps the most conspicuous of these Sixties events was a Detroit fair called the Carnaby Street Fun Festival. It featured Dick Clark introducing his package of bands and a going-away party for draftee Gary Lewis. As a centerpiece, a Motown publicist thought up the idea of a Mod Wedding. Since Andy Warhol was "the father of Pop Art," he became the perfect choice to play the father of the bride. A columnist for *The Detroit News* dug up a couple to get married—a twenty-five-year-old clothing salesman and his nineteen-year-old, unemployed go-go dancer girlfriend. While Gary Norris and Randi Rossi were married before a crowd of forty-five hundred, the Velvet Underground played "Here Comes the Bride," and a roadie pounded on a car with a sledgehammer. After the ceremony Andy signed some Campbell's Soup cans and threw them into the crowd, and he and the bride cut the six-foot cake with a sword. "It would be in better taste if you had those people throwing up on each other," Dick Clark told the event's organizer.

"Andy shows movies and we fuck dogs onstage."
—Lou Reed

❏

Throughout 1966 Valerie Solanas tried to arrange a production of her play, *Up Your Ass.* She first sent it to Paul Krassner, editor of *The Realist,* perhaps the most scabrous magazine in wide circulation at that time. "I rejected it on the grounds that I had no overwhelming desire to share Valerie's misanthropic evangelism with my friends," Krassner wrote. But he was sufficiently curious about the author that he arranged to dine with her at the Forty-second Street Automat, where they struck up an acquaintanceship. "She was a cross between an early Rosalind Russell movie and the Ancient Mariner," Krassner wrote, "only instead of plucking at the elbows of strange wedding guests on the street, you had the feeling she would rather be breaking up the honeymoon itself by somehow managing to get in the marriage bed, replacing the wife with her albatross." Krassner invited her to talk to his class at the Free University.

Undaunted by *The Realist*'s rejection, Solanas mailed *Up Your Ass* to Ralph Ginzburg at *Avant-Garde,* the highbrow magazine of erotica, whose style was a long way from her scruffy street language and corny humor. Ginzburg was so wary of the play that he insisted that if Valerie wanted it back, she had to personally pick it up at his office; he wouldn't subject it to inspection by the U.S. Post Office.

Richie Berlin, Brigid's sister, gave Solanas the telephone number of Nat Finkelstein, the photographer who shot events at the Factory and the Exploding Plastic Inevitable onstage and on tour. Valerie hoped he would read *Up Your Ass* and see if he had any ideas about getting it produced. *God, what a bore,* Finkelstein thought. *I'll give this to Andy.* Finkelstein was annoyed with Warhol at that point and did not mind introducing further chaotic characters into his life. By this means Valerie was able to get Warhol on the telephone. He thought the play's title was so promising that he invited Valerie to the Factory.

After Warhol looked at the play, he was afraid Valerie might be an undercover cop trying to entrap him. According to Paul Krassner's version of that meeting, Valerie replied, "Sure, I'm a cop," as she unzipped her fly, "and here's my badge."

In mid-October 1966, after her long absence from the Factory, Edie Sedgwick invited Gerard Malanga to visit. In his diary that night Gerard wrote,

> I've never seen her more beautiful. She puts on a pair of red leotards and red tight cotton top. I weed out the seeds and twigs

Paul Krassner
After a stint working for *Mad* magazine in 1958, Krassner began publishing a newsprint magazine called *The Realist.* "I wanted to combine entertainment with the First Amendment," he said. The magazine appeared monthly until 1974. (It resumed publication from 1985 to 2001.) The magazine was scabrous and funny, and Steve Allen described it as "the periodical equivalent of Lenny Bruce."

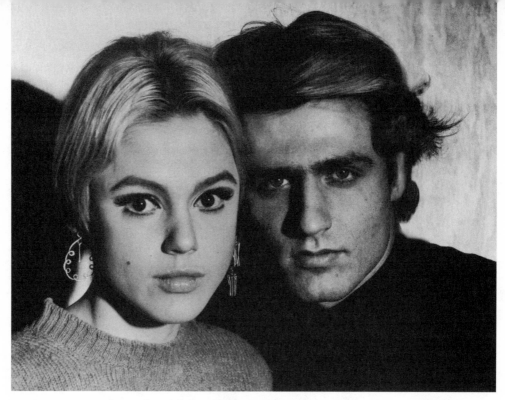

Gerard and Edie, 1966

from the pot and fill one-eighth full Camel with the Acapulco Gold. We get exceedingly high. She tells me how she wanted to run away from the mad publicity for an entire year, how it all frightened her, how transparent it all was, and how some of the men are so desperate for the faceless publicity—stark raving mad seeking acquisitions they want so desperately. How sorry Edie feels for them. How composed she remains. . . . I leave Edie falling asleep in her apartment.

A few hours later, around three that morning, the drapes in Edie's apartment caught fire from the candles she burned every night on the mantel. A neighbor found Edie nearly unconscious, but not burned, hanging over a staircase rail. The fire destroyed everything she owned, including the stuffed rhinoceros, Wallow, that had helped make her famous in *Vogue*. Only a leopard coat remained.

Edie was taken to Lenox Hill Hospital. Within twenty-four hours she was released, dressed in a beige miniskirt and a green jersey overblouse. A few days later she said to her friend Judy Feiffer, "I have an accident about every two years, and one day it won't be an accident."

Edie's parents urged her to move to the Barbizon Hotel for Women,

while others suggested the Sherry-Netherland. When Edie chose the Chelsea Hotel, the Sedgwicks cut off her allowance. Bobby Neuwirth arranged for a middle-aged money manager named Seymour Rosen to slow the outflow of money from her trust. He made arrangements to pay installments on the huge makeup bill at the Cambridge Chemists and on the dinners at the Ginger Man. But Edie still insisted she could ride only in limousines. The Chelsea Hotel was a familiar place to her, and she got reassurance from greeting people she knew along the hall.

Christmas was always a strange time for Edie Sedgwick, especially because it was a reminder of her brother Bobby's death two years earlier. After her friends cleared out of New York, she flew to Santa Barbara to be with her family. Her younger brother recalled that when she arrived at the ranch, she looked "like a stick, no body at all, and wearing the shortest skirts I've ever seen, superfake eyelashes hanging so heavy, her eyelids drooped. She was an alien."

The inevitable family explosion didn't happen until the second day, when she tried to refill a prescription for a form of speed called Eskatrol. "I'd been used to strong shots," Edie said, "and I used a lot of pills to keep from shaking the balance I'd arranged in my system." When Edie's parents found out about the prescription, they gave her Nembutals, waking her every few hours for another dose. When she refused to take it, they took the next step and committed her to the nearby Cottage Hospital, stating that their daughter was suicidal and homicidal.

When Bobby Neuwirth finally reached her at the hospital, Edie said, "Get me out of here! I'm a prisoner." A day later she returned to the Chelsea Hotel, showing no signs of the ordeal. She settled into Room 105, surrounded by an odd collection of fur coats, hats, and cigarette lighters in all shapes. She told a Chelsea neighbor that she had turned down two Hollywood offers, costarring with Nancy Sinatra in one and Burt Lancaster in the other. But for now she wanted to devote her energy to her iron-gray cat, Smoke, the offspring of Bob Dylan's cat.

Soon after Edie Sedgwick returned from California, her affair with Bobby Neuwirth went on the downturn. He had been instrumental in helping her hide from the world, and they had made their own domestic world, of sex and drugs. After a period of fearing close attachment to any man, she swung to craving intimacy, an obsession that found its perfect object in Neuwirth, whom she claimed was her great teacher about love and sex: "I was like a sex slave to this man. I could make love for forty-eight hours, forty-eight hours, forty-eight hours, without getting tired. But the minute he left me alone, I felt so empty and lost that I would start

popping pills. But if I wasn't practically in the act of lovemaking, I would be thinking of how to get hold of drugs. I really loved that man."

Neuwirth had briefly interrupted Edie's headlong fall into heroin, but she was now increasing her use. An East Village dealer named Rutherford Jones would knock on her door at the Chelsea, and he understood her needs explicitly: "If you're obsessed with a person and helpless, there is a way out—to fall in love with heroin," he said. "You see, it's immaterial if it's heroin or sex. It's very basic: the two are interchangeable."

Edie's relationship with Neuwirth came to a stormy end one night when she thought he had been sexually unfaithful. At a nightclub Edie flew into a fury and tried to extinguish her cigarette on Neuwirth's face. When he hustled her outside to a limousine, Edie attempted to throw herself in front of an oncoming truck. In the limousine, heading down to Twenty-third Street, Edie threw a fit that even the capacious limousine could barely contain, as Neuwirth tried to restrain her. By the time they reached the Chelsea Hotel, Edie's frenzy subsided to a nonviolent mode. Bobby Neuwirth delivered her to the bellboy and asked him to deliver her to Room 105.

Q: Is it more wonderful than awful to know the right people?
A: Yes.
Q: Why?
A: Because they're right.
Q: Who do you know?
A: Almost no one.

After their breakup in February 1966, Andy Warhol had not telephoned Henry Geldzahler for six months. As a gesture of reconciliation they decided to go together to the most important party of the year, Truman Capote's Black and White Ball in honor of Katherine Graham.

The dress code was strict—men were to wear black tie and a black mask, women were to wear a black or white dress, a white mask, and a fan—and the guest list of five hundred was distinguished. Weeks before the Black and White Ball took place in the Grand Ballroom of the Plaza Hotel, people wangled invitations. Halston and Adolfo were swamped, and the day before the party the hair salon Kenneth's was filled with party-goers. Taking place at the time when the countercultural identity of the Sixties was coalescing, Capote's guest list represented the *crème* of the old guard, a mixture of movie stars, old money, models, and celebrities. Leo Lerman, one of the invitees, noted that it "reads like an international list for the guillotine," a roster of those who would be the first to be shot after the Sixties revolution.

Shortly after ten-thirty that Monday evening Geldzahler and Warhol walked past a crowd of people outside the Plaza Hotel—some dressed in black and white to suggest that they were guests—and walked

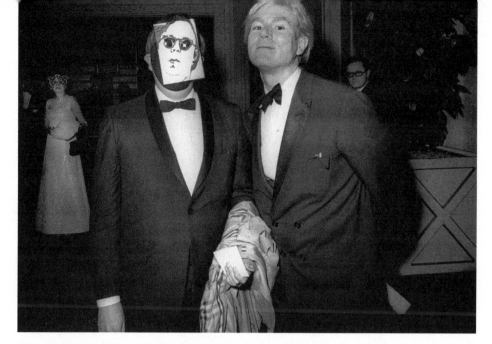

Henry Geldzahler and Andy Warhol at Truman Capote's Black and White Ball, November 28, 1966, by Henry Grossman

into the Grand Ballroom. Geldzahler wore a cardboard mask of his own face designed by Martial Rayse, and Warhol wore a large cow's head, in homage to his wallpaper, and a pair of black glasses. They were received by a man in white tie and tails who announced them to Truman Capote (wearing a thirty-nine-cent Halloween mask) and Katherine Graham. "As far as I could tell, this was the densest concentration of celebs in the history of the world," recalled Warhol. He turned to Geldzahler and said, "We're the only nobodies here." Henry agreed.

The party dominated the headlines in society pages all over the country, where it was called the ball of the decade. Warhol later reflected, "It was so strange, I thought: you get to the point in life where you're actually invited to the party of parties—the one people all over the world were trying desperately to get invited to—and it *still* didn't guarantee that you wouldn't feel like a complete dud!"

Andy Warhol had shot more reels of *The Chelsea Girls* than could be viewed in one sitting, so he and Paul Morrissey decided to cut the time in half by projecting two episodes side by side. By 1966 the use of multiple screens was an idea that was ready to move from the underground to the mainstream. Warhol had created a multiple-screen work months earlier when he shot *Outer and Inner Space,* which presented four images of

Guests at Truman Capote's Black and White Ball:
Lauren Bacall
Tallulah Bankhead
Cecil Beaton
William F. Buckley, Jr.
McGeorge Bundy
Herb Caen
John Knowles
Alfred Kazin
Pat and Peter Lawford
Norman Mailer
Gordon Parks
Harold Prince
Lee Radziwill
Arthur Schlesinger, Jr.
Monroe Wheeler
Candice Bergen
Penelope Tree

Edie Sedgwick side by side by side by side, evoking his preoccupation with portraits and serial imagery. He had also used multiple screens with the Velvet Underground. And most recently, around the margins of the June 2, 1966, *Village Voice,* Warhol scrawled some notes for movies. Along with "love affair," "15 year old," and "old people," he drew a hasty diagram: two joined rectangles, looking like two movie screens side by side, above which appeared the note "LSD Movie."

What distinguished *The Chelsea Girls* from its predecessors was the fact that the two screens were not used for ambient background images; nor was Warhol offering serial images of the same person. The double-screen plan was affected by the addition of sound, which added not simply another element but also a competition for the viewer's attention. (There had been sound in *Outer and Inner Space,* but with four tracks it was so incomprehensible that the viewer didn't struggle to understand it; it became undifferentiated noise.) In *The Chelsea Girls* the sound is audible from one side or the other, or both, and it is comprehensible enough to offer the viewer enormous choice in watching the screens, weighing sound and visual components. Even if Nico was silent, could you take your eyes off her? Are you drawn to a black-and-white image with sound, or to a color image that is presented silently?

Warhol described his conception to a *New York Times* reporter in mundane terms, suggesting that the double screen simply offered a way of avoiding the boredom for which his movies were famous: "If you get bored with one, you can look at the other." He also presented it as a sort of "dumb" solution to having too many hours of footage; simply cut the running time in half by putting on two at once. Simple math.

Warhol wanted to go even further than he did with *The Chelsea Girls.* "The two parts relate too well to one another," he said. "Next time I would like to have two entirely different films going at once, with two entirely different soundtracks—one could be a comedy and the other a tragedy, and you could watch either one or both at once, according to how you felt." Given Warhol's next multiscreen work, he wasn't just making up an outrageous statement for the press.

Just as *The Chelsea Girls* was being finished, the Fifth New York Film Festival was moving into high gear. Amos Vogel had started the festival in 1963 in Philharmonic Hall at Lincoln Center, when the only major film festivals were in Cannes and Venice. He wanted to bring world cinema to New York and felt the same missionary zeal as he had during the years at

Cinema 16, when he was virtually solely responsible for presenting the large menu of films that went undistributed in commercial theaters.

The organization of the Fifth New York Film Festival reflects the emerging place of the underground in the official film world. Six months earlier Vogel had decided that it was time to recognize the New American Cinema with a program of films, lectures, and symposia that dealt with what most people considered a new phenomenon. Vogel knew the handful of people who understood the background of the New American Cinema, and Parker Tyler was its most knowledgeable critic. The other critic of noncommercial film was Jonas Mekas, but ever since the founding of the Film-Makers' Cooperative, there had been distance between Vogel and Mekas.

The series devoted to the New American Cinema included only three films, not to be shown in Philharmonic Hall—where the other films were shown—but downstairs in the two-hundred-seat library auditorium. Amos Vogel accurately reasoned that they would draw a smaller audience than the Festival films. The three films shown downstairs were *Echoes of Silence* by Peter Goldman (a first-time director and the one who had complained two years earlier in *The Village Voice* about too much footage of Taylor Mead's ass), *Relativity* by Ed Emshwiller (the sole veteran filmmaker in the selection), and Tony Conrad's *Flicker*. Conrad's film represented the extreme of formal experimentation—it consisted of alternating black-and-white frames. Mekas wasn't pleased with the selection, for it ignored the three filmmakers he considered America's most talented and productive: Stan Brakhage, Gregory Markopoulos, and Andy Warhol. Andrew Sarris wrote at the time about the delicate situation: "Tactful overtures were made to all the warring factions in the Independent Cinema, and Andy Warhol was pointedly excluded from the proceedings so as not to offend the regular reviewers."

The Festival's public relations staff, perhaps necessarily attentive to the sound bites that would appeal to their target audience, said that the selection of underground films "will separate film poets from the poseurs, the gagsters from the real achievers." Those were fighting words, especially when printed in *Variety,* and Mekas not only spat them back in his column but helped organize protests against the Festival, including a black mass to be staged around Lincoln Center's Revlon fountain, the site of the demonstration a few years earlier on behalf of freedom of expression.

Jonas Mekas had been spoiling for a public fight with the New York Film Festival over its neglect of the New American Cinema. For the first

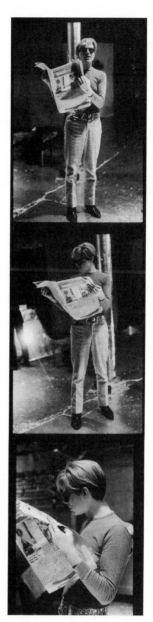

Andy, 1966,
by Gretchen Berg

three years Amos Vogel had attributed the lack of underground films on the program to the lack of a 16-millimeter projection system in Philharmonic Hall. For the 1964 festival Vogel had rigged up an Fairchild 400 projection machine in the lobby of Philharmonic Hall for showing *Kiss, Eat, Haircut,* and *Sleep,* accompanied by a La Monte Young score. Even if the showing was not an official part of the program, it reached a wider audience than any individual Festival film. But that was not enough for Mekas, and when there was still no 16-millimeter projection for the 1965 Festival, he wrote, "There should be a better excuse this year, or we are going to topple Lincoln Center. . . . The third New York Film Festival is an organized and well sponsored undertaking to prevent New Yorkers from seeing what's really going on in cinema. That's how it looks to me, despite the good intentions of the people involved." When Amos Vogel announced the Festival films for 1966, Mekas responded: "He names Bellochio, Forman, Teshigahara, Bertolucci, but is afraid to name Brakhage, Markopolous, Anger, Warhol, Smith."

The previous May a plan had been hatched for an organization called the Film-Makers' Distribution Center. At its core were the handful of filmmakers whose work could potentially cross over from the film society coterie to broader commercial distribution; they included Lionel Rogosin (*Come Back Africa*), Shirley Clarke (*The Connection, The Cool World*), and Emile de Antonio (*Point of Order*). Mekas hesitated to fully embrace the plan because it encouraged distinctions between an "acceptable" and "unacceptable" avant-garde, but he knew that it did little good to restrict the films to a circumscribed audience when the rest of America might be responsive. At this point underground filmmakers were already seeing their techniques absorbed into advertising and media style. Was the Film-Makers' Distribution Center underestimating the level of possibilities?

In this vital and contentious atmosphere *The Chelsea Girls* opened at the Cinematheque and soon moved up to Fifty-seventh Street. Even though it was not in the New York Film Festival, it became a litmus test of response to the New American Cinema. Spanish director Carlos Saura, for example, walked out of *The Chelsea Girls,* muttering, "This underground cinema is disastrous and a disgrace," and Agnes Varda dismissed intermedia films as "useless."

On September 10 *The Chelsea Girls* was first shown at the Filmmakers' Cinematheque, then located in the bowels of the Wurlitzer Building

at 125 West Forty-first Street. *The Chelsea Girls* would be shown in many theaters after that, but never with the same sense of experimentation as at those first screenings, when every night was a little different. Robert Cowan, the projectionist, recalled that the first shows were more like run-throughs, sorting out the hopeless reels before settling on a sequence. Warhol and Morrissey left Cowan with a projection sequence, and the projectionist rigged up a switchbox between the two projectors to cut the sound on one projector while the other came up. As he got to memorize the dialogue over repeated viewings, Cowan experimented with sound dissolves. Getting more ambitious in his experimentation, he occasionally used colored gels and distorted glass to alter the image, and sometimes he used a wide-angle lens on one projector so that a small image appeared inside a wide Cinemascope image; or he inserted a mirror so that a section of the movie would drift off the screen to the walls and ceiling. "I never ran it the same way twice if I could help it," recalled Cowan. "Probably the busiest few days I ever had as a projectionist."

The first public support for *The Chelsea Girls* came from Warhol's old friends Henry Geldzahler and Jonas Mekas. Geldzahler called the film "one of the most mind-widening experiences, it made me more aware what was possible to do with color than anything I've seen here." Mekas laid the critical groundwork for dealing with the film, and his comparisons—to *Birth of a Nation* and James Joyce—set the film in classical terrain. He challenged critics to take the movie seriously, warning that most would dismiss it as having nothing to do with either reality or cinema: "This is the first time that I see in cinema an interesting solution of narrative techniques that enables cinema to present life in the complexity and richness achieved by modern literature." Describing *The Chelsea Girls* in terms that went beyond film aesthetics, Mekas characterized it as a mirror of the Sixties zeitgeist and proposed that the hardness and terror on the screen mirrored what was going on in Vietnam and in the Great Society.

The Chelsea Girls became visible to a national audience when Jack Kroll, in the November 14 issue of *Newsweek,* called it "a fascinating and significant movie event . . . the *Iliad* of the Underground." He warned his readers that the four-hour film "sets the eyes on alert, the teeth on edge and the heart on trial. The heart is on trial because it fights against even wanting to know about the existence of Warhol's Chelsea-hell with its dottily damned." He encapsulated Brigid Polk as "a fat Lesbian pill popper who lives on the telephone like a junkie Molly Goldberg" and Eric Emerson as "an Achilles of narcissism, doing an onanistic mono-

"The greatness of this creature is that he's able to put . . . not only his finger on it but also his camera on it."
—Henry Geldzahler

Q: Are all the people degenerates in the movie?
AW: Not all people—just 99.9 percent of them.

"There is a place for this sort of thing, and it is definitely underground. Like in a sewer."
—*Time* on *The Chelsea Girls*

"He knows how to put people before a camera and make them come alive, as though they were in the Pepsi generation."
—*Richard Goldstein* on *The Chelsea Girls*

"Half Bosch and half bosh."
—*The New York Times* on *The Chelsea Girls*

"*The Chelsea Girls* is a travelogue of hell—a grotesque menagerie of lost souls whimpering in a psychedelic moonscape of neon red and fluorescent blue."
—*Dan Sullivan, The New York Times*

logue and strip in a colored stroboscopic light which makes him like Man regressing to a primal homunculus." Spurred by the *Newsweek* review and the sold-out engagements—there were even letters to *The Village Voice* complaining about the difficulty of getting a seat and about the fifty-cent rise in price for this engagement—a commercial engagement was booked at the Rendezvous Theater on Fifty-seventh Street.

In 1966 underground movies were occasionally screened in commercial art theaters, but they were usually run-down establishments that slipped in an underground film between foreign films and porn. When *The Chelsea Girls* was booked into the Rendezvous Theater, it was a clear sign of upward mobility. It opened there on December 1, with three shows a day, admission of $2.50 in the afternoon and $3.00 at night. The Rendezvous was elegant, had carpets, good seating, and a midtown location near the art gallery strip; it was a cut above either the slightly funky New Yorker uptown or the small Fifty-fifth Street Playhouse a few blocks away. Renting the Rendezvous was nonetheless a gamble, requiring a minimum investment of fifteen thousand dollars. To minimize risk, the theater managers booked Warhol's film for only two weeks, to be followed by *The Sound of Music,* while *The Chelsea Girls* moved on to the less prestigious Fifty-fifth Street Playhouse.

The attention the movie critics gave *The Chelsea Girls* was unprecedented for an underground film. *Time*'s review lagged behind *Newsweek*'s by six weeks, for Richard Berlin, the head of Hearst Publications, did not want to give more publicity to the movie that disgraced his family. His wife, Honey Berlin, had sneaked into the Rendezvous one afternoon, wearing a kerchief over her head in order to remain incognito. Honey told her daughter, "I can't believe you would lower your family like that." Soon Brigid found she could no longer charge at Best, Peck and Peck, or De Pinna.

The Chelsea Girls brought a previously invisible subculture into focus for a broader American public. The reviews reflect the popular media's vision of the burgeoning Sixties revolution. Many reviewers presented the film in terms of deviance, sleaze, and hell. The *Time* reviewer's remark that "the characters are all homosexuals and junkies" suggests how unified it looked from the outside: there was no difference between a speed freak and a junkie, a transvestite and a hustler. Whereas the earlier movies had been put down with simple condescension (*arty, camp, boring*), a new set of words attached itself to *The Chelsea Girls: degenerate, disturbing, homosexual, druggy, hell.*

The Chelsea Girls became enough of a *succès de scandale* that Bosley

Crowther of *The New York Times* felt it necessary to give Warhol a prim reprimand about his cinematic antics: "Now that their underground has surfaced on West 57th Street and taken over a theater with carpets . . . it is time for permissive adults to stop winking at their too-precocious pranks." Stanley Bard, the manager of the Chelsea Hotel, immediately instituted a redecorating scheme to "offset the kook curiosity" that the film had stirred up. He added fluorescent tube lighting in the lobby, painted the walls, and added bright modern accents, replacing the hotel's Victorian aura. Bard didn't want to attract the sort of guests portrayed in the film.

But to Andy, *The Chelsea Girls* didn't look like a horror show or a vision of hell. "To us it was more like a comfort—after all, we were a group of people who understood each other's problems."

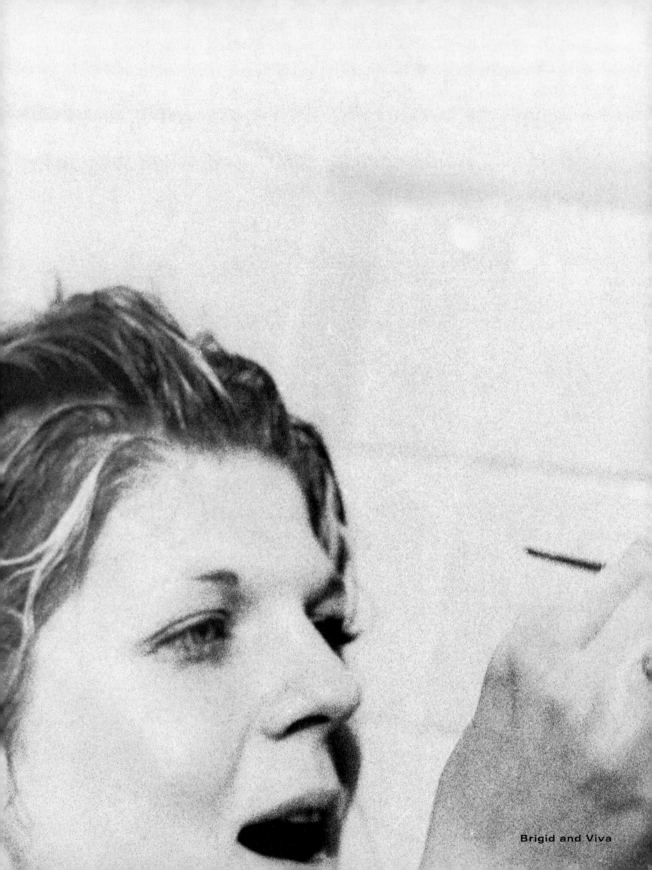

Brigid and Viva

1967

At the beginning of 1967, following the breathless pace of activity of the previous several years, Andy Warhol felt that everything was possible. "I felt so good about things then, like we could do anything, everything. I wanted to have a movie playing at the Radio City, a show on at the Winter Garden, the cover of *Life*, a book on the best-seller list, a record on the charts. . . . And it all seemed feasible for the first time." But the Factory's output in 1967 was looking thin. Where could he go after *The Chelsea Girls* that would not be an anticlimax? For the first eight months of the year, there was no new Warhol product on-screen. Warhol had publicly given up painting a few years earlier, and he had largely stuck to his promise, although he continued to produce silkscreens when he needed money for films. For the first year since 1962 he introduced no new artwork that aroused the art-world buzz of the *Soup Cans*, the *Marilyns*, the *Race Riots*, the *Brillo Boxes*, the *Flowers*, the *Silver Clouds*, or the *Cow* wallpaper. His involvement with the pop music world of the Velvet Underground had largely ended, while their record was stalled in the MGM bureaucracy.

Nevertheless, Andy kept up the same tireless pace. During 1967 he made dozens of hours of film. But most of them were screened only on a single day in December, when he projected all his footage as **** (aka *Four Stars*). His energy was less directed to new projects and was more focused on disseminating the Pop and the post-Pop idea, creating a Warhol brand that would cross over from downtown to a larger public. By 1967 his preoccupation with the fallout of fame—the demands for press appear-

ances, the emergence of a new wave of wannabe superstarlets and would-be fiancés, the demands of shipping and receiving work for international exhibitions—overshadowed his drive to re-create himself yet again. In retrospect, 1967 was less a time of aesthetic transformation than of commercial shift and a harbinger of what was to come: Andy Warhol reimagined as a commercial corporate enterprise.

Not only New York but also the entire country was beginning to go through a dramatic shift. As the media disseminated the shift, American culture was confronting a dramatic combination of racial politics, anti–Vietnam War mobilization, Edenic innocence, sexual revolution, and psychedelic aesthetics. Andy Warhol's place in this evolving world was unclear. *The Chelsea Girls* was shown in commercial theaters across America in 1967, but the universe of those claustrophobic hotel rooms contrasted sharply with images of the era: antiwar marches in the street, racial demonstrations, and the Summer of Love. In this changing atmosphere Andy Warhol, once the most "in" phenomenon of the mid-Sixties, was in danger of becoming "out." *The Book That Tells You How In You Really Are* pronounced that Pop Art was out, that "Jane Holzer" was the most out name to drop, that Andy Warhol was the most out director, and that the underground was the most out set. Fashion shifted quickly.

In the early months of 1967, Valerie Solanas formulated an ambitious plan to improve the corrupt and soulless world by ridding it of men. Her concerns had been with her at least since her college days, but they now took on a new urgency and articulation. She began to form her own organization and called it Society for Cutting Up Men, in short, SCUM. The first sentence of her manifesto read: "Life in this society being, at best, an utter bore and no aspect of society being at all relevant to women, there remains to civic-minded thrill-seeking females only to overthrow the government, eliminate the money system, institute complete automation and destroy the male sex."

Solanas posed the problem of maleness in a manner that reflected her college days in the research laboratory. The rats were now men, and in Valerie's mind that was not much of a stretch. Her laboratory focus on animal learning was adapted to explain the inadequacy of male genetics: "The male is a biological accident: the y (male) gene is an incomplete x (female) gene, that is, has an incomplete set of chromosomes. In other

words, the male is an incomplete female, a walking abortion, aborted at the gene stage. To be male is to be deficient, emotionally limited; maleness is a deficiency disease and males are emotional cripples."

In her passages describing male deficiency Valerie used the Freudian psychological constructs she had learned in psychology courses and turned them back on the white men who had formulated them. She roundly concluded, "Women, in other words, don't have penis envy. Men have pussy envy."

The manifesto is not solely about men. The middle two-thirds were divided into seventeen chapters that ranged from " 'Great Art' and 'Culture' " to "Fatherhood and Mental Illness." Most of them contained numbered subsections, so that the manifesto had the appearance of scrupulous organization and the apparent seriousness of a nineteenth-century scholarly treatise. The tone, however, could not be more different—Solanas managed to sustain her white-hot coruscating rage over all twenty-one pages and make it as funny as a Lenny Bruce routine.

Valerie's solution was the elimination of men from the world, effecting a complete female takeover. But the women who did not subscribe to her program had to be transformed, she knew, for they were not immune to societal brainwashing, and most of them were completely unconscious about their relations with men.

The conflict, therefore, is not between females and males, but between SCUM—dominant, secure, self-confident, nasty, violent, selfish, independent, proud, thrill-seeking, freewheeling arrogant females, who consider themselves fit to rule the universe, who have free-wheeled to the limits of this "society" and are ready to wheel on to something far beyond what it has to offer—and nice, passive, accepting, "cultivated," polite, dignified, subdued, dependent, scared, mindless, insecure, approval-seeking Daddy's Girls, who can't cope with the unknown, who want to hang back with the apes, who feel secure only with Big Daddy standing by, with a big, strong man to lean on and with a fat, hairy face in the White House . . . [the sentence continues for eleven more lines].

Solanas envisioned potential alliances with men who wanted to do the public service of hastening the inevitable demise of the male sex; they could collectively form the Men's Auxiliary. Among those who could be accepted into the Auxiliary were men who killed men; right-minded bio-

logical scientists (an homage to her college employer); "faggots, who by their shimmering, flaming example encourage other men to de-man themselves"; and culture disseminators who promoted SCUM ideas. Members of the Auxiliary would attend Turd Sessions, which would open with each man saying, in twelve-step fashion, "I am a turd, a lowly, abject turd," and then listing the manifold dimensions of his turd-dom. All males who did not join the Men's Auxiliary would be killed.

In early 1967, when Valerie Solanas wrote *The SCUM Manifesto,* women's rights were very much in the air. Solanas may have been piqued by the subject, but she rejected Betty Friedan's version of feminism, which had no bearing on her own life. After all, Friedan had written the book while being supported by a husband, and having her domestic tasks carried out by a full-time maid. Friedan had addressed the issues of housewives who made beds, fashioned matching slipcovers, and chauffeured children to Cub Scouts and Brownies, but she ignored issues of race, class, and lesbianism. One of Valerie's favorite insults was to describe a woman as "one of Betty Friedan's 'privileged, educated' girls."

Friedan's version of a women's movement took form in the National Organization for Women, which had been put together in October 1966. Directed toward professional women, the organization sought "to take the actions needed to bring women into the mainstream of American society—now, full equality for women, in fully equal partnership with men." NOW didn't question the existing power structure but aspired to become part of it.

While Betty Friedan was the media presence of the women's movement, less-known women who had experience in the radical civil rights and antiwar movements were formulating a more political analysis of women's place and function in society. Such figures had come to the conclusion that women's oppression was a class issue; political radicalism and female oppression often went hand in hand, as it did throughout the society. Most of the more radical women's movement—groups like the Redstockings and WITCH (Women's International Terrorist Conspiracy from Hell)—specialized in hectoring corporate organizations. This radical wing of the women's movement introduced the mottoes that would define the movement a few years later: "sisterhood is powerful" and "the personal is political." Since most of the radicals met in small groups, it is unlikely that Valerie Solanas had any knowledge of them as she sat down to type out her own manifesto.

"Some people think I'm saying, 'Women of the world unite—you have nothing to lose but your men.' It's not true. You have nothing to lose but your vacuum cleaners."
—Betty Friedan

❏

MGM-Verve finally released *The Velvet Underground and Nico* in March 1967. The album looked great, with Andy's life-size peelable banana on the front, and color photos by Paul Morrissey on the back. Sterling Morrison glimpsed Lou Reed dressed in a leather jacket, getting off the LIRR at Freeport, carrying a stack of albums, coming home a star. Or at least, he hoped so.

In the nine months since the Velvets recorded the album, the California bands they despised—the Mothers of Invention, Jefferson Airplane, and the Grateful Dead—had moved from being just a West Coast phenomenon to gaining national attention. California music had created a market for a more mellow sound that proved disastrous for the reception of the edgy Velvet Underground. MGM-Verve was afraid of the album and had little idea of how to put it out at a moment when American youth were moving away from hot-rods-and-chicks rock and roll toward the Age of Aquarius.

MGM-Verve released a pop version of "Sunday Morning" as a single, in an unsuccessful attempt to make the Velvet Underground palatable for AM radio. On the flip side, "Femme Fatale" got a note in *Cashbox*, which had chosen it among its "Newcomer Picks" and called it "a haunting, lyrical emotion-stirring chant." But the release of the complete album encountered a virtual media blackout. The only print publication to advertise it, *The Evergreen Review* (Grove Press), described the record as "Andy Warhol's hip new trip to the subterranean scene." Advertising was out of the question on AM stations, and even the fledgling FM rock stations declined. Most radio stations refused to play it—largely because of the dark content, but also because of the unconventional instruments and sound and the length of the musical tracks. Whatever momentum could have been built was halted in midrelease when Eric Emerson brought a suit against MGM: his face appeared within the multimedia collage on the back cover, and he had not given permission. According to Sterling Morrison, the real reason for the suit was that Emerson, recently busted for possession of LSD, needed to raise legal defense funds.

In May the album feebly made its way onto the hit charts—peaking in at 171 on the *Billboard* chart and 102 on the *Cashbox* chart; at about that time MGM-Verve pulled the record for six weeks to airbrush Emerson from the picture. By the time the album returned to the record stores, no one was talking about anything but the release of *Sergeant Pepper's Lonely Hearts Club Band*.

Grove Press (1948–85)
Barney Rosset bought Grove Press in 1951, when it had three books, and it became one of the most audacious American publishers of the 1950s, 1960s, and 1970s. Rosset's list of authors was a rich mix of (1) underappreciated Americans (Henry James, Sherwood Anderson); (2) Europeans (Samuel Beckett, Jean Genet, Antonin Artaud, Simone de Beauvoir, Alain Robbe-Grillet); (3) censorship challengers (Henry Miller's *The Tropic of Cancer,* the unexpurgated *Lady Chatterley's Lover*); and (4) new writers (Hugh Selby Jr., Franz Fanon, Robert Coover, Jack Kerouac, the San Francisco Renaissance poets). Rosset also published a quarterly magazine, *The Evergreen Review.*

❑

Through a small hole in the window of the sculptor Frosty Myers's studio shot a red laser beam, courtesy of a donated Electra Physics demonstrator model, Myers's ingenuity, and a timer that turned it on every night at eight o'clock and off again at four A.M. The laser was beamed across the deserted night street and bounced off a mirror that sent it down Park Avenue, off another mirror, and through the plate-glass window of Max's Kansas City, where it beamed in over the heads of the customers at the bar and all the way to the backroom wall. "Going down Park Avenue and then the angle into Max's," recalled one regular, "it was like following a star." On misty days the beam seemed to sparkle, and when it pierced through the smoke-filled room of Max's, it looked like a hot red wire. The laser served as a beacon for the establishment that became the epicenter of pop culture. "Max's Kansas City," said Andy Warhol, "was the exact place where Pop Art and pop life came together in New York in the Sixties."

Larry Rivers posed the question, "What is a bar?" and answered, "It's a space that has light that's usually fairly dark, where you go for a certain kind of social interaction. It's not a dinner party. It's not a dance. It's not an opening. You move in a certain way through this space, over a period of time, and you begin to recognize faces that begin to recognize you." Jutting out over the sidewalk was a black awning and above it a marquee that spelled out *max's kansas city* in white lowercase letters, followed by *steak, lobster, chick peas.* The exterior was black, with a huge plate-glass window that got broken about every six months when someone got into a fight.

On Park Avenue and Seventeenth Street people stopped to check out their evening's outfit in the security mirror over the night deposit box in the bank next door—Warhol called it the "last mirror before Max's." A line began to form by nine and was at its longest around eleven.

In the daytime one could walk right in, but at night there was a velvet rope. Behind it stood Mickey Ruskin or one of his trusted door persons. Ruskin had jet-black hair and a chipped gold tooth, and he didn't care about how he dressed, perhaps a sports shirt, too-short black pants, and red socks. He leaned on the rail by the cigarette machine or circulated through the bottleneck area by the bar, and while he distractedly picked his nose, he was simultaneously surveying the crowd inside and deciding which elements from the outside he wanted to add to the mix.

Mickey's on-the-spot rules to deny entrance were capricious and firm. It wasn't simply a matter of weeding out the too-obvious bridge-and-tunnel crowd but of creating the right mix of attractive women, hard

drinkers, artists, fashion people, Euroglitz, Lower East Side, and club kids. Mickey's rule of thumb was to reject people who might stifle the permissive atmosphere inside. When Mickey hired Dorothy Dean as a bouncer and door person, he told her that Max's "should be a place where old," she recalled, "he used the word 'old,' in particular artists, could feel comfortable. He said be very careful about refusing admittance to somebody who looks old and shabby, because it could have been somebody who started out as a painter. The most dreaded category of people, people he did not want in there, were what he called OBs, other boroughs."

Mickey also rejected men in suits and ties, in part because he was peeved that most good steak houses demanded coat and tie. He ordered even Warren Beatty to return to his hotel to change into more casual clothes. He told Janis Joplin to take a bath before she came in. His style was direct, and when one rejected customer questioned his judgment, he simply burped.

Once inside one looked left into the low light and saw a long room filled with red-tablecloth-covered tables, Formica-topped booths, and a long curved bar, dotted with bowls of chickpeas. Over the bar hung a clock that was four feet high and six inches wide, composed of boxes of colored lights, whose configuration changed every twenty minutes; only the initiated could read the time. Two piranha-filled fishtanks flanked the bar, and at a set meal hour each day Mickey Ruskin fed them goldfish. (The piranhas came to a bad end when a disgruntled employee cut his finger and dropped blood into the tank, driving the piranhas into such a frenzy that they tore each other apart.)

The booths and tables in the alcove were filled with a mix of fashion people and jet-setters and luminaries and downtown nobodies. One felt a buzz of glamour passing through this section, appraising the high attractiveness quotient and seeing unexpected juxtapositions.

Sitting at a banquette was sixty-three-year-old Cary Grant, scolding a waitress for allowing carcinogenic charcoal on his steak. Nearby sat the evangelist Marjoe Gortner. Mel Brooks talked Yiddish to the waitress, while Pilar Crespi swept by. Dennis Hopper was seated next to conceptual artist Joseph Kossuth. Janis Joplin always came in alone and often leaned on the jukebox holding a bottle of Southern Comfort in one hand and singing along. There was the Living Theater founder Julian Beck, rocker Brian Jones, and artist Colette flirting with Larry Poons, musician/composer/raconteur David Amram talking animatedly, and Ronnie Cutrone drifting in from the back room, looking for sex with a tourist.

"Max's became the showcase for all the fashion changes that had been taking place at the art openings and shows: now people weren't going to the art openings to show off their new looks—they just skipped all the preliminaries and went straight to Max's."
—Andy Warhol

"The Baldies" (artists who shaved their heads):
Larry Bell
Larry Poons
Malcolm Morley
Robert Smithson

There were also the artists who cast themselves in the heroic tradition of the Cedar Bar. Certain behaviors came along with the ab-ex heritage—alcohol, blustering stances, a life-and-death belief in art, and invocations of Clement Greenberg. Robert Smithson provided a vocal center in the front room; he was both rude and sensitive, morose and loquacious. "He loved conversation—he'd go to Max's Kansas City every night with a subject to throw out to the wolves," recalled Lucy Lippard. The cluster of artists in the front room included sculptors Richard Serra and Carl André, the conceptual artists Lawrence Weiner and John Baldessari, and painter Larry Poons. "The battles among the young sculptors were ferocious," said critic Ted Castle. "Carl André, Robert Smithson, Richard Serra, and John Chamberlain all had completely different ideas about what to do. But they were all in the same boat and respected each other a little bit. These arguments have long since gone up in smoke."

Frank Stella and critic Barbara Rose lived around the corner, so they regularly ate at Max's on a tab, as did their neighbor Donald Judd. John Chamberlain was frequently at the bar and got into many loud arguments. For younger artists such as Chuck Close, "it was really a heavy-duty life-or-death struggle for the soul of art—an incredible heady intellectual experience. The bar sort of ended up being sectioned off by generation." Close's generation hung out in front near the Donald Judd that hung over the front room banquettes.

There were a scattering of women in the front room, including female artists Dorothea Rockburne, Sue Hoffman (aka Viva), and Marisol. "I don't know if Mickey took a political position about women artists, but I don't think men in the art world were very comfortable with the subject," said Phillip Glass. "It was obvious that galleries were run for men and by men." Brigid Berlin stayed up front with the heavyweights and copied their drinking style, mixing shots of tequila and Jack Daniel's.

Moving on, one passed through a four-foot-wide hallway. There was a galley and a service station with a bowl of prescription amphetamine pills available to the waitresses to maintain their stamina through their long shifts. The two bathroom doors and the two phone booths opposite looked innocuous enough but served as ad hoc sites for sex. The wooden panels on the phone booths concealed the lower half, so that sex could be carried on in semiprivacy. The bathroom doors across from the phones offered the classic trio of possibilities: the stalls, the urinal, and the floor.

At the end of the hall was the back room. It was about thirty feet on each side, with red booths down two walls, backed by Formica paneling, tables in the middle, and a large round table in the front corner. When Max's first opened, the back room was a sort of no-man's-land. The first to use it, Ruskin remembered, was a group of twenty people led by Joan Baez, who danced in the unused space. In the spring of 1966 the Factory entourage began going into the back room, and it soon became their home away from the Factory.

No velvet rope denied entrance to the back room, but there was an invisible rope that deterred to those who didn't belong there. "It was not the kind of place you could buy your way into," said Lou Reed. "You either belonged or you didn't belong."

A warm red glow filled the room from the light given off by Dan Flavin's red light sculpture. It consisted of two red fluorescent tubes that met in the corner of the room, about six feet above the tables, while a third tube rested on top of them, forming a triangle in real space and suffusing the area with the glow that some compared to Hades and others to a warm home fire. The red light eased blemishes and blotches and minimized pallor. The small back corner booth just beneath the sculpture was called "the paranoid booth" because its occupants glowed so redly. Taylor Mead usually sat at the table next to it. "I loved the color, I loved the feeling in the room, and I loved the observation point," he said. "Also I was paranoid. I like to keep my eye on the door wherever I am."

The round table, sometimes called "the Captain's Table," provided a focal point and became Factory territory in the complex geography of the back room. Andy felt safe at the Captain's Table, just as he felt unsafe in the front room, where he was referred to as Wendy Airhole. "He just sailed through the front room," recalled Viva. "He'd say 'Viva, what are you doing with all those heavies?'"

The electricity generated in the back room climaxed sometime after midnight in a spectacle of exhibitionism called "Showtime!" One ringleader was Eric Emerson, who would jump up onto the Captain's Table, take down his leather hot pants, and yodel. A young woman named Andrea "Whipps" Feldman would sing "Everything's Coming Up Roses." Brigid Polk would stand up on the table, plunge a syringe of amphetamine through her jeans, into her ass, and announce to the room, "I'm up!"

Mickey Ruskin steered clear of the back room because he knew something would be going on that he should try to stop—tabletop nudity, drug-passing, chickpea wars. He created a simple rule: "If I like

"I'd like to have a nickel for everyone who got fucked in my phone booths."
—Mickey Ruskin

"At Max's you could fuck anyone in the room, and that was what was sweet about it."
—Danny Fields

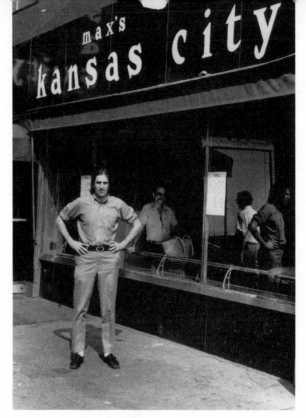

Owner Mickey Ruskin in front of his
restaurant, Max's Kansas City

somebody, as far as I was concerned, they had an absolute right to do
whatever they wanted."

The social energy generated at Max's Kansas City in the late Sixties
defies measurement or causality. Mickey Ruskin was one of the few Six-
ties figures who approached Andy Warhol's stature as a social sculptor,
and Max's Kansas City was stamped with the same contradictions of
personality. Max's was a center of gregariousness, while Mickey was shy;
Max's was the cutting edge of fashion, while Mickey wore seedy clothes;
Max's was a center of sexuality, yet Mickey remained a virgin until the
age of twenty-nine; Mickey had no plan or education in collecting art
and relied on the artist's personality to determine his judgment, yet
Max's was a vanguard art space.

Mickey Ruskin protected this world and made possible a completely
free-wheeling public life. Betsey Johnson compared him to a permissive
protective father who looked the other way whenever necessary. "Max's
was allowable," said Abbie Hoffman. "All the worlds could meet there,
and I guess you were kind of gooop [meaning gossip] proof. Whatever

happened there was off the record so there was as certain amount of protection."

By 1967 Mickey Ruskin was an experienced restaurateur and knew how to pull together a professional staff. He hired his waitresses on intuition, intelligence, and looks, and there were lots of applicants. He bluntly told his new employees: "I can get a waitress anywhere, they come a dime a dozen. And remember, the chef is always right." The waitresses at Max's added enormously to the animation of the space, as they swiftly maneuvered in their tiny miniskirts. They were attractive but not bimbos. One was the daughter of filmmaker Richard Leacock; another put her husband through medical school. "I always loved the tone of those women," said poet Robert Creeley, "not just that they were hip and sexy, but they were very bright people, almost without exception."

Waitresses hated working the back room, which they called Siberia, and Mickey Ruskin used it as a form of punishment. One waitress, Alice Zimmerman, summed up the back room: "People pulling off their clothes, yelling and screaming, customers never having anything straight, their eyes were always dilated, and NO TIPS." While alcohol was the drug of choice in the front, amphetamines ruled in the back room: people on amphetamines weren't interested in eating. And even if they were, many of them barely scraped together their rent money. As a result the waitresses in the front stations made a hundred dollars in tips on night, while the back room yielded about ten.

Mickey Ruskin hired people as bouncers with whom you would not fight. His first was Bob Russell, a man who mixed his preppy look and Gucci loafers with outlandish costumes—for a while he dressed as a priest to avoid conflicts. Dorothy Dean soon became the bouncer, inaugurating a tradition of short female bouncers; another was a woman named Ronnie who was even shorter than Dorothy Dean.

"No one is going to touch this little girl. No one will give her a hard time," said Mickey Ruskin. "She'll be able to kick people out." Mickey sometimes sent her to the bar if he saw a black man making unwanted advances on a white woman, and in one such instance the customer greeted Dorothy by saying, "Yo sister! Black is beautiful." Without missing a beat Dean replied, "First, my name is not Yo. Second, I am not your sister. And third, black is not beautiful, it's pathetic. Now get out."

The relationship between Max's Kansas City and the Factory served both sides. The Factory presence in the back room lent chic to Max's, and Warhol's publicity connections put the restaurant in gossip columns.

"Being a waitress at Max's was like being a rock star. It was like a talisman, wherever you went, your calling card all over the world."
—former waitress
Susan Bachelder

Warhol gained as much, if not more, from Max's. It became a common hangout around the time when there were too many people and too many complicated psyches to be accommodated at the Factory or at the rounds of evening parties. Just as the Factory had provided an alternative social space to Andy's home, Max's Kansas City provided an alternative to the Factory.

A Gathering of the Tribes for a Human Be-In takes place on January 14, 1967, in Golden Gate Park in San Francisco; Allen Ginsberg is a prominent force, and ten thousand are present.

In the week before Easter 1967 Manhattan residents began to see posters and handbills on kiosks and phone booths. The Day-Glo Peter Max design announced a Be-In to be held in Central Park on Easter Day; it said BRING PICNIC BRING FLOWERS BRING EASTER EGGS. Inspired by the Gathering of the Tribes in San Francisco two months earlier, the Be-In had no celebrities, nor even an agenda more specific than an engulfing support of spring and love. "We wanted it to be a celebration of being alive, of having that experience in that park," said Jim Fouratt, one of the four organizers. "People in New York don't look at each other, don't see each other, don't talk to each other." In contrast to the annual Easter Parade on Fifth Avenue, the Central Park event would be characterized as the East Coast coming-out party for a new generation of peace-loving, pot-smoking flower children who brandished their innocence and their flowers as their Day-Glo shield. The Be-In ushered in the Summer of Love.

Meanwhile Chuck Wein was cooking up ideas that would eventually give Edie Sedgwick a chance to be in a "real movie." The two had barely seen each other since the fall of 1965. He had been a consultant to Otto Preminger for a movie version (never completed) of John Hersey's novel about the Sixties, *Too Far to Walk*. (Wein had the odd prestige of being Hersey's model for a character named Chum Breed who embodied the devil in human form.) In the process he came into contact with David Weisman, another Preminger protégé, who introduced him to a fledgling producer named Robert Margouleff. When Wein realized that Margouleff could invest money, he launched into a rapid-fire pitch for *Stripped and Strapped*, a script that he and Genevieve Charbon were writing. Wein offered his experience with the Warhol movies as his calling card and his charismatic style as fuel. Margouleff got the idea that at the Factory Wein was "their god, their guide to the underworld, the spin-

ner of tales, the manipulator of rhetoric, the leader of one of Andy's competing subgroups." Margouleff bought the script for $200 and imagined an overall budget of $10,000. David Weisman would produce, and John Palmer would be the cameraman. *Stripped and Strapped* soon became *Ciao!Manhattan.*

Ciao!Manhattan offered a vision of the Sixties enacted by a cast of Factory figures. It combined elements of *vérité* skin flick, Sixties noir, and a love story with speed, a Be-In, and an orgy. Paul America played the romantic lead, and Baby Jane Holzer played an astrologer madame. For a large-scale orgy scene, shot at Al Roon's Health Club in the Ansonia Hotel, Chuck Wein enlisted the services of Brigid's sister Richie and a young artist named Sue Hoffman (aka Viva).

One night at Max Kansas City's Allen Ginsberg gave Wein a Be-In flyer and spoke enthusiastically about the event's potential. "It came from the West Coast, and we weren't so attuned to things from the other side," Wein recalled. "We weren't as effusively, consciously transcendental, but there was an easy gracefulness from the stuff out there." When Wein envisioned the event as a great Sixties movie scene, a deadline suddenly loomed, even though the script was only half finished. All the elements of the production had to be assembled in time to shoot the Be-In in Central Park, scheduled for March 26, 1967. The day before the event they still weren't sure about a female star. Susan Bottomly (aka International Velvet) was the main contender—she was beautiful and had experience with improvisational movies. On the night before the first day of shooting Wein said, "Well, what about Edie?" Wein knew that, even with the services of Dr. Bishop and his "supervitamin" shots, Edie would have trouble functioning. "She's almost dead," said Wein. "If Edie doesn't do this and come back, she's dead." Palmer and Wein found Edie Sedgwick in Room 105 at the Chelsea Hotel. She seemed spaced out but agreed to show up on Easter morning.

The Be-In event started at 6:45 A.M., when the first police car arrived at the Sheep Meadow and the few hundred already assembled rushed the car, pelted it with flowers, and yelled "Daffodil power!" Over the next few hours thousands more poured into the park. They wore paisley ties, capes, embroidered workshirts, mirrored disks on their foreheads, tinkling bells, and buttons that said MARY POPPINS IS A JUNKIE. People chanted mantras, lit bonfires on the hillside, offered jelly beans to the policemen (who feared they might be laced with acid), smoked banana skins, hid Easter eggs, climbed into trees, and made animal calls. The

crowd of ten thousand joyfully coexisted, and the police made no arrests, even when a few people took off their clothes. "Fantastic!" said Mrs. John Lindsay as she strolled by on the way home from church.

Among the crowd were Chuck Wein, John Palmer, and his crew, who arrived with a dolly and a 35mm camera. Edie Sedgwick showed up looking beautiful and wasted in her white ermine coat and leotards. John Palmer shot the stately line of buildings along Central Park West and the extraordinary foreground of Aquarian Age celebration. Edie looked incongruously beautiful in this setting, gazing up at a bearded Jesus freak holding a large cross aloft, and then she started to Charleston. It was a promising beginning for *Ciao!Manhattan.*

"The Be-In seems almost a sacred event, harking back to medieval pageants, gypsy gatherings, or the great pow-wows of the American Indians," wrote Don McNeill in *The Village Voice* that week. "At the same time it is a new and futuristic experience which, once refined, offers great promise. But it should be refined carefully. It is a lot of energy to deal with."

Slogans and Placards:
"Johnson Half Bright /
Kennedy Fulbright"
"MacBird Is a Hawk"
"Romney Is a Phony Too"
"Impeach Elbie Jay"
"Children in Vietnam Want
to Grow Up Too"
"Eat What You Kill"
"No Vietnamese Ever
Called Me Nigger"
"Hell No, We Won't Go"

The Spring Mobilization, an antiwar demonstration staged less than a month later, marked the point when activist energy against the war in Vietnam reached a critical mass. The April 15 march from Central Park to the United Nations building drew an estimated 200,000 people, a record number for a peace demonstration in the United States; the parade took five hours to cover the short distance from Central Park to the UN.

The participants in the Spring Mobilization included many factions—congressman-writing liberals, SDS activists, hippies, Martin Luther King Jr., and Stokely Carmichael—and opened possibilities for new alliances in the burgeoning American counterculture; there were also the seventy-five draft resisters who ignited their draft cards, one by one, in a coffee can held above the heads of the cheering crowd. They marched from Central Park, past the Sherry-Netherland, past the Playboy Club (where they chanted "Make Love Not War!"), south on Madison, and east on Forty-seventh Street, passing the Factory continuously for nearly five hours, a parade of ideologies on homemade placards.

Andy, who had always been politically disengaged, regarded this political spectacle as a good backdrop for Nico's face in the afternoon light. Most of the other figures at the Silver Factory also played little role in the narrative of the Sixties that focused on the war in Vietnam, the hippie counterculture, or Black Power. Nonetheless, the Silver Factory

was forced into political arenas of the era by such issues as censorship, homophobia, sex, and drugs. At the same time that Warhol relegated the Spring Mobilization to mere background scenery, *The Chelsea Girls* was providing nationwide consumable images of a different version of the Sixties generation, subversive in a different way. The political effect of the Silver Factory during the Sixties was essential to its meaning; it operated on the barricades of what was expressible.

On April 21 Valerie Solanas's first ad recruiting members for SCUM appeared in *The Village Voice*. She passed out mimeographed posters and leaflets on the streets. Initially they were just text, but she later added a crude drawing of a flipped middle finger. She mimeographed a few thousand copies of her twenty-one-page manifesto and hawked it on the street. She sold it to women for a quarter and to men for a dollar.

> "The draft is white people sending black people to make war on yellow people to defend the land they stole from red people."
> —**Stokely Carmichael**

On August 1, 1967, Valerie Solanas sent Warhol a SCUM recruiting poster to post in the Factory bathroom and suggested, "Maybe you know some girls who'd like to join. Maybe you'd like to join the Men's Auxiliary." Perhaps Warhol would like to film SCUM forums and rallies? She wrote: "SCUM's about to get into high gear. . . . The world'll be corroded with SCUM." Two weeks later she sent a second poster to be posted in "the Ladies Room" and a third "to keep under your pillow at night."

Valerie Solanas frequently called the Factory during the spring and summer of 1967. She wanted her copy of *Up Your Ass* back, demanded attention, and demanded money. At first Andy took her calls and tape-recorded them because Valerie was a great talker, but then he stopped.

The Exploding Plastic Inevitable played a few gigs that were timed to coincide with the release of *The Velvet Underground and Nico,* including the Rhode Island School of Design and the University of Michigan. In April they inaugurated the Gymnasium, a former Czech health club in Manhattan's East Seventies. The ads, featuring photos of Nico and Warhol, did not mention the Velvet Underground by name: "National Swinger's Nite with ANDY, NICO, LIVE BAND and FREAK OUT LIGHTS."

In the year that had passed since the Exploding Plastic Inevitable opened at the Dom, the multimedia-light-show phenomenon had exploded. Timothy Leary presided over a light show in what would become the Fillmore East, Salvation opened on Sheridan Square, and Cheetah was the granddaddy of the big commercial disco.

After the Gymnasium the Exploding Plastic Inevitable played one more New York date that spring at Steve Paul's Scene. Gerard Malanga, Mary Woronov, and Ronnie Cutrone danced that night, and Cutrone noticed something new: the audience was no longer reluctant to join them onstage. They used to depend on the EPI dancers to express their feelings but no longer. "It was a bit sad, because we couldn't keep our glory onstage," said Cutrone, "but we were happy because what the EPI intended to do had worked—everybody was liberated to be as sick as we were acting!"

John Cale met Betsey Johnson in May 1967 at Paraphenalia. When they first met, she was going out with Sterling Morrison, but John never took Morrison's commitment too seriously. Cale and Johnson began dating, and Cale understood fairly quickly that this relationship was more serious than anything he had previously experienced. "Here was somebody who was really alive, a sparkling personality and also generous. She was doing in fashion what we were doing in music."

Betsey Johnson was designing costumes for *Ciao!Manhattan* as well as clothes for Paraphenalia. By this time she was not alone in Pop fashion—designers from Paco Rabanne to Rudi Gernreich made dresses of plastic squares hooked by metal rings, high plastic boots, swirling psychedelic prints with 3-D appliqués, electric dresses equipped with hip-belt batteries, and skirts so short that the hemlines had nowhere to go but down. Betsey Johnson designed clothes for the Velvet Underground and traveled to some of the out-of-town gigs. It was the first alliance outside the band that had the potential to be threatening. "Lou pinned this as a betrayal," recalled Cale. Around the summer of 1967 the band's housing shifted once again. John moved into the Chelsea Hotel with Betsey, the Tenth Street apartment broke up, and Sterling Morrison moved into Paul Morrissey's apartment.

"We were regarded as freaks."
—Susan Bottomly

The most glamorous adventure that spring was a trip to France in mid-May. Warhol hoped to show *The Chelsea Girls* in the Critic's Choice section of the Cannes Film Festival. Warhol wanted to take along an entourage, but that led to the inevitable problems and joys of selection. Andy finally chose Gerard Malanga, Paul Morrissey, Susan Bottomly and her boyfriend David Croland, Eric Emerson, Lester Persky, and Warhol's boyfriend, Rod La Rod. The inclusion of Susan Bottomly and her

boyfriend suggested her prominence as the de facto glamour Girl of the Year, while Lester Perksy was along for deal-making. Eric Emerson was the most unlikely member to be invited—he had sued not only over the use of his photo on *The Velvet Underground and Nico* but to block the screen of his section of *The Chelsea Girls.*

At Cannes *The Chelsea Girls* was not screened because of fear about the film's reputation as a bacchanal of drugs and perversion. Warhol felt used and misled.

Susan Bottomly gained the most from Cannes. For the trip she had borrowed clothes from a variety of New York boutique shops—"shorter-than-God miniskirts" and metal and silver dresses. With her hair pulled back, French style, in a chignon, and her startling eyes set off by dramatically long earrings, Susan Bottomly inspired offers for modeling jobs. She didn't return to New York with the Warhol entourage but stayed in Paris for the fashion shoots that launched her career as a European model. "I now realize that that trip marked the beginning of the end of my Factory involvement," said Bottomly. "After that it was friendly but more intermittent."

Gerard Malanga went to Rome to visit Luigi Barzini, after sending him a group of his poems about Benedetta. Barzini told Malanga that the father of the poet's muse had probably never been so directly involved with the poet's process and work. When he arrived in Rome, Gerard shot film of Luigi Barzini for his feature-length film, *In Search of the Miraculous.* Since Barzini was not in contact with his daughter, he did not know of her breakup with Gerard; nor did Gerard communicate it. The situation resembled a Jamesian novel of discrepant awareness.

Warhol's entourage proceeded on to Paris, where *The Chelsea Girls* was shown at the Cinémathèque. Andy and Gerard saw their old friend Taylor Mead for the first time in two and a half years. Although Taylor had intermittently sent brief notes, they had conveyed very little of what he had actually been doing since he flew to Paris in November 1964.

After spending a few months in Paris, Taylor Mead had grown tired of its gray skies, so one night he hopped a train to Rome and stayed there a year. He found friends in Rome and spent aimless afternoons with artists and writers and members of the Living Theater at the Ristorante Rei Degli Amici. He showed *The Queen of Sheba Meets the Atom Man* with improvised sound at the prestigious Galleria Tartuga, with both Alberto Moravia and Michelangelo Antonioni in the audience. Moravia wrote an article about Mead, comparing him to Tati, Keaton, and Chaplin. This was about the only public exposure Mead had gotten, and his

Susan Bottomly, known as International Velvet, by Billy Name

acting career seemed to be in hiatus. He had shot a few films with his friend Jean-Jacques Lebel, but stretches of nudity caused them to be confiscated and destroyed by the developing labs. After a year Rome too depressed him: "It was too heavy with history or something," Taylor wrote, "maybe dead Christians."

During the Paris screening of *The Chelsea Girls* at the Cinémathèque, Mead had an epiphany about being in Europe. "Half the audience walked out of *Chelsea Girls*," he said. "They thought it was a put-on or something, and I realized, 'They don't get it.' I said to myself, 'What am I doing among these frogs? The United States has the best and the worst, and I'm going back.'" Warhol too urged Mead's return, saying, "Oh, Taylor, we have a lot of parts for you." But Taylor didn't put much trust in Warhol's promises.

After encountering Taylor Mead in Paris, the Warhol entourage stopped in London to talk with Brian Epstein about a European tour for the Velvet Underground. Epstein loved their first album, but no plan for a tour was made, and he died three months later from an overdose of Carbatrol.

Warhol and Morrissey also saw Nico in London. After a short time in Cannes she had gone to London to get medical attention for her perforated right eardrum; she was experiencing increasing deafness. She overstayed her welcome living in Paul McCartney's house, and Warhol and Morrissey urged her to fly back with them in order to sing with the Velvet Underground at Poor Richard's in Boston. When the three returned, they traveled to Boston for the engagement; the band had been playing without Nico for several months and did not allow her onstage. This snub marked the end of Nico's connection to the Velvet Underground. She flew west to California for the summer, to the Monterey Pop Festival, Brian Jones, and Jim Morrison.

During the filming of *Ciao!Manhattan* that spring Chuck Wein encouraged Paul America to live with Edie Sedgwick at the Chelsea Hotel in order to monitor her heroin use. Paul America seemed like an odd choice for the role, given the amount of acid, speed, and heroin he had ingested in the last two years. But he had recently kicked heroin himself, and he monitored Edie's withdrawal with the required firmness.

The chemistry between Paul and Edie was electric, in part because both were so emotionally precarious. "His psychic balance is very delicate—like Edie's, but *very* delicate," said Richie Berlin. "You could

almost say . . . that he had just landed from another planet. Almost a total telepath, I would say." Edie transferred her sexual obsession from Bobby Neuwirth to Paul America. "Paul is such a strange, zombielike guru," she said. "I hate him, but have this strange fascination, this kind of love and sexual addiction for him." His model-like facade was blank and impenetrable, and his rage erupted in odd ways. He could arrive at a friend's house wielding a plumber's wrench and demanding possessions, or show up at a party where he slit the guests' clothes. When his tensions got to be too much, he would head off to a commune to recover, returning healthy and strong, looking like a god.

Although Edie's heroin use declined, the couple's speed use continued, and Edie's apartment in the Chelsea Hotel became a speed marathon of stringing beads, cutting things up, and pasting things down. One evening her friend Danny Fields brought Leonard Cohen down the hall to meet his neighbor. Cohen immediately noticed Edie's configuration of candles on the mantel and warned her, "Those candles are arranged in such a way that they're casting a bad spell. Fire and destruction."

In May 1967 Edie awoke and found her room ablaze. She tried to open her locked door, and when the first attempt failed, she ran into the closet to hide. As the smoke began to seep under the closet door, she jumped out and tried again. Burning her hands on the white-hot knobs, she pulled the apartment door open and collapsed nude on the landing. A neighbor covered her with a blanket and moved her to the lobby. David Weisman arrived and transported her to St. Vincent's Hospital, where her brother Bobby had died two years earlier. The doctors assessed her burns as insufficient to warrant admission and sent her away. Dr. Bishop, who had been vacationing in the Hamptons, came in the next morning at seven and administered some basic first aid and some shots of speed and supervitamins.

Edie Sedgwick left behind a completely destroyed hotel room. Her bed had burned through the floor and fallen into the apartment below. None of her things could be salvaged. Her cat Smoke died in the fire.

"She was a star there . . . like Kay Thompson when she lived at the Plaza and wrote *Eloise*. Edie was the genius in residence."
—**Bob Neuwirth**

The most prestigious of the Velvet Underground's engagements in 1967 was a benefit concert for the Merce Cunningham Dance Company, staged in July at Philip Johnson's glass house in New Canaan, Connecticut. After a long period away from playing the art circuit, the Velvets were invigorated by playing on a bill with the music of John Cage,

orchestrated for viola, gong, radio, door slam, and car engines. The Velvets played in front of a modernist architectural icon on a perfect summer afternoon. There were no films, no light shows, just the band playing and Gerard Malanga dancing alone under the trees.

The engagement had been arranged by Fred Hughes, a dapper twenty-three-year-old man from Texas. He was socially ambitious and connected to Dominique and Jean de Menil, a wealthy Houston couple whose interests included African art, Surrealism, contemporary art, and Merce Cunningham's dance troupe. Henry Geldzahler had met Hughes at the Venice Biennale in June 1966 and immediately understood how he and Warhol could benefit from each other, and he encouraged an introduction. Christopher Scott described it as Henry's "reconciliation gift wearing chalk-striped hand-made suits." Although Hughes had little to do with the Silver Factory, he would become the most enduringly influential figure in Warhol's post-Factory career.

Warhol recognized that Hughes could be useful. "I never questioned whether we'd get along or not," said Hughes. "For one thing, he [Warhol] knew who I was, and he saw the pot of gold at the end of the rainbow, just like I did."

Upon returning to New York from New Canaan, the Velvet Underground discussed engaging Steve Sesnick as the band's new manager. Sesnick had arranged gigs at the Chrysler Museum in Provincetown and at the Boston Tea Party, which he partly owned. Lou Reed unilaterally decided to bring him in. New levels of dissension now began. Lou began referring to the group as "his band," and Sesnick would back him up by saying, "Well, Lou is the songwriter and lead singer, so it's really his call here." Cale had always been able to talk out his disagreements with Lou, but the additional layer of a manager alienated him. "In my mind Sesnick could not invalidate the relationship I had with Lou," said Cale, "because there had been that period in 1965 when we both had gone through intellectual puberty, creating a bond that could never be erased."

After the Chelsea Hotel fire Edie Sedgwick returned to the production of *Ciao!Manhattan* wearing baseball mitts to protect her burned hands. A journalist thought she looked "like a sweet fragile doll who has been pulled out of the furnace. There are scabs on the tip of her nose and the edges of her ears." Edie had been afraid that when the gauze was unwound, her hands would look grotesque, but they came out

unharmed, and she was able to get by with foundation makeup covering her burns. "Even in that state," Chuck Wein recalled, "she photographed beautifully."

Wein set up a charge account at Dr. Bishop's office to provide Edie and the rest of the cast with supervitamin and amphetamine shots. "He was the official astrologer-doctor," said David Weisman. "He had a horoscope in one hand and a syringe in the other." The other producer, Robert Margouleff, recalled that production began with good intentions—to portray "the madness, the alienation, the rage, the shock, everything these people were going through." As the weeks continued, the production began to embody that spirit. The movie's most astonishing scenes were staged in Al Roon's Health Club, where an orgy with couplings takes place on rubber rafts in a swimming pool. The marathon shooting went on for forty-eight hours, with Dr. Bishop on site for amphetamine shots. Robert Margouleff's father would periodically show up at the spa with his wife, large dog, and trays of smoked salmon and caviar. At his appearance everyone tried to act as if they knew exactly what the movie was about. But it soon became clear that the movie was out of control.

As John Palmer recalled, the diffuse energy was the product of amphetamine deterioration. After the chemically induced mania, grandiose disorganization followed. "Andy was a model of maintenance in his speed use," said Palmer, "but *Ciao!Manhattan* was a case of the movie's brain trust going out of control. Everything imploded."

By the end of the summer *Ciao!Manhattan* was unfinished and in complete disarray. They had gone through $47,000 and still had no clear story. The male star, Paul America, had stolen the Margouleffs' car and taken off for Indiana. By the time David Weisman and John Palmer found him, eight months later, he was in an upstate Michigan jail on a marijuana charge. The female star, Edie Sedgwick, had driven to Los Angeles with Sepp Donhauser, a new boyfriend, and settled into the Castle in Hollywood, one floor below Nico. "We were stuck with a pair of missing stars in unfinished scenes from an unfinished script," said David Weisman, and the production was shut down indefinitely.

In July Danny Fields engineered a meeting of Nico and Jim Morrison at the Castle. "I thought they would make a cute couple," Fields said. "They were both icy and mysterious and charismatic and poetic and deep and sensitive and wonderful." The two soon began an affair. One night when

"I think drugs are like strawberries."
—Edie Sedgwick
from *Ciao! Manhattan* tapes

"Oh, wow, what a scene that place was—that heavenly drug-down-sexual-perversion-get-their-rocks-off health spa."
—Edie Sedgwick

"That film reduced me to chicken-salad sandwiches, a little one-room office over a bar on Third Avenue, and holes in my shoes. It really changed the course of my life."
—Robert Margouleff

they were naked and stoned on LSD, hashish, and liquor, Morrison led Nico to the tower. He jumped on the parapet and walked it, then urged Nico to follow as a symbol of their embrace of danger and trust.

"He was the first man I was in love with, because he was affectionate to my looks and my mind," said Nico. "Everything was open to use; there were no rules. We had a too-big appetite." Nico was no stranger to drugs, but she learned from observing the ways that Morrison incorporated them into his creative process. "You could say that Jim took drugs because he wanted visions for his poetry. It is like people in the office who drink coffee to help them work. It is really the same."

With his rock promoter's sense of image, Danny Fields thought of Morrison and Nico as the Adam and Eve of the Summer of Love. Their life together was short—about a month—but it was lived on a mythic level, illustrated by hyperbolic visions induced by peyote buttons. Creating their own ritual of union, Nico and Morrison exchanged blood in the desert. The most important lesson she recalled was watching Morrison as he experienced Blakean visions of angels in trees in the desert. "And Jim showed me this is what a poet sees," said Nico. "A poet sees visions and records them."

This month-long summer encounter provided Nico with the impetus to take her next step toward independence as an artist. "He said to me one day, 'I give you permission to write your poems and compose your songs!' My soul brother believed I could do it. I had his authority." At that moment Morrison's popular authority was clear: "Light My Fire" had been released in June and held the number-one spot for three weeks and counting. When Nico said she was incapable of composing or mastering the mechanics of writing, Morrison told her to write down her dreams, literally, and to read Celine and Blake and Coleridge.

Soon afterward Nico began writing her first lyric, "Lawns of Dawn," which echoed her meeting with Morrison on the parapet and her vision in the desert:

I cannot understand the way I feel
Until I rest on lawns of dawns—
Can you follow me?

Following her month with Jim Morrison, Nico headed north to hang out with the Warhol entourage, who had come to San Francisco to promote the premiere of *The Chelsea Girls.* They arrived at the height of the Summer of Love; two months later a funeral march would be staged for "Hip-

pie, devoted son of Mass Media." In Haight-Ashbury the Warhol troupe encountered army pants and Indian bedspreads, patchouli oil and incense, dirty Day-Glo signs and offset broadsides for the Black Panthers. The flower children would glare at the entourage's Cadillac limousine. To egg them on, Morrissey rolled down the window and asked, "Say, where's the nearest Salvation Army? We wanted to buy ourselves some hippie clothes."

San Francisco in the summer of 1967 embodied much that Paul Morrissey disliked—faux hippie innocence, dependence on group conformity, rising use of drugs—and it provided him with the perfect target for his invective. He would say: "Oh God, the music in this city is so incredibly bad. Just think about it: San Francisco has not managed to produce even one individual of any musical distinction whatsoever. Not a Dylan, not a Lennon, not a Brian Wilson, not a Mick Jagger—*nobody*. Not even Phil Spector! They delude themselves that music is a *group* thing—the way they think everything is."

In the summer of 1967 Valerie Solanas met Maurice Girodias, a fellow resident of the Chelsea Hotel. His father, Jack Kahane, had founded the Obelisk Press in 1931, and for the next two decades he published books that alternated erotica and avant-garde writing. Maurice Girodias carried on this tradition with his Olympia Press, founded in 1953, financing the publication of serious literature with his line of "DBs" (dirty books). Girodias currently supported himself with the success of *The Olympia Reader*, published in 1965. He understood that, with censorship in retreat, Olympia Press would lose its niche as a publisher of DBs; he moved from Paris to New York in 1966, hoping to reinvent Olympia Press, and he ran an advertisement that encouraged Valerie Solanas: "You have been rejected by all existing publishers: well and good, you have a chance with us. We read everything—promptly, discriminatively and optimistically."

One day Girodias found in his box a note from Valerie Solanas, introducing herself to the publisher as a prospective writer. When he met her, he noticed she was "extremely energetic and brutal, like New York girls who beg and live by their wits are . . . she was naïve, she was very smart, she could not come to terms with these contradictory forces: the fact that she did not look quite like a woman but neither like a man." He had previously found militant lesbians to be boring and doctrinaire, but he appreciated her pungent humor: "Valerie pushed her distortions so

"Her fixed expression was that of a Douanier Rousseau personage frozen in wooden immobility against its picture-book background, and yet one could vaguely sense the sunken dreams fermenting inside."
—Maurice Girodias on Valerie Solanas

far in what she said and in what she wrote as to turn them, somehow, into a valid fantasy."

After listening to her salty monologue, and reading *The SCUM Manifesto,* Girodias found himself oddly supportive of her critique. He thought her solution of extermination "was obviously a verbal provocation *à la* Swift, a joke meant to emphasize her point." An intelligence as original as Valerie's, he thought, was wasted eking out a living on the street. He suggested that she write an erotic autobiographical novel, "along the lines of the manifesto," but filled with sex stories.

In August 1967 Girodias invited Solanas to dinner to sign a contract. He would give her immediately a $500 advance against royalties, with promised further installments accumulating to $1,500. When Valerie arrived that evening at the El Quixote restaurant, next door to the Chelsea Hotel, Girodias was struck by her feminized appearance. She had applied a faint trace of lipstick and eye shadow, and she wore a red dress. She said to him, "Don't you think I'm a good-looking girl?"

Girodias offered her a simple boilerplate contract—Paul Morrissey recalled it was only a few sentences long and that it said something like "I will give you five hundred dollars, and you will give me your next writing, and other writings." No binding control was involved, but it provided fertile ground for Valerie's paranoia. When she called the Factory to talk about the contract, Morrissey suggested that she get an opinion from Ed Katz, a lawyer that Warhol kept on retainer. Morrissey set up an appointment, and Solanas kept it. Katz assured her that the contract did not give Girodias the right to control all her future works, but Valerie was not put at ease by this legal consultation. "He screwed me, too," she concluded. "Said everything was okay. I think he was being paid by the publisher. You can't trust any of them." In her mind she was sure Warhol had front companies, and perhaps Girodias and Warhol's lawyer were in cahoots.

Sterling Morrison recalled how fine it was to be in New York during the 1967 Summer of Love:

> Roughly speaking, every creep, every degenerate, every hustler, booster, and rip-off artist, every wasted weirdo packed up his or her clap, crabs and cons and headed off to the Promised Land. This sleazy legion . . . then descended upon the hapless hippies (and their dupes) in San Francisco. But behind them in Man-

hattan, all was suddenly quiet, clean, and beautiful—like the world of Noah after the Flood. And so at the height of the "Summer of Love" we stayed in NYC and recorded *White Light/White Heat,* an orgasm of our own.

In September 1967 the Velvet Underground went into the Mayfair Sound Studios in New York with an experienced sound engineer named Gary Kellgren, who had never faced the sonic demands that the band was about to make.

"We wanted to go as high and as hard as we could," said Lou Reed, who went into the session prepared with a souped-up Gretsch Country Gentleman guitar. He had fitted it with preamps and speed/tremolo controls so that it could produce sixteen notes for each one played, added Stratocaster Fender pickup for more tremolo, and converted the Gretsch to stereo so that he could get low bass and high treble simultaneously. Reed was carrying a state-of-the-art, James Bond version of a rock-and-roll guitar.

Rather than laying down separate vocal tracks in common recording style, the Velvet Underground treated the studio performance with the all-out fury of their live performances. They turned the volume up until the sound bounced off the walls of the small studio. Over a half-dozen sessions in two weeks they were fueled by a variety of chemicals and the passion of a band at its peak. "Given our druthers we would have broken all the equipment," said John Cale.

When the recording engineer warned them that all the needles were on red, the band said they didn't want to hear about problems.

The intensity of the music on the album reflected both the internal tensions within the band and the musical energy that had been tightened by playing together on the road. Unadulterated by Nico, this record was the purest form of the Velvets' sound. "It was a very rabid record," said Cale. "The first one had some gentility, some beauty. The second one was consciously anti-beauty."

The most volatile track on the record is the seventeen-minute song, "Sister Ray." Reed wrote some of his best lyrics to tell a shaggy tale of drugs and blowjobs. "It's just a parade of New York night denizens. But of course, it's hard to understand a word of it," said Lou Reed. "Which is a shame, because it's really a compressed movie." The band used "Sister Ray" as an open-ended riff, often preceded by an improvised prelude in which Lou Reed seemed to be channeling characters from his head, and it grew longer and longer. The song became a free-for-all of sound, and

"Hippie":
Coined by Michael Fallon in the *San Francisco Examiner* on September 5, 1965, the term meant residents of the Haight-Ashbury section of the city. The term soon went beyond geographical roots to indicate a broad countercultural movement that embraced psychedelic drugs, tie-dyed T-shirts, long hair, communal living, organic food, and free sex.

"*White Light/White Heat* is a record principally known and adored for its molten overflow of guitar distortion and full-bore feedback terrorism."
—Velvet Underground boxed set liner notes

the Velvets decided they would record only one take: "No excuses or druthers," as Sterling Morrison put it. "Whatever you want to do, do it now."

The band started the song at a high level, and then Cale's Bach-like organ solo broke through the wall of sound. Morrison looked over and wondered where Cale was getting all the sound, until he saw him pulling out all the stops on his organ. "All of a sudden the organ is way louder than me and Lou," said Morrison. "I couldn't turn up; I was already maxed out." In the rumble of sound Lou surged through with his Gretsch guitar, his lyrics only sporadically audible. The high sound quotient and interminable length prompted one of the recording engineers to walk out, saying, "Let me know when it's over." In the legend that developed, the Velvet Underground's battle of sound is sometimes interpreted as a struggle between Lou and John. But Sterling Morrison recalled that in the studio they were all pulling in the same direction musically, no matter the personal strains. "We may have been dragging each other off a cliff, but we were all definitely going in the same direction. In the *White Light/White Heat* era our lives were chaos. That's what's reflected in the record."

The box office success of *The Chelsea Girls* inspired a theater manager named Maury Maura to contact the Factory. Maura managed two art film theaters on Broadway and had recently taken over the Hudson Theater on Forty-fourth Street just east of Broadway, in the sex movie strip around Times Square. "I've got a theater. Do you have any films to show?" he asked. "You know, that *Chelsea Girls* thing, have you got something like that?"

Morrissey thought of *My Hustler*. When they screened it at the Factory on an old projector, the sound had been terrible. But projected on a new Bell & Howell projector, Morrissey said, "Look at this, Andy, you can hear what they're saying! They want to show something, and the title will make them think it's a sex film like all the girl films being shown there." Morrissey edited into the film thirteen minutes of inserts that include Gerard Malanga dancing on a beach in a fur coat.

My Hustler opened in July 1967 at the Hudson Theater. It grossed $18,000 in its first week, of which Warhol received $4,000. *Confidential* reported on the surprise success: "*My Hustler* has touched off the trend toward full homosexual realism in the movies. The reason, according to

the film critics, is that it is the first full-length film to take a look at the lavender side of life without pointing a finger in disgust or disdain, but concentrating instead on the way life really is in the limp-wristed world."

At that moment in 1967 the art film circuit was opening its doors to sexual subject matter. After 1965 the 8mm Kodachrome loops that been strictly mail-order items for home showing were screened in a few theaters around the country, and other theaters soon followed suit. They identified themselves as "gay" or "all-male" and programmed a mixture of Mae West vehicles, art films like Kenneth Anger's *Fireworks,* and such oddball features as *Glen or Glenda,* Edward D. Wood's autobiographical melodrama of transvestitism. The theaters' bathrooms became popular sex sites until the police installed two-way mirrors; vice squad surveillance rapidly took notice of gay theaters.

Andy Warhol was intimately familiar with the world of Times Square. He used its Photomat booths and arcades, and he liked the porn and physique magazines he bought there. Gay porn theaters were usually twinned with hetero sexploitation theaters so that patrons could enter on the straight side and then move over to the other side under cover of dark.

Gay movies in Times Square in 1967 were mostly silent loops, a combination of exercise films often lumped together as "dangly movies." Sexploitation films drew from the menu of available types that Bob Mizer presented at Athletic Model Guild—schoolboy, boy-next-door, bodybuilder, blue-collar worker, cop, sailor, cowboy.

In early 1967 *The New York Times* forecast as a coming trend adult themes that would have been unimaginable five years earlier. Christopher Hampton's recently optioned play *When Did You Last See Your Mother?* suggested what Hollywood considered putting on screen: a homosexual teenager whose advances are rejected by his roommate and who makes love instead to his roommate's mother; she, upon learning of her lover's bisexuality, kills herself.

The article noted already-finished adult films (like Joseph Strick's *Ulysses,* complete with four-letter words) and new properties that had been picked up for production: *Midnight Cowboy* and *The Killing of Sister George,* the first with homosexual scenes, the second portraying a lesbian triangle. David Picker, a vice-president at United Artists, noted that the showing of *The Chelsea Girls* was especially influential because it depicted material that had rarely appeared in a commercially screened movie: a transvestite, male nudity, two men in bed together, a woman

"You had to dredge up another persona to go there. It was degrading to go and degrading to leave, but inside it was just fine."
—**Robert Richards**

My Hustler marquee at the Hudson
Theater, July 1967, by Billy Name

and a man shooting amphetamine on screen. Other Hollywood produc-
ers agreed that the major studios would be inevitably affected by its
example.

On the heels of *My Hustler*'s surprising success at the Hudson Theater,
Maury Maura wanted new Factory film product that was something like
the controversial Swedish "art house" movie, *I, a Woman,* which had
been released in early 1967.

Warhol and Morrissey pursued Maury Maura's request and decided
to call it *I, a Man.* The title is one of the wittiest things in the movie, and
had Jim Morrison, the man Warhol and Morrissey wanted for the lead,
starred in the title role, it could have been electric. The connection to the

Doors' singer came through Nico, and his appearance would have produced an utterly different movie. Morrison was ideally pansexual. He was long-haired and pretty (prettier than most of the women in *I, a Man*), and his body was practiced in the choreography of eroticism. People gossiped about how Morrison allowed girls to jerk him off while he was on downers, and about his pretending to masturbate onstage.

Morrison initially agreed to star in *I, a Man*, but his manager convinced him that it would be a bad career move, so a friend of Morrison's stood in for him. Tom Baker was a twenty-six-year-old actor who looked like a poor man's Chet Baker (they shot heroin together), with prominent cheekbones, a lean body, and deep-set eyes. His looks were not a problem, but he had little superstar radiance.

I, a Man showed Tom Baker in dalliances with eight women, a combination of Factory regulars and one-timers; the film was narratively structured so that it could appeal to both heterosexual and homosexual audiences. The only full nudity is of Tom Baker. He puts his hands on the women's flesh usually to give them a massage; their sexual activity never goes beyond touch. This was a major disappointment to Warhol, who had imagined a movie of pure fucking, in the same way that *Eat* and *Sleep* had been entirely eating and sleeping. But Baker was afraid that having sex would jeopardize his professional acting career. (As it turned out, *I, a Man* was the high point of his career.)

In the midst of production Valerie Solanas telephoned Warhol to ask for twenty-five dollars to pay her Chelsea Hotel rent. "So I said why didn't she come over and be in the movie and *earn* twenty-five dollars instead of asking for a handout," Andy recalled. Solanas had one scene.

Dressed in her trademark brimmed watch cap and laced vest, she talks a mile a minute. Dramatically lit from below, the shadows from the banister seem to cast jail bars against the two figures. While Baker dominates the other scenes, Solanas is unquestionably in charge now; the tables are turned. Valerie says she felt his ass in the elevator and liked it and wonders whether he is squishy all over. Baker vainly attempts to get her to open her apartment and even takes off his shirt to entice her, but her cap and laced-up vest remain inviolable. She forces him to talk instead about men's tits. He loses control of the scene, and Valerie says to him, "I've got the upper hand."

I, a Man opened at the Hudson Theater on August 24, 1967, and by its sixth and final week, business was slacking off. Maury Maura called the

Factory for a new movie to replace it. "There are these motorcycle movies, they're doing okay, do something like that," Maura said, referring to the Roger Corman B-movies that were currently playing around Times Square. That evening in the East Village Paul Morrissey ran into an attractive young man in a motorcycle jacket and asked him, "Are you a motorcyclist?" The man, Joe Spencer, said that he was from out of town and his bike was broken, but yes, he was a motorcyclist. Morrissey suggested that he call up the Factory and be in a movie.

When Joe Spencer telephoned the next day, Morrissey and Warhol quickly rounded up a cast. Ed Hood was in town; Ingrid Superstar was always available for anything; Brigid Polk could be convinced. "Oh, I met this really funny girl who just doesn't stop talking," Andy said. "I think she would be good for a movie." He was talking about Sue Hoffman.

The white-on-black title card, *Bike Boy,* is followed by a full color shot of Joe Spencer lathering up in a shower. At moments it looks like a remake of *Blow Job*—same frame, same face type—and Joe Spencer looks like a promisingly sexy leading man. The camera's visual caress is interspersed with strobe-cuts to nipples, armpits, and ears.

Like *I, a Man, Bike Boy* posed as hetero sexploitation—the classic movie fantasy narrative, working-class trade man who makes love to women for money. But it is more overtly framed as a movie for gay audiences. The first half-hour is devoted exclusively to men. After Joe takes his shower and endlessly brushes his hair, the scene moves to a men's shop. The camera shoots a line of three dressing rooms—perfect found serial imagery for a porn movie—as the male customers change into the fashions of the day, backed by psychedelic posters on the walls.

The movie mocks its hero's manliness during the second half, when Joe Spencer takes on three strong women. Ingrid Superstar talks endlessly and boringly about food, Brigid Polk says he looks like a fag, and the new actress, Sue Hoffman, soon to be renamed Viva, decimates Joe by correcting his pronunciation and telling him he must learn how to kiss.

Neither *Bike Boy* nor *I, a Man* offered the arousal value that sexploitation movies promised. But both offered something else: a "suitable" cruising arena for men. They offered a cloak of legitimacy, for anyone could attend a movie bearing the Warhol label without shame or silence—it was an "in" thing to do. For the men at the Hudson Theater the movies' length and nondemanding pace offered a sort of wallpaper for cruising activity in the balcony. (You didn't really have to worry if you missed anything.) On Friday and Saturday nights business was espe-

Valerie Solanas and Tom Baker in the Factory stairwell, shooting *I, a Man* **in August 1967, by Billy Name**

cially brisk. One audience member recalled, "Those Warhol films were real *events,* and people went to them regularly on the weekend. They gave new meaning to sticky floors."

Sandwiched between the two sexploitation films, Warhol and Morrissey shot sequences for an eight-hour epic to be called *The Loves of Ondine.* The film wouldn't be released for nearly a year, in a truncated form, and it ran briefly to lukewarm reviews. But *The Loves of Ondine* is important for introducing two superstars who would dominate the next stage of Factory filmmaking: Joe Dallesandro and Sue Hoffman (aka Viva).

Joe Dallesandro was last seen in 1965, posing for Bob Mizer's cameras in Los Angeles. His stay in California ended in violence, following an argument with a teenager who threatened Joe with a broken beer bottle. But no one would get the best of Joe, and he pushed his attacker's face into the shards. When Joe appeared in court on the charge of assault, he told the judge that he was just trying to survive. He must have been convincingly sympathetic, for the judge agreed to let him go, so long as he departed California immediately.

Many doors were already closed to him, including his father, school,

and any job that required a high school diploma. So Joe hung around Times Square. Even though he was not primarily homosexual, he found his niche in the homosexual world, both before and after its liberation.

A man in his early forties took Joe in and helped support him. Joe was eager to work, but he had no obvious vocation in the straight world. His dream, as he later told reporters, was to own a pizza place of his own. In the meantime he survived doing a variety of things. He worked as a cutter in a bookbindery, and he helped at a friend's after-hours gay club on Columbus Avenue and West Seventy-sixth Street.

When reporters later pointedly asked Dallesandro how he had supported himself, he simply said, "When you're young and beautiful, you do get a lot of propositions." Several years later Lou Reed wrote a song, "Walk on the Wild Side," that described Joe as a hustler. Putting a different spin on the song's lyric ("a hustle here, a hustle there"), Joe described his modus operandis during that period of his life: " 'Little Joe never once gave it away,' but I do work cheap, which has been both a blessing and a curse," he said. "I always said it wasn't about a hustle. It was about how you got people who wanted to be a part of your life. The pay was that they became a part of your life, even if for a short time."

In *The Loves of Ondine* Joe Dallesandro appears on-screen in an orange sweater, his hair freshly combed to the right. When he begins to talk, he is on a different planet from Ondine. "I'm nervous," Joe says. "I can't think of anything to say, and it sounds so boring if you keep talking about nothing." Joe then suggests giving Ondine a lesson in college wrestling, and suddenly Joe's on-screen potential becomes clear. He strips to his white shorts and becomes a very competent instructor, seemingly oblivious to the sexual dimension of the encounter, a deadpan stud.

Paul Morrissey studied faces, thinking about how they would appear on-screen. When Andy glimpsed Paul studying Joe's face up close, pulling back some hair to inspect its potential more closely, he understood how much Paul was champing at the bit to make his own movies. "Paul seemed to see Joe as another Brando or James Dean—a person with the kind of screen magic that'd appeal to both men and women."

"Who will ever forget Ondine, with his face buried in Joe D'Allesandro's underpants? . . . I haven't seen these films in twenty years, and I remember every frame. I've already forgotten *E.T.*"
—Gary Indiana, *The Village Voice*

"This boy, Joe Dallesandro, is good-looking and natural-acting enough to have a showbiz career beyond Warhol."
—*Variety*, August 21, 1968

On August 4 Betsey Johnson threw a party celebrating the Return of Leo, and it was there that Andy Warhol met Sue Hoffman. She approached him, announcing that she had recently made a movie with Edie Sedgwick, *Ciao!Manhattan*. When she continued on to other bits of gossip without missing a beat, Andy was struck by the extraordinary tedium of

her voice and the intellectual references she made. He casually offered her a part in his next movie.

When Sue Hoffman was born, on August 23, 1938, her parents snipped off a ringlet of her platinum hair and tied it with a pale blue satin ribbon. She was the prized first child, and soon five more girls and three boys appeared. But Sue held a particular niche in the family; it was a rare day, she recalled, when someone didn't call her a prodigy or the Brain.

Even before she reached adolescence, Sue recognized the narrow possibilities open to her. "I was annoyed with my role as a female," she said. "Plus I couldn't understand why I was supposed to grow up and have kids so they could grow up and get married and have kids. What's the point?" She attended a convent school where all the girls wore uniforms with girdles and stockings. With nuns as her models, Sue decided she wanted to become a saint.

When she put it all together years later, Sue diagnosed her family as a classic Catholic alcoholic family. "The behavior completely contradicted the spoken word," she recalled. No one talked about the issues that hung so palpably in the air, so she took it upon herself to break through the denial. She became verbally adept at skewering any hypocrisy she felt around her.

After Sue graduated from high school in 1956, she headed to Marymount College in Tarrytown, New York. She spent her junior year abroad in Paris, where she lived in a convent in Neuilly, studied at the Sorbonne, and drew naked life models at the Academie Julien.

After graduating from Marymount in 1960, Sue moved to New York and discovered how difficult the options were for an intelligent woman who wanted to be an artist. Her first experience selling her art was at the 1964 New York World's Fair, not far from Andy Warhol's painted-over *Thirteen Most Wanted Men*. She drew the silhouettes of Fair visitors, using a stylus on thin plates of copper, and her intuitive sense resulted in quick psychological studies. But before the Fair was over, her boss fired her for wearing a bright halter top that he considered provocative. This incident was another lesson in the contradictions of being a woman— you were supposed to be sexy, but you couldn't be too sexy.

By the time Sue Hoffman met Andy Warhol, she had modeled for print and for art classes. When she approached the Eileen Ford agency, they dyed her hair, gave her false eyelashes and green eye shadow, completely changing her look. She got support from her boyfriend, the photographer Louis Faurer, who thought her small breasts and Pre-

"The ass had to be an unmoving monolith and the nipples couldn't ever show through a sweater."

"Being a harpy comes naturally from being the oldest of nine and having an overdeveloped sense of responsibility."

—Viva

Raphaelite hair were beautiful. She felt more comfortable modeling for artists, where she brought her own costumes and props. "I was like an actress," she said. "I'd bring hookah pipes and cushions and do a whole Arab thing with a turban on my head."

Sue Hoffman painted during the day and at ten o'clock she walked to Max's Kansas City and drank with the art crowd in the front room. Plenty of men talked to her but rarely about painting. "When you're young and good-looking, you think people like you for your mind," she said. "You don't know they are just talking to you because you're fuckable. I've nothing against that, that's life."

It was at Max's that Sue Hoffman was "discovered" by Chuck Wein. He was amused by the qualities of her storytelling and thought she would look good on screen. He cast her in *Ciao!Manhattan,* for the scene in Al Roon's Health Club, and this experience fueled her confidence in approaching Warhol and asking to be in a movie.

When she showed up at the Factory the next day, Andy got off the phone just long enough to tell her the address of Henry Geldzahler's apartment on the Upper East Side. "Uh, you have to take your blouse off . . . uh . . . if uh . . . you don't want to do it, you can wait for the next," he said. She was initially frightened by the idea of appearing in a Warhol movie. "But after the Chuck Wein movie *Ciao!Manhattan* someone said, 'Oh, you're so good, you're so good, you should do it.' I felt I *had* to." Her resolve was further increased when Henry Geldzahler implied that she seemed psychologically too fragile to be good. "He thought I was too mentally weak to understand the assault of the Velvet Mafia—all the gay guys," she said. "I was afraid, and I felt I had to do what I was afraid of. If you're afraid of it, do it."

Contemplating on-camera nudity, she recalled the practice of young French women on the streets of Paris who wore Band-Aids over their breasts instead of a bra. Before she headed to the Upper East Side, Viva applied a circular Band-Aid to each of her nipples and over them wore a white satin blouse.

Sue Hoffman had one scene with Ondine, and in the middle of it Warhol told her she had to start removing her blouse. Hoffman transformed the seduction into an auction of her modesty. She asked for thirty dollars per button to take off her blouse. Once the blouse was gone, she raised the price for the Band-Aids, asking $97.82. In her insistent nasal voice she transformed a sexual encounter into a lesson in economics, down to selling the novelty of her second nipple—"What's wrong with my other nipple?" she whined. "It might be another color."

A few days after shooting *The Loves of Ondine* Sue Hoffman got a phone call from Paul Morrissey. He told her she was a "performing genius on the order of Mick Jagger, a comic Greta Garbo," and she had to come right down to watch her scene in *The Loves of Ondine*. She immediately got on the subway and headed downtown from East Eighty-third and Park. "I was amazed," she wrote. "Was that really me? What made my timing so flawless? My dialogue so brilliant?"

"From then on, it was just taken for granted that she'd be in whatever movie we did," Warhol said. She had to have a new superstar name, of course—"Sue Hoffman" would look lousy on a marquee—and so they settled on Viva! (Perhaps it was an homage to the 1965 Bardot-Moreau costarrer *Viva Maria!* or the new paper towel, Viva.) They soon dropped the exclamation mark, and Sue Hoffman acquired the name that she uses to the present day.

Viva recalled that her new name marked a switch in her vocation: "Paul said, 'Painting is a dead medium,' which I always thought myself. So I said, 'Fine, I'm a performing genius, painting is dead.' " She and Mary Woronov, who also painted, went to Viva's studio and ripped down the no-seam paper that had been stapled to the wall, and threw away all the brushes and paint.

Viva brought a different kind of woman's voice to the screen: an annoyed one with complaints about men's sexual inadequacies and the casual sexual abuse that is part of everyday American life. In her scenes Viva could hold her own against every man around. Jane Holzer had big hair, Edie Sedgwick had glamorous vulnerability, Nico had otherworldly beauty, and Viva had neurotic braininess. "Your mind is a gold mine," Andy told her over and over. She became the de facto Girl of the Year, 1967. The only trouble was that few male superstars could match Viva's verbal quickness, and her wit fell into a vacuum. She said:

> I was made to understand that I had no one to react against because none of my fellow actors (with the exception of Ondine, Taylor Mead, and Louis Waldon) could use their brains. They didn't have any brains. "Please, Viva," Andy pleaded. "You've got to *talk*. Say anything. Nobody else can."

Viva was initially dubious about the people at the Factory. "I thought they were a bunch of degenerates," she said. "Little did I know that it was a hotbed of puritanism. And soon it wasn't scary at all, it was comfortable."

"I always came in on the tail end of things. The dying gasp. I guess I give it the coup de grâce."
—Viva

Taylor Mead returned from Europe in the summer of 1967, and Warhol lost no time in recruiting him. He introduced Taylor to Viva and put them in a scene together to see their chemistry on film.

As a sexual tease, Viva pulled on the belt loop of Taylor's new St. Tropez pants, and it snapped. "I was furious and insulted by her misreading of my character," Taylor said. "I let her have it in the face with the back of my hand—a totally rare reaction on my part." Viva screamed and picked up a cut-glass ashtray to throw at Taylor when Paul Morrissey interceded.

Viva and Taylor soon became an on-screen duo. They could be relied on to talk, bat words back and forth, share a droll patrician sense of humor, and appear absolutely uncensored before the camera. "Only one critic, whose name I can't remember, got it right," Viva wrote. "He said, 'A Warhol film without Viva and Taylor Mead is like a Spanky and Our Gang without Spanky and the gang.' "

Their first feature together, *Nude Restaurant,* was shot at the end of October 1967 at the Mad Hatter restaurant in the Village. One can imagine that the title sounded good for ads, and the premise sounded promising: a restaurant staffed by a nude bar lady, Viva, serving nude customers, including Taylor Mead, Louis Waldon, Ingrid Superstar, and a young draft resister named Julian Burroughs. Everyone wore a black cache-sex, which was both legally necessary and also an allusion to the old-style soft porn of physique photography.

Nude Restaurant is remarkably unsexy. The brownish color of the setting sucks up light and does not flatter the actors' bare flesh, which has lost whatever tans they had two months earlier. Taylor Mead was a veteran of taking off his clothes, and his eyes appear eternally amused, but he is an unlikely object of desire. He sings a 1920s song, orders a root beer and gin, and discusses the rise of heterosexuality in Times Square after the demolition of the cruisy Penny Arcade. All of it, he said, had led to the hippies.

The attractive young draft resister was a last minute-addition to the film, and since he presents the most overtly political expression in any of Warhol's films, it is worth tracking how such an SDS-type character came into the apolitical Factory orbit. Andrew Dungan was his real name, but he adopted the pseudonym Julian Burroughs and pretended he was Williams Burroughs's son. This was not a matter of superstar renaming but one of necessity. Julian Burroughs was on the lam. Descended from a wealthy Sacramento family, he had attended

Stanford as an undergraduate, been drafted, and spent nine months in military training. In June 1967 he went on leave and never returned. He connected with David Harris at Stanford, who was leading the war resisters' movement. Julian Burroughs realized that he had to forge an underground identity and knew enough of William Burroughs's biography to fake it as Burroughs's son. He came east for the March on Washington on October 21 and 22 and directly after this he hopped a ride to New York, where he bumped into Andy Warhol and Paul Morrissey walking down the street. Burroughs recognized Warhol. Meanwhile, Morrissey saw that Burroughs was wearing an antiwar button and thought he could be a current "type" to cast in *Nude Restaurant.* On the spot Morrissey invited the young man to show up at the Mad Hatter that night to be in a movie. Burroughs was initially unsure, worrying that it was going to be a gay orgy, he recalled, but then he decided, "These are the experiences you cannot pass up." When he showed up that evening to shoot *Nude Restaurant,* he thought about the connection between the political underground represented by David Harris and the underground film world represented by Andy

David Harris was a key antidraft activist, beginning in 1966, functioning as president of the student body of Stanford University (1966–67) and organizing draft resistance. He married Joan Baez in 1967.

Taylor Mead and Viva in *Nude Restaurant*, October 31, 1967, by Billy Name

Warhol. "This could be a good place to hide out—it's like the Under-
ground Railroad, the way out." On film Julian Burroughs delivers an
earnest diatribe against the Vietnam War. Its presence in a sexploitation
movie suggests the anomalous place of politics at the Factory.

As the barmaid Viva carries the movie. She is always ready to pipe in
with a story of a lesbian nun or a priest fondling her. She assumes the
role of the woman destined to be frustrated by sex, and she fulminates
against all the difficulties of a woman having satisfying sex in hip,
modern-day America. Periodically casting her eyes up to some Catholic
Heaven from her days in parochial school, she proclaims the new poly-
morphous sexuality: "The new word is pansexuality. Like Pan-American,
it has stops at every port."

By mid-1967 a savvy lecture booker named Robert Walker realized that
Andy Warhol could be a hot commodity on the college circuit. The rea-
son wasn't simply the success of *The Chelsea Girls* among students but a
growing appetite for figures who reflected the new era on the campus. As
the head of the American Program Bureau, Walker lined up fifteen lec-
turers before even approaching Warhol—realizing that it would require
an ample carrot to enlist Warhol's agreement. The deal up front: Warhol
would get around fifteen hundred dollars per engagement, and from that
he had to pay travel expenses and the agent's fee of 20 percent.

Allen Midgette had just returned from a trip to the West Coast. The
strikingly handsome actor had appeared in two movies by Bernardo
Bertolucci but had had no success in Hollywood. When he came into the
Factory orbit, he was working as a waiter at the discotheque Arthur. He
performed in several films Warhol shot (including *Nude Restaurant* and
Lonesome Cowboys), but he would become best known as the man who
impersonated Andy Warhol. The deal was struck one fall evening in the
back room of Max's Kansas City, when Warhol and Morrissey were com-
plaining about the upcoming lectures that Robert Walker had lined up.
Morrissey recalled that Midgette proposed the plan—"I'll go and say I'm
you"—while Midgette recalled that it was Morrissey who made the
proposition. The outrageous idea served both sides: Midgette needed
money, and Warhol needed someone exciting to carry out his lecture
demands. "Bonnie and Clyde didn't look like Warren Beatty and Faye
Dunaway," Andy said to Midgette, "and I would rather have a good-
looking guy."

Allen bought large quantities of the lightest shade of Erase by Max

Factor and a silver shade of hairspray. "I erased my face, neck and hands, and then sprayed my hair with this toxic spray," said Midgette. "It was everything I didn't want to do." Midgette and Morrissey flew to Salt Lake City for the first event.

Midgette initially imitated Warhol's voice, but he soon realized that no one knew what he sounded like. The first question asked: "Why do you wear so much makeup?" Midgette replied, "I don't think about it." That seemed to deter any further investigation of his appearance for the day. After the next question, "Are you a homosexual?" Midgette recalled that "you could hear a pin drop." When he replied no (nothing more, just "no"), the audience pushed no further. Midgette gradually gained confidence. He realized that "Andy is forgettable, that is what people don't get, that he is a forgettable face." The press seemed equally taken in; *Time* later wrote that Midgette bore "a natural resemblance to Warhol" (didn't he *wish*), and local reporters remarked that he was much smarter in person than press coverage usually gave him credit for. Midgette had an epiphany during that trip. "When you get adulation from something you are not, you see through a lot of things. Andy helped me see into fame and through it—it's bullshit, it's still just fame."

The faux Andy Warhol lectured at four western campuses during a week in October, and both Morrissey and Midgette felt the anxiety of pulling off the hoax. Paul Morrissey recalled arriving in Salt Lake City, where the wind from the airplane propellers blew powder from Midgette's hair, and Midgette recalled moving his head and chewing gum to divert attention from his face. But Midgette got away with it until, a few months later, the hoax was discovered.

By the summer of 1967 Gerard Malanga felt alienated from the Factory. Ever since Warhol had "left art," Malanga's activity hadn't been sustained by silk-screening canvases, and dancing with the Velvet Underground was only an occasional activity. He felt rudderless and unappreciated at the Factory—and obsessed with Benedetta Barzini.

Gerard felt encouraged by the fact that the Bergamo Film Festival had accepted his first feature film, *In Search of the Miraculous,* a cinematic homage to Benedetta. Not long before Gerard's departure for Italy, Andy said, "Call me from Italy, and I'll send a return ticket." Gerard was pleased at Andy's offer, for he hadn't yet figured out how he'd get the means to return to New York.

In early September 1967 Billy Name helped Gerard pack a huge suit-

"Dig deep for your heroes. They're not on the surface."
—**Allen Midgette**

Allen Midgette impersonates Andy Warhol on the lecture circuit, fall 1967

"Godard used a lot of your techniques and tricks, playing up the fact that the audience is to get the impression that the actors are speaking directly to them, at times."
—Gerard Malanga to Andy Warhol

Ettore Sottsass and Fernanda Pivano
He was the artist/designer who later founded Memphis, and she was a translator of the Beats and Gertrude Stein.

case, and when they were finished, Billy kissed him on the forehead for good luck: "So I sent him on his way with a good blessing," Billy recalled.

Gerard was excited to go to Bergamo under his own steam, no longer in the shadow of either Andy or the Exploding Plastic Inevitable. *In Search of the Miraculous* appeared on a Sunday afternoon program along with Jean-Luc Godard's *Two or Three Things I Know About Her.* As there were no subtitles, Gerard understood almost nothing of the French on the screen, but he thought to himself, "How glamorous! I have a film in a major film festival that opens with Godard!!" Gerard wrote Andy that *In Search of the Miraculous* was well received, and he made the first of many attempts to solicit money for his return ticket home. "I can't move about or even plan on going to Rome without money," he wrote.

Gerard depended on the kindness of his flexible hosts, Ettore Sottsass and Fernanda Pivano. He had arrived with six dollars in his pocket and no return ticket. Each morning he trouped over to the office of Italian *Vogue* where his friend Flavio Luchini let him use the office phone to call the Factory long distance. He continued to do this for the next two weeks, getting only the answering service. During his enforced stay in Milan, Gerard screened *In Search of the Miraculous* and *Vinyl* in the apartment of Eugenio Montale, one of Italy's leading poets; at the end of the evening Montale slipped a hundred dollars to Fernanda Pivano for Malanga. "People were really looking out for my welfare," Gerard recalled.

As his stay was becoming awkwardly extended, his friend Peter Hartman invited him to come to Rome. The next day a member of the rock band Equipe 84 showed up with an overnight train ticket. Gerard was pleasantly ensconced in a compartment with his huge bag and a group of friendly Italians, with whom he conversed haltingly until he fell asleep. "When I woke up I thought I was in a dream," he recalled. "Here I am in a strange land, with no money, a one-way ticket, and no idea of what was in store. And now that everyone in my compartment had departed during my sleep, I was literally alone, by myself, on the train in the middle of the night."

Peter Hartman not only provided a room for Malanga in his apartment and fifty dollars a week spending money but also had acted as Gerard's publicity agent. "People were already anticipating my arrival in Rome," said Malanga, and within days his presence helped catalyze activity. An artist friend pulled together a rock-and-roll band and created slides, and Gerard danced. Soon they had created a miniversion of the Exploding Plastic Inevitable, and it played the Piper Club in Rome.

Every week seemed to bring adventure and new people, and Gerard moved no closer to figuring out a way of getting back to New York. In mid-December he wrote his friend Warren Sonbert that the city "has become a cast of characters, an act of discovery," and he felt his consciousness expanding in their presence. Gerard threw himself into activities and a new girlfriend, Patrizia Ruspoli, who was descended from a prominent Roman family.

Patrizia Ruspoli wanted a Warholesque silkscreen of Che Guevara to hang over her mantel, and Gerard transformed her request into a grander plan. He could silk-screen two paintings, one for Patrizia and one to sell as a Warhol silkscreen through La Tartuga, the gallery on the Piazza del Popolo where Taylor Mead had shown his films a year earlier. Gerard could also produce cheaper works on paper. The proceeds could not only buy a ticket home but could finance shooting on his new movie idea, *The Recording Zone Operator.* He described the big paintings in detail so that Warhol would be able to recognize the work if it were mentioned. Malanga had chosen an image of Che Guevara dead on a table and reproduced it as a yellow body over a silver background, with fourteen close-ups of Che's head and twenty-one shots of his body printed around the edges of the five-by-six-foot painting. Gerard conceded that the price of three thousand dollars might be low for a Warhol painting of that size, but he wanted a quick sale. He specified that if he did not hear from Warhol he would consider that the artist consented. "I also want to tell you that what I'm doing is a criminal act," Gerard wrote Warhol, "and that the only person who could deny the originality of this work is YOU, so I trust you won't get me into trouble."

The only words Gerard heard from Andy were secondhand, via Rona Page, who had read Andy one of Gerard's letters from Rome: "Oh Rona, how can you sit there like that and not say anything—the letter is hysterical," said Andy. "I mean, he must be on a trip—he's hallucinating—oh, it's just fantastic." But Gerard paid no heed to that secondhand reaction and proceeded: "And I hope you had a twinkle in your eye when you said these words, for I assume everything is OK with you about me selling an 'Andy Warhol' painting silk-screened by me."

"Things started to go wrong for Valerie with the decline of the summer," wrote her publisher, Maurice Girodias. In October, Solanas lost her long-running battle over back rent at the Chelsea, and after two years she was homeless again. "She wasn't friendly with anyone here," reported the

hotel manager. "She wanted to dispose of all men. Her activities didn't go down well with the tenants here." Valerie's room at the Chelsea—with a dresser, bed, table, and typewriter—had provided her the stability to write. Now that she had signed a contract for an autobiographical novel, she had no place in which to write it. She urged Girodias to publish *The SCUM Manifesto* instead of the novel.

When Girodias agreed to her plan, Valerie didn't mention any contract. But over the next few weeks she peppered him with phone calls, insulted him, and railed that Andy Warhol wanted to exploit her. (Girodias was bemused, since Valerie had little to exploit.) Around this time she began addressing Warhol as a "Vulture" and Girodias as "Girodias-the-Toad." But she would also ask Girodias what he thought of her, and the urgency in her voice revealed to him the flip side of her bravado. When she called him up at four A.M. to request a sleeping place in his room, Girodias noted that she made the outlandish request very sweetly and promised to keep out of his way.

After thirty years in the publishing business, Girodias was familiar with the eccentricities of authors. In the case of Valerie Solanas, "I shrugged and prepared to forget her. Obviously the pixies were moving in, pretty fast." An acquaintance who let Valerie use his house to write returned home one day to find in the typewriter ANDY WARHOL, just that, typed over and over.

When *I, a Man* opened in New York, Valerie took her sister to an afternoon matinee at the Hudson Theater. Judy was appalled at the movie, and Valerie was bitter. "It's for the lecher crowd," she said. "No one ever went broke underestimating the American public." Valerie's always-staccato speech seemed to her sister more intense and shrill than usual. "I studied her face through my dark glasses," Judy wrote. "When had she stopped smiling? I suddenly realized that although she laughed at some things, she no longer smiled. . . . Only someone who knew her well could see it, the light had vanished."

Near the end of 1967 Valerie Solanas was invited to appear on *The Alan Burke Show*, an eleven P.M. Saturday-night television talk show. *Variety* characterized its host as someone who enjoyed "doing the Torquemada bit." Appearing on Alan Burke represented to Valerie a chance for recognition, but to Burke she was a grotesque cartoon who would provide fodder for his audience. Two acquaintances who accompanied her to the studio worried about what would happen. "They put rouge on her and painted her up, and I said that she looked like a

deranged Coco the Clown," said Jeremiah Newton. ". . . It was horrible what he did to her."

There were about 150 people in the studio that Saturday evening, and Valerie noted that it looked "just the way you see it on television." She understood that the producer had given her license to say whatever she wanted, and that if it was a problem, it could simply be eliminated. When Burke opened by asking the reason for Solanas's organization, she replied, "Men have fucked up this world." The audience gasped, and Burke told her to watch her language. "Bleep it out if you don't like it," she said, and continued talking in her characteristic style. When Burke told her that she was offending his studio audience, Valerie said, "Fuck your studio audience." Burke asked her to leave and said that if she didn't, he would. Burke stalked off the studio platform, leaving Valerie alone before the studio audience. "If she had a gun she should have blown Burke's head off," recalled Jeremiah Newton. "And the audience was howling for her blood." Valerie Solanas's appearance on *The Alan Burke Show* was never aired.

In the late fall an aspiring journalist named Robert Marmorstein called Solanas to request an interview. She consented to meet him on the corner of West Twenty-third Street and Eighth Avenue, as long as he wasn't going to ask her to get into a car. (She had had "funny experiences with strange guys in cars," she told him.) She was displeased when he took her to a Chinese restaurant, hoping for more substantial fare. Valerie knew this might be her last big meal for a while.

When the journalist asked if she was serious about SCUM, Solanas replied, "Dead serious. I want a piece of a groovy world myself. That peaceful shit is for the birds. Marching, demonstrating. That's for little old ladies who aren't serious. SCUM is a criminal organization, not a civil disobedience luncheon club. We'll operate under dark and as effectively as possible and get what we want as fast as possible."

She told him that she had rented a hall and advertised for a public forum on SCUM. About forty people showed up, she said, most of them men, whom she described as creeps and masochists. The women were mostly young, she said, and very pretty, and they lived in the Village or else lived with their parents. They had no money.

They're willing to help any way they can. Some of them are interested in nothing but sex though. Sex with me. I mean I can't be bothered. I'm no lesbian. I haven't got time for sex of

any kind. That's a hang-up. I work twenty-four hours a day for SCUM.

Years later Valerie Solanas admitted that there had never been a SCUM meeting, that SCUM was all a state of mind, and Valerie Solanas was its only member.

By the fall of 1967, the Play-House of the Ridiculous had become recognized as a downtown institution, presenting the most radical theater in New York, both in the text and performance style, filling a vital niche after the Living Theater moved to Europe in 1964. When Ronald Tavel and John Vaccaro staged *Shower* and *The Life of Juanita Castro* in July 1965, they had no idea they were inaugurating a new kind of theater, but by 1967 it had become known as the Theater of the Ridiculous. In the years between, Ronald Tavel had continued to adapt Factory scenarios (*Screen Test*, starring John Vaccaro and Mario Montez, produced in September 1966) as well as writing new plays (*The Life of Lady Godiva*, produced in April 1966) and *Indira Gandhi's Daring Device* (produced in September 1966).

The Original Ridiculous Theatrical Company:
Charles Ludlam
Lola Pashalinski
Bill Vehr
John D. Brockmeyer
Black-Eyed Susan
(Susan Carlson)
Jeanne Phillips
Gary Tucker (aka Eleven)

By September 1967 the Play-House of the Ridiculous was mired in its stalled production of Charles Ludlam's *Conquest of the Universe*. City officials had kicked the troupe out of the Seventeenth Street theater, and they had rehearsed in John Vaccaro's loft through the summer and early fall. The Ridiculous idea was marked by splits—Ronald Tavel split from Warhol and subsequently from John Vaccaro. In October Vaccaro fired Charles Ludlam from his own play; the cast walked out in protest. The next day they met in Mario Montez's apartment. At the end of the meeting the cast decided to form its own company. Seven members became the core of the new group, and they decided to call themselves the Ridiculous Theatrical Company. "We felt that Vaccaro could be the 'Play-House,' " said Ludlam, "but we are the 'Company.' "

When Rene Ricard broke the news of the cast's wholesale defection, Vaccaro said, "So? Let's get some people!" Ricard provided the link between the Ridiculous and the Factory. The speed in rounding up a cast reflected not only the flexibility of the Ridiculous aesthetic but the readymade stable of performers available at the Factory. The lead role of Tamburlaine went to Mary Woronov. She had just demonstrated her power onstage at the Caffe Cino in *Vinyl*, in which she was described as "a vicious beauty in a highly stylized nightmare." She began to inhabit

the role onstage and off, as was the style of a Vaccaro production. Ondine was cast in dual roles, and Ultra Violet was cast as the Natolia. When there was no role for Taylor Mead, Vaccaro simply opened the script to the middle, pointed his finger, and said, "You can come on here." (A swing was installed in the theater, and Taylor swung out over the audience in the middle of the first act and sang "I'm Flying," dressed as Peter Pan.) Rene Ricard retained his role as the elegantly anguished Magnavox, and Vaccaro assumed the role of Bajazeth.

The Factory stars were game to step into this let's-put-on-a-show-FAST scenario, but they had never confronted direction like that of John Vaccaro. Both he and Warhol were trying to enable their actors to feel complete freedom in performance, but their methods were utterly different. Warhol's passivity contrasted strongly with Vaccaro's extreme aggression. "I have gone beyond Artaud," Vaccaro said at the time of the rehearsal. "In order to be cruel to the audience, you have to be cruel to yourself. . . . I force them to bring out all the psychological hang-ups. I humiliate them. I do it in private, not in front of the others."

Performing the task at hand required the focused discipline—learning lines, for example, and stage blocking—that was unknown in Warhol productions. The dynamics were potentially precarious—a combination of nonprofessionals, egotists, and drugs—but when Ondine showed his respect for Vaccaro, others quickly followed suit. "Nobody took any nonsense from anyone," said Taylor Mead. Soon the cast and director were welded together by the pressure of time. "Vaccaro had a group of mad people in his hands, and he knew it, himself being mad, and he would encourage that madness," said Ultra Violet. "He had a lot of 'psychology' and knew how to set people free. Or believe that they were free, which is the key."

Mickey Ruskin sent waitresses a dozen blocks from Max's Kansas City bearing food, and the cast was able to work long hours in Vaccaro's loft on Great Jones Street. Discipline reigned. When an actor showed up late, the director would close his eyes and say, "I killed him." The cast took this metaphorically, until one night just before a performance Vaccaro began strangling a cast member when he saw her shooting up.

Conquest of the Universe was a fantastic fable that offered room for improvisation. "The script was one big anecdote," said Taylor Mead, and critic Stefan Brecht described Ludlam's text as "a fire sale of theatrical properties." When Ultra Violet had trouble with her lines, Vaccaro turned them into Middle English so that it didn't make any difference. He added a grotesque tone to the text, which reflected the extraordinary

"She moved like a whip."
—John Vaccaro on
Mary Woronov

"Even the cast members were a little afraid of her."
—Ultra Violet

"I think the great decisions of the world have been decided in bed. Everything has been decided in bed. Everything is sexual. War is sexual."
—John Vaccaro

times when the nation was split by political issues. "All of this stuff about the Vietnam War, and the hippie thing and the drugs and the sex was going on all around me," said Vaccaro, "and I was observing it all." To each of his productions Vaccaro added music—"I thought it was important to have a little diversion." *Conquest of the Universe* had a rock band called the Third Eye and songs like "There Is Power in the Flower."

Conquest of the Universe opened in mid-November to rapturous reviews. In *The Village Voice* Michael Smith wrote that Vaccaro "incorporates moldiness and tackiness into a grand design à la Radio City Music Hall, and he has managed to shape *Conquest of the Universe* into a coherent if staggering experience." Perhaps the nicest compliment came from Marcel Duchamp, who came to the play on November 21 and wanted to be filmed with the cast. "This is a Dada play," he said.

Conquest of the Universe provided a connection not only to the Dada past but to the Ridiculous future; Charles Ludlam staged his own production of his play in December 1967, under the title *When Queens Collide*. The December 1967 production marked the beginning of the Ridiculous Theatrical Company, an influential offshoot that would continue for two decades.

In the early days of the Factory Billy Name had been Andy's main source of on-site, all-purpose competence. But the issues that arose in 1967, a year filled with lawyers and lecture bookings and movie distribution, were handled by Paul Morrissey, who provided the organization and competence that Andy so completely lacked.

Morrissey appeared at a time when disorder and tension were rising at the Factory, with its growing entourage. Warhol needed a buffer against the competing demands. The temperature was too high and emotions were too brittle. "Andy needed it to be easy, he couldn't deal with conflict and friction," said Billy Name. "He would just freeze."

Paul's emergence as Andy's right-hand man redefined Billy's role at the Factory. Although he now had less to do with the Factory's daily activities, he still carried symbolic weight. After Gerard Malanga's departure in the fall of 1967, Billy provided the last link to beginning of the Factory. Looking back, Ondine said to Billy, "We are the oldest stars in the Warhol studios! The oldest! And perhaps the gayest, the most vintaged."

Billy Name's constancy guided his role at the Factory and also provided its photographic documentation. His eight thousand photographs

provide the fullest visual memory of the Silver Factory. His face rarely appears in them, and he rubber-stamped them on the back with the anonymous credit: FACTORY FOTO. Neither the visual artifacts he left, nor the silver installation he created, nor the technical know-how he embodied adequately describe his importance at the Factory. Billy himself described his role as that of a sherpa.

> I was always going to be there to make sure you didn't get lost or hurt yourself, so you could experience the peril of chaos but still be at ease with it and experience it. Whatever you were doing, you would get the essence of it, therefore you were still an enlightened person and you weren't overtaken by it.

People were sometimes sent to Billy for their first acid trip, and he also offered a constant daily safety, not only at the Factory but in the speed dens. "You can't have just chaos, you need a protector, someone who knows how to protect and nurture it," Mary Woronov said. "Billy was capable of doing that. We could all be insane and Billy would make sure that everything was together. That was his insanity." When Billy heard Woronov's description thirty years later, he approved. "The first principle was chaos. It wasn't the type of chaos of being jumbled up, mixed up—it was chaos as a pure wedge in the cosmos. Like the deep valley where nothing is defined."

By the fall of 1967 Billy was beginning to feel the symptoms of his earlier fatigue, and many thought his daily speed use over the last four years was taking its toll. He spent more time in the darkroom and became a less visible figure. His longer hours alone were dictated in part by the needs to print photos for the catalog of Warhol's upcoming retrospective at the Moderna Museet in Stockholm and to complete work for *Andy Warhol's Index (Book)*.

As Billy became more fatigued, the Silver Factory grew more physically bedraggled, especially when it got closer to the end of its lease in January 1968. When Ingrid Superstar was asked to describe the Factory, she gazed at the space and ticked off a mix of objects—a big clock that didn't work, an old fan hanging on a pipe, one wall with bricks showing through, a red light over the exit sign, a toilet that overflowed, a silver fire extinguisher, a photo of Nico modeling clothes—that reflected the physical state of the Factory. Ingrid Superstar could have added the abiding presence of Susan Pile, who came to Factory in the fall of 1966, taking the subway after her undergraduate classes at Barnard. She sat cross-legged

at a low desk typing things for Gerard Malanga and Andy Warhol, including the transcript of *a* and pieces for *Intransit: The Andy Warhol–Gerard Malanga Monster Issue*. Near the door was a sign: "Please telephone to make or confirm visits, appointments etc. No Drop-Ins. All Junk Out." When an occasional sheet of silver foil peeled off the ceiling, Billy left it in its state of artful droop, showcasing his installation in the process of disintegration. Sometimes when the dust got to be too thick, he simply sprayed it silver.

Just as Dorothy Podber had dramatized "shooting a picture" in late 1964, another shooting took place during the last months of the Silver Factory. This time it was not a Dadaist performance, and the target was not paintings but people.

One afternoon in November Andy and others (including Nico, Paul Morrissey, Taylor Mead, Susan Pile, Patrick Tilden Close, and Billy Name) were looking at movie listings, considering whether to go to *Point Blank, Bonnie and Clyde, A Man and a Woman,* or *Thoroughly Modern Millie*. At that moment a young man high on amphetamine burst through the stairwell door with a pistol.

"He was more beautiful than Alain Delon or any of those European movie stars," said Billy Name. "We thought he was trying to audition for us to get in our films, that's what we were all secretly hoping." The interloper had a five-hundred-dollar drug debt, and Dorothy Podber suggested to him that Andy Warhol might have cash lying around.

The young man made them line up on the couch and behind it— Paul Morrissey was sitting on the far right, with Nico and Taylor behind him. "I want my money, or I'm going to start shooting!" said the interloper. Nico started giggling, "Ha ha! You don't have any bullets in that gun." That made him angry, so he fired a bullet that ricocheted all over the Factory. Then he removed the bullets from his gun, except one, and said to Morrissey, "I'm going to click at your head until I get as much money as I want!" Those sitting on the couch fished for dollar bills, but none of it added up to much. The gunman pointed his pistol three inches from Morrissey's head and pulled the trigger. It was a blank. Morrissey kept talking and reminding him that the police would come any minute. "I remember very vividly, because it didn't bother me a bit," Morrissey said later, for the out-of-control young man with a gun seemed so unreal.

The interloper forced everyone to kneel down, and he began tying a girl's hat on Warhol's head. Taylor became incensed: "Who is this punk insulting a genius!" When someone on the couch gave him money, the young man grew suddenly contrite. "I don't want to hurt anybody! I actually need the money! I don't want to hurt anybody! Here, I'll prove it to you!" He handed the gun to Patrick Tilden Close, who said he didn't want it and handed it back. At that point Paul Morrissey said, "Okay, I'll take it," and held the gun behind his back, while the young man tried to retrieve it. Taylor ran to the window and yelled, while the young man ran for the stairs. Although there was no physical harm done, danger seemed more tangible.

The building at 231 East Forty-seventh Street was in the process of being condemned, giving way to the construction of a high-rise. In the fall of 1967 Andy, Billy, and Paul looked at possible buildings for their new home, just as Andy and Gerard had four years earlier. The one Billy most liked was on East Fourteenth Street, next to the Academy of Music, where the first two floors were available. "I liked the fact that it was street level and funky, and these two huge floors were like Hollywood sound-stages," said Billy.

Paul Morrissey wasn't looking for a funky soundstage; he wanted something that reflected the more organized look of Warhol enterprises. He favored the sixth floor at 33 Union Square West, emphasizing the beauty of the wooden parquet floors, the tall windows, and the light.

Choosing the new space provided an arena for transition of power. Billy saw the change coming and felt little desire to stop it. "I didn't care if Andy made money commercially. I didn't care if we got written up in *Variety*," he said. "No one would edge me out without my immediately sensing it. There was no way Paul could dislodge me because I just out-ranked him. We never had direct conversations about this, but I let him know by the way we talked that I would not contest what he was doing. But he better know that I was there, and that I had rank." When Billy heard about Andy's decision to move to 33 Union Square, he was not unhappy about it, but he recognized the future it foretold. "The first time I knew Paul was the controller was when Andy went with his choice," said Billy. "Paul was still enhancing his power. Mine already peaked."

Andy Warhol and Paul Morrissey arrived at the New Cinema Playhouse on West Forty-first Street on December 15, 1967, with fifty reels of film—

> "They always talk about the end. I guess that's when they pulled the silver down from the wall."
>
> **—Patti Smith**

most of the footage they had shot during 1967. The first reel started at eight-thirty P.M. and the last ended at nine-thirty the following evening. It has never been shown in this form since.

Since the film was nearly impossible to describe, Warhol provided the rave review right there in the title: ****. This nonnarrative presentation reflected Warhol's fascination with taking duration and random complexity to the extreme. (During the same year Warhol talked about filming *The Warhol Bible,* in which each page of the Bible would be projected long enough for the audience members to read it.) Shortly after *The Chelsea Girls* was released, Warhol said he wanted to raise the level of cacophony in filmmaking.

As **** flashed across the screen over those twenty-five hours of December 15 and 16, the year 1967 virtually replayed itself in nonchronological, cut-and-paste fashion. Ondine, Nico, and Ultra Violet in a psychedelic Haight-Ashbury with a rock soundtrack. Rene Ricard playing Andy Warhol opposite Edie, with his sound cut off. Harriet Teacher going wild with a machete, swiping at a crystal chandelier. A nude restaurant where the customers don't even wear G-strings or underwear. Brigid Berlin and Ondine playing the unlikely parents of Patrick Tilden Close. Mary Woronov playing John F. Kennedy opposite Ondine's Lyndon Johnson and Ingrid Superstar's Loony Bird. Nico among the docks of Sausalito, intoning a line from her dream book.

Warhol felt he was seeing it all for the first time, that these events were more real on film than they had been in life, and he was flooded with memories of his days of making movies, "just for the fun and beauty of getting down what was happening with the people we knew. . . . I knew we'd never screen it in this long way again, so it was like life, our lives, flashing in front of us—it would go by once and we'd never see it again."

At the time, Warhol didn't think of the **** screening as a landmark. But looking back a dozen years later, he said, "I can see that it marked the end of the period when we made movies just to make them."

WEATHER

Mostly Sunny, 80.

Tomorrow: Sunny, 80-85.

SUNSET: 8:22 PM
SUNRISE TOMORROW: 5:26 AM

New York Post

© 1968 New York Post Corporation

Vol. 167
No. 169

NEW YORK, TUESDAY, JUNE 4, 1968

10 Cents
15c Beyond 50-mile Zone

LATE CITY

Over the Counter Stock

ANDY WARHOL FIGHTS FOR LIFE

Marcus Taking Stand

By MARVIN SMILON and BARRY CUNNINGHAM

Ex - Water Commissioner James Marcus was expected to be the government's first witness today in the bribery conspiracy trial that has wrecked his career and saddled the Lindsay Administration with its only major scandal.

His opening testimony follows a dramatic scene in U. S. District Court yesterday when Marcus, 37, changed his plea to guilty in a surprise switch which visibly jolted four of the five other defendants in the alleged $40,000 kickback plot.

The dapper former aide and confidante of the Mayor said he was in no way coerced or promised anything to change his original plea of

Post Photos by Boxer and Engel

Pop artist-film maker Andy Warhol makes the scene at a recent Long Island discotheque party. Valeria Solanis, who surrendered to police after he was shot and critically wounded, is shown as she was booked last night.

By JOSEPH MANCINI
With JOSEPH FEUREY and JAY LEVIN

Pop artist Andy Warhol fought for his life today after being gunned down his own studio by a woman who had acted in one of underground films

The artist - sculptor - fil maker underwent 5½ hours of surgery performed by four-man team of doctors Columbus Hospital late la

Andy Warhol: Life and Tim By Jerry Tallmer. Page 3.

night and was given a "5 50 chance to live."

He remained in critic condition today and chances for life had not proved.

At 7:30 last night, ju three hours and 10 minut after the shooting, Valer Solanis, 28, a would writer-actress, walked up a rookie policeman direc ing traffic in Times Sq. a surrendered.

She reached into h trench coat and hand Patrolman William Schm lix, 22, a .32 automatic a a .22 revolver. The .32 h been fired recently, poli

Continued on Page 2

Continued on Pag

1968

Looking back, 1968 seems to be the year when things began to explode in America. The country moved into a state of flux and destabilization unknown since the Depression. The counterculture created odd coalitions—hippies, Black Power, antiwar groups, the Yippies—and assumed more theatrical forms. Such leaders as Eldridge Cleaver, Bobby Seale, Abbie Hoffman, and Arlo Guthrie had attained the status of media stars, and even during his long exile of healing from his motorcycle accident in 1966, Bob Dylan remained a legend. Meanwhile in the highest levels of government the cultural fissures were felt, as John Gardner and Robert McNamara left the cabinet and Arthur Goldberg left his post at the United Nations and Lyndon Johnson declined to seek office as president. A few events from those first months of 1968 suggest the rising tide of cultural resistance in America.

On January 5 Dr. Benjamin Spock and four others were indicted on charges of conspiracy to encourage violations of the draft laws as a result of their participation in October demonstration at the Lincoln Memorial. (Many of the younger generation had been raised by Spock's child-rearing methods, so he provided a powerful metaphorical figure.) A few days after the ten-thousandth U.S. airplane was lost over Vietnam, a huge crowd gathered at Town Hall in solidarity with Dr. Spock. They crowded into the aisles to sign a petition stating that they would counsel, aid, and abet draft resisters. Through the two microphones each signer announced his/her name: Susan Sontag, Allen Ginsberg,

Noam Chomsky, Conor Cruise O'Brien, Jane Jacobs, and on and on until five hundred people had put themselves at risk of five years' imprisonment and a ten-thousand-dollar fine.

Five days later Bob Dylan made his first public appearance since the motorcycle crash, performing with Arlo Guthrie and Pete Seeger in a tribute to Woody Guthrie. When they joined together in the finale, singing fifteen choruses of "This Land Is Your Land," the audience stamped their feet, and the powerful ad hoc coalition of two generations of folk singer–activists was tangible and exciting.

That February an annual charity event called the Diamond Ball was held at the Plaza Hotel. When Truman Capote's Black and White Ball was held there a year and a half earlier, the crowd was fascinated. But now they were enacting the maimed and wounded of Vietnam, ready to hurl plastic bags of blood in protest of what they called the "Festival of the Vultures."

That same month Abbie Hoffman, Paul Krassner, Jerry Rubin, and Ed Sanders declared 1968 as the Year of the Youth International Party. The Yippies married the radical politics of the left to the transgressive theatrical style of the Ridiculous. "We're creating a myth," said the media-savvy Abbie Hoffman. "People make myths around blank spaces." (He could have been talking about Warhol.)

On April 4, after meeting with the leaders of his Poor People's March on Washington, Martin Luther King Jr. stepped out of the Lorraine Motel in Memphis and was shot with one round from a 30.06 rifle by James Earl Ray. King's death a few hours later sparked race riots in Baltimore, Boston, Chicago, Detroit, Kansas City, Newark, Washington, and many other cities across the country. Meanwhile Secretary of Defense Clark Clifford was steadily increasing the number of Vietnam troops. In Paris on "Bloody Monday" (May 6) a march of five thousand people ended in riots, galvanizing a strike that began with students and instructors from the Sorbonne and inspired sympathetic strikes throughout France. (Nine million were on strike by May 22.) In Washington Ralph Abernathy and other African American leaders organized an encampment on the Mall, where more than twenty-five hundred people lived (despite a month of rain).

In March *The New York Times Magazine* published a long article on "The Second Feminist Wave." It recognized the growth of the National Organization for Women (twelve hundred members nationwide) and

Diamond Ball Guests:
Hubert Humphrey
Nelson Rockefeller
Marietta Tree
Paul Newman and
Joanne Woodward
Jacqueline de Ribes

"Rise up and abandon the creeping meatball!"
"We demand the politics of ecstasy!"
—Yippie slogans

Time-ese for counterculture:
"The psychedelic **pot left** mixing **Vietniks** and **Peaceniks, Trotskyites** and **Potskyites.**"

"*The Chelsea Girls* [is] a 3.5 hour **experimental peekture.**"

recounted the dismal employment figures for women, but the most striking thing about the article was that Betty Friedan was not feminism's primary spokesperson.

The article's principal focus was Ti-Grace Atkinson, the president of the New York chapter of NOW, the most radical of all the forty-five chapters in the United States, comprising 30 percent of NOW's national membership. The New York chapter drew women who had been involved in civil rights and Students for a Democratic Society, where the men promoted sexual emancipation because that benefited them; "free love" meant more available sex.

Ti-Grace Atkinson provided a more compelling model than Betty Friedan—the *Times* described the twenty-nine-year-old as "softly sexy," dispensing her message in a Philadelphia Main Line accent. Her intellect was unimpeachable; she had been the founding director of the Institute of Contemporary Art in Philadelphia and was currently pursuing a Ph.D. in art history at Columbia. But her radical message was harder to swallow than Betty Friedan's. In the spring of 1968 Atkinson was writing an article, "Vaginal Orgasm as a Mass Hysterical Response," and compared the institution of marriage to slavery: "It separates people in the same category, keeps them from identifying as a class."

The concerns of the Factory overlapped minimally with the revolutionary dimensions of 1968, although in the haze of memory 1968 = Sixties style = Andy Warhol. In the Factory little attention was paid to Vietnam, abortion, civil rights, legalization of drugs, or any political position that was consciously countercultural.

From a very young age Brigid Berlin had developed a strategic intelligence that allowed her to be a food binger, a drug maniac, a shoplifter, and a successfully manipulative daughter. She had down pat the sociopathic skills that were helpful: near-perfect vocal mimicry and such highly developed forgery skills that she could copy a signature after one look. And she had the medical intelligence to be able to accurately prescribe medication within her catholic range of pills.

Few doubted Brigid's ability or intelligence, but no one knew if it would ever take a form beyond rage at her parents. In the back room at Max's Kansas City, she wore her "lava-lavas," topless sarongs and dyed corduroys in a rainbow of colors. "I would buy twenty pairs of Levi's corduroys at a time and I would dye them in the bathtub every day a differ-

> Seven percent of doctors are women, 3 percent of lawyers, and 1 percent of engineers.
> —*The New York Times*, 1968

> "The twentieth century woman is in what our motherfucking-loving sociologists call 'transition': from death to death. . . . I'm a little bored with the abortion issue now. I'd rather talk about the demise of marriage."
> —Ti-Grace Atkinson

> "She shoplifted in only the best stores with the composure of a right-wing Republican, and shot up in the finest restaurants, slamming the spike through her jeans, through her skin, and into her system as casually as if she were fixing her lipstick after dinner."
> —Mary Woronov

ent color—hot pink, lavender, purple," said Brigid. "I had the whole mix going, of Rit mixed with Tintex. I was the only one who did that."

Despite her girth Brigid had enormous physical grace that reflected the upper-class leisure activities of her childhood, like making a perfect three-point dive into a pool and skating at Rockefeller Center. She had a lethal wit, the dexterity to use it, and the class-bred presumption that she deserved to dominate others. "I recognized the type immediately from boarding school—she was the fat girl who loved to torture other girls," wrote Mary Woronov, "and I got along with her great."

Brigid Berlin could be a graceful monster, a highly effective sociopath, a more-than-competent doctor, and a brilliant talker. One day Andy said, "You'd be a good artist if you directed your energy in the right way."

On Tuesday evenings, when the Bouwerie Lane Theater was dark during the run of *Conquest of the Universe*, Brigid Berlin advertised a "mixed media" performance called *Brigid Polk Strikes: Her Satanic Majesty in Person*. The mixed-media show consisted of randomly played electric guitar music, an icicle of transparent cellophane, a mattress thrown over two stainless-steel boxes, and a telephone that was hooked into the theater's amplifiers. "To strike," in Brigid's terms, meant to coax money out of someone for her own use. She began at 8:40 each night, and the people in the audience paid two dollars to watch her perform her art.

"I made these real phone calls from the stage and asked people for money," said Brigid. "I called Huntington Hartford and asked him for money for an abortion. He said he'd give it to me." Brigid then hailed a cab, traveled north to Beekman Place, procured the money from the A&P magnate, and headed back to the theater to continue her performance. "I called my parents, and I remember them saying, 'You only come around when you want something. Take everything, give nothing, go through life on a free ride, let the old son of a bitch pay.' "

Valerie Solanas had never communicated regularly with either her sister or her mother; at most she sent a postcard to notify them that she had moved. Beginning in the first months of 1968, however, she began inundating them with letters and long-distance telephone calls. All she could talk about was Andy Warhol and Maurice Girodias. She imagined they were stealing her work from her, dubbing new lines over her voice in *I, a Man*, that Warhol was using her writings in his lecture tours.

"As graceful as a little killer whale. She wasn't just good, she could show class, skating beautifully, backward, figures, dives, leaps, her great form balanced effortlessly and swooping past me in circles."
—Mary Woronov

"A powerful atmosphere of sheer, aimless, frustrated hostility, directed at anyone and everyone who is unwilling to participate in its expression. This goes on and on and on. After an hour and a half I leave."
—A. D. Coleman, reviewing *Brigid Polk Strikes*

In the same period Solanas stepped up her campaign of communicating with Warhol and Girodias. She called long distance, reversing the charges, and Girodias recalled how adept she was at hurling "snappy insults" in those few moments before he hung up. Warhol was alternately addressed as "Boy," "Daddy," and "Toad." Valerie, the insult queen, boiled down her vision of her adversaries to a single venomous sentence.

> Toad, you and your fellow toad Girodias (2 multi-millionaires) working together control only bums in the gutter, and then only with relentless, desperate, compulsive, effort. Valerie Solanas

That winter Valerie appeared at her sister Judy's house in San Jose, California, at six A.M. She was carrying several boxes of manuscripts and mimeographed copies of *The SCUM Manifesto*. Valerie's matted hair was long, and she looked so disheveled that her sister barely recognized her. She put Valerie in the shower, scoured her from head to toe three times, cut her hair short, and deposited all her clothes in a Dumpster. She replaced them with new clothes, tennis shoes, and flannel pajamas.

Valerie stayed only a few weeks in San Jose, then left for San Francisco, where she wanted to peddle the manifesto and consign it to bookstores. It was in the Bay Area that she met Geoffrey LeGear, who became her most committed follower.

A few weeks later Valerie showed up at Judy Solanas's workplace in the lobby of a high-rise building. She was wearing every piece of clothes she owned, in bulky layers. She insisted that she had to get back to New York. After her first anxious experience with an airplane, she vowed she would never again ride one, and she kept her vow. She boarded a Greyhound Bus for a long trip across the America, returning to her twin nemeses.

> "I knew something was wrong, this was too bizarre even for Valerie."
> —Judy Solanas

In November 1967, during a lecture tour in Arizona, Andy Warhol and Viva had stood on a motel balcony, gazing down on a man mowing a green, watered lawn. "Gee, I bet it's a really nice life to do that," he said. "Out in the sun all day in a nice warm climate. I think I might like to do that." Viva upped the ante. "In fact I'm not getting on the plane," she said, "unless you promise me we can come back and make a movie." On November 7, 1968, Warhol told *The Arizona Republic* that he liked the desert and was thinking of making a movie called *The Unwanted Cowboy*. Viva told the press that she would ride bareback.

Back in New York in December Warhol and Morrissey developed plans for their first full-fledged Western. "It was the first film I thought would be a production of sorts," said Morrissey, a long way from the first Factory Western, *Horse.* To raise production money, Warhol silkscreened a commissioned portrait of Lita Hornick, the patron who was responsible for Kulchur Press. "We want a portrait that looks like Marilyn Monroe," she told him. After slight negotiation (from $10,000 to $8,000), the commission was carried out, providing more than enough funds for the production. Fred Hughes was enlisted as sound man.

Paul Morrissey cooked up a Western story, and its typed two-page plot description suggested a new level of premeditated organization at the Factory. "The new movie, *Ramona and Julian,* is based on *Romeo and Juliet,*" Morrissey told the press. "But in our version Romeo is younger than Juliet, and Juliet goes after him. The girl's name is Ramona and the guy is called Julian. And Ramona has a male nurse."

The character of Ramona was clearly pegged for Viva, and the male nurse for Taylor Mead. Julian, originally slated for Julian Burroughs (the draft dodger who provided the politics of *Nude Restaurant*), instead was played by Tom Hompertz, a San Diego art student/surfer/Adonis whom Warhol and Morrissey had met on the lecture tour. For the rest of the cast, a band of brothers and a sheriff, they picked Eric Emerson, Julian Burroughs, and Louis Waldon. The youngest brother was seventeen-year-old Joe Dallesandro, who agreed to go to Arizona only if Warhol matched the salary he was making in his job at the bookbindery. For the sheriff, they selected Francis Francine, who had been Andy's costar back in *Normal Love* and more recently played one of the Fire Women in Vaccaro's production of *Conquest of the Universe.* Jackie Curtis came up to the Factory, eager to be in any Factory movie. "Why the fuck did I want to get mixed up with Andy Warhol? Media. Media. Media. Media," he said. But no matter how open the casting at the Factory, no one could imagine Jackie Curtis as a cowboy.

In the last week of January Andy's entourage boarded a plane for Tucson, carrying ten thirty-five-minute-long reels of 16mm color film.

A regular in the back room of Max's Kansas City who called herself Vera Cruise drove a stolen car to Arizona, accompanied by Eric Emerson, breaking speed limits across the country. Along the way she picked up John Chamberlain and Allen Midgette in Phoenix. (Chamberlain wanted to make his own films and looked forward to watching Warhol in action, and Allen Midgette was along for the ride.) Just before the Midgette-as-Warhol hoax had been revealed, Midgette headed south,

eventually ending up in Mexico for a safe stay out of the way of the law. Brigid Berlin had been cast as the leader of a rival cowboy gang, and Ondine as Padre Lawrence, but both bailed out at the last minute. Vera Cruise met the Factory entourage in Tucson, where she had rented a touring bus that could seat eighteen. Andy gave the cast some money to go to secondhand stores to buy their costumes.

In the last week of January, everyone converged in Oracle, Arizona, thirty miles north of Tucson, for their first day of shooting. Warhol spent hundreds of dollars to rent Old Tucson, a fake Old Western Main Street set that had been erected in 1939 for Wesley Ruggles's *Arizona,* and had served ever since as a standard Western location, especially for the *Death Valley Days* television series. Paul Morrissey announced, "Now that everyone's here, we've got to think of a script."

Taylor Mead was virtually the only one who had paid attention to Paul's original scenario, and when he started improvising on camera about Viva running a brothel, Andy stopped him: "Oh, Taylor, too much plot." Mead immediately understood that Andy meant that, story or no story, this film was going to be made just as usual.

Paul Morrissey strove for narrative coherence and took charge of the direction since the sheer number of people and horses demanded organization that Warhol was incapable of coordinating. Even with Morrissey's organizing, however, the scenes got pretty woolly. "Let 'em loose," said Mead. "Of course, at the time, we're all on our own things." Andy was on Obetrol, Taylor was on a prescription of Quaaludes, and most of the rest used a combination of marijuana and amphetamine. Paul abstained, and Viva took nothing more than a few puffs of pot.

Ropes were set up to keep about seventy tourists from wandering into the scene, while the Old Tucson's leathery regular technicians looked on at the odd production techniques. "Every time they rehearse it's a different scene!" said one, and another asked, "Doesn't anyone call 'cut' around here?"

The tide of the locals' indulgent curiosity shifted at about the time Eric Emerson began doing his barre exercises at a hitching rail, explaining to Joe that it was a good way to firm up the buttocks. Taylor Mead's effeminacy and Viva's verbal obscenities became a source of contention. Viva was initially adept at handling the barbs; when someone skeptically inquired why she was wearing a black riding habit instead of period Western wear, she replied, "I think I'm out riding on a fox hunt in Maryland with Jackie Kennedy, but I had a bad trip." A local construction worker tried to sabotage the movie by sawing and hammering during

the shoot (not realizing that the Warhol aesthetic allowed all sorts of simultaneous realities as part of the stew). Even Robert Taylor, in town to shoot a *Death Valley Days* episode, wandered over to the set and looked on disapprovingly. (Warhol noted gleefully that his cast of unknowns had drawn more tourists in a light drizzle than Robert Taylor had on a sunny day.) By the time the Warhol company finished shooting their scenes in Old Town, the locals seemed ready to run them out of town. Shooting on the second set, Rancho Linda Vista, proved more soothing, as the cast camped out in separate bungalows dotting the eighty-acre guest ranch. The two youngest members of the cast, Tom Hompertz and Joe Dallesandro, were initially nervous about improvising lines. "Joe kept saying, 'I can't do this, what do they want?' " Taylor recalled. Mead's response freed Joe: "There is nothing that they want from you, Joe, except what you feel like. That's all they want." Feeling more comfortable, Joe watched Tom Hompertz struggle to make up lines and coolly observed, "He's just a beauty, a pretty boy."

Taylor Mead and Viva during the shooting of *Lonesome Cowboys*, January 1968

During the film's shooting Andy demonstrated his lack of interest in narrative. While Viva was improvising a great line—"This is a clean town, and I don't want horse piss in the middle of the street"—Andy focused on a sign. When a horse reared, Andy shot in a different direction. "Maybe I should just shoot a cactus for thirty-five minutes," he said one morning. "If we have to think about art, cactus is the most beautiful piece of sculpture around." (It would have been like a Western version of *Empire*.)

Paul Morrissey was moving in a different direction—trying to capture star personalities playing characters in stories. A narrative demanded continuity, and key scenes needed to be shot. But the cast were improvising their characters toward no consistent end.

During the shooting, the cowboy "brothers" staged an impromptu rape scene as Viva rode into the corral ready to play the next scene. They jumped her, wrestled her to the ground, and pulled down her underwear. Viva was appalled that they had pulled down her panties in front of children. "For God's sake, find me a doctor," she yelled to Sheriff Francis Francine. "After all, I can't go to Japan and have my hymen resewn in." The parents looking on were not amused. One of them issued a complaint that an obscene film had been made and transported over state lines. The complaint generated dozens of pages of correspondence, and the FBI put the film under surveillance.

"Men seem to have trouble doing these nonscript things. It's a natural for women and fags—they ramble on. But straight men can't."
—Viva

As soon as Andy Warhol and Paul Morrissey returned to New York, all attention was focused on the move to the new studio. For four days, beginning February 5, the contents of the Silver Factory were moved to the sixth floor of 33 Union Square West, a distinctly different environment. Instead of reflective tinfoil and silver concrete, the new studio featured light pouring through tall windows and natural wood on the floor. Morrissey immediately began thinking about the sleek new headquarters. His first consideration was, What was going to happen with Billy Name? Morrissey said to Warhol:

"We are constantly under attack."
—from *Andy Warhol's Index (Book)*

It's going to be a problem because he'll come here now and live in the back and at night he'll come out and spray everything silver again. We have to set up a signal that we don't want to have any silver or any other paint on surfaces. What we'll do is hire somebody to remove paint. When he sees that somebody's

being paid specifically to remove paint from woodwork, he'll understand that nothing is to be painted with silver.

One afternoon not long after the move a nineteen-year-old Western Union messenger rode up the elevator. The circumstance that brought Jed Johnson to the Factory was that he and his twin brother, Jay, visiting from Sacramento, had been robbed and had gone to Western Union to wire home for money. An employee who took pity on the twins suggested they deliver telegrams and make enough on tips to get by. One of Jed's first deliveries, to the Factory, would change his life and Warhol's. Paul immediately liked the quiet messenger and wanted to incorporate him into their new Factory enterprise. Hiring Jed would kill two birds with one stone, he reasoned: he could strip paint and thereby ward off the fear of Billy silvering the space.

Jed Johnson was hired to strip wood but soon graduated to more general duties, becoming the Factory's first regular salary-paid employee since Gerard Malanga. That spring he would sometimes arrive early to spend a few hours in bed with Billy Name before Paul arrived. Then Jed would set to stripping layers of old paint, creating the elegant look of the Union Square Factory.

The new space was sharply divided into two domains. The larger, front area was painted entirely white, and the glass-topped desks seemed to suggest the auspicious good taste of its occupants. (The design solutions looked more expensive than they actually were—black felt was sandwiched between a piece of glass and a door, held up by file cabinets.) They began dressing to fit in with the new look of the space: Paul wore white instead of black, and Andy began wearing French jackets.

The smaller back space was black, and it combined a small bathroom, Billy Name's darkroom in the larger bathroom, a TV, a stereo, a screening room, and of course a couch. (The Silver Factory couch had departed just as it had arrived four years earlier, on the street—it had been stolen during the move.) The front-and-back solution provided an elegant way of dividing the space. Billy regarded the Union Square Factory as a "cuter space, a mix of modern and moderne, that was less wild and strange. . . . I have to have a concept of where I'm working," he said. "So for me, it was 'the black-and-white Factory.' "

In the Silver Factory Billy Name's darkroom had been erected over a single small toilet. He had built shelving, and in that cramped four-by-five-foot space he had developed the Factory Fotos that defined the mythical Warhol milieu. At the "black-and-white Factory" Billy gradu-

"When they moved to the new place, the only part of the Factory that was the *old* Factory was Billy Linich's back room. The old world was really up there. Outside was this—this—this *Juilliard*."
—Ondine

ated to a larger men's room, which had originally contained a sink, two standing urinals, and two toilets. When everything was removed but a toilet and sink, Billy had, for the first time, an adequate space for developing his photographs.

In early 1968 Gerard Malanga was still in Rome proceeding on his plan to sell Warholesque silkscreens of Che Guevara in order to finance his ticket home. He showed ingenuity, an intimate knowledge of Warhol's production methods—and an utter misunderstanding of the art market. How could Malanga ever get away with a Warhol of Che Guevara, in an unheard-of edition of two, for a price that vastly undercut Leo Castelli's? How could Malanga have thought that no one would hear of it in New York? Andy never replied to any of Gerard's letters, nor to any of his pleas for the three hundred dollars that could get him a ticket home.

Gerard sold the twenty works-on-paper of *Che Guevara* directly to the La Tartuga gallerist. The large *Che* silkscreen was on the verge of selling to a gallery client. But when the gallerist contacted Leo Castelli about this Warhol work, the New York dealer was understandably confused. The resulting uproar could easily have ended with Gerard being arrested for forgery, held without bail, and sentenced to up to twenty years. Gerard spent three sleepless nights, until a telegram arrived on February 18: CHE GUEVARAS ARE ORIGINALS HOWEVER MALANGA NOT AUTHORIZED TO SELL CONTACT ME BY LETTER FOR ADJUSTMENTS ANDY WARHOL.

The telegram saved Gerard from prison, but he still seemed unaware of the trouble his plan had caused. He justified his action by quoting liner notes from Nico's upcoming album *Chelsea Girl:* "Andy likes other people to become Andy for him; . . . he doesn't want to be always in charge of everything. 'It's part of pop art, I guess, that everybody can impersonate somebody else . . . that you don't always have to be you to be you.'" Gerard ended his letter, "I became you for both of us. Four years of devotion and love is not easy to forget." When money arrived for the sale of Gerard's poetry manuscripts to Syracuse University, he quickly bought a ticket to New York on a Pan Am flight.

No sooner had Malanga returned and set his bag down at a friend's house on St. Mark's Place than he headed a few blocks north to the new Factory. As he waited twenty-five minutes for Andy to arrive, Gerard absorbed the new environment. Warhol arrived, and did a double-take when he saw this unexpected visitor. Gerard followed him into his cubi-

cle and tried to explain what had happened. "He wasn't listening," Gerard said. "He just wasn't having it. The one remark out of his mouth was, I should have known better. I got the signal and I left. At that point I realized my working relationship with Andy was pretty much over."

For much of early 1968 Andy Warhol was on the road. After shooting *Ramona and Julian* (which was released as *Lonesome Cowboys*) Paul Morrissey, Viva, and he headed off to Stockholm for his first international museum retrospective, organized by Pontus Hulten at the Moderna Museet. The museum's facade was covered with *Cow* wallpaper, whose bright hues stood out in the stark wintry landscape. Warhol wore two pairs of shocking-pink tights beneath his pants.

The retrospective presented the extraordinary range of Warhol's work, beginning with ten *Marilyns* and ending with some recently screened *Electric Chairs*. The most revolutionary thing about the exhibition was the catalog, which turned its back on art-historical exegesis. Its only text was fourteen pages of aphorisms selected from Andy's conversation. The rest consisted of 270 pages of Billy Name's photographs and 180 pages of Stephen Shore's photographs—each given its own full page.

Suspicion about the faux-lecturer Andy Warhol had been aroused in the fall of 1967, but the informant to the press was a New Yorker who knew the inside story. On returning from Sweden, Warhol confronted the story of the Allen Midgette impersonation. In *Time* and *Newsweek* the hoax rather than the Moderna Museet retrospective got attention, for it was exactly the sort of sound-bite news item they associated with Warhol. "Well, they liked him better than they would have me," Warhol told the *New York Post*. Those who had paid the fees were not amused.

"Oh well, we just did it, well, I, uh, because, uh, I don't really have that much to say."
—**Andy Warhol**

As part of his punishment, Warhol had to fulfill his obligations, and he brought along Viva and Paul Morrissey to make the experience more bearable. On one typical four-day tour the three of them went to two college campuses in Wisconsin and two in Minnesota. The sense of being "constantly under attack" was pervasive, as one school administrator complained to the lecture bureau that the presentation was objectionable. Warhol wasn't interested in fanning controversy, especially on the issue of drugs. He said Ondine used amphetamines "to slim himself," and "No one uses drugs anymore." When asked about homosexuality in

the movies, Viva piped in, "Well, those are the old ones. They're all straight now. I've converted them."

These lecture trips were not satisfying, but they provided a bonding experience for the trio of Morrissey, Warhol, and Viva. They were a small domestic crew. Viva especially felt such nonsexual comfort with these two men that she suggested that they get married. Her desire wasn't like Ivy Nicholson's obsessive passion—Viva had no desire to sexually possess either of them—but she enjoyed a sort of familial intimacy.

On returning from Sweden, Viva felt more aware of male privilege at the Factory. Her feelings came to a climax a few weeks later when she arrived at Union Square for a photography session and was caught outside in heavy rain. When Andy emerged from his taxi, he saw Viva kicking at the door to the building. "She looked up and saw me—her face had a crazed expression," he said. "She screamed hysterically that she demanded keys to the Factory, that only the *men* had keys." Before Andy could duck, Viva threw her army surplus bag and hit him in the head. "I was stunned for a second," said Andy. "After a scene like that you can never trust a person in the same way again, because they might do a repeat and freak out again."

"You want to know the truth about Andy? He really digs women. He digs being around them more than men. But he can't associate sex with his emotional life like the rest of us, so he puts women on a pedestal."

—Viva

Of all the Factory regulars only Viva identified her ideas with feminism, and she described herself as "the first neofeminist." From the perspective of a former model, she grasped the physical constraints of packaged womanhood, and her annoyance about the relations between men and women was articulated with dry intelligence. "She would *talk* very liberated," said Warhol, "but she seemed to expect men to do little things for her—like support her!"

In early 1968 Viva wrote a piece that oddly married her antiwar sentiments, her irritation with Catholicism, and her new proto-Yippie feminism. Upon hearing that Father Philip Berrigan had used imported Dutch duck's blood to pour on Selective Service files, she proposed in *The Realist* a feminist antiwar action.

> For years I have been saying that power should be in the hands of the women and this pallid priestly protest only proves the point. Women, stand up and be counted! You can begin with the number you're most familiar with: 28. Every 28 days those of you who rely on that old Catholic standby, Kotex (we've heard that the Church recommends this archaic diaper to its female

Betsey Johnson and John Cale on the way to their wedding
at City Hall, April 1968, by Billy Name

members inasmuch as the use of Tampax may be a cause of
grave sin, due to the pleasure of insertion), can stage a mass san-
itary drop-in.

Those of you of the Protestant faith could stage a plug-out
by quietly pulling the collective strings of your Tampaxes.

One night in 1967, John Cale asked Betsey Johnson to design a costume
so that his hands could be on fire while he played his viola. Betsey
recalled that as the moment she fell in love with him. Cale appreciated
Betsey's canny, practical instincts and her industriousness. He was
impressed that she could move into a raw loft space and immediately
equip it with industrial-strength pots and pans for the kitchen. "That's
the way she approached everything; you get the stuff that works," Cale
recalled.

Their romance culminated in April 1968 in a wedding. It represented
the first real wedding ceremony in the Factory group. Marriage was a
bow to commitment, but neither Betsey nor John wanted a traditional
ceremony. The simple events they planned were nothing like the full-
blown New Age weddings that would proliferate in the next few years,

Guests at the Johnson/Cale wedding included Viva, Lou Reed, and Paul Morrissey, by Billy Name

but Johnson and Cale were grappling with the same question of how a new generation could create its own rituals of commitment.

They arranged a simple breakfast of scrambled eggs at Ratner's, followed by an appearance at City Hall for the official ceremony, ending with a party for a few dozen at their loft on LaGuardia Place. For the wedding Betsey designed for John a suit of black sailcloth canvas, its severity softened by a paisley scarf. For herself Betsey sewed a burgundy velveteen pantsuit.

When the couple arrived at City Hall, the officials informed them that a woman could not be legally married wearing pants. Betsey returned home, combined an outfit that was severely architectural in its lines with a tiny red miniskirt, and returned to City Hall with Cale; officials bestowed blessings on the couple.

Billy Name brought the Olympus Pen-F camera he had recently bought because it allowed two photos for each frame of film, creating unexpected diptychs. He photographed the wedding guests in color as they gathered outside the loft on LaGuardia Place: Lou Reed in a blue Carnabyesque jacket, tight jeans, and low black boots; Viva carring a full spring bouquet; Nico in black; Andy Warhol in a brown leather jacket carrying in his right hand his tape recorder and microphone. In retro-

"They wouldn't accept a woman in a pantsuit, but it was okay to wear a crotch-showing miniskirt! And this was 1968!"
—Betsey Johnson

spect, Billy Name's photographs of the wedding assumed another layer of significance: they were snapshots of the last formal gathering of the Silver Factory crowd before they met again at Columbus Hospital two months later.

On the morning of June 3, 1968, Valerie Solanas woke up firmly resolved to put an end to her fevered obsessions of the last few months. She dressed in tight-fitting tan jeans, a yellow jumper, a black turtleneck sweater, blue sneakers, no socks, and a sheepskin-lined brown coat—many layers for a day that promised to reach into the low eighties. She carefully brushed her brown hair into a bouffant. She applied lipstick and even mascara.

Andy Warhol awoke late in his townhouse on Lexington and East Ninetieth, and sitting on his canopy bed he talked on the telephone with Fred Hughes until noon. He heard about Hughes's turmoil of the previous evening—Hughes had been mugged by three young black kids with knives in front of his apartment just across Union Square from the Factory offices. Warhol mused that "attitudes out on the street weren't like the summer before, when everybody was acting so enchanted." He put on his outfit for the day, an ensemble of Beatle boots, a beach T-shirt, pressed jeans, and a brown leather jacket. Before leaving for the day, he descended three flights to join his mother in a prayer, kneeling at the shrine Julia had constructed in her basement room. Then he set off to do errands, calling on his lawyer, Sy Litvinoff, renewing his prescription for Obetrol, and shopping at Bloomingdale's.

That morning Valerie Solanas visited her former neighbor, May Wilson, at 208 West Twenty-third Street. It wasn't a social call. A few weeks earlier, since she had no stable home, Valerie had asked Wilson to keep her laundry bag under her bed. Wilson agreed, even though she immediately recognized something odd—the laundry bag contained no clothes. There was something that felt like a gun, but having worked in vaudeville, Wilson thought it might be a stage prop gun. Valerie collected her laundry bag and its contents. She stuffed in a brown paper bag her address book, a Kotex pad, and two handguns: a .32 automatic and a .22 revolver. She had paid sixty-five dollars for the .32, but she didn't trust it, so she added the second gun.

Valerie set off to confront Maurice Girodias in his office at 36 Gramercy Park East. Now he would be forced to listen to her complaints about his mishandling of the publication of *The SCUM Manifesto.* Now

he would see that she meant it, every word. The secretary at Olympia Press told her that Girodias was in Montreal on business and wouldn't return until the following day.

Valerie walked south to Union Square, where Paul Morrissey found her when he arrived at the Union Square Factory. He hadn't seen her in a long time and informed her that Andy was not in and wasn't expected, and she absolutely could not hang out waiting for him. She went downstairs to wait, leaning against a wall on Sixteenth Street, clutching her brown bag and perspiring in the heat of the day. She periodically went upstairs to see if Andy had arrived. Morrissey recalled a half-dozen such attempts, and each time he dismissed her.

Other members of the Factory were meanwhile attending to their own affairs. Brigid Berlin hailed a cab and told the driver to head for 33 Union Square, but then she decided to return to the George Washington Hotel to dye corduroys. Gerard Malanga was preparing to meet Andy at the Factory to borrow forty dollars to pay for a promotional postcard for Gerard's film *In Search of the Miraculous,* at Jonas Mekas's latest incarnation of his floating cinematheque. Billy Name was holed up in the back bathroom, developing Factory photographs. Viva had an appointment at Kenneth's hair salon to get her hair dyed for her upcoming part in *Midnight Cowboy.*

At four-fifteen Andy Warhol pulled up to 33 Union Square West in a Checker taxi. Jed Johnson rounded the corner carrying fluorescent lights and greeted him. Valerie Solanas joined them on the sidewalk. Andy made no attempt to dissuade her from joining them, and the three rode the elevator to the sixth floor. During that ride he noticed that she was wearing an odd coat for this early summer day—a fleece-lined winter coat—but did he think what this bizarre fashion suggested about her state of mind? Did he think it odd that she was wearing makeup? Did he notice that she was bouncing on the balls of her feet? Did he wonder what was in her brown paper bag and why she was twisting it? Or was his mind on art dealer Mario Amaya, who had been waiting for an hour to discuss an upcoming London retrospective of Warhol's works?

When Andy walked into the Union Square headquarters, Andy said to Paul that Valerie was looking good. Morrissey responded that she did indeed, but he said to her, "You gotta go now, 'cause we got business, and if you don't, I'm gonna beat the hell out of you and throw you out." He later recalled, "I don't usually tease people much like that, but I just said this funny thing to her—that I was going to throw her out. And she had this funny look in her eye." Morrissey left the front office to go to the

Billy Name's astrological charts for June 3, 1968, the day Valerie Solanas shot Warhol

bathroom. Fred Hughes looked up from his glass-topped desk and asked Valerie if she was still writing dirty books. Mario Amaya noted that she looked shaky and thought she might break into tears at any moment. On the phone Andy listened to Viva discussing the issue of her hair color, and then he signaled Fred to cut in on his phone line.

At this point Valerie Solanas pulled the .32 automatic from her paper bag and pointed it at Andy. No one showed any awareness of what she was doing until they heard the first explosive crack, which missed. Each person interpreted the sound in a different way. Mario Amaya thought it was a sniper firing at them from another building. Fred Hughes thought it was a bomb detonating at the headquarters of the Communist Party two floors above. Hearing it over the phone, Viva thought someone was cracking a whip. Billy Name, who was holed up in the darkroom, heard the sound, but he knew if he opened the door, he would ruin the photographs he was developing. Andy was the first to realize what was happening and yelled, "No! No! Valerie! Don't do it!"

Valerie's second shot missed Warhol, who crawled under a desk. Now he was trapped. She became more purposeful, carefully laid her paper bag on the desk, moved closer, and fired at close range. The third bullet from the .32 entered Andy's stomach on the right side, punctured his lung, and ricocheted through his esophagus, gall bladder, liver, spleen, and intestines, coming out on the left side. He described the sensation as "a horrible, horrible pain, as if a firecracker had exploded inside me."

Valerie Solanas strode over to the crouching figure of Mario Amaya, aimed, missed, and shot again. The bullet went through his hip, but it didn't prevent him from running into the back room and then leaning his bleeding body back against the double doors to keep Valerie from following him there. Paul Morrissey and Billy Name ran from the back and joined him. Amaya told them that Andy had been shot. Valerie tried to push open the doors, but Billy threw his body against them.

Giving up on the doors, Valerie tried to pursue Jed Johnson into Andy's office, but he held the doorknob to prevent her from entering. She turned to Fred Hughes, whose abject fear had prevented him from moving away from his desk. Standing directly in front of him a few yards away, she responded purposefully to his pleas. "I have to shoot you," she said. Hughes claimed his innocence: "I didn't do anything to you. Please, just leave."

She backed away from him and pushed the elevator button. But she wasn't yet finished with the job. She moved back to Hughes and aimed the .32 revolver at his forehead. When it jammed, she grabbed her backup gun, the .22 revolver, from her bag. Just then the elevator doors opened, and Hughes pleaded, "There's the elevator, Valerie. Just take it."

She ran to the elevator, and the doors closed, Valerie inside. The elevator descended six stories, and Solanas exited onto Union Square.

Inside the Factory pandemonium reigned. Hughes tried to administer artificial respiration to Andy, but the pain was so great—"It hurts, Fred, it hurts," said Andy—that he stopped. As Morrissey called an ambulance and blood flowed from Andy's stomach, Billy thought that Andy was dying and began to cry. Andy whispered to him, "Oh, please don't make me laugh, Billy. Please. It hurts too much." Billy cradled Andy's head in his lap. The phone rang—it was Viva calling from Kenneth's trying to confirm that the crack and the screaming she had heard were just a joke. Fred told her that Andy had been shot and hung up. Paul tried to jam the elevator doors, fearing that Valerie would return. But when the doors next opened, the occupants were Gerard Malanga, Angus MacLise, and his wife, Hettie; Gerard had come to pick up a forty-dollar check so he could send postcards to promote *In Search of the Miraculous*. When Gerard saw that Andy had been shot, he thought immediately of Julia Warhola. Paul thrust some bills into his hand, and he headed back down the elevator. He figured the subway would be as fast as a taxi, and headed uptown on the number six. Just as Julia opened the door to him, Gerard heard the telephone ring and intercepted the caller so that he would be the one to break the news. He gently told her

that Andy had been "hurt in the stomach" (not shot), and he wanted to take her to the hospital.

At four forty-five, twenty-three minutes after the shooting, two members of the Emergency Medical Service arrived at the Factory with a stretcher. They refused to administer a painkiller. After laying Warhol on the stretcher, they found it could not fit in the elevator. They carried him down the six flights of stairs, which were dark and slippery, and Warhol continued to bleed. As he was lifted into the waiting ambulance and placed next to Mario Amaya, he lost consciousness. The ambulance headed uptown to Columbus Hospital. For an extra fifteen dollars, the driver offered to turn on the siren, and Amaya urged him so do so. Leo Castelli would pay, he said.

Viva ran up from the Union Square subway stop, saw the empty stretcher, and started screaming. The first man she saw looked like he was wearing a mask of grief, and it occurred to her that maybe it wasn't real, that maybe someone at United Artists had put acid in her Coke. Only when she saw Billy Name did she realize it was true. "He was really in pain. I knew it was true; at least with Billy it wasn't a mask." When she went upstairs to the Factory, she found eight plainclothes policemen. They were digging through slides, opening drawers, looking at old receipts, scanning stills from *Lonesome Cowboys,* hoping to find something incriminating. They put tape over the holes left by the bullets and acted suspicious of everyone on the scene. But all the while they failed to notice Valerie Solanas's brown bag on the desk, containing her address book and a Kotex pad.

At Columbus Hospital Andy Warhol was wheeled into the emergency room, to be operated on by Dr. Giuseppe Rossi. The surgeon had been summoned just as he was about to leave; no one knew the patient's identity. While they were checking the pulse, inserting a catheter, and examining the wounds, Warhol drifted into consciousness and heard voices saying, "No chance."

Mario Amaya also overheard them and screamed at the doctors, "Don't you know who this is? It's Andy Warhol. He's famous. And he's rich. He can afford to pay for an operation. For Christ's sake do something!" Six minutes after he arrived in the emergency room, Warhol was pronounced clinically dead.

Dr. Rossi hadn't given up on saving Warhol. He cut open his chest and massaged the heart. No one, not even the doctors, knew if there was a chance. Rossi began an operation that required four doctors and five hours.

In the hospital waiting room about two dozen friends and reporters had arrived. Impromptu press conferences were in full session. Andy's old friend David Bourdon told a reporter, "I was stunned when I heard the news but not surprised. It seems to me he created the environment, the atmosphere that made situations like this possible. He was very permissive about people, tolerated everything, not only sexual habits but, you know, less popular forms of activity." Dressed for the occasion in a Chanel suit, Ultra Violet pronounced: "Violence is everywhere in the air today. This underground movie world is a mad, mad world. Maybe this girl, Valerie, was mad herself." Leo Castelli took the opportunity to plug the new commercial status of Warhol's art: "I'm afraid there are not that many paintings left." Gerard Malanga burst into the waiting room with Julia Warhola in a black coat, a babushka, and nylons with runs in them. Before Julia was given sedatives and wheeled away, she asked over and over, "Why did someone harm me [*sic*] Andy?"

Each member of the Factory reacted in a different way to the shock of the shooting.

Nico insisted that she and International Velvet light candles, sit on the floor in the Chelsea Hotel, and pray.

Taylor Mead wept.

Billy Name began a silent vigil outside the hospital. He couldn't bear to return to the Factory, so he spent the next few nights sleeping with Peter Hujar.

Joe Dallesandro, who had been scheduled to begin working at the Factory the day of the shooting, felt responsible for what had happened.

Maurice Girodias, returning from Montreal, heard what had happened and was appalled to realize that what he had regarded as a Swiftian joke had been transformed into reality. Girodias thought Valerie could not have chosen a more inappropriate icon of male oppression to slay. "After all, from John Wayne to Francisco Franco, the world is well-stocked with self-appointed protagonists of male supremacy. All the sniveling studs in Hollywood! All the pestilent dictators! But seriously, Andy Warhol!" Girodias did not yet know that Valerie's first target had been Girodias himself.

On hearing about the shooting, Henry Geldzahler said to his lover, Christopher Scott, "Do you know what that does to the values of the paintings?" He quickly added, "Don't ever tell anyone that I said that."

"The pop art king was the blond guru of a nightmare world, photographing depravity and calling it truth."

—*Time*'s "Felled by Scum," Warhol's cruelest review

Two days later Geldzahler invited Warhol to recuperate in his house in East Hampton.

Julia Warhola stayed in her basement and prayed before her altar that her Andy would survive this assault and marry Viva.

Andy Warhol was clinically dead for one and a half minutes. Five and a half hours later the team of four doctors had removed his spleen and repaired as well as possible the enormous damage caused by the ricocheting bullet. At two-thirty A.M. a spokesperson for Columbus Hospital told *The New York Times* that they did not know whether Warhol would live through the night.

At six A.M. Warhol was still alive, and they were more hopeful.

Before the operation was even completed, Valerie Solanas had turned herself into the police. After escaping to Union Square, she had walked around for nearly four hours. At eight P.M. she approached a twenty-two-year-old rookie traffic cop just north of Times Square and said, "The police are looking for me." She pulled two guns from the pockets of her fleece-lined coat. He reported that she said: "I am a flower child. He had too much control of my life."

Valerie Solanas's surrender prompted extraordinary publicity for her ideas. While the police were booking her in the East Twenty-first Street station, she smiled engagingly for the press and delivered sound bites. "It's not often that I shoot somebody. I didn't do it for nothing," she said, and urged people to read *The SCUM Manifesto.* She denied shooting Warhol because he wouldn't produce her play. "It was for the opposite reason," she said. "He has a legal claim on my works. Warhol had me tied up lock, stock, and barrel."

Appearing in court on June 5, Valerie told the presiding judge she regretted nothing, and she refused to accept a Legal Aid lawyer. One who tried to interview her told the press, "She wouldn't tell me anything. She's very tense, like a rubber band stretched out as far as it could go." When Judge Getzoff warned her that the charge was a serious one, she replied, "That's why it's going to remain in my competent hands." The nonplussed judge put her under observation in the psychiatric wing of Elmhurst Hospital.

"Look, I'm a revolutionary, not a nut. That kind of thing takes organization. I'm practical, not stupid."
—**Valerie Solanas**

Although Valerie Solanas was pleased that her ideas were now being recognized in the press, she was disgusted by the newspapers' handling

of the story. Headlines described her as an actress rather than a writer, and an article in *The Village Voice* stated that she was a man-hater, not a lesbian. She considered that defamation of character. Most of all she was appalled that she was quoted as saying she was a flower child. "I would never say such a sick thing."

Andy Warhol remained in a kind of limbo for many days. "I wasn't sure if I *was* back. I felt dead. I kept thinking, 'I'm really dead. This is what it's like to be dead—you think you're alive but you're dead. I just think I'm lying here in a hospital.' " As he regained consciousness, he heard the words *Kennedy, assassin,* and *shot* on television, and he imagined it was John again instead of his brother Robert, that after you die, they play reruns. Then he saw the mourners at St. Patrick's Cathedral. "It was all so strange to me, this background of another shooting and a funeral—I couldn't distinguish between life and death yet, anyway, and here was a person being buried on the television right in front of me."

After the shooting Valerie Solanas was valorized as "one of the most important spokeswomen of the feminist movement." Florynce Kennedy and Ti-Grace Atkinson, representing the National Organization for Women, talked to *The New York Times*. Each wore a black-and-red FREE-DOM FOR WOMEN button and said Solanas was being treated badly because she was a woman. Solanas fit neatly into the two women's feminist beliefs, and Atkinson wrote a press release on June 13.

> "She [Solanas] has been called a female Genet, but she has not been taken seriously."
> **—Florynce Kennedy**

The New York chapter of the NOW presented Solanas's actions as politically motivated. "The woman thing is going to be like the campus thing," predicted Florynce Kennedy. "Women may be the third force to link up with youth and black people." Betty Friedan fired off a telegram the next day to Atkinson and Kennedy, asking them to immediately desist from linking Solanas with NOW, saying, "Miss Solanis' [*sic*] motives in the Warhol case are entirely irrelevant to NOW's goals of full equality for women in truly equal partnership with men."

But it was too late to stop the story from appearing in *The New York Times*. Valerie Solanas became inextricably linked with the most militant wing of the women's movement. A Lower East Side revolutionary group called Up Against the Wall Motherfucker embraced Valerie as a heroine. They passed out a leaflet that summer that suggested the revolutionary possibilities in the shooting. The leaflet read, in its entirety:

VALERIE LIVES!

Andy Warhol shot by Valerie Solanas. Plastic man vs. the Sweet Assassin—the face of plastic fascist smashed—the terrorist knows where to strike—at the heart—a red plastic inevitable exploded—non-man shot by the reality of his dream as the cultural assassin emerges—a tough chick with a bop cap and a .38—the true vengeance of Dada—tough little chick—the "hater" of *men* and the lover of *man*—with the surgeon's gun—*Now*—against the wall of plastic extinction—an epoxy nightmare with a dead superstar—the Statue of Liberty raped by a chick with balls—the Camp master slain by the Slave—and America's white plastic cathedral is ready to burn. *Valerie is ours and the sweet assassin lives.*—SCUM in Exile.

For many days Andy Warhol was not allowed to have visitors in his hospital room. Among the first to see him were Viva and Gerard Malanga, who sneaked in a back door about two weeks after the shooting. One of the first things Andy did was to hand Gerard the forty-dollar check that had been waiting since the day of the shooting. This gesture represented not only Warhol's steely attention to the practical but also his appreciation that Gerard had taken care of Julia in the moment of crisis.

Viva had also cared for Julia, spending a few evenings with her. On each visit Julia repeated the same thing to Viva: "You are an angel, and I pray to the good Jesus that he will save me Andy so he can marry you." Viva told her that "Andy and I are just good friends, we can't get married. You have to be in love to get married." But Julia had an idée fixe; on later visits she counseled Viva to be careful about her dowry and told her that her forty-dollar dress cost too much and was "too short, too short, no decent man will marry you with such a short dress."

Warhol wouldn't allow Brigid Berlin to visit the hospital because he was afraid she would make him laugh and that she would steal pills from the nurses' station. "So I'd sit across the street at a friend's house," Brigid recalled, "and just write him these long letters about how boring it was without him."

Paul Morrissey's first solo movie at the Factory resulted from the confluence of two events of summer 1968—the shooting of *Midnight Cowboy* and the shooting of Andy Warhol.

Director John Schlesinger and producer Jerome Hellman had approached Warhol in the spring to play an underground film director in *Midnight Cowboy*. Andy suggested instead that Schlesinger employ out-of-work friends from the Factory. It would be a way to feed them and keep them out of his hair. A group of Factory-ites were put on the payroll for twenty-five dollars a day and reported to Filmways Studio in Harlem. Among those performing in the Sixties party scene were Taylor Mead, Joe Dallesandro, Viva, Ultra Violet, and International Velvet.

They found that Hollywood filmmaking involved a lot of sitting around; unable to tolerate the boredom and the kitsch version of the Sixties they were enacting, Ondine stalked out in a rage. Others stayed on through the muggy June, waiting for their Sixties party scene. John Schlesinger suggested the party guests wear white face, and Taylor Mead realized it looked phony from the get-go.

A phone call between Paul and Andy set up the idea for a new movie. Both men resented the fact that Schlesinger had moved into their territory, and wouldn't it be ironic if a Brit who didn't know the underground landscape got credit for putting it on-screen for the American people? "They were spending three million dollars of United Artists' money to make a story of a hustler, and it didn't seem realistic," said Morrissey. When Paul reported that the Factory people were mostly used as extras in *Midnight Cowboy*, Warhol suggested, "Why don't you go out and make a movie like that, and we could have it out before theirs? And you could use all the kids that they didn't bother to use."

Morrissey loved the idea. "Furthermore, I thought, you know, that really is a good idea, because I finally won't have Andy operating the camera. . . . So this was a good chance to disengage from Andy having to be there to push the button."

Morrissey assembled a cast of people he knew, and at the center was Joe Dallesandro. Over six weekends that summer he shot the entire movie for under four thousand dollars, less than one percent of *Midnight Cowboy*'s budget.

Ever since he had seen John Ford's little-known *Flesh*, Morrissey had carried the title in his head, and he now found a way of using it. "The movie's very schematic, with all these different people's attitudes toward flesh," said Morrissey. "It's kind of intellectual, but in a very flimsy way."

Morrissey's *Flesh* follows a male hustler who must raise two hundred dollars to pay for an abortion for his wife's girlfriend. With Joe Dallesandro as the central figure, Morrissey cast the secondary figures from people he knew. As the hustler's wife and her girlfriend, Morrissey cast

Midnight Cowboy:
Starring Jon Voight and Dustin Hoffman, it won the Academy Award for Best Picture in 1969.

Casting List for the Party Scene in *Midnight Cowboy:*

6 male hippies
9 female hippies
3 hustlers
1 poetic fag
2 dike [*sic*] ladies
6 social types
3 black leather boys
1 super star
1 American Indian woman
2 student activists
1 nude (painted) in a coffin
1 fag hag
6 chic hippies and theatricals
5 high fashion types
2 black nationalists
1 Polynesian prince

"That was one of Andy's simple-minded suggestions that are very sensible: 'Use the leftovers.' "
—Paul Morrissey

Geraldine Smith and Patti D'Arbanville, both frequenters of the back room of Max's Kansas City. Factory regular Louis Waldon played a warm, butch john who liked to show off his war scars. For the role of an elderly English artist who sketched Joe assuming classical posturing, Morrissey cast Maurice Braddell, an elderly English actor who had appeared in the English classic *Things to Come.* The youngest actor was Jackie Curtis; ever since Morrissey rejected him for *Lonesome Cowboy,* Jackie had reappeared at the Union Square Factory, always hoping for a movie role. At the same time Morrissey was putting together a cast, Candy Darling was rehearsing for a revival of *Glamour, Glory, and Gold,* which opened in August 1968. Morrissey suggested that Jackie bring Candy along.

Morrissey could shoot only on weekends, because he worked at the Union Square Factory from nine thirty to seven each weekday. "By starting it with one scene, I had an initial idea, and then I had time during the week to think about what I had done and develop that. I didn't have a strong preconceived idea," said Morrissey. "The preconceived idea was who would show up. That I knew, and that was enough for me to work with once they got there."

With Paul Morrissey in charge of *Flesh,* Joe Dallesandro became an ideal object for the camera's adoration. The film opened with a long unmoving shot of Joe, sleeping nude on the bed, perhaps an homage to Warhol's first film, *Sleep.* To many in the audience it looked like a Warhol film, but it soon became clear that something was different from other Warhol films. Not only was there a plot of sorts, but the camera was used in its service. In contrast to Warhol's relentlessly independent camera, Morrissey focused on the main action.

Morrissey shot a scene at the Union Square office. On one side of the frame stands Joe Dallesandro, his back to us, a pair of experienced hands around his buttocks as a sign that oral sex is in process. The hands belong to Geri Miller, a real woman with big, black, synthetic hair who stripped professionally at Al Goldstein's M&M Club and at the Metropole. The soundtrack was provided in counterpoint by Candy Darling and Jackie Curtis, making their screen debuts. Jackie wore a chartreuse dress and a simple lank wig. Slightly unshaven, he looked more like a hausfrau than a movie queen as he flipped through a 1942 issue of *Hollywood* magazine, reading found lines like "When is a toupee right for you?" Candy Darling assumed full control of his white-blond persona, in a striped blouse and dotted scarf. Candy barely moved and threw out such lines as "That's a very petty trick you know. Trying to make the likes of me jealous."

Flesh: Joe Dallesandro, looking at Geraldine Smith
(his wife in the film and in life) and Patti D'Arbanville,
directed by Paul Morrissey, 1968

Flesh ended, mirroring its beginning, with Joe Dallesandro lying on his bed. At the end he was the outsider next to his wife and her girlfriend.

The film contained full nudity, an erection, voyeurism, transvestitism, fetishism, and lesbians. Yet its overall tone was sweet, largely due to Joe Dallesandro's presence. Joe could evoke many of the earlier physique magazine types—the hustler, the athlete, the Greek poser—but he was also believable as a contemporary, feeling human being. Joe offered a capsule description of his life at that moment: "Nobody's straight—what's straight? You just do whatever you have to do. It's hard to learn how to do that but once you got it down pat, don't even think about it no more. . . . He's only going to suck your peter." With the release of *Flesh*, Joe Dallesandro became the first modern pansexual star, attractive to men and women alike.

At the time *Flesh* was released in the fall of 1968, the movie industry was beginning to recognize the potential of the gay market. *Flesh* was the first

"He was like 'a beautiful still life.' "
—**Billy Name on Joe Dallesandro**

"Warhol" film wholeheartedly endorsed by *The Advocate*, the nation's largest gay publication.

> At last a perfect film has emerged from the Warhol Factory. . . . Paul Morrissey has added the heretofore missing ingredients— a strong directorial touch and superb camera-artistry, along with judicious editing. . . . Dallesandro is a man of a thousand faces—the shifting of a lock of hair changes his appearance. . . . Prediction: Joe Dallesandro will be a top American film star.

The prediction came true. *Flesh* made Joe Dallesandro an international film star, crossing over the boundaries of straight-gay and underground-overground. In Germany *Flesh* became one of 1969's top-grossing films.

While the popular press regarded *Flesh* as the latest Warhol product, to Jonas Mekas's eyes, it was completely distinct. "I am a little bit amazed how anyone could mistake it for an Andy Warhol film," he said. "*Flesh* remains on the level of a caricature. In a Warhol film, even when an 'actor' acts, it looks like he's living it; in a Morrissey film, even when an actor lives it, it looks like he's acting."

Andy Warhol returned from Columbus Hospital on July 28, and for the next several weeks he remained in his four-poster bed on the second floor of his townhouse. Many of the things that Andy liked best, he could do in bed—watch television, flip through magazine ads, and talk on the phone.

Taking showers required Andy to remove his bandages and see the purplish red and brown scars. "I look like a Dior dress," he said. "But it's not that bad. The scars look pretty in a funny way. It's just that they are a reminder that I'm still sick and I don't know if I will ever be well again."

Andy could not remain idle more than a few weeks. In August he began painting a commissioned portrait of Happy Rockefeller. It marked his reentry into work, and it signaled the direction his career would take over the next two decades—painting commissioned portraits of the rich, famous, and well-connected. When Ondine and Billy Name visited Warhol at his townhouse one August afternoon, they found him painting little pink canvases of Happy Rockefeller in a line that stretched from

his living room window into the next room. The activity seemed especially heroic because Andy looked so frail.

Andy Warhol reappeared publicly on September 4. He went with Viva and Morrissey to a party celebrating the completion of *Midnight Cowboy* and afterward talked to a *Village Voice* reporter named Leticia Kent. Warhol's voice sounded vulnerable and real in the resulting article, stripped of his shield of dumbness and blank enthusiasm. When the reporter asked whether the shooting prompted any change in his lifestyle, Warhol replied:

> I've been thinking about it. I'm trying to decide whether I should pretend to be real or fake it. We were serious before so now we might have to fake a little just to make ourselves look serious. . . .
>
> Before I was shot I always believed I was watching TV instead of living life. Right when I was being shot I knew I was watching television. Since I was shot everything is such a dream to me. I don't know whether or not I'm really alive—whether I died. It's sad. Like I can say hello or goodbye to people. Life is like a dream. . . . I wasn't afraid before. And having died once, I shouldn't feel fear. But I'm afraid. I don't understand why. I am afraid of God alone, and I wasn't before.

The closing of an era can't be described with chronological precision, but the shooting of Andy Warhol, combined with the move to the Union Square Factory, clearly marked such an end. In the previous few years all kinds of experiments were encouraged, all layers of society were welcomed, and the commercial motives were minimal. After Valerie Solanas shot Andy Warhol, all this changed.

The narratives that follow reflect some of the ways that people responded to the change.

Andy Warhol gradually returned to the Union Square Factory that September, spending a few hours each day. The passenger elevator led to a bolted, steel-covered door with the sign KNOCK AND ANNOUNCE.

"People only want art so they can talk about it. This way they can take the art home, show it to their friends, take Polaroids of it (which I will sign), make tape recordings. And after the week is over, they'll still have anecdotes."
—**Andy Warhol**

As a sort of symbolic security, Cecil B. DeMille's stuffed dog stood guard. Warhol startled each time he heard the elevator doors open, never opened a package, and never ate the food sent to him at Christmas. But his crisis was not simply about physical safety. Two things that had fueled his activities were wild people and Obetrol. In his new regime, Warhol could tolerate neither. When Morrissey suggested that all people in "tenuous mental health" be barred from the premises, Andy feared that he would be cut off from his creative sources: "I was afraid that without the crazy, druggy people around jabbering away and doing their insane things, I would lose my creativity. They'd been my total inspiration since 1964.... I didn't know if I could make it without them."

Warhol recalled that the last sixteen months of the 1960s were his most aimless of the decade. He flailed about, rudderless, his output inconsequential. He shot countless Polaroids and made tapes and pursued a few desultory art projects; he wanted to make machines that would produce snow, wind, and rain; he considered a television show of surveillance footage called *Nothing Special;* he wanted to make a group sex movie called *Orgy;* he wanted to tape/write a new novel with Ondine, a sequel to *a* to be called *b.* None of these projects came to fruition.

Grove Press published *a: a novel,* all 451 pages of transcript, in the fall of 1968. After the endless process of transcription by four different women, with the respective mistakes of each incorporated into the manuscript, publisher Barney Rosset gave Warhol a $2,500 advance for a book to be called *24 Hours on Amphetamine.* By the fall of 1968 the title had been changed to *a* (amphetamine, Andy, the beginning of the alphabet) and the jacket design was derived from a large red *a* that Brigid Berlin ripped from a typography magazine. Grove's press release reported that Warhol liked the book's physical appearance, "but wished that the ink were blue instead of black. This is because he considers the novel part of his 'blue' period, and that color seemed to him to best suit the action of the novel."

The media paid attention to the novel, but mostly to dismiss it as unreadable. "Zzzzzz," said *Time.*

"The transcription was a counterpoint to the idea of not writing. Because transcribing becomes writing in itself."
—Gerard Malanga

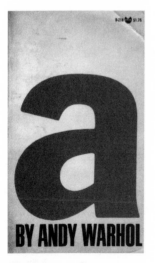

The cover of *a,* Andy Warhol's tape-recorded novel, published by Grove, fall 1968

Andy Warhol made one last movie in September 1968. It was classic Warhol: there was no editing, no script, just a heterosexual couple before, during, and after having sex. This situation allowed Warhol to finally realize his ambition of projecting on-screen the behavior of real

sex. This time he would not rely on strategies of double entendres (as in *Mario Banana*), explicit presentation/avoidance (*Blow Job*), or soft-core sexploitation (*I, a Man; Bike Boy*).

Viva conceived the idea one evening when she was tripping on LSD with an actor from the Shakespeare Festival. In a moment of psychedelic ambition she decided that the world needed a movie about real sex. "What I'd had in mind was a leisurely, sensual pas de deux," she said. "It was a beautiful idea, but it was unworkable."

Andy invited Louis Waldon, who had been Viva's boyfriend a few years earlier, to be in the movie. Walking on a cane, Warhol met them in Central Park to discuss the idea. "I trusted Andy a hundred percent," said Waldon, who had already performed in *Nude Restaurant, Lonesome Cowboys,* and *Flesh* and who understood Warhol's aesthetic and style of working. Waldon had appeared in a handful of porn films a few years earlier but never considered himself a star. "In T&A movies the woman was always the focus, the man was just a prop," said Waldon. "When Andy said he wanted us to make love, I knew it wasn't going to be a dong-and-balls movies, it was going to be sensitive."

Still physically weak, Andy telephoned his old friend David Bourdon and asked to use his high-rise Greenwich Village apartment for the movie. It offered a view of the Hudson River and New Jersey beyond, and Andy liked its "tacky modern" quality. When Bourdon objected, Andy said, "C'mon David, help me get on my feet again. We'll be there on Saturday at eleven A.M." Bourdon's bed was moved into the living room. Warhol determined its position and did all the filming. The rest was up to Viva and Louis Waldon. As the film opened, they were lying on the bed, Viva in pants and a very thin blouse that snapped at her crotch and Louis wearing a bright shirt printed with tulips all over.

Viva and Louis gradually shed their clothes, all the while talking and joking. Both the pleasure and the battle between the sexes are evident from the outset, played out in the running issue of whether Viva will suck Louis's cock. The last time this happened, Viva had taken Louis's penis out of her mouth to say, "Okay, that's it. This is really *boring.*"

In the second reel Viva and Louis performed sexual intercourse. The camera employed none of the close-ups of sexploitation films; it simply watched. There is nothing "abnormal" about the sex. "We weren't just fucking, we were playing around," said Waldon. "I really loved Viva, but I knew we could never make it together. For me, this situation was two people having their last fuck. We meet for the last time, and we do everything backward. We meet, we fuck, we eat."

"Is Viva the Camille of the '60's? Is overripeness all?"

—**Ross Wetzsteon and Sally Kempton,** *The Village Voice*

Sexploitation movies, summer 1969
Hetero:
Gutter Trash
Like Mother Like Daughter
Sands of Ecstasy
Hot Skin and Cold Cash
Copenhagen Call Girls

Homo:
Queen for a Knight
Horatio Hornblower
The Trick's a Treat
A Tisket, a Tasket, What Is this Pretty Basket
Welcome Fellow Travelers

Blue Movie opened on July 21, 1969, at the Garrick Theater. It was described in the press notes as "a film about the Viet Nam war and what we can do about it." Warhol told reporters that he meant the words seriously because "the movie is about . . . uh—love not destruction." On the eleventh day of *Blue Movie*'s presentation, at the five-thirty screening, the police confiscated the film.

On September 17, 1969, a three-judge panel deliberated for less than thirty minutes and ruled that *Blue Movie* met the criteria for hard-core pornography on all three counts: it aroused prurient interest; it offended community standards; and it had no redeeming social value. Saul Heller, the sixty-six-year-old manager of the Garrick, was fined $250 or thirty days in jail. "I don't think anyone was harmed by this film," said Heller. "I saw other pictures around town, and this was a kiddie matinee compared to them."

"What's pornography anyway?" Warhol said. "The muscle magazines are called pornography, but they're really not. They teach you how to have good bodies. . . . *Blue Movie* was *real*. But it wasn't done as pornography—it was done as an exercise, an experiment. But I really do think movies *should* arouse you, should get you excited about people, should be prurient."

That September when Andy Warhol returned to the Factory, Valerie Solanas arrived at Matteawan State Hospital in Beacon, New York, and wrote Warhol a conciliatory letter. "I intend to forget the past—harbor no grudges, regret no mistakes & begin completely anew," she wrote. "I'm very happy you're alive & well, as, for all your barbarism, you're still the best person to make movies with, &, if you treat me fairly, I'd like to work with you."

Warhol did not press charges against Valerie Solanas, but this further enraged her. She was convinced that he secretly realized her superiority to all the other superstars and that that was one reason he was so determined to control her works. "You can ride along only so far with Viva, Brigid Polk & the rest of your trained dogs. Having worked and associated with me, you have a taste of honey, and it must be awfully difficult to have to go back to Viva saying 'Fuck You' in restaurants." Valerie's invective never lost its edge. "Weren't you saying some-

thing, Boy, last June 3 about how if I turned in 2 more works, signed a bunch of contracts with The Great Toad with you, then did the movie, you'd allow me a few crumbs of publicity? I won the first round; I'll win the rest."

Throughout the fall of 1968 Valerie Solanas's primary supporter was Geoffrey LeGear, whom she had met in San Francisco a few months earlier. He rented an apartment in Beacon so that he could be near her, he made over two dozen visits, and he wrote earnest letters to Warhol and Girodias explaining her actions. He repeatedly asked, "Did you really take her as seriously as she deserved to be taken?" Solanas was grateful for his constant attention—LeGear would be a perfect candidate for leading the SCUM Male Auxiliary—but that didn't give him the right to explain her, and she told him it was wrong to have tried. "Only I can interpret me," she wrote.

Mattawean State Hospital finally allowed her to stand trial in December. The judge ruled that she should be psychiatrically reexamined and return in a month. He set ten thousand dollars' bail, which was promptly put up by Geoffrey LeGear. Neither Girodias nor Warhol was informed of Solanas's month of freedom. On Christmas Eve she contacted her twin nemeses. She wrote Girodias that before she would allow him to publish her next work (*Why I Shot Andy Warhol and Other Chit Chat*), he would have to publish a self-incriminating work called *The Confessions of a Toad*. That same day she telephoned the Factory and stated her demands: drop all charges, put her in more movies, pay her twenty thousand dollars for her manuscripts, and arrange for her to appear on television shows. Paul Morrissey told her that neither Warhol nor himself wanted to have anything to do with her. Valerie replied, "I can always do what I did before."

In January Solanas underwent mandated psychiatric examination by two doctors, who were impressed with her superior range of intelligence and the vulgarity of her talk. "Frequently she alluded to 'Warhol and Warhol's crowd' who were attempting to control her by stealing the rights to her literary works," the doctors wrote. "She was especially incensed that Warhol's crowd was deliberately sending information to the newspapers to ruin her reputation. She felt that her attack on Warhol was a crime only in legal sense of her present society, and should be considered 'a misdemeanor at the worst.' " The psychiatrists diagnosed her as "Schizophrenia, Chronic, Paranoid Type," and recommended that she be placed in a closed-ward setting in a state hospital.

"You're trying to get credit for great nobility and compassion without doing one noble or compassionate thing."
—Valerie Solanas to Warhol

Appearing in court before Judge Culkin on February 25, 1969, Valerie Solanas pleaded guilty to assault in the first degree. "I didn't intend to kill him," she said. "I just wanted him to pay attention to me. Talking to him was like talking to a chair." She faced up to fifteen years' imprisonment. The judge's sentence was surprisingly light: three years in state prison. Valerie Solanas became inmate number 5216 at Bedford Hills.

"Certainly I would advocate everybody using drugs," Andy Warhol had said to Gerard Malanga at the end of 1966, "but only the drugs that are given by prescription." After the shooting, when Andy could no longer use his favorite prescription drug, Obetrol, he wondered how he could function. He also saw that people were getting increasingly strung out.

Aldous Huxley, who supported the use of hallucinogens for spiritual insight, added speed to the list of the seven deadly sins. "Speed Kills" became a popular slogan on buttons. The laws were slow to regulate amphetamine, in part because it was such a capitalist-friendly drug, used by people in all walks of life. It remained only minimally regulated for most of the decade—records of amphetamine prescriptions were not mandated until 1966, and even those laws were toothless, for the Food and Drug Administration could advise only on "acceptable therapeutic applications." When the government began enforcing the drug laws at the end of the 1960s, the legal production of amphetamine pills, tablets, and capsules exceeded twelve billion. Legitimate sources soon dried up, and good amphetamine was harder to find. Once a matter of visiting the local pharmacist, scoring amphetamine became a process of dealing with semicriminal types for a homemade product potentially riddled with unpredictable irregularities.

As the speed era drew to a close, the wreckage was rarely as dramatic as Freddie Herko's dramatic leap in 1964. There might have been a few years lost in picking lint from carpets, stringing beads, and making necklaces of pop-top cans or cleaning every groove in the apartment with Q-tips, or missed parties because the whole evening was spent trying *every* combination of clothes and accessories possible; there might have been voids in consciousness, random tricks of vision which meant seeing anonymous people waving from a window or bugs in the food. "I think people look back on the speed years," said Danny Fields, "and they think, 'Did I spend those years wallpapering an apartment with stamps when I could have been writing a play?' "

More disturbing than the lost years were the physical effects. Bones became brittle, teeth dropped out, facial skin seemed to lose its tone, and smiling became a chore. Heavy speed users sweated and smelled funny, and their compulsive energy grew more diffuse. A spotless bathroom coexisted with rotting vegetables and stacks of unwashed dishes in the kitchen. Prolonged use of amphetamine led to dead ends, most of which were excruciatingly boring.

The ascendence of other drugs contributed to the end of the speed era. Those with more money, especially the rock-and-roll crowd, used cocaine. "It was easier, you sniffed it, your teeth didn't fall out, and it was more glamorous," said Danny Fields. "Speed lost its cachet."

After Andy was shot, Billy Name withdrew from the black-and-white Factory; it no longer felt like comfortable territory. Billy's genial shyness evolved into a hermitlike existence. The Factory bathroom that served as his darkroom soon became the compass of his world. He left his black-painted room only at night, when no one was around. He allowed two people inside—Ondine and Lou Reed—because they were the only ones who could understand his occult vocabulary.

"The stories that have been told are fantastic, but the reality is even more fantastic," said Billy. As if he were replaying Andy's *Campbell's Soup* series at the Ferus in 1962, Billy subsisted mostly on cases of Campbell's soup. He ate one or two cans a day and went through each of the thirty-two flavors.

Billy's eighteen months in the darkroom consisted of eating and meditating and doing astrological charts and printing photographs. Billy repeatedly calculated the astrological reading for the day of Andy's shooting, and his handwriting grew increasingly pressured. Much of Billy's interior life was devoted to esoteric and occult literature and astrology, and he was especially interested in Alice Bailey. Alone in his room, he tried to escape the man-made structures of syntax and rational thought that clogged his mind, by default. He wanted to return to pure chaos, the first principle. "Another part of why I sealed myself away was, I discovered that when you are approaching thirty, you are having your first Saturn return," said Billy. "The planet Saturn comes back to the place where it was at your birth. It . . . is the first noticeable accounting of your life. You withdraw into yourself, and you know another phase is coming. And it's going to be a totally different life."

Even Ondine was disturbed by Billy's appearance in the dim bath-

Parachute Drug:
The drug that allows an easy come-down from amphetamine: "Then begins the desperate, frenzied search for a parachute drug."
(Don McNeill)

Punding:
A Swedish forensic psychiatrist named G. Rylander coined the term to describe the effects of amphetamine overuse: the loss of the "capacity to perform complex sequential acts in a rational manner determined by the gestalt of the object or process at hand. Instead he persists in repetitive and compulsive, but subjectively rewarding, manipulative tasks for hours or even days."

Highnesses of the Crystal:
The enforcement agencies (police, FBI, National Narcotics Division) who supervise the drug trade.

Billy Name's self-portrait in the bathroom of the Union Square Factory, c. 1969

room light. His eyes looked yellow, scabs dotted his face, and his hair was growing in concentric circles. "He was possessed by lesser spirits, spirits of the earth," Ondine said. "You could hear them, you could hear them raging through his body. There was some kind of fire going on in Billy's brain."

Paul Morrissey warned Andy that Billy would die and the newspapers would run a banner headline: ANDY WARHOL LOCKS MAN IN TOILET FIVE YEARS. Mary Woronov recalled that many of them worried about Billy, for they had witnessed the demise of other speed freaks. "But others believed he had buried himself alive like a mystic, renouncing everything till he became invisible," she wrote. "He couldn't be crazy; crazy people didn't read the *Kabbala*." Warhol grew more disturbed when he heard voices coming over the transom of the Factory bathroom. For a

while he thought someone had moved in with Billy. "It turned out that both voices were Billy's," Andy said.

Some thought that Billy was waiting for Andy to ask him to come out. Warhol replied that he didn't understand why Billy had gone in, so how could he ask him to come out? "Billy had always seemed to know exactly what he was doing," said Andy, "and I just didn't want to butt in; he'd come out when he wanted to, I figured—when he was ready to."

When Warhol returned to the Union Square Factory in September 1968, the Velvet Underground was in turmoil. Cale and Reed had grown increasingly tense throughout the summer. In early September Reed called a meeting of the band at the Riviera Café on Sheridan Square. Cale was not invited. Reed delivered an ultimatum to Sterling Morrison and Maureen Tucker: John Cale was out of the band, permanently. "I said we were a band, and it was graven on the tablets," Morrison recalled. "A long and agonizing argument ensued, with much banging on tables, and finally Lou said, 'You don't go for it? All right, the band is dissolved.' "

That was the last thing Morrison and Tucker wanted to hear, so they tried to keep a band going. Sterling delivered the news to John.

Cale didn't feel only the bitterness of being handled secondhand; the point was the music. "The idea that kept us struggling with rock and roll as the medium of choice," he said, "was the combination of the study of time through sonic backdrop from La Monte, and the subconscious of Lou. It was an attempt to control the unconscious with the hypnotic." In retrospect, Cale felt that the Velvet Underground had not fulfilled its potential. "With tracks like 'Heroin,' 'Venus in Furs,' 'All Tomorrow's Parties,' and 'Sister Ray,' we defined a completely new way of working. It was without precedent. Drugs, and the fact that no one gave a damn about us, meant we gave up on it too soon."

> "It was a conceit of mine (and maybe still is) that art demanded that you create it. It was there as a facilitator. It made me know more of who I was, and I enjoyed it."
> —John Cale

After the shooting, many speculated that Andy no longer felt comfortable with biological women. Drag grew in vogue at the Factory, thanks to Candy Darling, Jackie Curtis, and Holly Woodlawn.

An uneasy question hovered over their lives: How could such determinedly fantastic creatures survive in the real world? As the late 1960s gave way to the early 1970s, the drag trio helped create a wave of gender outrageousness, and for a few years they rode it. It was an odd moment when a man in drag could appear in fashion magazines, rub shoulders

with Café Society, appear in a Tennessee Williams play (Candy Darling in *Small Craft Warnings*) or an international art house hit (Jackie Curtis in Dusan Makaveyev's 1971 *W.R.: Mysteries of the Organism*), or perform a cabaret act in Huntington Hartford's Ballroom in the Sky (Holly Woodlawn). The trio's unlikely celebrity resulted from a combination of talent, association with Warhol, and the topsy-turvy times, when gender, sexual orientation, and the sexual revolution occupied not only the national libido but also the national mind.

When the University of Notre Dame convened a conference on pornography, the organizers invited the Play-House of the Ridiculous to perform. A dozen cast members gathered at Grand Central Station for the departure; Jackie Curtis was one of the last to arrive, wearing a dress on the street for the first time, as a result of dropping acid on New Year's Eve 1968 and having an epiphany that he should go on the streets as a woman.

At Notre Dame the Play-House performed *The Life of Lady Godiva* and *The Life of Juanita Castro*, shocking both the university's President and its students. They organized a picket line, and the Play-House left South Bend before they were scheduled to do so.

On that return train trip Jackie Curtis surged along on a handful of Desoxyns and wrote his second play. Glancing at the daily racing form, he saw two horses' names: Heaven Grand and Amber Orbit; he knew he had a play. Before the train pulled into Grand Central Station, he had completed a draft of *Heaven Grand in Amber Orbit*. Set in a Forty-second Street Bickford's, all the characters were named after horses running at the track that day.

John Vaccaro wanted to direct Jackie's play, but he wanted to change characters from customers at Bickford's into sideshow freaks. Vaccaro transformed Jackie's manic comedy into a grotesque, musical, political antiwar statement. This was 1969, after all, when the Vietnam war pervaded the public consciousness, and a sideshow offered an appropriate metaphor; *freak* was a favorite Sixties word.

Shortly after Jackie's return from Notre Dame, Eric Emerson agreed to a proposition to marry Jackie, so long as Jackie made the arrangements and provided for a big, well-publicized wedding.

The wedding took place on July 21, just as *Blue Movie* was having its premiere and less then a month after the Stonewall Rebellion, which

marked the beginning of gay liberation. Among the two hundred guests on a rooftop on East Eleventh Street were Andy Warhol, Paul Morrissey, Holly Woodlawn, John Vaccaro, and a number of people with made-up names, including Penny Arcade, Reginald Rimmington III, and Marlene D-Train.

Wearing a white antebellum gown and dangling faux-pearl earrings, his russet hair extravagantly teased, Jackie Curtis carried a bouquet of daisies in one hand and a carton of milk in the other. The minister, Louis Abolafia (aka Captain of the Love Movement), wore Catholic vestments and a button that said NEW YORK'S MAYOR IN '69.

Holly Woodlawn recognized John Vaccaro at one end of the roof. He went over and boldly asked Vaccaro to cast him in Jackie's play, *Heaven Grand in Amber Orbit*. Holly wore a chiffon dress with only a G-string beneath, and even Vaccaro's experienced eye did not recognize that he was talking to a man. He asked if Holly used speed. Well counseled ahead of time, Holly said no. "That's all you need," said Vaccaro. "You're in!"

"Superstars Jackie Curtis (*Flesh, Cock Strong, The Moke Eaters*) and Eric Emerson (*Chelsea Girls, Lonesome Cowboys*) to be married. Everyone Welcome!"
—**Jackie's press release**

Jackie Curtis's wedding on an East Village rooftop, July 21, 1969, by Jed Johnson

Eric Emerson did not show up for the wedding. Jackie Curtis and his bridal party huddled behind pipes and chimneys at the back of the roof. Finally Jackie took the situation in hand and decided to marry another man, when Stewart Eaglespeed stepped gallantly to the makeshift altar, and the two were "married."

Heaven Grand in Amber Orbit opened in September and became a phenomenon that could only have happened in the high Sixties. One might expect *The Village Voice* to embrace a production that combined the politically incorrect, the sexually extreme, and the egregiously tasteless. But one wouldn't have expected as mainstream a magazine as *Newsweek* to hail it as "the wildest and in some ways the best show in New York." Describing an anarchic show in printable terms for a family magazine was not easy. Jack Kroll called it "a plotless farrago which yet asserts itself strongly as a coherent upheaval of a mad but intensely human community flaunting its appetites and stylized tropism in the face of repressive forces felt to be everywhere."

Despite Holly Woodlawn's small role, he made a sufficient impression to attract an interview with John Heys in *Gay*, one of the earliest post-Stonewall magazines. When Paul Morrissey read the article, he was amused to read about Holly's fabulous and fabulated career as a Warhol superstar. Morrissey had a brainstorm about a new film, initially called *Drug Trash* and later *Trash*. "It was to be a picaresque account of the life of drug addict. I thought: What if this poor negative character was involved with someone quite the opposite, someone who was hellbent on survival instead of destruction, someone who lied and stole and cheated to get something out of life, as opposed to someone drifting inexorably down the gutter to death?"

Morrissey invited Holly Woodlawn to perform in a scene and purposely decided not to meet him ahead of time. The next Saturday afternoon, in mid-October, Holly Woodlawn appeared at Paul Morrissey's brownstone on East Sixth Street, between First and Second Avenues, wearing a lavender dress and a ratty raccoon coat. "I had started going toward the Jackie Curtis look, that strange look with my hair all frizzed out," said Holly. "I wore even more eye makeup and plucked my eyebrows more. Plus I was doing a lot of speed, so I was so skinny. I stopped wearing bras . . . because the Twiggy look was in. And of course the thrift store look was in."

On the *Trash* set Holly found Morrissey and Joe Dallesandro and the

movie crew, which consisted of Jed Johnson as lighting man, grip, and gofer. There were two lights, an old wrought-iron bed, a birdcage, a lobster trap in the middle of the room as a cocktail table, and an old sink for peeing in. That was it.

Initially Holly felt nervous about acting with Joe Dallesandro. "I couldn't tell what he thought about me, and in the beginning I felt uncomfortable." On the first day Joe went out to buy cigarettes and two brands of beer (Olde English 800 and Miller High Life) for Holly, and he even lit Holly's cigarettes. There soon developed a chemistry that had nothing to do with sexual attraction. Joe thought Holly was ugly, and Holly was devoted to a sixteen-year-old boyfriend and claimed he didn't think of Joe in sexual terms. "I was in love, and my boyfriend was with me," said Holly. "I was never into Joe Dallesandro, sexually."

That first afternoon Morrissey shot for about one hour, and Morrissey recalled "I knew within minutes of filming that my hunch was right and my instinct had paid off. I knew that I had my two basic characters, and I would then have a movie."

The other women included Andrea Feldman, who delivered a rant about sex; Geri Miller, returned from *Flesh,* still wanting sex with Joe,

Sixteen-year-old Jane Forth and Joe Dallesandro in *Trash*, 1969

now with silicon-enlarged breasts; and sixteen-year-old Jane Forth from Grosse Pointe.

Holly Woodlawn offered the most give-and-take and the most emotional connection to being a wife. "Holly struck me then as now as a basically very shy and unassuming person, unfailingly polite and instantaneously likeable," wrote Morrissey. "That so much determination and energy lurked beneath this facade was still, that first afternoon, only another hunch."

A few weeks later Holly revealed all in a scene that was hatched on the spot. One Saturday afternoon Joe Dallesandro returned to Paul's brownstone with a king-size bottle of beer for Holly. While Jed Johnson was loading the next reel of film, Paul Morrissey suggested that Holly act out her sexual frustration by masturbating with the beer bottle. Holly performed the scene wearing only panties and frosted-white Revlon nail polish. "Holly generously gave me that performance; I didn't trick it out of him," wrote Morrissey. "Although he had never acted before on film, what I think I did was somehow suggest that I knew he could do it."

While Paul Morrissey was editing *Trash*, Holly Woodlawn was in search of money for heroin. Holly shared a fourth-floor walk-up on East Third Street and Second Avenue with his sixteen-year-old boyfriend, Johnny, who appeared in *Trash*. Behind a scavenged cuckoo clock that hung over the stove, they kept their ten-dollar bags of heroin. Holly tied himself off with an orange scarf, alternating heroin and speed, one for the vivid, drifting dreams, and the other for energy.

Holly met a Factory assistant named Silver George, a friend of Rotten Rita. Silver George suggested a dubious plan for making some fast money: by passing himself off as Viva, Holly could charge a two-thousand-dollar camera to Warhol's account. They tried it, but when the clerk called the Factory for approval, Silver George and Holly ran. It didn't stop them from trying another scheme. Silver George came into possession of the bankbook and passport of Madame Cardonet, a French diplomat's wife. It sounded like a screwball comedy—Holly would impersonate the wife of the French ambassador to the United Nations and thereby forge a check. Holly practiced the signature from a canceled check and tried to assume a French accent, while Silver George replaced the passport photo with one of Holly in ostrich feathers. Holly wore a black Chanel dress and a tasteful pink scarf to the United Nations and successfully withdrew two thousand dollars. It worked.

Heroin ate up the money quickly, however, and Holly decided to try the same thing again. When he instructed the teller to withdraw everything from Madame Cardonet's bank account, he was immediately accosted. When the prison matron strip-searched Holly, his sexual deception was discovered. Holly was remanded to the Men's Detention Center at the Tombs.

After Warhol's previous experience with Holly, trying to charge an expensive camera to him, he didn't bail Holly out. During his weeks in the Tombs, Holly Woodlawn slept in a gray bunk bed and rose at five A.M., when the lights flashed on. He hung out with the other queens in jail—Morgana, Francesco, Chico, and Shasta—and created ad hoc makeup by rubbing colored magazine pictures into their cheeks. In early October 1970, when Larry Rivers put up the six hundred dollars to bail Holly out, *Trash* had just opened at the Cinema II. Holly first heard the news from a prison guard.

Trash became the first Factory movie to be distributed by Donald Rugoff's company, Cinema V. Rugoff was known for releasing films that trod the line between art films and underground movies (*Putney Swope* and *The Endless Summer* were Rugoff releases, as well as such foreign hits as *Z* and *Elvira Madigan*). Rugoff was a big step from the world of Jonas Mekas. He approached Howard Smith to write a blurb; this *Village Voice* "Scenes" columnist wasn't a critic, but Rugoff regarded him as the right person to describe *Trash,* which in his mind hovered between a real movie and sociological exploitation of the Sixties' East Village drug scene. When Smith offered as his blurb: "A beautiful and funky movie," Rugoff was aghast. "We can't use that kind of language in the press!" he said, and only after rigorous consultation did he use Smith's line, which became the tagline for the movie's highly successful release. With Joe Dallesandro's bare body on the ads and buzz about Holly Woodlawn's performance, the movie became the biggest commercial hit ever produced by either Warhol or Morrissey.

Years later Joe Dallesandro recalled that the idea of acting "became serious to me with the movie *Trash.* . . . it kind of caused me a hard time later because people were believing I really was a drug addict. I'm trying to take this thing that started as a joke and turn it into a serious career."

Holly Woodlawn became the oddball celebrity of the moment. He milked the attention for all it was worth. He attended two dozen screenings of *Trash* during its first six weeks, appeared in fashion magazines, and began thinking that he looked like Sharon Tate. Fans recognized Holly on the street. He seemed to be always in costume, with glitter on

Holly Woodlawn on the minimal set of *Trash*, fall 1969

"A comic-book Mother Courage."
 —Vincent Canby on Holly Woodlawn

his upper lip and eyelids, his hair extravagantly ratted at the sides. "I don't want them not to like me," Holly told *Village Voice* columnist Arthur Bell. "I feel frightened and mmmmmmm, I love them." George Cukor circulated petitions for an Academy Award, while David Susskind featured Holly, wearing a modified nun's habit, on his deep-think talk show.

Candy Darling was appalled at the attention given Holly Woodlawn, writing Andy:

> Everyone is sick to hear about Holly being nominated for an Academy Award. The *idea!* That she should be given an award just for being the slob that she really is. Can you believe that? They're sending Holly to all the photographers. She's in the *Times,* and I'm the forgotten woman.

Paul Morrissey filming
Women in Revolt

In the aftermath of being shot by Valerie Solanas, Andy Warhol wanted to make a movie about women's liberation without using biological women on-screen. The working title was *P.I.G.S (Politically Involved Girls).* Paul Morrissey, who directed the movie and conceived its loose story, initially regarded Warhol's response to Solanas as an unlikely commercial prospect. "I was very much aware that it was a bad idea and that Andy was deliberately doing it," said Morrissey. "It was one of the few things Andy ever did as a deliberate challenge, a show of defiance, but as soon as I realized that he really wanted to do it, I was very much behind it." The movie, made in 1970 and released in 1971 as *Women in Revolt,* starred Candy Darling, Jackie Curtis, and Holly Woodlawn. Their different drag personae reflected their off-screen lives and ambitions.

In the wake of *Trash,* Holly Woodlawn was the best-known of the three, the most histrionic, and the scrawniest. In *Women in Revolt* he played a fashion model tied to men by a voracious need for sex, ending up a Bowery wino. But Holly's attempt to outdo his *Trash* performance seemed strident, particularly since there was no Joe Dallesandro as a counterbalance in the scenes.

Candy Darling provided a cooler note, playing a postdebutante socialite, snobbish and bored, who lends her name to women's liberation in order to become a movie star. Candy's role offered him a chance to display hauteur and glamour and the opportunity to do his much-practiced impersonations of Joan Bennett, Lana Turner, and Kim Novak. Candy's breathy monologues were usually performed at parties or in

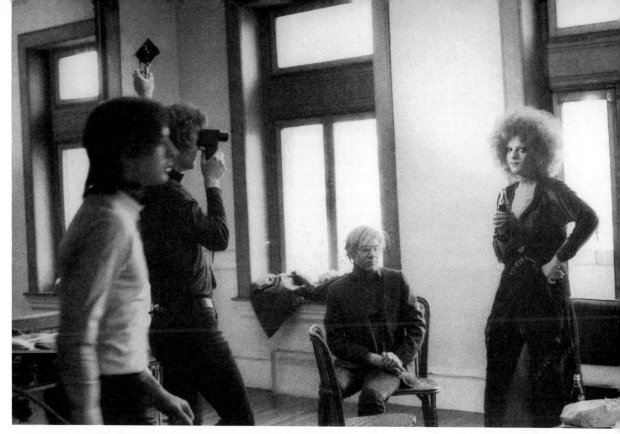

Paul Morrissey and Jackie Curtis during the shooting of *Women in Revolt*, 1970, by Gretchen Berg

taxicabs, commanding all the attention in the room. For a few years Candy Darling commanded attention that befitted a star—he appeared in society columns with Jane Fonda, Truman Capote, Dina Merrill, and Peter Beard, and he corresponded with Diana Vreeland about feminine screen beauty.

Jackie Curtis played the most committed feminist of the trio—organizing meetings and giving instructive lectures on the superiority of women—until he discovers orgasm and deserts the cause for a life as a single mother lesbian in Bayonne, New Jersey. In real life on the Lower East Side, Jackie was often verbal about issues of gender and gay liberation, but it didn't add up to a coherent political agenda.

> I believe in lib. My lib. Ad lib. We each have our revolution to fight and they won't all be won with rosewater and glycerine. A cause is attention. Making attention is causing a tension. There are tenses—past, present, future—and the politicos want it to be always. But you have to live in the now.

"Candy's after pussy, Holly's after cock. What I'm after is something—intangible."
　　　—Jackie Curtis in Women in Revolt

"Probably no man, not even Norman Mailer, will ever have the last word on women's liberation, but until one does, perhaps the Andy Warhol–Paul Morrissey *Women in Revolt* will do"
　　　—Vincent Canby, The New York Times

"It was beyond my wildest imagination that I would be brought back to the Factory," said Gerard Malanga. But at the end of summer 1968 Andy called Fred Hughes and said he wanted Gerard to be rehired. In hindsight, Malanga attributed Warhol's unexpected generosity to two things: guilt about not providing a return airplane ticket from Italy, and gratitude for caring for Julia Warhola on the day of the shooting. "Andy made the connection that I would get his mother," said Malanga, "not someone else."

When Gerard returned to the Factory after the shooting, there was no silk-screening, for Warhol was too weak to undertake such a physical process. Gerard instead worked editing a new magazine and overseeing the booking of Factory films. The magazine would provide a harbinger of the future, and the films marked the end of the Silver Factory past.

Initially called *Inter/VIEW: A Monthly Film Journal,* the magazine appeared in a cheap black-and-white tabloid format. John Wilcock, who published his own East Village tabloid, *Other Scenes,* proposed the idea, suggesting that he would do the typesetting and Warhol would pay the printing bill, which ran about six hundred dollars an issue. The magazine could be produced cheaply, since they used publicity stills, and the articles were simply transcribed interviews with nothing left out. (Sort of like *a* in bite-size pieces.) Wilcock wanted Warhol to put his name on the cover, reasoning, "Otherwise, why would people buy another crappy newspaper?"

The first issue appeared on the stands in the fall of 1969, with a cover photo of Viva in Agnes Varda's *Lions Love.* Gerard Malanga, Paul Morrissey, Soren Angenoux, and Pat Hackett were involved with the first issues. *Inter/VIEW* soon changed to *Interview,* and under Bob Colacello's editorship and with Peter Brandt's money, it grew larger and glossier in the 1970s. Long after Warhol's death, it continues to be a magazine he would enjoy flipping through, pausing at the advertising layouts.

A cover of an early *Inter/View,* 1969

In stark contrast, Gerard Malanga's work in booking Silver Factory films was uncommercial in 1970 and remained so. A few years earlier Jonas Mekas had offered three choices for underground movies: "1. To be swallowed by the Establishment, like many other avant-gardes and undergrounds before them; 2. A deeper retreat into the underground; 3. A smash through the lines of the Establishment to the other side of it thus

surrounding it." *The Chelsea Girls* had offered the promise of crossover from underground to mainstream, and the Film-Makers' Distribution Center was set up as the theatrical arm of the Cooperative. But *The Chelsea Girls* proved to be an anomaly; in Amos Vogel's trenchant article "Thirteen Confusions," he cited as number ten: "Confusing One Swallow with a Summer." The distribution center was not geared to aggressive salesmanship, and it made little commercial impact. "We discovered very soon that to open up the market, we had to adopt all the practices of the commercial system," said Jonas Mekas. "You immediately become involved in competition; it can't be done."

By 1970, when Malanga stopped working at the Factory, the independent filmmaking community had grown increasingly splintered, and Mekas's vision of a single filmmaker-led organization had proved untenable. Independent film production activities became the province of such organizations as Millennium and the Collective for Living Cinema, and some filmmakers withdrew their films made alliances in favor of commercial distributors. But it was a pie too small to cut.

Jonas Mekas recognized the tenuous position of the New American Cinema—it belonged neither to movie commerce nor to museum art—and he directed his efforts to organizing the Anthology Film Archives, which was conceived in 1969 and formally founded in 1970. Mekas and four others created a canon, the Essential Cinema, to be shown in perpetuity, in order "to define the art of film in terms of selected works which indicate its essences and parameters."

Several films Warhol produced at the Silver Factory were included among the "Essentials." When Gerard Malanga left in November 1970, there was no longer a circulation system, and films were de facto withdrawn from circulation. The Silver Factory participants had dispersed, and the films of their collaborations were buried.

Warhol films included in *The Essential Cinema* (as determined by Jonas Mekas, Peter Kubelka, James Broughton, P. Adams Sitney, Ken Kelman):
Blow Job
Eat
Harlot
Kiss
My Hustler
Sausalito
The Chelsea Girls

Aftermath

During the long period of researching this book, when I would mention to people that I was writing about the Silver Factory, a common response was: "Are any of them still around?" It seemed superficially an odd query, since most of the people connected with the Factory were, at the time of writing, just turning sixty. The question reflects the popular perception that the Factory people existed only in the framework of that physical/temporal space, came into being through Warhol's eerily magic touch, and went out of existence when he moved on.

The biographical vignettes that follow don't intend to project an overarching post-Sixties narrative. They are individual stories, and they suggest the variety of ways that the Factory people coped with the end of an era, the transformations they made, and the prices they paid.

In the spring of 1970 Billy Name decided to leave his darkroom, the Factory, and New York. He was ready for the next phase of his life. In his mind Billy had accomplished his apprentice stage with Nick Cernovich and his journeyman stage with Andy Warhol, and it was time to embark upon his own master work. In retrospect, he looked on his decision as logical and inevitable. He had come to the Factory to help create an art space with Andy. By 1970 it was not an art space but a commercial space. Even Andy was no longer accessible. "It was the Cardboard Andy," Billy said, "not the Andy I could love and

play with. He was so sensitized you couldn't put your hand on him without him jumping. I couldn't even love him anymore, because it hurt him to touch him."

Billy received three hundred dollars for a photograph to be used on an album called *The Velvet Underground*, with Doug Yule replacing John Cale. It was the most money Billy had ever been given for a photograph. He put it in his pocket as emergency money and walked out of his darkroom one night. When others arrived the next morning, they found the door to Billy's darkroom unlocked. Inside the foul-smelling room were hundreds of cigarettes butts and astrological charts on the walls. On the door a note was tacked up: ANDY—I AM NOT HERE ANYMORE BUT I AM FINE. LOVE, BILLY.

Billy left no forwarding address, and no one tried to contact him. The lack of communication was a combination of respect for his privacy and a recognition that, in many ways, he had left long ago. The bathroom was cleared out, the walls were painted white, and a Xerox machine was installed.

Billy Name's mother enrolled him in Graymoor, a Catholic hospital/retreat not far from Poughkeepsie, where he began to recover his health after seven years of daily amphetamine use. Even in simple tasks like painting a fence, Billy envisioned abstract issues. When they asked him to paint a fence, he responded: Did the fence want to be painted?

After his years rooted in the geographically specific domain of the Silver Factory, Billy Name spent his next few years in transit. He lived in the parks of New York one summer, picked squash for six months on a black-owned farm in Georgia, lived in migrant housing in Tallahassee, and moved to New Orleans, where he fell in with a group of people drawn together by spiritual matters and magic and LSD. "I ended up hitchhiking across the country to California," said Billy. "I went off by myself and spent a lot of time being very hermetic. . ."

"I am not just a photographer and New York character on the hip scene, but what is sometimes called the searcher, the one who goes on the path and insists on finding what it is about," Billy said. He contemplated universal order as it was reflected in sonic structures and developed a system combining long and short vowels and hard and soft consonants. Along the way he discovered that his system corresponded to the sonic structures of the Indo-European languages. After years Billy summed it up: "I have developed a sonic canon of sounds, and I call it the concrete poetry canon."

In 1977 Billy Name returned to his birthplace, Poughkeepsie, to his

three-room house, with a front porch and a backyard. It is filled with mementoes of the past, and Billy continues to live there to the present. He has survived long periods with little money, but increasingly his Factory photographs bring him recognition. He said recently:

> I have little existential angst, because I have no need to control the future. I have settled on the fact that we are just a star in a sky and we will go through our flaming creature stage and burn out and become part of another star. That's one of the things I started out seeking, and I have settled it. I'm one of the people who have achieved their quest. I can call myself a complete philosopher.

When Edie Sedgwick returned to her family's California ranch in the fall of 1968, she had lost motor control and had trouble speaking. She wobbled about the house and fell down, but she was determined to recuperate, as she had many times before.

A numbing sameness characterized the circular pattern of Edie's life over the next two years. She would land in a hospital, leave, return to drugs, get strung out, and return to the hospital. Her cohorts were different, ranging from a group of bikers called the Vikings to street addicts in Isla Vista, and the drugs varied from reds to heroin to LSD. But the end of the story was always the same: she ended up where she had been born, in Cottage Hospital. She was under the care of a psychiatrist named Dr. Mercer, a round man with a bristly mustache whom Edie called "Big Daddy" or "the egg-and-walrus man." She maintained an attitude of optimism that things would change, no matter how far these hopes diverged from reality. When Henry Geldzahler briefly visited her in the hospital, he was impressed by the strength of her fantasy: "She was going to get out, finish *Ciao!Manhattan,* be a model, be an actress, and start up again at exactly the point where she'd left off without realizing that something had intervened."

In the fall of 1970 David Weisman and John Palmer picked up the scattered pieces of *Ciao!Manhattan.* The footage contained beautifully shot scenes, mixed with thousands of feet that were impossible to incorporate.

When Edie Sedgwick told Weisman and Palmer that she was ready to start her life again, they moved ahead and created a new story to accommodate the changed Edie. It would be a new movie, with the old

"It went from mini to maxi, Day-Glo to dark. Zigzags to roses. From Saturn to Terrytown."
—**Betsey Johnson**

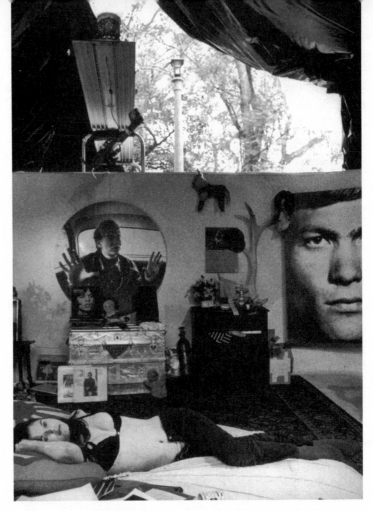

Edie in *Ciao! Manhattan*, on the set that was the bottom
of an empty Pasadena swimming pool, 1970

movie inside it. While Palmer's footage from the spring of 1967 had been
shot in black and white, his new footage would be in color, showing an
older Edie meeting a young California drifter, telling him the tales of the
Sixties, a fabled era now ended. In this version Edie was an Aquarian Age
Norma Desmond, living in the bottom of an empty swimming pool on a
large estate east of Pasadena.

Dr. Mercer authorized Edie's release from Cottage Hospital so that
she could complete her film. She became obsessed with her appearance
in the movie. Taped to the window of a Santa Barbara shop called the
Bikini Factory, Edie saw an eight-by-eleven-inch ad for silicone breast
enlargement, and she impulsively underwent the operation. Proud of
her new breasts, Edie liked to flip up her shirt and show them to friends.

Edie approached the movie with more professionalism than anyone

imagined possible. She was particularly eager to accurately portray a scene of electroshock therapy, shot in Cottage Hospital. John Palmer recalled Edie's preparations for the scene:

> It was a funny sight to see Edie with her rainbow dress, the gag in her mouth, and those electrodes attached to her head, sort of half asleep, waiting maybe forty-five minutes on the table while we set everything up. She wore that dress because she thought it had dramatic value, and another thing, she had to have this cross. And she had to have her mirror there. She hid it tucked in underneath her bottom, so Janet would come in with the lip gloss and the eyeliner and the mascara, and she'd glue her lashes down and comb the fall out. Edie adored it. It was like mainlining for her.

The sequence, scheduled to take two hours to shoot, required two days. But Edie withstood the pressure in good condition, and the crew moved on to shoot the swimming pool scenes in Los Angeles. Although the temperatures were low during the January 1971 shooting, Edie insisted on playing her scenes topless to show off her new breasts, and between scenes she placed heating pads on them.

As the film's wrap neared, Edie Sedgwick got slower and slower. A few nights before the end she suggested that the filming should go on forever. When it came to her final lines ("Oh God, that's what I hate about California, they roll up the fucking sidewalks at night."), Edie lay on a waterbed and muffed the line for three hours.

When the filming was over, Edie Sedgwick fell apart. She returned to Cottage Hospital, received shock treatments, and remained there for five months. On July 24, 1971, six weeks after leaving the hospital, she married Michael Post, whom she had recently met as a fellow inpatient. At the wedding, held behind the Sedgwick ranch, Edie wore a white satin dress, accompanied by bridesmaids in yellow picture hats. The couple walked down an aisle of agapanthus connected by white ribbon, with a Mendelssohn piece playing from a phonograph and cattle grazing nearby. Edie remained in control throughout the afternoon, she tossed the small wedding bouquet of magnolias, and she drove off with her new husband.

Edie Sedgwick lived four more months; she died on November 15, 1971. After all her theatrical near-death experiences, the real one was undramatic: she was at home asleep. When her husband awoke to the seven-thirty alarm, he found Edie facedown in the pillow, unmoving.

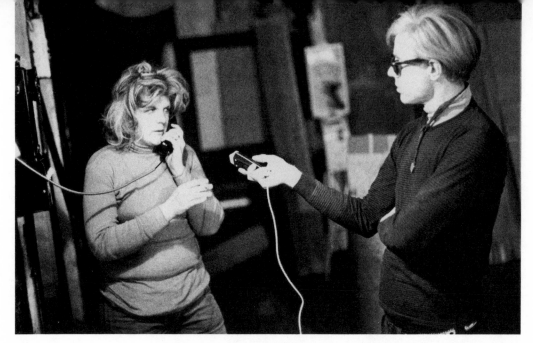

Andy Warhol tapes Brigid Berlin, by Billy Name

She had taken so many downs that she couldn't summon the energy to raise her head from the pillow, and she suffocated.

Although Brigid Berlin insists that she was never an Andy Warhol groupie, of all his friends from the Silver Factory era, she maintained the most enduring relationship with him. From 1976 until his death, she transcribed Andy's tapes and answered the phone, at the Factory, but their most intimate contact was on the telephone. The two talked daily, and both parties recorded the conversations. Brigid said,

> There are two originals, and they both start instantaneously at the same time. I did something very interesting. Andy never marked any of his, he was a slob. He didn't care about the quality. I did. I wanted life to be cut in to what was going on in the daytime. So I would unplug a phone call, turn on WINS News, tape a little bit of Patty Hearst's thing from Cinque, a little of Barbara Walters on TV. When I started to tape, I think I had a whole historical sense to it. Each tape was like a diary.

From these conversations came the seeds of Warhol's book in collaboration with Pat Hackett, *The Philosophy of Andy Warhol*. Brigid's extraordinary conversation also became the basis for a play, *Pork*.

At night Brigid hung out at Max's Kansas City, where she solicited participants for her new form of print, which operated with Warholian simplicity. She asked men to make prints of their penises, and women to make prints of their breasts. Andy insisted that Brigid should always have a good tit print hanging at the Union Square Factory.

Brigid Berlin continued her taping project until 1975, when she stopped taking speed. Then her life changed completely. The turning point came when she entered the hospital for gallbladder pains, under the care of the Duke of Windsor's physician. She weighed 260 pounds. When her doctor said there was absolutely nothing the hospital could do until she lost 50 pounds, Brigid walked out of the hospital.

> I thought I'd stop at this little place called Philly Mignon, where they had these little hoagie steaks and Verner's ginger ale. I didn't do it, I went to Versessi Hardware on Twenty-third Street and bought a scale. I started to fast. I lived for the magazines, and I watched television all day, and I lived to weigh myself every day, and I lost 160 pounds.

After she stopped speed, Brigid's intake of Majorska vodka increased. She entered AA and recalled a few slips when she woke up some mornings among the plants at Studio 54. She has now been sober for over two decades. The compulsive routines of her speed days have assumed only slightly different forms—beading, caring for her two pugs Happy and Honey Berlin, smoking cigarettes and drinking Diet Coke, shampooing her rugs, and shopping for new cleaning products at Gracious Home. Brigid lives in a meticulous and very proper Upper East Side apartment with images of pugs on needlepoint pillows and boxes.

Brigid Berlin has begun to revisit her past, in memoir writing and in *Pie in the Sky,* a documentary film by Vincent and Shelly Fremont. When the film crew for the documentary took her back to the Chelsea Hotel, she said, "I want to get out of here. It's kind of scary. I never want to come back here."

Vincent Fremont came to the Factory in the summer of 1969 and became a long-term and indispensable figure there, producing and shooting most of the video projects, later becoming an agent for Warhol's work.

Nico was unhappy when she listened to her first solo album, *Chelsea Girl,* which was released by Verve in July 1968. She liked the Billy Name photo portrait on the cover, and the songs offered an impressive combination by Bob Dylan, Lou Reed, John Cale, Jackson Browne, and Tim

Hardin. But producer Tom Wilson had sweetened the musical arrangements with strings and an especially annoying flute. The album seemed to Nico an intermediate stage in her development, and she looked forward to the time when she would record her own songs and no longer depended so overtly on the cachet of her association with Warhol. She asked John Cale to create the orchestrations for the album, and he agreed to do so only if he could also produce the album. Producing albums would become Cale's next career.

Over the past three years the two had played music together, fought together, and lived together, and the experience dovetailed with the needs for their collaboration on *The Marble Index*. Cale was casting about for a profession, and Nico was looking for someone who could honor her musical eccentricity. John Cale coped with the odd requirements of Nico's recording; the notes of her harmonium were musically different from other instruments. "It is not exactly in tune with itself, or with anything else," Cale said. "Its notes were 'in the cracks'—getting a guitar to play along with it was a bloody pain."

Dominated by long drones on his viola, layered with a rich pulsing of strings, mouth organ, and bosun's pipe, John Cale's "orchestrations" for the nine songs on *The Marble Index* created a score that was independent and minimal and that complemented Nico's singing.

When Cale allowed Nico to hear the songs, she cried. She had finally created music that was her own, and it didn't depend on following the tune of men in a band. In Nico's mind forever after, *The Marble Index* was her "first real record."

From this time forward Nico's image changed radically. She became increasingly dark and unbeautiful. "What is white can be black," she said. When Paul Morrissey saw her he said, "Here she was with this awful crimson hair and unshapely clothes and screaming to the world, 'I don't want to be beautiful anymore.' " Her hair had darkened beyond the red tinge of the Jim Morrison days, and she never lightened it again. Nico plunged more heavily into heroin. She had been no stranger to drugs, and her heroin use dated back to 1968, not long after Warhol got shot. But in 1970 she was taught that smoking the powder wasted the impact. They taught her how to liquify it instead and shoot it into her veins. "And then you can say that heroin became my lover," she said. All her life the world had seen a perfect beauty, unmindful of the demons inside. "What I have seen and what tragedies I have lived by, next to nobody can equal," Nico said. "And they think I am just some name with nothing behind it."

At the end of the seventies, Nico came into fashion with the arrival

"Nico was like a European gargoyle. It was like something from another age, or another planet. And it wasn't a fashion or anything, she wasn't following some trend."
—John Cale

of punk rock. She was viewed as the Ur-mother of punk, and teenagers, dubbed Nico-teens, began to imitate her Gothic style. Between 1980 and her death in 1988, Nico performed more than 1,200 concerts. Such uncharacteristic industry was necessary in order to pay for her heroin habit. She earned at least 12,000 pounds a year from concerts and at least 8,000 pounds from record royalties, but the economics of heroin were steep. At 60 pounds a gram, used nightly, her heroin came to 22,000 pounds. Nico's daily occupation was heroin—scoring it, shooting it, recovering from it, thinking of ingenious ways to smuggle it over borders. This part of her life doesn't form a narrative but a flat, unchanging image—the details of the heroin life are various, but the downward trajectory of addiction is implied from the start.

Nico's son, Ari, sought out his mother in England when he was twenty-two years old. She threw out her young lover, a model for Laura jeans, in order to make Ari the center of her life. The musicians on her tours found her devotion sugary and unbelievable; some realized that Nico was trying to enact a role that could not fit, in a language she did not know. What she hoped to give her son was the ultimate experience. For her that was top-grade heroin, an addict's idea of the best Christmas gift. "My mother helped me to inject heroin and we shared needles," said Ari. "I became addicted like my mother."

Nico's life ended in Ibiza on July 17, 1988, when she was a few months shy of fifty. Late one morning on one of the hottest days of the year, Nico told Ari that she was going into town to buy some marijuana. She spent nearly an hour looking at herself in the mirror, winding and rewinding a black scarf around her head. On her typewriter were the final words of a new song: "The last days of a singer." She started bicycling down a hill in the heat of the day; an hour later a taxi driver found her lying by the side of the dusty road. He hoisted her into the backseat of the car and raced to the nearest hospital, which refused to admit her on the grounds that she was a foreigner. The second hospital did the same. The third thought she was an old hippie with sunstroke, not worth attention. The fourth, which accepted her only after the taxi driver's vociferous arguing, diagnosed sunstroke and left her overnight. The next morning, a doctor realized Nico had suffered a cerebral hemorrhage. She was declared dead at 8 P.M. on July 18, 1988.

After Lou Reed forced John Cale out of the Velvet Underground in September 1968, the band continued on. Reed brought in Doug Yule, a bass

player from Long Island, and by November the newly reconfigured band was already recording *The Velvet Underground*.

The band performed all over the country, but it wasn't until mid-June 1970 that the Velvets played their first New York engagement since 1967. For ten weeks they performed five nights a week in the upstairs room at Max's Kansas City, before a highly appreciative crowd. The band created a new atmosphere for Mickey Ruskin's upstairs which had previously been a place for the bridge-and-tunnel overflow; there they launched the music era at Max's Kansas City.

Reed recalled the last night at Max's as his favorite performance. It would also be the last night he performed with the Velvet Underground. Brigid Berlin was present in the audience, carrying her audio recorder, and taping everything. On Danny Fields's advice, she sold her makeshift cassette to Atlantic for ten thousand dollars.

After the Velvet Underground's long engagement at Max's Kansas City, Lou Reed moved back to his parents' home in Freeport and decided to leave the group. "It dawned on me that I'm doing what somebody else is telling me to do supposedly for my own good because they're supposed to be so smart," Reed said. "I plugged into objective reality and got very sick at what I saw, what I was doing to myself. I didn't belong there."

The remaining.members struggled on for a while (dubbed the Velveteen Underground), but the band was effectively finished. "It was a process of elimination from the start," said Reed. "First no more Andy, then no more Nico, then no more John, then no more Velvet Underground."

Lou Reed began to transform himself into a solo performer, and his first album, *Lou Reed*, was released in May 1971, selling only seven thousand records. (Brigid Berlin's makeshift taping at Max's sold more.) But *Transformer* (produced by David Bowie), appearing in late 1972, catapulted Reed from cult favorite to rock-and-roll star. His breakout single, "Walk on the Wild Side," described such Factory figures as Candy Darling, Joe Dallesandro, and Holly Woodlawn, and peaked at number sixteen on the U.S. pop charts. Reed, who rode the wave of "glitter rock," was dubious about being promoted as a "phantom of rock," a cartoon son of Andy Warhol, and in his next few albums (*Berlin, Rock 'n' Roll Animal,* and *Sally Can't Dance*), he continually reinvented himself as a new kind of rock-and-roll star.

In the years the Velvet Underground's dissolution, the band's growing importance became clear. During the punk-era generation of bands, the Velvet Underground provided a key model. A *Rolling Stone* survey

listed *The Velvet Underground and Nico* among the top ten albums of all time, and the Velvets as more influential than any other rock band of the Sixties except the Beatles. Just as there were recurrent hopes for a Beatles reunion, many wanted the Velvet Underground to get back together.

The first step toward such a rapprochement occurred on April 1, 1988, when Billy Name brought John Cale and Lou Reed together. The two soon collaborated on an album called *Songs for Drella,* released in 1990. In June 1991 Cale and Reed agreed to perform a few pieces from *Songs for Drella* at the Cartier Foundation in Paris, and they invited Sterling Morrison and Maureen Tucker to join them onstage for an unrehearsed rendition of "Heroin." This brief and spontaneous reunion led to a full-scale European tour in the summer of 1993.

All the band members agreed that it couldn't have happened earlier; the old wounds were still too raw. (And it couldn't have happened much later, for Sterling Morrison died from cancer in 1995.) While rehearsing for the tour, they found it easy to pick up musically where they had left off fifteen years earlier. When the Velvet Underground opened on June 1, 1993, at the Edinburgh Festival, the crowd stood and applauded for five minutes before the band even played a note. The Velvet Underground performed in London, Amsterdam, Rotterdam, Hamburg, Prague, Paris, and Berlin, and the tour was a huge success. There would be no more Velvet Underground reunions. The band broke up due to the strains of control, in 1993 as in 1968, but the legacy of their records remains intact. Lou Reed asked, "How long do you need to have it demonstrated that this was for real, completely sincere, aboveboard and meant in exactly the way it seemed to be meant? Look at the records. They speak for themselves."

"Straightaway in rehearsals, the sound was there, basically a very good garage band."
—**John Cale**

"I remember thinking, 'Shit, that's Lou Reed out there, that's John and Sterling and this is still the best band in the world.'"
—**Mo Tucker**

Holly Woodlawn was never able to create a movie role as memorable as the one in *Trash,* despite his attempts in *Women in Revolt, Scarecrow in a Garden of Cucumbers* (1973), and *Broken Goddess* (1974). But Holly found other venues. He talked on the Geraldo Rivera show, posed as a *National Lampoon* centerfold, and occasionally modeled. The most lasting of his venues was cabaret. Encouraged by Lewis Friedman, the entrepreneur who ran Reno Sweeney and spurred the cabaret revival of the 1970s, Holly played a combination of glamour and Carmen Miranda. Holly also played opposite Divine in two Tom Eyen plays, *Women Behind Bars* and *Neon Woman.* The man who directed those plays, Ron Link, told Holly years later, "You made the one mistake, you lived. You can't become a legend and stay alive in that group. You gotta die early, darling."

Holly Woodlawn lived on, moved to Los Angeles at the end of the 1980s, and continues to live there. Holly's memoirs were published in 1991: *A Low Life in High Heels.* A decade later he hopes for the movie version.

Viva left New York in November 1968, heading for Paris. "After the Solanas shooting, Andy's attitude toward me had inexplicably changed," she wrote. "I was no longer the adored sidekick, and Ultra was back in. Andy sullenly accompanied me to buy my ticket to Paris, paying for it and adding another seven hundred dollars to my Pierre Clementi dowry."

As it turned out, Viva's relationship with the actor was short-lived. She met and soon married Michel Auder, a French video artist, who shot many hours of Viva. She soon became pregnant with her first child, Alexandra. Before the baby was born, Viva completed *Superstar,* a thinly veiled autobiographical novel about growing up Catholic and her experience at the Factory.

In the years immediately after the shooting, Viva made a few commercial movies (including a role as Woody Allen's blind date in *Play It Again, Sam*). When she recently looked at some of the Factory movies, Viva continually pressed the fast-forward button and recalled, "When we were doing them, we thought we were changing the history of filmmaking—no more scripts—this is really revolutionary. Probably will be fifty years from now. But you know what Picasso said: 'The originator always makes the thing ugly and the imitators make it pretty.' "

Viva spent many years in the Chelsea Hotel, raising her two daughters—Alexandra, who was the subject of Viva's second book, *Baby,* and Gabrielle. She wrote a many articles and eventually returned to her early love, painting.

When I visited her in September 2000, Viva was living in a cabin on the grounds of her family's summer compound on the St. Lawrence River. As long as the weather permits, Viva goes out each day in a boat, sets up an easel, and paints large canvases in oil of outdoor scenes in the nineteenth-century tradition. She hopes to capture nature and light *en plein air.* "Look at that water lily over there," she said, pointing from her boat. "Isn't it limpid? Of course, it will be dead in a few weeks. Of course, we'll be dead in a few years." She laughed and said, "Life! It is such a comical situation."

When Ronald Tavel's full-length play *The Boy on the Straight Back Chair* opened in 1969 at the American Place Theater, his critical reputation changed. No longer the Bad Boy Playwright, he was now a New Voice in the American Theater. Around the same time some critics began to look back on the Ridiculous era as the pioneering days of Off-Off Broadway, as a phenomenon whose time was already waning. (Reflective reveries about the Sixties were already an element by 1969.) In *Vogue* Martin Gottfried wrote that the Play-House of the Ricidulous had offered what few others had: "a refreshed sense of life, a new dimension for looking at things."

All this made it possible for Tavel, throughout the 1970s, to support himself with a string of major grants; he was the first playwright to receive two Rockefeller grants. By the end of the 1970s he began to resent the pressure of turning in a manuscript every year and wasn't sure he could keep it up. "That's all I could do, was stay in New York and write," he said. "I was running out of material, scraping the bottom of the barrel. I was just not getting enough experience."

Because of his agoraphobia, which began in 1962, Tavel never felt able to leave New York. "Everyone else took off when they realized the movement was over and the Sixties were over," he said. "Those who thought fast got those last university jobs and were set up. But I was brought up that a writer or an artist should not be in a university—it's bad enough to *go* to one."

For the past dozen years Ronald Tavel has lived in Asia, and most of that time in Bangkok, where he rents a modest apartment in Pitak Court for about two hundred dollars a month. After years of painstaking work, he completed a novel in 2002. Unlike the Warhol screenplays that were written in days, or the plays that were written in weeks, his novel has taken years. At this writing, Tavel will call his novel *Chain,* and his screenplays for Warhol are scheduled to be published by the University of Minnesota Press in 2004.

After Max's Kansas City, Mickey Ruskin ran several more restaurants. Although he was an entrepreneur rather than a reflective writer, at the end of his life he was at work on a book about Max's Kansas City, which had by this time become legendary. Such a book didn't appear during his

> "It looked to them like 'the black sheep returns to the fold.' And as it says in the Bible, God appreciates someone coming by the back door more than by the front door."
> **—Ronald Tavel**

Mickey Ruskin's
Restaurants:
Broome Street Bar
Max's Terre Haute
The Locale
Chinese Chance

lifetime, but it came to fruition years later, when his widow put together an oral history of the Max's era, *High on Rebellion*. In the last two years of his life Mickey complained of fatigue. The sheer scale of the fickle hip club scene in the early 1980s weighed on him; what had once been a matter of spontaneous instinct had become an industry. Mickey never stopped working to make ends meet. His fiscal situation was a combination of generosity, bad business decisions, partners who were skimming money, and an expensive heroin and cocaine habit. At three A.M. on May 16, 1983, he died of an overdose combining the two.

At Mickey's final send-offs (there were two) Philip Glass played music, Neil Williams and John Chamberlain offered eulogies, and an elderly New Jersey rabbi officiated. At Mickey's last restaurant they served only Sauza Tequila and played only country-western music, Mickey's favorites. Howard Smith's obituary in *The Village Voice* asked: "Why did this man whose interpersonal style often came across kind of flat, quizzically offhand, melancholy, affect people so profoundly? . . . When a painter, a sculptor, a poet, or a photographer dies, the space that is left can often be assessed; with a spirit like Mickey Ruskin, the depth of the hollow is more difficult to perceive."

When Valerie Solanas returned to New York in 1972 after her imprisonment, she resisted taking the antipsychotic medication that her doctors prescribed. Her ongoing paranoia attached itself to people who had come into her orbit—both in reality (Maurice Girodias, Viva) and in fantasy (Howard Hughes, Robert Sarnoff). They received letters that said, "I have a license to kill." Viva received letters threatening to shoot her husband, Michael Auder. ("I am not going to shoot you because I want to make you suffer," Valerie explained.)

Valerie Solanas popped up in the media in 1977 when Howard Smith, the "Scenes" columnist for *The Village Voice,* interviewed her. When he asked her if there were other women in SCUM, Solanas replied: "It's hypothetical. No, hypothetical is the wrong word. It's just a literary device. There's no organization called SCUM—there never was, there never will be. It's either nothing or it's just me, depending on how you define it. I mean, I thought of it as a state of mind. In other words, women who think a certain way are in SCUM. Men who think a certain way are in the Men's Auxiliary of SCUM."

Valerie Solanas still sold *The SCUM Manifesto* on the street for two dollars and still considered her shooting of Andy Warhol a moral act. Since leaving jail, she had been "on strike," but she said she had a new book planned and was getting a hundred million dollars' advance. Outside of letters to editors, however, Valerie Solanas never completed any further writing.

Shortly after Warhol died in 1987, Ultra Violet decided to find Valerie Solanas. In November, by searching the SSI rolls and pretending to be her sister, Ultra Violet located her in San Francisco. Valerie was going under the name of Onz Loh and felt numbed by her medication. Valerie said that she had written nothing since *The SCUM Manifesto.* "Do you have the newspaper edition of the manifesto?" she asked Ultra Violet. "I don't have a copy anymore."

One of the last sightings of Valerie Solanas was by a hotel employee who saw her typing, with a pile of pages by her side. On April 25, 1988, she was found dead of bronchial pneumonia, brought on by emphysema, in her room in a large welfare hotel at 56 Mason Street, in the heart of San Francisco's seedy Tenderloin district. The police report read:

> Victim was found kneeling on the floor of the one room apt., and her upper torso was facing down on the side of the bed. Her body was covered with maggots and the room appeared orderly.

Valerie Solanas, after leaving prison, c. 1975

After her death Valerie Solanas became an increasingly legendary figure culminating with the 1996 film about her life, *I Shot Andy Warhol* (directed by Mary Harron), starring Lili Taylor.

Solanas has become a favorite figure in academic discourse, where she is identified with feminist studies, queer studies, and performance studies. One scholar (James Harding) described her shooting of Warhol as "the pivotal gesture in a radically subversive project aimed at recalibrating the trajectory of the American avant-garde." Another (Janet Lyon) argued that "SCUM is the vengeful, victorious daughter of the avant-garde manifestoes of Apollinaire, Tzara, Marinetti, Debord." In ways that she could never have expected—and would probably ridicule—Valerie Solanas got her message out.

Mary Woronov was in Europe when Warhol was shot, and she never returned to the Factory: "Things weren't the same, so there was nothing to go back to." Instead, she made theater central to her life, returning to

Ronald Tavel's plays (*Kitchenette, Arenas of Lutetia*) and to John Vaccaro's direction. (One of her favorite roles was playing Ondine's alter ego in Ken Bernard's *Nightclub.*) In 1973 Mary Woronov was widely recognized for her performance in David Rabe's *In the Boom Boom Room.* Not long afterward she moved to Los Angeles and has continued performing, racking up more than a hundred acting credits to date. At least two of her films have become cult classics: *Eating Raoul* (as a murderous wife) and *Rock and Roll High School* (as a fascistic high school principal).

By the time she reached fifty, Woronov's doctor reported that she had destroyed her liver. Woronov stopped using all drugs, alcohol, and cigarettes and stopped eating fats and meat. She found that it led her toward writing. Her first book, *Wake for the Angels,* combined stories with Woronov's expressionist figurative paintings. *Swimming Underground,* her memoir of the Warhol era, recalling everything from reality to the semifantastic amphetamine state of mind among the Mole People, captured a dimension of the Factory that had not yet been explored. Her two most recent books—*Snake* and *Niagara,* both fiction—signal her pursuit of more subjective terrain. When Mary Woronov is not writing, she is painting or swimming or walking her dog. "When I was a child, I wanted to be loved," she said. "As a young girl, I wanted to be feared or simply recognized. As a woman, I wanted to be admired. And now, as an old maid, I would like to be left alone."

Beginning in his senior year in high school, Gerard Malanga decided that he was a poet, but while interviewing the poet Charles Olson for *Paris Review* in 1969, he took a photograph that captured the poet so successfully that he was inspired to take on another identity as well: photographer.

When Gerard left the Factory in November 1970, photography became the focus of his initial burst of energy. Within that first post-Factory year he shot portraits that ranged from Charles Olson and Robert Lowell to Abbie Hoffman, Virgil Thomson, and Mick Jagger. The connection to the literary community that he forged in high school has continued over the last three decades, through his many books of poems and his instinct for recording and archiving that community. He became the first photography archivist for the City of New York. When I interviewed him, his prodigious archives—in sturdy banker's boxes filled with photographs, manuscripts, first editions, and little magazines—was stacked against all available walls in his apartment. Malanga continues to

write and compile books. The most recent of those efforts—*Archiving Warhol: An Illustrated History*—brought him back to the Factory era.

Andy Warhol repeatedly said that he wanted to make a Hollywood movie, but it was Paul Morrissey who had the Hollywood instincts—affection and respect for its studio system—and could approach Hollywood on its own terms. Morrissey found a way to transform the improvisational Factory style of movie-making into Hollywood-style narrative distribution, to cross over from the art house and college campus circuit.

After the success of *Trash*, he followed the strategy of an old-time movie studio: he planned new spin-off vehicles for its stars. For Holly Woodlawn, Candy Darling, and Jackie Curtis, he directed *Women in Revolt*. For *Trash* supporting players Michael Sklar and Jane Forth, he created *L'Amour* (budget $100,000), a comedy of three women in Paris. For Joe Dallesandro, he reimagined *Sunset Boulevard* and *Written on the Wind* and completed his Dallesandro trilogy. *Flesh*, *Trash*, and *Heat* sounded good together and have become Morrissey's best-remembered works.

Joe Dallesandro was Morrissey's top-drawing star, and his international appeal was especially strong in Germany, where *Flesh* and *Trash* had been huge hits. (*Trash* was number two in the 1971 box office, after *Easy Rider*.) Shot in Hollywood in June and July 1971 and released in 1972, *Heat* combined Joe Dallesandro with Sylvia Miles, who had been nominated for an Academy Award for *Midnight Cowboy*. Both the Cannes and Venice film festivals featured *Heat*, an honor denied any Warhol film, leading to a Euro-production deal with a budget much larger than that of Morrissey's previous films.

Producer Carlo Ponti had hoped to shoot a 3-D horror movie with Roman Polanski, but when the director pulled out, Ponti approached Paul Morrissey to make it. Morrissey proposed a three-week shooting schedule of only $350,000, and Ponti said, "Is that all? Then let's make two."

Flesh for Frankenstein and *Blood for Dracula* were shot back to back over a two-month period in March 1973 and were released in 1974. *Frankenstein* grossed over $20 million worldwide and *Dracula* did nearly as well. They would be the last films on which Paul Morrissey and Joe Dallesandro worked together.

They split partly over issues of money; Joe wanted a larger percentage. Joe did not want to be a star of art films, and he wanted to break free of Paul Morrissey, who had prescribed a regimen of behavior: don't take drugs, don't act, don't talk too much. Many people assumed that Morrissey was in love with Dallesandro, but the relationship was in fact nonsexual and resembled that of a strict father and a wayward son, following the Catholic narrative of *Boys Town*.

In New York Dallesandro had lived with his wife in Paul Morrissey's East Village brownstone, and he remained under his guidance in Europe. "Whatever Paul told me to do, I did. He worked real hard on me." Dallesandro had problems with violence and recalled that Morrissey

> knew all the buttons to push to set me off, and he would do it on a regular basis. We were restoring the brownstone on the Lower East Side, and he would say things to set me off, just so I would learn not to get pushed. He'd do it and he'd run behind a door, and I'd come crashing through. By the time he got to the bathroom door, I realized I'd broken down two doors, so then I was going to have to fix them. Then I'd calm down and say, okay, now I can talk.

Paul Morrissey provided the ideal foil for Dallesandro, who benefited from strict limits. Each would continue to work separately, but neither would make such influential signature works again.

After Paul Morrissey and Joe Dallesandro parted ways in 1973, Morrissey made six more feature films, from *Hound of the Baskervilles* in 1978 to *Spike of Bensonhurst* ten years later. He worked outside the studio system, following his instincts in choosing unknown actors, but none of his later casting rivaled the inspiration of Holly Woodlawn or Joe Dallesandro. From the profits of *Flesh* and *Trash,* Morrissey bought 5.7 acres of land with Warhol in Montauk, perched at the eastern end of Long Island. Having bought the property for $225,000 in 1971, Morrissey recently put it on the market for $50 million.

Morrissey is galled by the fact that his films are invariably credited to Andy Warhol. In May 2002, when the Cannes Film Festival organized a tribute to Morrissey, he wrote,

> It can only be deemed ironic that a series of films that had been written, photographed, edited, and directed by one person only, should, even today in this period's search for directorial signa-

tures, be routinely assigned either to their presenter, Andy Warhol, or with a newly invented credit to include celebrity name value for journalists as Warhol-Morrissey films. All of which only bears witness to the primacy of media mythology.

In the years following his separation from Morrissey, Joe Dallesandro stayed in Europe. He knew he could not work in Hollywood because he was too much associated with Andy Warhol. In Europe he was widely appreciated and worked with several major directors, as well as minor ones. Directors associated with the French New Wave cast him in their films—Louis Malle directed him in *Black Moon* (1975), and Jacques Rivette cast him in *Merry-Go-Round* (1983). Joe appeared in at least fourteen other movies (mostly Italian) before he returned to New York in 1979.

Joe recalled that many people thought he was dead—"because, of course, so many other people in the Warhol clan were." There were soon plans for a *Trash* sequel. In this version, *Trashier,* Joe and Holly aspired to move from the Lower East Side to Lodi, New Jersey, with four drug-pusher offspring. Joe worked in a pizza joint, and Holly performed as a nightclub entertainer (as he did in real life by this time). But Joe was not interested in revisiting this episode in his life. In the spring of 1980 the deal, with Alan Ladd as producer, fell through.

After his period in Europe Joe Dallesandro supported himself for a few years by driving a cab and didn't work in films again until 1984, when Francis Ford Coppola cast him in *The Cotton Club.* Subsequently he has been directed by John Waters in *Cry-Baby* (1990) and Steven Soderbergh in *The Limey* (1999) and appeared in Calvin Klein commercials. Joe Dallesandro has never again played a starring role but still embodies the unvarnished authenticity that has always been his strength.

Taylor Mead goes on being a public downtown figure long after the Sixties ended, and a list of his performances and readings would fill pages. Taylor has never been satisfied with the recognition he has received, and he often blames Andy Warhol for that state of affairs. The films Mead made at the Factory were withdrawn from circulation for many years, and Warhol's remarks that sometimes the films were better unseen left Taylor eternally annoyed. "So we're buried," said Mead, "buried alive!" That fact that he titled his unpublished epic memoir *Son of Andy Warhol* suggests the influence of his Factory experience.

Yet Mead lived in the same way before, during, and after those years

"We are all to a greater or lesser extent sons of Andy Warhol."
—**Taylor Mead**

in the Sixties; he seems to simply sidestep the principle of progress or change. He has managed on a monthly seven-hundred-dollar trust fund from his father's estate, supplemented by the kindness of friends and local cafés. Since 1979 Taylor has lived in a rent-controlled apartment on Ludlow Street; even though the neighborhood has become fashionable, the rent was only $265 a month when I visited him there in 2002. His two small rooms contained a refrigerator, his paintings on the wall, a small television, a toaster oven, and a radio. He never bought a table or a bed; at night he unrolls his foam pad over the papers, cords, and cat litter. In the context of Mead's style of living his long life, there was nothing upsetting about this, but a few weeks after I visited him, the landlord declared that his piles of garbage, the detritus of years, constituted a fire hazard and public nuisance, and took steps to condemn his apartment as a health hazard.

Taylor Mead has always seemed radically incapable of adapting to the rhythms of conventional workaday survival. Approaching eighty, the man who most successfully refused to grow up has survived the longest.

Ondine had always occupied a seminal position in the Silver Factory. He had feuded and stayed away for months at a time, but his presence permeated the space, defining the trademark lack of limits and the possibilities of chaos. Even after he stopped using speed in 1969, he was exactly the unpredictable sort of person who had little place in the more ordered and businesslike regime that followed Andy's shooting.

To audiences of the 1970s, "an Andy Warhol film" actually meant a movie that Paul Morrissey directed, featuring superstars of a later era. "They're all bouncing off an idea," Ondine said in 1978. "They're all bouncing off an image that had been created before them. And that goes for Holly Woodlawn, Jackie Curtis, the whole group of them: the way had been laid, the ground had been paved, it was over. We had forged the way."

When the movies from the Silver Factory era were withdrawn from circulation, Ondine knew that his performances were in danger of becoming invisible. He asked Warhol for prints of the movies in which he had appeared. He looked through the hundreds of reels of film and could find only three of his films: *Vinyl, The Chelsea Girls,* and *The Loves of Ondine.* "I am lucky that Andy gave me those three films," Ondine said, "because frankly, my work would have been buried."

Throughout the 1970s Ondine became a traveling missionary for these films. He carried the reels of *Vinyl* and the Pope Ondine reels from *The Chelsea Girls* and screened them in colleges and film societies. He wasn't paid much—a couple hundred dollars a showing, with cheap lodging and a bus ticket. But this activity gave Ondine money to live on and a mission.

"I'm the only one to take these films from city to city," he said. "I've watched a whole new generation of people coming up since 1975, when they weren't interested," said Ondine. "It's like Callas's last tour—they want to know what it's all about, what caused the furor, all the hysteria, and they've got a right to know." He traveled everywhere from Pittsburgh and Los Angeles to Saskatoon and Moose Jaw. He showed the films and talked afterward—Dorothy Dean described them as "beloved Ondine's chalk-talks." He not only introduced the films but also tried to communicate an idea of the era that produced them.

On these trips he sometimes encountered old friends. In the early 1980s Mary Woronov attended his introduction of *Vinyl* at the Nuart Theater in Los Angeles. "I knew he was the same, only his audience had changed," she later wrote. "No longer surrounded by the fabulous chaotic speed freaks, he was adrift on a desolate sea of uncomprehending faces." When he finished talking to the unresponsive audience and the lights went down, Mary went into the lobby to see him.

"Look at them," he waved his arm to the audience. "Oh, it's not their fault, that they are too stupid to understand, which makes me a sideshow—I can't be anything else, so how do you think I am? I mean, I don't mind, actually, you know I love it, but if I can't tell them the simplified version and they can't imagine the real one—what am I supposed to say? Darling, they are below shock, but why bother preparing the truth for them when lies are so much more appetizing?"

By this time Ondine had long stopped using speed and going to the baths. His delights were largely limited to opera and books. He kept a hardcover schoolboy notebook in which he pasted photographs and wrote sections of a memoir or autobiographical novel (he described it both ways) and reported that his friends were going to help assemble its 550 pages. (It is doubtful that anything now exists; after his death his mother was upset by what she read in it and reportedly burned the pages.)

"I don't drink, I don't have sex, I find the idea of a fling nauseating. My commitments took ten years off my life. I want single beds and reading."
—Ondine

For a period in the mid-1980s Ondine experienced one death after another, many from AIDS, including his former lover Roger Jaccoby. In the 1980s he resumed performing, a way of asserting that he had an identity after the Factory. He performed in a variety of Off-Off Broadway venues—a gay gender-fuck theater group called the Hot Peaches, playing Oscar Wilde in *Oscar;* playing Bishop Shean in Ray Dobbins's *Shean's Outside;* and performing in Jackie Curtis's much-revived *Glamour, Glory, and Gold.*

"Performing is what I live for," Ondine said a year before he died. "Let's face it, nobody has sex or takes drugs anymore. . . . It's too risky. . . . I saturated myself with drugs. I lived for drugs. I just took as much as I could at every possible moment, and I really fucked my liver."

His last days were spent in his mother's house, surrounded by Maria Callas memorabilia and music. "He was very uncomfortable and became very gracious," said his oldest friend, Joe Campbell. "He called me and said, 'Joe I've swollen up like a balloon, and I can't see my feet. It's all water and my kidney's gone and I'm going to die.'"

The funeral card for R. Stutzman and Son Funeral Home in Queens Village read "In Loving Memory of Ondine, Entered into Eternal Rest April 28, 1989."

Andy Warhol lived nineteen years beyond his first death on June 3, 1968. "That shooting was wonderful in a way because of the great myth," observed Ultra Violet. "In order to become a myth you must be shot. And survive of course." The activities of the Silver Factory were put away, like artifacts at the end of an era. When he moved to Union Square, Warhol began a routine of putting everything that came over the transom into same-size cardboard boxes, which were coded by month with a color patch. "I want to throw things right out the window as they're handed to me, but instead I say thank you and drop them into the box-of-the-month," he said. "But my other outlook is that I really do want to save things so they can be used again someday." Andy accumulated about six hundred of these time capsules before he died.

The outlines of Andy Warhol's second life can be determined from his first projects after returning from the hospital: painting a commissioned portrait (Happy Rockefeller) and a commissioned advertisement (Schrafft's). In the 1970s Warhol left the underground behind and courted the era's all-purpose aristocracy through a web of enticement

that included his portraits, *Interview,* famous Factory lunches, and a media embrace of celebrity culture.

Warhol still saw a few friends from the Silver Factory era, but by the mid-1970s they seemed to him like ghosts from his past. The people who were connected to the early *Inter/VIEW*—Ondine, Jackie Curtis, Gerard Malanga—had little place in the magazine as it was transformed into the flashier version of *Interview* that has survived to the present. Warhol's Silver Factory friends were not in evidence at Studio 54, the arena that became associated with 1970s Warhol as much as Max's had been during the 1960s.

Warhol's *Diaries,* which start in 1977 and were published after his death, suggest how little he connected to his associates from the earlier era. These daily reports, delivered to Pat Hackett by telephone, document whom he saw during his last ten years. Brigid Berlin appears most frequently, with reports on her weight losses and gains. (At one point she has plunged from 350 pounds to 125, and when she later starts to gain weight, Andy urges her to go to church and pray.) He runs into Joe Dallesandro in Paris and reports that he is drinking too much bourbon and has dirty teeth. He sees Nico and says she "look[s] older and fatter and sadder." When he encounters Ultra Violet, he is amused to see her wearing the same pink Chanel miniskirt and boots she was wearing when he met her thirteen years earlier. Warhol is sad to see that Jackie Curtis is fat and has lost teeth, but he still sees the potential: "Somebody clever *has* to do something with him, figure out how to use his talent." When Andy sees Viva with her daughter, he predicts: "Viva will do everything the opposite of her parents, and it'll be just as bad." When he hears of Valerie Solanas being sighted, he worries, "Would she want to shoot me *again?*" Ondine pops up only when Paul Morrissey mentions that he is still traveling around the country showing his print of *The Chelsea Girls,* and Warhol worries what will happen when the print wears out. Warhol wonders if Billy Name will come to town on a bus carrying a YMCA satchel and imagines that he will be too shy to let people see how much weight he has gained.

Outside of these periodic mentions of the past, the Silver Factory figures are barely present in Warhol's *Diaries.* He had moved on to business art, to a new set of associates, and he rarely looked back. Warhol may have been the same person before and after the shooting—there is wide disagreement about this—but his strategy and his crowd definitely changed.

In the Sixties commissioned portraits had helped finance Warhol's movies, and in the remaining years they became his staple. They relied on the same kind of immediate production as his filmed *Screen Tests* from the mid-1960s, but he now used a Polaroid Big Shot to capture the subject. They had none of the risk involved in those earlier social experiments in real time, in which a subject has, by the end of the reel, exhausted his repertoire of mannerisms and been revealed. Warhol's commissioned portraits, in contrast, are idealized versions, with lines, bags, puckers, and extra chins excised. The other difference between the screen portraits and the commissioned portraits was their commodity value. They never brought Warhol money during his lifetime, for they had little place in movie distribution and were not ownable.

In contrast, Warhol's commissioned portraits brought in an average of fifty thousand dollars, depending on how many panels the subject purchased. Society, as envisioned by Warhol, became a matter of industrial production; the amount of fame a client got depended on how many panels were bought. Warhol produced between fifty and a hundred portraits each year, earning a tidy sum of money in the process. It was his way of "bringing home the bacon."

Andy Warhol's final works were based on an engraving of *The Last Supper*. The series of large paintings placed Jesus Christ among his apostles, some overlaid with price tags, combining the religious imagery so dear to Julia Warhola with commercial Pop imagery. The constellation resembled the Silver Factory, with Andy at the center.

Andy Warhol's last public performance, in mid-February 1987, took place in a new nightclub called Tunnel, where he appeared on the runway as a fashion model. Shortly afterward his doctor told him that he needed an operation on his severely inflamed gall bladder; the problem had first been diagnosed in 1973, but Warhol's phobia about hospitals had prevented treatment. This time Dr. Denton Cox told him that without treatment he would die. Warhol entered New York Hospital, signing himself in as Bob Robert. He had memorized his insurance number. He brought with him two books, Kitty Kelley's new biography of Frank Sinatra and a volume of Jean Cocteau's diaries. (And of course his wig, which he wore throughout the operation.) He repeatedly told the doctors he wouldn't make it, but they assured him it was a safe and routine operation. There were no complications during surgery (during which they also repaired Warhol's hernia), performed from 8:45 to 12:10 on Sat-

urday, February 21, 1987. By 9:30 that evening Andy was comfortably watching television in his hospital bed. A private nurse had been hired to monitor his vital signs, his blood pressure, and his urine output. She had no idea who Andy Warhol was, although the head nurse informed her that he was an important American artist. During the night the hired nurse read her Bible and went to the nurses' station to pick up his morning medication. Around 4:45 A.M. she observed that the patient had turned very pale. He couldn't be awakened. The quickly summoned cardiac arrest team could not insert a tube into his throat because rigor mortis had already set in. Andy Warhol was pronounced dead at 6:31 A.M., diagnosed as the result of "cardiac arrhythmia of undetermined origin."

His death at the age of sixty was as unexpected as his return from death nineteen years earlier had been.

Andy Warhol was buried in a black cashmere suit, a paisley tie, and sunglasses in St. John the Baptist Byzantine Cemetery, just outside Pittsburgh. He rests next to his parents, with a stone, smaller than theirs, reporting only his name and his dates (August 6, 1926–February 22, 1987).

The memorial ceremony in New York filled St. Patrick's Cathedral. After it was over about four hundred of the guests went to the Century Hotel, where its owners, Steve Rubell and Ian Schrager, had the basement spray-painted silver in honor of the occasion.

After his death, Andy Warhol's estate was divided up. His mammoth collection of collectible items, high and low, brought $25 million when it was auctioned at Sotheby's in 1988. The Museum of Modern Art organized the first major posthumous retrospective in 1989, and the most recent large exhibition started in Berlin and then traveled to London and Los Angeles. And in the intervening years, it could be said that the sun never set on a Warhol show somewhere in the world. The prices for Warhol's paintings have soared, and he has been consistently listed in the top five artists, based simply on investment value. After dying twice, Warhol has enjoyed an extraordinary art career.

While the artworks have increased in value and exposure, the movies have mostly gone into eclipse, and they have remained the odd stepchild of the Warhol estate. Until 1988, the films could not be seen anywhere, aside from Ondine's intrepid stewardship of *The Chelsea Girls* and *Vinyl*. The exhumation of the Warhol films began in 1982 when John Hanhardt at the Whitney Museum and Mary Lea Bandy at the Museum partnered in order to conserve them. In the last interview he gave,

Warhol expressed reticence about screening them at an upcoming show at the Whitney in 1988. "They're better talked about than seen," Warhol said. He nonetheless had put them on deposit at the Museum of Modern Art in 1984, which preserved thirteen of the films. Further conservation, ninety hours at the time of writing, was supported by considerable funds from the Andy Warhol Foundation. The selection was informed by consultation from Callie Angell, who began a decade of researching Warhol's films in 1991, as the Curator of the Andy Warhol Film Project at the Whitney Museum, and preparing for a catalog raisonné of the movies. Many films can now be seen—they are regularly screened at the Andy Warhol Museum in Pittsburgh and can be rented from the Museum of Modern Art.

In the meantime, the films of the Factory era are resting safely in the Museum of Modern Art's film vault in a rural setting outside Scranton, Pennsylvania. They reside at an eternal 38 degrees, and if they are to be seen, they must first spend a few days in the warming-up room. Art and artifact, they record the Sixties like nothing else.

DO YOU WANT TO DANCE AND BLOW YOUR MIND WITH

THE EXPLODING PLASTIC INEVITABLE

live

ANDY WARHOL
THE VELVET UNDERGROUND

and

NICO

Superstars Gerard Malanga And Mary Woronov On Film On Stage On Vinyl

LIVE MUSIC, DANCING, ULTRA SOUNDS, VISIONS, LIGHTWORKS BY DANIEL WILLIAMS, COLOR
SLIDES BY JACKIE CASSEN, DISCOTHEQUE, REFRESHMENTS, INGRID SUPERSTAR, FOOD, CELEBRI-
TIES AND MOVIES INCLUDING: VINYL, SLEEP, EAT, KISS, EMPIRE, WHIPS, FACES, HARLOT, HEDY,
COUCH, BANANA, ETC., ETC., ETC. ALL IN THE SAME PLACE AT THE SAME TIME.

FIRST COME FIRST SERVED. OCCUPANCY BY MORE THAN 750 PEOPLE IS CONSIDERED UNLAWFUL. PROGRAM REPEATED SATURDAY
APRIL 9TH 3 PM, FOR TEENAGE TOT AND TILLIE DROPOUT DANCE MARATHON MATINEE. $1.00

AT THE OPEN STAGE 23 ST. MARK'S PLACE (BET. 2ND & 3RD AVES.) 9-2 NITELY

NO MINIMUM, WEEKNIGHTS $2.00, FRIDAY AND SATURDAY $2.50 674-9742

Chronology

The Silver Factory

1960

Billy Linich, after arriving in New York in June 1958, becomes connected to the downtown arts scene via the San Remo; he works as a waiter at Serendipity 3.

In San Francisco, Ron Rice meets Taylor Mead and shoots *The Flower Thief.*

Mickey Ruskin opens his first restaurant, the Tenth Street Coffee Shop, which becomes a center for poetry readings.

Emile de Antonio begins his first film, *Point of Order,* about the McCarthy hearings; he completes it in 1963.

Spring—Warhol meets Emile de Antonio, who becomes an informal agent for his postcommercial-art works.

Summer—Gerard Malanga graduates from high school and silk-screens fabric for Rooster Ties.

Context

1960

Claes Oldenburg organizes *Ray Gun Spex* at the Judson Church, a series of multimedia events involving Dick Higgins, Robert Whitman, Al Hansen, Allan Kaprow, and Jim Dine.

La Monte Young, after working with Terry Riley on music composition, moves to New York.

February 1—African American students begin "sit-downs" in segregated areas, focusing on Woolworth and Kresge policies.

March 25—*Lady Chatterley's Lover* is ruled not obscene after a thirty-year ban in the United States.

May 9—The Federal Drug Administration approves Enovid, a form of oral birth control.

Pepsi-Cola coins the slogan "For Those Who Think Young."

Students for a Democratic Society (SDS) and the Stu-

July 15—Henry Geldzahler begins working at the Metropolitan Museum, as a curatorial assistant in the Department of American Painting and Sculpture, under Robert Beverly Hale.

July 18—Ivan Karp brings Henry Geldzahler to Warhol's studio, beginning an important relationship.

September—Lou Reed, Betsey Johnson, and Sterling Morrison matriculate at Syracuse University.

September 6—Brigid Berlin turns twenty-one and inherits $150,00 from a family friend.

September 28—The New American Cinema Group, which becomes the Film-Makers' Cooperative, convenes its first meeting in New York, initiated by Jonas Mekas; twenty-three independent filmmakers participate.

Warhol buys a four-story townhouse at 1342 Lexington Avenue.

Nico is filmed in *La Dolce Vita*.

1961

Ronald Tavel meets Jack Smith at the apartment of painter Joel Markman.

Paul Morrissey makes his first short 16mm film.

Jimmy Slattery begins making trips from Massapequa to New York City, where he dresses in semidrag.

February—Henry Geldzahler plays the part of a "soft father" in a Claes Oldenburg Happening *Ironworks/Fotodeath* at the Reuben Gallery.

April—Warhol exhibits comic-strip and display-ad paintings in Bonwit Teller's shop windows for one week, behind five mannequins in spring dresses and hats, including *Advertisement, Little King, Superman, Before and After,* and *Saturday's Popeye.*

July—Fred Herko and Yvonne Rainer make their debuts as choreographers at a group dance concert organized by James Waring.

September—Gerard Malanga enrolls in Wagner College.

c. December—Ivan Karp brings Leo Castelli to Warhol's townhouse.

December—Irving Blum visits Warhol and offers him an exhibition at his Ferus Gallery in Los Angeles.

December—Claes Oldenburg's installation *The Store* opens at a real store on the Lower East Side.

dents Nonviolent Coordinating Committee (SNCC) are founded.

The first Playboy Club opens in Chicago.

Fall—The Castelli, Green, Judson, Tanager, Martha Jackson, Stable, and Hansa galleries arrange shows by Johns, Rauschenberg, Oldenburg, Wesselmann, Lichtenstein, Rosenquist, Segal, Indiana, Stella, Red Grooms, Jim Dine, Lucas Samaras, Robert Whitman, and others in the new American wave.

Late Fall—LeRoi Jones and Diane di Prima publish *The Floating Bear,* a part of the mimeograph revolution in little magazines.

Independent Film:

Primary by Richard Leacock, A. Maysles, D. A. Pennebaker, and Robert Drew.

Jazz on a Summer's Day by Bert Stern

Lemon Hearts by Vernon Zimmerman (starring Taylor Mead)

Inner and Outer Space by Robert Breer

1961

The Art of Assemblage opens at the Museum of Modern Art.

Homemade amphetamine production is on the rise.

February—Lenny Bruce performs at Carnegie Hall.

March–July—At the AG Gallery George Maciunas and LaMonte Young stage a series of interdisciplinary "Literary Evenings and Musica Antiqua et Nova" concerts.

April 15–20—American air strikes on Cuba's Bay of Pigs are unsuccessful.

George Maciunas coins the word *Fluxus,* and Dick Higgins describes its elements: internationalism, experimentalism, iconoclasm, intermedia, resolution of the life/art dichotomy, play, ephemerality, and specificity.

La Monte Young organizes a series of music concerts at Yoko Ono's loft on Chambers Street.

Published: *Silence* by John Cage, *Franny and Zooey* by J. D. Salinger, *Psychotherapy East and West* by Alan Watts *Preface to a Twenty Volume Suicide Note* by LeRoi Jones, *Kaddish* by Allen Ginsberg, *Black Like Me,* by John Griffin, *The American Dream* by Edward Albee, *Tropic of Cancer* by Henry Miller.

December 26—John Vaccaro arrives in New York and lives in the East Village.

December—Warhol visits Floriano Vecchi, who provides basic instruction in silk-screening.

Billy Linich meets individuals associated with Black Mountain College, including Nick Cernovich, Dorothy Podber, and Ray Johnson.

1962

John Vaccaro meets Jack Smith.

Jack Smith creates Cinemaroc Studios.

Mickey Ruskin opens a new restaurant, Deux Magots, which becomes a center for poetry readings.

January—The New American Cinema Group disbands; Jonas Mekas founds the Film-Makers' Cooperative, a distribution system for independent films, leading to the end of Amos Vogel's Cinema 16.

May—Lou Reed edits two issues of *Lonely Woman Quarterly* at Syracuse University and publishes his first story.

May 11—*Time* includes Warhol in the first mass-media article on Pop Art ("The Slice-of-Cake School").

June 4—Henry Geldzahler suggests that Warhol start painting darker subjects, pointing to the day's headline in *The New York Mirror:* 129 DIE IN JET. This marks the beginning of Warhol's *Death and Disaster* series.

July 9–August 4—Warhol's show of *Campbell's Soup Can* paintings runs at the Ferus Gallery in Los Angeles.

Summer and fall—Jack Smith shoots *Flaming Creatures* on the roof of the Windsor Theater in New York. Actors include Rene Rivera (Mario Montez), Francis Francine, Marian Zazeela, and Joel Markman, and Ron Tavel and Billy Linich, provided tech assistance.

July—Warhol photo-silk-screens, beginning with baseball player and movie star canvases (*Warren Beatty, Troy Donahue*).

Fall—Edie Sedgwick enters Silver Hill, a psychiatric hospital in Connecticut, for treatment of eating disorders.

September 18—Michael and Ileana Sonnabend offer

Independent Film:
Cosmic Ray by Bruce Connor
The Sin of Jesus by Robert Frank
Arabesque for Kenneth Anger by Marie Menken
No. 12 (Heaven and Earth Magic) by Harry Smith

1962

Filmmaker Shirley Clarke wins her New York State case against censorship of *The Connection.*

February 14—Ralph Ginzburg begins publication of *Eros,* a high-toned magazine about eroticism. After a few issues, a campaign led by the National Office for Decent Literature lands the publisher in jail.

June—*Artforum* magazine is published in San Francisco, edited by Philip Leider.

July 6—The Judson group, not yet called the Judson Dance Theater, gives its first concert as an outgrowth of a dance composition class.

August 13—Borders between East and West Berlin are closed, leading to the Berlin Wall.

September—The first Fluxus concerts are staged in Wiesbaden, Germany.

Fall—The Judson dancers continue to stage weekly workshops, showing their dance compositions to one another; from 1962 to 1964 the group stages nearly 200 works, and revolutionizes dance.

Fall—The Judson Poets Theater, begun by Al Carmines and Bob Nichols, stages its first productions: Joel Oppenheimer's *The Great American Desert* and Guillaume Apollinaire's *The Breast of Tiresias.*

The Twist starts at the Peppermint Lounge.

87 percent of homes in the United States have television sets.

Ray Johnson initiates the New York Correspondance [*sic*] School, a network of artists who use the mail system for their art.

Debuts: Diet Rite, Polaroid color film, Kmart, Esalen Institute, the Twist.

John F. Kennedy inaugurated as the thirty-fifth (and youngest) President of the United States.

September 30—James Meredith is the first African American to enroll at the University of Mississippi.

November—George Wallace is elected governor of Alabama.

Warhol a show in their soon-to-be-opened gallery in Paris.

October 31—Jim Dine, Roy Lichtenstein, Claes Oldenburg, James Rosenquist, George Segal, Warhol, and Tom Wesselmann are included in a group show entitled *The New Realists* at the Sidney Janis Gallery.

November 6—A show of Warhol paintings opens at Eleanor Ward's Stable Gallery. Henry Geldzahler throws a party following the opening.

December 13—The Museum of Modern Art holds a symposium on Pop Art, featuring Dore Ashton, Leo Steinberg, Stanley Kunitz, and Hilton Kramer. Geldzahler is the only one to support Pop.

1963

Chuck Wein moves to Tangiers, tutors the son of William Burroughs, and returns to the United States in spring 1964.

Early—Jonas Mekas's Monday-night midnight screenings of independent films move to the Bleecker Street Cinema, where they continue until June.

Early—Warhol gets a prescription for Obetrol, a diet pill that is a mild amphetamine.

Early—Warhol rents a two-story brick firehouse at East Eighty-seventh Street, as a studio, for $150 a month.

Throughout the year Warhol sees many underground films at the Film-Makers' Cooperative, the Charles Theater, and the Bleecker Street Cinema organized by Jonas Mekas.

January—Billy Linich moves to California in order to recuperate from a lack of energy; lives with Diane di Prima.

Spring—Edie Sedgwick receives a day pass to leave Bloomingdale Hospital, has sex, gets pregnant, and has an abortion.

May—In *The Village Voice* Jonas Mekas announces the beginning of a cinematic revolution, embodied in Ron Rice's *The Queen of Sheba Meets the Atom Man,* Jack Smith's *Flaming Creatures,* Ken Jacobs's *Little Stabs at Happiness,* and Bob Fleischner's *Blonde Cobra.*

Memorial Day Weekend—Warhol gets the idea of filming John Giorno sleeping. In his first attempts

First New York one-man shows include James Rosenquist (January, Green Gallery), Roy Lichtenstein (February, Leo Castelli), Wayne Thiebaud (April, Allan Stone), Robert Indiana (Stable Gallery).

Published:

Sex and the Single Girl by Helen Gurley Brown

Another Country by James Baldwin

Catch-22 by Joseph Heller

One Flew Over the Cuckoo's Nest by Ken Kesey

Silent Spring by Rachel Carson

Pop Art is featured in national magazines, including *Time, Life,* and *Newsweek,* and cover stories begin in 1963.

Bob Dylan's first album is released.

Late in the year—A newspaper strike in New York causes the circulation of *The Village Voice* to jump from 17,000 to 40,000.

Independent Films:

Dog Star Man: Part 1 by Stan Brakhage

Thanatopsis by Ed Emshwiller

Scotch Tape by Jack Smith

1963

1963–1964—Festivals become a popular form, including Fluxus festivals and Charlotte Moorman's First Festival of the Avant-Garde.

Acoustical folk singing becomes popular, including Peter, Paul, and Mary and The Kingston Trio.

Published:

The Fire Next Time by James Baldwin

The Other America by Michael Harrington

The Bell Jar by Sylvia Plath

The Group by Mary McCarthy

Dylan records "The Times They Are A-Changin.'"

Timothy Leary and Richard Alpert [aka Baba Ram Dass] are fired from Harvard for testing LSD on students.

February—First meeting of the Open Theater, organized by Joe Chaikin (including seventeen actors and four writers).

February—Jack Smith, Tony Conrad, and Henry Flynt picket the Museum of Modern Art, Lincoln Center, and the Metropolitan Museum carrying signs: DEMOLISH SERIOUS CULTURE! DEMOLISH ART

at filmmaking, he uses a camera borrowed from Wynn Chamberlain. The film is underexposed and unwatchable.

Summer—Harold Ajzenberg (aka Holly Woodlawn) arrives in New York, from Miami.

Summer—Barbara Rubin becomes associated with Jonas Mekas and the Film-Makers' Cooperative.

Summer—Ondine introduces Billy Linich to amphetamine.

June 13—Charles Henri Ford introduces Warhol to Gerard Malanga after a poetry reading by Frank O'Hara and Kenneth Koch in the New School garden. Two days later Malanga becomes Warhol's silk-screening assistant.

July—Accompanied by Gerard Malanga and Charles Henri Ford, Warhol buys a Bolex 16mm at Peerless Camera.

July–August—Warhol films John Giorno sleeping, and this becomes *Sleep.*

August—John Cale arrives in New York, after a month at Tanglewood, and meets La Monte Young.

August 11–12 weekend—Andy Warhol, Gerard Malanga, Diane di Prima, Mario Montez, and others participate in the shooting of Jack Smith's *Normal Love* in a glade behind Eleanor Ward's summer house in Old Lyme. Warhol films a three-minute "newsreel" of Smith filming *Normal Love.*

Summer—Ethel Scull commissions Warhol to create a portrait of her, resulting in *Ethel Scull Thirty-six Times.*

Summer—Paul Morrissey films *Taylor Mead Dances,* starring Taylor Mead.

Late summer—Edie Sedgwick moves to Cambridge to study art with Lily Saarinen, her cousin.

Fall—Warhol films the first *Kiss* movies: three-minute black-and-white close-ups of couples kissing.

September 9—Erik Satie's *Vexations,* an eighty-seven-second piano piece, is repeated 840 times, performed by a rotating team of pianists, including John Cage and John Cale; it begins at six P.M. and ends the next day at 12:40 P.M.

September—Delmore Schwartz begins teaching at Syracuse University and soon meets Lou Reed.

September—Warhol is notified that his firehouse studio building will be put on the auction block.

MUSEUMS! NO MORE ART! DEMOLISH CONCERT HALLS! DEMOLISH LINCOLN CENTER!!

February 9—The Beatles appear on the *Ed Sullivan Show,* and Beatlemania begins.

February 19—Betty Friedan's *The Feminine Mystique* is published and becomes a paperback bestseller, inspiring an organized feminist movement.

Mid-March—Guggenheim Museum opens "Six Painters and the Object," including Warhol, Dine, Rosenquist, Jasper Johns, Robert Rauschenberg, Roy Lichtenstein.

May—Robert Rauschenberg has his first one-person museum show, at the Jewish Museum.

May 11—"Yam Day" begins the Fluxus-inspired Yam Festival. The month-long festival, organized by George Brecht and Robert Watts, runs communal group events at various locations and includes *The Billy Linich Show.*

Edward Albee, Richard Barr, and Clinton Wilder organize the Playwrights Unit, producing workshop productions at the Village South Theater on Van Dam Street.

Red Grooms founds Ruckus Productions as a multimedia performance company.

April—The notorious 1913 Armory Show (which introduced modern art to New York) is re-created in situ.

April 1—The Judson Dance Theater begins calling itself by this name and sponsors Yvonne Rainer's evening-length work, *Terrain,* which Warhol attends.

May 13—The Living Theater's production of *The Brig* is the last play produced at the Living Theater's Fourteenth Street space.

June—Kennedy establishes a national arts commission, taking the first step toward the creation of the National Endowment for the Arts.

August 28—Martin Luther King, Jr., delivers his "I Have a Dream" speech to more than 250,000 in The March on Washington, staged to promote civil rights.

Group exhibitions of Pop Art in museums proliferate: *Pop! Goes the Easel* (Houston Contemporary Arts Museum, April); *The Popular Image* (Washington Gallery of Modern Art, April); *Pop Art, USA* (Oak-

c. September 25—Warhol, Malanga, Taylor Mead, and Wynn Chamberlain drive to Los Angeles for the September 30 opening of Warhol's show at the Ferus Gallery, featuring *Elvis Presley* paintings; none sell.

Early October—Warhol shoots *Tarzan and Jane Regained . . . Sort Of,* starring Taylor Mead and featuring Naomi Levine, Dennis Hopper, and others.

October 8—Warhol, Malanga, Mead, and Chamberlain attend the opening of *By or of Marcel Duchamp or Rrose Selavy* at the Pasadena Art Museum, curated by Walter Hopps.

October—*C* magazine number 4 is published, featuring Warhol's front and back covers with Denby and Malanga kissing.

Mid-October—Warhol and entourage return to New York; Warhol begins looking for new studio space.

November—*ARTnews* publishes the first Warhol interview, conducted by Gene Swenson.

November—Lou Reed hears a Bob Dylan concert in Syracuse.

Late November—Warhol accompanies Ray Johnson to a haircutting party at Billy Linich's apartment, which has been entirely covered in silver. Warhol suggests Billy do the same thing to his new raw studio space.

December—Warhol rents space at 231 East Forty-seventh Street, a former hat factory. The fifty-by-one-hundred-foot space will soon be dubbed "the Factory."

December—Warhol films *Haircut #1,* with Billy Linich, John Dodd, Fred Herko, and James Waring.

December—Warhol begins shooting *Screen Test* series; Gerard Malanga is the first subject. The series will continue until 1967.

1964

Jimmy Slattery (aka Candy Darling) meets Harold Azjenberg (aka Holly Woodlawn).

Early 1964—Jack Smith uses the word *superstar* in print, in *Gnauoua.*

January—Warhol shoots *Screen Test #1,* featuring Ronald Tavel interrogating Philip Fagan.

land Art Museum, September); *Mixed Media and Pop Art* (Albright–Knox Art Gallery, November)

September—First New York Film Festival is organized by Amos Vogel at Lincoln Center.

October—*Artforum* publishes the catalogue essay by Coplans for *Pop Art, USA,* which was "the first exhibition to attempt a collective look at the movement in this country."

October 17—The Internal Revenue Service closes down the Living Theater and the Becks are arrested and imprisoned.

Naked Lunch is banned in Boston and put on trial for obscenity.

The Cedar Tavern closes; it opens later under new management but never catches on as an artist-writer hangout.

November 22—President John F. Kennedy is assassinated.

December—Joe Chaikin's Open Theater presents its first public performance at the Sheridan Square Playhouse.

Late 1963—George Maciunas produces Fluxus Editions—cheap open editions of artist's events, scores, games, and concepts. He soon opens a store on Canal Street and discovers that few people are interested in buying the Fluxus works.

Café La Mama begins in a basement at 82 Second Avenue, founded by Ellen Stewart, beginning with productions of Harold Pinter, Eugene O'Neill, and Tennessee Williams.

Independent Films:

Scorpio Rising by Kenneth Anger

Blonde Cobra by Ken Jacobs

Little Stabs at Happiness by Ken Jacobs

Flaming Creatures by Jack Smith

The Queen of Sheba Meets the Atom Man by Ron Rice

Christmas on Earth by Barbara Rubin

Twice a Man by Gregory Markopoulos

1964

Lincoln Center's second building, the New York State Theater, opens.

Early in the year—The Living Theater leaves for a four-year European self-imposed exile.

January 17–20—Jonas Mekas screens *Sleep* at the Gramercy Arts Theater.

Warhol buys his first tape recorder.

Late January—Billy Linich starts to renovate the raw space at 231 East Forty-seventh Street, and by February he makes the Factory his primary residence.

c. February—Warhol begins a romantic/sexual relationship with Billy Linich; it lasts a few months, but their closeness continues long afterward.

February 1—Scheduled date for the first publication of *Stable*, edited by Gerard Malanga, published by Eleanor Ward, with cover by Andy Warhol. The magazine never materialized.

February 2—Warhol films Robert Indiana in a twenty-seven-minute film, *Eat;* it is first shown July 16, 1964, at the Filmmakers' Cinematheque.

February 14—Mario Montez and Jack Smith, both living at 89 Grand Street, invite Andy and others to view an in-progress version of *Normal Love.* (Smith will never finish the film.)

February 18—*Tarzan and Jane Regained . . . Sort Of* premieres at the Grammercy Arts Theater.

March 4—Edie Sedgwick's brother Minturn hangs himself on the day before his twenty-sixth birthday. Shortly thereafter she meets Chuck Wein.

March 23—Taylor Mead stars in LeRoi Jones's *The Baptism* and Frank O'Hara's *The General Returns from One Place to Another,* for which he wins an Obie award.

April—Warhol installs the *Thirteen Most Wanted Men* series at the New York World's Fair, but Governor Nelson Rockefeller objects. On April 16 Philip Johnson informs Warhol that he has twenty-four hours to replace or remove the mural. On April 17 Warhol instructs that his mural be painted over silver.

April 20—Edie Sedgwick's twenty-first birthday party is held at the Harvard Boat House; she comes into a trust fund from her maternal grandmother.

April 21—Warhol's exhibition of *trompe l'oeil* sculptures of about four hundred grocery boxes opens at the Stable Gallery. The post-opening party is the first public event held at the Factory.

Spring—Leo Castelli invites Warhol to join his gallery, and Warhol accepts.

The National Endowment for the Arts is established.

The Playwrights Unit group, as Theater 1964, produces plays at the Cherry Lane (including LeRoi Jones's *Dutchman* and plays by Arrabal, Beckett, Pinter, and Albee) and the East End Theater (including Adrienne Kennedy's *Funnyhouse of a Negro.*)

February—The Moderna Museet, in Stockholm, opens its exhibition, *Amerikansk Pop-konst.*

February—*The New Art,* curated by Sam Green, opens at the Wesleyan art gallery; it included Warhol, Roy Lichtenstein, Richard Artschwager, Claes Oldenburg, Tom Wesslemann, Marisol, Agnes Martin, John Chamberlain, and Yoyoi Kusama.

February 9—The Beatles debut on the *Ed Sullivan Show,* singing "I Want to Hold Your Hand."

February—The Fifty-fifth Street Playhouse opens as the first commercial theatre devoted exclusively to the showing of "experimental and avant-garde" movies.

February 25—Cassius Clay defeats Sonny Liston and becomes the heavyweight champion of the world, joins the Nation of Islam the following day, and changes his name to Muhammad Ali.

March 7—Kenneth Anger's *Scorpio Rising* seized by L.A. Vice Squad.

March—Malcolm X separates from the Nation of Islam to plan an all-black nationalist party.

March—The Gramercy Arts Theater is closed down by the New York City License Department. Mekas moves screenings to the New Bowery Theater, where he is arrested for showing *Flaming Creatures,* and a second time for showing Genet's *Un Chant d'Amour.* Warhol's three-minute "newsreel" on the making of *Normal Love* is confiscated and never recovered.

March 17—Kenneth Anger and Stan Brakhage show cancelled at the New Bowery Theater.

March 18—Kuchar Brothers film program canceled at the New Bowery Theater under pressure.

April—The Judson Dance Theater stages its sixteenth and last group concert.

April 7—Lenny Bruce is arrested during his performance at Café à Go Go for "indecent performance."

April 22—New York World's Fair opens.

April 22—To promote freedom of expression, about

The Silver Factory	Context




The Silver Factory

Spring—During his last term at Syracuse University, Lou Reed writes "Heroin" and "I'm Waiting for My Man."

Spring—Warhol films *Batman/Dracula,* starring Jack Smith; it is never screened.

Spring and summer—Warhol films three-minute silent scenes for *Couch.*

Early May—Edie Sedgwick arrives in New York.

June—Before graduating from Syracuse University, Betsey Johnson is invited to work at *Mademoiselle* magazine, where she quickly learns about fashion.

June—Lou Reed graduates from Syracuse University with honors.

July 25–26—Warhol shoots *Empire,* with concept by John Palmer.

September—Lou Reed begins working for Pickwick International; during the next five months he publishes at least five songs.

September 5—Warhol films *Taylor Mead's Ass,* starring Taylor Mead.

Fall—John Cale moves into an apartment with Tony Conrad at 56 Ludlow Street.

Fall—Dorothy Podber visits the Factory, pulls out a gun, and shoots a stack of four *Marilyn* paintings through the forehead.

Late September—Four Warhol films (*Sleep, Eat, Haircut,* and *Kiss*) are represented at the New York Film Festival by three-minute loops, each played simultaneously in the lobby on four Fairchild 400 projectors, with a score by La Monte Young.

October—Warhol meets Philip Fagan, who becomes his boyfriend.

October 27—Freddie Herko goes to John Dodd's apartment in Greenwich Village, puts on Mozart's *Coronation Mass,* dances naked out a fifth-floor window, and dies.

November—Warhol meets Ronald Tavel, introduced by Gerard Malanga at the Café Le Metro.

November 21—Warhol's exhibition of *Flower* paintings opens at the Leo Castelli Gallery.

November—Warhol buys an Auricon sound camera.

December 7—At midnight Warhol receives the sixth annual *Film Culture* award, cited by Jonas Mekas, for *Sleep, Haircut, Kiss, Eat,* and *Empire.*




Context

200 people gather at Bryant Park and march to Lincoln Center; participants include Taylor Mead, Jonas Mekas, Judith Malina, Julian Beck.

May 25—First issue of *Los Angeles Free Press* is published.

Summer—After *The Dutchman,* LeRoi Jones becomes known as an African American playwright with a radical political vision.

Summer—Jasper Johns, Robert Rauschenberg, and Claes Oldenburg are included in the Venice Biennale and Rauschenberg becomes the first American to win the top prize.

Summer—A large-scale civil rights voter registration project is conducted by over 800 volunteers throughout the South.

August 10—The Gulf of Tonkin resolution gives President Johnson unlimited authority to pursue war in Vietnam.

September 24—The Warren Commission Report is released, describing the Kennedy assassination as Lee Harvey Oswald acting alone.

Fall—Susan Sontag's "Against Interpretation" is published in the *Evergreen Review* and "Notes on Camp" is published in *Partisan Review.*

October—When political activity is banned from the Berkeley campus of the University of California, students protest.

October 14—Martin Luther King, Jr., is awarded the Nobel Peace Prize.

November—Lyndon Johnson is elected President, and Hubert Humphrey Vice President.

December—800 Berkeley students are arrested in a sit-in on behalf of free speech on campus.

Published:

Understanding Media by Marshall McLuhan

Lunch Poems by Frank O'Hara

Anti-Intellectualism in American Life by Richard Hofstadter

The Beatles' first tour of the United States contributes to their position as the most popular music-group in the English-speaking world.

The Surgeon General's report, *Smoking and Health,* links smoking and lung disease.

Independent Films:

Dog Star Man, part III and IV by Stan Brakhage




December 13—Warhol shoots his first sound film, *Harlot,* scenario by Ronald Tavel, starring Mario Montez, Gerard Malanga, Billy Linich, and others.

December 31—On New Year's Eve Edie Sedgwick's brother Bobby crashes his motorcycle and dies eleven days later. In California Edie crashes a car, which is totaled, but Edie emerges with only small facial scars and her leg in a cast.

December—Tom Wolfe calls Jane Holzer "Girl of the Year."

Late 1964—Warhol and Malanga begin Thermofax series.

1965

Valerie Solanas writes "A Young Girl's Primer on How to Attain the Leisure Class," which will be published in *Cavalier* in 1966.

Joe Dallesandro, convicted for a variety of legal offenses, is sent to Camp Cass Rehabilitation Center for four months.

January—Lou Reed meets John Cale and soon joins Cale, Tony Conrad, and Walter de Maria to record "The Ostrich."

January—Jonas Mekas declares a new era of underground stars.

February—Lou Reed moves into 56 Ludlow, sharing the apartment with John Cale.

February—Warhol films *Screen Test #2.*

February—Sterling Morrison joins Lou Reed and John Cale in their band.

March—Warhol shoots Ronald Tavel's script *The Life of Juanita Castro.*

March 26—Edie Sedgwick and Chuck Wein meet Warhol at Lester Persky's birthday party for Tennessee Williams.

April—Warhol films *Horse.*

April 9—Sedgwick and Warhol attend a preview at the Metropolitan Museum of Art. They are treated in the press as "the" Pop couple.

April—Sixteen-year-old Stephen Shore begins to shoot photographs at the Factory.

Late April—Warhol films *Vinyl,* with script by Ronald Tavel, starring Gerard Malanga, Ondine, and, in her first appearance, Edie Sedgwick.

Babo 73 by Robert Downey
Chumlum by Ron Rice
The Brig by Jonas Mekas
Fleming Faloon by George Landow
Breathdeath by Stan Vanderbeek

1965

January—Ondine opens on East Fifty-eighth Street; along with Arthur, it is one of the first discotheques in New York.

February—*The Responsive Eye* opens at the Museum of Modern Art, focusing on Op Art. Simultaneously Briget Riley has her first one-person show and sells out on opening day.

February 8—Lyndon Johnson initiates bombing raids on North Vietnam.

LeRoi Jones leaves Greenwich Village.

February 21—Malcolm X is assassinated at the Audubon Ballroom in Harlem.

March 25—The National Guard protects a civil rights march from Selma to Montgomery, Alabama.

March—Bob Dylan's album *Bringing It All Back Home* is released.

April—Stokely Carmichael is elected president of SNCC.

July 24—Bob Dylan "goes electric" at the Newport Folk Festival.

August 10–13—Riots occur in the black ghetto of Watts; more than 30 African Americans are killed.

Summer—A Free University is organized in New York.

Summer—Charles Cowles takes over as publisher of *Artforum* and moves it to Los Angeles, its offices located over the Ferus Gallery.

Summer—LSD becomes commonly available in New York.

July 10—The Rolling Stones' "I Can't Get No Satisfaction" is #1.

October—Bob Dylan's album *Highway 61 Revisited* is released.

October 1—The *East Village Other* begins bi-weekly publication, with initial circulation of 2,500.

October 4—The Pope visits New York.

November 7—Jack Smith's play *Rehearsal for the*

April 25—Lester Persky and Warhol stage the Fifty Most Beautiful People Party at the Factory.

April 30—Warhol, Sedgwick, Wein, and Malanga arrive in Paris for an exhibition of Warhol's *Flower* series at the Sonnabend Gallery. Warhol says publicly that he wants to stop painting in order to concentrate on movies.

May–July—Warhol shoots episodes in the life of Edie Sedgwick, organized by Chuck Wein. The resulting films include *Restaurant, Poor Little Rich Girl, Beauty #2*, and others.

Spring—Two "ritual happenings" organized by Angus MacLise and Piero Heliczer are staged at the Filmmakers' Cinematheque. Lou Reed, John Cale, and Sterling Morrison perform behind a screen.

June—Warhol films *Kitchen* in Buddy Wirtschafter's white studio.

c. Summer—During a three-month stay in Los Angeles, Joe Dallesandro poses for physique photographs taken by Bob Mizer (Athletic Model Guild) and by Bruce Bellas (aka Bruce of Los Angeles).

July—Lou Reed, John Cale, Sterling Morrison, and Angus MacLise record a rehearsal tape that includes "Heroin" and "Venus in Furs."

July—*Vogue* launches Edie Sedgwick as a representative of the Youthquaker generation.

July 19—*Vinyl* and *Poor Little Rich Girl* are screened in a double bill at the Astor Place Theater. Paul Morrissey, via Gerard Malanga, meets Warhol.

July 29—Two plays by Ronald Tavel (*The Life of Juanita Castro, Shower*) open at the Coda Galleries in New York, directed by John Vaccaro. This production marks the beginning of the group that will be known as the Play-House of the Ridiculous.

July 30—Warhol tapes the first twelve hours of Ondine and others for *a: a novel*. On the same day a Norelco videotape camera and monitor arrive at the Factory on a month-long loan. Warhol shoots at least eleven tapes, including two that are incorporated into *Outer and Inner Space*.

September—Warhol shoots *My Hustler* on Fire Island, featuring Paul America, Joe Campbell, Genevieve Charbon, and Ed Hood, with concept by Chuck Wein.

Destruction of Atlantis opens at the Filmmakers' Cinematheque.

Published:

Games People Play by Eric Berne

The Kandy-Kolored Tangerine-Flake Streamline Baby by Tom Wolfe

I Lost It at the Movies by Pauline Kael

Culture and Society by Herbert Marcuse

The Autobiography of Malcolm X

November—Ken Kesey and the Merry Pranksters cross the United States in their bus, "Onward," and hold the first acid test open to the public.

November—An "Expanded Cinema" festival at the Filmmakers Cinematheque, organized by Jonas Mekas, explores the use of multiple screens, multiple projectors, hand-held projectors, moving slide projections. Participants include Claes Oldenburg, Nam June Paik, Robert Rauschenberg, Robert Whitman, and emerging light artists Jackie Cassen, Don Snyder, Rudi Stern, and the USCO group. Warhol's evenings, on November 22 and 23, feature split-screen movie projection.

November—Norman Morrison, a Quaker pacifist, immolates himself in front of the Pentagon in protest of the Vietnam War.

United Farm Workers Organizing Committee launches a strike against California grape growers.

Color television becomes popular in the United States.

Miniskirts become fashionable.

Independent Films:

Kustom Kar Kommandos by Kenneth Anger

The Art of Vision by Stan Brakhage

Aviary by Joseph Cornell

Peyote Queen by Storm de Hirsch

Echoes of Silence by Peter Goldman

Sins of the Fleshapoids by Michael Kuchar

Short Wave by Michael Snow

O Dem Watermelons by R. Nelson

1966

January—United States resumes bombing North Vietnam.

The United States Federal Government declares LSD illegal.

Late September—Paraphernalia opens on Madison Avenue, featuring Betsey Johnson's designs and live models frugging in the display window.

October—Gerard Malanga meets Mary Woronov in Ithaca, New York.

October 4—Several people gather on the roof of the Factory and inflate with helium the first versions of the *Silver Clouds,* conceived as a farewell to art.

October 8—Warhol's first retrospective exhibition opens at the Institute of Contemporary Art in Philadelphia.

November 11—The Velvet Underground play their first paying engagement at Summit High School in Summit, New Jersey.

Early December—Discotheque entrepreneur Michael Mayerberg invites Warhol to become an attraction for a disco, to open in spring 1966. Morrissey conceives the idea that Warhol should sponsor a band.

December 15—The Velvet Underground begin a two-week engagement at Café Bizarre. Via Barbara Rubin they meet Gerard Malanga, Andy Warhol, Paul Morrissey, and Nico.

December—Warhol films *Lupe.*

Late December—Sedgwick and Cale begin a romantic relationship that lasts about a month.

1966

January 10—The Exploding Plastic Inevitable play their first engagement at Delmonico's, for a psychiatrists' black tie banquet.

January 15—Mickey Ruskin stages the opening party for Max's Kansas City.

Late January—Sedgwick breaks relations with Warhol and asks that her films not be shown.

February—Warhol films *Hedy.*

February 6—Leo Castelli introduces Gerard Malanga and Benedetta Barzini.

c. February—Henry Geldzahler announces his selection for the Venice Biennale exhibition; Warhol is not among them and they do not talk for several months.

March 30—Jackie Curtis meets Harold Azjenberg

Canyon Cinema, organized by Bruce Baillie and Larry Jordan, opens in San Francisco, modeled on the Film-Makers' Cooperative.

January 17—The Great Trips Festival is held in San Francisco. Ken Kesey and the Merry Pranksters participate in an "Acid Test," experimenting with LSD; this event is considered the first conclave of hippies.

January—Automatic draft deferments for college students are abolished.

February 1—Congress passes Senator Christopher Dodd's bill, "The Drug Abuse Control Amendment of 1965," requiring increased recordkeeping of manufacture, prescription, and sale of amphetamine.

Late April—The Cheetah, a 1500-person-capacity discotheque, opens on Broadway and Fifty-third Street.

May—Jonas Mekas starts the Film-Makers' Distribution Center to expand distribution of independent film.

June—James Meredith begins a civil rights march across Mississippi and is wounded by a sniper on the second day. Stokely Carmichael and Martin Luther King, Jr., continue the march.

The slogan "Black Power" is first used, and explained by Carmichael in an essay, "What We Want," published in *The New York Review of Books.*

Summer—Jimi Hendrix becomes popular.

August 3—Lenny Bruce overdoses on heroin.

August 5—John Lennon says that the Beatles are currently more popular than Jesus Christ.

Black Panthers organize in Oakland.

Fall—An organized draft resistance movement is initiated by pledges of students to refuse military service; their slogan is "We Won't Go."

November—The Doors come to New York for the first time and perform at Ondine.

November 28—Truman Capote throws a Black and White Dance in The Grand Ballroom of the Plaza Hotel, inviting five hundred distinguished guests.

Berkeley students demand "student power," and others campuses follow.

Bob Dylan's *Blonde on Blonde* is released.

Published:

Quotations of Chairman Mao

(Holly Woodlawn) and Jimmy Slattery (Candy Darling) while watching *Color Me Barbra* on television.

April 2—Warhol's second exhibition at Leo Castelli opens, featuring *Cow* wallpaper and floating *Silver Clouds;* it runs till April 21.

April 8—The Exploding Plastic Inevitable open at the Polsky Dom Narodny in the East Village. During their two-week run the Velvet Underground and Nico record the majority of the tracks for their first album.

April 21—A double bill of two Tavel plays, *The Life of Juanita Castro* and *The Life of Lady Godiva,* opens; they are the first works officially produced by the Play-House of the Ridiculous.

Spring—Gerard Malanga introduces Susan Bottomly (aka International Velvet) to the Factory.

May 1—The Exploding Plastic Inevitable travel to the West Coast, where they open on May 3 in Los Angeles at the Trip, and play at the Fillmore Auditorium in San Francisco on May 26.

June–September—Warhol shoots about fifteen one- and two-reel films at the Factory, in various apartments, and at the Chelsea Hotel. These reels will become *The Chelsea Girls.*

Summer—Henry Geldzahler's exhibition (Lichtenstein, Olitski, Frankenthaler, Kelly) opens at the Venice Biennale; there Geldzahler meets Fred Hughes, whom he later introduces to Warhol.

July—Delmore Schwartz, Lou Reed's mentor, dies of a heart attack. Reed leaves Beth Israel Hospital, against medical advice, to attend the funeral.

July 26—Danny Williams drowns in Massachusetts.

September 10—*The Chelsea Girls* opens at the Filmmakers' Cinematheque on West Forty-first Street.

September—The Exploding Plastic Inevitable perform at the Dom, now called the Balloon Farm and managed by Albert Grossman.

Mid-October—Edie Sedgwick's apartment catches fire; she moves to the Chelsea Hotel.

1967

January–March—Valerie Solanas writes *The SCUM Manifesto.*

Human Sexual Response by Masters and Johnson
Love's Body by Norman O. Brown
In Cold Blood by Truman Capote
Against Interpretation and Other Essays by Susan Sontag
Valley of the Dolls by Jacqueline Susann
On Aggression by Konrad Lorenz
Hell's Angels by Hunter Thompson
National Organization for Women (N.O.W.) is founded by Betty Friedan and others.
A federally funded corporation for Public Broadcasting is begun.
Timothy Leary tours campuses, espousing the possibilities of LSD, using the slogan "Turn on, tune in, and drop out."
Independent Films:
Castro Street by Bruce Baillie
The Flicker by Tony Conrad
Hold Me While I'm Naked by George Kuchar
Chafed Elbows by Robert Downey
Amphetamine by Warren Sonbert

1967

An article observes that sixteen of the top forty records contain "positive drug messages."

Arab and Israeli forces engage in a six-day war.

January—*The Brig, Scorpio Rising,* and *Echoes of Silence* open at the New Yorker Theater.

January 14—"Gathering of the Tribes for a Human Be-In" happens in Golden Gate Park in San Francisco; Allen Ginsberg is a prominent force, and ten thousand are present.

February—The first organizing meeting is held of the New York chapter of the National Organization for Women.

March 20—Twiggy arrives in New York, immediately visits Betsey Johnson.

April 15—"Spring Mobilization" demonstrations against the Vietnam War are staged throughout the country, culminating in marches in New York (200,000 participants) and San Francisco (65,000 participants).

April—The Resistance forms in California, focusing on noncooperation with the draft.

June 16–18—The Monterey Pop Festival is held.

Kulchur Press publishes *Screen Tests* by Gerard Malanga and Andy Warhol, including Malanga's poetry and stills from *Screen Test* movies.

c. February—Jackie Curtis writes *Glamour, Glory, and Gold, The Life and Legend of Nola Noonan.*

March—*The Velvet Underground and Nico* is released.

March 26—The Be-In, staged in Central Park on Easter Sunday, marks the beginning of the shooting of *Ciao! Manhattan,* continuing through June.

April 21—Valerie Solanas buys her first recruiting advertisement for SCUM in *The Village Voice.*

April—The Exploding Plastic Inevitable perform at the Gymnasium.

May—Warhol takes an entourage to Cannes Film Festival to show *The Chelsea Girls,* but he is not allowed to screen it. During this trip he reconnects with Taylor Mead.

July—Warhol and the Velvet Underground go to Philip Johnson's Glass House in New Canaan, Connecticut, where the band performs for a Merce Cunningham Dance Company benefit.

July—Nico meets Jim Morrison and begins a month-long affair.

July—*My Hustler* begins a successful run at the Hudson Theater in Times Square.

July—Warhol films *I, a Man,* starring Tom Baker and, in a supporting role, Valerie Solanas. (It opens August 24 at the Hudson Theater.)

August 4—Susan Hoffman (aka Viva) meets Warhol at a party given by Betsey Johnson, and she soon appears in her first Factory film, *Bike Boy.*

August—Valerie Solanas meets Maurice Girodias, who offers her a contract to write a novel for the Olympia Press.

September—The Velvet Underground record their second album, *White Light/White Heat,* in New York.

Fall—On a lecture tour Allen Midgette impersonates Warhol on several occasions before being discovered.

Fall—Joe Dallesandro meets Warhol shooting *The Loves of Ondine.* Paul Morrissey invites him to appear in a scene.

September 10—Gerard Malanga goes to Italy, where his film *In Search of the Miraculous* is shown at the

June—*Sergeant Pepper's Lonely Hearts Club Band* is released.

July 29—The Doors' "Light My Fire" becomes the most popular single in America.

Summer—Unrest among African Americans leads to widespread urban rebellion, notably in Newark (26 dead), Detroit (43 dead), New York. Property damage due to fires and riots is in the hundreds of millions.

Summer—The "Summer of Love" takes place in San Francisco.

Summer—*The Chelsea Girls* plays on screens throughout the United States.

September—Bob Mizer's Physique photographs of Joe Dallesandro, taken in 1965, are published in *Physique Pictorial,* volume 16, number 3. This is the last issue of the magazine in which models do not show frontal nudity.

September—The national Black Power conference is held in Newark.

September—Sheldon Renan and Gregory Battcock's books on underground film are published, the first such books on the New American Cinema.

October 7—Che Guevara is killed.

October—Robert Rauschenberg stages a news conference happening to announce the merging of art and technology, part of E.A.T. (Experiments in Art and Technology).

October 21–22—The March on the Pentagon is staged, including notable intellectuals, Noam Chomsky, Norman Mailer, Dwight MacDonald.

Published:

Black Power! by Stokely Carmichael

The Medium Is the Message by Marshall McLuhan.

R. Crumb's *Zap* comics are the first underground comics to reach a large audience.

Muhammad Ali is stripped of his heavyweight championship title because he refuses to serve in the army.

United States troops in Vietnam increase to 474,000 and the death toll exceeds 13,000.

Independent Films:

Portrait of Jason by Shirley Clarke

Report by Bruce Conner

The Iliac Passion by Gregory Markopolous

David Holzman's Diary by Jim McBride

Bergamo Festival. Malanga will not return to New York until March 1968.

October—*Glamour, Glory, and Gold* by Jackie Curtis opens at Sebastiano's Cellar.

October 6—*Bike Boy* opens at the Hudson Theater.

October 31—Warhol shoots *Nude Restaurant.*

December—Producing works by "Andy Warhol," Gerard Malanga silk-screens images of Che Guevara.

December—Random House publishes *Andy Warhol's Index (Book).*

December 15—**** in its twenty-five-hour-long version is shown, beginning at eight-thirty P.M. and ending at nine-thirty P.M. the following evening.

1968

January—Valerie Solanas travels to California and stays for about five months.

January 9 and 16—*Brigid Polk Strikes: Her Satanic Majesty in Person* is staged at the Bouwerie Lane Theater.

Last week in January—Warhol and Morrissey shoot *Lonesome Cowboys* in Oracle, Arizona. The cast includes Joe Dallesandro, Viva, Taylor Mead, Louis Waldon, Tom Hompertz, and Eric Emerson.

January 30—The Velvet Underground's second album, *White Light/White Heat,* is released but is banned from the radio; sales are minimal.

February 5–8—The Factory moves from 231 East Forty-seventh Street to the fifth floor at 33 Union Square West.

February—Jed Johnson delivers a Western Union telegram to the Factory, is hired by Paul Morrissey to be an assistant at the Union Square Factory, and later becomes Warhol's boyfriend.

February—Warhol's first European retrospective, curated by Pontus Hulten, is staged at the Moderna Museet in Stockholm.

February—Allen Midgette's impersonation of Warhol as lecturer is publicized.

March—Gerard Malanga returns to New York.

April—Betsey Johnson and John Cale marry at City Hall.

May—Warhol and Morrissey film *San Diego Surf* in

Fuses by Carolee Schneemann
Wavelength by Michael Snow

1968

The Filmmakers' Cinematheque, designed by George Maciunas, opens at 80 Wooster Street.

Motorcycle films, such as *The Savage Seven* and *The Mini-Skirt Mob,* become popular.

Published:
Soul on Fire by Eldridge Cleaver
Language and Mind by Noam Chomsky
Armies of the Night by Norman Mailer
The Double Helix by James D. Watson
Electric Kool-Aid Acid Test by Tom Wolfe
Slouching Toward Bethlehem by Joan Didion.

Philip Berrigan is sentenced to six years in prison for pouring duck blood on draft files.

January 5—Dr. Benjamin Spock and others are indicted for conspiracy to encourage violation of the draft laws.

Choreographer Merce Cunningham uses Warhol's *Silver Clouds* as the floating décor for *RainForest.*

February—Abbie Hoffman and Jerry Rubin found the Youth International Party (aka the Yippies).

March—The Peace and Freedom Party holds its founding convention in California.

April 3—*2001, A Space Odyssey* opens, featuring Hal, the first movie computer character.

April 4—Martin Luther King, Jr., is assassinated by James Earl Ray, followed by riots in black ghettos throughout the country.

Spring—Feminist Ti-Grace Atkinson begins writing her book, *Women and Oppression.*

Spring—*The Boys in the Band* opens Off-Broadway, portraying gay characters.

April—Students at Columbia University occupy buildings and stage a student strike.

April 29—*Hair* opens on Broadway (after an initial opening at the Public Theater), featuring Broadway's first frontal nudity.

May—Dr. Ralph Abernathy leads a march of 50,000, culminating the Poor People's Campaign in Washington, D.C., erecting Resurrection City around the Lincoln Memorial.

La Jolla, California; the cast includes Taylor Mead, Joe Dallesandro, Ingrid Superstar, Eric Emerson, and Tom Hompertz. (The film was never shown.)

June 3—Valerie Solanas shoots Andy Warhol. (Mario Amaya is also wounded.) Warhol is declared officially dead for one and a half minutes. Solanas turns herself in.

June—Viva, Taylor Mead, Ultra Violet, and others play parts in John Schlesinger's *Midnight Cowboy.*

June–July—Paul Morrissey films and directs *Flesh,* Joe Dallesandro's first starring vehicle, featuring Jackie Curtis, Candy Darling, and others.

July—Nico's first solo album, *Chelsea Girl,* is released.

July 28—Warhol returns home from Columbus Hospital.

August 1—*The Loves of Ondine* is released at the Garrick Theater; it is commercially unsuccessful.

September 4—Warhol makes his first public appearance after the shooting, with Viva and Paul Morrissey.

Early September—Lou Reed demands that John Cale leave the Velvet Underground, and he does.

Fall—Entry to the Union Square Factory becomes more restricted.

Fall—Billy Name retreats to the converted bathroom in the back of the Factory, admitting only Ondine and Lou Reed; he remains there until spring 1970.

December 13—Random House publishes *a: a novel,* and most critics respond with ridicule; the book is not a commercial success.

1969

Betsey Johnson leaves New York for California, stays nine months, and feels she has returned to a changed city.

Ondine settles down with a steady boyfriend, Roger Jaccoby, stops amphetamine use, and works as a mailman in Brooklyn.

January 10—Judge Schweitzer gives Valerie Solanas a three-year sentence for shooting Warhol.

February—Tavel's *The Boy on the Straight Back Chair* opens at St. Clement's Episcopal Church and is widely acclaimed.

May—Revolts begun by students in France spread to Germany and Italy.

June 6—Presidential candidate Robert F. Kennedy is assassinated in Los Angeles.

July—Pope Paul IV bans artificial birth control methods.

August—The Democratic convention meets in Chicago, is met by demonstrations and violence, nominates Hubert Humphrey for President.

September—Feminists stage a protest at the Miss America contest.

October—African American athletes protest at the Olympic Games in Mexico.

November—Two related exhibitions open: *The Machine as Seen at the End of the Mechanical Age* at the Museum of Modern Art, and an E.A.T.-organized exhibition at the Brooklyn Museum.

November 5—Richard Nixon and Spiro Agnew are narrowly elected to office, beating Hubert Humphrey and Edmund Muskie.

United States troops in Vietnam reach 500,000.

Independent films:

The Bed by James Broughton

The Secret Life of Hernando Cortez by John Chamberlain (featuring Taylor Mead, Ultra Violet)

Bouncing Two Balls Between the Floor and Ceiling with Changing Rhythms by Bruce Nauman

The Horseman, the Woman, and the Moth (Stan Brakhage)

1969

The radical activist Art Workers' Coalition is founded in New York.

Midnight Cowboy is released and wins the Academy Award for best picture of the year.

Films depicting varieties of youth revolt become popular, including *Alice's Restaurant, Easy Rider, Putney Swope, Medium Cool,* and motorcycle movies *Hell's Belles* and *Hell's Angels.*

More than half of campus colleges stage anti-war protests.

SDS supports women's liberation, and the movement gains prominence.

January—The Dwan Gallery features *Conceptual Art.*

May 5—*Lonesome Cowboys* opens in New York at the Fifty-fifth Street Playhouse and the Garrick Theater in the Village.

July 21—*Blue Movie* premieres at the Garrick Theater; ten days later it is seized by the police for obscenity.

July 21—Jackie Curtis and Eric Emerson stage a wedding, but Emerson does not show up. Holly Woodlawn meets John Vaccaro, leading to casting in *Heaven Grand in Amber Orbit* and ultimately in *Trash*.

September—*Heaven Grand in Amber Orbit* opens on Forty-third Street in a small funeral-home-turned-theater.

October—Paul Morrissey begins shooting *Trash*; production continues on weekends until mid-December.

October—Nico records *The Marble Index* with the collaboration of John Cale.

Fall—At the suggestion of John Wilcock, Warhol starts an underground movie magazine called *Inter/VIEW*. Initially Gerard Malanga and Paul Morrissey appeared on the masthead.

January—*Harlem on My Mind* opens at the Metropolitan Museum of Art, arousing controversy and protest.

July 20—Neil Armstrong and Buzz Aldrin are the first human beings to walk on the moon.

Museum exhibitions attempt to connect with the lifestyle of the moment, including "Feel It" (Museum of Contemporary Crafts, New York); "When Attitude Becomes Form" (Institute of Contemporary Art, London); "Human Concern, Personal Torment" (Whitney Museum); "Art by Telephone" (Museum of Contemporary Art, Chicago).

Published:

Documents I by the Art Workers' Coalition

Trout Fishing in America by Richard Brautigan

Woodstock Nation by Abbie Hoffman

A Year from Monday by John Cage

An Essay in Liberation by Herbert Marcuse

The Godfather by Mario Puzo

Portnoy's Complaint by Philip Roth

August 9—Charles Manson and associates murder Sharon Tate and others in Los Angeles.

August 15–17—The Woodstock Rock Festival in Bethel, New York, attracts over 400,000 people.

September 24—The Chicago 8 conspiracy trial begins; defendants include Bobby Seale, Abbie Hoffman, and Jerry Rubin.

November—The largest anti-war demonstration in the nation's history is staged in Washington, attracting over half a million people.

December—The Selective Services System holds its first draft lottery since 1942.

Independent films:

Invocation of My Demon Brothers by Kenneth Anger

Me and My Brother by Robert Frank

Reverberation by Ernie Gehr

Tom, Tom, The Piper's Son by Ken Jacobs

Cosmos by Jordan Belson

Sources

The history of the Silver Factory is largely gathered from oral histories; these were not, for the most part, people who communicated in the written word. I am grateful to those who preceded me in conducting interviews (including Patrick Smith, Victor Bockris, David Bourdon, and Pat Hackett). My additions to the oral history of the period are noted here, in alphabetical order, with the medium of interview described.

Following these interviews, published sources are listed by subject. These lists are not exhaustive and overlap, but they seem the most useful way to introduce material to future investigators.

Interviews

George Abagnalo: April 26, 2000 (video)
Daisy Aldan: October 23, 1999 (audio)
Penny Arcade: June 15, 1999 (audio)
Gretchen Berg: December 21, 2001 (video)
Brigid Berlin: February 26 and July 29, 1999 (audio)
Victor Bockris: March 21, 2000 (notes only)
Randy Borscheidt: January 27, 2000 (video)
Susan Bottomly: May 14, 2002 (notes only)
Lorraine Brooks: June 24, 1999 (notes)
Ed Burns: March 7, 2002 (video)

John Cale: February 10, 2000 (video)
Joe Campbell: May 11, 99 (video)
Wynn Chamberlain: May 29, 1997 (audio); September 12 and 14, 2001 (video)
Jackie Curtis: November 1978 (audio)
Ronnie Cutrone: September 17, 2001 (video)
Joe Dallesandro: November 3, 1999 (audio)
Sarah Dalton: May 20, 2001 (notes only)
Norman Dolph: February 14, 2001 (video)
Andrew Dungan [aka Julian Burroughs]: May 17, 2000 (video)

Mary Lowenthal Felstiner: May 17, 1999 (audio)

Danny Fields: December 14, 1998 (audio)

Nat Finkelstein: May 15, 2001 (video)

Charles Henri Ford: March 8, 2000 (video)

John Giorno: October 2, 2001 (video)

Nathan Gluck: December 8, 1999 (video)

Samuel Adams Green: October 6, 1999 (video)

Pat Hackett: December 3, 2001 (video)

Robert Heide: April 22, 1998 (audio)

Ed Hennessy: (correspondence, May 24, 1999)

Stephen Holden: September 19, 1998 (audio)

Jane Holzer: June 23, 2000 (video)

Dale Joe: May 4, 1999 (audio)

Betsey Johnson: March 8, 2001 (video)

Jill Johnston: June 23, 2000 (notes only)

Fred Jordan: July 20, 1999 (notes only)

Ivan Karp: October 5, 2001 (video)

Ron Link: November 14, 1999 (audio)

Donald Lyons: October 16, 2001 (audio)

Nelson Lyons: August 12, 1999 (audio)

Gerard Malanga: October 1978; February 4, February 13, April 8, and August 2, 1998; January 13, 1999 (all audio); August 5, 1999, January 2, 2001, and October 22, 2002 (video)

Judith Solanas Martinez (e-mail interview and phone, notes, 1999)

Hudson Mead: June 12, 2001 (notes only)

Taylor Mead: August 1978; February 17, February 28, May 15, and June 1, 1998 (audio); January 28, 2000; and February 2, 2002 (video)

Jonas Mekas: February 4 and April 7, 2000 (video)

Alan Midgette: April 9, 2000 (video)

Paul Morrissey: August 6 and December 13, 2001 (audio)

Billy Name: April 29 and July 29, 1998 (audio); July 29, 1999; November 19, 2000; and July 11, 2002 (video)

Jeremiah Newton: April 7, 1998, and June 5, 1999 (audio)

Ann Olivo: June 21, 1999 (notes only)

John Palmer: 2002 (e-mail interview)

Lola Pashalinski: October 19, 2000 (video)

John Perreault: August 12, 2001 (audio)

Rosebud Pettit: July 15, 1998 (audio)

Ruby Lynn Reyner: October 8, 2001 (video)

Robert Richards: September 20, 1999 (audio)

Carolee Schneemann: May 4, 2001 (video)

Christopher Scott: January 2, 2002 (video)

Stephen Shore: February 8, 2000 (video)

Michael Smith: May 13, 2000 (video)

Robert Smith: June 15, 1999 (notes only)

Holly Solomon: April 21, 2000 (video)

Rudi Stern: February 13, 2002 (video)

Amy Taubin: July 2, 2000 (video)

Harvey Tavel: October 5, 2000 (video)

Ronald Tavel: November 14, 1998 (audio); November 25, 1999, September 15, 2000, and April 9, 2002 (video)

John Vaccaro: April 20, 1999, and January 11, 2001 (video)

Floriano Vecchi: January 17, 1999 (notes only)

Ultra Violet: March 31, 2001 (video)

Viva: August 31, 2001 and September 1, 2001 (video)

Amos Vogel: March 21, 2001 (video)

Chuck Wein: June 2, 1999, and October 23, 2000 (video)

Louis Waldon: March 8, 1999 (video)

David Weissman: July 2002 (notes only)

Holly Woodlawn: March 7, 1999 (video)

Mary Woronov: March 12, 1999 (audio); November 2, 1999, May 4, 2000, and April 22, 2002 (video)

Andy Warhol

Alexander, Paul. *Death and Disaster: The Rise of the Warhol Empire and the Race for Andy's Millions.* New York: Villard Books, 1994.

Bockris, Victor. *Warhol.* New York: DaCapo Press, 1989.

Bourdon, David. *Andy Warhol.* New York: Harry N. Abrams, 1989.

Giorno, John. "Andy Warhol's Movie SLEEP." In John Giorno, *You Got to Burn to Shine: New and Selected Writings (High Risk).* New York: Serpents Tail, 1994.

Koestenbaum, Wayne. *Andy Warhol.* New York: Viking, 2001.

Kramer, Marcia, ed. *Andy Warhol et al.: The FBI File on Andy Warhol.* New York: Un Sub Press, 1988.

Smith, Patrick, ed. *Warhol: Conversations About the Artist.* Ann Arbor, Mich.: UMI Research Press, 1988.

Warhol, Andy. "Nothing to Lose." Interview by Gretchen Berg. *Cahiers du Cinéma* (1967).

———. *a: a novel.* New York: Grove Press, 1998.

Warhol, Andy, and Pat Hackett. *The Philosophy of Andy Warhol: From A to B and Back Again.* New York: Harcourt Brace Jovanovich, 1975.

———. *POPism: The Warhol Sixties.* New York: Harcourt Brace Jovanovich, 1980.

———, ed. *The Andy Warhol Diaries.* New York: Warner Books, 1989.

Wilcock, John, ed. *The Autobiography and Sex Life of Andy Warhol.* New York: Other Press, 1971.

Wolf, Reva. *Andy Warhol, Poetry, and Gossip in the 1960s.* Chicago: University of Chicago Press, 1997.

Films

Angell, Callie. "Andy Warhol, Filmmaker." In *The Andy Warhol Museum.* New York: Distributed Art Publishers, 1994. *The Films of Andy Warhol: Part 2.* New York: Whitney Museum of American Art, 1994.

Blue Movie. Words by Viva and Louis Waldon. New York: Grove Press, 1970.

Hoberman, J. Introduction to Parker Tyler, *Underground Film: A Critical History.* New York: Grove Press, 1970.

James, David E. *Allegories of Cinema: American Film in the Sixties.* Princeton: Princeton University Press, 1989.

—*To Free The Cinema: Jonas Mekas and the New York Underground.* Princeton: Princeton University Press, 1992.

Koch, Stephen. *Stargazer: The Life, World and Films of Andy Warhol.* Rev. ed. New York: Marion Boyars, 1991.

MacDonald, Scott, ed. *Cinema 16: Documents Toward a History of the Film Society.* Philadelphia: Temple University Press, 2002.

Mekas, Jonas. *Movie Journal: The Rise of a New American Cinema 1959–1971.* New York: Macmillan, 1972.

O'Pray, Michael. *Andy Warhol: Film Factory.* London: British Film Institute, 1989.

Renan, Sheldon. *An Introduction to the American Underground Film.* New York: E.P. Dutton, 1967.

Sitney, P. Adams. *Visionary Film: The American Avant-Garde 1943–1978.* New York: Oxford University Press, 1974.

———, ed. *The Film Culture Reader.* New York: Praeger, 1970.

Tavel, Ronald. "The Banana Diary: The Story of Andy Warhol's *Harlot.*" *Film Culture* 40 (Spring 1966), 66.

Tyler, Parker. "Fashion or Passion: The NAC and the Avant-Garde." *Evergreen Review* 48 (August 1967).

———. Parker Tyler papers. Courtesy, Catrina Neiman.

Warhol, Andy. Interview by David Ehrenstein. *Film Culture* 40.

The Velvet Underground

Bockris, Victor. *Transformer: The Lou Reed Story.* New York: Simon & Schuster, 1994.

Bockris, Victor, and Gerard Malanga. *Up-tight: The Velvet Underground Story.* London: Omnibus Press, 1983; rev. ed., 1995.

Cale, John, and Victor Bockris. *What's Welsh for Zen? The Autobiography of John Cale.* London: Bloomsbury Publishing, 1999.

Marsh, James, dir. *John Cale.* Documentary. BBC, 1998.

McNeil, Legs, and Gillian McCain, eds. *Please Kill Me: The Uncensored Oral History of Punk.* New York: Grove Press, 1997.

Reed, Lou. *Between Thought and Expression: Selected Lyrics of Lou Reed.* New York: Hyperion, 1991.

———. *Pass Through Fire: The Collected Lyrics.* New York: Hyperion, 2000.

Saunders, Timothy Greenfield, dir. *Lou Reed: Rock and Roll Heart.* WNET Channel 13, New York.

Shore, Steven. Text by Lynne Tillman. *The Velvet Years: Warhol's Factory 1965–67.* London: Pavilion, 1995.

The Velvet Underground. Liner notes, including essay by David Fricke. Polygram Records, 1995.

Zak, Albin III, ed. *The Velvet Underground Companion.* New York: Schirmer Books, 1997.

Billy Name

Name, Billy. *Andy Warhol's Factory Photos: Factory Foto.* Tokyo: Uplink, 1996.

———. *All Tomorrow's Parties: Billy Name's Photographs of Andy Warhol's Factory.* London: Frieze; New York: DAP, 1997.

Name, Billy, and Deborah Miller. Foreword by John G. Hanhardt. *Stills from the Warhol Films*. Munich and New York: Prestel-Verlag, 1994.

Sinking Bear. Issues of 1963 and 1964, archives of the Andy Warhol Museum.

Brigid Berlin

Berlin, Brigid. "Sweets." *Grand Street* 68

Coleman, A. D. "Brigid Polk Strikes." *The Village Voice*, January 11, 1968.

Fremont, Vincent, and Shelly Fremont, prods. *Pie in the Sky*. Documentary. 2001.

Candy Darling, Holly Woodlawn, and Jackie Curtis

Curtis, Jackie. "Autobiographical Adlibs." Joe Preston collection.

———. Jackie Curtis papers. Joe Preston collection.

Darling, Candy. *Candy Darling*. New York and Madras: Hanuman Books, 1992.

———. *My Face for the World to See: The Diaries, Letters, and Drawings of Candy Darling, Andy Warhol Superstar*. Edited by D. E. Hardy, Jeremiah Newton, and Francesca Passalacqua. Honolulu: Handy Marks, 1997.

———. Candy Darling papers. Jeremiah Newton collection.

Rader, Dotson. "Twilight of the Tribe: The Wedding That Wasn't." *The Village Voice*, July 31, 1969.

Woodlawn, Holly, and Jeff Copeland. *A Low Life in High Heels*. New York: St. Martin's Press, 1991.

Joe Dallesandro

Ferguson, Michael. *Little Joe Superstar*. Laguna Hills, Calif.: Companion Press, 1998.

Gerard Malanga

Malanga, Gerard. *No Respect: New and Selected Poems 1964–2000*. Santa Rosa: Black Sparrow Press, 2001.

———. *Archiving Warhol: An Illustrated History*. New York: Creation Books, 2002.

———. Gerard Malanga Papers. Harry Ransom Humanities Research Center, University of Texas, Austin.

Taylor Mead

Anthology Film Archives. Program notes on Taylor Mead, January–February 1998.

Mead, Taylor. *Son of Warhol*. Unpublished manuscript.

———. *Anonymous Diary of a New York Youth*. New York: Self-published, 1962.

———. *On Amphetamine and in Europe*. New York: Boss Books, 1968.

Mead, Taylor. "The Movies Are a Revolution." *Film Culture* 29 (Summer 1963); rpt. in Gregory Battcock, ed., *The New American Cinema: A Critical Anthology*. New York: E.P. Dutton, 1967.

Paul Morrissey

Yacowar, Maurice. *The Films of Paul Morrissey*. Cambridge, Eng.: Cambridge University Press, 1993.

Nico

Ofteringer, Susanne, dir. *Nico-Icon*. Documentary. Fox Lorber, 1995.

Witts, Richard. *Nico: The Life and Lies of an Icon*. London: Virgin Books, 1993.

The Play-House of the Ridiculous (including Jack Smith, Ronald Tavel, John Vaccaro, and Mario Montez)

Bernard, Kenneth. "Confronting the Ridiculous." *Confrontation* (Spring/Summer 1976).

Brecht, Stefan. *Queer Theater*. Frankfurt, Ger.: Suhrkamp Verlag, 1978.

Hoberman, J. *On Jack Smith's "Flaming Creatures" (and Other Secret-Flix of Cinemaroc)*. New York: Granary Books, 2001.

Markman, Joel. "From the Writings of Joel Markman." *Film Culture* (Spring 1964).

Smith, Jack, edited by Edward Leffingwell. *Flaming Creature: The Life and Times of Jack Smith, Artist, Performer, Exotic Consultant*. New York: Serpents Tail, 1997.

Smith, Jack, edited by Edward Leffingwell and J. Hoberman. *Wait for Me at the Bottom of the Pool: The Writings of Jack Smith.* New York: Serpents Tail, 1991.

Smith, Jack. Interview by Gerard Malanga. *Film Culture* 45, summer 1967.

Tavel, Ronald. "Theatre of the Ridiculous." *Tri-Quarterly,* 6 (1966).

———. Interview by David James. *The Persistence of Vision* 11 (1995).

Tomkins, Calvin. *The Scene: Reports on Post-Modern Art.* New York: Viking Press, 1976.

Edie Sedgwick

Hennessy, Edmund. "Fresh from the Factory." *Vogue,* February 1989.

Plimpton, George, and Jean Stein, eds. *Edie: American Girl.* New York: Knopf, 1982.

Wrbican, Matt, curator. *Edie Sedgwick: Silver Hill to Silver Screen.* Exhibition at Andy Warhol Museum, Pittsburgh, June 9 to September 2, 2001.

Valerie Solanas

Harron, Mary, and Daniel Minahan. *I Shot Andy Warhol.* New York: Grove Press, 1996.

Harding, James M. "The Simplest Surrealist Act: Valerie Solanas and the (Re)Assertion of Avant-garde Priorities." *TDR* (Winter 2001).

Marmorstein, Robert. "A Winter Memory." *The Village Voice,* June 13, 1968.

Martinez, Judith Solanas. *Valerie: Child of Rage.* Unpublished manuscript. Courtesy Judith Martinez.

Smith, Howard. "Scenes." *The Village Voice,* August 1, 1977, and May 31, 1983.

Solanas, Valerie. *The SCUM Manifesto.* New York: Olympia Press, 1968.

———. Letters. Andy Warhol Museum, Pittsburgh.

Viva

Viva. "The Menopause That Refreshes." *Realist,* March 1968, p. 15.

———. *Superstar.* New York: G. P. Putnam's Sons, 1970.

———. "Viva and God." *The Village Voice.* May 15, 1987.

Mary Woronov

Woronov, Mary. *Swimming Underground: My Life in the Warhol Factory.* Boston: Journey Editions, 1995.

Other Factory Figures (including Dorothy Dean, Henry Geldzahler, Freddie Herko, Jane Holzer, Ondine, Ultra Violet)

Als, Hilton. *The Women.* New York: Farrar, Straus & Giroux, 1996.

di Prima, Diane. *The Freddie Poems.* Point Reyes, Calif.: Eidolon Editions, 1974.

———. *Recollections of My Life as a Woman.* New York, Viking, 2000.

Geldzahler, Henry. *Making It New: Essays, Interviews, and Talks.* New York: Turtle Point Press, 1994.

McDonough, Jimmy. *The Ghastly One: The Sex-Gore Netherworld of Filmmaker Andy Milligan.* New York: A Cappella Books, 2001.

Violet, Ultra. *Famous for Fifteen Minutes: My Years with Andy Warhol.* San Diego, Calif.: Harcourt Brace Jovanovich, 1988.

Warhol, Andy. *a: a novel.* New York: Random House, 1968.

Wolfe, Tom. "Girl of the Year." In Tom Wolfe, *The Purple Decades.* New York: Farrar, Straus, & Giroux, 1982.

Downtown Culture and Art World (including Max's Kansas City, sex, drugs, feminism)

Allyn, David. *Make Love Not War: The Sexual Revolution, An Unfettered History.* Boston: Little, Brown, 2000.

Banes, Sally. *Democracy's Body: Judson Dance Theater, 1962–1964.* Chapel Hill, N.C.: Duke University Press, 1993.

———. *Greenwich Village 1963: Avant-Garde Performance and the Effervescent Body.* Chapel Hill, N.C.: Duke University Press, 1993.

Bender, Marilyn. *The Beautiful People.* New York: Coward-McCann, 1967.

Clay, Steven, and Rodney Phillips. *A Secret Location on*

the Lower East Side: Adventures in Writing 1960–1980. New York, Granary Books, 1998.

Grinspoon, Lester, and Peter Hedblom. *The Speed Culture: Amphetamine Use and Abuse in America.* Cambridge, Mass.: Harvard University Press, 1975.

Gruen, John. *The New Bohemia: The Combine Generation.* New York: Shorecrest, 1966.

Lobenthal, Joel. *Radical Rags: Fashions of the Sixties.* New York: Abbeville Press, 1990.

Marwick, Arthur. *The Sixties.* Oxford, Eng.: University of Oxford Press, 1998.

Morgan, Robin. *Sisterhood Is Powerful.* New York: Vintage Books, 1970.

Newman, Amy, ed. *Challenging Art.* New York: SoHo Press, 2000.

Sanders, Ed. *Tales of Beatnik Glory.* 2 vols. New York: Citadel Press, 1995.

Sewall-Ruskin, Yvonne. *High on Rebellion: Max's Kansas City.* New York: Thunder's Mouth Press, 1998.

Sukenick, Ronald. *Down and In: Life in the Underground.* New York: William Morrow, 1987.

Chronology

Isserman, Maurice, and Michael Kazin. *America Divided: The Civil War of the 1960s.* Oxford, Eng.: Oxford University Press, 2000.

Seitz, William. *Art in the Age of Aquarius 1955–1970.* Washington D.C.: Smithsonian Institution, 1992.

Stitch, Sidra. *Made in U.S.A.* Los Angeles: University of California Press, 1987.

Teodori, Massimo, ed. *The New Left.* New York: Bobbs-Merrill, 1969.

Acknowledgments

The witnesses of the Silver Factory provided the spine and heart of this book, and I thank them for their generosity and candor in talking about this period. The many scholars whose work contributed to this book are cited in the bibliography, but I want to especially acknowledge Callie Angell for sharing her work on Warhol's films, and Victor Bockris for his work on Andy Warhol, Lou Reed, John Cale, and the Velvet Underground. At the Andy Warhol Museum, I wish to thank Matt Wrbican and John Smith for their guidance in the Warhol archives, Geralyn Huxley and Greg Pierce for their assistance with Warhol's films, and Tom Sokolowski for his overall support. Among the people who read the manuscript, I thank Stephen Holden, Paul Kaiser, Donald Rosenfeld, and Wayne Koestenbaum. Most of all I appreciate the scrupulous intelligence of Robert Atkins, who read the manuscript in *all* its stages. Deborah Chow helped manage the potentially overwhelming amount of information and became a core support in researching this book. Nathan Lee developed a maniacal connection to the Warhol cinema that rubbed off. At Pantheon, I especially thank Shelley Wanger, whose engaged imagination spurred this book. For the many stages of publishing I thank Andy Hughes, Altie Karper, Archie Ferguson, Elizabeth Woyke, Johanna Roebas, and Grace McVeigh.

I want to thank: Susan Pile for sharing her collection from the period; Judith Solanas Martinez, Diane Tucker, and Mary Harron for help on Valerie Solanas; David Weisman and John Palmer for discussion of *Ciao!Manhattan;* Roberto Guerra and Kathy Brew, for corrupting me to use digital video; Bill Kirkley and Crystal Moselle for help on Taylor Mead; Joe Preston and Craig Highberger for sharing material on Jackie Curtis; Ed Leffingwell and Jim Hoberman for help on Jack Smith; Neil Holstein and Maria Carola for help on Mickey Ruskin.

Finally, I thank many people whose assistance and support is not always easily defined: Ric Burns, Donald Rosenfeld, Jay Reeg for the 1968 Museum, Eugenio Ballou, Mason Cooley, Peter Carter, Michael Duncan and Barry Sloane, Saun Ellis and Francisco Drohojowski, Mary Jo Kaplan, Agosto Machado, Stephen Maas, Mohammad Moughal, Jeremy Tomanini, John, Janet and Philip Watson, Robert and Loranda Watson, Michael de Lisio, William Wilson, Ellen and Daniel Yaroshefsky, Mound High School, Vincent Fremont, John Perreault, Jeff Weinstein, Don Christal, Jimmy Camicia, Seramieux Joseph, Ralice Leston, Beth Groubert at Sister Ray, Susan Bachelder, Eric Mendlow, Michael Ward von Uchtrup, Tony Scherman, Maria Lopez, Ron Gilad, Tony Scherman, John Mhiripiri, Robert Haller, Carol Huebner, and Rose Marie Morse.

Permissions Acknowledgments

Grateful acknowledgment is made to the following for permission to reprint previously published material.

Advocate: Excerpts from "Gay Moviegoers Have Their Say" from *Advocate* (January 1969). Reprinted by permission of *Advocate*.

AK Distribution: Excerpts from *The S.C.U.M. Manifesto* by Valerie Solanas. Reprinted by permission of AK Press, Edinburgh, Scotland. *www.akuk.com.* www.akpress.org.

Alfred A. Knopf: Excerpts from *Edie: An American Biography* by Jean Stein and George Plimpton. Copyright © 1982 by Jean Stein and George Plimpton. Reprinted by permission of Alfred A. Knopf, a division of Random House, Inc.

Condé Nast Publications: Excerpts from "A Second Fame: Good Food" by Ninette Lyon from *Vogue* (March 1, 1965) and excerpts from "Blue Movie and Andy Warhol" by Leticcia Kent from *Vogue* (March 1, 1970). Copyright © 1965, 1970 by Condé Nast Publications. All rights reserved. Reprinted by permission of Condé Nast Publications.

Confrontation: Excerpts from "Confronting the Ridiculous" by Kenneth Bernard from *Confrontation* (Spring/Summer 1976). Reprinted by permission of *Confrontation*.

David Ehrenstein: Excerpts from "Andy Warhol Interview" by David Ehrenstein from *Film Culture #40.* Copyright © 1982 by David Ehrenstein. Reprinted by permission of the author.

Farrar, Straus and Giroux, LLC: Excerpts from "Girl of the Year" from *The Purple Decades Woman* by Tom Wolfe. Compilation coyright © 1982 by Tom Wolfe. Reprinted by permission of Farrar, Straus and Giroux, LLC.

Michael Ferguson: Excerpts from *Little Joe Superstar: The Films of Joe Dallesandro* by Michael Ferguson (Companion Press, 1998). Reprinted by permission of the author.

The Gale Group: Excerpts from *Contemporary Authors Autobiographies* by Gerard Malanga. Reprinted by permission of The Gale Group.

Georges Borchardt, Inc.: Excerpts from *Movie Journal: The Rise of a New American Cinema 1959–1971* by Jonas Mekas. Copyright © 1972 by Jonas Mekas. Reprinted by permission of Georges Borchardt, Inc.

John Giorno: Excerpts from "Andy Warhol's Movie SLEEP" from *You Got to Burn to Shine* by John Giorno. Reprinted by permission of the author.

Globe & Mail: Excerpts from "An Interview with Ondine" by Jonn Bentley Mays from *The Globe and Mail* (February 12, 1983). Reprinted by permission of *The Globe and Mail.*

Lionel Goldbart: Excerpt from the song lyric "Space Cadets" by Lionel Goldbart. Copyright © by Lionel Goldbart. Reprinted by permission of the author.

Grove/Atlantic: Excerpts from *A: A Novel* by Andy Warhol (Grove Press, 1968). Reprinted by permission of Grove/Atlantic.

Harcourt, Inc. Excerpts from *The Philosophy of Andy Warhol (From A to B and Back Again)* by Andy Warhol. Copyright © 1975 by Andy Warhol. Excerpts from *Popism: The Warhol '60's* by Andy Warhol. Copyright © 1980 by Andy Warhol. Reprinted by permission of Harcourt, Inc.

Harry N. Abrams: Excerpts from *Andy Warhol* by David Bourdon (Harry N. Abrams, New York, 1989). All rights reserved. Reprinted by permission of Harry N. Abrams.

Gerard Malanga: Excerpts from "The Secret Diaries" by Gerard Malanga from *Out of this World* edited by Anne Waldman. Excerpts from "Interview with Jack Smith" by Gerard Malanga from *Film Culture #45.* Copyright © by Gerard Malanga. Reprinted by permission of the author.

Gerard Malanga and The Kulchur Press Archive: Excerpts from "Andy Warhol: Interview by Gerard Malanga" from *Kulchur* (Winter 1964–65). Copyright © by Gerard Malanga. Reprinted courtesy of the author and The Kulchur Press Archives, Rare Book and Manuscript Library, Columbia University.

Jonas Mekas: Excerpts from an article from *The Village Voice* (April 9, 1964) by Jonas Mekas and for excerpts from an article from *The Village Voice* (April 29, 1965) by Jonas Mekas. Reprinted by permission of the author.

The New York Post: Excerpts from "Andy Warhol Fights for Life" by Jeffrey Allen from *The New York Post* (June 4, 1968). Copyright © 1968 by NYP Holdings, Inc. Reprinted by permission of *The New York Post.*

The New York Times Co.: Excerpts from "Interview with Valerie Solanas" from *The New York Times* (June 14, 1968). Copyright © 1968 by The New York Times Co. Excerpts from "So He Stopped Painting Brillo Boxes and Bought a Movie Camera" by Elenore Lester from *The New York Times* (December 11, 1966). Copyright © 1966 by The New York Times Co. Reprinted by permission of The New York Times Co.

Newsweek, Inc.: Excerpts from "Underground in Hell" by Jack Kroll (*Newsweek,* November 14, 1966). Copyright © 1966 by Newsweek, Inc. All rights reserved. Reprinted by permission of Newsweek, Inc.

Omnibus Press: Excerpts from *Up-Tight: The Velvet Underground Story* by Victor Bockris and Gerard Malanga. Copyright © 1983 by Omnibus Press, London. Reprinted by permission of Omnibus Press.

Simon & Schuster Adult Publishing Group and Victor Bockris: Excerpts from *Transformer: The Lou Reed Story* by Victor Bockris. Copyright © 1994, 1995 by Victor Bockris. Reprinted by permission of Simon & Schuster Adult Publishing Group and the author.

St. Martin's Press, LLC: Excerpts from *Low Life On High Heels: The Holly Woodlawn Story* by Holly Woodlawn with Jeffrey Copeland. Copyright © 1991 by Holly Woodlawn. Reprinted by permission of St. Martin's Press, LLC.

Illustration Credits

Index

Page numbers in *italics* refer to illustrations.